LIECHTENSTEIN
THE PRINCELY COLLECTIONS

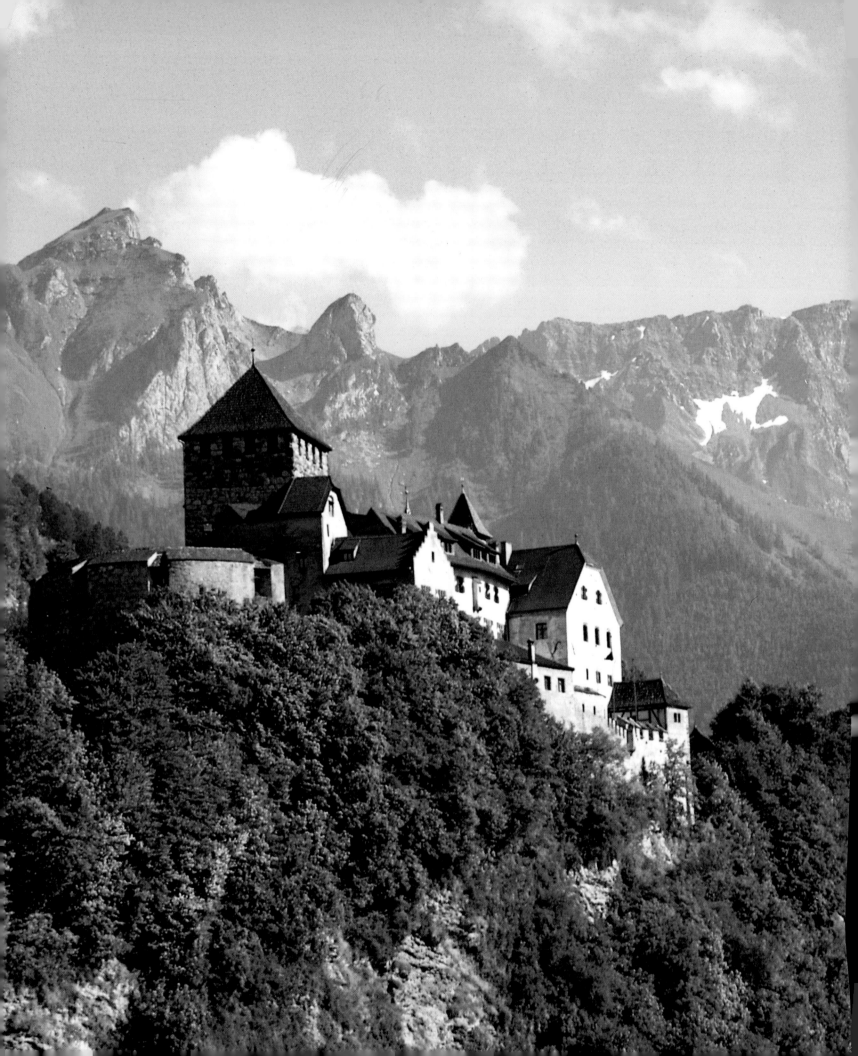

LIECHTENSTEIN
THE PRINCELY COLLECTIONS

The Metropolitan Museum of Art
The Collections of the Prince of Liechtenstein

This publication was issued in connection with the exhibition *Liechtenstein: The Princely Collections* held at The Metropolitan Museum of Art from October 26, 1985, to May 1, 1986.

The exhibition *Liechtenstein: The Princely Collections* has been made possible by IBM and The Vincent Astor Foundation.

An indemnity has been granted by the Federal Council on the Arts and Humanities.

Published by The Metropolitan Museum of Art, New York
Bradford D. Kelleher, *Publisher*
John P. O'Neill, *Editor in Chief*
Kathleen Howard, *Editor*
Stuart W. Pyhrr, *Project Coordinator*
Bruce Campbell, *Designer*

Liechtenstein maps and the chart for Franceschini cycles by Kathleen Borowik; chart for Roelant Savery's *A Bouquet of Flowers* (cat. no. 184) by Dr. Sam Segal.

All photography by Walter Wachter, Schaan, Liechtenstein, except for cat. nos. 142–43 (Geoffrey Clements, Inc., New York), cat. nos. 3–10 and 132 (Metropolitan Museum's Photograph Studio), and cat. no. 104 (Ronald V. Wiedenhoeft—Saskia Ltd.).

Translation of German texts (Introduction; "The Golden Carriage"; "The Paintings Collection"; cat. nos. 104–108, 112) by Joel Agee; translation of French text (cat. no. 121) by Richard Miller.

Type set by U.S. Lithograph Inc., New York
Printed and bound by Drukkerij de Lange/van Leer bv, Deventer, The Netherlands

Frontispiece: Schloss Vaduz, Liechtenstein
Front cover/jacket: Peter Paul Rubens, *Clara Serena Rubens* (detail from cat. no. 204)

LIBRARY OF CONGRESS CATALOGING IN PUBLICATION DATA

Metropolitan Museum of Art (New York, N.Y.)
Liechtenstein, the princely collections.

Exhibition catalogue.
1. Liechtenstein, House of—Art collections—Exhibitions.
2. Art—Private collections—Liechtenstein—Exhibitions. I. Title.
N5280.L52L56 1985 707.401471 85-11562
ISBN 0-87099-385-2
ISBN 087099-386-0 (pbk.)
ISBN 0-8109-1292-9 (HNA)

CONTENTS

FOREWORD
by His Serene Highness the Reigning Prince
Franz Josef II von und zu Liechtenstein

My family has derived the greatest pleasure and satisfaction over many generations in building up and preserving their art collections, of which a broad selection of the finest pieces is shown in this exhibition at The Metropolitan Museum of Art. I am especially pleased that the people of New York and visitors to this cultural capital of the New World should be the first to share our enjoyment of these treasures since our last major exhibition in Lucerne, Switzerland, in 1948.

I particularly welcome the opportunity given by this exhibition to scholars and art historians, including those of the Metropolitan Museum, to have direct access to so many works of art from our collections, which can, as a result, now be studied and discussed in a wider context.

A large team has contributed to the successful realization of this exhibition. I would, however, like to express my appreciation of the central role played by Philippe de Montebello, Director of The Metropolitan Museum of Art, without whose personal involvement and dedication this project would never have been realized in such a harmonious and imaginative fashion.

FRANZ JOSEF VON LIECHTENSTEIN

FOREWORD

For successive generations members of the Princely House of Liechtenstein have been devoted collectors of art. With a high degree of appreciation of artistic achievement, they have pursued a centuries-long family tradition of acquiring not only great paintings and sculpture but also rare firearms, fine porcelain, and other works of art. The result of this tradition is a collection of masterpieces that in its depth and breadth mirrors more than four hundred years of European history and ranks among the world's greatest private collections.

Only a profound commitment to keep the collections intact has enabled them to survive the political and economic crises that have continuously ravaged Europe. Consequently, not only do the collections reflect these dramatic events but they also give an insight into the history of the princely family, particularly since many of the paintings and sculptures were commissioned as a result of close personal relationships between individual family members and artists.

A few special displays of works from the collections have been held, but this is the first occasion on which so many of its masterpieces have been presented to the public. The Reigning Princes have until now been reluctant to allow these great treasures to travel. However, the increasing desire of art lovers throughout the world to discover works of art that are rarely exhibited has fortunately coincided with the refinement of a technology of transporting fragile objects to a degree that has enabled us to mount this major exhibition.

It was five years ago that H.S.H. the Reigning Prince Franz Josef II von und zu Liechtenstein, his eldest son, H.S.H. the Hereditary Prince Hans Adam, the Director of the Princely Collections, Reinhold Baumstark, and I began to explore the possibility of a full-scale exhibition. Once this fundamental decision had been taken, it was clear to us that the first showing should be in the United States and in a museum of international prominence. However, our choice of venue was to be guided not only by the reputation of the museum but also by its capacity to form an ongoing relationship that would assist us in preserving and developing the collections in future years. Initial discussions with Philippe de Montebello, Director of The Metropolitan Museum of Art, soon convinced us that the Metropolitan Museum should become our partner in this exciting event.

We could not at that time fully appreciate the extensive time and effort that the enterprise would require both in Vaduz and in New York. These efforts have, however, been enormously rewarding, due both to the incalculable value of what both parties have learned and to the personal contacts that have become friendships—enduring relationships that will help ensure future cooperation.

We are indebted to the princely family for their readiness to permit the collections to travel to the United States. The swift and enthusiastic commitment of The Metropolitan Museum of Art to embark upon this venture surely testifies to its unique capacity to host an exhibition of this kind.

The generosity of International Business Machines Corporation and the Astor Foundation have made it financially possible for the Metropolitan Museum to realize this complex undertaking. Planning for the exhibition was developed and refined at the Metropolitan Museum by Philippe de Montebello, Director, Sir John Pope-Hennessy, Consultative Chairman of the Department of European Paintings, and Olga Raggio, Chairman of the Department of European Sculpture and Decorative Arts, and in Vaduz by Reinhold Baumstark, Director of the Princely Collections. Stuart Pyhrr of the Metropolitan Museum has served as coordinator of all preparations. Important restoration work was accomplished in New York by John Brealey and in Vaduz by Hubertus von Sonnenburg. This distinguished group of people, along with their staffs, has given tirelessly of their knowledge, experience, and energy to ensure the excellence of this exhibition.

This exhibition also creates important opportunities for the country and citizens of Liechtenstein, a country founded by the princely family and named after it. I hope that the people of Liechtenstein will be able to benefit from these opportunities and also to view the Princely Collections as they are now being presented.

Our gratitude extends to everyone on both sides of the Atlantic who has worked devotedly to bring about the unveiling of the exhibition.

CHRISTIAN NORGREN, *President*
Prince of Liechtenstein Foundation

FOREWORD

The Metropolitan Museum of Art is deeply honored and privileged to have been chosen by the Reigning Prince of Liechtenstein as the venue in the United States of America for the exhibition of his fabled collection. We were not his only suitors, and we were pleased to place at his disposal the full resources of the Metropolitan—not least its curatorial staff whose expertise covers every area of knowledge required by the collection. This superb, rich, and varied panoply of paintings, sculpture, and other works of art not only represents the paradigm of a great European princely collection but also has the added distinction of being the collection of the only surviving monarchy of the Holy Roman Empire and of a princely house that traces its distinguished lineage back to the twelfth century.

The collection shown at the Metropolitan was formed over a period of three and a half centuries by Princes of the House of Liechtenstein who acquired and commissioned works of art in order to decorate their magnificent palaces, to display their rank and wealth, to make known their distinction as great collectors, and to satisfy their princely sense of noblesse oblige. These motivations ensured that the works they collected had merit as well as éclat, and their connoisseurship has resulted in the dazzling array of works currently on display at the Metropolitan Museum—objects of consummate beauty and importance.

Many masterpieces of a spectacular nature make up the Princely Collections. Most memorable, perhaps, is the great cycle of eight canvases by Peter Paul Rubens—the history of Decius Mus, the Roman consul—the only complete ensemble of this type now in private hands. The compelling portrait of the artist's daughter Clara Serena is beguiling and utterly pleasing. The soaring, monumental work of Rubens's maturity, the *Assumption of the Virgin*, is one of the revelations of the exhibition. The profusion of paintings by Dutch and Flemish masters, especially cabinet pictures, displays a propinquity of taste to that of the Hapsburgs to whom the Princes of Liechtenstein were ever loyal. The assemblage of sculpture, notably of the Florentine school, as well as two rare life-size bronzes by Adriaen de Fries, attests to the acumen and taste of the Princes.

The exhibition presents a sense of the continuum of collecting on the part of the Princes with a series of high points revolving around specific moments in the history of the House of Liechtenstein. The paintings by Marcantonio Franceschini that once decorated the Liechtenstein Garden Palace in Vienna evoke the splendor of the Princes' residences throughout Austria, Moravia, Bohemia, and Silesia. The magnificent pietre dure tables call to mind the close ties that the Princes of Liechtenstein had with the court of Emperor Rudolf II in Prague. A wealth of elaborately decorated firearms dating from the late sixteenth through the eighteenth century recalls the role of the Princes not only as aristocratic huntsmen but also as great military leaders in the service of the Holy Roman Empire. The Liechtensteins' sense of service to the Emperors and their refined taste are perhaps best symbolized by the spectacular Golden Carriage, a Rococo masterpiece of French carriage building.

The exhibition at the Metropolitan results from the benevolence of the Reigning Prince Franz Josef II von und zu Liechtenstein. At every stage in the lengthy, complicated, and interesting preparation for this display, more than three years in the making, the Metropolitan has been skillfully aided by Christian Norgren, the President of the Prince of Liechtenstein Foundation, and by Reinhold Baumstark, the Director of the Princely Collections. Without their professionalism, cooperation, and ingenuity, the exhibition would not have been possible.

Many members of the staff of the Metropolitan Museum have also greatly contributed to the organization and coordination of the exhibition. Stuart W. Pyhrr, Associate Curator, Department of Arms and Armor, has admirably orchestrated all aspects of the Museum's curatorial, conservation, editorial, design, and registrarial work, facilitated by many other members of the curatorial staff who contributed to the shaping of this exhibition and the redaction of the catalogue. The complex task of editing the scholarly catalogue has been capably carried out by Kathleen Howard, Senior Editor, Editorial Department.

Without the splendid support provided by IBM and The Vincent Astor Foundation, who recognized the importance of the project very early on, as well as the indemnity granted by the Federal Council on the Arts and the Humanities, this exhibition would not have been possible, and the Museum's gratitude to all three is immeasurable.

PHILIPPE DE MONTEBELLO, *Director*
The Metropolitan Museum of Art

Fig. 1 Liechtenstein Castle near Maria Enzersdorf, south of Vienna, was the first seat of the Liechtenstein family.

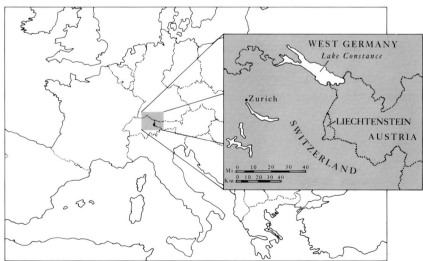

Fig. 2 Europe (present boundaries)

INTRODUCTION

I. A HISTORICAL OVERVIEW

Liechtenstein is one of the smallest European states, a principality situated between Austria and Switzerland in the Upper Rhine Valley, and it is the only surviving monarchy among German-speaking countries. The nation is less than three hundred years old, but the ruling family whose name it bears traces its lineage back to the early Middle Ages. The family's importance in the history of the Holy Roman Empire may seem incomprehensible today in view of the dimensions of present-day Liechtenstein. But the territory that makes up the principality did not form part of the family's sphere of influence until fairly late in its history, nor did the family take up residence there until recently. Although the country was meant to embody the sovereignty of the House of Liechtenstein, it did not, for a long time, play a major role in the actual destiny of its rulers.

The rise of the House of Liechtenstein took place in the constituent countries of the Hapsburg monarchy, Austria, Moravia, and Bohemia. Their capitals, Vienna, Brünn, and Prague, were the centers of its activities. The Princes of Liechtenstein were always noted for their influence, wealth, and position, and the members of this House succeeded over several generations, by dint of great tenacity and astuteness and some good fortune as well, in reaching and sustaining a position of singular splendor and power. They were always counted among the foremost followers and supporters of the Dukes of Austria, the Kings of Bohemia, and the Holy Roman Emperors. Again and again, in the more than eight-hundred-year-old history of the House, one encounters Liechtensteins whenever the fate of Austria and of the Hapsburg monarchy was weighed and decided, wherever politics and war, economics and art called for the enterprise of remarkable individuals. Today, when several of the countries they once administered and fought for are no longer shown on maps, when the royal families they once served no longer hold power, and when their own sphere of influence has been curtailed by the restructuring of Europe after World War II, the Princes of Liechtenstein have nevertheless been able to preserve their sovereignty. The Principality of Liechtenstein and its rulers represent a last, living branch of the Holy Roman Empire.

The history of the House of Liechtenstein began in the twelfth century with the erection of a mighty castle near Maria Enzersdorf, south of Vienna. The building, set on a narrow chalk cliff six hundred feet high, is visible far and wide and is known as the "*lichte Stein*," the stone of light. This castle is the family's ancestral residence, and the name "Liechtenstein" derives from it. The castle also evidences the position its founders once held in the medieval class system as lords (*domini*). As members of the aristocracy, they were expected to participate in warfare as well as to assist in the administration of the government of the realm. The Liechtensteins excelled in both areas, devoting their services first to the Babenbergers and later to their successors—the Hapsburgs—as Dukes of Austria. As early as 1249, their lands extended into Moravia and thus into the realm of the crown of Wenceslaus, the territory formed by the lands of the Margraves of Moravia and the Kings of Bohemia. This alignment with both Lower Austria and Moravia, and thereby with their rulers in Vienna and Prague, was the essential driving force behind the House of Liechtenstein's astounding growth in wealth and influence through the centuries. These divided spheres of interest naturally gave rise to tensions, and not until the Danube Monarchy eliminated the political differences between these countries did the Liechtensteins' century-long balancing act between competing claims of loyalty and politics reach a stable equilibrium.

As far back as the Middle Ages, the Liechtensteins regularly succeeded in advancing to the post of High Steward (*Obersthofmeister*), the highest position that could be attained within the monarch's immediate retinue. The High Steward acted as the monarch's right hand in all administrative matters. Usually the person who held this post also presided over the Secret Council, where political plans were made and actions decided upon. The first member of the House to attain this position was Johann I von Liechtenstein. For more than twenty-five years, beginning about 1368, he served the Hapsburg Duke Albrecht III of Austria as *magister curiae*. In the early fifteenth century, Heinrich V von Liechtenstein held the same post under Duke Leopold of Austria. In 1584 Heinrich IX became High Steward to Archduke Matthias, and in 1600 Emperor Rudolf II appointed Karl von Liechtenstein (who later was given the rank of Prince) President of the Secret Council. The appointments to the High Steward's office continued with Prince Gundaker under Emperor Ferdinand II (beginning in 1624), with Prince Anton Florian under Emperor Joseph I (1695) and under the future Emperor Charles VI (1703), and with Prince Emanuel under Empress Amalie (1743). Even when the Hapsburg Monarchy came to an end and the old forms of service were reduced to purely ceremonial functions, it was again a Prince of Liechtenstein, Rudolf, who held the High Steward's office under Emperor Franz Josef II (1896). The history of the House of Liechtenstein rests on these pillars of a tradition that spurred individuals to uphold the examples of previous generations.

Two Liechtenstein buildings, in addition to the ancestral castle, provide further tangible evidence of the medieval history of the House of Liechtenstein from its earliest beginnings be-

fore its ascent to great wealth and power. The first of these is the round church of Saint John at Petronell, a jewel of mid-twelfth-century Austrian Romanesque architecture. The manor and village of Petronell (the Roman *Carnuntum*), built on an ancient encampment of a Roman legion next to one of the most important crossing points on the Danube, came into the possession of Hugo von Liechtenstein, the earliest recorded member of the House, in 1142. He probably built the church, which is a remarkable monument to the Liechtensteins' early presence in Lower Austria. Situated on a hill above the plain, the church formed part of the village's fortifications and was designed to offer a place of refuge and military defense in times of war. The round main building and its semispherical apses are conjoined like the turrets of a castle, and their narrow apertures reflect the defensive character of the structure. The carefully chiseled stonework, on the other hand, as well as the half-columns and a round-arched frieze provide purely decorative elements. The stark beauty and enduring solidity of this fortified church are highly symbolic of an aristocratic knight's world.

While Petronell is about half a day's ride from the ancestral castle of Liechtenstein, the second building—the Torre Aquila of the Castel del Buonconsiglio in Trent (in the Lombard region of Northern Italy)—demonstrates even more dramatically the geographical breadth of the family's achievement. Georg III von Liechtenstein was appointed Bishop of Trent in 1390, after excelling as provost of the Cathedral of Sankt Stephan in Vienna and as chancellor of the University of Vienna. In his capacity as Prince-Bishop, he was the first Liechtenstein to be granted the title and prerogatives of a *principe*. In the family's history throughout the centuries, he is also the only member who ever attained a high position in the Church. The Torre Aquila, a gate tower that formed part of the fortifications of the Prince-Bishop's castle, still contains the most precious artistic legacy of Georg von Liechtenstein—a famous fresco cycle of the months, festive scenes full of colorful details and great cultural interest. These images depict the labors of the peasants—sowing, reaping, storing—during each month, and they are juxtaposed with the enjoyments of the nobility, such as hunts, tournaments, and amorous games. This fresco cycle must have been created before 1407, the date of the first of several revolts against Georg von Liechtenstein by the people of Trent in the course of which he repeatedly fell into captivity and his see became embroiled in military struggles that had a bearing on the whole empire. Even though these conflicts forced Georg von Liechtenstein to take up the sword, he is remembered as a man of knowledge and refined sensibility, the patron of one of the finest examples of art in the courtly International Style of the years around 1400. The Liechtensteins had risen from the beginnings of independent knighthood to membership in the court aristocracy. The prominence of the nobility in the frescoes of Torre Aquila is representative of their own social position as well.

The continued rise of the Liechtensteins and, in addition, the emergence of several family branches eventually produced a need to strengthen and unify the House. In 1504 the first of several family treaties introduced a system of seniority, placing leadership in the hands of the oldest member of the family in order to prevent the family's estates from being split up. These regulations, however, failed to produce an enduring effect. About a hundred years later, therefore, a new agreement was reached, an accord that must be regarded as a turning point in the modern history of the House. On September 29, 1606, the brothers Karl, Maximilian, and Gundaker von Liechtenstein signed a treaty at Feldsberg Castle, which decreed that the family's estate was to be entailed as a whole and could not, therefore, be alienated, devised, or bequeathed. According to the rules of primogeniture, the right of succession would go to the first-born male descendant, who would assume "rulership" of the House and hence responsibility for the family's interests. Extensive decision-making powers were granted to him for this purpose. With this concentration of the estates under one leader, the three brothers laid the foundation upon which the continued existence and independence of the House of Liechtenstein still rest. Today, as in 1606, primogeniture determines the rulership of the House, and after the entail became extinct in 1938, it was replaced with a family foundation, thus effectively adapting to modern conditions the old ground rules of keeping the family's estates unified.

Karl, Maximilian, and Gundaker had not only acted in fraternal accord, but they had also wisely prepared for the most decisive event of all: the elevation of the House of Liechtenstein to princely rank. The importance of these three members of the House is particularly evident in that each of them achieved distinction in his own right. In 1608 King Matthias accorded the status of Hereditary Prince to Karl von Liechtenstein, and in 1623 Maximilian and Gundaker received the same honor at the hands of Emperor Ferdinand II. Elevation to the rank of Prince was the highest dignity the Emperor could bestow; the Liechtenstein brothers received it in recompense for their unstinting commitment to the House of Hapsburg at a time of extreme danger to the empire and to the imperial family. Karl, who between 1600 and 1607 had served Emperor Rudolf II as High Steward and thus as Prime Minister and closest confidant, and who had also been Governor of Moravia, had already been honored, in 1607, with the title of Grand Palatine (*Pfalzgraf*). This ceremonial honor entitled him to mint coins, bestow titles, and name cities and to exercise other functions that remain prerogatives of the dynasty to this day. In the political chaos that occurred as a result of Emperor Rudolf II's temporary incapacity to govern, followed by a quarrel with his brother Matthias (the heir to the throne), Karl von Liechtenstein put not only all the weight of his prestige but also all his discernment as a statesman to bear in the cause of Matthias. This step, however disappointing and even tragic its implications were for the Emperor in Prague, had become the unavoidable price of

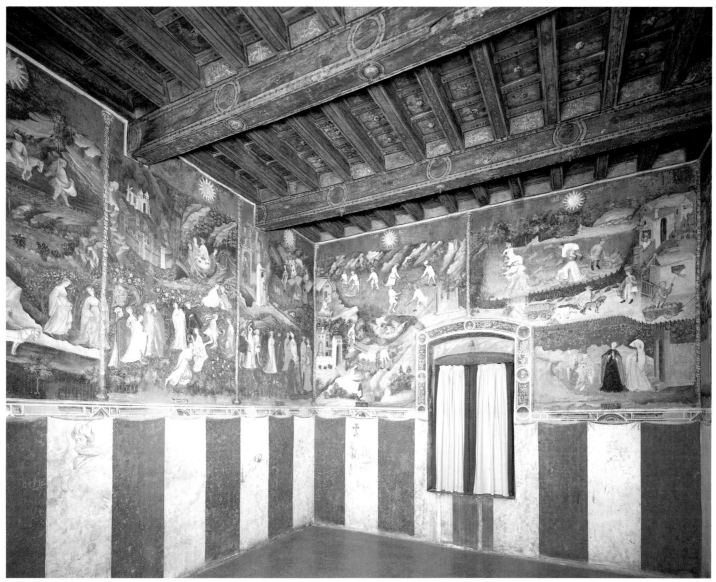

Fig. 3 Interior of the Torre Aquila, Castel del Buonconsiglio, Trent. Painted for Georg von Liechtenstein, Bishop of Trent, shortly before 1407, the decorative frescoes depict the cycle of the months.

preserving the monarchy's hold on the Danube countries. In recognition of his accomplishments during years of faithful service and in the hours of dangerous decisions, Matthias elevated Karl von Liechtenstein to Prince, the rank for which Rudolf II had already prepared him with his appointment as Grand Palatine.

Maximilian and Gundaker, too, had offered their services to their country and Emperor at the outbreak of the Thirty Years' War (1618–48). Maximilian served as Imperial Court Counselor and Chief Equerry to Emperor Matthias and later as one of the foremost military leaders of the empire. Gundaker became a master of pragmatic statesmanship, which he first practiced as Governor of Upper Austria, then as Marshal of Lower Austria, repeatedly as Imperial Ambassador, and finally as President of the Imperial Chamber of Deputies, and—following in

the footsteps of his brother Karl—as High Steward. Although the elevation in rank of the three brothers was, in the main, a reward to them personally for their deeds and services and an acknowledgment of their exceptional character, it accrued, by virtue of its hereditary nature, to their House as well: their entire issue, both male and female, were entitled to carry princely rank. Thus the family treaty of 1606 and the entitlements, the personal attainments, and the imperial accreditations join together like bridgeheads to form a sturdy and enduring structure across the stream of family history. Although Maximilian died childless and Karl's line became extinct in the fourth generation, Gundaker's branch continues to thrive on the family tree in the present day.

Princely status, however, was not just a matter of title and rank, of splendor and power. It was a condition that trans-

formed the individual as much as it did his House and impressed itself upon all areas of private and public life. Being a Prince of the Holy Roman Empire implied ancient lineage and the possession of a territory extensive enough to allow its owner to exercise his rights in a sovereign manner, subject in the final analysis only to the approval of the monarch. And although the Liechtensteins had good reason to be proud in regard to the first condition, it is interesting to note that Karl I, as a Prince and as ruler of his House according to the family treaty of 1606, nevertheless conducted intensive genealogical research. Well-known historians were commissioned to record the succession of generations in the Liechtenstein family as far back as they could be traced, and the Prince expressly set great value on verified documentation, to a degree that appears quite modern. The fruit of these efforts was published in 1621 in Ingolstadt under the title *Genealogia illustrissimae familiae Liechtensteiniae a Nicolspurg etc.* by Hieronymus Megiser.

As for a Prince's claim to an appropriately extensive domain, the House's territories in Austria and Moravia were hardly adequate, though they had grown considerably. For this reason, six years after raising Karl von Liechtenstein to the rank of Prince, Emperor Matthias awarded him the Duchy of Troppau in order to provide Karl with the economic and territorial basis consistent with "the exercise of his princely status," as the deed of conveyance expressed it. In 1623 Emperor Ferdinand II bestowed upon Karl the Duchy of Jägerndorf, a territory (like Troppau) situated in Silesia. Now Karl, like every subsequent ruler of his House, bore the title of Duke of Troppau and Jägerndorf in addition to that of Prince of Liechtenstein. The assumption of rulership over a particular territory was reflected in the House's heraldry, newly designed at that time. It lives on today in the family's present coat of arms as well as in the Great State Coat of Arms of the Principality of Liechtenstein.

Prince Gundaker, too, was concerned with finding territorial holdings appropriate to his rank. In 1622, he had acquired the domains of Kromau in Moravia and of Ostra in Hungary, and eleven years later, Emperor Ferdinand II elevated these lands to the status of a principality with the name of Liechtenstein. But this first country to bear the name of the dynasty had one fundamental political disadvantage—which was also true of the duchies of Troppau and Jägerndorf. These territories did not permit their rulers a seat and a voice in the Council of Princes (the *Fürstenbank*), which was part of the Imperial Diet, the permanent representation of the Holy Roman Empire in Regensburg. Such a seat, with its visible political participation in the decision making of the empire at the highest level, was reserved for a small number of Princes and was, furthermore, linked to the possession of territory that was subject to the Emperor only. Admission to the Council of Princes in Regensburg was the missing link in the long line of honors and the House's social elevation, and it was toward this goal that the energy of the House of Liechtenstein was directed during the following generations.

Only at the end of the seventeenth century did an opportunity present itself; the time was, once again, a moment when the future of the dynasty depended on foresight and decisive action. On the southwestern border of the empire, an area run down by its owner was being offered for sale. This small territory was virtually infertile with only a few inhabitants living in the villages, and a large part of the land was mountainous and impassable. Possession of such a territory was hardly conducive to the splendor of one's House, and yet it was a territory subject only to the Emperor. In 1699 Prince Johann Adam Andreas, the grandson of Karl I, bought a portion of the land, the Schellenberg domain, for 115,000 florins. In 1712 he acquired the County of Vaduz, and with it the rest of the territory, for 290,000 florins. The Prince was not able to experience the success of his enterprise, however, because he died the same year that he purchased Vaduz. But the goal of his House had been attained. In 1713 the Prince of Liechtenstein received a seat and a voice in the Council of Princes, and on January 23, 1719, Emperor Charles VI elevated the united territories to the status of Principality of Liechtenstein and to membership in the Holy Roman Empire. This event was the crowning achievement in the determined rise of the House of Liechtenstein.

———

Another constant feature in the history of the House of Liechtenstein is its permanent readiness to offer its services to the Austrian army. An aura of chivalrous prowess surrounds the dynasty's earliest recorded deeds, and again and again old sources stress the daring exploits of individual Liechtensteins fighting on the side of their sovereign. One of those whose life's work was fulfilled in military service was Georg VI von

Fig. 4 Paul Loebhart (1774–1850) and Matthäus Waniek (d. 1834), *Interior of the Imperial Arsenal in Vienna (1818)*, watercolor, 12½ × 21⅞ in. (31.9 × 55.4 cm.). The monument honoring Prince Joseph Wenzel von Liechtenstein seen in its original setting (see cat. no. 111). Heeresgeschichtliches Museum, Vienna

Liechtenstein (1480–1558). Beginning at the age of nineteen, he fought on the side of Emperor Maximilian I, initially in the war against the Swiss and then in the Northern Italian campaigns against Venice. For a while he held the rank of a Commander in Chief. As late as 1529, when the Turks laid siege to Vienna for the first time, Georg von Liechtenstein was among the besieged city's military leaders. His sepulcher in Saint Michael's Church in Vienna shows the commander of a mercenary troop in full armor, with an open visor, a sword in one hand and an unfurled flag in the other. He lives on in memory as the liege of Maximilian, the "last knight."

In 1502 Georg von Liechtenstein became the Emperor's Grand Master of Artillery and entered into a field of weapons technology in which members of his House would continue to excel. A hundred years later another Liechtenstein, Karl I's brother Maximilian (1578–1643), served under King Matthias (beginning in 1608) and Emperor Ferdinand II (beginning in 1620) as Grand Master of the Ordnance. Numerous manuscripts in the Princely Archive, written in Maximilian's own hand, document his growing technical expertise and his pioneering spirit in artillery development. A century later the Liechtenstein contribution to the use of artillery as a mobile and effective weapon reached its zenith in Prince Joseph Wenzel (1696–1772), the "father of the Austrian artillery."

Prince Joseph Wenzel, ruler of the Princely House since 1748, was one of the great figures in the history of his family. A man of many talents who made his mark with brilliant missions to the courts of Europe, he was a born soldier. He began his military career under Prince Eugene of Savoy, who as the great victor over the Turks decorated Joseph Wenzel outside the city of Belgrade in 1717. In the years to come, Prince Joseph Wenzel rose to the rank of Cavalry General, Field Marshal, and Generalissimo of the Austrian army in Northern Italy. There, in Piacenza, in 1746 he led the Austrian troops against the united forces of France and Spain to their first victory under the rule of Empress Maria Theresa, thus securing Austria's hegemony in Northern Italy for the next half century. Of even more far-reaching military importance was the reorganization, indeed the virtual recreation, of the imperial artillery under Joseph Wenzel's direction, beginning in 1744 and continuing until the end of his life in 1772. Commissioned by the Empress as Director General of Artillery, he was in charge of the monarchy's entire gunnery. Heading a staff of experts he had convened from all parts of Europe, he improved the quality of the troops' theoretical and practical training. Even more important were the technical innovations that he introduced—among them the standardization of both caliber and carriage design. The Prince invested large sums in his artillery projects, and he used one of his own estates, Ebergassing, as terrain for shooting and drill ranges, laboratories, and workshops for the casting and boring of bronze cannon. The "Liechtenstein artillery," the Prince's life work, successfully passed the test of battle in the Seven Years' War (1756–63). From then on, his system was adopted

by all the great European powers. Not only did the "Liechtenstein reform" put its stamp, with only minor changes, on the artillery used in the Napoleonic Wars, but it was also maintained as the standard design for most armies until the middle of the nineteenth century. No other enterprise connected with the name of Liechtenstein has proved to be as forward-looking or as influential as this one.

Prince Joseph Wenzel's contemporaries did not fail to recognize the worth of his achievements. When King Frederick II (the Great) of Prussia (a friend of the Prince, despite their opposition in war, since their joint military training under Prince Eugene) lost the Battle of Kolin (1757) due to the effectiveness of the artillery designed by the Prince, he made the following statement: "The Austrian artillery is outstanding; it gives great honor to Liechtenstein." The Empress's expression of gratitude was unprecedented in the history of the monarchy: a year after the Austrian victory at Kolin, Maria Theresa commissioned the sculptor Balthasar Ferdinand Moll to create a life-size, gilded bronze bust of the Prince, and she had it installed in the Vienna arsenal as a monument to a living hero. It was surrounded by an arrangement of various weapons and accompanied by an explanatory inscription. Moll's bust (cat. no. 111) evokes both the proud appearance and the illustrious memory of a man whose triumphant claim to public renown is unequaled in the history of the family.

Though the history of Liechtenstein is rich in records of martial exploits by individuals, this introduction is not the appropriate place to examine them all in detail. Instead, we shall turn our attention to the vicissitudes of war as they have affected the destiny of the House of Liechtenstein. The great crises of Europe have left indelible marks on the history of the House. One such turning point was the outbreak of the Thirty Years' War (1618–48). The war began with a rebellion in Bohemia and Moravia that threatened imperial authority and the supremacy of the Catholic Church in those areas. During this time of great political, religious, and social upheaval—when everything could be gained or lost—the brothers Karl, Maximilian, and Gundaker von Liechtenstein cast their lot with the Emperor and lent support to the badly beleaguered Imperial House. When the allied imperial troops marched to Prague, the two older brothers held important positions. Prince Karl, the highest-ranking civilian, was an imperial commissar in charge of coordinating the political and military leadership, while Maximilian was a colonel in the army. The decisive victory at the Battle of the White Mountain on November 7, 1620, which sealed the fate of the rebels, was in part due to the two Liechtenstein brothers. Karl I had addressed the hesitant military leaders in a war council, urging them to accept a battle at Prague, and Maximilian himself took the place of the imperial Commander in Chief, who had become ill. According to contemporary reports, Maximilian risked his life at a decisive moment, charging at the head of his cavalry regiment, thus contributing greatly to the Emperor's victory.

Fig. 5 Europe in 1797

In the ensuing reign of the victors, a central role fell to Prince Karl von Liechtenstein. His task was to conduct the trial of the rebels and to supervise their execution. The ensuing correspondence between Karl and Emperor Ferdinand II, concerning not only the rebels' trial but also important questions of administration in conquered Bohemia, indicates that the Prince had to follow the Emperor's instructions even in small details. Karl's appeals for clemency were rejected in Vienna. The monarch's decision was to establish a deterrent by inflicting merciless retribution on the rebels.

In 1622 Karl von Liechtenstein was appointed Viceroy and Governor of Bohemia, a position that made him the Emperor's representative in Prague. One of his functions was to supervise the confiscation of the rebels' estates on behalf of the Emperor. This time of upheaval offered him and his brothers, whose financial circumstances were far sounder than those of the Imperial House, a variety of opportunities for acquiring property. By means of wise purchases, by imperial investitures, and by the receipt of land against unredeemed loans to the Emperor, they succeeded in expanding their estates to five times their original size. With the support of an already considerable family fortune, the Liechtensteins applied their economic acumen to take advantage of the moment. Had the House of Liechtenstein fought on the side of the rebels, its history would probably not have continued into the present. But at this time its economic foundation was laid for the flowering of succeeding generations, for the proverbial splendor of the Liechtenstein dynasty. Just as in previous centuries, loyalty to the Imperial House had determined its course of action; it was now rewarded by the honor of the princely rank. Thus, emerging from the

troubled years of wars and politics, the House of Liechtenstein attained greatness.

On a later occasion the fate of the Liechtensteins was by contrast decided in the aftermath of military defeat. The Holy Roman Empire in the early nineteenth century had collapsed under the onslaught of Napoleon's troops. During those years when far-reaching historical decisions were made on the battlefields and when Europe had become a stage for the mobilization of armies, the House of Liechtenstein produced a man who must be regarded as the greatest soldier in its history. Prince Johannes I von Liechtenstein (1760–1836) became a professional soldier in his twenty-second year. He served in the Turkish Wars under Emperor Joseph II, and he fought in the revolutionary wars against France. He rose swiftly in the military hierarchy and ended his career as Field Marshal and Generalissimo of the Austrian army. Indeed, he is remembered as one of the last great cavalry leaders in European history.

After his victory at Austerlitz (1805), Napoleon required that Prince Johannes I, as representative of the Emperor, should mediate the armistice and peace negotiations. In the course of long discussions, the two men came to know and probably to respect one another. The degree of esteem in which Napoleon held the Prince after these talks was demonstrated when Napoleon asked for a meeting with Emperor Franz II to which Johannes von Liechtenstein was the only other person admitted. Napoleon and the Prince met on a second occasion during the negotiations leading to the Peace of Pressburg (1809). In that year Austria had again lost a war against the French, but together with its various lost battles Austria had succeeded in inflicting on Napoleon his first defeat on the battlefield, at Aspern on May

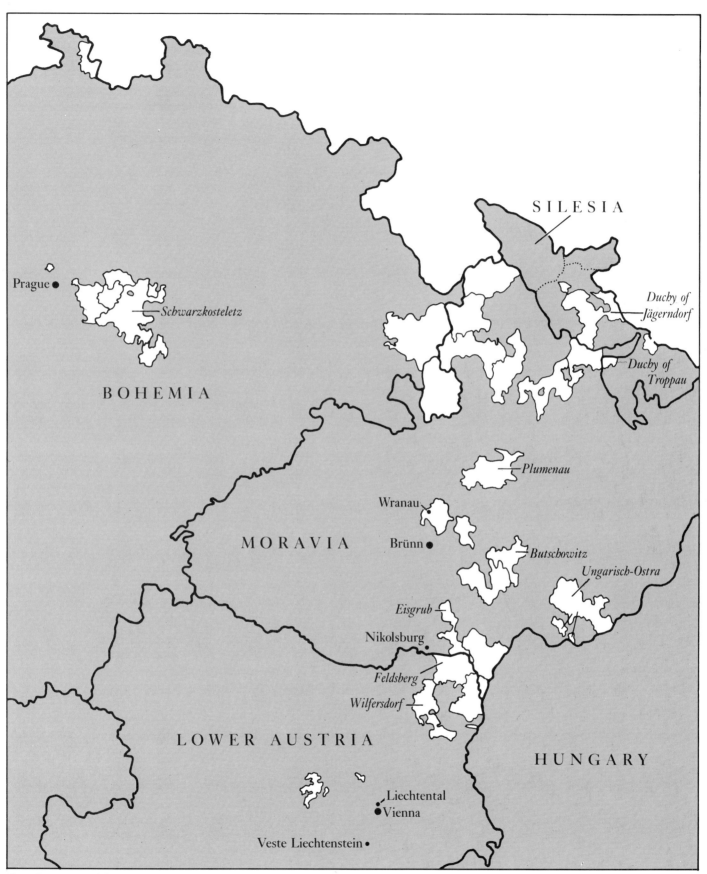

SILESIA

Prague ●

—Schwarzkosteletz

BOHEMIA

Duchy of
Jägerndorf

Duchy of
Troppau

Plumenau

Wranau
●

MORAVIA

Brünn ●

—Butschowitz

Ungarisch-Ostra

Eisgrub

Nikolsburg
●

Feldsberg

Wilfersdorf

LOWER AUSTRIA

HUNGARY

Liechtental
● Vienna

Veste Liechtenstein ●

Fig. 6 Properties of the Reigning Prince in 1797

21 and 22, 1809. Prince Johannes I had contributed decisively to that victory at the head of his mounted troops. Now, in the peace negotiations with Napoleon, the Prince made tenacious and ultimately successful efforts to soften the conditions set by the French victor. But he was profoundly disappointed when his labors were only half-heartedly acknowledged by Emperor Franz II; as a result, at the pinnacle of his career he took leave of the army and devoted the rest of his life to the private concerns of his House, whose ruler he had become in 1805.

Behind the battlelines, the reshaping of the Continent during the Napoleonic era had resulted in circumstances that proved highly significant for the future of the House of Liechtenstein. On July 12, 1805, the Principality of Liechtenstein, the territory originally acquired by Prince Johann Adam, was included in the Confederation of the Rhine, an alliance of German countries under the French protectorate. The members of this confederation were required formally to declare their withdrawal from the Holy Roman Empire, in exchange for which they rose to sovereign status, although only by the grace of Napoleon. It is a quirk of history that Napoleon, by granting sovereignty to the Principality of Liechtenstein, honored and furthered the cause of one of his most determined adversaries on the battlefield. One motive may have been respect for the Prince's chivalrous deportment, but probably it was also a diplomatic chess move. Prince Johannes was wise enough not to reject this political recognition of his country and thus of the House of Liechtenstein, but he made his loyalty to the Austrian camp unmistakably clear. He appointed his youngest son, the three-year-old Prince Karl, as the Principality's ruler, while nevertheless acting as the child's regent. To prevent the inhabitants of Liechtenstein from having to fight on the side of Napoleon, as was stipulated by the confederation's treaty, a contingent of soldiers from Nassau was hired.

Thus a new chapter in Liechtenstein history began. The Principality was recognized as a sovereign state, despite the disintegration of the Holy Roman Empire and the absorption of its many small constituent entities into larger states. As if by a miracle, Liechtenstein escaped this fate, to which it had seemed doomed by its small size. It rose from the ruins of the old empire as a small autonomous state, needful of protection yet capable of preserving its sovereignty even when Napoleon's empire collapsed, taking with it the power blocs he had created, among them the Confederation of the Rhine. In 1815 the Principality of Liechtenstein joined the newly founded German Confederation, the successor of the Holy Roman Empire in the form of a union of "sovereign Princes and cities of Germany." Liechtenstein was thus still part of a larger nation, and during the nineteenth century, a chapter in the history of German constitutional law—the step-by-step introduction of democratic rights—was played out in Liechtenstein as well. For example, delegates of Liechtenstein were represented in the first German parliament, the National Assembly in Frankfurt, whose members were all elected by the people.

The Princes of Liechtenstein emerged with increased strength from the vicissitudes of a war that had introduced a new European order in the seventeenth century and again in the early nineteenth century. Not only had they increased their possessions and prestige, but in addition they had been accorded the rank of sovereign monarchs. And yet the House was not immune to the tribulations of fate. In World Wars I and II, the Principality of Liechtenstein and its rulers were able to declare their neutrality and avoid immediate involvement in the armed struggle, though neither the country nor its House was wholly spared the afflictions and arbitrary rulings that followed in the wake of these conflicts. In 1918 the House of Hapsburg, with which the Liechtensteins had been allied for centuries, was forced to abdicate, and the Danube Monarchy splintered into individual successor states. The Princely House now found its interests and domains divided between the two young republics of Austria and Czechoslovakia. The Treaty of Versailles (1919) redefined the border between these two countries, and as a result the Lower Austrian domain of Feldsberg, the Liechtenstein dynasty's ancestral seat since 1387, became part of Czechoslovakia. At the same time the Czech land reform of 1919 deprived the House of Liechtenstein of more than half of its landed estates, which before the collapse of the Danube Monarchy had comprised more than twelve times the area of the Principality of Liechtenstein, or approximately 700 sq. mi. (1,800 sq. k.). However, the family's patrimony of castles and palaces, which had been built and preserved throughout the centuries, was left untouched. In addition, the House of Liechtenstein continued to exert a powerful influence on the cultural and economic life of the former regions of Bohemia and Moravia. But the end of World War II also brought the end of the Liechtensteins' presence in Czechoslovakia. The Iron Curtain, which since then has cut off Eastern Europe from the West, disrupted as well a chain of tradition that, for the House of Liechtenstein, reached back to 1249, the year when it acquired its first lands in the area then subject to the crown of Wenceslaus. Not only was 85 percent of the House's physical holdings expropriated, but also much of the aura of Liechtenstein history, relics of sovereign authority and cultural enterprise, of courtly elegance and connoisseurship, was lost as well. These include the family's baroque ancestral residence, Feldsberg Castle; the magnificent nineteenth-century castle of Eisgrub with its famous gardens (Liechtenstein property since 1370); Butschowitz Castle, the gem of Moravian Renaissance architecture (since 1597); the palace of Plumenau (since 1602); the medieval castle of Sternberg (since 1695); as well as the castles of Rabensburg, Aussee, and Ullersdorf (since 1385, 1597, and 1802 respectively). Other castles and palaces that had once made up the great Liechtenstein estates throughout Bohemia, Moravia, and Silesia were also lost. So too was Wranau, the monastery church above the three-hundred-year-old crypt where, beginning with Prince Karl I, all the rulers of the House and their closest family members have been buried. The House of

Liechtenstein was thus cut off from its historic roots and was struck to the very core of its existence.

Immediately after Germany's annexation of Austria in 1938, Franz Josef II von Liechtenstein, who was then Prince Regent, moved his residence to Vaduz, the capital of the Principality of Liechtenstein, in order to emphasize the neutrality of his country. It was the first time in Liechtenstein history that a Prince—he became the ruler just a few months later—had taken up residence in the country that had borne the name Liechtenstein ever since the family had acquired it more than 250 years earlier. Prescient though his decision was in view of the threat of worldwide conflict, he could not foresee the fateful historical meaning his move would acquire in the aftermath of the war. Once the family's possessions and estates in Czechoslovakia had been lost, the Principality offered a guarantee of independence and sovereignty. Though the foundation had become smaller, it consisted of an independent state, which after the war won the respect of people all over the world for its traditions and the flowering of its economy. And even though so much of the princely heritage had been lost, the Viennese palaces had been preserved, as had the artistic treasures of the House. During the final months of World War II, under perilous circumstances and at the risk of the lives of those involved, the Princely Collections were transferred to the neutral principality of Liechtenstein. They have since been kept at the princely family's residence, as they had been over the previous centuries.

II. SYMBOLS OF PRINCELY RANK

The elevation of the House of Liechtenstein to princely rank in 1608 was not only an honor but also a challenge. The House had to prove the worthiness of its elevated status in the eyes of its contemporaries, and the new rank had to be reflected in the bearing of the Prince in society and demonstrated by a conspicuous display of courtly style. The rapidly growing princely household, for instance, provided a framework for the Prince's social appearances and for his exercise of the prerogatives of his position. The Prince's bodyguard and court musicians, the stables, the treasury, the art collection, and also the chancelleries that administered the newly acquired duchies were used to reflect the splendor of the Princely House. The dynasty's position, its claim to territorial dominion, and its proof of aristocratic lineage were given visible expression by a princely coat of arms. The new heraldry appeared on Liechtenstein buildings, distinguished precious objects in the collection, was used as a seal on official documents, was minted on the reverse of Liechtenstein coins (and thus was given wide circulation), and was proudly displayed on the ceremonial halberds carried by the Prince's bodyguard.

The most impressive symbol of the new dignity was the crown of the House of Liechtenstein. Ever since Karl von Liechtenstein was elevated to the rank of Prince in 1608 and made Duke of Troppau in 1614, both he and his successors were entitled to wear the traditional Prince's bonnet (*Fürstenhut*), a tall red hat with a scalloped, turned-up brim of ermine. This insignia was now placed above the Liechtenstein coat of arms. But Prince Karl's ambition to possess a fitting regalia for his dynasty reached beyond that. In 1623, a politically significant year (Jägerndorf was acquired as an additional duchy and the Prince's dominion over Troppau was reaffirmed), Prince Karl commissioned the making of a ducal crown whose pretensions were extraordinary even for that time. The crown consisted of a tall hat of red velvet encircled by a broad gold band with foliate finials set with an abundance of diamonds, rubies, and pearls. The basic form of the crown was modeled on the Austrian archducal crown of 1616, which also combines a velvet hat and a jeweled metal crown in a single unit, but the crown made for Karl I was distinguished by an even more exuberant display of splendor and a more extravagant form. Indeed, the gem-studded band of the Liechtenstein crown with its lily-like finials was inspired by that on the famous crown of Emperor Rudolf II, made in Prague in 1602, when Karl von Liechtenstein was serving the Emperor as High Steward. Thus the Hapsburg symbols of rulership were adopted as a model for the insignia of the House of Liechtenstein, reflecting not only the family's elevation in rank but also the dignity of imperial favor bestowed on it.

Like the crown of Emperor Rudolf II, the ducal crown of Prince Karl I was decorated with a dazzling array of precious stones. The glittering wealth of these treasures of nature mirrors the special interest in such objects at the court in Prague around 1600. The Emperor believed in the mysterious powers of precious stones, which, concealed deep in the earth, were thought to contain sparks of the divine power of creation. Such symbolic interpretation of stones is particularly apparent in the new Liechtenstein crown, whose tall finial was formed from a single diamond. This finial apparently served as a punning allusion to the name Liechtenstein: "the stone of light." Famed for its extreme hardness since ancient times, the diamond was adopted shortly thereafter with the same meaning for the Liechtenstein impresa on the halberds of Prince Karl Eusebius. These ceremonial weapons, dated 1632, display the "stone of light" upon an anvil, above which a hammer is being swung. An inscription surrounding the emblem reads: VIRTVTE ELVDITVR ICTVS (By its strength it eludes the blow). The meaning of such sophisticated and witty Renaissance emblems and of the humanist speculations concerning the power of nature in precious stones later became incomprehensible; indeed, in the second half of the eighteenth century, the age of the Enlightenment, the ducal crown inexplicably disappeared from the dynasty's ancestral treasures, having perhaps been destroyed as an unappreciated relic of a bygone era. A single pictorial record survives, a drawing dated 1756 (cat. no. 20), which depicts the crown's precise appearance and size, thus preserving the memory of one of the earliest and proudest expressions of the rank of the House of Liechtenstein.

In this era, architecture also became a meaningful symbol of dignity. This is especially true of palace architecture, which clearly reflects, together with rank, the personality and taste of its builder. The Liechtenstein castles and palaces represent a remarkable example of the significance attached to architecture, and they can best be understood and appreciated by referring to a literary source of exceptional importance, the *Treatise on Architecture* written by Prince Karl Eusebius (1611–84). As the son and successor of Prince Karl I, Karl Eusebius directed his energy into fields that were markedly different from the accomplishments of previous generations. He neither served at the imperial court nor sought public office; nor did he aspire to high military rank. Instead, Karl Eusebius devoted himself almost exclusively to the administration of his domains and residences. He thus represents a second important strain in the history of the House of Liechtenstein, that of brilliant administrative ability, in contrast to the political enterprise of other members of the House. Prince Karl Eusebius exemplifies another Liechtenstein tradition as well: the collecting of works of art. He pursued this activity with a passion, an understanding, and an uncompromising demand for quality that were equaled by few of his contemporaries. In contrast to the *Kunst- und Wunderkammer* that his father had built in the spirit of the Late Renaissance, Karl Eusebius assembled and carefully organized a collection of paintings and sculptures: the Liechtenstein gallery. The Prince recorded the rationale for his decisions and demonstrated the extensive range of his knowledge in voluminous writings, among them a book on the education of princes that reflects the class consciousness of the nobility and its effects on the individual.

His most important book, the *Treatise on Architecture*, must be regarded as the source par excellence for our appreciation of the conception by which architecture in the age of the Baroque was commissioned. Part of the book is devoted to the patron's theoretical and artistic considerations, and there is also a section on practical advice for the actual construction. Although this volume can be used as a handbook on architecture, it is actually a pedagogical work addressed to the author's son and to later generations, very much in the spirit of a *monita paterna* (fatherly admonition). Architectural patronage, according to Prince Karl Eusebius, is not necessarily to be regarded as an individual's occupation, but as an ongoing tradition that enhances the reputation of one's dynasty and preserves it for posterity; the abundant means at the disposal of the Prince and his successors are to be used in laying the foundations of the princely family's public esteem. Two of Karl Eusebius's guiding tenets for future generations of his House were: "money's sole use is for the bequeathing of beautiful monuments" and "to spend upon rare and good, beautiful and noble works is laudable and worthy of praise, in that a lasting, great, and supreme memorial may remain; but to throw away money upon worthless and imperfect things is foolish." Pointing out that ancient buildings are the only visible testimony of their time, the Prince appeals to his successors to emulate the great examples of the past and to raise buildings "that will represent and preserve all of our living history and make our name glorious and eternal, now and for all posterity, as no written history can."

The son and successor of Prince Karl Eusebius, Prince Johann Adam Andreas von Liechtenstein (1657–1712), took up his father's legacy with characteristic vigor and organizational talent. With the same grandiloquent style with which he commissioned the building of palaces and castles, he also acquired works of art. Indeed, Prince Johann Adam is the most important collector the House of Liechtenstein has produced. Drawing on the income from his estates, a wealth that enabled him to lend millions even to the Imperial House (his contemporaries referred to him as "Hans Adam the Rich"), he spent considerable sums on the acquisition of paintings and sculpture for his collection. Without doubt, the wealth that had been accumulated by the previous two generations was an indispensable foundation for these activities; and yet, such acquisitions would not have been possible without the Prince's keen intelligence in all matters of economics, finance, and administration. (The Imperial House recognized the Prince's abilities and appointed him for a time as President of the State Bank in Vienna.) A contemporary reporter's comment in 1709 that "the Princely House of Liechtenstein giveth persons of princely rank in Germany a beautiful model of how to live like a prince and how to hold court" (Zwantzig 1709, p. 162) is particularly illuminating of the reputation that Johann Adam had acquired. No doubt his palaces—which were of "exceeding splendor and magnitude" in keeping with Karl Eusebius's admonitions—contributed significantly to the writer's judgment.

The first building erected by Johann Adam was the palace of Plumenau in Moravia, begun in 1680, when he was still a Hereditary Prince. The impressive facade with its massive row of fifty-four columns (in the original conception it was even larger) is a vivid illustration of the Prince's aesthetic ideal: "For whatever is splendid in a building, must be of some length—and the wider, the nobler—for this is the greatest renown and glory, to behold a large number of windows and columns; and it must be of three stories in number, for herein is embodied the whole essence of splendor, magnificence, and complete beauty." The palace of Plumenau, the plans for which had probably been developed by Karl Eusebius, betrays in its design a certain conservatism uncharacteristic of Johann Adam's taste. In his subsequent architectural projects—renovations and entirely new structures—the younger Prince relied on Italian architects, the elite of his day. These building activities comprised the palaces of Feldsberg in Lower Austria, Aussee in Moravia, Koledey outside Prague, and Landskron in Bohemia. But the most remarkable architectural commissions of Prince Johann Adam were accomplished in Vienna, the center of the Holy Roman Empire and the Emperor's residential city. Beginning in 1692, before the eyes of a discerning public, the Liechtenstein Garden Palace rose outside the city gates, and two years later

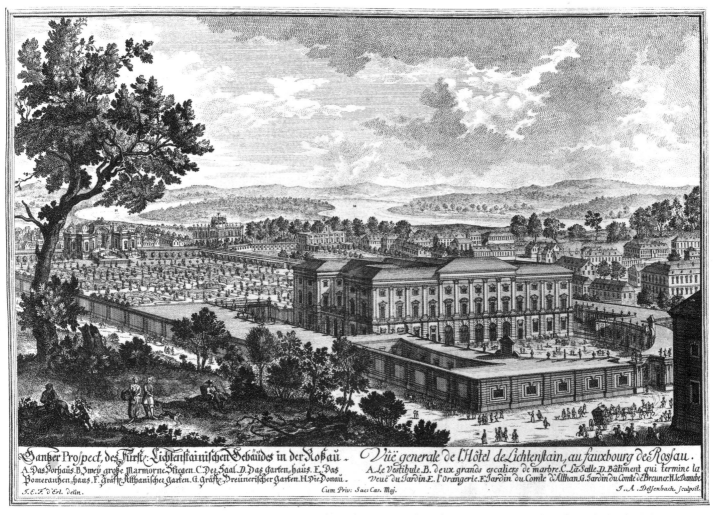

Fig. 7 Johann Adam Delsenbach (1687–1765), *Panoramic View of the Liechtenstein Garden Palace in Vienna*, engraving after a design by Johann Bernhard Fischer von Erlach (1656–1723), 8⅞ × 13 in. (22.6 × 33.1 cm.). Princely Collections, Vaduz

construction commenced on the Liechtenstein City Palace: the *dioscuri* of great architectural ambition.

The Prince intended the Liechtenstein Garden Palace to be something more than just a country estate. Instead he envisaged with it the founding of a small but exemplary town. According to contemporary reports, the Prince wanted to give the city a memorable example of "how to manage economically one's affairs." In 1687, only four years after Vienna had been liberated from the Turkish menace, Johann Adam began to purchase a broad expanse of meadows, vineyards, and arable fields in the Rossau area northwest of Vienna. Along with the erection of the Garden Palace, the construction of the district immediately adjacent to the palace was carefully planned, with an organized system of roads, a church, and a brewery. By 1701, eighty houses had been built, and the town was growing rapidly. Out of bare fields and meadows, the Prince's organizing genius had created a small model community and not without pride was his dynasty's name conferred upon this urban creation—the only one of its kind in the history of the princely family. Today Vienna's IXth district is still called Liechtental (Liechtenstein Valley), extolling the memory of its illustrious founder.

Liechtental's most prominent landmark, of course, was the Prince's Garden Palace (see cat. nos. 1–2). The rational organization of the architectural ensemble immediately impresses the viewer. A semicircular entrance court, framed by stables and carriage houses (parts of which were demolished at the beginning of the nineteenth century), opens onto the wide, three-story, freestanding block that makes up the main building. In the eighteenth century a French parterre garden extended behind it (today it is an English park), whose distant focal point at the rear was marked by a lofty belvedere with an open central arch that permitted a wide view over the surrounding landscape. (This building, a work of the Viennese architect Johann Bernhard Fischer von Erlach, was demolished in the late nineteenth century.)

After the fantasy of this belvedere and the gaiety of the garden's flower beds, sculptures, and fountains, and in deliberate

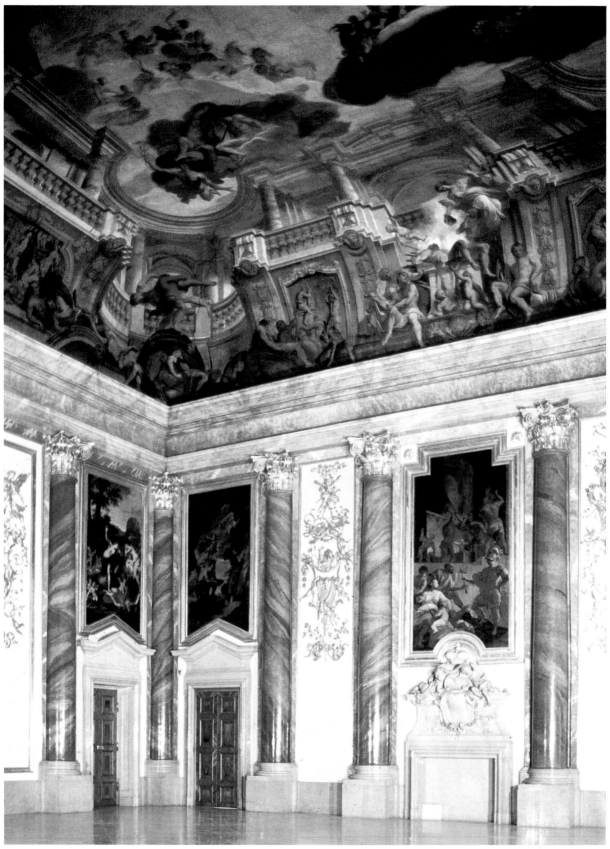

Fig. 8 The Great Hall of the Liechtenstein Garden Palace in Vienna, designed by Domenico Martinelli (1650–1718). The ceiling fresco by Andrea Pozzo (1642–1709), painted in 1704–1708, depicts the Entry of Hercules into Olympus.

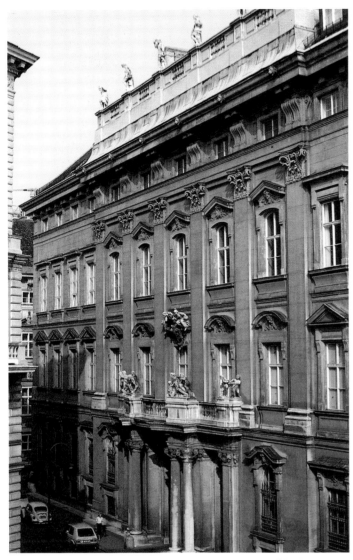

Fig. 9 The Liechtenstein City Palace in Vienna, designed by Domenico Martinelli (1650–1718) and built in 1689–1700, was the princely family's main residence until 1938.

contrast to the low buildings around the front court, the palace itself is a structure of severe symmetry and impressive dignity. The work of Domenico Egidio Rossi and later of Domenico Martinelli, it is an example of purely Italian architecture. Italian *grandezza* characterizes the organization of the interior as well, with its triad of dramatic spatial effects: first, the (formerly) open vestibule leading through the depth of the entire building, connecting the court with the garden and thereby establishing a natural rendezvous for those enjoying courtly garden life; second, the great double staircases that rise up in mirror image on either side of the vestibule; and finally, at the head of the staircases, the Great Hall—a reception room of monumental proportions surrounded by colossal wall columns of red stucco marble and surmounted by an illusionistically painted ceiling, which, as a masterpiece of Italian art, represents a radiant apotheosis of the building's splendors. In 1704

Prince Johann Adam had succeeded in engaging for this project the famous Roman fresco painter, the Jesuit Padre Andrea Pozzo (1642–1709), who twenty years earlier had created one of the great works of illusionistic fresco decoration on the ceiling of San Ignazio in Rome. In these years before his death in Vienna in 1709, Pozzo met the last great challenge to his virtuosity with the commission for the ceiling of the Garden Palace. Here he depicts the celestial realm of the Olympians, towering above structures of imaginary architecture; scenes of the deeds of Hercules are skillfully set into the architectural frieze of the fresco, and the center of the composition is given over to the hero's reception among the gods.

If the rational planning of the town of Liechtental was a novelty for Vienna, and if the Italianate architecture of the Garden Palace introduced an as yet unfamiliar idiom into the architectural language of the capital, the powerful sequence of the interior with its crescendo of vestibule, staircases, and Great Hall set a trail-blazing example. The Great Hall itself was and remains unrivaled in its monumental solemnity. A climax had been reached in this felicitous coincidence of Italian art and the patronage of a Prince who sought to provide his House with a setting so overwhelming that it would surpass even the imperial residence. Karl Eusebius's challenge to his successors to erect a building "that will represent all of our living history" was thus fulfilled in the very next generation.

The Garden Palace was still under construction when Prince Johann Adam decided to build a new residence in the center of the imperial city as well. The Liechtensteins already owned a stately palace in the Herrengasse that was renowned for the splendor of its interior, but the Prince's ambition was to create an even more imposing building. In 1694 he acquired a property in the Schenkenstrasse (today's Bankgasse) immediately next to the city wall. Count Dominik Andreas Kaunitz had already commissioned the Bavarian court architect Enrico Zuccalli to design a palace on this site, and the first story had already been built. Although the basic plan—four wings surrounding an interior courtyard—was thereby fixed, the project now received a more dynamic impetus, developing an austerity and a clarity of line under Domenico Martinelli's direction. Its proximity to the city wall required that the palace have a high elevation, and this height, together with the visibility of the building from three sides, imparts a monolithic presence that still dominates the surrounding streets. The design has clearly been inspired by the Roman High Baroque, not only in the isolated position of the massive block but also in the bold articulation of the facade, with its monumental windows and portal. Among Vienna's many aristocratic palaces, the Liechtenstein City Palace still offers one of the most impressive sights. Even today, after the nineteenth century set new values for the city's architecture, the Roman solidity of Prince Johann Adam's work is still deeply imposing.

Just as the Garden Palace's interior rooms gave expression to the lofty ambition of the patron and to the dignity of the Princely

House, the same is true of the City Palace's exterior. Neither the viewer standing underneath Pozzo's ceiling fresco nor the passerby in front of the facade to the Bankgasse can fail to be moved by this determination to create monuments in keeping with the dignity of the family, whose inalienable property the palaces have remained until this day. The art collection assembled by the Prince in the City Palace was quite as impressive as the building that housed it (the collection was later transferred to the Garden Palace). Even in the nineteenth century, when Prince Alois II of Liechtenstein (1796–1858) decorated (1836–47) a sequence of rooms in the lavish style of the Second Rococo, this palace was considered a touchstone of aristocratic taste. And today the City Palace still serves as the Viennese residence of the Reigning Prince of Liechtenstein and as the setting for his social and political functions.

Not only was the architecture of both palaces designed by Italian artists, but so too was their interior decoration. Antonio Belluci from Venice delivered for the City Palace more than forty ceiling paintings on canvas, some of them of monumental proportions, depicting mythological scenes in radiant Venetian colors. (They were transferred to the Garden Palace in 1807 and have been kept there since.) Pozzo's ceiling fresco in the Great Hall of the Garden Palace brought one of the great examples of Roman illusionistic painting north of the Alps. A contrast to Pozzo's Roman pathos was provided by the Bolognese classicism in the works of Marcantonio Franceschini, which the Prince had commissioned over the years. More than thirty canvases by Franceschini, some of them of colossal size, had been delivered from Bologna, paintings that depict mythological scenes and which originally were used to adorn the ceilings and walls of three halls on the Piano Nobile of the Garden Palace. Besides these three distinctive schools of Italian painting from Venice, Rome, and Bologna, there was but a single representative of Austrian art, Michael Rottmayr, whose ravishing frescoes decorate the ground floor of the Garden Palace. Paintings by Italian masters again were also included in the Prince's extensive collections in the City Palace where they were counterbalanced, however, by paintings of the Northern schools, including one of the most important contemporary collections of works by the Flemish master Peter Paul Rubens. Thus in the palaces of the Prince of Liechtenstein an impressive variety of European art had been assembled and an international forum had been created that reached beyond Vienna and the empire. This cosmopolitan spirit was not confined to the Liechtensteins' architectural setting at home, but also provided a stunning backdrop to their public appearances in the great capitals of Europe.

—————

The symbolic representation of a Prince's rank was not, however, limited to the splendor of his regalia and to the magnificence of the palaces in which he lived; court ceremonial, too, added greatly to the aura surrounding him. Impressive public appearances and the performance of time-honored rituals demonstrated the level of privilege, emphasized the hierarchical structure, and furnished tangible proof of authority. Festivals and processions took courtly representation into the streets and public squares and thus provided the populace with a living image of the order of the state. The Princes of Liechtenstein contributed significantly to such ceremonial displays, with which, in the Baroque Age, the great courts of Europe competed with one another.

The most important elements of any public ceremony were horses and carriages. Horses especially—the companions of heroes and favorites of kings since ancient times—were eminently suited to elicit the crowd's admiration amidst the colorful pageantry of a procession. The breeding of noble horses had always attracted the attention of aristocracy, and during the seventeenth and eighteenth centuries, horse breeding became such an important concern of the House of Liechtenstein that its stables were considered the foremost in Europe, comparable only to those of the Dukes of Mantua.

In the year 1600, the Elector Joachim Friedrich of Brandenburg had turned to Karl von Liechtenstein with a request for a horse for his personal use, since according to the Elector the Liechtenstein stud was the most renowned in Bohemia. But it was not until the time of Prince Karl Eusebius that the stables at the Liechtenstein estates of Eisgrub in Moravia and Schwarzkosteletz in Bohemia, which numbered at times as many as 120 stallions of various breeds, achieved their real importance. With his characteristic thoroughness the Prince treated the subject of horse breeding in a pedagogic treatise as well as in a special ordinance he wrote for the management of the stud; he also gave precise instructions in his *Treatise on Architecture* for the building of stables. Once again it was his son, Prince Johann Adam, who brought his father's architectural ambitions to fruition. In 1688 he initiated the construction in Eisgrub of one of the grandest royal stables of the Baroque Age. The architect was none other than Fischer von Erlach. This "palace for horses"—a four-wing structure intended to accommodate 180 horses, three wings of which were completed—provided an appropriate setting for these treasured horses, which were second in value only to the Liechtenstein art collection.

The horses from Eisgrub (which included piebalds, a highly prized breed in the Baroque Age) were ennobled by their architectural surroundings, and their magnificent appearance was celebrated with a gallery devoted to equine portraits (cat. nos. 106–107) in the Viennese Garden Palace. Furthermore, a painting produced in 1702 depicting the young Archduke Karl (later Emperor Karl VI) receiving equestrian instruction on a horse bred in Eisgrub (cat. no. 108) gives proof of the high standing of the Liechtenstein stable. Yet the main purpose of these animals was to stride in front of a gala carriage in matched pairs, in teams six or eight strong, with perfect harmony of build and movement. Prince Karl Eusebius frequently made presents of such teams to other princely courts, and there are records of Eisgrub horses being given to the Kings of France, England, and Denmark. Even on the occasion of the entry of Louis XIV

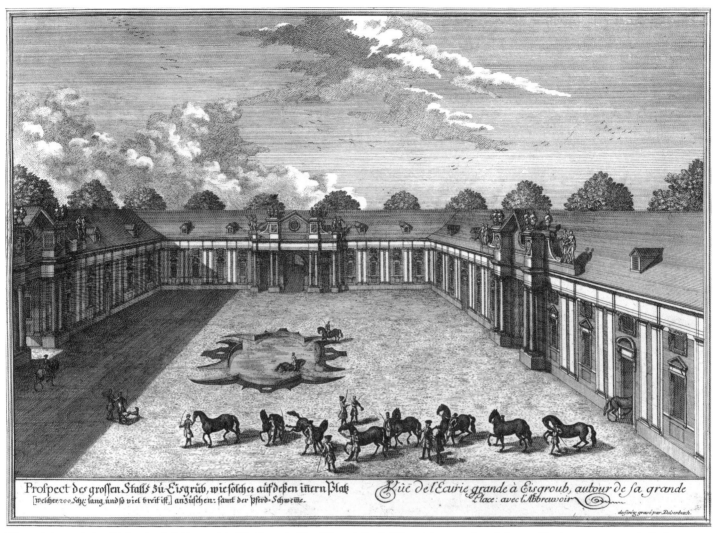

Prospect des grossen Stalls zu Eisgrub, wie solcher auf dessen intern Platz [welcher 200 Schu lang und so viel breit ist,] anzusehen: samt der Pferd-Schwemme.

Küe de l'Ecurie grande à Eisgroub, autour de sa grande Place: avec l'Abbreuvoir

desseig. gravé par Delsenbach.

Fig. 10 Johann Adam Delsenbach (1687–1765), *The Great Stable of Eisgrub Castle (Moravia)*, engraving, 8⅝ × 12¼ in. (21.9 × 31.2 cm.). Built in 1688–98 to house the Liechtenstein horses, the stable was designed by Johann Bernhard Fischer von Erlach (1656–1723). Princely Collections, Vaduz

and his Spanish bride into Paris in 1660—one of the most imposing demonstrations of regal dignity in the seventeenth century—the Prince of Liechtenstein's gift of horses, singled out to serve as a team for the Queen's royal carriage, caused a major sensation.

An opportunity for a comparable demonstration—but this time in a purely Liechtenstein context—arose in 1689, when Prince Anton Florian (1656–1721), the cousin of Prince Johann Adam and ruler of the House after the latter's death in 1712, was appointed as the Emperor's envoy to the papal court in Rome. This was the Prince's first important official position before he distinguished himself as educator and High Steward of Archduke Karl, and before he accompanied the latter as Prime Minister on his Spanish campaign and presided over the Austrian Privy Council from 1711 until his death. His appointment was considered an extraordinary event, for it was the first time that the Imperial House was represented in Rome by a

man who was not of the clergy and because in 1691 Prince Anton Florian was raised to the exalted rank of an ambassador, a title rarely held by his predecessors. On March 19, 1691, the Prince made his ceremonial entry as ambassador into the city, an occasion for which he was obliged to borrow carriages and livery from Cardinal Medici, Protector of the German Nation. On Christmas Eve of the same year the Prince conducted a second procession, this time with thirteen impressive state coaches of his own, drawn by teams from the Eisgrub stables. An engraving commemorates the moment when the Prince's cortege leaves the Pope's residence, the Quirinal, in ceremonial solemnity, and a publication of the year 1694 offers a detailed description, illustrated with engravings of seven of the ambassadorial carriages. These *sontuose carrozze* (sumptuous carriages) were true masterpieces of sculptural quality: in their combination of elaborate carving, resplendent gilding, and richly colored precious textiles, they were designed to surround their occupant in the-

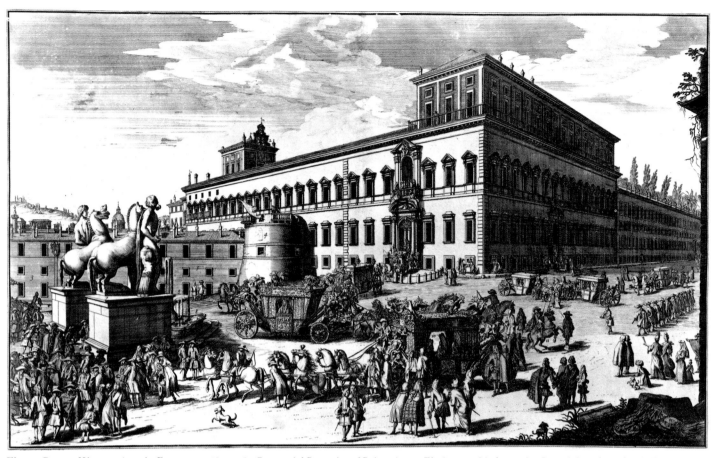

Fig. 11 Gomar Wouters (act. in Rome ca. 1680–96), *Ceremonial Procession of Prince Anton Florian von Liechtenstein, Imperial Ambassador, in Rome on December 24, 1691*, engraving, 17⅝ × 27¼ in. (44.8 × 69.2 cm.). Princely Collections, Vaduz

atrical pomp. The ambassador's first carriage was crowned with the imperial double-headed eagle and was decorated with allegorical sculptures symbolizing the victory of the imperial troops over the Turks—thus revealing that the real purpose of this triumphal display was a visible representation of the Emperor's power. At the same time, the state carriages were proof of the taste of Prince Anton Florian, of whom Leibniz wrote in a letter dated 1714: "*Son Altesse Serenissime est grand connoisseur des beaux arts*" (His Serene Highness is a great connoisseur of the fine arts).

The events in Rome were but a prelude to another ceremony, a generation later in Paris, that proved to be the most magnificent public demonstration in the history of the House of Liechtenstein. Prince Joseph Wenzel (1696–1772), whose accomplishments as a soldier and reorganizer of the Austrian artillery have been discussed above, resided in Paris as Imperial Ambassador from 1737 to 1741. The political motive for his mission was the signing of the Peace of Vienna in 1738 and the confirmation of the Pragmatic Sanction (which recognized female succession in the House of Hapsburg), but though these efforts produced no lasting success, the years in Paris represented for the Prince the zenith of his career. On December 21, 1738, Prince Joseph Wenzel conducted his ceremonial entry as ambassador into Paris,

followed two days later by a similar procession to the palace of Versailles, events that were marked by a display of extraordinary splendor and luxury, the like of which, according to eyewitness reports, had not been seen within the living memory of the French public. Here the House of Liechtenstein had lent its prestige and proverbial wealth for the honor of the House of Hapsburg, and rarely had imperial sovereignty been so magnificently represented. Prince Joseph Wenzel had spent the first year of his unofficial stay in Paris preparing for the ceremonial entry. He commissioned the foremost artisans of the French metropolis to create not only five splendid gala carriages, but also headgear, bridles, and trappings for the horses and liveries for his retainers. One of the carriages—an elegant berlin, which occupied fourth place in the procession—is still preserved in the Princely Collections. The so-called Golden Carriage (cat. no. 104) is the only Parisian-made gala carriage of its period to survive the French Revolution, and thus provides unique evidence of the exuberance of Rococo decoration and the masterful achievements of Parisian carriage building, which set the standard for all the other courts of Europe.

At the end of his term as ambassador, Prince Joseph Wenzel took his carriages with him to Vienna and used them repeatedly on other official occasions. In 1760 the Golden Carriage

and three other gala carriages from the Parisian cortege accompanied the Prince to Parma, where Joseph Wenzel had been sent by Empress Maria Theresa to represent Archduke Joseph, heir to the Austrian throne, in the marriage-by-proxy to Isabella of Parma. At the bride's ceremonial reception in Vienna on October 6, 1760, Prince Joseph Wenzel rode in his Golden Carriage immediately ahead of the bride's state coach (again taken from the earlier Parisian cortege) at the end of a procession numbering ninety-four gala carriages. Contemporary paintings show the Prince surrounded by his retinue and festively framed by his carriage resplendent with gilded wood and bronze, crystal, brocade, and decorative painting (cat. no. 112). As a recognized emblem of state authority and aristocratic privilege, the carriage thus served as tangible proof of the elevated status and political power of the Prince and his House.

In 1764, twenty-five years after the Golden Carriage had been constructed, Prince Joseph Wenzel employed it for a last time in Frankfurt for the procession he organized on the occasion of Joseph II's election and coronation as King of the Romans (heir to the imperial throne). One of the observers of the ceremony was the young Goethe, who later wrote in *Dichtung und Wahrheit*: "The dignified personality of the Prince of Liechtenstein made a good impression; but there were connoisseurs who claimed that the splendid liveries had already been used on a previous occasion." The radiance of the Rococo was fading, the age of ceremonial splendor was nearing its end, and the Golden Carriage was soon to be withdrawn from practical use and transferred to the safekeeping of the Princely Collections. The proud emblem of sovereignty had become a work of art.

It would be superficial to regard the collection and preservation of works of art as the accumulation of merely decorative accessories. Originally, art collections were an integral element of courtly life, well suited to enhancing the splendor and reputation of an aristocratic residence. The collector's passion, therefore, was motivated—apart from his aesthetic preferences—by the constant desire to give adequate expression to his rank. Not until the political upheavals of the nineteenth and earlier twentieth centuries were the accumulated art collections in the residences of the great ruling families of Europe—be it in Madrid or Leningrad, Florence or Munich, Paris or Vienna—transferred into museums and thus made available to the public. By now all but a few of the once numerous princely collections have been wrested from the foundations of their dynastic origins, and it is in these last remaining ones that we can recognize, more clearly than would be possible in a museum, that collecting art requires more than connoisseurship and wealth—namely, a tradition and an historical consciousness that spans generations. The collections of the Reigning Prince of Liechtenstein —one of the oldest collections still in the ownership of the same family—allow the heritage of the great European collections to be experienced in its original function. Although their history is marked by rises and falls, gains and losses, the beneficence and adversity of fate, the Princely Collections remain an enduring monument to the House of Liechtenstein and to the generations of Princes that made them great.

Reinhold Baumstark

Fig. 12 Martin von Meytens (1695–1770), *Ceremonial Entry of Princess Isabella of Parma, the Bride of Archduke Joseph II, in Vienna on October 6, 1760*, oil on canvas, 153½ × 223 in. (390 × 566 cm.). Detail showing Prince Joseph Wenzel von Liechtenstein riding in his Golden Carriage (see cat. no. 104). Schönbrunn Castle, Vienna

CONTRIBUTORS TO THE CATALOGUE

GCB GUY C. BAUMAN
Assistant, Department of European Paintings,
The Metropolitan Museum of Art

RB REINHOLD BAUMSTARK
Director, The Princely Collections, Vaduz

KC KEITH CHRISTIANSEN
Associate Curator, Department of European Paintings,
The Metropolitan Museum of Art

JDD JAMES D. DRAPER
Curator, Department of European Sculpture and
Decorative Arts, The Metropolitan Museum of Art

JH JOHANNA HECHT
Associate Curator, Department of European Sculpture and
Decorative Arts, The Metropolitan Museum of Art

GK GEORG KUGLER
Director, Wagenburg, Vienna

CLC CLARE LECORBEILLER
Associate Curator, Department of European Sculpture and
Decorative Arts, The Metropolitan Museum of Art

WL WALTER LIEDTKE
Associate Curator, Department of European Paintings,
The Metropolitan Museum of Art

JP-H SIR JOHN POPE-HENNESSY
Consultative Chairman, Department of European Paintings,
The Metropolitan Museum of Art

SWP STUART W. PYHRR
Associate Curator, Department of Arms and Armor,
The Metropolitan Museum of Art

OR OLGA RAGGIO
Chairman, Department of European Sculpture and
Decorative Arts, The Metropolitan Museum of Art

DT DOMINIQUE THIÉBAUT
Conservateur au Département des Peintures,
Musée du Louvre

CV CLARE VINCENT
Associate Curator, Department of European Sculpture and
Decorative Arts, The Metropolitan Museum of Art

ACKNOWLEDGMENTS

The organizers and authors would like to thank the following for their assistance: Christopher Baswell, Barnard College, New York; Christian Beaufort Spontin, Waffensammlung, Kunsthistorisches Museum, Vienna; Shirley N. Blum, State University of New York, Purchase; Lionello G. Boccia, Museo Stibbert, Florence; Nolfo di Carpegna, Rome; Rudolf Distelberger, Kunsthistorisches Museum, Vienna; Claude Ducourtial, Musée National de la Légion d'Honneur, Paris; Mechthild Flury, Abegg-Stiftung, Riggisberg; the staff of the Frick Art Reference Library; Ortwin Gamber, Waffensammlung, Kunsthistorisches Museum, Vienna; Lois R. Granato, New York; J. H. Guttmann, New York; Eugène Heer, Institut Suisse d'Armes Anciennes, Granson; Roman Hollenstein, Zurich; Franz Kaindl, Heeresgeschichtliches Museum, Vienna; James D. Lavin, Williamsburg, Va.; Barbara Manhart, Princely Collections, Vaduz; Neil MacGregor, *The Burlington Magazine*, London; Heinrich Müller, Museum für Deutsche Geschichte, Berlin; Edgar Munhall, The Frick Collection, New York; Ottfried Neubecker, Wiesbaden; Graf Georg Nostitz, Vienna; Evelin Oberhammer, Princely Archive, Vaduz/Vienna; Baron Pinoteau, Académie Internationale d'Héraldique, Paris; Robert Rainwater, New York Public Libary; J. P. Reverseau, Musée de l'Armée, Paris; E. P. Riabinka, Museum of Western and Oriental Art, Kiev; Dieter Schaal, Historisches Museum, Dresden; Erich Schleier, Staatliche Museen Preussischer Kulturbesitz, Berlin; Ewald Schneider and Hans Ewald Schneider, Hasenkamp Internationale Transporte, Cologne; Sam Segal, Amsterdam; Hubertus von Sonnenburg, Doerner-Institut, Munich; Mario Stutz, Swissair, Zurich; Christian Theuerkauff, Skulpturengalerie, Staatliche Museen Preussischer Kulturbesitz, Berlin; Christopher Tilley, Geneva; Helmut Trnek, Sammlung für Plastik und Kunstgewerbe, Kunsthistorisches Museum, Vienna; Rudolf Wackernagel, Münchner Stadtmuseum, Munich; Curt Weller, Munich; G. M. Wilson, The Armouries, H. M. Tower of London; and John Brealey, John Buchanan, John Canonico, Robert Carroll, Daphne Eastwick, Paul Ettesvold, Elayne Grossbard, Mary Howard, Marie Koestler, Herbert Moskowitz, Mary Myers, Helmut Nickel, Catherine Leslie Parker, Doralynn Pines, Donya-Dobila Schimansky, Richard E. Stone, and Leonid Tarassuk of The Metropolitan Museum of Art.

I

The House of Liechtenstein

THE LIECHTENSTEIN GARDEN PALACE

Historical events—the conclusion of a great battle or the transfer of power from one monarch to another—frequently have a symbolic value when tracing the history of taste and the evolution of style, and in any discussion of the cultural life of Vienna in the seventeenth century the year 1683 takes on this significance. In that year the Turks, who had threatened the very existence of the city, were soundly defeated by the combined forces of the Emperor Leopold I, the King of Poland, and the Electors of Bavaria and of Saxony, backed by financial aid from the Papacy, Savoy, Tuscany, Genoa, Spain, and Portugal. For the first time in at least two decades the city could safely expand beyond its walls. Among the first to take advantage of the new situation was Prince Johann Adam Andreas von Liechtenstein (1657–1712), who in June 1687 purchased property in the outlying district of Rossau for the construction of a summer palace and garden.

A young man of immense culture and wealth—he was later known as "Hans the Rich"—Johann Adam had inherited from his father not only property but a passion for art, the basis of which was a thoroughgoing knowledge of architecture. "You ought to become a perfect architect surpassing Michael Angello Bonarota [Michelangelo], Jacomo Barozio Daviniola [Vignola], who is our esteemed master, from whom we learned and accepted the five Orders, Bernin [Bernini], and others" (Fleischer 1910, p. 83), Prince Karl Eusebius had written to his son in 1681, just three years before his death. Nor was this idle talk, for, in addition to his writings on education and horse breeding, the older Prince bequeathed to his son a treatise on architecture, which seems to have deeply affected Johann Adam's taste, and he left his own example as an amateur architect. As might be surmised from the list of architects that he held up to his son as paradigms, Karl Eusebius had a marked bias for Italian architecture. "In its buildings Italy [*Welshlandt*] surpasses the whole world, so that its manner and no other should be followed, for it is fine, imposing, and majestic" (Fleischer 1910, p. 183) reads one line of the treatise. It was a prejudice that was widely shared in seventeenth-century Austria, where itinerant Italian architects and craftsmen were to be found in abundance. Johann Adam proved particularly susceptible to its message.

For the plans of the Garden Palace—the Prince's first large-scale project—Johann Adam turned to the most gifted Austrian architect of the day, Johann Bernhard Fischer von Erlach, an almost exact contemporary who had just returned from Italy after sixteen years. The architect designed the Belvedere and park gates for the newly acquired property (see fig. 7). The Belvedere—an arched structure with two wings and symmetrical, curved staircases—was both imaginative and grandly Roman, a testament to the shared tastes of patron and architect. It was, alas, demolished in 1873 to make way for another

Italianate structure, but it is visible in the somewhat modified form in which it was built, in the background of Bellotto's painting *The Liechtenstein Garden Palace in Vienna Viewed from the Side* (cat. no. 2), its pediment-crowned central arch echoing the profile of the distant mountains. The Prince also employed Fischer von Erlach to create palatial stables for his country seat in Moravia (fig. 10), but when it came to the Garden Palace itself, Johann Adam insisted on an architect who was Italian by birth as well as by training. Vincenzo Fanti, the eighteenth-century compiler of the Liechtenstein collections, identifies this man as the Tuscan Domenico Martinelli of Lucca, who had been a pupil of Carlo Fontana in Rome and who arrived in Vienna in 1690. His credentials were certainly those sought by the Prince. Recent scholarship, on the other hand, points to the Bolognese-trained Domenico Egidio Rossi as the inventor of a plan to which Martinelli later made significant modifications. Rossi had a well-established reputation throughout Central Europe and would also have been a logical choice. In the event, the identity of the presiding architect is of less consequence than the character of the building eventually constructed.

The early plans that have come down to us show a three-story building (or *corps de logis*) flanked by lower wings—a solution reminiscent more of the French pavilion system of palace architecture than of current Italian practice. It was the sort of plan that Karl Eusebius had singled out for censure in his treatise, preferring instead the more compact "Palatio in quadro" (Fleischer 1910, p. 183). In keeping with his taste for a large, unified blocklike structure, Martinelli introduced a number of features from the two most famous Roman palaces of the day, Bernini's Palazzo Chigi-Odescalchi and Palazzo Barberini. From the former, he took over the motif of a monumental order of pilasters raised on a basement story, while from the latter he adapted the projecting window moldings of the attic, endowing the facade with the character of an urban rather than a country palace and contrasting the front of the palace that faced the city with the less formal garden side, with its two wings flanking a central forecourt. The change in plan as well as in architect must have been due to Johann Adam's insistence that Italian models be followed: his new city residence (fig. 9), also designed by Martinelli, was based even more closely on Bernini's Palazzo Chigi-Odescalchi, and when, in 1694, the Prince decided to build a palace in Landskron, Bohemia, he approached Martinelli's master, Carlo Fontana, giving explicit instructions that the design produced be "alla Romana."

It was not only Johann Adam's architect who was Italian. His chief sculptor, the Venetian Giovanni Giuliani; his stuccoist, the North Italian Santino Bussi; and even his mason, Giuseppe Antonio Riva, were one and all Italians, although Riva was forced aside by the local Viennese guild. Giovanni Giuliani and Santino

Bussi, like Domenico Egidio Rossi, became, to all intents, ex-patriots (Giuliani was buried in the Cistercian abbey of the Heiligenkreuz near Baden, where he had been employed). Through the combined efforts of these men the Garden Palace acquired its dazzling gilt interior and a series of delicate, stucco frames for the paintings inserted into the ceilings of various rooms.

It should come as no surprise that the Prince decided against the Northern custom of decorating his palace with tapestries and instead commissioned pictures to be set into frames to fill the spaces above doors and between windows, as well as illusionistic frescoed ceilings for the largest rooms. In 1692, when construction was barely under way, he wrote to the leading exponent of Bolognese classicism, Marcantonio Franceschini, that "in one of our buildings we wish to decorate two rooms with paintings instead of tapestries," and to this end he commissioned from the artist two series of paintings—twenty-six canvases in all—with subjects taken from Ovid (cat. nos. 3–10), thereby inverting the taste of his father, who considered tapestries the equivalent of paintings (Fleischer 1910, p. 201). These were installed in the rooms of one of the wings overlooking the garden. Once again, the Prince showed himself attentive to the smallest details. The pictures, Franceschini was told, were to be four feet (1.2 m.) above the floor to allow furniture to be placed below them, and the commission was only finalized after the artist had submitted a detailed description of his proposed compositions. Franceschini was later asked to make ceiling paintings for additional rooms, and in 1704, upon completion of the fabric of the palace, the Prince approached him with a task that aimed at bestowing upon the interior the character of a true Italian residence. Franceschini was invited to come to Vienna with a specialist in perspective to undertake the decoration in fresco of further rooms. Only after the Bolognese artist's refusal did the Prince turn to the Austrian painter Johann Michael Rottmayr to carry out the task. Rottmayr had spent thirteen years in Venice and had just completed a fresco in the Great Vestibule of the imperial palace of Schönbrunn. The Prince reserved the vast, continuous surface of the ceiling of the main hall of the Garden Palace for a fresco decoration by the greatest Italian master of perspective, Padre Andrea Pozzo, who, upon completion of his tour de force on the ceiling of Sant'Ignazio in Rome, had moved to Vienna in 1704 to work for the imperial court. The Prince's pride in having secured the Jesuit painter's services can be gauged from a letter written to Franceschini that year. "This work," he wrote, referring to the ceiling in the main hall, "has been given to the Jesuit father Pozzo, who has done various works in Rome and who is a great virtuoso in perspective."

Two further incidents shed additional light on the Prince's exacting taste. The first concerns some pictures offered for sale by Franceschini, whom Johann Adam also employed as an agent in and around Bologna. In 1706 Franceschini wrote to the Prince about a painting he had seen by "Luca d'Olanda." "And since I know that those who create a rich gallery, as does Your High-ness, like to have works by all the famous masters, I thought . . . that perhaps you would like to acquire this picture." The Prince replied, "Concerning the proposed painting by Luca d'Olanda, we are not certain what master you mean. One is named Luca Cranich [Cranach]; if it is by him, it is dry and hard. I have very beautiful pictures by these Flemish masters, that is, by Wandik [van Dyck], Rubens, Holbein, and Purbus [Pourbus]. We don't have a very high estimate of the others, because they have not painted according to the good Italian taste [*sul bon gusto italiano*], with softness [*morbidezza*]." The second incident relates to the Prince's dealings with the Roman painter Giacinto Brandi. In 1690 he wrote to his second cousin, Prince Anton Florian, then in Rome, asking that he speak "with a certain painter by the name of Cinto Brandi and find out from him how much he would ask for a piece containing three or four figures—they must be life-size—of the enclosed height and width. I leave him the liberty of choosing the subject, provided only that it does not show the story of Susanna, since among the pictures I have had painted by the best modern masters in Italy there is already such a picture. . . . I don't want the price to exceed two hundred crowns, since I am unfamiliar with the style of this painter and cannot know whether he paints to my taste [*nach meinem Gusto*]."

Of equal importance to the decoration of the palace interior were the gardens, which were laid out with the rigorous geometry and carefully contrived changes in elevation that were de rigueur. It is again a painting by Bellotto—*The Liechtenstein Garden Palace in Vienna Viewed from the Belvedere* (cat. no. 1)—that gives the best impression of their appearance: a central allée, with a water jet in the middle and rows of urns and statues marking the sides, and large parterres punctuated by carefully pruned topiary—all enclosed by rows of trimmed trees. Once again, primary importance was attached to the Italian pedigree of the decorative components. The Florentine sculptor Massimiliano Soldani was paid for models of statues—mainly copies of famous works in the Medici collections in Florence—and drawings for urns that were executed in sandstone in Vienna by Giuliani. Some of the pieces were based on bronze casts of famous ancient and Renaissance works or on bronze statuettes in the Liechtenstein City Palace. To the first category belongs the copy of the *Medici Venus*—visible just beyond the balustrade of the Belvedere in Bellotto's painting (cat. no. 1)—a full-scale cast of which had been commissioned from Soldani by the Prince. To the second category belongs the sculptural group seen just behind Prince Joseph Wenzel's extended hand in the same picture. This work takes as its point of departure Giovanni Bologna's small bronze *Hercules and Antaeus*, a cast of which, by Giovanni Francesco Susini, is also in the Liechtenstein collections (see cat. no. 39). In a similar fashion, the statue at the foot of the stairs in Bellotto's painting seems to derive its languid pose from François Duquesnoy's bronze statuette *Apollo Teaching Cupid How to Use a Bow* (cat. no. 50), a work Johann Adam's father had purchased more than a half a century earlier. In-

deed, the description given by Fanti of the sculpture housed in the City Palace is a necessary prelude to an appreciation of the garden statues and to Giuliani's creative procedure. The aesthetic behind this reference to earlier sculpture was based on Karl Eusebius's recommendation that copies of famous ancient statues be made to redress the lack of original pieces in Germany. Although the idea may strike us as misconceived, the practice was widespread, and to contemporaries its overall effect must have been dazzling: the recreation of the splendors of Italy just outside Vienna was a testament to what a "buon gusto italiano" could achieve.

Keith Christiansen

1

Bernardo Bellotto
Venetian, 1720–80

THE LIECHTENSTEIN GARDEN PALACE IN
VIENNA VIEWED FROM THE BELVEDERE
Oil on canvas; 39⅜ × 59 in. (100 × 150 cm.)
Liechtenstein inv. no. 889

The garden and palace, located on the outskirts of Vienna, in Rossau, are viewed from the curved terrace of the Belvedere designed for Prince Johann Adam Andreas by Fischer von Erlach in 1687. To the right stands an aristocratic figure plausibly identified as Prince Joseph Wenzel (see Fritzsche 1936, p. 64), who would have been sixty-four years old when the picture was painted. He is served by a turbaned black servant, and he offers a treat to his two spaniels, one of which performs by standing on its hind legs. To the Prince's right is one of a pair of symmetrical curving staircases flanked by two of the sandstone statues carried out by the Venetian Giovanni Giuliani for the garden between 1705 and 1709. Beyond this stretches the grand allée, decorated by vases and statues, and the two parterres, punctuated by ornamental hedges and elaborate topiary. Among the statues are a few recognizable copies after the antique, such as the *Medici Venus* immediately to the left and behind the Prince. Like some of the vases, they were based on models furnished by the Florentine Massimiliano Soldani. At the back is the palace itself, designed by the Lucchese architect and perspective painter Domenico Martinelli and built between 1691 and 1704 (the two rooms decorated by Franceschini with the Adonis and Diana cycles, cat. nos. 3–10, are located on the *piano nobile* of the right wing). Beyond the palace is Vienna with, to the left, the Church of the Servites, the tower of Sankt Maria am Gestade, the Gothic spire of the Cathedral of Sankt Stephan, and the facade of the Jesuit Kirche am Hof with, behind it, the cupola of the Peterskirche. To the right of the palace are the tower of the Schwarzspanierkirche and Strudelhof, the villa of Peter von Strudel (see Menz 1965, p. 66, no. 53).

Bellotto arrived in Vienna in December 1758 or January 1759, after a decade of service to Augustus III in Dresden. He stayed in Vienna for only two years, but during that time he painted thirteen canvases for the Empress Maria Theresa, one for her Chancellor, Count Kaunitz, and the two for Prince Joseph Wenzel exhibited together here. In Dresden Bellotto had painted panoramic views of the city, its squares, and of Augustus's favorite pleasure pavilion and gallery, the Zwinger, and Maria Theresa employed him to a similar end. His work for her encompassed a panorama of the city, some of the city's squares, and a series devoted to her palaces, including two paintings of Schönbrunn. However, Bellotto's views of Vienna differ from those of Dresden in their sense of intimacy and relative informality; this was partly a function of the layout of the city itself (see Kozakiewicz 1972, vol. 1, pp. 116–17). These traits are well in evidence in the two Liechtenstein paintings. Typically, Prince Joseph Wenzel chose to have the Garden Palace rather than his city residence portrayed, and he preferred to have the garden facade and side elevations as the subject rather than the more formal facade facing the city. Bellotto has created the impression of informality—of the palace as a place of aristocratic leisure—by, in each picture, creating a strikingly asymmetrical composition in which the palace seems only a backdrop for casual activities—a stroll through the gardens, a conversation on the terrace, or the taking of refreshments. In the present picture Bellotto has even managed to play down the formal layout of the garden, with its strict symmetry, by viewing it from a side staircase of the Belvedere, sweeping the eye down a subsidiary avenue and transforming the geometrical scheme of the parterres into inviting patches of green punctuated at seemingly irregular intervals by the conical shapes of the shrubbery. There could be no greater contrast to the near-axial view of the Zwinger of perhaps a decade earlier in the Gemäldegalerie, Dresden. A further virtue of the scheme of the Liechtenstein picture—with the balustraded terrace defining the foreground and the Prince shown relatively large—is the impression it gives the viewer of proximity to the scene and, by extension, of participation in the pleasures it depicts. This is again in marked contrast to the distant point of view Bellotto habitually assumed in his earlier work. Whether or not the scheme is derived from theater conventions (see Baumstark 1980, no. 24), the effect is one of great immediacy and vibrancy, enhanced by the dazzling depiction of light and the pattern of sharply defined shadows.

There are drawings for the figures of the Prince and his servant, the man standing at the left, the couple ascending the steps, and the man at the bottom of the steps whose back is to

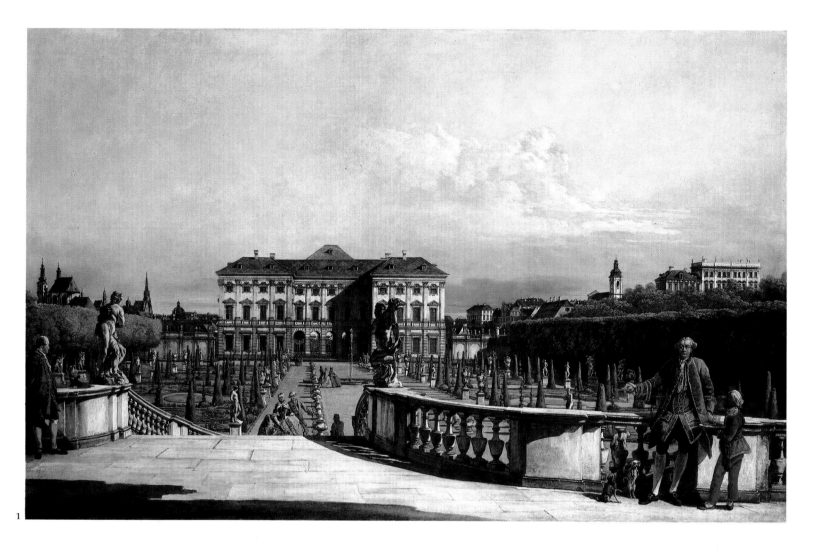

1

the viewer, as well as of the two spaniels (reproduced in Kozakiewicz 1972, vol. 2, figs. 273–76).

KC

FURTHER REFERENCES: Höss 1908, pp. 22, 137; Tietze 1919, p. 22, pl. 16; Borenius 1921, pp. 108ff., pl. IIC; Tietze 1926, pl. 101; Cat. 1931, no. 889; Seidlitz 1911, p. 488; Fritzsche 1936, pp. 64–65, 102, 115, no. 111, pl. 84; Trost 1947, pp. 17, 25, no. 14, pl. 14; Lucerne 1948, no. 11; Sedlmayr 1956, p. 218, pl. 234; Kozakiewicz 1957, pp. 26–27, nos. 44–47; Donzelli 1957, p. 17; de Logu 1958, p. 204; Pallucchini 1960, p. 226, fig. 593; Lippold 1963, p. 32, pl. 53; Menz 1965, pp. 22ff., 59, 66, 114, no. 53, pl. 74; Kozakiewicz 1972, vol. 1, pp. 114ff., pl. XXVI, vol. 2, pp. 212ff., no. 271, pl. 271; Camesasca 1974, pp. 84, 107, no. 164, fig. 164; Pötschner 1978, p. 287, no. 31, pl. 31; Knofler 1979, pp. 109–10, pl. 35; Neubauer 1980, p. 43, pl. 1.

2

Bernardo Bellotto
Venetian, 1720–80

THE LIECHTENSTEIN GARDEN PALACE IN VIENNA VIEWED FROM THE SIDE
Oil on canvas; 39⅜ × 62⅝ in. (100 × 159 cm.)
Liechtenstein inv. no. 887

This picture was commissioned, like its pendant (cat. no. 1), by Prince Joseph Wenzel from Bellotto during the artist's stay in Vienna in 1759–60. It has been incorrectly suggested that the three figures seated on the terrace show Prince Wenzel's wife, his son, and his son's wife or a sister (Camesasca 1974, p. 107). In point of fact, the Prince's son died in 1723 and his recognized heir was his nephew, Franz Joseph, who would have been thirty-four when the picture was painted. There is a drawing for the group as well as one for the spaniel they watch in the Muzeum Narodowe, Warsaw (reproduced in Kozakiewicz 1972, vol. 2, figs. 278–79). Behind them is a courtyard where a coach

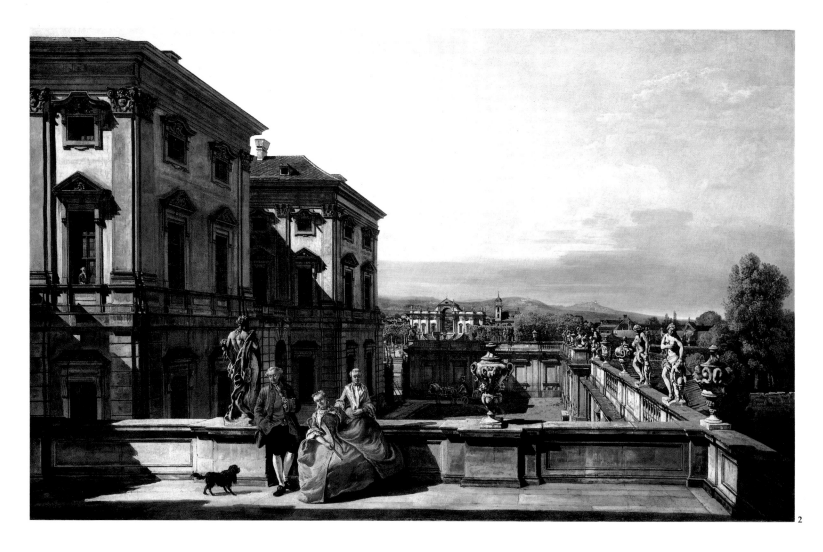

2

has just arrived; the two wings of the southeast facade of the palace; and a partial view of the garden, dominated by Fischer von Erlach's Belvedere (destroyed in 1873 to make way for another palace). The church in the distance is Liechtentaler Kirche, and the range of hills includes the Kahlenberg and Leopoldsberg (Menz 1965, p. 66, no. 54). For the statues and vases on the balustrade see Baum 1964 (pp. 10, 28ff., 51ff., nos. 74, 76, 80, 90, pp. 76–77, 83).

To an even greater degree than its pendant, the picture is conceived as a combined group portrait and a narrative of aristocratic life set against the backdrop of a sumptuous summer palace and garden. The figures, who seem to have gathered on the terrace to pass the afternoon quietly in the sun, are observed by a young man—possibly a servant—who leans out of one of the large windows of the stair landing. Their attention is directed to a little black spaniel. Although no one is visible in the garden or on the balcony of the Belvedere, the angle of the shadows is the same as in the pendant, emphasizing that the difference in mood and activity—or lack of activity—is occasioned by the change in locale rather than the time of day. This is the private, as opposed to the public, view of life in the

Garden Palace, and Bellotto has, in consequence, chosen a higher viewpoint to emphasize the isolation of the family group: he does not invite the viewer's participation. The composition is even more audacious than its pendant in the skillful balancing of the foreshortened mass of Martinelli's Italianate palace against the distant cloud-streaked sky. It was a pictorial formula Bellotto had experimented with several years earlier in his view of the fortress of Sonnenstein at Pirna, and he employed a similar scheme in his contemporary painting of the Kaunitz palace, but it is particularly effective in the Liechtenstein picture.

KC

FURTHER REFERENCES: Höss 1908, pp. 22, 137; Ferrari 1914, pl. 40; Tietze 1919, p. 22, pl. 17; Borenius 1921, pp. 108ff., pl. IID; Levetus 1923, ill. p. 125; Tietze 1926, pl. 100; Cat. 1931, no. 887; Seidlitz 1911, p. 488; Fritzsche 1936, pp. 64–65, 102, 115, no. 110, pl. 85; Stix and Strohmer 1938, pp. 93–94, no. 22; Trost 1947, pp. 17, 25, no. 15, pl. 15; Lucerne 1948, no. 10; Sedlmayr 1956, p. 218; Kozakiewicz 1957, p. 27, nos. 48–49; Donzelli 1957, p. 17; de Logu 1958, p. 204; Kozakiewicz 1972, vol. 1, pp. 114ff., vol. 2, pp. 212ff., no. 277, pl. 277; Camesasca 1974, pp. 84, 107, no. 163, fig. 163; Pötschner 1978, p. 287, no. 30, pl. 30; Knofler 1979, pp. 109–10, pl. 36; Baumstark 1980, no. 25; Neubauer 1980, p. 43, pl. II.

3–10

Marcantonio Franceschini

Bolognese, 1648–1729

SCENES FROM THE MYTHS OF ADONIS AND OF DIANA

The commission for the two series of paintings to which the following eight pictures belong dates from September 4, 1692, when Prince Johann Adam Andreas von Liechtenstein wrote to Marcantonio Franceschini in Bologna that "in one of our buildings we would like to have two rooms decorated with paintings instead of tapestries, if first we can learn what you would ask for such work in order that a contract can be drawn up."* The building in question was the Garden Palace on the outskirts of Vienna, for which the Prince had acquired property in 1687. Plans must have been in hand by December 10, 1691, when a mason was hired (see Passavant 1967, pp. 109ff.). In any event, detailed drawings showing the positions and sizes of the pictures accompanied the letter to Franceschini on September 4, 1692. Franceschini had behind him a number of large decorative commissions, the most recent of which was his work in the Cathedral of Piacenza, and he must have seemed a logical candidate for the task, especially since a number of Bolognese citizens in the Prince's service were able to give first-hand reports of his work (letter of October 26, 1692, from the Prince to Franceschini). Nonetheless, the actual offer was preceded by several lesser commissions to familiarize the Prince with Franceschini's capabilities. In 1691 the Prince commissioned two pictures from the artist of half-length figures of Prudence and Justice (see Cat. 1767, pp. 29, 54, 57, nos. 315, 334). These were followed by a commission for a narrative picture ("un quadro historiato") of a profane subject, "since all of the pictures in this gallery are secular" (letter of June 12, 1691). Curiously, the theme Franceschini settled upon was the Finding of Moses; he sent off the picture a year later. It was this painting (now in the Kunsthistorisches Museum, Vienna) that decided the Prince to offer the commission for the two large decorative cycles in his Garden Palace to Franceschini.

As laid out in the letter, there were initially to be seventeen pictures divided between two rooms. The first room was to have three large vertical pictures (the bottom edges of these were to be four feet [1.2 m.] from the floor, allowing furniture to be placed along the wall below), one slightly smaller picture over a fireplace, five horizontal canvases to serve as overdoors, and one ceiling piece. The second room was to have three large canvases (again with their bottom edges four feet [1.2 m.] from the floor), one smaller picture over a fireplace, two horizontal overdoors, and a ceiling piece (both ceiling pieces were later specified as circular). "And in each room," the letter specifies, "a different story or fable from Ovid is to be treated, since profane things are more in keeping with that place." The insistence on the profane character of the two cycles must have been prompted by the Prince's disappointment in receiving the *Finding of Moses* instead of the secular picture he had requested. Indeed, only gradually did Franceschini come to understand the taste of the Prince and alter his own self-confessed prudery to accommodate his patron. In August 1692—just prior to commissioning the cycles—the Prince had ordered a nude Venus from Franceschini, which the artist, in a fascinating note, proposed modifying by showing her clothed, "since otherwise I would find the great readiness that I should have in obeying your very esteemed instructions impeded by my insuperable scruples in painting lascivious things ... since I have already made a firm resolution never in my life to paint [a nude figure]" (letter of September 10, 1692). The genuineness of this sentiment is borne out by Zanotti's characterization of the artist in his 1739 biography. The Prince agreed, provided that the Venus "would not be completely covered except in those shameful places" ("non anche per tutto cuoperta se non in luogho vergognoso"—letter of October 12, 1692). A month later Franceschini assured the Prince that there would not, after all, be much drapery. These two incidents, marking Franceschini's growing understanding of the Prince's taste, were to be fundamental in determining the character and—in the case of the cycle of Diana—even the choice of subjects for the pictures under examination.

On September 24, 1692, Franceschini responded to the Prince's offer, proposing a price for the individual pictures and requesting measured lengths of string to ensure no error in their sizes. The Prince, in turn, requested drawings or a description of the proposed scenes to enable him to evaluate the prices Franceschini had quoted. He also brought up the matter of Franceschini's frequent use of Luigi Quaini (1643–1717) as an assistant, expressing his hope that the work Franceschini carried out would be entirely from his hand, "since the said Quaini has painted for us two ovals that did not meet our satisfaction" (letter of October 26, 1692). The remark proves, again, how well-informed and demanding a patron he was. On November 12, 1692, Franceschini sent the Prince a description of his proposal for the two cycles. Although he stated that he did not have the time required to make sketches of the canvases, it is clear that he had given each composition some thought. He had chosen two stories from Ovid, "both of them filled with such events as might lend themselves to the distribution between large and small pictures and in the ceiling of each room." For the first room he proposed the story of Phaeton and for the second the story of Adonis. He intended to treat both cycles in their proper narrative sequence, "so that proceeding from the left upon entering [each room ... the visitor] will see the story completely painted with the same order in which it is described by Ovid. The large pictures will be copious, perhaps with ten figures in each, and the small ones will have half as many or a little less. However, I do not want to bind myself to a precise number, but rather to such as will be most suitable to realizing the expressions and richness of the work."

ADONIS CYCLE

DIANA CYCLE

ADONIS CYCLE

1 The Birth of Adonis (cat. no. 3)
 a. *The Divine Dryad of the Forest Brings Myrrh as Gifts*
 b. *Venus and Cupid*
2 Venus Enamored of Adonis
 c. *The Spinner and Cupid*
 d. *Sleep Assists Love*
3 Venus and Adonis Hunting (cat. no. 4)
 e. *Mercury and Cupid Mending Nets*
 f. *Mercury Snares Birds and Cupid Hearts*
4 The Death of Adonis (cat. no. 5)
5 The Dead Adonis Discovered by Venus
6 Venus Anointing the Dead Adonis (cat. no. 6)
7 Diana and Mars Watch Cupid Being Chastised

DIANA CYCLE

1 The Birth of Diana and Apollo (cat. no. 7)
2 Latona and the Lycian Peasants (cat. no. 8)
3 Diana and Apollo Slay the Python (cat. no. 9)
4 Diana and Arethusa (?)
5 Diana and Callisto
6 Diana and Pan (?)
7 Diana and Actaeon (cat. no. 10)
 a. *Putti Bathing*
 b. *Putti Playing with the Nymph's Arms*
 c. *Putti Hunting*
8 Diana and Her Nymphs Hunting
9 Diana and Endymion
10 Diana Carries Endymion to Olympus

Fig. 13 Adonis and Diana cycles

The task Franceschini set himself was not simple. It required that in each story he find four episodes lending themselves to treatment on a large, vertical picture field and in one case five and in the other two episodes involving only a few figures that could be shown at a consistent scale on a picture field approximately two thirds the width and only a bit over a third the height of the larger paintings. Additionally, these episodes had to follow both the narrative sequence and the succession of sizes dictated by their placement. In the second room, three large pictures were succeeded by an overdoor, a large canvas, and another overdoor. The subjects he proposed were the birth of Adonis (cat. no. 3); Venus enamored of Adonis (Franceschini anticipated filling out the scene with the Three Graces and putti); Venus and Adonis hunting (cat. no. 4); the death of Adonis (cat. no. 5); Venus discovering the dead Adonis (here Venus would be shown descending from her chariot); Venus anointing Adonis's body (cat. no. 6); and, in the ceiling, Mars and Diana. (On the basis of a preliminary drawing in the Louvre and a drawing of the same composition in the Art Institute, Chicago, that is squared for transfer, Miller, in his forthcoming study, plausibly suggests that the final ceiling showed Mars and Diana watching the chastisement of Cupid; the ceiling painting is lost.) The components of this cycle remained unchanged (see diagram).

The story of Phaeton posed far greater restrictions, and simply reading through Franceschini's description, it is not surprising that he eventually opted for another subject. For example, in the fifth canvas—one of the overdoors—Phaeton was to be shown in Apollo's horse-drawn chariot with Apollo crowning him and Aurora nearby. This was to be followed by a large canvas showing Phaeton in the sky losing control of the chariot, with shepherds and nymphs below. It is difficult to imagine how Franceschini could have shown all the protagonists in the smaller canvas in the same scale as those in the larger picture.

Yet not until 1697 did he abandon this subject (see below).

Franceschini also assured the Prince that although it was true that Quaini had worked with him on frescoes, the two artists habitually painted their own canvases (this was not, strictly speaking, true) and that Franceschini valued his own reputation more than money. He is, nonetheless, known to have employed Quaini for the landscape backgrounds on a later commission of the Prince's, as a payment to Quaini in 1708 proves (see Miller's forthcoming study). Zanotti's report of the incident suggests that Quaini was employed in the same capacity in the present pictures as well (1739, vol. 1, p. 227).

On December 6, 1692, it was decided—at Franceschini's suggestion—to add nine long, narrow canvases to the commission. These would go over three windows in the first room and six in the second room and would complement but not interfere with the narrative sequence of the other pictures (see diagram). A final price of 6,600 ducats for the entire enterprise was agreed to by the artist on February 4, 1693.

There is little specific information on Franceschini's progress on the cycle in the subsequent five years. The artist was engaged in the frescoed decoration of the Chiesa del Corpus Domini in Bologna from 1689 until 1696 and with the ceiling of the Palazzo Ducale in Modena in 1696. The Prince's commission was necessarily postponed: there was little pressure to hurry since the palace was very far from complete. Indeed, Franceschini's surviving correspondence during these years (a good deal from the years 1694 to 1698 seems to be lost) is mostly concerned with the purchase of works of art for the Prince's collection. Nonetheless, a general outline of the execution of the two cycles emerges clearly enough.

Franceschini only began to draw payments on a regular basis in mid-1695: a first payment of 500 ducats was made in April 1693, while the second, of 1,000 ducats, was not paid until late June 1695. Two payments of 500 ducats each followed in February and May 1696. During this time all references to the commission describe the cycles as Phaeton and Adonis. Since the subject of Phaeton was eventually dropped, there can be little doubt that work was focused exclusively on the cycle of Adonis. On June 29, 1697, an additional payment of 400 ducats was made, and on July 22 the ultimate subject of the second series—Diana rather than Phaeton—was first mentioned by Franceschini. It is therefore safe to assume that by this date the Adonis cycle had been finished and sent to Vienna and that Franceschini was now turning his attention to the second series. Indeed, according to the prices agreed upon in 1693 (500 ducats for the ceiling piece, 350 ducats for each of the four large paintings, 200 ducats for each of the two overdoors, and 100 ducats for each of the six window paintings), the total sum of 2,900 ducats paid to Franceschini would exactly cover the cost of the pictures for the one room. From this point on progress was rapid and can be followed in great detail (indeed, only the date the ceiling piece was sent cannot be deduced from the correspondence). On December 13, 1697, Franceschini received 1,000 ducats—most

likely the first payment for the second series to cover the rather large outlay the artist would have had to make to purchase materials. This was followed by 500 ducats in August 1698 and 1,000 ducats on December 10 of the same year. On December 23 the four large canvases of the second cycle were crated and sent off. In a letter dated December 24, Franceschini included a detailed description both of the scenes and of their sequence in the cycle: Latona and the Lycian peasants (cat. no. 8; designated the second in the series); Diana and Callisto (the fifth in the series); Diana and Actaeon (cat. no. 10; the seventh in the series); and Diana and her nymphs hunting (the eighth in the series). By July 22, 1699, Franceschini was able to inform the Prince that work on the five overdoors was advancing. He foresaw sending everything—including the "scherzi di Putti," the three canvases depicting putti playing that were to be placed over the windows—that winter, and he requested another 500 ducats, which was paid to him in October. By then work was almost complete, and on December 3, 1699, Franceschini requested instructions for sending the eight canvases, which he thought would have to be rolled. This was of some concern, since one of the large pictures had arrived damaged (letter of February 11, 1699, from the Prince to Franceschini). On February 3, 1700, he received payment of a residual sum of 700 ducats (the 3,200 ducats for the various canvases plus 500 extra, as agreed upon in 1693) and a promised bonus of 100 gold coins. The eight pictures were sent that March, and in his letter on the seventeenth of that month Franceschini—ever concerned with the proper sequence of the pictures—informed the Prince that he had numbered the backs of the overdoors to ensure their correct placement; these numbers are still visible on the reverse of at least two of the canvases (see cat. nos. 7, 9). This was necessary since not all of the episodes in the Diana cycle are told by Ovid, and Franceschini had to some extent to create his own narrative sequence; this had not been the case with the Adonis series. He also included instructions for the placement of the decorative canvases with putti, making it clear that the window pieces complement the scene they flank. The canvases to either side of Diana bathing, for example, showed, in one, putti bathing "on the example of the nymphs," and, in the other, putti who put on the nymphs' clothes and play with their weapons.

Receiving no immediate response from the Prince upon the arrival of the pictures, Franceschini wrote him on December 1, 1700, describing how the lack of a letter was "causing me to live with great fear and anxiety at having involuntarily committed some error." But he need not have worried, since a letter was on its way expressing "Nostro contento." And, indeed, four years later the Prince was to offer Franceschini further employment in the Garden Palace, this time to paint frescoes with the collaboration of an expert in perspective ("un quadrista").

The installation of the pictures in the Garden Palace did not long survive Prince Johann Adam: by 1780 a number of them had already been moved to the City Palace and distributed with

Fig. 14 Detail from cat. no. 4

no attention to their narrative sequence. An even worse fate was to follow. Of the Diana series, two of the window pieces were sold in 1880 and another in 1924. In the latter year three other canvases from the cycle were also sold. The Adonis series has fared somewhat better, although only one of the six window pieces is still in the Liechtenstein collection (on the window pieces, see Miller 1979) and the whereabouts of the ceiling piece is unknown (for the whereabouts of the various canvases connected with the two cycles, see Miller's forthcoming study).

The rooms in which the two cycles originally hung are, however, easily located, since only two rooms on the main floor of the Garden Palace have the proper number and sequence of doors, windows, and a fireplace mentioned in Franceschini's detailed letter of November 12, 1692. These are the two *stanze reali* on the garden side of the palace, just off a long gallery, numbered 2 and 3 on the plan of the palace published in 1864 (see Passavant 1967, fig. 117)—just as they were on the plan sent to Franceschini in September 1692. In his letter of October 26, 1692, the Prince suggested that Franceschini number his pictures beginning with the canvas nearest the entrance to the room. This plan was adopted by the artist. There are, however, three entrances into the room where the Diana cycle was placed, and this meant that, theoretically, the cycle could begin in three different places—each choice would alter the sequence of canvas sizes. In the original Phaeton cycle, Franceschini began the narrative with a large canvas immediately to the left of a door from an adjacent room, whereas in the Diana cycle he began the narrative with an overdoor to the left of another entrance

(from the gallery). The latter, final, solution had the incidental advantage of utilizing a door on an axis with the main entrance into the second room.

The reasons Franceschini decided to change the subject of one cycle almost five years after the commission are never spelled out in the correspondence, but by 1697 Franceschini had probably realized that a cycle that included two bathing scenes of Diana and her nymphs would please the Prince more than one devoted to Apollo's son. It would also complement the Adonis series more effectively (both have hunting themes) as well as be more appropriate to a garden palace. The Prince had expressed his admiration for a masterly representation of nudes more than once (see, for example, his letter to Franceschini of March 25, 1693), and the correspondence over the nude Venus had not been lost on Franceschini. When the four large pictures from the Diana cycle arrived in Vienna, the Prince's reply vindicated Franceschini's choice (assuming that he, and not the Prince, was responsible for the change): "This time you have done so well that we find [everything] to our taste and special satisfaction. Nor do we doubt that in what remains you will not do less, for it seems that the window pieces that we already have [two of which showed partly draped women] are not as beautiful ["non vi è tanta vaghezza"] as in the above-mentioned works" (letter of February 11, 1699).

In the accompanying diagram, Franceschini's ordering has been followed. There remains some uncertainty regarding the sequence of three of the overdoors in the Diana cycle (nos. 4, 6, and 9), and the placement of the six window pieces accompanying the Adonis cycle. The overdoors were numbered on their reverse, but in the event that these numbers have not been transcribed (the whereabouts of one is unknown and the other two are in the Rathaus in Aachen; see Miller's forthcoming study), their relative positions in the cycle must remain tentative. The case is somewhat different with the six window pieces, all of which were engraved by Franceschini's pupil Francesco Antonio Meloni, for although Franceschini never mentions their subjects (for which see Callahan 1979), they were to complement the scenes of the large canvases they flanked, and a more secure arrangement can be proposed.

The commission of these two narrative cycles was pivotal to Franceschini's career. At the time he began work for the Prince in 1691, he had become the most sought-after decorator in Bologna and the leading exponent of classicism. Zanotti (1739, vol. 1, p. 221) tells how, while still an assistant of Carlo Cignani working in the church of San Michele in Bosco, the young Franceschini spent hours in the cloister copying the celebrated frescoes of Ludovico Carracci, and several scenes in the two cycles he carried out for the Garden Palace in Liechtenstein reveal an equally intense study of the work of Domenichino and Albani (see Miller 1957, pp. 233–34; and cat. nos. 4, 10). However, more important than the work of any single artist was the Bolognese academic tradition that was the legacy of the Carracci and their pupils, with its emphasis on drawing as the

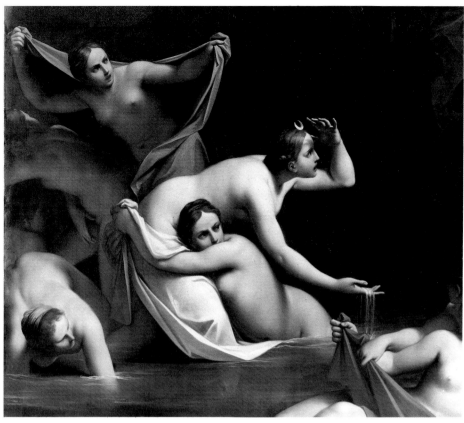

Fig. 15 Detail from cat. no. 10

means of translating visual experience into a realm of ideal beauty, and the use of carefully conceived gestures and expressions (or *affetti*) to convey the sense of a story. According to Zanotti (1739, vol. 1, p. 245), Franceschini was devoted to drawing, and the anonymous author—possibly Franceschini's son—of another biography describes how Franceschini spent his evenings working out his various projects in preliminary compositional sketches. Details would then be studied from life. The final step was a compositional drawing that could be squared for transfer to a canvas or worked up into a cartoon for frescoes. This was the method bequeathed by Annibale Carracci and passed on to Franceschini by his teacher, Carlo Cignani, who had been a pupil of Albani (see Zanotti 1739, vol. 1, pp. 155–56, 161). Equally important was Franceschini's devotion to literature, again attested by Zanotti. Franceschini himself outlined his goals in a letter he sent to Prince Johann Adam Andreas on June 11, 1692, by way of elucidating the *Finding of Moses* he had just completed for the Prince. "I have endeavored to express those characteristics that accord with the meaning of the story," he writes. "[In the child] I have attempted to bring out a loving sweetness, showing him stretching out his arms almost as though he were caressing and asking for mercy." An attendant of the Egyptian princess "is shown advising the princess to save the child and, placing her hand near her breasts, she offers to nurse him." The letter, as much as the painting, may have convinced the Prince that Franceschini was eminently qualified to treat in detail two mythological subjects from Ovid.

It is, in any case, clear that the commission offered Franceschini a unique opportunity to put his ideas about narrative painting into practice. A reading of Ovid's text reveals just how close a relationship Franceschini posited between painting and the written word.

According to Luigi Lanzi (1795–96, vol. 2, pt. 2, p. 185), no less an artist than Mengs spent hours studying Franceschini's ceiling (now destroyed) in the ducal palace of Genoa. Franceschini's paintings do indeed seem to anticipate aspects of the nascent Neoclassicism of Mengs and Batoni of half a century later. The careful, frequently friezelike grouping of his idealized figures, the emphasis on narrative clarity, and the clear tonality of his colors are shared by the two later artists. What is lacking in Franceschini's work, however, is the archaeological interest and doctrinaire approach that characterize Mengs's most forward-looking paintings, and Miller (1957, p. 233 n. 19) has emphasized that Franceschini "stands at the end of a tradition, not at the beginning of another." Franceschini's Liechtenstein paintings may, more properly, be viewed as the middle term between Bolognese seicento classicism and Roman Neoclassicism of the eighteenth century (see Miller 1982).

KC

* A study by Dwight C. Miller of Franceschini's work for Prince Johann Adam with transcriptions of his correspondence by Herbert Haupt is in preparation. Citations to Franceschini's correspondence and references to D. Miller (forthcoming study) are to this manuscript, which I was generously permitted to consult. I have, however, preferred not to discuss Miller's reconstruction of the two cycles as installed, since this would be preemptive.

THE ADONIS CYCLE

3

THE BIRTH OF ADONIS
Oil on canvas; 189 × 100¾ in. (480 × 256 cm.)
Liechtenstein inv. no. 30

Adonis was the offspring of the incestuous relationship of Myrrha and her father, Cinyras. Cinyras had been the unwitting partner in the affair, and when he discovered the identity of his lover, his anger was such that Myrrha fled. Exhausted after nine months of wandering and filled with remorse, she prayed to be changed so that she should be denied both life and death, whereupon the gods transformed her into the myrrh tree. Ovid (*Metamorphoses* 10.503–15) writes: "But the misbegotten child had grown within the wood, and was now seeking a way by which it might . . . come forth . . . like a woman in agony, the tree bends itself, groans oft, and is still wet with falling tears. Pitying Lucina stood near the groaning branches, laid her hands on them, and uttered charms to aid the birth. Then the tree cracked open . . . and it gave forth its living burden, a wailing baby boy. The naiads laid him on soft leaves and anointed him with his mother's tears." In his letter of November 12, 1692, to Prince Johann Adam, Franceschini described his conception of the subject as "the birth of Adonis which, with Lucina assisting at the birth along with nymphs, satyrs, and putti, will be most copious."

Lucina, lunar symbol in her hair, hands Adonis to a nymph, while two others gaze in astonishment at the opening in Myrrha's trunk. Ovid describes the child as looking "like one of the naked cupids portrayed on canvas" (10.515–16), and the artist translates this analogy into visual terms. Behind Lucina a satyr— perhaps Pan, a frequent companion of the nymphs—points out the astonishing occurrence to a companion. Franceschini represented the subject some years earlier in a small horizontal canvas now in the Gemäldegalerie, Dresden, that Miller (1971, p. 127) identified with a picture commissioned in 1684 by a P. Gremisi in Bologna. A drawing for that picture is in the Metropolitan Museum (see Bean 1979, p. 149, no. 189). Considering the different format and size of the two pictures, the main features of the compositions are remarkably similar, though the grouping in the Liechtenstein canvas is more compact and the relationships between the figures more carefully worked out. In the Metropolitan drawing Franceschini showed Adonis with his head turned toward the viewer. Abandoned in the Dresden painting, this motif was revived in the Liechtenstein canvas (though the position of the child is reversed). In the Liechtenstein picture the hand of the foreground nymph once covered her nipple. Franceschini, no doubt having in mind the tastes of his patron, lowered the hand to expose the breast. Miller (forthcoming study) notes four studies for individual figures in the Gabinetto dei Disegni e Stampe, Genoa.

It is probable that the two window pieces flanking this, the first of the Adonis series, showed, on the left, Sylvanus, the Roman god of the woodlands, with a putto transformed into a myrrh tree offering him a branch (the composition is accompanied by an inscription reading "The Dryad of the Forest Brings Myrrh as Gifts" in Francesco Antonio Meloni's engraving; see Miller 1979 and Callahan 1979), and, on the right, Cupid leaving Venus after having inadvertently wounded her with one of his arrows. The first of these scenes makes an obvious allusion to the story of Myrrha, and the second is actually an episode in the Adonis story, since Venus's wound caused her to fall in love with Adonis.

KC

4

VENUS AND ADONIS HUNTING
Oil on canvas; 189⅜ × 100⅜ in. (481 × 255 cm.)
Liechtenstein inv. no. 77

Venus, having fallen in love with Adonis, joins him in hunting and "ranges with her garments girt up to her knees after the manner of Diana. She also cheers on the hounds and pursues those creatures which are safe to hunt, such as the headlong hares, or the stag with high-branching horns, or the timid doe; but from strong wild boars she keeps away" (Ovid, *Metamorphoses* 10.535–39). In accordance with his proposal of 1692, Franceschini shows "Adonis with Venus attended by shepherds, nymphs, and putti, with dogs and other hunting equipment pursuing less dangerous game, like deer . . . " The two putti are counterparts to Venus and Adonis, and their presence adds a lighthearted touch to the scene. This playful mood was enhanced by the flanking window pieces, which showed in one Mercury and Cupid mending nets and in the other Mercury snaring birds and Cupid hearts (see Miller 1979 and Callahan 1979). This is the third scene of the narrative cycle. Miller (forthcoming study) notes four related drawings in the Gabinetto dei Disegni e Stampe, Genoa.

Though in the representation of figures Franceschini was eminently gifted, he was no animal painter, and the stag and dogs in this painting sadly compromise its beauty. It is worth comparing the pose of the shepherd at the right with Domenichino's boatman in the fresco *The Calling of Peter and Andrew* in Sant'Andrea della Valle, Rome, as an indicator both of Franceschini's sometimes close dependence on the model of his great predecessor as well as of the limits of his more refined but less thoroughgoing classicism.

KC

FURTHER REFERENCES: Cat. 1767, no. 327; Cat. 1780, no. 610; Smith 1829–42, vol. 1, p. 349, no. 502; Parthay 1863–64, vol. 2, p. 813, no. 500; Cat. 1873, no. 670; Cat. 1885, no. 430; Hofstede de Groot 1908–27, vol. 2, pp. 553–54, no. 908; Cat. 1931, no. 430; Thieme-Becker, vol. 36 (1947), p. 267; Lucerne 1948, no. 1977; Cat. 1970, no. 80.

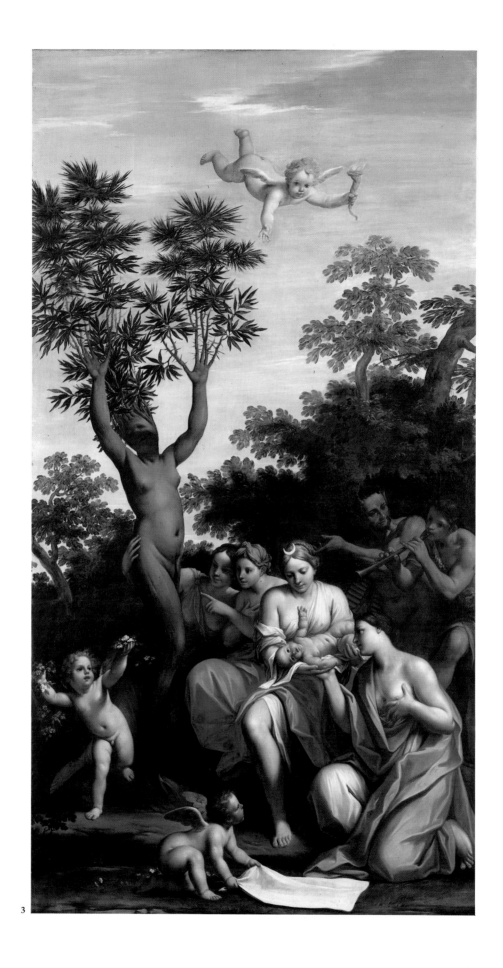

3

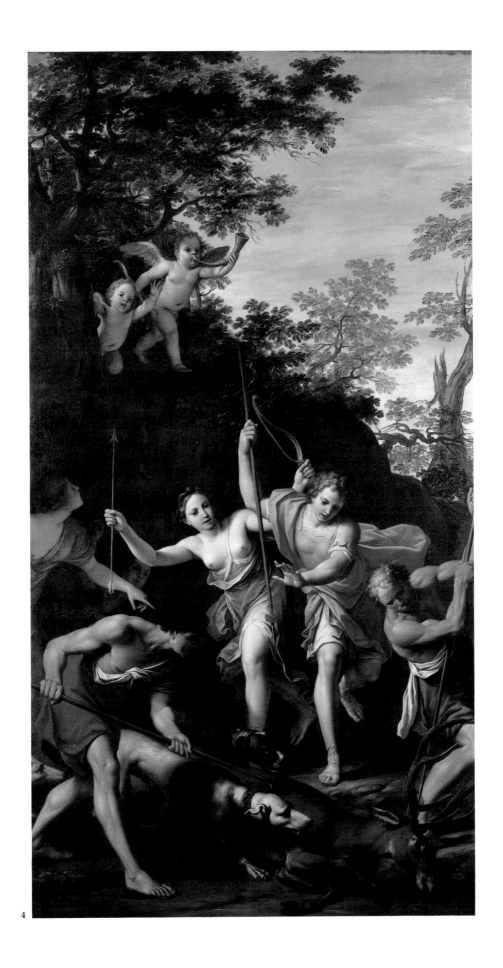

4

15

5

THE DEATH OF ADONIS
Oil on canvas; 69¼ × 82⅝ in. (176 × 210 cm.)
Liechtenstein inv. no. 6

Disregarding Venus's warnings not to hunt wild boars, Adonis pursued one and was set upon by the animal, who "sank his long tusks [in Adonis's groin] and stretched the dying boy upon the yellow sand" (Ovid, *Metamorphoses* 10.715–16). In his letter of November 12, 1692, Franceschini mentioned "in the distance shepherds who flee." In painting the canvas he opted for a fleeing putto, who was painted over the completed foliage. Perhaps

the least successful of the series—the combination of violent action and an emphasis on animals put Franceschini at a double disadvantage—this is the fourth episode and was intended as an overdoor.

KC

6

VENUS ANOINTING THE DEAD ADONIS
Oil on canvas; 69¼ × 82⅝ in. (176 × 210 cm.)
Liechtenstein inv. no. 8

5

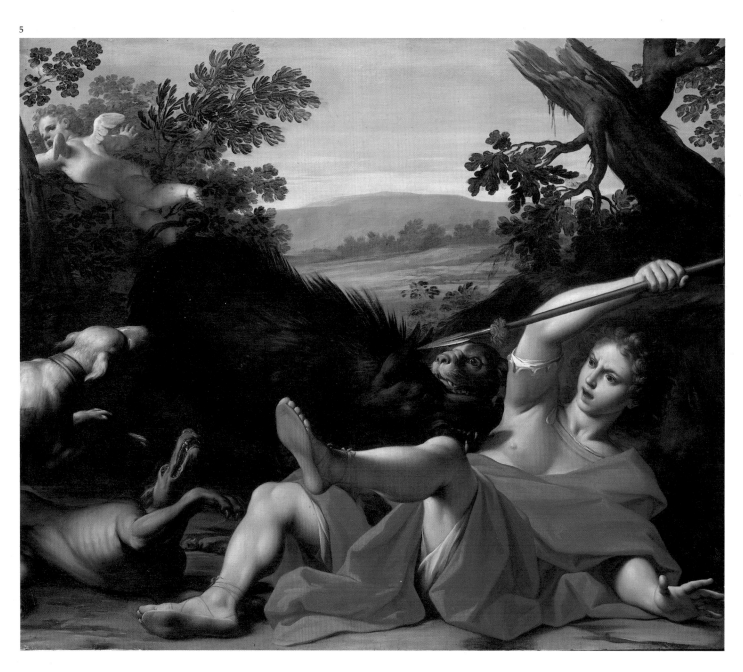

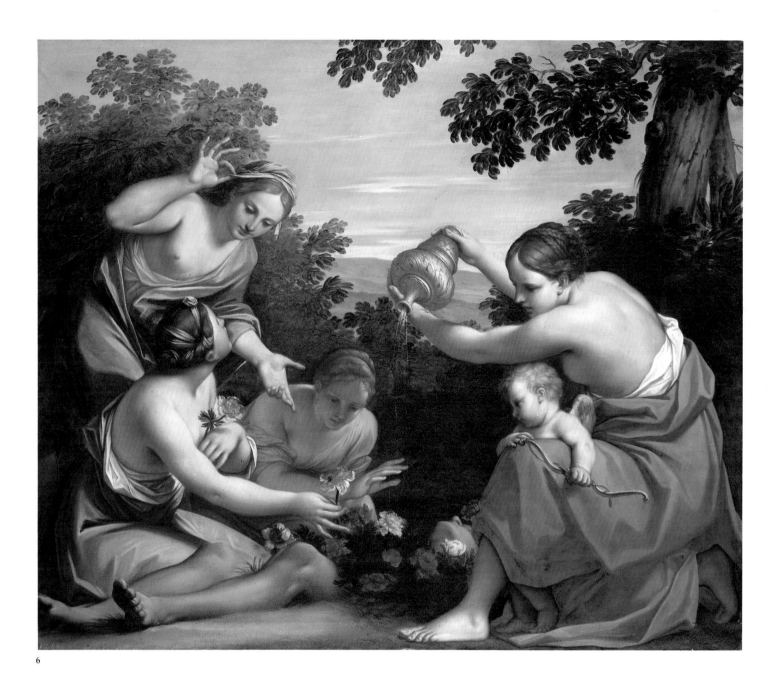

6

In token of her grief over the death of her lover, Venus "with sweet-scented nectar sprinkled [Adonis's] blood; and this, touched by the nectar, swelled as when clear bubbles rise up from yellow mud. With no longer than an hour's delay a flower sprang up of blood-red hue. . . . But short-lived is this flower; for the winds from which it takes its name [Anemone] shake off the flower so delicately clinging and doomed too easy to fall" (Ovid, *Metamorphoses* 10.731–39). In 1692 Franceschini already envisaged all the main features of this, the sixth and last of the series: "In the small sixth [picture will be] the transformation of Adonis into anemones, with Venus pouring ambrosia on the dead youth, changing him into flowers which some nymphs or Graces gather to adorn their bosoms and hair."

Miller (forthcoming study) notes a drawing for the figure of Adonis in the Gabinetto dei Disegni e Stampe, Genoa, in which the youth's posture is reversed; it also includes an additional figure that does not appear in the final composition.

This is one of the most beautiful pictures in the cycle and one in which Franceschini seems to have best grasped the poetic basis of the *Metamorphoses*, which is not the tragedy or drama of an individual's life, but the poignant transformation—or absorption—of that life into the eternal cycle of the seasons. The string on Cupid's bow is unattached, and the emphasis is placed on the expressions of the enraptured nymphs (seemingly the same who had attended Adonis's birth).

KC

The Diana Cycle

7

THE BIRTH OF APOLLO AND DIANA

Oil on canvas; 69¼ × 82⅝ in. (176 × 210 cm.)
Inscribed (upper left on reverse): 1
Liechtenstein inv. no. 29

Latona conceived twins by Jupiter, and for that love affair she was pursued by Juno. She at last took refuge on Delos where, "reclining on the palm and Pallas' tree in spite of their stepmother, she brought forth her twin babies. Even thence the new-made mother is said to have fled from Juno, carrying in her bosom her infant children, both divine" (Ovid, *Metamorphoses* 6.335–38). The children, lying on a white sheet and looking up at their mother, are distinguished by the moon (Diana) and rays (Apollo) above their heads. Appropriately, Latona reclines beneath an olive, the tree of Pallas. In the sky, accompanied by her symbol, the peacock, is Juno, who remonstrates with Latona with an upraised arm.

Miller (forthcoming study) notes a drawing in the Gabinetto dei Disegni e Stampe, Genoa, for the upper torso and head as well as of the legs of Latona. The composition was adapted with minimal changes to suit a vertical format in the Diana cycle Franceschini carried out in the Palazzo del Podestà in Genoa in 1715 and 1721 (see Miller 1957). The various changes introduced there all weaken the conception of the Liechtenstein composition, which has a clarity and elegance that anticipate the work of Batoni. Interestingly, in Genoa Franceschini decorously covered Latona's bared breast, while here the drapery was lowered. There are a number of minor pentimenti, the most important being in the contour of Latona's right leg. The branches of the tree in the right middle ground that overlap the figure of Juno were painted over her completed form.

Franceschini had intended to begin his cycle of Phaeton with a large canvas and end it with two overdoors. When he changed the subject to Diana, he chose to begin with an overdoor, thereby better integrating the cycle with the architectural rhythm of the room (see diagram).

KC

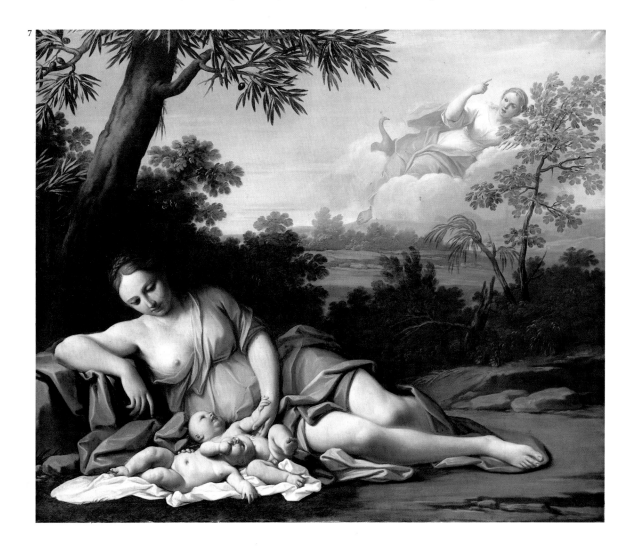

7

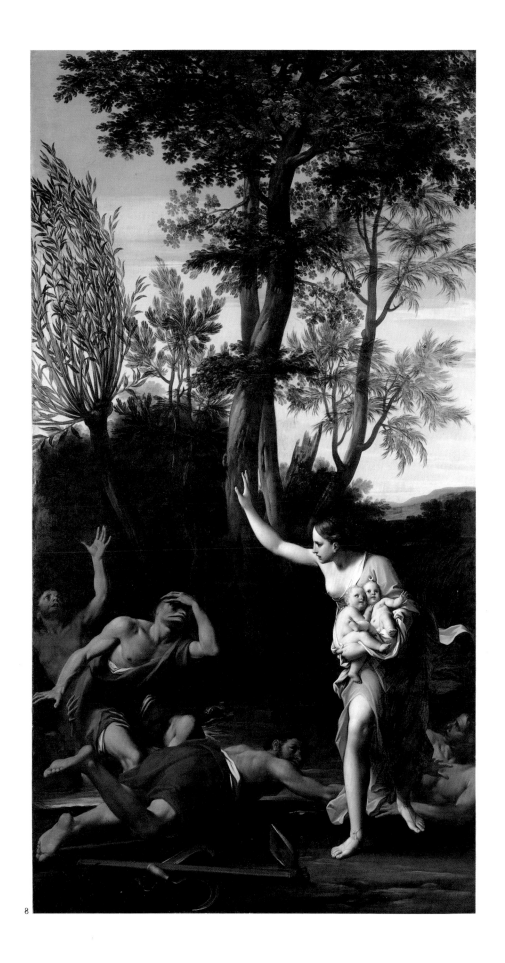

8

8

LATONA AND THE LYCIAN PEASANTS
Oil on canvas; 188¼ × 100⅜ in. (478 × 255 cm.)
Liechtenstein inv. no. 72

Fleeing Juno, Latona stops with her two children at a lake in Lycia to drink. Peasants busy gathering "bushy osiers with fine swamp-grass and rushes of the marsh" denied her permission to drink from their waters "and persisted in denying with threats if she did not go away; they even added insulting words. Not content with that, they soiled the pool itself with their feet and hands, and stirred up soft mud from the bottom, leaping about, all for pure meanness. Then wrath postponed thirst . . . and stretching up her hands to heaven, [Latona] cried: 'Live then for ever in that pool.' It fell out as the goddess prayed. It is their delight to live in water; now to plunge their bodies quite beneath the enveloping pool. . . . But even now, as of old, they exercise their foul tongues. . . . Their voices are hoarse, their inflated throats swell up, and their constant quarrelling distends their wide jaws . . . and as new-made frogs they leap in the muddy pool" (Ovid, *Metamorphoses* 6.344–81). Franceschini has lavished all his narrative inventiveness on this, the second canvas in the series, showing the Lycian peasants in various states of transformation into frogs, with the tools they had so recently employed left abandoned on the shore. The picture is described by Franceschini in a letter of December 24, 1698, at the time of its transport to Vienna, along with the three other large canvases of the Diana cycle.

Miller (1983; and forthcoming study) has noted a number of preparatory studies in the Gabinetto dei Disegni e Stampe, Genoa, and the Accademia Carrara, Bergamo, as well as a general compositional study sold at Christie's, London (July 1, 1969, no. 16). The drawing sold at Christie's is clearly an early idea on the subject and has the interest of documenting a significant change in Franceschini's conception of the theme, since it shows the peasant on the right, his head already changed into that of a frog, watching Latona. The figure was worked up in a detail drawing at Bergamo (no. 1989). In the picture he is still human. He turns his head and raises his arm in astonishment at the transformation of his companions. It is the progressive metamorphosis of the peasants into frogs that clearly fascinated Franceschini, who brilliantly contrasts the two still-unchanged peasants at the left—one leaping like a frog, and the other raising his hand in a froglike gesture—with their two semimetamorphosed companions who cower together moments before losing all signs of their humanity. An enormous frog swims ominously in the pool.

KC

9

APOLLO AND DIANA SLAY THE PYTHON
Oil on canvas; 69¼ × 82⅝ in. (176 × 210 cm.)
Inscribed (upper left on reverse): 3
Liechtenstein inv. no. 1

According to Ovid (*Metamorphoses* 1.441–42), the Python was a huge and terrifying serpent that was formed spontaneously from the earth as the flood-soaked ground was heated by the sun's rays. The poet writes that "this monster the god of the glittering bow destroyed with arms never before used except against dogs and wild she-goats." While it is likely that Franceschini's point of departure was Ovid, he has shown himself to be just as erudite as Zanotti (1739, vol. 1, p. 245) claims him to have been. Ovid makes no mention of Diana's presence, but according to Pausanias (*Description of Greece* 2.7.7) the two siblings slew the serpent together. Franceschini also doubtlessly knew that the event was thought to take place while the two were still infants or children and that it should therefore immediately follow the scene of Latona and the Lycian peasants. The greatest license was taken in the representation of the serpent as a winged dragon, over whose rather silly features he labored considerably (there are vast changes in the position of the head and claws). Apollo's smooth-limbed body and calculated pose are clearly evocative of ancient sculpture.

KC

10

DIANA AND ACTAEON
Oil on canvas; 188⅜ × 100⅜ in. (479 × 255 cm.)
Liechtenstein inv. no. 2

The unfortunate hunter Actaeon wandered by chance into the grotto where Diana and her nymphs bathed. "As soon as he entered the grotto bedewed with fountain spray, the naked nymphs . . . filled all the grove with their shrill, sudden cries. Then they thronged around Diana, seeking to hide her body with their own; but the goddess stood head and shoulders over all the rest. . . . Then, though the band of nymphs pressed close about her, she stood turning aside a little and cast back her gaze; and though she would fain have her arrows ready, what she had she took up—the water—and flung it into the young man's face," transforming him into a stag (Ovid, *Metamorphoses* 3.177–90). In most earlier representations of this scene Actaeon is shown partly transformed. Here he halts in enraptured delight, unaware of the fate about to befall him. Franceschini lays the emphasis on the bath scene, and his letter to the Prince on December 24, 1698, announcing the departure of the picture for Vienna, reveals this intention: "In the third [canvas], which

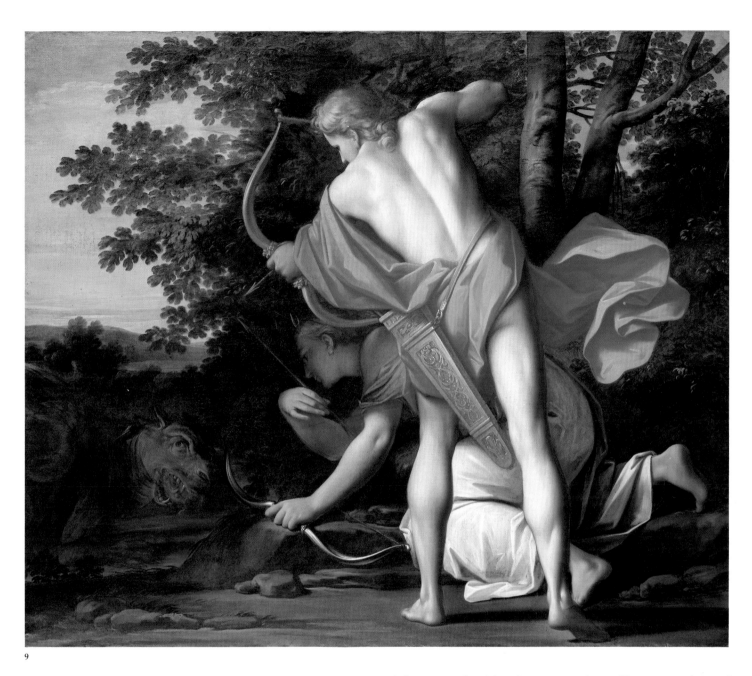

9

will be the seventh [scene in the series], is a woodland bath where Diana is in the act of sprinkling water toward Actaeon to transform him into a stag; the other nymphs are covering themselves from the sight of the youth."

This was a scene calculated to please the Prince, and Franceschini has painted it with a refinement rare even for him. The poses of the figures create a beautiful pattern of interlocking curves, and the supple bodies have a purity of form that evokes an ivory or alabaster bas-relief. Franceschini's point of departure for the composition was almost certainly a work by his Bolognese predecessor Francesco Albani. Perhaps the closest parallel is with a composition of Diana and Actaeon by Albani formerly with David Carritt, where the foreground is again dominated by two nude nymphs while Diana is shown to the left, grouped with other companions. Yet, comparison of Franceschini's composition with this or other versions of the theme by Albani (for example, the two pictures in the Louvre or that in the Gemäldegalerie, Dresden) necessarily underscores the degree to which Franceschini has gone beyond the earlier artist in abstracting the figures and in creating an ideal realm purged of any real sensuality: his are chaste goddesses frozen in a pool of crystal. The relief-like composition of the figures is greatly enhanced by the crisply painted still life of Diana's hunting equipment, in which, however, the effect of the foreshortened quiver is compromised by the abruptly cut-off shafts of the arrows, continued on a part of the picture surface that was folded over when the canvas was restretched upon its arrival in Vienna. It is in this picture—perhaps the master-

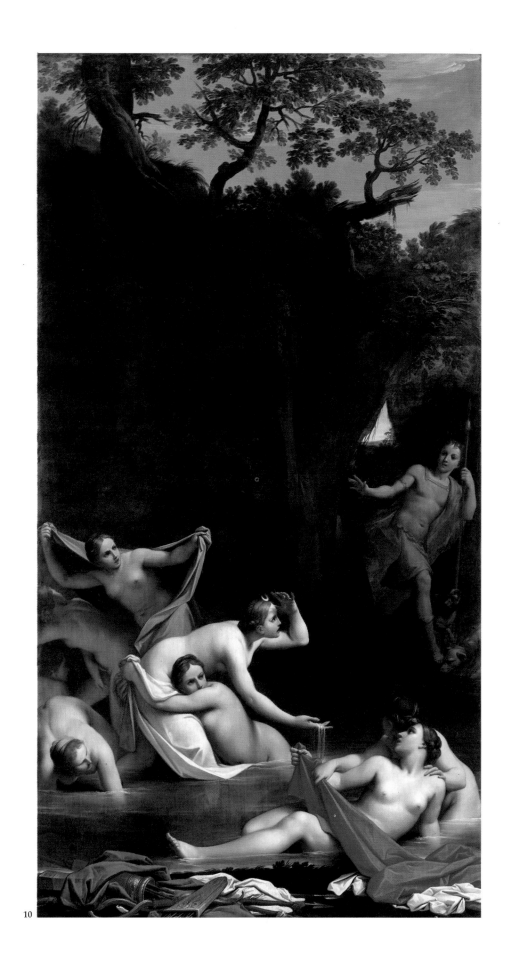

10

piece of the two cycles—that Franceschini takes the premise of Bolognese classicism to the threshold of Neoclassicism, though without the archaeological study of ancient art on which the later achievement of Neoclassicism was based. Typically, there are pentimenti in the left hand of Diana and the right arm of Actaeon.

In its original setting the painting was flanked by two window pieces showing putti bathing and putti playing with the nymph's weapons.

<div align="right">KC</div>

FURTHER REFERENCES FOR THE ADONIS AND DIANA CYCLES (cat. nos. 3–10): Cat. 1767, p. 29; Cat. 1780, pp. 2, 193ff., 117–18, nos. 295–313, 330–32; Wilhelm 1911, cols. 93–94, 121ff. letter 5, 129–30 letter 9; Wilhelm in Thieme-Becker, vol. 12 (1916), pp. 298, 300; Cat. 1931, pp. 1ff., 42ff., nos. A1–A2, A4–A7, A9, A100–A103; Kurz 1955, p. 105; Miller 1957, pp. 232ff.; Volpe 1959, p. 182; Miller 1961, pp. 133–34; Roli 1977, pp. 101, 259, figs. 124a, 124b, 125a, 125c; Miller 1979, pp. 2ff.; Callahan 1979, pp. 9–10; Baumstark 1980, no. 21; Miller 1983, pp. 21, 26ff.

11–12

Giuseppe Mazza
Bolognese, 1653–1741

VENUS
Bologna, 1692
Marble; height 29⅞ in. (76 cm.)
Inscribed: G.M. 1692
Liechtenstein inv. no. 1365

ADONIS
Bologna, 1692
Marble; height 29⅞ in. (76 cm.)
Inscribed: G.M.F. 1692
Liechtenstein inv. no. 1366

Mazza's reputation rests chiefly upon the brilliantly decorative complexes of sculptures in stucco which he created for many churches in Bologna and other towns in Emilia, from 1681 to about 1735, as well as on his rich output of small works in terracotta, mostly of devotional subjects. Throughout his long career Mazza maintained close ties with contemporary Bolognese painters, and his works often bear close comparison to the paintings of his teacher Lorenzo Pasinelli and his friends and collaborators Gian Gioseffo Dal Sole and Marcantonio Franceschini. His works in marble were far fewer and mainly executed for private patrons. The most important of these was Prince Johann Adam Andreas von Liechtenstein (1657–1712), to whom he is known to have furnished, between 1692 and 1702, four marble busts (*Venus* and *Adonis*; *Bacchus* and *Ariadne* [cat. nos. 13–14]), two over-life-size marble statues (*Hercules* and *Bacchus*), eight small terracotta groups of mythological subjects, and three terracotta models for vases (Zanotti 1739, vol. 2, p. 10).

The two signed and dated busts of Venus and Adonis were finished on March 2, 1692, and have been correctly identified

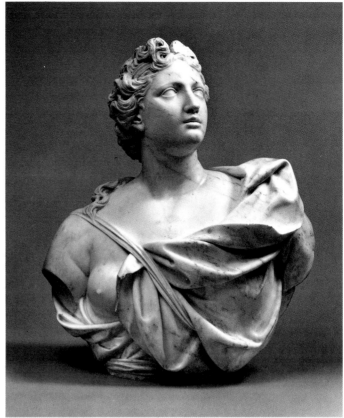

11

12

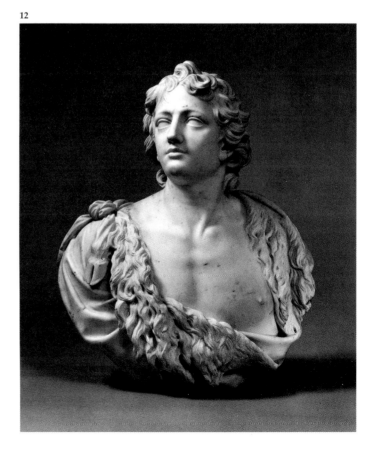

23

by Arfelli (1934, pp. 419, 425–26) as those mentioned in two letters by Mazza to the Prince of Liechtenstein. Designed as pendants, they allude to the story of Venus's passionate love for the young hunter Adonis (Ovid, *Metamorphoses* 10.524ff.) in a pictorial manner which is entirely typical of Mazza and of the Bolognese classicism he so ably represented. The poetic and dreamy mood of the two figures and the treatment of their gently pleated garments and softly tousled hair are especially close to the types and style of Mazza's large stucco figures in Santa Maria de' Poveri, Bologna (Riccomini 1972, pls. 225–29), a complex executed in 1692, in close partnership with Gian Gioseffo Dal Sole, who frescoed the cupola of the same church.

OR

FURTHER REFERENCES: Cat. 1767, p. 69, nos. 47–48 (misidentified as Ariadne and Bacchus); Fleming 1961, pp. 210, 215.

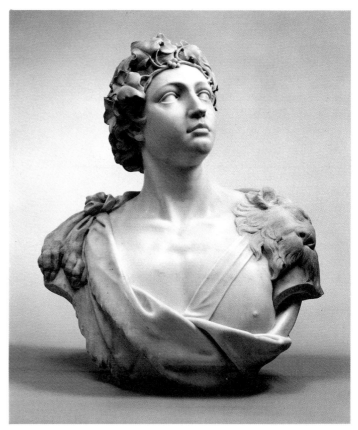

13

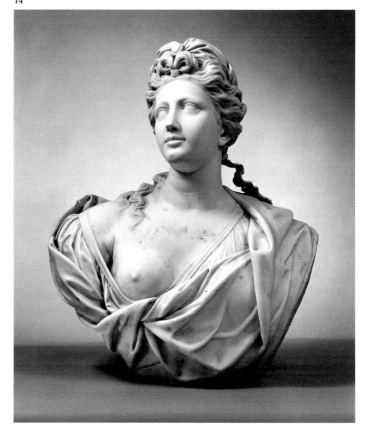

14

13–14

Giuseppe Mazza
Bolognese, 1653–1741

BACCHUS
Bologna, ca. 1695–1700
Marble; height 33½ in. (85 cm.)
Liechtenstein inv. no. 1367

ARIADNE
Bologna, ca. 1695–1700
Marble; height 34½ in. (87 cm.)
Inscribed: GIOSEPPE MAZZA BOL.F.
Liechtenstein inv. no. 1368

Designed as a heroic couple, *Bacchus* as the youthful god of wine and *Ariadne* as a princess, these two busts show Mazza working in a very different mode from that used in the earlier *Venus* and *Adonis* (cat. nos. 11–12). A declamatory tone rather than a lyrical mood seems to have inspired these two "half figures," as Zanotti (1739, vol. 2, p. 10) called them, as if the sculptor had wanted to echo the grand decorative manner practiced in fresco by Marcantonio Franceschini and Enrico Haffner (Roli 1977, figs. 24a–b). Instead of a chiaroscuro softness of modeling, we see Mazza adopting a breadth of modeling, a clarity of outline, and an interest in such decorative details as Ariadne's beribboned coiffure that are best explained if we remember his close collaboration in 1690–95 with these two artists in the decoration of the church of Corpus Domini, Bologna (Riccomini 1972, p. 96, no. 102, pl. 233). But even more significant is the deep stylistic affinity shown by these two busts with the large and decorative neo-Domenichino manner that Franceschini adopted in another series of works: the two cycles of the myth of Diana and the story of Venus and Adonis, which he painted

24

between 1691 and 1700 for the Prince of Liechtenstein (cat. nos. 3–10).

It was this willingness and ability of Mazza to harmonize his style with that of his fellow Bolognese painters that Zanotti praised as the unusual "painterly fantasy" (*estro pittorico*) of the sculptor. The similarity between these busts and the Franceschini cycle suggests that the sculptures were executed about 1695–1700.

OR

FURTHER REFERENCES: Cat. 1767, p. 70, nos. 59–60; Arfelli 1934, p. 421.

15–16

Filippo Parodi

Genoese, 1630–1702

VIRTUE

Genoa, ca. 1684–94
Marble; height 29⅞ in. (76.5 cm.)
Liechtenstein inv. no. 15

VICE

Genoa, ca. 1684–94
Marble; height 29½ in. (75 cm.)
Liechtenstein inv. no. 11

The laurel crown, the sunburst on her chest, and the spear under her right arm identify the young woman as an allegory of Virtue, depicted with the three attributes that characterize her, according to Cesare Ripa (*Iconologia*, 1603, p. 510). Her counterpart, shown as a man screaming in terror, struggling to free himself from the chains tied around his chest, is clearly an allegory of Vice, shown in the guise of Tityus, the traditional personification of punished iniquity (Comes, *Mythologiae*, 1567, p. 191).

Virtue's smoothly luminous face, set off by the large, exuberantly undercut wreath and the lively movement of her minutely pleated, fluttering drapery, so readily recalls the sculptures of the Genoese Filippo Parodi that an attribution to him of both busts, carved in the same manner, can be confidently proposed here. A similar pictorial contrast between richly animated draperies and crisply carved flowers occurs in the famous marble figures of *The Metamorphoses*, executed about 1680 by Parodi for Palazzo Durazzo in Genoa (Rotondi 1959, figs. 36a–c, 37a–b; Gavazza 1981, pp. 34–35). We recognize in these the same type of face, with small, slightly pursed lips, strong nose, and large, dreamy eyes, that occurs again in Parodi's *Madonna* in the church of San Carlo, Genoa (Rotondi 1959, fig. 39), as well as the tightly pleated draperies that became so typical of his works in the 1680s and the 1690s.

It is with the sculptures of this later period, especially with those executed in Venice and Padua, that the two Liechtenstein

15

16

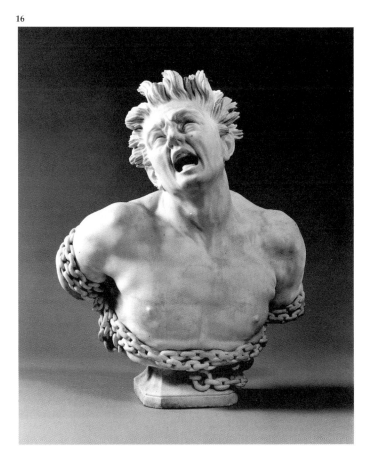

busts have the closest affinities. The same fluent and dynamic style can be recognized in the allegorical figures of Fame and Time on the funerary monument of the Patriarch Francesco Morosini in San Nicola dei Tolentini, Venice, a complex executed by Parodi and his assistants about 1680–83 (Rotondi Briasco 1962, figs. 29, 33). Further comparisons can be drawn with Parodi's allegorical figures in the Chapel of the Relics at the Basilica of the Santo, Padua (1689–95; Sartori 1962). Here Parodi's *Humility* (Rotondi Briasco 1962, fig. 53), with her over-sized wreath, streaming hair, and deeply gouged draperies, is especially close to the Liechtenstein *Virtue*, while the nearby figure of *Penance* (Rotondi Briasco 1962, fig. 56) has much in common with the exasperated expressivity, belabored modeling, and brittle detailing of the Liechtenstein *Vice*.

It is known that during the years of his residence in Padua, between 1689 and 1695, Parodi was also able to work for a number of private patrons. The marble busts of *Flora* and *Bacchus* at the Villa Pisani at Stra (Rotondi Briasco 1962, figs. 51–52) are rare surviving examples of a type of decorative commission for which the Genoese master must have been in considerable demand. *Flora*, with its pleated drapery wrapped around one shoulder, gathered into a knot on the other side, and falling over the small hexagonal socle, is so similar in design to the Liechtenstein *Virtue* that the authorship of the two works and an approximately contemporary dating seem to be evident.

It may also be worth noting that an inventory of the contents of Parodi's house, made after his death, listed a bust of Vice among the models found in his studio (Rotondi Briasco 1962, p. 88). A rare subject, this may well have been a terracotta model used for the Liechtenstein marble.

It has been repeatedly observed that Parodi often used well-known sculptures by Bernini, Puget, or Algardi as starting points for his own compositions. In the case of the two Liechtenstein busts, Parodi was obviously inspired by Bernini's *Anima Beata* and *Anima Dannata* (Wittkower 1981, pls. 5–6), both of them, however, reelaborated and transformed into rhetorically expressive images closely related to the allegorical figures frequently depicted by Genoese late Baroque fresco painters such as Domenico Piola and Giovanni Andrea Carlone (Gavazza 1971, pp. 217–57, figs. 175, 178).

The flourishing of the Genoese school of painting and sculpture during the last quarter of the seventeenth century did not escape the attention of Prince Johann Adam Andreas. We know from a letter dated February 3, 1690, to Paolo Girolamo Piola, that the Prince was eager to secure from him a large painting illustrating a sacred or profane story (Bottari and Ticozzi 1832, vol. 6, XXVII, p. 147). Similarly, in an unpublished letter of January 27, 1694, addressed to Marcantonio Franceschini, the Prince wrote: "We who have had so many marble busts by the most different sculptors from everywhere in Italy have found none better than Parodi and Mazza: all others do not deserve the name of true artists" (Princely Archive). The passage not only tells us that Parodi did indeed execute some marble busts

for the Prince but implies also that these may have been commissioned a few years earlier than 1694. Since Prince Johann Adam began collecting works of art in connection with his many building projects soon after succeeding his father in 1684, Parodi's *Virtue* and *Vice* may be most convincingly dated within this decade.

OR

FURTHER REFERENCES: Rotondi 1959, pp. 63–73; Sartori 1962, pp. 141–205; Gavazza 1981, pp. 29–37.

17

Giacomo Antonio Ponsonelli

Genoese, 1649 or 1654?–1735

MARS
Genoa, ca. 1695–1700
Marble; height 27 in. (68.5 cm.)
Liechtenstein inv. no. 9

A student of the Genoese sculptor Filippo Parodi, whose daughter he married in 1680, Ponsonelli was for many years closely associated with his teacher. His proficiency as a marble carver seems to have ensured him an important role in Parodi's busy studio, and according to his biographer Ratti (1769, vol. 2, pp. 356–61), he followed Parodi to Venice and Padua.

No modern study has yet been devoted to Ponsonelli's work, but Ratti writes that he achieved distinction in numerous commissions, many of which were sent outside Genoa and outside Italy. Among his foreign patrons, one of the most important must have been Prince Johann Adam Andreas. Fanti's 1767 catalogue of the Liechtenstein gallery ascribed to Ponsonelli two statues of Venus and three pairs of mythological busts. Among these was a bust of Mars, which should most probably be identified with the present one (Cat. 1767, p. 69, no. 53).

Ponsonelli's authorship of this bust can be confidently sustained on the basis of its close stylistic similarity with a marble of Diana in the Louvre that carries the signature of the artist (Gaborit 1984, p. 59). The two busts show the same lively sideways motion, emphasized by the great horizontal wave of the sinuous drapery thrown around the shoulders and across the chest. The *Diana* is even more calligraphic in design, while the drapery of the *Mars* still retains some of the strength of the Parodi prototypes on which it is clearly based. Both busts, however, interpret their classical subjects with an elegant, lighthearted, and almost frivolous mood that has its pictorial counterpart in the Genoese frescoes of Gregorio de' Ferrari (1647–1726) and, like them, presages the Rococo style of the eighteenth century.

Like Parodi, Ponsonelli looked for inspiration to the works of the great sculptors of an earlier generation, especially Bernini and Puget. For the Liechtenstein *Mars*, his source was undoubt-

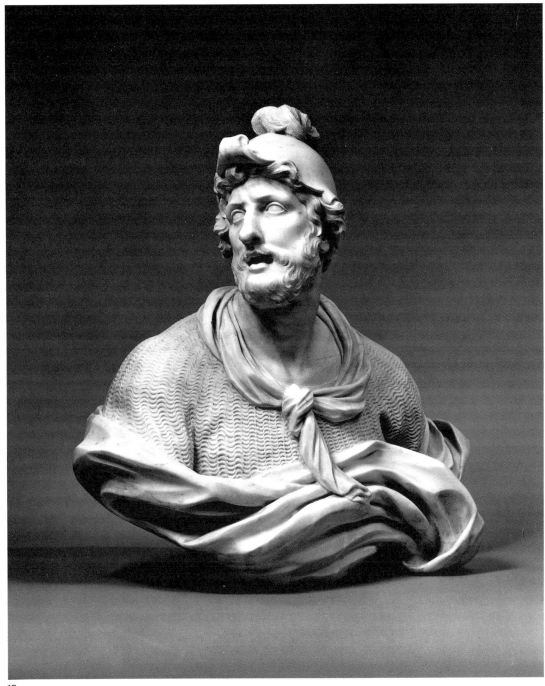

17

edly one of Puget's works: a marble bust of King David, executed about 1667–68 for a Genoese patron and now in the National Gallery of Canada, Ottawa (Herding 1970, p. 152, no. 31, figs. 100, 102–3). Ponsonelli clearly based his bust on that of Puget, borrowing its sideways motion, its facial features, with their intense, pathetic expression, and its colorful interplay between the tightly woven shirt of mail and the drapery surrounding it. Yet, in transposing Puget's model into his own expressive language, he totally changed its stylistic significance. Instead of the compact plasticity and self-contained drama of Puget's

David, Ponsonelli's *Mars*, whose parade helmet echoes the sinuous outlines of his drapery, displays a descriptive, slightly mannered elegance.

This way of transforming earlier Baroque prototypes into images of almost fragile gracefulness recalls some of the sculptures created by Filippo Parodi for Genoese churches: the two statues of Saint Theresa and Saint John of the Cross (ca. 1681) in San Carlo, which, according to Ratti, were actually carved by Ponsonelli (Gavazza 1981, p. 32, figs. 4–5), and the figure of Saint Pancratius (ca. 1690), formerly in the church of San

Pancrazio (Preimesberger 1969, p. 49, fig. 2). In the last years of his life, Filippo Parodi, who died in 1702, was probably too busy to fulfill all the many commissions he received. This bust for Prince Johann Adam Andreas must have been carved by Ponsonelli between 1695 and 1700, at a time when he was establishing a studio of his own in Genoa and developing a personal style, essentially more decorative than that of his master, Parodi.

<div align="right">OR</div>

FURTHER REFERENCES: Cat. 1780, p. 258, no. 28; Gaborit 1984, pp. 58–60.

18

Giuseppe Gaggini

Genoese, ca. 1643–1713

APOLLO

Genoa, ca. 1690–1700
Marble; height 29⅛ in. (74 cm.)
Inscribed: APPOLLO *(on front) and* IOSEPH GAGINO SCVLPSIT *(on back)*
Liechtenstein inv. no. 16

18

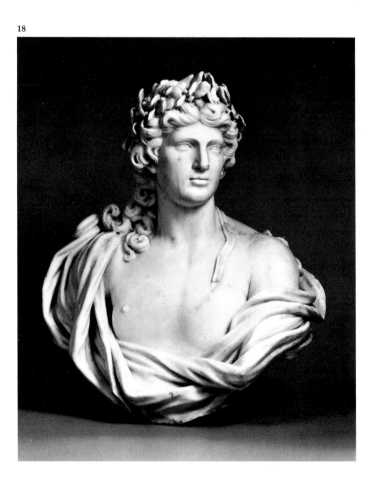

Probably born at Bissone, near Como, like his better-known brother Giacomo, Giuseppe Gaggini belonged to a well-known family of Lombard craftsmen who for generations specialized in the carving of marble. According to a document published by Cervetto (1903, p. 284), the two brothers shared the same workshop in Genoa from at least 1680. Here they carved architectural elements, friezes, and capitals, as well as ornamental or figurative sculptures and decorative pseudo-antique busts.

Based upon the canonical prototype of the *Apollo Belvedere*, the Liechtenstein bust shows an awareness of French classicistic sculpture in the design of its fashionable wiglike coiffure, while its expert craftsmanship speaks for the accomplished métier of the Gaggini. Its conservative character is best understood when compared with the sculptures of Giacomo Gaggini in the Doria Chapel at Sestri Levante (Cervetto 1903, pp. 182–86, figs. XXX, XXXV–XXXVIII). A certain boldness, however, in the movement of its drapery, defined by narrow, twisted folds, suggests that Giuseppe may have nurtured an admiration for the works of his Genoese contemporary Filippo Parodi (1630–1702) or may have even been in contact with his studio.

<div align="right">OR</div>

19

Franz Xaver Messerschmidt

Austrian, 1736–83

FOUNTAIN FIGURE: THE WIDOW
POURING OIL

Vienna, 1769–70
Tin-lead alloy; height, not including pedestal, 68 in. (172.8 cm.)
From the Savoyisches Damenstift, Vienna

The Savoyisches Damenstift, in the Johannesgasse, was one of several Viennese charities instituted by Princess Maria Theresia Felicitas von Liechtenstein (1694–1772). The fourth daughter of Prince Johann Adam Andreas, she inherited vast estates and married Prince Emanuel Thomas of Savoy-Carignan, nephew of Prince Eugene of Savoy. Widowed at the age of thirty-five, she soon lost her only son and turned her attention to benevolent acts. In her will, written in 1769, she created the Savoyisches Damenstift that was to house, in the Princess's Vienna residence, twenty noblewomen facing reduced circumstances (they subsequently occupied an adjacent building).

In 1766–67 the Princess commissioned Messerschmidt to adorn the facade of her Vienna residence with a lead Virgin of the Immaculate Conception. Messerschmidt had already shown great promise in his full-length lead statues of the imperial couple, Maria Theresa and Francis I, resplendent in coronation robes (1764 and 1766; Österreichisches Barockmuseum, Vienna). He also modeled a portrait in bronze of the Princess of Savoy-

Carignan, since lost. The iconographic content of her last commission to Messerschmidt in 1769—the remodeling of an existing fountain in the courtyard of her residence—underscores the Princess's charitable intentions regarding the building's use. The fountain as it appears today following renewals and restorations (the last in 1977–79) occupies a niche of imposing Neoclassical design. Above, between massive columns, is a fresco with an allegory of Abundance, painted late in the nineteenth century but no doubt imitating what remained of an earlier fresco. Capping the enframement of the fountain itself is a lead relief of a prophet writing. He is Elijah, as certified by the inscription on the frieze below: ELISEUS MACHET EINE WITWEN REICH AN OHL IV B. K. C. IV (Elijah makes a widow rich in oil, Fourth Book of Kings Chapter IV). Our comely statue, the *Widow*, stands within the niche. She is meant to pour water (in place of oil) from a ewer, while two lead infants at the basin's rim sit among three vessels already "filled" or waiting to be filled. Lead lions flank the whole. Messerschmidt's contract with the Princess, dated 1770, survives in the Princely Archive. In it Messerschmidt states that he had already received metal, presumably melted down from elements of the fountain in its previous form. The relief with Elijah seems to be a remnant of the fountain in that earlier stage. The contract further states that Messerschmidt's sculptures would be of an alloy three parts tin, one part lead. In Vienna lead and tin were used extensively for fountains rather than bronze, and Messerschmidt shows his particular ability at exploiting the properties of the pewter-like alloy in the *Widow*, with her beautiful dark luster and incisively chased details.

The chronicler of Kings (II, 4:1–7 in the English text) tells how a widow approached Elijah, fearful that her two sons would be sold into slavery. When Elijah asked what she had in the house, she replied that she had only a pot of oil. He instructed her to collect all her neighbors' empty vessels and begin filling them with oil. Miraculously, her modest stock of oil filled all the neighbors' vessels that her sons could bring, and Elijah commanded her to sell the oil in order to redeem her sons from slavery. The point would not have been lost on visitors to the courtyard that the widowed Princess of Savoy-Carignan also served as an instrument of the Lord in dispensing her bounty.

Girls pouring from ewers were a staple of German fountain decoration since the Renaissance, but Messerschmidt's statue is in touch with recent trends abroad. The frilly edges and facets of the figure's dress, a garment both humble and chic, are the only traces of German Rococo embellishment in the *Widow*. The carefully studied contrapposto shows a commitment to Neoclassical tenets which he must have gained first during a stay in Rome in 1765. He may have come into contact with the latest strides being taken by the prodigious French school of sculptors training in Rome. From the elaborately braided coiffure through the swaying contrapposto, his *Widow* resembles in inverted form the *Venus* by Christophe-Gabriel Allegrain in the Louvre (marble, finished in 1766); possibly bronze reductions of the Allegrain *Venus* were already in circulation. Be that as it may, the *Widow* is a far cry from the radical experimentations in Neoclassical simplification for which Messerschmidt is justly famous: the terrifyingly icy "character heads," products of the second half of his career, which was spent in psychological turmoil and isolation.

JDD

FURTHER REFERENCES: Pötschner 1981, pp. 96–103; all other literature analyzed by Pötzl-Malikova 1982, pp. 34–35, 231, no. 32, and the contract on pp. 127–28, doc. X.

THE RISE OF THE PRINCELY FAMILY
AND THE COURT AT PRAGUE

Karl von Liechtenstein, the first Prince of Liechtenstein, was born in 1569 to a noble Protestant family with extensive land holdings in Lower Austria and Moravia. In 1592 he married Anna Maria Boskowitz, an heiress from an old and land-rich family in Moravia, and, in 1596, upon the death of an uncle, he became the head of the Liechtenstein family. Before the end of the century, through a combination of inheritance, gifts, and financial acumen, he had become the richest noble in Moravia, a position that enabled him to lend both money and counsel to the Holy Roman Emperor.

In the late sixteenth century Moravia, now a region of the modern state of Czechoslovakia, was a virtually autonomous province of the Kingdom of Bohemia. It was ruled by the Hapsburg Holy Roman Emperor Rudolf II (1552–1612), who was at the same time King of Bohemia and Hungary. Rudolf II's chosen residence was in Prague, the ancient capital of the Kingdom of Bohemia and the seat of the Bohemian Estates. Rudolf held his councils in Prague and received foreign ambassadors there, making Prague for a time the capital of all the territories of the Holy Roman Empire. Although Rudolf took up the chronic war against the Ottoman Turks on the Hungarian border of the empire in 1590 and pursued it in desultory fashion for most of his reign, the lands of the Holy Roman Empire were spared the destructive religious strife that racked the countries of Western Europe during the second half of the sixteenth century because of the religious accommodation reached under the Peace of Augsburg in 1555. Despite the fact that he was Catholic and was under increasing pressure both from Rome and from his Spanish Hapsburg cousin Philip II to pursue the Catholic reconquest of Central Europe, Rudolf's policy toward the Protestants of various persuasions who made up the overwhelming majority of his Bohemian and Moravian subjects was a remarkably tolerant one.

Rudolf's interests were cosmopolitan in the extreme, and the imperial court at Prague became a Late Renaissance center of art, science, and humanist learning. Like his father, Emperor Maximilian II (1527–76), Rudolf II surrounded himself with an extraordinary group of scholars and artists from every part of the empire, as well as from elsewhere in Northern Europe and Italy. Of the three painters who are chiefly associated with the Rudolfine court, Giuseppe Arcimboldo (1530–93), Bartholomäus Spranger (1546–1611), and Hans von Aachen (1552–1615), the first two, in fact, had been favorites of Maximilian. The Milanese Arcimboldo, organizer of imperial festivals and tournaments, is best known for his bizarre portraits, in which his subjects, instead of having human features, were composites of objects of a related theme, such as fruits or vegetables. Al-though by no means as outlandish as that of Arcimboldo, the work of the two Northerners, Spranger and von Aachen, in its abstruse subject matter, artificiality, elegant, elongated forms, and erotic imagery, also seems to belong to the tradition of the Italian *maniera*, an assumption, however, by no means universally accepted. A group of landscape painters from the Netherlands—followers of Pieter Brueghel the Elder—most of whom traveled or settled in Italy, were also drawn to the Rudolfine court. They created a new and fanciful form of landscape, with mysterious and foreboding forests dotted with ruins, castles, and peasant huts. Among these, painters Pieter II Stevens of Malines (ca. 1567–after 1624) and Lodewyk Toeput of Antwerp (ca. 1550–1603/1605) provided inspiration for the Castrucci family from Florence, whose Prague workshop reproduced their designs in hardstone. From Milan, the Emperor enticed Ottavio Miseroni (d. 1624), a member of one of the most illustrious families of lapidary workers, who specialized in cutting and polishing small sculptures and three-dimensional objects of hardstone or rock crystal. His attempt to lure the sculptor Giovanni Bologna from the Florentine court of Grand Duke Ferdinand I (1549–1609) failed, but in Giovanni's Dutch pupil, Adriaen de Fries (1545–1626), Rudolf found an excellent substitute.

As a collector, Rudolf II's taste was broad. Early in his reign, Jacopo Strada (1515–88), one of the most remarkable antiquaries of the sixteenth century and another holdover from the court of Maximilian II, was his chief adviser and agent, but Rudolf also charged his artists and diplomats with amassing the enormous collection that was housed in the Hradschin, his castle in Prague. This collection included a picture gallery of favored Pieter Brueghels, Dürers, and Titians, as well as the all-but-legendary imperial *Kunstkammer*, a kind of encyclopedic grouping of artifacts and natural curiosities, such as minerals and gems, stuffed animals, bird and fish skeletons, scientific instruments, globes, clocks that demonstrated the motions of the heavens, coins, medals, porcelains, small bronzes, and all manner of objects made of rare and precious materials.

Although the present distinctions between the sciences and pseudo-sciences were not yet precisely drawn, Rudolf II's patronage of astronomers and natural scientists carried over into support for an extravagant variety of astrologers, alchemists, numerologists, and unabashed wizards. Yet, in the Danish astronomer Tycho Brahe (1546–1601) and the German mathematician Johannes Kepler (1571–1630), who between them put the Copernican system into something resembling its modern form, the imperial court sustained both the greatest observational astronomer and the foremost theoretician of the age. It is

believed that at least one of Brahe's instruments was the work of the imperial instrument maker Erasmus Habermel (d. 1606), while Jost Bürgi (1552–1632), probably the most inventive clockmaker who ever lived and certainly one of the most skillful, was lured from Landgrave Wilhelm IV's observatory in Kassel by an imperial appointment.

Karl von Liechtenstein's taste was largely formed in the Prague of Rudolf II. However, little is known about his activity as a collector before his conversion to Catholicism and his subsequent appointment to the office of High Steward (*Obersthofmeister*) in 1600 beyond the fact that, as early as 1597, he had come to Emperor Rudolf's attention as the possessor of a painting deemed worthy of inclusion in the imperial collection. He left Prague early in 1607 and returned to Moravia as Governor. In the following year he was elevated to the rank of Prince. By then, he was already in the service of Archduke Matthias (1557–1619), the Emperor's brother and successor: Matthias, as Emperor, added substantially to Prince Karl's territories, naming him Duke of Troppau in 1613. He remained a loyal supporter of the Hapsburg Emperor during the Bohemian revolt in 1618, and, after the defeat of the Protestant rebels at the Battle of White Mountain in 1620, a third Holy Roman Emperor, Ferdinand II (1578–1637), appointed him Viceroy and Imperial Governor of Bohemia. As Viceroy, Prince Karl presided over the execution of the rebel leaders and the confiscation of their property, the drafting of a new constitution, and the introduction of a thorough-going Counter-Reformation in Bohemia. In recognition of his services, the Emperor bestowed upon the Prince numerous estates and, in 1623, a second duchy, Jägerndorf.

During his years of stewardship to Emperor Rudolf II, Karl von Liechtenstein had been privy to most of the details of the Emperor's patronage. From 1600, when he became High Steward, until his death early in 1627, Prince Karl's own household accounts contain the names of many of the artists and artisans who had been employed by the Emperor: the court painters Hans von Aachen and Georg Hoefnagel and the engraver Aegidius Sadeler, the sculptor Adriaen de Fries (cat. nos. 35–36), the imperial goldsmith Magnus Kornblum, the imperial stonecutter Ottavio Miseroni, the imperial instrument maker Erasmus Habermel, and the imperial clockmakers Christof Margraf and Jost Bürgi. An inventory of the Prince's household made in 1613 describes several paintings by the Rudolfine favorite, Bartholomäus Spranger. Cups and vases of rock crystal, jasper, and exotic materials, of the kind prized by the Emperor, are listed in both the 1613 inventory and another drawn up in 1623. Finally, from an eighteenth-century gouache (cat. no. 20), we know that even the design of Prince Karl's crown was patterned on that made for Emperor Rudolf II about 1602. Most of these objects are now lost, but an exquisite astronomical clock commissioned by Prince Karl from Jost Bürgi is today one of the treasures of the Kunsthistorisches Museum, Vienna. In addition, the ingenious perpetual calendar (cat. no. 24) made by Erasmus Habermel and the numerous pietre dure landscapes from the Castrucci workshop, preserved individually as well as mounted in the magnificent casket and tabletops (cat. nos. 25–26, 28–30) that are still in the Liechtenstein collection, survive to exemplify the highly distinctive objects produced under Prince Karl's patronage.

Clare Vincent

The Liechtenstein Crown Jewels

Austrian (Vienna), 1756

Pencil, pen and ink, and gouache on vellum; 27½ × 18⅞ in. (69.8 × 48 cm.)
Inscribed: Auf diesem Abriss oder Abzeichnung, ist der sämmentliche zur
 Fürst. Liechtensteinischen Primogenitur gehörige, und in einem in Triplo verfasst.
 unter heutigem Dato gefertigten Instrument, welches sich auf diesen nämlichen
 Abriss oder Taffel referiret, ordentlich beschriebene Geschmück, in dem Stand, wie
 sich solcher gegenwärtig befindet, abgeschildert zu sehen. In dem nämlichen Stand,
 in eben dieser Gestalt, Form und Fassung, solle all-solcher dahier abgezeichnet und
 in besagtem Instrument beschriebene Geschmück, besonders aber die Zwey
 Toisons samt der Agraphe, zu allen Zeiten verbleiben und unabgeändert gelassen
 werden. Urkund dessen unsere- und deren hierzu erbettenen Hochansehnlichen
 Herren Zeugen/diesen jedoch ohne Schäden und Nachtheil/ beygesetzte Fertigung.
 Wienn den Ersten Monaths Tag Septembris des Ein Tausend Sieben Hundert
 Sechs und Fünfzigsten Jahrs (On this sketch or copy is to be seen illustrated the
 complete jewelry belonging to the Princely Liechtenstein Primogeniture as properly
 described in this instrument, drawn up under today's date and written out in
 triplicate, as referring to this selfsame sketch or illustration, showing the condition
 as it is right now. In the selfsame condition, in the very same shape, form, and
 mountings as illustrated here and as described in the above-mentioned instrument,
 this jewelry, and in particular the two [Golden] Fleeces together with the brooch,
 shall remain for all times unchanged and unaltered. In testimony whereof herewith
 be attached our signature and those of the Most Honorable Witnesses we have asked
 to do us this favor without prejudice or injury to themselves. Vienna, the first day
 of the month September of the one thousand seven hundred six and fiftieth year)
Liechtenstein inv. no. 360

During the reign of Prince Joseph Wenzel von Liechtenstein (1748–72), it was decided that the Liechtenstein ducal crown as well as a number of jewels in the Prince's personal possession should be made a part of the patrimony of the House of Liechtenstein. The decision provided the occasion for this drawing which illustrates both the crown and the jewels. The lengthy inscription above the crown explains the purpose of the drawing, one of three made in Vienna to record not only the form of the jewels but also the existence of each of the gems and pearls with which they were set. The drawing is dated September 1, 1756, and signed by Prince Joseph Wenzel and by his brother Prince Emanuel and his nephew Prince Franz Joseph, as well as by several other members of the nobility who attested to its accuracy.

Shown are a girdle (no. 14), earrings (nos. 18–19), a necklace (no. 1), and a pair of bracelets (no. 3), all made of pearls; two diamond and ruby pendants of the Hapsburg Imperial Order of the Golden Fleece, founded in 1429 by the Burgundian Prince Philip the Good (nos. 11–12); a diamond and ruby pendant (no. 13), pendant brooch (no. 22), pendant earrings (nos. 20–21), and three finger rings (nos. 6, 23–24); and some unmounted gems and pearls.

Most of the jewelry appears to have been made during the second quarter of the eighteenth century. The two jeweled pendants of the Order of the Golden Fleece are quite similar to one made about 1740 for Augustus III of Saxony, which is still in the collection of the Grünes Gewölbe, Dresden (Evans 1953, p. 154, pl. 143). The crown, however, is a great deal older, and a detailed study of it published by Wilhelm (1960) permits us to be quite specific about the circumstances of its origin and its subsequent history.

The crown was commissioned by the first Prince of Liechtenstein in 1623. As Karl von Liechtenstein (1569–1627) he had inherited the extensive Boskowitz lands in Moravia and had built up a great fortune. In 1593 he became a military commander in the service of the Holy Roman Emperor Rudolf II (1552–1612), and as a result of the important role he subsequently played at the imperial court in Prague, he was elevated to the rank of Prince. Rudolf's successors, Emperor Matthias (1557–1619) and Emperor Ferdinand II (1578–1637), added to Prince Karl's honors, creating him Duke of Troppau and Duke of Jägerndorf, as well as Imperial Governor of Bohemia.

Upon receipt of the Duchy of Jägerndorf, Prince Karl commissioned a crown from Daniel de Briers of Frankfurt am Main. Little is known about de Briers. He is first mentioned in 1607 in the record of a dispute between the sculptor Adriaen de Fries and the imperial court (Haupt 1983, Quellenband, p. 324). Later, as a jeweler and art dealer, he had a good deal of contact with the imperial court. In the year of the commission of the Liechtenstein crown, he purchased some decorative objects made of hardstones and rock crystal from the imperial *Kunstkammer* in Prague, as well as a large number of paintings, many of them described in the imperial accounts as originals by such favorites of Emperor Rudolf as Hans von Aachen and Bartholomäus Spranger.

Records in the Princely Archive show that between 1623 and 1626 the gemstones for the crown were assembled partly by de Briers and partly from Prince Karl's own collection. Work on the crown was divided among various specialists, the most important being de Briers's brother-in-law Jobst von Brüssel. Although he was born in the Netherlands, Jobst's tombstone indicates that before his death in Prague in 1635 he had become jeweler (*gemmarius*) to the Emperors Rudolf II and Matthias (Lhotsky 1945, pt. 2, 1st half, p. 249). He held the same appointment to Emperor Ferdinand II (Zimmerman 1910, p. xxiv, no. 19792), and he had furnished a number of precious objects for Prince Karl's own collection before being employed in the work on the ducal crown. Gottfried Nick (d. 1640), a goldsmith of Frankfurt am Main who worked for Ferdinand II in Vienna, was engaged to make the frame of the crown. The services of a hat maker, Adam Michell, and a hat trimmer, Mathes Gabriel, a furrier, Lorenz Hainrich, and a purse maker, Hans Berckman,

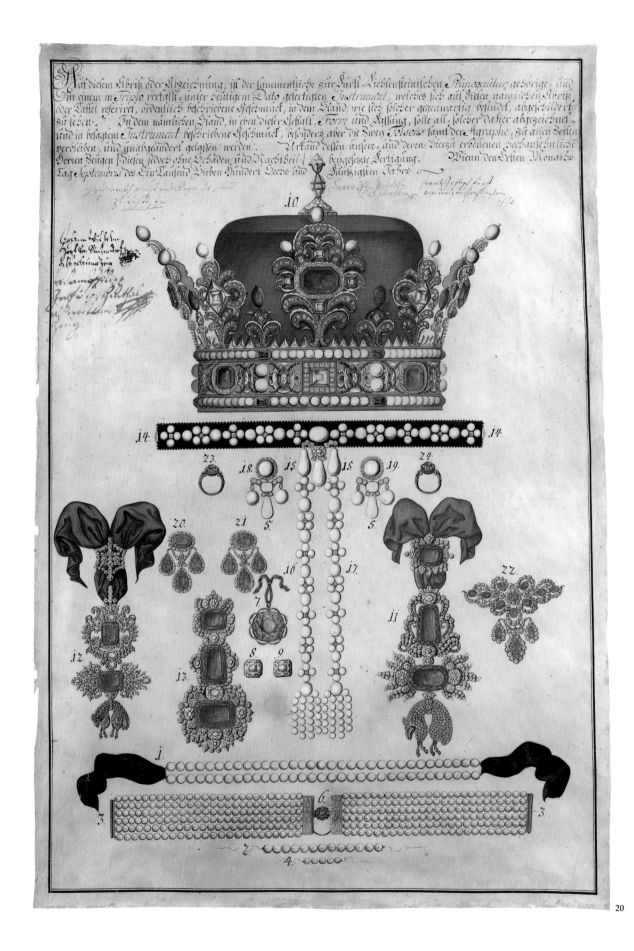

were required to finish the crown. In addition, a cutler, Martin Jürger, was paid for work on a case for the crown, and Anselmo Sardati, a Jew, for supplying the carmine-red velvet to cover the case.

Surviving correspondence between de Briers and Prince Karl seems to suggest that the frame of the crown was made in Frankfurt am Main by Nick and set with the gems and pearls that were supplied by de Briers. Nick then transported the unfinished crown to Prague, where the gems from Prince Karl's collection were added. On September 7, 1626, de Briers was paid 9,000 florins for the completed crown. Jobst von Brüssel had received 4,500 florins in May and June of that year; Nick, 27 florins, 30 kreutzer. The total expense has been estimated at more than 16,000 gulden or florins (Wilhelm 1976, p. 24).

The gold circlet of the crown was set with large table-cut diamonds and rubies surrounded by smaller stones and alternating with pairs of pearls, bordered by bands of pearls, and supporting sixteen golden standards also set with diamonds, rubies, and pearls. The circlet enclosed a high, stiff hat made of crimson velvet, and perched on the top was a kind of finial made of diamonds. An unusual, if not unique, feature, the finial apparently represented a compromise between the plain circular hat with ermine trimming ordinarily adopted by Princes of the Holy Roman Empire (the so-called *Fürstenhut*) and the jeweled circlets supporting semicircular arches which were the prerogative of the Hapsburg Archdukes. The design of the circlet and of the standards of the Liechtenstein crown, in fact, owes a great deal to those of the crown finished in 1602 for Emperor Rudolf II, which is now in the collection of the *Schatzkammer*, Vienna (Leithe-Jasper and Distelberger 1982, p. 24). The similarities are not surprising, given the connections of Jobst von Brüssel with the Imperial Court Workshop where Rudolf's crown was made.

It is tempting to see the influence of the thinking of the Rudolfine court in the choice of gems for the crown, and Wilhelm (1960, pp. 16–17) has suggested that the lapidary treatise *Gemmarum et lapidum historia* (Hanau, 1609) by Emperor Rudolf's physician, Anselm Boëtius de Boodt (1550–1632), may have played a part in the choice. According to de Boodt, diamonds have an inherent power that wards off evil spirits, rubies protect against illness and poison and will warn the wearer when danger threatens by turning dark, and pearls strengthen the health of the wearer and counter the effects of poison.

Prince Karl I, however, lived only a few months after the completion of the crown. It became part of the inheritance of his son, Prince Karl Eusebius (1611–84), and is first listed in an inventory of Prince Karl I's jewels and precious objects made after his death in February 1627 (Haupt 1983, Quellenband, p. 284, no. 726). Prince Karl Eusebius in turn willed the crown to Prince Johann Adam (1657–1712) and Johann Adam to Prince Joseph Wenzel (1696–1772). Its ultimate fate is unknown. In 1781, the year of the death of Prince Joseph Wenzel's successor, Prince Franz Joseph I, an inventory mentions without explana-

tion that the crown was no longer in the entailed collection. In 1976, a replica of the crown based on the drawing of 1756 was presented by the country of Liechtenstein to Prince Franz Josef II on the occasion of his seventieth birthday.

CV

FURTHER REFERENCES: Fleischer 1910, p. 11; Wilhelm 1960, pp. 7–20; Wilhelm 1976, pp. 24–26; London 1980, p. 6, 131, no. G46; Carrington 1980, pp. 12–13; Haupt 1983, Textband, frontispiece, pp. 28, 52, 88 n. 44, Quellenband, p. 258, no. 555, p. 269, no. 558a, p. 272, no. 574a, p. 278, no. 641, p. 279, no. 659, p. 280, nos. 664–68, p. 281, nos. 683, 687, p. 282, no. 692, pp. 324, 329, 333.

21

BANNER
Austrian, dated 1606
Silk damask, paint; 108¼ × 43⁵⁄₁₆ in. (275 × 110 cm.)
Liechtenstein inv. no. 1853

The long, swallow-tailed form is composed of panels of red and yellow floral-patterned silk damask stitched together in alternating quarters. Each side is painted overall with flames, yellow on the red quarters and brown (formerly red?) on the yellow quarters, outlined in black, that flicker in the direction of the fly. The obverse (that is, the side visible when the shaft is on the left) is painted with a Saint Andrew's cross (a saltire of two crossed ragged staves), yellow on the red quarters and brown (formerly red?) on the yellow quarters, and outlined in black. The date 1606 is painted in the upper angle of the cross. A German doggerel in script is painted along the upper edge, *Obwoll der Wilde Hauff so gross aussicht, mich solchs darumb wenig anficht* (Although the wild horde looks ever so large, nevertheless it troubles me little), and along the bottom edge, *Wen ich gedenckh der rechten sach ichs frisch im Gottes Namen wag* (When I am mindful of the just cause, I venture forth boldly in God's name). On the reverse is a crucifix, with Christ's body painted naturalistically, and a label attached to the top of the cross inscribed with the traditional INRI (Iesus Nazarenus Rex Iudeorum = Jesus of Nazareth, King of the Jews). Above the crucifix is the motto in capital letters DEO DVCE (With God as guide), and below the crucifix AVSPICE FORTVNA (With this protector comes good fortune). Sewn to the edges of the banner is a fringe of alternating yellow and white silk.

This military banner evokes a turbulent era in which the Holy Roman Empire was troubled by a long Turkish war (1596–1606) and by the smoldering religious unrest that would soon ignite as the Thirty Years' War (1618–48). This same period saw the rise of the House of Liechtenstein, with its increasing political influence and rapidly growing wealth, through military service and political loyalty to the Hapsburg Emperors.

The banner is one of the earliest dated and best-preserved imperial cavalry banners (*Rennfahnen* or *Reiterfahnen*) of the seventeenth century. Its immense size and distinctive shape, with parallel sides and a deep V-shaped cutout forming two long tails of equal length, as well as its medium (floral-patterned silk damask painted in oil), are features common to cavalry banners of the first half of the seventeenth century. Banners of this type are exceedingly rare, though notable examples are preserved in

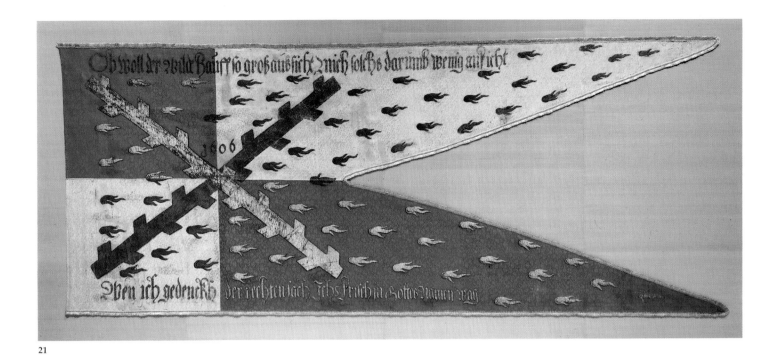

21

the Waffensammlung of the Kunsthistorisches Museum, Vienna (inv. nos. A1352, A1452), and in the Esterházy collection at Forchtenstein Castle, Austria (see Szendrei 1896, nos. 2596, 2614, 2706, 2709–10, 2712, 2719–20, 2732). The decoration of the Liechtenstein banner, with its combination of political and religious imagery, belongs to a tradition of military flags and banners used throughout the Holy Roman Empire since the early sixteenth century. The Saint Andrew's cross and the flames are derived from the emblems of the Order of the Golden Fleece, the chivalric order founded by Duke Philip the Bold of Burgundy and inherited by the Hapsburgs in 1478, with the marriage of Maximilian I and Mary of Burgundy. The red and yellow colors are those of the Liechtenstein coat of arms (per fess, or and gules) and also of the livery worn by the retainers of Karl von Liechtenstein (Haupt 1983, Textband, p. 63).

This banner is in fact one of three cavalry banners that were formerly in the Liechtenstein collection, the two others having been sold in New York in 1926 (American Art Association, sale cat., November 19–20, 1926, lots 131–32, ill.). One of the banners was of yellow damask painted overall with silver flames; the obverse was painted with a crucifix, the motto CRUX CHRISTI PROTECTIO NOSTRA (The cross of Christ is our protection), and the date 1605, while the reverse was painted with an emblem consisting of a pyramidal diamond in a stormy sea, with the motto IMMOTA MANET (It remains unshaken) and the date 1605. The third banner, undated but presumably contemporary with the other two, was of red damask painted on one side with the Madonna and Child and on the other with a crucifix. The three banners are so similar in size, shape, media, and iconography as to be considered a single, homogeneous group. Their excellent state (judging from photographs of 1926) suggests that

Fig. 16 Reverse of cat. no. 21

they were carefully preserved in the same conditions, and probably in the same collection, since the early seventeenth century.

The three banners are first recorded in 1842 when they were described as hanging in the armory in Seebenstein Castle, Lower Austria (see Leber 1856, pp. 175–76; also Feil 1856, p. 199). They are illustrated in a watercolor of the Seebenstein armory painted by Rudolf von Alt in 1850 (Liechtenstein collection, inv. no. 35). Seebenstein Castle entered Liechtenstein possession in 1824, when it was purchased by Prince Alois II. It had previously been the home of the romantic chivalric society known as the Wildenstein Knightly Association on the Blue Earth (*Wildensteiner Ritterschaft zur blauen Erde*), which lasted from 1790 to 1823. Descriptions of Seebenstein in 1815 and again in 1820 (see Leber 1856, p. 160) mention the presence of an armory, but its exact contents are unknown. The possibility therefore exists that the banners may have entered Liechtenstein possession only in 1824. Circumstantial evidence, on the contrary, suggests that the banners were old Liechtenstein property and

were most likely transferred to Seebenstein when it was refurbished as a Liechtenstein property. (The seven Limoges plaques from the collection of Prince Joseph Wenzel [cat. nos. 135–41] were also kept in Seebenstein.) As noted above, the red and yellow of the present banner are Liechtenstein colors, and the emblem on the banner of yellow damask is related to those used by Karl I and his son Karl Eusebius. The device of a rock or a diamond in a stormy sea is found in emblem books of the sixteenth and seventeenth centuries as a symbol of steadfastness or faith in the face of adversity (Henkel and Schöne 1967, cols. 67, 86; Gelli 1928, pp. 80, 262). A medal struck for Prince Karl I in 1616 includes the device of a rock rising from a stormy sea that is surmounted by a shining star and the motto DOMINUS ILLUMINATIO MEA (The Lord is my light) (Missong 1882, pp. 38–39). On the halberds made for Karl Eusebius's corps of bodyguards in 1632 (cat. no. 23), the Prince's device makes use of a diamond about to be struck by a hammer, with the motto VIRTVTE ELVDITVR ICTVS (By its strength it eludes the blow). Both emblems incorporate stones, and each is a rebus, or punning reference, to the name Liechtenstein, which can be translated as a bright or shining stone. The emblem on the yellow banner thus may also be a reference to Liechtenstein.

It has been suggested by Pappenheim (1956) that all three banners can be associated with Karl von Liechtenstein, who in the winter of 1604–1605 was appointed Lord-Lieutenant (*Landeshauptmann*) of Moravia, with the task of maintaining the peace and order in that region. The Eastern provinces of the empire were threatened with Turkish attacks and with a religious and political rebellion in Hungary and Transylvania. In May 1605 the troops of István Bocskay, leader of the rebels, invaded Moravia, and later in the summer a counteroffensive was launched by imperial troops against rebel-held areas in Hungary. A truce was soon established in the winter of 1605–1606. The peace negotiations conducted in Vienna were finally concluded in June 1606 with a treaty signed and sealed by Karl von Liechtenstein. The Liechtenstein banners, two of them dated 1605 and 1606, were most likely carried by imperial troops, quite possibly in the Moravian-Hungarian theater of war. If this is indeed the case, it is likely that the banners were preserved by Karl as souvenirs of this military campaign.

<div align="right">SWP</div>

FURTHER REFERENCE: Neubecker 1973, col. 1069.

22

SIXTEEN HALBERDS FOR THE GUARD OF PRINCE KARL I VON LIECHTENSTEIN

South German, 1620–23
Steel, wood, fabric; length overall between 88⅞ in. (225.7 cm.) and 93⅜ in. (237.2 cm.)
Liechtenstein inv. nos. 1862–64, 1884–89, 2755–57, 4151–54

These sixteen halberds are similar in form and decoration. The head of each consists of an ax-blade with concave cutting edge, a sharply pointed fluke on the opposite side, and a tall, double-edged apical blade of flattened diamond section. The sides of the ax-blade and fluke and the base of the apical blade are decoratively cusped. The heads are etched with foliate scrolls on a dotted and blackened ground. One side of the ax-blade is etched with the Prince's arms (Kuenring, Liechtenstein, Troppau, and Silesia) surmounted by a *Fürstenhut* (the red velvet bonnet with ermine border that was the insignia of a Prince of the Empire); on the other side is the Prince's monogram, two c's (for Carolus) addorsed and entwined, superimposed on two crossed palm branches and surmounted by a coronet. The head—with its hollow socket and two side straps through which it is nailed to the shaft—is made in one piece. One halberd (inv. no. 1886) is struck on one side of the fluke with a petal-shaped mark of a yet-unidentified bladesmith or arms-making center. The oak shafts, mostly of rectangular section with shaped corners, vary slightly in length; many of them are incised with geometric designs, letters, or numbers, which members of the guard presumably added as identifying markings. Some of the halberds are mounted with red silk tassels, while others have red-and-yellow silk tassels and red velvet coverings on the upper shaft.

These are the first of two series of halberds carried by the Liechtenstein guard (*Trabantengarde* or *Leibgarde*). The coat of arms on this first series is that used by Prince Karl I (1569–1627) between April 7, 1620, when he was granted the right to augment his arms with those of the extinct Kuenring family, and May 13, 1623, when he was awarded the Duchy of Jägerndorf (in Silesia), whose arms (a gold hunting horn on a blue field) were subsequently added at the point of the shield (Wilhelm 1947–50, pp. 7–8). The same arms and monogram appear on the pietre dure casket and tabletop made for Karl during this period (cat. nos. 25–26).

By equipping his bodyguard with such halberds, Karl I was following a long-established Hapsburg tradition. In Austrian lands the guards of the Emperors and of their relatives, the Archdukes, were furnished with either halberds or *Kuse* (shafted weapons with long knifelike blades) elaborately etched with the owner's arms, motto, and device and a date. These ceremonial weapons were usually made for an important occasion, such as the Emperor's coronation or wedding or an Archduke's assumption of new political duties. Karl I's halberds are not dated, but they were probably made when he was named Governor of Bohemia, a title conferred on him by Emperor Ferdinand II on January 17, 1622. The halberds may have been ordered between this date and April 27 of the same year, when Karl was awarded the Order of the Golden Fleece, whose insignia is conspicuously absent from the halberds' decoration. (The hasty production of these halberds during the early months of 1622

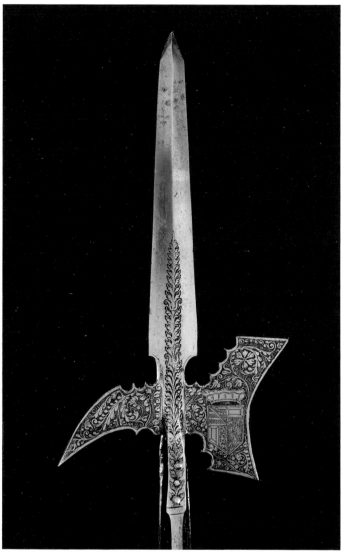

Liechtenstein inv. no. 1862

would explain the lack of finish and the differences that can be observed from one halberd to another.) Karl I's halberds thus may be seen as symbols of his new rank and as a reflection of his increasing social and political importance. It is interesting to note that, apart from the weapons carried by the guards of the Emperors, the Archdukes, and the Prince-Archbishops of Salzburg, the Liechtenstein halberds are the only heraldically charged polearms made for a noble family within the hereditary Austrian lands in the seventeenth century.

Liechtenstein documents from the period of Karl I mention a bodyguard armed with guns (*Leibschützen*), but no reference is found to either a corps of halberdiers or their weapons. Karl's retainers wore a livery of red and gold, the colors of the House of Liechtenstein, and it is likely that the original tassels on these halberds (the present ones, of two different types, appear to be of nineteenth-century date) were of the same colors. The Prince was deeply interested in genealogical and heraldic matters, so it is not surprising that the halberds carried by his bodyguard

bear his family arms and personal monogram. The equipment of his *Leibschützen*—described in the 1605 inventory of the Prince's armory as seven German guns decorated with silver plaques and the Liechtenstein arms, accompanied by seven powder flasks and bullet pouches fitted in red and gold—reflects similar concerns with heraldic display (Haupt 1983, Textband, pp. 63–64, and Quellenband, p. 145).

Karl I's guard probably consisted of no more than 50 men. The imperial bodyguard at this time apparently numbered as many as 100 to 110 men (Thomas 1969, p. 65) and that of the Prince-Archbishop of Salzburg 50 men (Schedelmann 1963, p. 36); it is unlikely that Karl's guard would be larger than that of the more powerful Prince-Archbishop. A document of 1617 in the Princely Archive refers to an order placed by Karl I for 100 armors and 200 halberds (Wilhelm 1976, p. 33), but military equipment commissioned in such quantities was probably intended for troops under his command rather than for his personal guard. In any case, the present halberds are of a later date and therefore cannot be those mentioned in 1617.

At least thirty-three halberds of this series are still in existence. Besides the sixteen halberds in this exhibition, nine others were acquired from the Princely Collections by an American collector, Dr. Bashford Dean of New York: of these, four were sold at public auction in 1926 and 1928 (American Art Association, New York, sale cat., November 19–20, 1926, lots 294–95, and November 23–24, 1928, lots 233–34), and four others were disposed of privately from Dean's estate in 1929. Three halberds from this widely dispersed group are now in American public collections (the Metropolitan Museum, the Philadelphia Museum of Art, and the Saint Louis Art Museum), while two others have since been reacquired by the Princely Collections and are counted among the sixteen examples in this exhibition. Ten further halberds are owned by another branch of the Liechtenstein family in the Styrian province of Austria.

SWP

FURTHER REFERENCES: Cat. 1952, p. 25, no. 103, p. 67, no. 374; Schedelmann 1963, pp. 35–41; Kienbusch 1963, p. 243, no. 557.

23

THIRTEEN HALBERDS FOR THE GUARD OF PRINCE KARL EUSEBIUS VON LIECHTENSTEIN
South German, dated 1632
Steel, wood, fabric, gold; length overall between 85⅜ in. (216.8 cm.)
 and 94 in. (238 cm.)
Liechtenstein inv nos. 1869–70, 1873, 1875, 1878, 1880–83, 2753–54, 4155–56

These thirteen halberds are virtually identical in form and decoration. The head of each is etched with large foliate scrolls on a dotted and blackened ground. The ax-blade is etched on one side with the quartered arms of Karl Eusebius (Kuenring, Boskowitz, Troppau, and Silesia, with Jägerndorf at the

point of the shield and an inescutcheon with the Liechtenstein arms) surmounted by a princely bonnet (*Fürstenhut*); on the opposite side is an oval medallion containing the device of a hammer-wielding hand poised above a diamond, the medallion frame inscribed VIRTVTE ELVDITVR ICTVS (By its strength it eludes the blow). The ribbed apical blade is etched on either side with the Prince's monogram, two addorsed and entwined c's (for Carolus), surmounted by a princely bonnet; the date 1632 appears on both sides of the fluke. Traces of gold remain on the arms, device, monogram, and date and along the edges of the etched panels. The square socket has decoratively shaped corners and is etched with foliage; it has a threaded end that screws into a nutlike fixture at the end of the oak shaft. Four side straps are dovetailed and brazed onto this fixture and are nailed to the shaft. The oak shafts are of rectangular section with shaped corners and are marked with letters, numerals, and other identifying marks; some of the halberds are mounted with red silk tassels, while others have red-and-yellow silk tassels and red velvet coverings on the upper shaft.

This second series of Liechtenstein halberds was made for the bodyguard of Prince Karl Eusebius (1611–84) upon his coming of age in 1632, at which time he became head of the princely house. The coat of arms on these halberds differs from that found on the earlier series made for his father (cat. no. 22) by the inclusion of the arms of the Duchy of Jägerndorf (awarded to Karl I in 1623, the arms appearing in the point of the shield as a gold hunting horn on a blue field) and the substitution of the arms of Boskowitz (in memory of his mother, Anna von Boskowitz) in the second quarter, the Liechtenstein family arms (per fess, or and gules) having been transferred to the inescutcheon. This revised coat of arms remained that of the Liechtenstein Princes descending from Karl I until the extinction of the Caroline branch of the family in 1712. Karl Eusebius's personal emblem—a diamond about to be struck by a hammer, with the Latin motto "By its strength it eludes the blow"—refers to the steadfastness of the Prince in the face of adversity. Similar devices are found in the emblem books of the sixteenth and early seventeenth centuries; a particularly close example appears in Denis Lebey de Batilly's *Emblemata*, published in Frankfurt am Main in 1596 (Henkel and Schöne 1967, col. 85, ill.; see also Gelli 1928, p. 440, no. 1557). The diamond may also be understood in this context as a visual pun on the family's name —*lichter Stein*, a bright or shining stone. Karl Eusebius's emblem was used again by Prince Joseph Wenzel (1696–1772) on a series of medals struck in 1758 (Missong 1882, p. 74, nos. 160–62).

Karl Eusebius followed his father's example in having a series of halberds made for his bodyguard, though he did not occupy a comparable position of political power. These halberds appear to have been modeled after those carried by the guard of Emperor Matthias (reigned 1612–19), dated 1612, or that of Emperor Ferdinand II (reigned 1619–37), dated 1620, which are similar in shape and decoration and have the same placement of the owner's arms, device, and monogram and the date. It is not known where the Liechtenstein halberds were made (they are unmarked), but the lively etched ornament suggests a South German city like Augsburg, from which many of the Hapsburg halberds and *Kuse* were also ordered. The construction, in which the head screws onto the shaft, is impractical

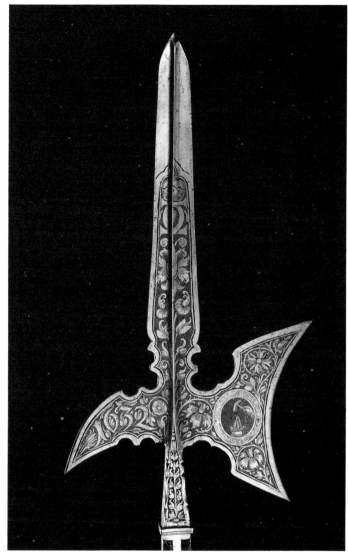

Liechtenstein inv. no. 1875

for a fighting weapon and demonstrates the ceremonial nature of these halberds. (Similarly constructed shafted weapons are generally of later date, such as the partisans of the Saxon Swiss Guard, about 1656, or the partisans of the Polish noble guard of Augustus II "the Strong," King of Poland and Prince-Elector of Saxony, about 1725.)

The size of Karl Eusebius's guard, and therefore the original number of halberds, is not known, though there is a record that he had a mounted guard armed with carbines that numbered fifty men (Falke 1868–82, vol. 2, p. 314). Twenty-nine halberds of this series can be accounted for. Besides the thirteen halberds in this exhibition, seven are now owned by another branch of the Liechtenstein family, two examples are in the Odescalchi collection, Rome (Carpegna 1969, p. 68, cat. nos. 408–9; these were previously in the Thill collection, Vienna, about 1900), and ten others were acquired from the Princely Collections by Dr. Bashford Dean of New York in 1926 and are now widely dispersed. Of the halberds once owned by Dean,

four were sold at public auction (American Art Association, New York, sale cat., November 19–20, 1926, lots 296–97, and November 23–24, 1928, lots 235–36), and the rest were sold privately from Dean's estate in 1929. Three of these halberds are now in the Metropolitan Museum; both the Philadelphia Museum of Art (Kretschmar von Kienbusch collection) and the Art Institute of Chicago (George F. Harding collection) have one in their collections; another is in a private collection in England; three others have been reacquired by the Princely Collections and are included among the thirteen halberds exhibited here.

SWP

FURTHER REFERENCES: Cat. 1952, p. 26, no. 107, p. 67, no. 373; Kienbusch 1963, p. 244, no. 558.

24

Erasmus Habermel

Working in Prague probably ca. 1576–d. 1606

PERPETUAL CALENDAR

Bohemian (Prague), ca. 1587–95
Gilded copper and brass; 14⅜ × 11¾ in. (36.5 × 30 cm.)
Signed (on front, below shackle): Erasmus Habermel scu:
Inscribed (on back, below shackle): Erwichwerender Calender. Sampt Tabulen
auf etliche gewisse Jahre daras man künfftich beyde nach dem Altē
und Neuen Stilo alle Festage Evangelia Mohnscheī Tageslenge
Planetēstunde Finsternusse an Sōnen und Mohn Leichtlich finden
kan. (Complete tables for several years to come in which one can easily find,
in both the old and new modes, all the evangelic feast days, phases of the
moon, length of the day, hours of the planets, eclipse of the sun and moon.)
Liechtenstein inv. no. 1440

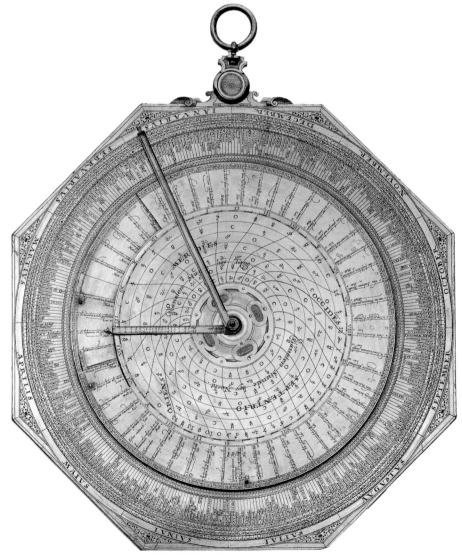

24 (front)

40

The calendar is made in the form of an octagonal plate of gilded copper suspended from a brass shackle. The front is divided into concentric circles engraved with the following calendrical information: the month, the day of the month, the dominical letter (a system in which letters of the alphabet are used to determine the day of the week on which any given date falls), the age of the moon within its monthly cycle, saint's days and holidays, and the time of sunset on each day of the year for the latitude of Prague, 50°51′. An inner revolving disk with adjustable sliding panels and two revolving indices can be used to find the dates of the moveable feasts of the Church, which depend upon the date of Easter. The inner disk also supplies various astrological data. On the back are engraved circular tables for determining the months in which Easter and Advent fall, as well as the dates of Easter and Advent Sunday according to the

Gregorian calendar for every year from 1582 to 1900. A second set of tables gives similar information for finding the date of Easter from 1550 to 1700 according to the Julian calendar. In the center is a square table of the eclipses of the sun and moon for a forty-year period beginning in 1582, and above is a smaller rectangular table for calculating the information needed to determine the date of Easter for every year to 4499. A much more complete description of the instrument is given by Bertele and Blau (1977, pp. 27–39), along with numerous demonstrations of its uses.

The Liechtenstein perpetual calendar is closely modeled on another instrument now in the collection of the Österreichisches Museum für angewandte Kunst, Vienna (inv. no. F1171), which is discussed not only by Bertele and Blau, but also by Eckhardt (1976, pp. 60–62, fig. 5; 1977, p. 27, no. 22), by Zinner (1956, p.

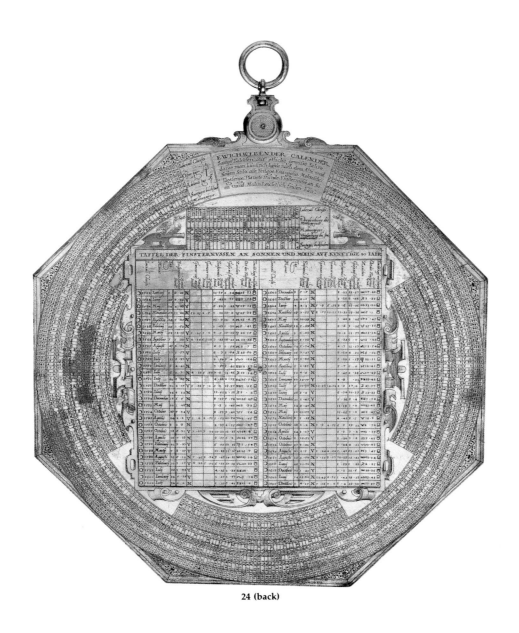

24 (back)

334), and by Rohde (1923, p. 102, fig. 125, p. 103, fig. 126, and pp. 104–6). The Vienna calendar is inscribed and dated "Geordnet und gerechnet durch Hermannum Bulderum von Ossenbrugk und durch Erasmum Habermel zugerichtet 1587" (Drawn up and calculated by Hermann Bulderus of Osnabrück and made by Erasmus Habermel, 1587), and the shackle of the instrument is engraved with the arms of Prince Wilhelm von Rosenberg for whom the calendar was made.

Prince Wilhelm (d. 1592) has been described by Evans (1973, pp. 34, 39, 41, 65, 140–143) as the head of one of the most powerful of the great landed families of South Bohemia and, like Karl von Liechtenstein, a staunch supporter of the Hapsburg Holy Roman Emperors. Prince Wilhelm and his brother and successor as Prince Rosenberg, Peter Vok (d. 1611), were highly cultured patrons of the arts and sciences, and the brilliance of the Rosenberg court in the time of Peter Vok's reign stood second only to that of the imperial court in Prague. Among the recipients of their patronage was the mathematician and physician Hermann Bulderus, whom Prince Wilhelm sent to study astronomy in Prague. From a letter preserved in the former Schwarzenbergsches Archiv, Wittingau (now the Třeboň Stádní Archiv) quoted by Rhode (1923, pp. 105-106), we know that Bulderus designed the calendar with its elaborate conversion tables for the newly adopted Gregorian calendar and presented it to Prince Wilhelm in thanks for supporting his astronomical studies. In the letter Bulderus boasted that the instrument would supply more astronomical information about the sun and the moon than could be obtained from the famous astronomical clock of Strasburg Cathedral, and that he had worked for seventeen weeks with the engraver (*Kupferstecher*) in order to produce it. Not a great deal seems to be known about Bulderus, except that he had a strong interest in Paracelsian medicine (Evans 1973, p. 143) and that he corresponded with the great German mathematician Johannes Kepler (Zinner 1925, no. 1860), who also enjoyed the patronage of the Rosenberg family.

Considerably more is known about the engraver of the instrument, Erasmus Habermel (or Habermehl), although Eckhardt, the author of the most extensive Habermel study (1976, pp. 55–91), has concluded that it is not possible to say when or where Habermel was born, or even where he was trained. A notebook and compendium signed and dated "Erasmus Habermel Pragae 1576" is recorded by Zinner (1956, p. 331), but Eckhardt has been unsuccessful in locating this object (1976, p. 60). We are on firmer ground with a group of instruments dated 1580 and believed to have been made for a Paduan doctor of medicine. Habermel also made at least one other instrument for Prince von Rosenberg which is now in the Paris Observatoire (Eckhardt 1976, p. 68, fig. 12; 1977, p. 51, no. 103).

In 1593 Habermel was appointed astronomical instrument maker (*Astronomischer Instrumentenmacher*) to Emperor Rudolf II (1552–1612), and he died in Prague in 1606. During the period from 1593 to 1606 he produced some of the most exquisitely engraved, as well as some of the most inventive instruments in Late Renaissance Europe. The 1607–1611 inventory of Emperor Rudolf's *Kunstkammer* lists only three instruments by Habermel (Bauer and Haupt 1976, p. 115, nos. 2220, 2223, 2232), but he is known to have made observational instruments of a practical nature for the imperial court. A sextant signed and dated 1600, now in the Národní Technické Muzeum, Prague (inv. no. 24,551), from the Old Clementinum Observatory in Prague is believed to have been used in Prague (Horský and Škopová 1968, pp. 28–29, no. 5, pl. VI) and perhaps by Rudolf II's imperial astronomer, Tycho Brahe (Eckhardt 1976, p. 57, and 1977, p. 30, no. 37).

There is no published record of the commission of the Liechtenstein calendar, nor is it mentioned in early inventories of the Liechtenstein collection. It seems likely, however, to have been made shortly after the original Rosenberg instrument, and it most probably dates not much later than 1587 or the early 1590s, at the latest. Haupt's publication of records in the Princely Archive from the reign of Prince Karl I von Liechtenstein (1569–1627) does not begin until the year 1596 (Haupt 1983). Haupt did, however, record the purchase of a gilded writing pen from Habermel on October 24, 1600, for 2 florins, 35 kreutzer (1983, Quellenband, p. 136, no. 47). Karl von Liechtenstein is known, therefore, to have been a patron of the imperial instrument maker, and as he undoubtedly had connections as well with the Rosenbergs at the imperial court, it seems quite likely that this copy of an instrument designed expressly for Prince Wilhelm von Rosenberg was, in fact, made for Karl von Liechtenstein not long after 1587 and probably well before 1596.

CV

FURTHER REFERENCES: Wilhelm 1976, p. 31; Eckhardt 1977, p. 32, no. 41; Bertele and Blau 1977, pp. 23–44.

25

Workshop of the Castrucci
Act. 1596–1622?
Probably finished in the workshop of Ottavio Miseroni (act. 1588–1624)

CASKET
Bohemian (Prague), finished ca. 1620–23
Hardstones, marble, garnets, gilt bronze, and ebony veneer; 21⅝ × 34⅝ × 19⅛ in. (55 × 88 × 48.5 cm.)
Arms (on front of casket): Quarterly, barry of ten or and sable, a crown of rue in bend vert (Kuenring); per fesse or and gules (Liechtenstein); per pale gules and argent (Troppau); and or, an eagle displayed sable charged on the breast and wings with a crescent argent, treflé at the ends (Silesia); all surmounted by a Prince's bonnet (Fürstenhut) in the form of a circular hat trimmed with ermine.
Monogram (on front of casket): Interlaced, addorsed c's surmounted by a coronet (Prince Karl I von Liechtenstein, 1569–1627)
Liechtenstein inv. no. 599

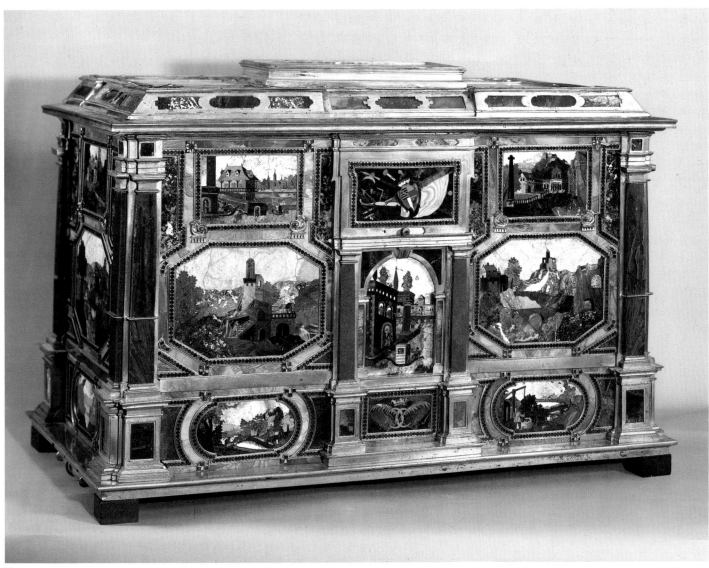

25

The twenty-four panels of inlaid hardstone that provide the chief decoration of this casket are arranged within an architectural framework reminiscent of a type of casket set with rock crystal and hardstones that is believed to have originated in Venice in the late sixteenth century. For an example now in the Basilica di Santa Barbara in Mantua, see Chambers and Somers Cocks 1981 (pp. 207–8, no. 213). Another, formerly in the collection of Lord Astor of Hever, appears in the Sotheby Parke-Bernet & Co. sale catalogue, *The Hever Castle Collection* (vol. 2, May 6, 1983, pp. 70–71, lot 287).

The Liechtenstein casket opens at the top by means of a hinged lid secured by a coffer lock with a keyhole secreted behind a spring device in the gilt-bronze frame below the panel with the coat of arms. The lid and sides of the casket continue the architectural organization of the front, containing in all twenty-four

Fig. 17 Detail from cat. no. 25

hardstone or pietre dure panels of various sizes and shapes, mostly landscapes with figures, but some with cityscapes and others with imaginary evocations of Venice with gondolas floating on canals. The top and bottom center panels of the front contain the arms and monogram of Prince Karl I; the center panel of the lid, a ribbon-tied bouquet of roses, carnations, magnolia, and jasmine on a black marble ground, is probably of Florentine origin. Hardstone pilasters and smaller bits of various colored minerals and stones, shaped to fit the areas between the irregularly sized pietre dure panels within garnet-studded gilt-bronze frames, give the entire surface of the casket an extraordinary aura of preciousness more usually associated with the contents of jewel caskets than with their exteriors. The back of the casket is more severe, repeating the architectural motif of the front, but in ebony. Retracting carrying handles of gilt bronze are attached to the bottom of each side, and originally the casket stood on four gilt-bronze bun feet.

Florence is recognized as the chief center of production of the variety of inlaid stone called Florentine mosaic or pietre dure work (*commesso di pietre dure*) used in the execution of the pictorial plaques of this casket. It is a technique which has more in common with wooden intarsia work than with the traditional mosaics made of numberless small cubes of stone or glass. Florentine mosaic is made instead of larger, irregularly shaped pieces cut and polished to exploit the color and figure of the stones—marble, petrified wood, and hardstones such as jasper, agate, chalcedony, alabaster, lapis lazuli, and onyx—in order to create naturalistic pictorial effects. The Florentine workshop for this medium, the Opificio delle Pietre Dure, was established in the Uffizi by 1586, and two years later it was reorganized under the Medici Grand Duke Ferdinand I (1549–1609). Grand Duke Ferdinand gave a table with a Florentine pietre dure top to the Emperor Rudolf II (1552–1612), and shortly thereafter Rudolf ordered a second table from the Florentine workshops (Neumann 1957, pp. 168–73). The Milanese brothers Gian Ambrogio and Stefano Caroni (d. 1611) and Cristofano Gaffuri (d. 1626) began work on the second tabletop in Florence in 1590 under the supervision of the goldsmith Jacques Bylivelt (1550–1603). The final payment was made in 1597, and the table became one of the prized possessions of the Emperor's *Kunstkammer* in Prague (Fock 1982, pp. 264–67). At about the same time, the Emperor installed two Florentine specialists in pietre dure, Cosimo Castrucci and his son Giovanni, in the workshops at his imperial court in Prague.

Neumann was the first to recognize the artistic identity of the two Castrucci in several pietre dure plaques now in the Kunsthistorisches Museum, Vienna (inv. nos. 3037, 3397, 3002). He identified these with entries in the inventory of the Prague *Kunstkammer* of the Emperor made between 1607 and 1611, discovered in recent times in the Liechtenstein collection by the former director of the collection, Gustav Wilhelm, and published by Bauer and Haupt (1976). Neumann noted that the earliest mention of Cosimo Castrucci as a stonecutter in Prague

was a record of a payment in 1596. Payments to Giovanni Castrucci were made between 1605 and 1610. Additional records were subsequently discovered in Florence by Fock (1974, pp. 123, 146), by Krčálová and Aschengreen-Piacenti (1979, pp. 251–53), and by Przyborowski (1982, vol. 1, pp. 276–77, and vol. 2, pp. 593–94). Giovanni was made hardstone cutter to the Emperor (*Kammer Edelsteinschneider*) in 1610, suggesting that Cosimo had died in that year. The next year Giovanni was invited to work in the Florentine Opificio, but he seems to have stayed in Prague and to have died there about 1615. The workshop in Prague also employed Giovanni's son Cosimo di Giovanni at least as early as 1615, and a son-in-law, Giuliano di Piero Pandolfini, who is mentioned in a document of 1622. The existence of still another member of the Prague workshop, Hans Bartzels, is evident from the record of a payment to him as late as 1627 (Haupt 1983, Quellenband, p. 324), but it is not known just how long the workshop remained in existence.

The only unquestioned work by Cosimo Castrucci is a signed landscape in the Kunsthistorisches Museum, Vienna (inv. no. 3037), which is dated either 1576 or 1596, depending upon how the third digit is interpreted (Neumann 1957, p. 168, figs. 197–98, p. 184 n. 111, p. 199, no. 1) and which is believed to have been sent from Florence to his prospective employer by Castrucci as a sample of his work. Giovanni's style is documented in a landscape with a bridge and obelisk with the imperial arms, based on an engraving by Johann Sadeler I (1550–ca. 1600) of 1599 after a drawing by Lodewijk Toeput (Neumann 1957, p. 170, fig. 200, p. 171, fig. 201, p. 185, and p. 199, no. 3). Neumann listed a second plaque (inv. no. 3002) by Giovanni (1957, p. 175, fig. 203, and p. 199, no. 4), but it has been suggested that this one is only a workshop piece.

The pietre dure plaques of the Liechtenstein casket are surely products of the workshop, if not by either Cosimo or Giovanni Castrucci. The one on the bottom right of the front of the casket with a landscape in which a man uses a well-sweep to draw water from a circular well is quite similar in design to the second of the works (inv. no. 3002) given by Neumann to Giovanni Castrucci himself. Wilhelm (1976, p. 24) has noted, however, that the Liechtenstein account book for 1623 contains a record of the payment of 1,134 gulden to Ottavio Miseroni and the artisans who worked with him to make a chest for the Prince, and Distelberger (1980, p. 63) has suggested that the Prince's chest is none other than this one. The Milanese-born Miseroni (ca. 1560–1624) is known to have been working at the Prague court of Rudolf II since 1588, and he is associated with lapidary work of various kinds: cameos, relief mosaics, and small sculptures of colored hardstones, as well as ornamental vases and cups made of both polished hardstones and rock crystal mounted in enameled gold. He is not, however, known to have produced the kind of illusionistic pietre dure work found in the plaques of the Liechtenstein cabinet.

We can be fairly certain of the approximate date of the completion of the Liechtenstein casket. Evidence provided by

Wilhelm (1947–50, pp. 7–8 and p. 11, fig. 6) indicates that Prince Karl I did not use the quartering for Kuenring in his coat of arms until 1620 and that when he became Duke of Jägerndorf in 1623 he promptly added the golden hunting horn of Jägerndorf to his escutcheon. Thus, this coat of arms would have been in use for only the short period between 1620 and 1623.

The supposition that the pietre dure plaques were made before 1620 is strengthened by the similarity of some of them to engravings made in Prague in the period around 1600–1618. Although none are as close to engravings as the Giovanni Castrucci plaque in Vienna (inv. no. 3397) is, several, notably the gondola scene of the center of the front of the casket, the castle with a bridge and an arched ruin beside it, the landscape with a man fishing at the bottom left of the front, and a scene with a steep pathway leading to a fortified castle on a hill on the lid of the casket, seem to be based loosely on Aegidius Sadeler's engravings (see Hollstein, vol. 22 [1980], p. 63, no. 250, p. 64, nos. 251–52, p. 66, no. 255, and p. 74, no. 271). Sadeler was a Flemish painter and engraver, born in Antwerp about 1570, who came to Prague in 1597; he became the leading engraver to the court of Rudolf II, and died in Prague in 1629. All of the Sadeler engravings from which the landscapes in the plaques are derived are based, in turn, on designs by another Flemish artist, Pieter Stevens (ca. 1567–after 1624), who worked at the Prague imperial court between 1594 and 1612. Not all of the plaques in pietre dure are from the same source of design, however. There is one on the left side of the casket showing an arch between a group of buildings and a tower that can be identified with those of the Roman ruins of Ripa Grande, probably from an engraving by Willem van Nieulandt II (ca. 1584–1636) also illustrated by Hollstein (vol. 14 [1956], p. 165, fig. 18). Van Nieulandt was in Rome between 1602 and 1605, and his engraved series of Roman ruins appeared shortly thereafter.

If the casket is indeed a product of the Miseroni workshop, then Ottavio Miseroni must either have employed Castrucci stonecutters, as suggested by Neumann (1957, p. 191), or have used unmounted plaques from an earlier period of the Castrucci workshop's existence. The latter possibility would account for the irregularities in size and shape of the plaques of this casket, necessitating the use of many smaller pieces of stone to fill and complete the overall design. The frame is a product of lapidary and metal workers rather than of cabinetmakers. Certainly when compared with the other surviving cabinets with plaques from the Castrucci workshop, all of them framed in ebony—one in the Kunsthistorisches Museum, Vienna (Neumann 1957, p. 193, fig. 218, and p. 201, no. 31), one in the Uméleckoprùmyslové Muzeum, Prague (Bukovinska 1972, pp. 363–65, figs. 1–2, and p. 369), one in the Museo dell'Opificio delle Pietre Dure, Florence (Giusti, Mazzoni, and Pampaloni Martelli 1978, figs. 348–58, and p. 312, no. 434), one in the Rosalinde and Albert Gilbert collection (Los Angeles 1982, pp. 83–84, no. 1), and one in an anonymous private collection (Philippovich 1981, pp. 22–27, figs. 1–2)—the difference between these more con-

ventional pieces of cabinetry and the Liechtenstein casket, with its rich embellishments of gold and sensuously colored stones, becomes obvious.

CV

FURTHER REFERENCES: Cat. 1767, p. 47, no. 24; Cat. 1780, p. 264, no. 90; Lucerne 1948, p. 69, no. 285; Neumann 1957, pp. 191–92, fig. 217, and p. 201, no. 32; Wilhelm 1976, p. 24; Distelberger 1980, pp. 61–63.

26

Workshop of the Castrucci
Act. 1596–ca. 1622?

TABLETOP
Bohemian (Prague), probably finished ca. 1620–23
Hardstones, garnets, and gilt bronze; 36⅝ × 35 in. (93 × 88.5 cm.)
Arms (in the center of the tabletop): Quarterly, barry of eight or and sable, a
* crown of rue in bend vert (Kuenring); per fess or and gules (Liechtenstein);*
* per pale gules and argent (Troppau); and or, an eagle displayed sable,*
* charged on the breast and wings with a crescent argent treflé at the ends,*
* supporting in the center a cross (Silesia); all surmounted by a Prince's*
* coronet (Fürstenhut) in the form of a circular hat trimmed with*
* ermine*
Monogram (in the four corners of the tabletop and on a banner in one of the
* military trophies): Interlaced, addorsed c's surmounted by a coronet*
Liechtenstein inv. no. 1401

The surface of this splendid tabletop is composed of plaques of inlaid hardstones and minerals, or Florentine mosaic, organized around a central plaque of decorative foliate scrolls framing the Liechtenstein coat of arms. The inner band of plaques consists of alternating landscapes and geometric figures; the outer band, of smaller landscape panels flanked by military trophies and, in the four corners, by the monogram of Prince Karl I (1569–1627). Each of the inlaid hardstone (pietre dure) plaques is framed in flat bands of gilt bronze set with garnets. They are separated by bands of reddish-brown jasper which are, in turn, inlaid with rosettes, geometric figures, and various creatures.

Like the pietre dure plaques of the Liechtenstein casket (cat. no. 25), those of this table are attributable to the Prague workshop of the Castrucci, if not to either Cosimo or Giovanni Castrucci. Two of the landscapes of the tabletop, the scene with a fisherman seated beneath a tree and the one with a man drawing water from a well, are, in fact, repetitions of two of the plaques on the casket, and the man drawing water from a well repeats a design on the plaque in the Kunsthistorisches Museum, Vienna (inv. no. 3002) that Neumann attributed to Giovanni Castrucci (1957, p. 175, fig. 203, p. 199, no. 4). In comparison with the plaque in the Kunsthistorisches Museum and the scenes on the casket, however, the landscapes on the tabletop are a great deal less successful in creating illusionistic effects, and the selection and cutting of the stones would seem to have been

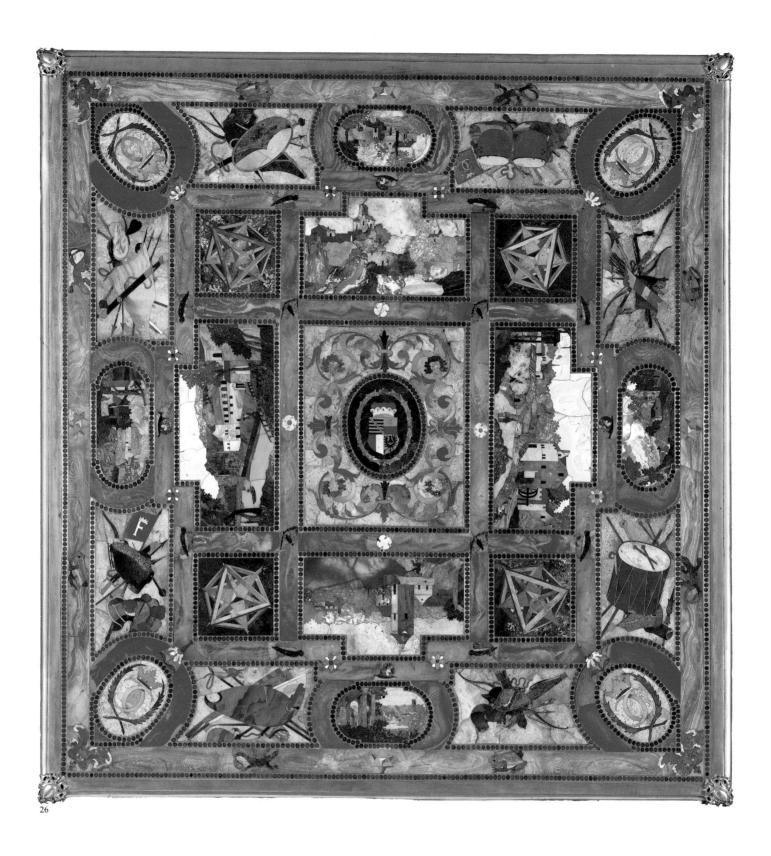

26

left to a craftsman less skillful than either Cosimo or Giovanni is known to have been.

The pictorial style of the landscapes has been shown to have been strongly influenced by Flemish artists working at the end of the sixteenth century and the beginning of the seventeenth at the imperial court of Rudolf II in Prague (see the discussion in cat. no. 25). The geometric figures used in the ornamental scheme of the tabletop have their origins in an earlier period of the sixteenth century. They are direct copies of a fanciful construction of a star octahedron nested inside an openwork octahedron in pl. E.VI of Wenzel Jamnitzer's *Perspectiva corporum regularium*, published in Nürnberg in 1568, with plates engraved by Jost Amman (1539–91). The small geometric figures on the outermost borders of jasper are taken from another figure in plate A.IIII of the *Perspectiva*, that of two interpenetrating tetrahedrons. In Jamnitzer's treatise, the Platonic solids are equated with the elements of Renaissance cosmology: the tetrahedron with fire, the octahedron with air. The identification of these figures also helps to explain the presence of the small lizards, frogs, caterpillars, snails, and moths that populate the jasper borders separating the pietre dure plaques of the tabletop.

Jamnitzer (1508–1585) is better known as the greatest of the Nürnberg goldsmiths of the sixteenth century who specialized in the kind of literal borrowing from nature found in the decorative motifs on the Liechtenstein tabletop. The 1607–1611 inventory of Rudolf II's Prague *Kunstkammer* contains references to no less than eleven works by Jamnitzer, but one of the best extant examples of his decorative use of various creatures cast from life is a silver inkwell from the Schloss Ambras collection of the Emperor's uncle, Archduke Ferdinand II of Tirol (1529–95), which is now in the Kunsthistorisches Museum, Vienna (Leithe-Jasper and Distelberger 1982, p. 96). The inkwell is one of the most extreme examples of the style christened "Stil Rustik" by Ernst Kris, a style which had its beginnings in the artificial grottoes and fountains of Italian gardens in the 1530s but soon traveled northward with School of Fontainebleau artists of the 1540s and had perhaps its most exuberant expression in the late sixteenth century among the goldsmiths of Nürnberg and Augsburg. Taken together, the choice of these decorative motifs for the tabletop—the creatures of water, earth, and air, together with the geometric constructions representing fire and air, and the military trophies which according to Jamnitzer may also represent fire—suggests a deliberate play upon their correspondences with the four elements: earth, air, fire, and water.

In its use of rare and costly materials and in the scheme of its decoration, the table reflects a taste formed by the intellectual and artistic atmosphere of the Prague court of Rudolf II (1552–1612), who was perhaps the greatest patron and collector of his age. Prince Karl I was three times High Steward (*Obersthofmeister*) to the Emperor during the years from 1600 to 1606. In his official position he was not only close to the Emperor but also very involved with the practical problems of the support of the wide variety of artists, scientists, and craftsmen who held court appointments. During the period of his stewardship, Prince Karl's own collection remained quite modest, probably, as Distelberger has pointed out (1983a, pp. 71–72), a wise policy to avoid the possibility of arousing the Emperor's jealousy. By 1613, the year after the Emperor's death, a Liechtenstein household inventory shows that the Prince had started to collect objects made of precious stones, rock crystal, and hardstones, a taste which he surely developed in the Emperor's service. The Emperor's *Kunstkammer* was renowned for its collection of such objects, many made in Prague, but others from the great Italian centers of the lapidary arts, Milan and Florence, and even from the Spanish workshop of the Milanese Leoni family, who were employed by Rudolf's cousin King Philip II.

The Emperor also spent large sums on minerals and gems, and his *Kunstkammer* contained an extensive collection of these, which he prized not only as natural specimens but also for their mystical properties. The influential *Gemmarum et lapidum historia*, a treatise on precious and semiprecious stones and minerals, written by the Emperor's personal physician, Anselm Boëtius de Boodt (1550–1632), demonstrates how pervasively the science of description and classification was still allied with the notion of the occult. The splendidly decorative objects made in these intractable media could thus be viewed by the initiated on various levels: as costly rarities, as prodigies of craftsmanship, or as symbols or visual manifestations of higher abstractions. Evans has included an excellent analysis of this typical Rudolfine way of thinking in the chapters on art and science in *Rudolf II and His World* (1973), but in the introduction to the first edition of his *Gemmarum* (Hanau, 1609) de Boodt himself explains that one sees concentrated in the smallest stone the beauty and power of all the world, which in turn is only a reflection of the divine Creator. The decorative scheme of the tabletop reflects, therefore, not only the aesthetic discrimination of the Prince, but above and beyond, it suggests a man cognizant of the new intellectual interest in the natural and mathematical sciences, as well as their importance to the greater understanding of the cosmos and its Creator.

There is no published record of the commission of the tabletop, but for reasons connected with the design of the Liechtenstein coat of arms it, like the casket (cat. no. 25), must have been nearly complete by about 1620–23. Distelberger (1980, p. 63) has suggested further evidence for a date after about 1620 in the interpretation of the crowned F on a banner in one of the plaques depicting military trophies as an allusion to Ferdinand II (1578–1637), whose election in 1619 as Holy Roman Emperor and defeat in 1620 of the Palatine Elector Frederick V in a struggle for control of Bohemia constituted the opening events of the Thirty Years' War. Prince Karl was subsequently made Governor and Viceroy of Bohemia.

There are two other known tables decorated with landscapes in the style of the Castrucci workshop, although the two small

plaques incorporated into the top of another pietre dure table-top in the Liechtenstein collection (cat. no. 27) may have been produced by craftsmen from the workshop of the Castrucci. Of the two tables, one with a pietre dure plaque embedded in its top is in the Schatzkammer of the Residenz in Munich (Kreisel 1968, pp. 169–70, pl. VI). The table itself was made in Augsburg by Lukas Kilian and Hans Georg Hertel, and it is mentioned in 1629 in the correspondence of Philipp Hainhofer (see Gobiet 1984, p. 512). The second, now in the Museo degli Argenti, Florence, has a pietre dure top which incorporates nine Prague landscapes and is believed to have been made during the first quarter of the seventeenth century (Baldini, Giusti, and Pampaloni Martelli 1979, figs. 18–28, p. 260, no. 13).

CV

FURTHER REFERENCES: Cat. 1767, p. 59, no. 26; Cat. 1780, p. 263, no. 86; Fleischer 1910, p. 207; Lucerne 1948, p. 69, no. 284; Wilhelm 1976, p. 24; Philippovich 1981, p. 26, fig. 3.

27

Probably by Giuliano di Piero Pandolfini (or Pandolfi)
Florentine, recorded ca. 1615–37

TABLETOP
Italian (Florence), probably finished in 1636
Hardstones, marble, gilt bronze; 50⅝ × 37 in. (128.5 × 94 cm.)
Arms (in center of tabletop): Quarterly, barry of seven sable and or, a
* crown of rue arched in bend vert (Kuenring); gules, a chevron argent*
* surmounted by seven points of the same (Boskowitz); per pale gules and*
* argent (Troppau); or, an eagle displayed sable charged on the breast and*
* wings with a crescent argent treflé at the ends (Silesia); per point in point*
* azure, a hunting horn stringed or (Jägerndorf); and in pretense, per fesse or*
* and gules (Liechtenstein); all surmounted by a Prince's bonnet (Fürstenhut)*
* in the form of a circular hat trimmed with ermine*
Liechtenstein inv. no. 1402

The design of this tabletop is a mixture of naturalistic elements, flowers, birds, and butterflies with ornamental devices drawn from the decorative vocabulary of the Late Renaissance, but transformed by a Baroque exuberance of form. The design consists of irregularly shaped cartouches and candelabra ornaments with floral sprays radiating from a central cartouche that encloses a military trophy supporting an escutcheon with the coat of arms of Prince Karl Eusebius von Liechtenstein. It is framed by a band of cartouche-shaped plaques containing pietre dure birds and butterflies separated by shell forms, by more cartouches framing brightly colored hardstone plaques, and by sprigs of pietre dure flowers. The entire design is inlaid in a ground of black marble and framed by a gilt-bronze molding with strapwork cartouches in the corners.

The Medici love of objects made of polished hardstone goes back at least as far as the time of Lorenzo the Magnificent (1449–92), whose collection is still one of the chief treasures of the Museo degli Argenti, Florence, but serious encouragement of the local production of such objects began in the reign of Grand Duke Cosimo I (1519–74). It was Cosimo's son, Francesco I (1541–87), who in 1586 first brought many of these lapidary specialists together in a workshop in the Grand Ducal residence at the Uffizi (Przyborowski 1982, vol. 1, p. 38). Two years later, Francesco's successor, Grand Duke Ferdinando I (1549–1609), reorganized the workshop, and the year 1588 has, until quite recently, been regarded as the date of the founding of the Opificio delle Pietre Dure. Ferdinando I also commissioned its most ambitious and long-lived project, the marble and hardstone decoration of the Medici Chapel of the Princes at San Lorenzo, Florence. Work at San Lorenzo began in 1594 and continued well past the middle of the twentieth century. Although it is no longer housed in the Uffizi, the Opificio still exists in Florence as a training school for lapidary craftsmen.

While the particular variety of inlaid marbles and hardstones associated with the work in the Chapel of the Princes was by no means a Florentine invention, Florence became the preeminent center of its production, and ultimately it came to be known as Florentine *commesso di pietre dure*, or Florentine mosaic. From the late sixteenth through the nineteenth century the Opificio specialized in making tabletops in this medium.

In its use of floral sprays combined with cartouche ornament, the Liechtenstein tabletop can be compared with a table now in the Museo degli Argenti, Florence (Baldini, Giusti, and Pampaloni Martelli 1979, pl. 11 and p. 258, no. 9), which was made in the Opificio in the first quarter of the seventeenth century and has been identified in an inventory of 1624. The design of this tabletop is organized in a comparable way, but it remains very much more geometric and compartmentalized, and stylistically it still belongs to the Late Renaissance period rather than to the Baroque. On the other hand, the design of the Liechtenstein tabletop seems to anticipate the combination of floral sprays, cartouches, and shell ornaments on another table now in the Uffizi, Florence (Baldini, Giusti, and Pampaloni Martelli 1979, pls. 126–32 and pp. 287–88, no. 96). This tabletop is known to have been made for the Medici between 1633 and 1649 by Iacopo di Gian Flach, known as Il Monnicca, who had earlier been employed in the Chapel of the Princes.

On stylistic grounds, the Liechtenstein table can thus be dated somewhere between about 1625 and 1649. We have even better evidence for the date, however, in the Liechtenstein arms that appear in the central cartouche. Here, for the first time on the Liechtenstein objects made of pietre dure, are displayed the Jägerndorf and Boskowitz quarterings, and the Liechtenstein escutcheon has been shifted to the center in a position termed "in pretense" in heraldic parlance. In an article on the heraldry of the period of Prince Karl I, Wilhelm (1947–50, p. 9 and p. 11, fig. 7) states that while the Jägerndorf arms were added

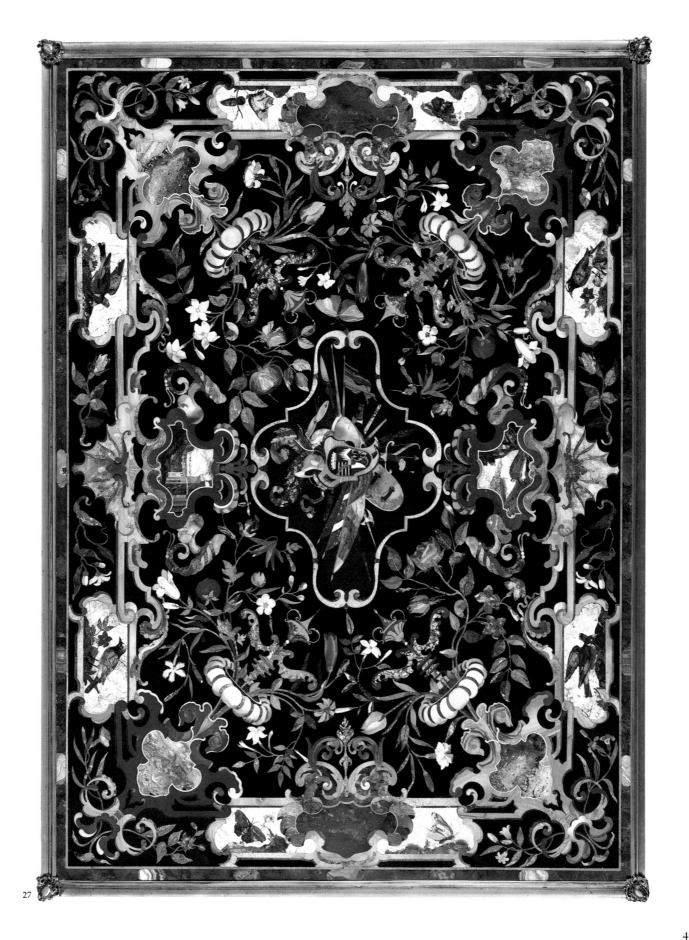

when Prince Karl became Duke of Jägerndorf in 1623, the Boskowitz quartering and the use of the Liechtenstein arms in pretense were first adopted about 1632 by Prince Karl's son, Prince Karl Eusebius (1611–48), upon reaching his majority.

The tabletop is, in all probability, the one described as made of "Jaspis" (jasper) bought by Prince Karl Eusebius from Giuliano Pandolfini (or Pandolfi) while on a visit to Florence in 1636. Pandolfini was paid 1,700 scudi for it in 1637 (Wilhelm 1976, p. 56). Pandolfini was Giovanni Castrucci's son-in-law, and he had worked in Prague. He and Giovanni Castrucci's son Cosimo di Giovanni supplied a finished pietre dure plaque depicting Abraham and the Three Angels to the Florentine court, for which the Florentine Archivo di Stato contains a record of payment in 1622 (Przyborowski 1982, vol. 2, pp. 593–94). The plaque is now in the Museo dell'Opificio delle Pietre Dure (Giusti, Mazzoni, and Pampaloni Martelli 1978, pl. 79 and p. 290, no. 75). Pandolfini and Cosimo di Giovanni Castrucci apparently delivered the plaque to Florence personally. Whether or not they remained in Florence is uncertain, but in his list of masters who worked for the Florentine Opificio during the reign of Grand Duke Ferdinand II (1621–70), Antonio Zobi (1841, p. 266) referred to him as a Florentine. Still another link between Pandolfini and the Castrucci is provided by the cartouche used to enclose the military trophy and coat of arms in the center of the Liechtenstein tabletop, for it is almost identical in form to that of a pietre dure plaque with a winged figure of Fame (Giusti, Mazzoni, and Pampaloni Martelli 1978, fig. 67 and pp. 290–91, no. 81). The design of Fame is attributed to Bernardino Poccetti (1548–1612), but recently mention of it has been found in a document of 1659 as having been executed by Cosimo di Castrucci (Krčálová and Piacenti 1979, p. 251).

Pandolfini worked for Prince Karl I von Liechtenstein as well as for Prince Karl Eusebius, for there is a record in the Liechtenstein Archives for a payment of 449 gulden for a "chest of jasper" dated March 22, 1627, a date which seems too late to apply to the surviving pietre dure casket from the Castrucci workshop (Haupt 1983, Quellenband, p. 287, no. 738). Several elements in the decoration of the Liechtenstein tabletop indicate that it was made with Prague patronage in mind. The cartouches on the short axis of the design contain two landscapes in the style of the Castrucci workshop made of Bohemian hardstones. Whether the landscapes on the Liechtenstein tabletop were actually made in Prague or in Florence seems open to question. Pandolfini was evidently employed in the Castrucci workshop before joining the Florentine Opificio, however, and according to Zobi, his Florentine work was recognized as showing Northern influence. Moreover, Bohemian hardstones and minerals were imported by the Opificio. In the early seventeenth century, Giovanni Castrucci was, in fact, recorded as having been instrumental in their supply (Fock 1974, p. 146 n. 266). Similarly, two of the birds in the border of the Liechtenstein tabletop suggest a Prague connection. While flowers—most of them readily identifiable—butterflies, and birds were stock motifs in Flor-

entine pietre dure work and plaques decorated with these motifs were incorporated into Florentine cabinets or *stipi*, imported by the cabinetmakers of South Germany and used in making furniture as far north as Denmark, the two birds with spread wings on the Liechtenstein tabletop are not typical of those found in surviving seventeenth-century cabinetry ornament. They are instead almost identical to the bird in one of the two oval plaques in the Liechtenstein collection (cat. no. 31) that were probably made in Prague. Here again is evidence that the connections between the two centers of pietre dure production must have continued to be close.

CV

FURTHER REFERENCES: Cat. 1767, p. 59, no. 27; Cat. 1780, p. 264, no. 89; Wilhelm 1976, p. 56; Distelberger 1980, pp. 63, 65–66.

28

Workshop of the Castrucci
Act. 1596–ca. 1622?

LANDSCAPE WITH A TOWER AND HOUSES ON A ROCK
Bohemian (Prague), late 16th–early 17th century
Hardstones; 7¼ × 10⅛ in. (18.3 × 25.5 cm.)
Liechtenstein inv. no. 1461

A man with a walking stick and a bundle on his head climbs a steep flight of steps in the foreground of this landscape. To the left is a river, and a path in the center leads up the side of the rock to two houses. From there, steps continue up to a tower built atop the rock. In the far distance additional buildings nestle at the foot of a low mountain range.

Extraordinary care has been taken to select and arrange stones which provide the textures and colors necessary to the creation of a naturalistic landscape in which the effects of light and air have been captured to a degree almost unknown in pietre dure work of the period. Both Neumann (1957, p. 202, no. 33a) and Distelberger (1980, p. 63) unhesitatingly assigned this plaque and two other landscapes in the Liechtenstein collection (cat. nos. 29–30) to the Prague workshop of the Castrucci. As Distelberger has correctly observed, the three are among the best of the surviving Castrucci works in pietre dure, and they are thus to be dated quite early in the history of the workshop.

The scene is closely based on an engraving signed "Joan Sadeler excudit" and dated 1593 (Boon, vol. 21 [1980], p. 288, no. 26, vol. 22 [1980], p. 227, no. 26). The print, in turn, is believed to have been made from a drawing of the subject in reverse, which is now in the Hessisches Landesmuseum, Darmstadt. The drawing has been attributed to Paul Bril (1554–1626) on the basis of an inscription giving the artist's name; the place,

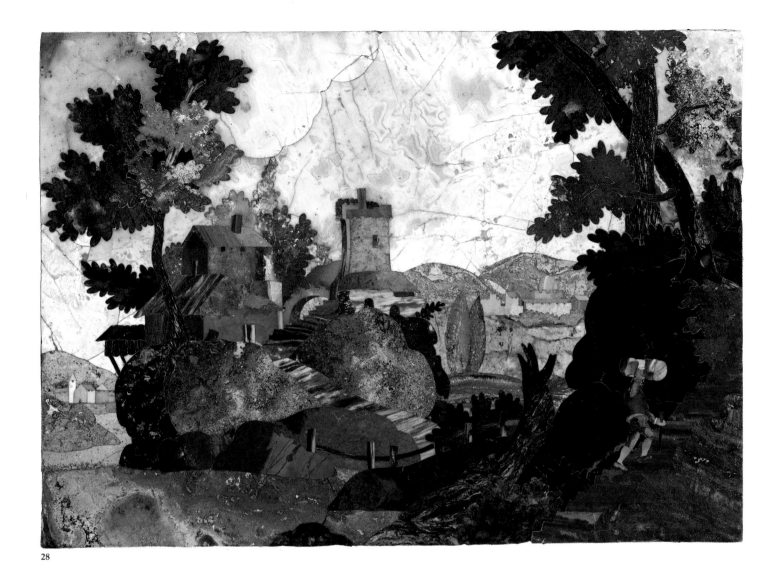

28

Rome; and the date, 1603, in the lower-right-hand corner (Bergsträsser, vols. 18–19 [1979], p. 31, no. 21). Boon thinks the inscription is a later addition and that the drawing may be by Bril or by another artist of the so-called Netherlandish-Venetian landscape school, Lodewijk Toeput (ca. 1550–1603/1605), who, like Bril, spent a great deal of his career in Italy. Given the existence of the print dated ten years earlier than the date inscribed on the drawing, Boon's caution seems justified. A somewhat different version of the scene exists, however, in another print signed "Justa[s] Sadeler excud." and "Paulus Bril inventor" (Boon, vol. 21 [1980], p. 205, no. 69, vol. 22 [1980], p. 180, no. 69), and there is a third engraving that shows the same tower in a somewhat rearranged landscape, this one by Bril himself (Hollstein n.d., vol. 3, p. 219). The Bril engraving is identified as a view of the coast of Campania, and it is dated 1590.

Whatever the source of the drawing, the Johannes Sadeler engraving of 1593 is clearly the source of the pietre dure land-scape. The plaque differs from the engraving only in the omission of a small rowboat in the river and the addition of two poplar trees in the middle ground and the man trudging up the steps in the foreground. The foliage on the trees has also been rearranged, probably to suit the configurations in the available stone. Like the other two plaques in this group, this one was formerly incorporated in the decoration of a wooden cabinet of nineteenth-century origin.

CV

FURTHER REFERENCES: Cat. 1767, p. 59, no. 26; Cat. 1780, p. 263, no. 86; Fleischer 1910, p. 207; Lucerne 1948, p. 69, no. 284; Wilhelm 1976, p. 24; Philippovich 1981, p. 26, fig. 3.

Workshop of the Castrucci
Act. 1596–ca. 1622?

LANDSCAPE WITH A TEMPLE BESIDE A RIVER
Bohemian (Prague), late 16th–early 17th century
Hardstones; 7 × 9¾ in. (17.8 × 24.8 cm.)
Liechtenstein inv. no. 1460

A wide river runs through this landscape. A small town lies at the foot of the ruin of a circular temple on the hillside above the left bank; in the foreground a woman converses with a bearded man who is seated in front of the remains of several arches of another ruin. In the care with which the smallest details are executed, for example, the dress of the two figures and the tiny boat on the river, in the choice of media, and in the handling of the difficult problems of aerial perspective, this plaque ranks

with the very best of the Castrucci landscapes, rivaling even the landscape made by Cosimo Castrucci himself for the Holy Roman Emperor Rudolf II (1552–1612), now in the Kunsthistorisches Museum, Vienna (Neumann 1957, p. 168, figs. 197–98, p. 199, no. 1).

<div align="right">CV</div>

FURTHER REFERENCES: Neumann 1957, p. 202, no. 33c; Distelberger 1980, p. 63.

Workshop of the Castrucci
Act. 1596–ca. 1622?

LANDSCAPE WITH A RIVER AND TOWN
Bohemian (Prague), late 16th–early 17th century
Hardstones; 7⅛ × 9¾ in. (18.1 × 24.7 cm.)
Liechtenstein inv. no. 1462

29

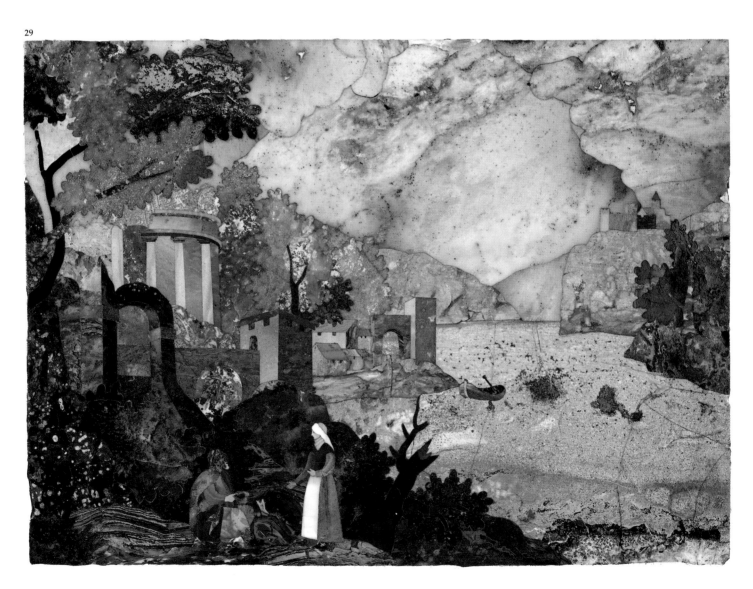

30

In the foreground of this landscape are two trees and a man carrying a basket on his back. The man is headed toward a group of houses on a riverbank. A bridge leads to a walled town with numerous towers and a church on the opposite side of the river. A range of snowcapped mountains rises in the distance behind the town.

Another version of this scene exists in a plaque attributed to the Castrucci workshop in the Kunsthistorisches Museum, Vienna (inv. no. 3000; Neumann 1957, p. 187, fig. 212, p. 200, no. 25). Although it is difficult to discern a personal style in the execution of individual pietre dure plaques made in the Prague workshop of the Castrucci, comparison of the two plaques provides a fine illustration of the tremendous range in skill among the lapidary craftsmen employed there. The landscape in the Vienna plaque is very much simplified in design, and such details as the man bearing a basket and the church have been omitted. The choice of stones used to simulate the forms and colors of nature is far less successful, and above all the Vienna

plaque lacks the remarkable sense of depth and spaciousness that is so striking in all three Liechtenstein plaques belonging to this group (cat. nos. 28–30).

CV

Further references: Neumann 1957, p. 202, no. 33b; Distelberger 1980, p. 63.

31

EUROPEAN GOLDFINCH IN A LANDSCAPE

Probably Bohemian (Prague), early 17th century
Hardstones and composition; 5⅜ × 7¾ in. (13.5 × 19.6 cm.)
Liechtenstein inv. no. 1412

This is one of three pietre dure plaques in the Liechtenstein collection (cat. nos. 31–33) depicting birds which are framed as a set. As all three are made of Bohemian hardstones and set within landscapes that are typical of the Prague workshop of the Castrucci, it seems more than likely that they were made in Prague. There are, however, no documented birds of pietre dure from the Castrucci workshop, and the only evidence that plaques of the kind did indeed exist in early seventeenth-century Prague lies in the listing of seven pieces of mosaic work with portraits, birds, and fish in the inventory of the Prague *Kunstkammer* of the Holy Roman Emperor Rudolf II (1552–1612), made between 1607 and 1611 (Neumann 1957, p. 200, nos. 9–15; Bauer and Haupt 1976, p. 140, f. 389ᵉ, no. 2808). No artist's name is connected with these plaques, but they are described in the inventory as being kept in the same box with seven hardstone landscapes by Giovanni Castrucci.

An intriguing aspect of this Liechtenstein plaque is that a bird of the same species, the European goldfinch, perched in precisely the same position on a fallen tree stump appears in two of the plaques incorporated into the tabletop made in the Florentine Opificio delle Pietre Dure around 1635–40 for Prince Karl Eusebius von Liechtenstein (cat. no. 27). Bohemian hardstones were used in a number of the pietre dure panels in the Florentine tabletop, including the goldfinches and two landscapes. The stylistic similarities between these landscapes and Castrucci landscapes of the early seventeenth century have been remarked upon in the entry for the tabletop (cat. no. 27),

and it is tempting to suggest that they might have been imported from Prague.

On the other hand, the tabletop is probably a work of the 1630s at the earliest, and there is no incontrovertible evidence that this kind of pietre dure work continued to be made in Prague past the decade of the 1620s. We know also that Bohemian hardstones were imported by the Florentines for use by the Opificio, but if the plaques in the table were made in Florence of imported stone, they were executed by someone who knew the pietre dure work of Prague quite well and who had drawings, models such as this plaque, or perhaps this very plaque from which to work.

CV

32

EUROPEAN GOLDFINCH IN A LANDSCAPE

Probably Bohemian (Prague), early 17th century
Hardstones and composition; 5⅜ × 7¾ in. (13.5 × 19.6 cm.)
Liechtenstein inv. no. 1411

A bird of the same species as the one in the other oval plaque in this group (cat. no. 31) perches on a broken tree branch against a background landscape with buildings, trees, and mountains in the distance. All three plaques of the group (cat. nos. 31–33) are framed in mustard-colored composition, and the stone pieces that form their images are cemented to thin plaques of black slate through which holes have been drilled at regular intervals to permit the greater adhesion of the cement.

CV

31

32

33

BIRD CLUTCHING PREY IN A LANDSCAPE

Probably Bohemian (Prague), early 17th century
Hardstones and composition; 6⅛ × 6⅝ in. (15.5 × 16.7 cm.)
Liechtenstein inv. no. 1413

A bird of prey, probably either a kite or a long-legged buzzard, is perched on a nearly leafless tree and clutches a greenshank in one talon. In the foreground there is a clump of leaves; in the distance a pale green mountain range set against a milky sky made of Bohemian alabaster that is typical of the landscapes of the Castrucci workshop in Prague. While birds were a specialty of the Florentine Opificio delle Pietre Dure, there is a trace of awkwardness in the design of these two birds that is most unlike the pietre dure designs known to have been produced in Florence. In addition, the birds of all three plaques in this group (cat. nos. 31–33) display evidence of the kind of close attention to recording naturalistic detail that is one of the characteristics associated with the artists of the Rudolfine court in Prague.

CV

34

Dionysio Miseroni
Bohemian (Prague), ca. 1607–1661

VASE WITH COVER (MAIENKRUG)
Bohemian (Prague), 1638–41, with early 19th-century Viennese mounts
Smoky crystal, mounted in gilt bronze and silver gilt, partly enameled; height, with cover, 14¾ in. (37.5 cm.); width 11¾ in. (30 cm.); depth 4½ in. (11.5 cm.)
Liechtenstein inv. no. 310

The vase is made of two pieces cut from a single, thirty-five-pound piece of smoky crystal and joined at the neck. Its hexagonal shape, determined by the natural form of the crystal, is embellished with deeply cut volutes and striations. On the two long sides of the hexagon, these form grotesques with scrolled eyes, flat, button noses, and bow-shaped mouths half hidden by beards masquerading as leaf forms. Below these are oval cartouches enclosing the escutcheon of Liechtenstein (per fesse or and gules) on one side and of Troppau (per pale gules and argent) on the other. Both escutcheons are surmounted by coronets. The cover, also cut from the same piece of crystal, is quatrefoil shaped, with a hexagonal knop at the top.

Prized for its size and for the brilliance of its decoration, which exploits the light-reflecting properties of the material to an extraordinary degree, the vase is also the earliest completely documented work by Dionysio Miseroni, the best of the Prague lapidary artists of the seventeenth century. Most of what is known about Dionysio personally has been summarized by Klapsia (1944, pp. 301–4). Dionysio's father, Ottavio, a member of one of the most illustrious families of lapidary artists in sixteenth-century Milan, left Italy to become imperial hardstone cutter (*Edelsteinschneider*) to Emperor Rudolf II (1555–1612) in 1588 and spent the rest of his life in Prague. Dionysio's birth date is unknown, but he is believed to be the son recorded to have been christened in Prague in 1607. When Ottavio died in 1624, Dionysio was old enough to succeed him in the imperial workshop, and before 1637 he had been appointed to the position of keeper of the imperial treasures (*Schatzmeister*). He survived the Swedish sack of Prague in 1648 to be granted a patent of nobility in 1653 by Emperor Ferdinand III (1608–1657), and he held various other influential and lucrative imperial appointments, as well as maintaining the family lapidary workshop at Wachsen. He remained active as a specialist in the cutting and polishing of hardstones and rock crystal until his death in 1661.

The commission drawn up on September 10, 1638, for the cutting and polishing of the vase was found in the Princely Archive. A summary of it was first published by Klapsia (1944, p. 304), but Wilhelm and Distelberger have given fuller accounts of it. According to its terms, Miseroni promised Prince Karl Eusebius (1611–84) to make the vase and cover, as well as two columns, now lost, from the same piece of smoky crystal.

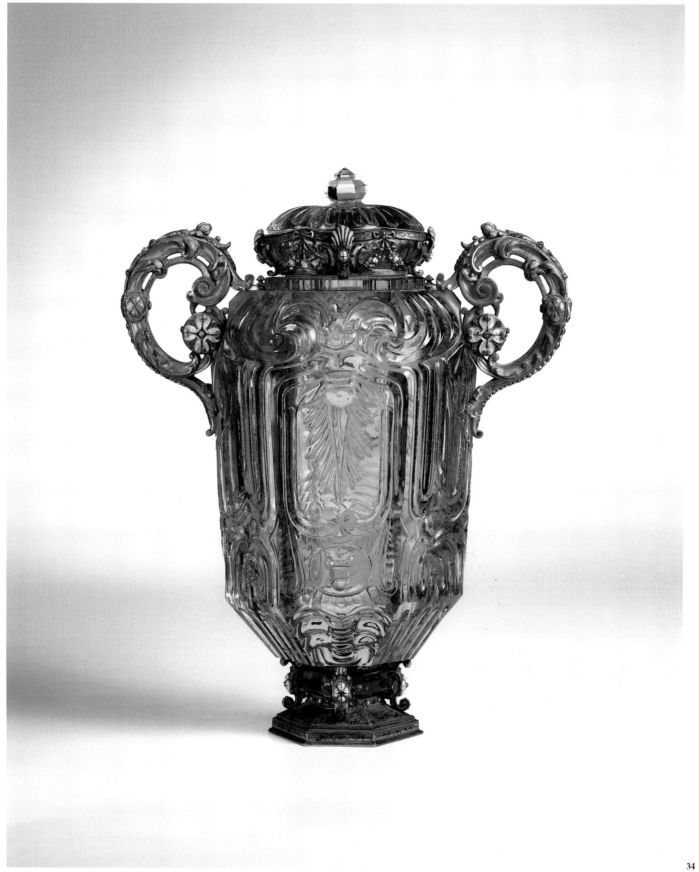

The vase was to conform to a furnished model and to be completed within a year's time. Miseroni was to pay his assistants and supply his own material for working (for example, diamonds and emery for cutting and polishing the crystal). Miseroni was paid 3,000 gulden in five installments. The last payment was made on October 6, 1639.

Other documents record that the crystal itself, a variety of quartz often but incorrectly called topaz, was purchased by Prince Karl Eusebius from a Martin Dominik Wagner of Ankerstein (or Ankerburg) on March 1, 1638, for 1,200 gulden. By 1639, when Dionysio had completed the cutting and polishing of the crystal, Prince Karl Eusebius had become Captain-General (*Oberhauptmann*) of Silesia and was living in Breslau. A Breslau goldsmith, Tobias Vogt, was commissioned to make enameled gold mounts for the vase. Vogt was paid 1,030 gulden for the gold and 260 gulden for his work. A clockmaker named Johann Engerdt made an unspecified contribution to the work, and finally a bookbinder, Andreas Strauss, and a belt maker, Gallus Partsch, made a carrying case for it. The vase was completed in 1641; its total cost was 5,493 gulden. (While comparisons are difficult to make, one of the two splendid bronze portrait busts of Emperor Rudolf II by Adriaen de Fries which are now in the Kunsthistorisches Museum, Vienna, was valued about thirty years earlier at only 800 gulden.)

According to Distelberger (1979, p. 124), the original mounts of the vase are described in a Liechtenstein inventory of 1678. Four golden lizards supported the foot, while the handles were in the form of two more golden lizards. The original mounts were still intact in the eighteenth century when the vase was displayed in the Liechtenstein gallery in Vienna, for the catalogue of 1780 described it as "richly mounted in gold" (Cat. 1780, p. 263, no. 88). But in 1810 a Viennese bronze caster named Kremnitzer was paid 550 gulden for new mounts. These were presumably the two scrolled handles of gilt bronze now attached to the shoulders of the vase. Although they must have been made about the same time, it seems unlikely that the rest of the present mounts would have been supplied by Kremnitzer, as both the foot and the ornaments on the neck of the vase are of enameled silver gilt.

<div align="right">CV</div>

FURTHER REFERENCES: Klapsia 1944, pp. 304–6, 357–58; Lucerne 1948, p. 61, no. 256; Bregenz 1967, p. 56, no. 80, fig. 123; Wilhelm 1976, pp. 49–50; Distelberger 1979, pp. 121–25; Distelberger 1980, pp. 65, 67.

35

Adriaen de Fries
Dutch, 1545–1626

CHRIST IN DISTRESS

Prague, 1607
Bronze with brown natural patina; height 58⅝ in. (149 cm.)
Inscription engraved on back of base: ADRIANUS FRIES HAGENSIS/FECIT 1607
Inscription cast on left side of pedestal: EMPTI/ESTIS/PRETIO/MAGNO
Inscription cast on back of pedestal: CAROLVS/ALIECHTEN/STEIN RUD.II/IMP.CAES. P.E./AUG. SACRI/PALATII/PRAEFECTVS/DEDICAVIT/ AN. P.C.N./MIƆCVII.
Liechtenstein inv. no. 515

On May 1, 1601, Adriaen de Fries was officially named court sculptor to the Holy Roman Emperor Rudolf II (1552–1612). Soon thereafter, de Fries moved to Prague, where the Emperor resided. For most of the following decade, he devoted himself to the execution of bronze sculptures for Rudolf II, carrying out three official portraits of the Emperor, several allegorical reliefs and groups, and other bronzes for Rudolf's famous collections. Quite exceptionally, during those years, he was also allowed to undertake a few private commissions, mostly of religious works, for some trusted high court officials who belonged to the Emperor's entourage. The most prominent among these officials was Karl von Liechtenstein (1569–1627), who, soon after his conversion to Catholicism in 1599, attained the highly influential position of High Steward of the Palace of the Holy Roman Emperor Rudolf II; this title is spelled out in Latin in the dedicatory inscription on the back of the pedestal of this figure.

An impressive, nearly life-size devotional sculpture, the *Christ in Distress* is essentially a meditation on the Passion of Christ and its role in the Redemption of Mankind. A quotation from Paul's First Epistle to the Corinthians (6:20)—EMPTI ESTIS PRETIO MAGNO (You are bought at a price)—is cast on the pedestal; it stresses this meditative quality and underlines the emotional appeal conveyed by Christ's suffering features and the supplicant gesture of his hands, raised in prayer as if to avert the last stage of his sacrifice. The statue is meant to show us Christ on Calvary, as he sits on a stone and waits for the executioners to stretch him on the cross. The episode does not have a scriptural source, but Christ in Distress (*Christus in Elend*) was a devotional subject of late medieval origin that seems to have been especially popular in German countries; it is quite distinct from the more frequent depictions of the Man of Sorrows, which shows Christ crowned with thorns and with hands, feet, and side pierced by nails and lance.

It has been often pointed out that the composition of the Liechtenstein *Christ in Distress*, with his cross-legged pose, was inspired by one of the most famous of Dürer's works: *The Man of Sorrows*, the woodcut from the title page of the large *Passion* of

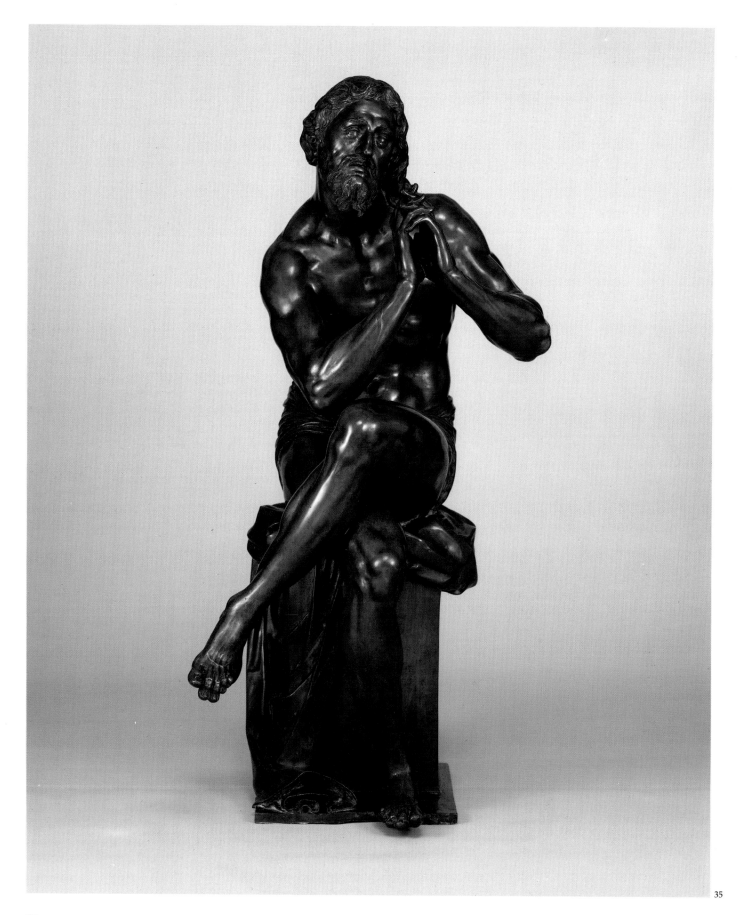

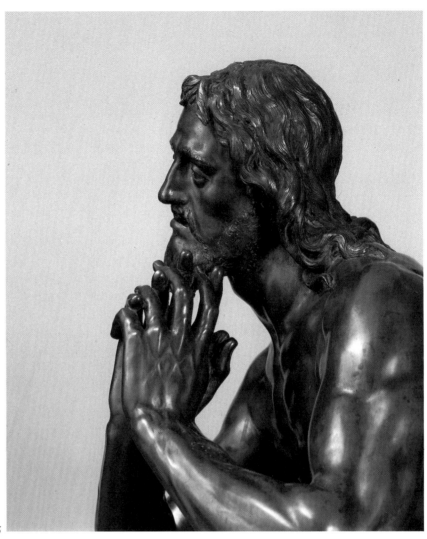

Fig. 18 Detail from cat. no. 35

1511 (Frankfurt 1981, fig. 32). Beginning about 1580 and continuing well into the seventeenth century, Dürer's works enjoyed immense popularity, especially at the court of Prague, and such a borrowing is not surprising. It must be stressed, however, that de Fries's *Christ* is far from being just a three-dimensional translation of Dürer's design. The emotional power of de Fries's sculpture has a different meaning and is realized by different expressive means. While Dürer's *Man of Sorrows* is a graphic image that symbolizes the idea of Christ's perpetual Passion, de Fries's *Christ in Distress* conveys the anguish of a specific moment during the Passion. The spiritual tension created between Christ's sorrowful features and the classical beauty of his heroic nude body is profoundly attuned to the art of the Counter-Reformation and is characteristic of de Fries's religious works.

The physiognomy of Christ is the same as that which de Fries created three years earlier for the bronze *Christ at the Column* on the funerary monument of Adam Hannewald at Rothsürben (Waźbiński 1983, p. 47, fig. 6): this Christ reflects a type established by Giovanni Bologna in the late 1570s, but here the Savior is older and has been reinterpreted with the warm naturalism typical of de Fries. In the treatment of Christ's nude body, de Fries goes back to his fundamental experience with Hellenistic sculpture and with the works of Michelangelo, which he studied during his years in Florence as well as in Rome. The upper part of Christ's body and the torsion of his shoulders derive from the *Belvedere Torso*, just as much as the fullness of the body's modeling is indebted to such sculptures as Michelangelo's *Christ* at Santa Maria Sopra Minerva, Rome. Both classical and Mannerist elements are fused, however, in de Fries's own style which echoes the devotional intensity of some Northern Italian painters of the Counter-Reformation; among the artists active in Rome with whom he had such an affinity was Gerolamo Muziano, whose late *Saint Jerome in the Wilderness* (Pinacoteca, Bologna), also derived from Dürer's woodcut, de Fries may have seen in Rome or known through an engraving by J. Sadeler (da Como 1930, p. 150).

The superb workmanship of this bronze sculpture recalls that of some of de Fries's works for Emperor Rudolf II: its firm and broad modeling, the luminous treatment of its rippling

surfaces, and its finely pictorial chasing are in many ways comparable to those of the two busts of Rudolf II in Vienna, especially the smaller one in the Weltliche Schatzkammer, modeled in 1607 (Larsson 1967, fig. 91).

Nothing is known about the circumstances or the purpose for which this impressive sculpture was commissioned by Karl von Liechtenstein. However, since the date of 1607 is mentioned in its dedicatory inscription in conjunction with his title as High Steward, one must assume that it was executed during the early part of that year, before he resigned this position and withdrew to his lands as Governor of Moravia. The first months of 1607 were marked by the beginning of the rift between Karl von Liechtenstein and Rudolf II, who, after refusing to recognize the treaty signed by Archduke Matthias and Hungary, sank into one of his deep depressions. During this crisis Karl von Liechtenstein, who no longer had access to the Emperor, seldom attended meetings of the Privy Council and spent many hours each day with the influential and saintly Capuchin monk Lawrence of Brindisi (Haupt 1983, Textband, p. 18). The Capuchins, whom the Pope had established as missionaries in Prague, had been allowed to found in 1599 a new monastery and church, Maria Loretto, on the Hradschin. Since the large size of the *Christ in Distress* suggests that it was meant for a church rather than a private chapel, it is quite possible that, as Haupt surmises, the sculpture may have been intended as a donation from Karl von Liechtenstein to the Capuchin's new church in Prague.

OR

FURTHER REFERENCES: Ilg 1883, p. 127; Frimmel 1884, p. 226, fig. 10; Buchwald 1899, pp. 60–61; Fleischer 1910, p. 4; Tietze-Conrat 1918, p. 43, fig. 31; Brinckmann 1923, pp. 18, 37, pl. 83; Strohmer 1947–48, pp. 98, 104, no. 14; Kauffmann 1954, pp. 34–35, fig. 11; Larsson 1967, pp. 54, 124, no. 45, fig. 110; Weihrauch 1967, p. 357; Bregenz 1967, p. 90, no. 167, fig. 78; Woeckel 1967, p. 469; von der Osten and Vey 1969, p. 326; Frankfurt 1981, pp. 15–16, 144–46, no. 86, ill.; Larsson 1982, p. 233, fig. 28; Haupt 1983, Textband, p. 45; Waźbiński 1983, p. 55.

36

Adriaen de Fries
Dutch, 1545–1626

SAINT SEBASTIAN

Prague, ca. 1613–15
Bronze with olive-brown natural patina; height 78⅛ in. (199.5 cm.)
Inscribed: ADRIANUS FRIES HAGIENSIS BATAVUS
Liechtenstein inv. no. 562

This slightly over-life-size statue shows the young martyr tied against a tree, his body still unpierced by the executioners' arrows, his head slightly bent, his face expressing great suffering and resignation. Unusual in its emphasis on the saint's spiritual anguish rather than on a literal depiction of his torture, de Fries's *Sebastian* presents the drama of its subject in a way subtly calculated to appeal to the emotions of the onlooker. The contrast between the youth's softly modeled face, with half-parted lips and gently tousled hair, and his heroic nude body, powerful in its strength yet passively exposed as a target, conveys the sense of accepted martyrdom. An unexpected lyrical note is added by the flowering branches, engraved and chased with delicate care, which climb around the tree behind the saint.

The pictorial freedom of the Liechtenstein *Saint Sebastian* and the proto-Baroque sensitivity it so eloquently proclaims suggest a dating considerably later than the *Christ in Distress* of 1607 (cat. no. 35). The expansive, almost palpitating quality of its modeling and the openness of its outline recall the works of a successive stylistic phase: a mature manner, which first appears in de Fries's group *Empire Triumphant* of 1610 (National Gallery of Art, Washington, D.C.) and which is further developed in the figures of the Fountain of Neptune (ca. 1615–17) at Fredericksborg, Denmark, and in those of the Mausoleum of Count von Schaumburg-Lippe (1619–20) at Stadthagen, West Germany.

Particularly enlightening comparisons can be drawn between the *Saint Sebastian* and those private religious commissions which de Fries was able to accept and carry out after the death of Rudolf II in 1612. In the *Martyrdom of Saint Vincent*, a relief at Breslau (now Wrocław, Poland) finished in 1614 (Waźbiński 1983, p. 43, fig. 2), a similar fluidity of carefully studied contours and the same combination of broadly pictorial surfaces and sharply graphic details suggest that the *Saint Sebastian* was executed at about the same date. Equally convincing is its resemblance, noted by Larsson (1967, p. 56) and Leithe-Jasper (Vienna 1978, p. 188), to the bronze statuette *Christ at the Column* in the Kunsthistorisches Museum, Vienna. Derived, like the Liechtenstein *Saint Sebastian*, from Giovanni Bologna's *Christ at the Column* in the Bargello, Florence (Vienna 1978, p. 187, fig. 94), the Viennese statuette shows the same tremulous modeling of Christ's heavy limbs, the same sketchiness and softness in the treatment of his face and hair, and especially the same self-contained expression of spiritual suffering.

Other similarities can also be observed between the handling of the Liechtenstein bronze and that of the *Resurrected Christ* at Stadthagen (Cahn 1966, fig. 58). In the *Christ*, as in other figures on the same funerary monument, we recognize the same impressionistic chasing that has even left traces of the original clay investment in such details as the streaked, softly massed hair: an astonishing experimentation with pictorial devices that became characteristic of de Fries's later stylistic development.

A dating of the *Saint Sebastian* to about 1613–15 seems to be confirmed by a letter written in June 1613 from Prague to Count Ernst von Schaumburg-Lippe in which the Prince of Liechtenstein is mentioned along with several other German nobles as one of de Fries's numerous patrons (Bruck 1917, p. 73). If the letter alludes to a current commission, it is likely to have been this particular statue (Larsson 1967, p. 55).

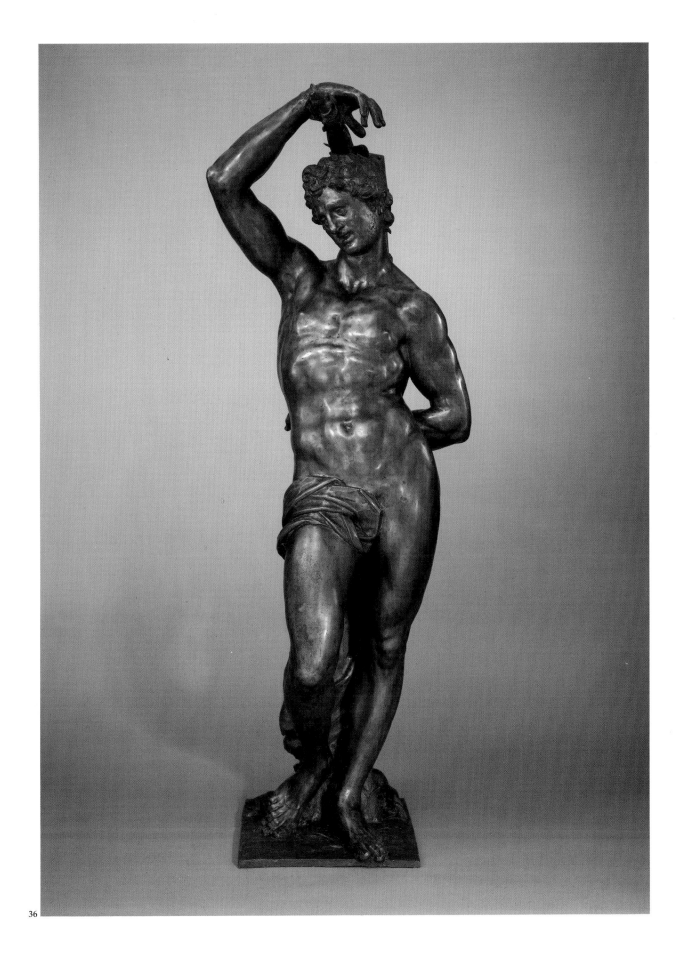

In the absence of a more precise documentation, we may surmise that so imposing a bronze may have been intended for one of the many churches and chapels in the Liechtenstein domains. A particularly good candidate would seem to be a chapel of Saint Sebastian at Eisgrub, Moravia, which Karl Eusebius describes in his *Werk von den Architektur* as being built on a hill overlooking the countryside, not far from the castle itself (Fleischer 1910, p. 185). This suggestion is especially convincing when we remember that Eisgrub was the favorite summer residence of Prince Karl and that it was precisely in 1613–14 that much work was being carried out at his order in the gardens and throughout the property (Haupt 1983, Textband, p. 42).

OR

FURTHER REFERENCES: Tietze-Conrat 1918, p. 44, fig. 33; Brinckmann 1923, pp. 18, 37, pl. 84; Strohmer 1947–48, p. 104 no. 13; Weihrauch 1967, pp. 357–58; Larsson 1967, p. 124, no. 46, fig. 112; Bregenz 1967, no. 168, fig. 79; Woeckel 1967, p. 469; Larsson 1982, p. 233; Waźbiński 1983, p. 55.

THE COLLECTION OF SCULPTURE

Karl Eusebius von Liechtenstein (1611–84) was only sixteen years old when his father, Prince Karl I, died on February 12, 1627, and he succeeded him as Reigning Prince. Although he had been given a careful humanistic education by the Jesuits, his uncles, the Princes Maximilian and Gundaker von Liechtenstein, decided that he needed a period of travel in the West. In 1629 he and his cousin Hartman, accompanied by their tutor, left for Brussels—then the most important Hapsburg city in Western Europe—where he was to study law. The trip lasted three years, and the young man visited the Netherlands, Paris, perhaps England and Spain, and most certainly Rome and Florence. In 1632 he returned home to Feldsberg (now Valtice), the family seat on the border of Lower Austria and Moravia, where Karl I had frequently resided when he could leave Prague and his duties as Governor and Viceroy of Bohemia.

In this ancestral home Karl Eusebius spent most of his life, finding refuge there during the Thirty Years' War, when his Silesian lands, the duchies of Troppau and Jägerndorf and other vast estates in the vicinity of Prague, were ravaged by civil strife, by foreign armies, and by chronic poverty and lawlessness. Although Emperor Matthias already had moved his residence from Prague to Vienna, and by 1621 only part of the famous *Kunstkammer* created by Rudolf II remained in Prague, Karl Eusebius always maintained close personal ties with the Emperors Ferdinand II (1619–37), Ferdinand III (1637–57), and Leopold I (1658–1705). He was besieged for many years by a series of lawsuits brought against him by the Bohemian Estates, which disputed his rights to the lands acquired by his father, and it was only through the eventual intervention of the Emperor that his possessions and titles were confirmed. After 1666 he could finally devote his fortune to enlarging his art collections.

The knowledge acquired by Karl Eusebius during his first trip abroad, and at least one other visit to Italy, determined the direction in which his interest in painting, sculpture, and architecture developed. During these travels he also established contacts in the artistic centers of Europe—specifically in Italy and in the Netherlands—from which, in addition to Vienna, he would obtain many of his acquisitions.

Karl Eusebius probably did not enjoy the same freedom of access to the Emperor's collections as his father had, when he borrowed scores of paintings and tapestries from the Prague *Kunstkammer* to have copies made for his own use (Fleischer 1910, p. 11; Haupt 1983, Textband, p. 60), but he too wished, at the outset, to surround himself with objects that in some way reflected the taste of Rudolf II. This is made especially clear by the collection of some thirty bronzes described in 1658 in an inventory of the Prince's "Guardaroba" in Feldsberg (Fleischer 1910, pp. 69–71). Seven of the items listed were well-known models by Giovanni Bologna or his workshop: *Hercules*

and Antaeus, two examples of the *Rape of a Sabine* (a two-figure and a three-figure group), *Nessus and Deianira*, a *Kneeling Bather*, a *Lion Attacking a Horse*, and a *Leopard Attacking a Bull* (cat. nos. 38–41). Characteristically, nearly all of these were models represented among the twenty-seven Giovanni Bologna bronzes listed in the 1607–11 inventory of Rudolf II's *Kunstkammer* (Leithe Jasper 1978, pp. 76–77).

The bronzes by Giovanni Bologna owned by Rudolf II were all cast in the sculptor's lifetime, most of them by Antonio Susini. Although Karl Eusebius could not expect to acquire such early examples, he knew that in Florence Giovanni Bologna's models continued to be cast and sold, especially to foreign clients, by Antonio Susini's nephew, Giovanni Francesco Susini (ca. 1575–1653), who had inherited his uncle's studio in 1624. It was undoubtedly in the hope of obtaining bronzes after Giovanni Bologna's models that Karl Eusebius contacted the younger Susini, to whom the casts inventoried in 1658 can be confidently attributed. In addition, Karl Eusebius bought several of Susini's own compositions—the *David with the Head of Goliath*, the *Venus Chastising Cupid*, and the *Venus Burning Cupid's Arrows* (cat. nos. 42–44), as well as a number of bronzes after such celebrated antiquities as the *Farnese Hercules* (cat. no. 45), the *Farnese Bull*, and the *Laocoön*.

Karl Eusebius's interest in bronzes was by no means limited to his acquisitions from Giovanni Francesco Susini. Even before then he must have established contact with the Fleming François Duquesnoy, who had left his native Brussels in 1618 and moved to Rome, for, as early as 1633, a silver relief by "Francisco Fiamengo," showing "three boys eating grapes, in an ebony frame with corners of lapis lazuli" was in the Princely Collections (Haupt 1983, Textband, p. 304). Duquesnoy's famous bronze statuettes of *Mercury* and *Apollo* (cat. nos. 49–50) were listed in the 1658 inventory, but in reading the inventory's descriptions, one wonders whether other bronzes, now lost, might also have been by Duquesnoy—as, for instance, "a sleeping Christ Child lying on a black ebony cross," or "two small children by a fountain, fighting with each other and holding reeds as if they wanted to hit the water." Duquesnoy is mentioned again in a later inventory of Karl Eusebius's collection of ivories, drawn up shortly after 1678: "Two reliefs, with four *putti* in each of them, by Francisco Fiamingo" (Fleischer 1910, p. 226).

Karl Eusebius also collected waxes and an important group of ivories. Many of the waxes were purchased from Daniel Neuberger, an artist from Augsburg who specialized in the modeling of colored waxes and worked for the Emperor in Vienna from 1651 to 1663. As for the ivories, Karl Eusebius had his own *Kammerbildhauer*, Adam Lenckhardt (1610–61), a gifted master from Würzburg, whom he employed from 1642 to 1660 (Theuerkauff 1965, pp. 30–31). As described in the 1678 inventory, many of the ivories—works with both religious and

mythological subjects—can be recognized as by this artist, attesting to the breadth and versatility of the Prince's interests.

Endowed by nature with unusual talents as a connoisseur and a dilettante architect, Karl Eusebius had a fundamentally classicizing and Italianate taste. Its roots lay in his humanistic studies, as well as in the general artistic climate of Bohemia, where North Italian architects and masons had introduced a vigorous late Renaissance and proto-Baroque style in the many palaces and churches they built in Prague after 1620. Feldsberg itself, an imposing Italianate structure, owed its late Renaissance design to Giovanni Battista Carlone, who had been entrusted in 1621 with the remodeling of the castle (Haupt 1983, Textband, p. 42). It was Giovanni Giacomo Tencala, working under Karl Eusebius, who designed the large church of the Assumption in Feldsberg. Work was begun in 1631 but was not completed until 1663. The building's airy architecture and rich, early Baroque stucco decoration, carried out by Bernardo Bianchi and Johann Tencala, is strongly evocative of the Lombard and Emilian churches of the Counter-Reformation and is an eloquent illustration of its patron's passion for Italian architecture.

Karl Eusebius's knowledge in this area, and the other artistic endeavors that he saw as worthy of a Prince's ambition, inspired the famous treatise on architecture that he wrote about 1675–80 for the benefit of his son and successor (Fleischer 1910, pp. 87–209). After having described in great detail his own views on the ideal palace and the ideal gardens, Karl Eusebius explained that a genuine Prince should be, above all, a true connoisseur (curiosissimus). He should collect rare and outstanding paintings, and sculptures which are "a beautiful and necessary curiosität," and fill his gallery and his gardens with them. In fact, he adds, the Prince should have two separate galleries, one for statues and one for paintings.

In writing about his ideal collection of sculptures, Karl Eusebius had antiquities especially in mind. The gallery he described belonged not to the tradition of the German Kunstkammer, but rather to that of the Italian collections that he must have had occasion to admire in Rome and in Florence. In urging his successor to collect ancient marble sculptures, Karl Eusebius added that since none were to be had in Germany—Italy being the only place where they could be found—one should avoid the perils of transportation for such heavy yet fragile objects and instead have replicas of them made in bronze. To obtain such replicas, a very good sculptor was needed who would take plaster molds and, after casting them in bronze, carefully chase them so that they became as fine as the originals themselves. For the larger statues, one could also be satisfied with plaster casts which, being white, are closer to the appearance of actual marble. Statues could also be modeled in clay and fired. These would be less fragile than the plaster casts, but they would be far less pleasing in color. Finally, Karl Eusebius added, marble statues might be commissioned as long as the stone chosen was not pure white, but closer to flesh color. For ultimately as with paintings, the beauty and perfection of sculptures lie in their resemblance to nature. This last statement demonstrates that despite his classicism Karl Eusebius already stood on the threshold of a new age. Indeed, the triumphal arrival of the Baroque, only a few years away, would totally transform the conservative and somewhat closed world in which he lived.

Karl Eusebius died in 1684, one year after Vienna had been rescued from the Turkish menace. It was the son and successor whom he had so carefully instructed in architecture and the arts, Prince Johann Adam Andreas (1657–1712) who would play a major role in the new era dawning in Austria and its neighboring lands. Educated in Vienna, Johann Adam had spent a year traveling in France, the Netherlands, and Italy and had gained practical experience in directing the construction of one of the family castles at Plumenau in Bohemia, designed by Karl Eusebius himself. Like his father, the young Prince was passionately interested in building, but he embarked upon it on a grander scale, concentrating on Vienna, where he immediately undertook the construction of two palaces, in what was the latest Roman Baroque style: a garden palace at Rossau, outside the city walls, begun in 1688; and a new city palace, close to the Hofburg, on the Bankgasse, begun in 1694. Both palaces were finished shortly after 1710, and Johann Adam devoted his considerable energies to their decoration, obtaining paintings, frescoes, and sculptures from the vast network of contacts he had established with dealers and artists throughout Europe.

His interest in sculpture reflected his desire to secure works that would harmonize with the grand design of the two Liechtenstein palaces and with the paintings he was commissioning for their galleries. He was acquainted with some of the great palaces of Italy; he knew Rome and Florence, and probably Genoa and Venice, and wanted to procure a series of marble busts by the best sculptors available. He was not much interested in their subject matter but wished them to be as close as possible to nature, as Karl Eusebius had advised. Above all, he wanted sculpture, regardless of its medium, to have the morbidezza (softness of contours) he admired in Italian paintings.

As early as 1691, the painter Marcantonio Franceschini put him in touch with the foremost Bolognese sculptor of his time, Giuseppe Maria Mazza. The Prince corresponded with Mazza from 1692 to 1702 and obtained from him six mythological marble busts (cat. nos. 11–14), two marble statues (Hercules Strangling the Serpents and the Infant Bacchus), twelve terracotta groups of mythological subjects, and three terracotta models for vases (Arfelli 1934). All the terracottas were to be copied in stone for the gardens at Rossau.

The pictorial quality of Mazza's sculptures must have particularly pleased Johann Adam, who tried in vain to lure him to Vienna. In the meantime, as more works were needed to fill the vast spaces in the new palaces, he turned to artists from other Italian cities. In Genoa he obtained marble busts from Filippo Parodi and Giacomo Antonio Ponsonelli (cat. nos. 15–17), and in 1694 he began a correspondence with Massimiliano Soldani, one of the best sculptors at the Medici court, who had been

recommended to him by the Marchese Vitelli, the Florentine envoy to the papal court.

The relationship between Soldani and the Prince echoed that between G. F. Susini and Karl Eusebius. From the start, Johann Adam had wanted Soldani to make him bronze replicas after "those beautiful things one finds in the gallery of the Grand Duke," since "bronze copies can be just as fine as the originals," as long as one is careful with the chasing of their surfaces, where great care must be taken "che le cose restino morbide e che non si guasti qualche contorno." Soldani, on the other hand, was anxious to sell the Prince some works of his own invention, such as the reliefs of *Peace and Justice*, *Time Revealing Truth*, and the *Bacchanal* (cat. nos. 52–54).

Johann Adam's relationship with Soldani, documented in a wealth of correspondence from 1694 to 1709, proved to be extremely fruitful. Never having forgotten his father's advice to have bronzes cast after antique models, rather than attempting to have ancient marbles or marble copies shipped to Vienna, Johann Adam obtained from Soldani a series of bronze heads of Roman Emperors and philosophers, cast after busts in the Medici Galleria delle Statue (cat. nos. 55–62); a series of small wax models after the most famous statues and of drawings after classical urns and vases in the Granducal collections; three full-size bronze replicas after Michelangelo's *Bacchus* (cat. no. 63); the *Medici Venus* and the Medici *Dancing Faun*; and two heads after works by Bernini (cat. no. 64). With these, the High Baroque entered Vienna in Florentine, rather than Roman, garb.

One of the most interesting aspects of Johann Adam's approach to sculpture was his deep appreciation for purely aesthetic and formal values. In writing to Mazza, for instance, the Prince insisted that the sculptor could choose any subject he wanted, or any material, as long as it showed "belli nudi e belle idee," adding that such works would find a place in his gallery because "we do not care about the material they are made of, but only about their excellence as works of art" (Arfelli 1934, p. 429). This also explains Johann Adam's interest in some of the best ivory sculptors, whom he patronized in Vienna: Matthias Rauchmiller, whose extraordinary tankard (cat. no. 67) he obtained several years after the sculptor's death, and Ignaz Elhafen, from whom he probably commissioned a series of exquisitely carved reliefs (cat. nos. 68–74).

There is no doubt that the nature of Johann Adam's patronage, and the presence in Vienna of so many late Baroque sculptures from Italy, exercised a profound influence on Viennese art. The pictorial quality and expressivity of the work of Soldani, Mazza, and Parodi shaped the direction in which Baroque sculpture developed in early eighteenth-century Vienna. It was perhaps Johann Adam's high regard for the works of Filippo Parodi that led Prince Eugene of Savoy to entrust the sculptural decoration of the Lower Belvedere to Filippo's son, Domenico Parodi. Certainly, the sandstone sculptures carved after their models by Johann Adam's "house sculptor," Giovanni Giuliani, for the gardens at Rossau, and the portals and staircases of the two Liechtenstein palaces inspired a style of decoration that would soon be adopted by many of the Baroque palaces of "Vienna gloriosa."

Olga Raggio

37

Giovanni Bologna and Antonio Susini
Giovanni Bologna: Flemish (act. in Florence), 1529–1608;
Antonio Susini: Florentine, act. ca. 1580–d. 1624

EQUESTRIAN STATUETTE OF FERDINANDO I DE' MEDICI
Florentine, cast ca. 1600, modified from a design of 1587–93
Bronze with traces of reddish-gold lacquer; height 25¼ in. (64 cm.)
Signed (on horse's girth): IOAN. BOLO. BELG.
Liechtenstein inv. no. 575

Acquired by Prince Joseph Wenzel in the mid-eighteenth century (it is one of the items marked with a star by Fanti [Cat. 1767, p. 71, no. 65; Tietze-Conrat 1918, p. 75]), this stately bronze appears to be the only Giovanni Bologna composition in the Liechtenstein collection to have been cast during the master's own lifetime, probably around 1600. It has, however, been difficult to define its precise place in a complex and interrelated group of equestrian sculptures, created both by Bologna himself and by his followers. Was the Liechtenstein statuette a model for a larger equestrian monument or was it cast for its own sake? Did the master, by then old and increasingly infirm (Watson 1983, pp. 18–26), create the entire design or did others in his workshop collaborate? These fundamental questions have preoccupied scholars for the last sixty years.

One thing is clear—the essential composition of this statuette derives from Giovanni Bologna's great equestrian statue *Grand Duke Cosimo I de' Medici*, erected in the Piazza della Signoria, Florence, in 1594 (Dhanens 1956, pp. 274–85). It was the city's

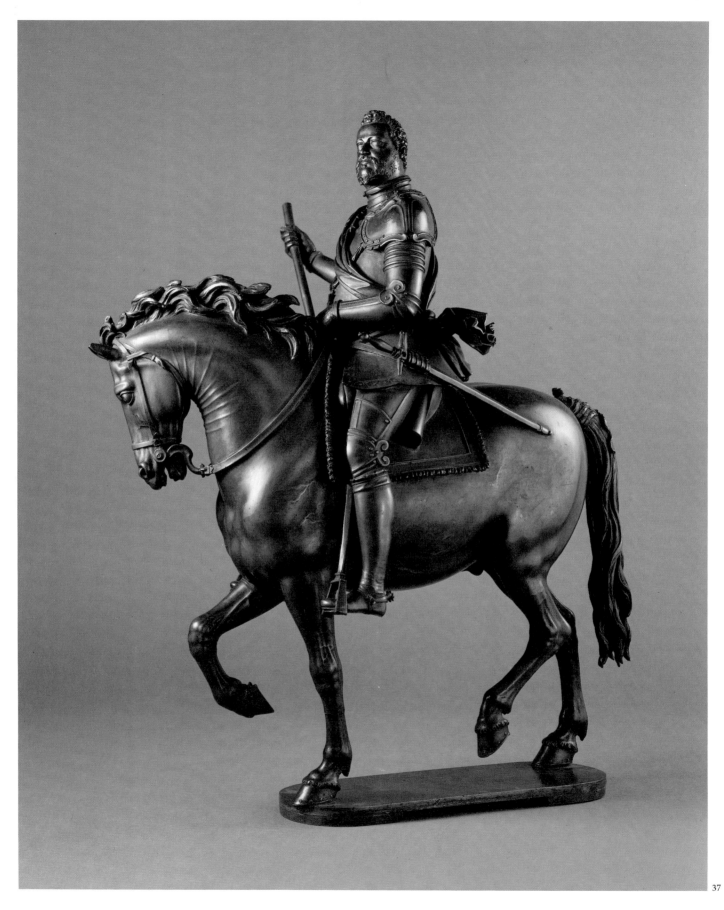

first equestrian monument and exerted a vast influence on the genre. One of its earliest progeny was the Liechtenstein statuette, which so closely resembled the Cosimo monument that Fanti misidentified it as "la statue equestre di bronzo de Cosimo Primo."

Tietze-Conrat (1918, pp. 6–8) first recognized that the statuette was actually a portrait of Cosimo's son Ferdinando (1549–1609), who had commissioned his father's monument at the time of his own accession to the Grand Dukedom in 1587. Tietze-Conrat argued further that it was a discarded model for yet another monument, the equestrian statue that Ferdinando commissioned for himself in 1601. This statue still stands in the Piazza della SS. Annunziata, Florence, where it was erected in 1608. Beyond the fact that it too bears the Cross of the Order of Saint Stephen, it does not resemble the Liechtenstein statuette at all. The Ferdinando monument is altogether new. The rider's armor, general proportions, and demeanor are all quite different from those of the smaller work; the horse is a different type in an entirely different pose. Although the Liechtenstein statuette preserves most of the essential elements of the earlier Cosimo monument, Ferdinando's own monument reverts to the Cosimo design in only one respect: Cosimo's cloak, evocative of the Roman *paludamentum*—and of the Medicis' regal aspirations—which was borrowed from the most influential equestrian statue in Italy, the ancient bronze of Marcus Aurelius, which Michelangelo had recently installed on the Capitoline Hill in Rome. It is particularly striking, then, that Ferdinando's otherwise conservative statuette has no cloak but sports instead a jaunty, waving sash. This new motif has been the crux of a learned and tortuous debate over the authorship of the statuette.

Tietze-Conrat considered the Liechtenstein statuette an autograph Giovanni Bologna: it bore the master's signature and its elegant and refined surface treatment seemed to display his personal touch. Subsequent scholars have disagreed. Most recently, Watson (1983, pp. 172–76; Edinburgh 1978, no. 150) argued that the handling of the sash showed the hand of Pietro Tacca, Giovanni Bologna's principal assistant in his declining years and successor as Grand Ducal sculptor.

Watson noted (as had Popp [1919, pp. 557–58] before her) that the sash resembles other decorative, fluttering sashes that Tacca employed in a later series of monuments and statuettes: the Henry IV (destroyed in 1792) on the Pont Neuf, Paris (Edinburgh 1978, no. 159); the Philip III monument in the Plaza Mayor, Madrid, and the Philip IV monument in the Plaza de Oriente, Madrid (Torriti 1975); and the statuettes of Louis XIII of France in the Bargello, Florence (Torriti 1975), and of Carlo Emmanuele of Savoy in the Löwenburg, Kassel (Edinburgh 1978, no. 163).

Watson (1983, p. 175) also considered the Giovanni Bologna signature less than conclusive proof of exclusive authorship. She observed that the master's signature (which graces fewer than a dozen known bronzes) was evidently not intended to distinguish bronzes personally finished by him from those of his assistants but rather may have served to impart a special luster to important state gifts. She further theorized that the increasingly infirm artist may have assigned Ferdinando's new commission to Tacca as part of his growing responsibilities. She speculated that the younger sculptor took over the basic model for the statue of Cosimo and added to it a new decorative motif that later appeared as a notable feature of Tacca's mature manner. In this account, the Grand Duke rejected this revision of the Cosimo model because it was still too close to the original. The workshop was therefore compelled to resort to a different horse model, as well as a model for the ruler that, while new, remained unambiguously infused with the *gravitas* of imperial Rome.

This case for Tacca's authorship of the statuette rests largely on conjecture and an unconvincing stylistic comparison. The objects themselves and the hard evidence adduced by Watson and others fit more easily into a scheme that assumes the collaboration of another important assistant of Giovanni Bologna, namely Antonio Susini.

Although it is reasonable to see a fluttering sash and think of Tacca, the style of the sash on the statuette appears closer to Susini's work. In particular, it resembles the faceted, zigzagging scarf which descends along the centaur's belly on the so-called B-type *Nessus and Deianira* (Edinburgh 1978, no. 66), another variant of a Giovanni Bologna model now generally attributed to Susini. By contrast, the relationship of the Liechtenstein statuette's sash to those on Tacca's later equestrian figures is far less pointed. Not only the sash but also every other salient aspect of the Liechtenstein bronze is modeled in a crisp and controlled manner that does not really resemble the soft, sinuous handling of detail on Tacca's independently executed works.

Watson's other main line of argument is based on her own extremely thorough investigation of Tacca's early activity in the Giovanni Bologna workshop. However, much of the evidence she marshals works equally well to prove that either Tacca or Susini, who left the studio around the turn of the century (and possibly as late as 1605 [Watson 1983, pp. 58–59 n. 57]), could have worked on the statuette.

References to equestrian statuettes (surely based on the Cosimo model) date to 1600, the year preceding Ferdinando's commission for his own monument in the Piazza della SS. Annunziata. In October 1600 a description of the proxy wedding of Maria de' Medici to Henry IV of France alludes to a sugar statuette of the bridegroom on a pacing horse, made by Tacca (Watson 1978, pp. 20–26). However, earlier that year, in May, there is record of a payment to Fra Domenico Portigiani, the bronze founder, for a bronze statuette of the Grand Duke himself (Bregenz 1967, pp. 26–27, no. 14). There is no indication of the artist responsible for this statuette's actual design, although it is reasonable to suppose that it was based on the Cosimo monument model.

A second reference to a bronze statuette of Ferdinando (perhaps the same that was paid for earlier) occurs in the inventory of the Portigiani foundry in 1602 (Watson 1983, pp. 174,

185). The Liechtenstein statuette is, however, more suavely finished than work we usually associate with Portigiani and, in fact, eventually received a reddish-gold patina, of which only traces remain, which we do not usually associate with casts produced by his foundry. Portigiani was evidently not responsible for the statuette's finish. He may, however, have produced the cast itself, which could have been finished in the Giovanni Bologna workshop. We do know of earlier instances where Susini refinished the casts of others (Draper 1978, pp. 155–56).

Finally, it has been suggested that the piece molds from which this statuette was formed were used even earlier for another statuette (Weihrauch 1967, pp. 224ff.): the *Rudolf II* in the Nationalmuseum, Stockholm, which has been associated with an ambiguous reference in a letter from the year 1594 (Dhanens 1956, p. 358). There is no reason to believe, however, that this letter refers to the casting of a statuette, and this bronze, an even simpler version of the Cosimo model, with nothing over the armor at all, is not mentioned in the inventory of Rudolf's collection of 1607–1611 (Bauer and Haupt 1976). In any case, whether or not it was cast from piece molds developed for another bronze, the origin of the Liechtenstein statuette can be placed with fair certainty around 1600.

The equestrian monuments undertaken in Giovanni Bologna's workshop during his lifetime were all to a certain extent collaborative efforts. Gregorio Pagani, Ludovico Cardi (called Il Cigoli), and Susini all played a part in the creation of the Cosimo monument. The Ferdinando monument, as finally executed, was at least in part Susini's design (he signed a small bronze horse of the same model [Edinburgh 1978, no. 162]). Even the later Henry IV monument appears to have been designed in part by Cigoli (Tietze-Conrat 1918, p. 7). In sum, there seems to be no compelling reason to believe that Tacca more than any other assistant would have had a hand in the Vaduz statuette. And Susini could very well still have been active in the workshop in May 1600, when the first Portigiani payment was made.

While the statuette may in fact have remained in Portigiani's foundry until 1602, its subsequent history is unclear. Holderbaum's suggestion that this is the bronze that was sent to the Duke of Lorraine in 1618 (Edinburgh 1978, no. 150) would appear to be mistaken. If the document he cites is the same as that published by Langedijk (1983, vol. 2, p. 751, dated 1624), the gift to the dowager Grand Duchess's cousin involved a statuette only ⅔ braccia (ca. 15½ in. [40 cm.]) in height and is thus clearly not to be identified with the much larger Liechtenstein model. There is no reason to believe that the statuette of 1600 remained in Florence so long after its creation.

The question remains: what was the purpose of the statuette in the first place? To join Tietze-Conrat and Watson in calling it a presentation model for the Ferdinando monument, one must be willing to support the unlikely notion that Giovanni Bologna thought such a superficial variant of the Cosimo monument would satisfy the Grand Duke's ambitions. And, although the workshop may later have cloned existing monument designs to serve distant monarchs, it is hard to imagine that such a duplication would be proposed for a major monument within Florence itself. It is just as improbable that a sketch for such a model would be cast in bronze without the Grand Duke's approval. Even for the Giovanni Bologna workshop, bronze casting was a serious and expensive undertaking, not to be embarked upon lightly or on speculation.

It makes much more sense to suppose that the statuette was cast as a piece in its own right for an important but less formal purpose than the equestrian sculpture on which it is based. Indeed, the jewel-like changes the workshop wrought on the Cosimo model turned an elaborate civic monument into an appealing smaller piece fit for more private presentation and display. And as it happens, history records an almost ideally appropriate occasion for such a gift. On April 30, 1600, the engagement of Ferdinando's niece Maria to Henry IV of France was announced. The very next month, the initial payment for the statuette was made to Portigiani.

This scenario explains the mood and the timing of the work. It also explains why a seemingly collaborative cast produced in the twilight of Giovanni Bologna's career should bear his signature: the statuette was indeed a diplomatic gift that celebrated the crowning dynastic achievement of the Medici family line.

At the time of the wedding the following October, one of the guests, the young Peter Paul Rubens, made a sketch of a bronze statuette of a horse very like this one (Müller-Hofstede 1965, p. 110 n. 81). Evidently he had visited Giovanni Bologna's studio. Not long afterward, Rubens worked the sketch into his 1603 equestrian portrait of the Duke of Lerma. Eventually the fame of Rubens's painted equestrian portraits came to rival that of Giovanni Bologna's and Tacca's monuments. Indeed, they were held up to Tacca as models when, late in his career, he was commissioned to supply a monument for Philip IV (erected in Madrid in 1638; Torriti 1975, pp. 46–52). This full-scale equestrian monument, the first ever to show a figure on a rearing horse, was the major achievement of Tacca's career and opened a new chapter in the history of monuments. And, like every previous equestrian figure Tacca designed, it incorporated the sash motif which we believe was originally composed by Antonio Susini for the appealing statuette in the Liechtenstein collection.

JH

FURTHER REFERENCES: Cat. 1780, p. 256, no. 4; Tietze-Conrat 1918, pp. 74–75, 87; Planiscig 1930, p. 47, pl. 107, fig. 354; Lucerne 1948, no. 243; Dhanens 1956, pp. 197ff.; Vienna 1978, no. 150; Langedijk 1983, vol. 2, p. 749, no. 75.

After a composition by Giovanni Bologna
Flemish (act. in Florence), 1529–1608

Probably cast by Giovanni Francesco Susini
Florentine, ca. 1575–1653

KNEELING BATHER
Florence, second quarter of 17th century
Bronze with golden-brown lacquer patina; height 10 3/16 in. (25.9 cm.)
Liechtenstein inv. no. 569

More than any artist before him, Giovanni Bologna ensured the fame of his sculptural ideas by means of their proliferation in the form of small bronzes. This model vies with his *Mercury* as one of his most replicated compositions. It was apparently preceded by a smaller figure modeled as early as the 1550s, variously known as Susanna or Venus, in which the subject looks up as if surprised, her right hand also raised. The early model is best represented in a bronze in the Bargello, Florence, and reflects Giovanni Bologna's interest in the *Venus Anadyomene* of Doidalses, known in the sixteenth century in fragmentary examples in Rome, in Palazzo Madama and in the collection of Cardinal Cesi. Subsequently, he developed the composition in the form preserved in the Liechtenstein bronze. Limbs bent at elbow, wrist, knee, and ankle keep the viewer's eye traveling admiringly round and round the nude figure, a fine realization of the master's outstanding contribution to the history of sculpture, known as the *figura serpentinata*. His uncanny adjustment of spiraling forms for purely aesthetic reasons was never equaled by another figural sculptor. This involvement with formal dynamics came to overwhelm Giovanni Bologna's concern for subject matter. His iconographic nonchalance is well attested in a letter to Ottavio Farnese regarding his two-figure *Rape* group, which, he said, "may be interpreted as the Rape of Helen, or perhaps as that of Proserpina, or of one of the Sabine Women" (Vienna 1978, no. 56). Contemporaries seem to have respected this attitude; the earliest mention of the present model, in the 1584 inventory of Cardinal Ferdinando de' Medici, describes rather than identifies "a woman who is with one knee on the ground, one hand at her head and the other at her left breast, with a cloth at her feet" (Keutner 1978, no. 19). The 1658 Liechtenstein inventory (Fleischer 1910, p. 70) also emphasizes figure over subject: "a small image of a woman, who kneels and washes herself." Only later was the model occasionally known as a "Crouching Venus."

The Bargello possesses a brilliant example of this model —perhaps the one in the 1584 Medici inventory just cited —which is signed I.B.F. on an arm bracelet. A cast in the Huntington Collection (San Marino, Calif.), though unsigned, equals it in quality. Several of the type, including one at the University of Bath and two in the Metropolitan Museum

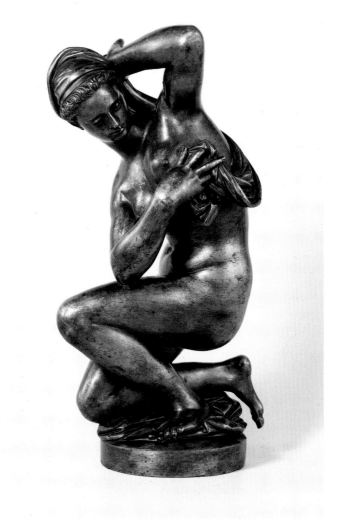

38

(24.212.15, 68.141.25), have the tightly knit appearance of casts from the workshop of Antonio Susini. The Liechtenstein bronze, a little less focused, perhaps more generalized for the sake of fluidity, was no doubt produced, as Tietze-Conrat (1918, pp. 35, 90) believed, by Antonio's nephew Giovanni Francesco Susini. Filippo Baldinucci (1772 ed., vol. 12, p. 206) lists "the woman washing herself" among Giovanni Bologna's inventions copied by Giovanni Francesco. This cast has the same golden-brown patina as the signed *David* (cat. no. 42) and similarly heavy-lidded eyes. In spite of its subject matter, or lack thereof, it may even have been intended as a pendant to the *David*. In the Baroque systematization of the Vienna gallery, as outlined by Fanti's guide, the two definitely seem to have been used as a pair.

JDD

FURTHER REFERENCES: Cat. 1767, p. 85, no. 104; Planiscig 1930, fig. 367; Lucerne 1948, no. 222; Landais 1958, p. 70 (as Antonio Susini); Bregenz 1967, no. 16; Leithe-Jasper 1978, no. 19a (as Antonio Susini).

After a composition by Giovanni Bologna
Flemish (act. in Florence), 1529–1608

Cast by Giovanni Francesco Susini
Florentine, ca. 1575–1653

HERCULES AND ANTAEUS
Florence, second quarter of 17th century
Bronze with golden-brown lacquer patina; height 15¹³⁄₁₆ in. (40.2 cm.)
Liechtenstein inv. no. 559

The bronze was catalogued in the 1658 Liechtenstein inventory as "a man who holds another man high by the chest and squeezes him to death" (Fleischer 1910, p. 70). That assessment is correct, if limited. In mythological accounts, Hercules was obliged to lift the giant Antaeus completely into the air, because each time Antaeus's feet touched ground, his mother, Terra, gave him fresh strength to continue the fight.

The earliest notice of the composition dates to 1578, when Giorgio d'Antonio cast Giovanni Bologna's model in silver, one of six silver groups with Labors of Hercules made for the Tribuna of the Uffizi according to Giovanni Bologna's designs. The bronze in the Kunsthistorisches Museum, Vienna, which figures in the Prague inventory of Rudolph II (1607–1611), is considered with justice generally to be the best surviving cast. It was probably executed by Antonio Susini.

Giovanni Bologna mixed several ingredients in the composition. Hercules has the stance, in reverse, of the ancient marble *Hercules and Antaeus* in Palazzo Pitti, which came to Florence from Rome around 1560. For Antaeus's flailing shape, Giovanni Bologna reached back to prototypes by the Florentine sculptors Antonio del Pollaiuolo and Bartolommeo Ammanati.

A softening of the model's tension and details is evident in the Liechtenstein bronze and one of comparable quality, though with a dark-brown patina, in the Wallace Collection, London, which stems from the royal French collections; Louis XIV, in fact, owned three examples of this subject.

Tietze-Conrat (1918, pp. 35–36, 87) and Leithe-Jasper (1978, no. 87a) both thought the Liechtenstein cast to be by Giovanni Francesco Susini, Antonio Susini's nephew. They are borne out by the delicate golden-brown lacquer patina, which it shares with the signed *David* and the *Kneeling Bather* (cat. nos. 42, 38). The sleek tooling is very comparable in both. The suspicion grows that Giovanni Francesco was the chief supplier to the House of Liechtenstein of Giovanni Bologna's models, as well as those of his own invention, providing bronzes with patinations in two basic ranges: this golden-brown tone and darker brown surfaces as in his Venus and Cupid groups and the fighting animals (cat. nos. 43–44, 40–41). It is not clear when he made the various Giovanni Bologna copies. Baldinucci (1772 ed., vol. 12, p. 206) implies, by his ordering of events, that Giovanni

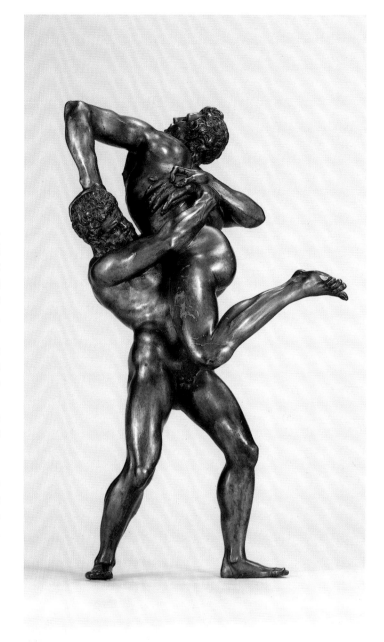

39

Francesco was already producing bronzes after Giovanni Bologna before his trip to Rome, dated here in the 1620s (see cat. no. 42). Baldinucci cites four unspecified Labors of Hercules among these replicas.

Chances are good that he made replicas after Giovanni Bologna both before and after the Roman visit. The easy confidence of handling in this *Hercules and Antaeus* might support a date after the Roman visit, when Susini can be expected to have further streamlined the workshop's output. JDD

FURTHER REFERENCES: Cat. 1767, p. 70, no. 57; Bregenz 1967, no. 154.

40–41

After compositions by Giovanni Bologna
Flemish (act. in Florence), 1529–1608

Cast by Giovanni Francesco Susini
Florentine, ca. 1575–1653

LION ATTACKING A HORSE
Florence, ca. 1630–40
Bronze with warm brown lacquer patina; height 9⁷⁄₁₆ in. (24 cm.)
Liechtenstein inv. no. 547

Modeled and cast by Giovanni Francesco Susini
Florentine, ca. 1575–1653

LEOPARD ATTACKING A BULL
Florence, ca. 1630–40
Bronze with warm brown lacquer patina; height 7ⁱ⁄₁₆ in. (17.9 cm.)
Liechtenstein inv. no. 544

Paired groups of horse and bull being savaged by felines are assigned by early authors to Giovanni Bologna (Markus Zeh, 1611; Filippo Baldinucci, 1688). Casts of a *Lion Attacking a Horse* in the Detroit Institute of Arts and a *Lion Attacking a Bull* in the Louvre are signed by Antonio Susini, as are a pair from Palazzo Corsini, now in the Museo di Palazzo Venezia, Rome. The Liechtenstein *Lion Attacking a Horse* is quite close to those in Detroit and Rome. In his original model Giovanni Bologna "completed" the composition of an ancient fragmentary marble now in the garden of the Palazzo dei Conservatori, Rome. The

marble, whose appearance before it was restored in 1594 is recorded in an engraving (Cavalieri [before 1584], vol. 2, pl. 79), lacked the horse's head and legs when Giovanni Bologna visited Rome in the 1550s. His Mannerist approach led him to energize the composition by having the horse's neck rear violently back toward the lion and to set up a sinuous flow of waning movement in the horse's collapsing legs.

The Liechtenstein *Leopard Attacking a Bull* is unique, altogether different from the Louvre and Museo di Palazzo Venezia lions attacking bulls. Here the predator is not a lion but a leopard, as shown by the animal's spots, lightly and scrupulously worked with a dot punch. The composition itself is also entirely new. In the Antonio Susini casts after Giovanni Bologna, the lion lunges straight onto the bull's back, biting into it, and the bull's neck thrashes back in a direction complementary to that of the horse in the companion groups. Sculptures of struggling lions and bulls existed in antiquity, but it is less likely that Giovanni Bologna was imitating one of these than that he was simply fashioning a mate to the lion and horse group. In the Liechtenstein group, the leopard attacks stealthily from the side, biting into the bull's shoulders, while the bull's head has less sideward movement and his haunches sag closer to the ground than in Giovanni Bologna's composition. This makes the Liechtenstein composition slightly less tense and dramatic from the front view. It is best seen from the right side, as pointed out by Leithe-Jasper (1978, no. 173c).

The *Leopard Attacking a Bull* may originally have been modeled as a pendant to a variant of the lion and horse composition, as represented by a bronze in the Kunsthistorisches Museum, Vienna (Leithe-Jasper 1978, no. 173a, as Antonio Susini after Giovanni Bologna), which adheres closely to the ancient proto-

40

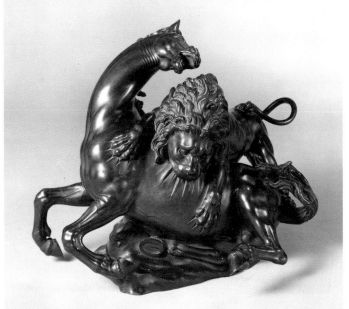

41

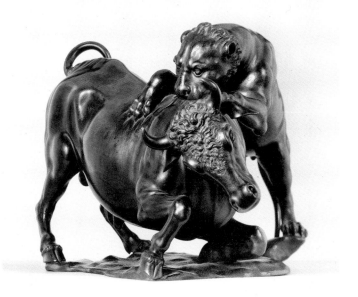

type after its restoration, in which the horse sinks down more passively, head lowered. The Vienna bronze is not comparable in execution, but it is easy to visualize the two versions being planned together as decorations, with the lion and horse being placed to the left and the leopard and bull to the right. Although they are identically cast, the actual pairing of the Liechtenstein bronzes is less ideal—but then there is more than one way to view these complex compositions, full as they are of spirals and energy.

Filippo Baldinucci (1772 ed., vol. 12, p. 203) lists the "Horse slain by the Lion, the Bull killed by the Tiger" among Giovanni Bologna models cast by Giovanni Francesco Susini. Tietze-Conrat (1918, pp. 84–86) and Leithe-Jasper (1978, nos. 172a, 173c) both attribute the present casts to Giovanni Francesco. This seems a certainty. The millwork on the bases of the Liechtenstein pair is the same as that on the signed Venus and Cupid groups (cat. nos. 43–44). The undersides of the heavyish animal groups show a casting technique identical to that of the *Hermaphrodite* in the Metropolitan Museum (1977.339), signed and dated 1639. Giovanni Francesco would have known the ancient marble lion and horse group after its restoration, which is reversed, in a sense, in the *Leopard Attacking a Bull*. The latter can also be interpreted as Giovanni Francesco's experimentation with a Baroque loosening of forms, opening up the Mannerist model of Giovanni Bologna.

<div style="text-align:right">JDD</div>

FURTHER REFERENCES: Cat. 1767, p. 68, nos. 43–44; Fleischer 1910, p. 70; Bregenz 1967, no. 157.

42

Giovanni Francesco Susini
Florentine, ca. 1575–1653

DAVID WITH THE HEAD OF GOLIATH
Florence, ca. 1625–30
Bronze with golden-brown lacquer patina; height 11¹³⁄₁₆ in. (30 cm.)
Signed in punched characters (left edge and rear of sgabello*):* FRAN. SVSINI F.
Liechtenstein inv. no. 565

Preliminary studies for this work exist in the form of a drawing and a clay model. In the history of bronze statuettes, the survival of such studies is extraordinary, and in this case they attest to the care with which Susini approached his composition. The rapid red-chalk sketch is in a manuscript discovered by Lombardi (1979, pp. 763–64) in the Biblioteca Nazionale, Florence. Half-treatise, half-sketchbook, the booklet is signed by Susini and dated June 1618. The drawing, itself unmemorable, has David clothed and kneeling in a conventional pose worthy of a painter such as Matteo Rosselli. The same manuscript contains several ink notations of sword hilts similar to but not identical with that of the bronze statuette. By coincidence, Susini's model of unfired clay also belongs to the Biblioteca Nazionale. Elastically shaped with tremulous surfaces, it is immeasurably more exciting than the drawing. Numerous differences between it and the finished bronze include the raised hand, which gripped the (missing) sword less passively, and an oblong base. Where Goliath's head overlaps the base, the model already indicates the severed arteries, in turn more studiously detailed in the bronze. The sword in the bronze is huge in relation to the figure, making the point that it belonged not to David but to the slain Philistine.

This is the only known bronze cast of the composition. With its strongly marked diagonals creating concentrations of light and shadow, it must be accounted one of Susini's finest independent performances. With its air of stark isolation, it can also be seen as a rare reflection of Caravaggio's influence on Florentine sculpture. Classical influence is present in the legs, positioned similarly to those of the *Ludovisi Mars* in the Museo delle Terme, Rome, an ancient marble acquired by the Ludovisi family in 1622. Susini's signed bronze reduction of the *Mars* is in the Ashmolean Museum, Oxford, and shows the ancient statue as it appeared before it was restored in 1622 by Bernini. But a connection perhaps should not be forced between the sketchbook's date of 1618 and the date of the *David* statuette. The final composition could well have evolved slowly, after Susini's period in Rome and his exposure to the *Mars*. The time and length of his Roman visit, mentioned by Filippo Baldinucci (1772 ed., vol. 12, p. 204), are unknown, but real progress must have resulted from the trip. Susini's earliest dated work (1592), an *Irene and Pluto* in a private collection (Vienna 1978, no. 188), inspired vaguely by the antique, showed little promise and none of the refinement of bronzes by his uncle Antonio. Giovanni Francesco was enrolled in the Accademia del Disegno only in 1617. Antonio died in 1624, and Giovanni Francesco took over his studio in the via de' Pilastri some time thereafter. His name appears to be absent from Florentine records during the 1620s. In any case, Baldinucci states that in Rome he copied the *Dying Gladiator*, the *Mars*, and the *Hermaphrodite* as well as other antiquities. Some if not most of these copies would have been cast only after his return to Florence—the *Hermaphrodite* in the Metropolitan Museum (1977.339) is signed and dated 1639.

Susini's *David* was known in Rome. An ivory replica made later in the century for Cardinal Leopoldo de' Medici and attributable to Balthasar Stockamer in his Roman period (Aschengreen-Piacenti 1963, pp. 100–101, 105, no. 9) is in the Museo degli Argenti, Palazzo Pitti, Florence.

<div style="text-align:right">JDD</div>

FURTHER REFERENCES: G. F. Susini, ms. dated 1618, XVII.4, fols. 43, 68–72; Cat. 1767, p. 85, no. 103; Fleischer 1910, p. 70; Tietze-Conrat 1918, pp. 9–10, 90; Lucerne 1948, no. 224; Bregenz 1967, no. 151; Avery and Leithe-Jasper 1978, nos. 249–50.

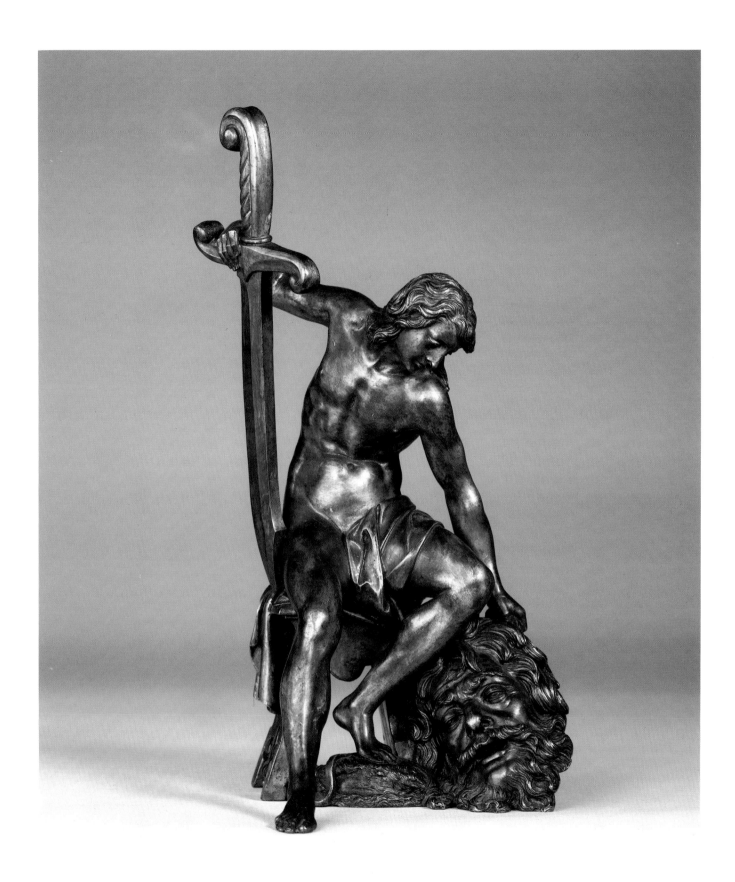

Giovanni Francesco Susini

Florentine, ca. 1575–1653

VENUS CHASTISING CUPID

Signed (on back of tree trunk): 10. FR. SVSINI. FLOR. FAC./MDCXXXVIII

VENUS BURNING CUPID'S ARROWS

Signed (on quiver): 10. FR. SVSINI. FLOR. F./MDCXXXVIII

Florence, 1638
Bronze with warm brown lacquer patina; height 22⅞ in. (58.2 cm.)
and 21⅞ in. (55.5 cm.)
Liechtenstein inv. nos. 542a, b

Susini's thoroughgoing absorption of Baroque compositional tenets is most evident in his *Rape of Helen*, a bronze three-figure group signed and dated 1626, in the Dresden Skulpturensammlung. It combines the spiraling effects obtained by Giovanni Bologna in his famous *Rape of the Sabines* with an analytic classicism derived from Susini's study of ancient sculpture and a new dramatic urgency learned from Bernini's *Rape of Proserpina* (1621–22) in the Galleria Borghese, Rome. Later, as in the present groups, the Roman influence was submerged in the gracile manner that was standard among the followers of Giovanni Bologna. Thus the open pose of the goddess in *Venus Chastising Cupid* derives from Giovanni Bologna's popular model of *Fortuna*, though there is a hint of Roman Baroque fervor in her activation and in the varying of textures. And the closed pose of Venus in the companion group, *Venus Burning Cupid's Arrows*,

43

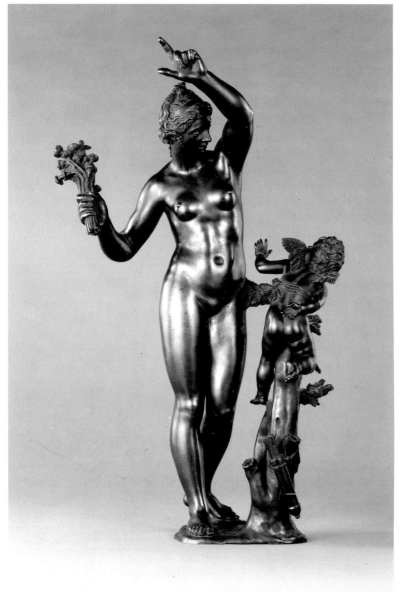

44

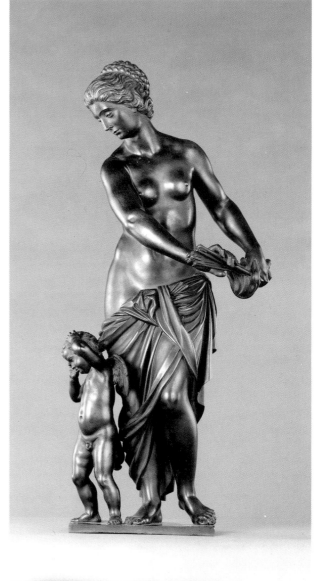

may well reflect the classicizing canon of Roman Baroque models such as François Duquesnoy's *Portia* and *Santa Susanna*.

Although the themes of the disarmament and the punishment of Cupid complement each other, the two groups were not necessarily modeled concurrently. Of the two, Filippo Baldinucci (1772 ed., vol. 12, p. 206) mentions only *Venus Burning Cupid's Arrows*, a cast of which "was sent to Lucca." A full-scale marble, belonging to Sir Harold Acton at La Pietra (Florence), is signed and dated 1637. Even so, the *Venus Chastising Cupid*, with its more impulsive overtones of Giovanni Bologna and Rome, was probably modeled some years earlier than the relatively self-contained *Venus Burning Cupid's Arrows*, which would have been conceived only somewhat later as a pendant.

Maclagan (1920, p. 240) pointed out that the subject of *Venus Chastising Cupid* goes back to a fourth-century eclogue by Ausonius, *In qua Cupido cruciatur*, in which poor Cupid is bound to a myrtle tree, as in the bronze, before being scourged. More immediately, Maclagan observed, Susini could have turned to a poem then widely read, the *Adone* of Giambattista Marino (Paris, 1623), which has Venus wielding rose branches. Neither Ausonius nor Marino appears to have described the burning of the arrows among Cupid's misfortunes. Pictorial tradition more commonly assigned the latter act to Minerva, a vestal, or a nymph.

The statuettes recur as a pair in the Louvre, bearing the dates of 1638 (*Venus Chastising Cupid*) and 1639 (*Venus Burning Cupid's Arrows*). They were bequeathed to Louis XIV by André Lenôtre in 1693. The Liechtenstein *Venus Chastising Cupid*'s naturalistic base probably once fitted into a rectangular plinth to agree with the support of its mate, as in the bases of the Louvre pair. Several collections own later casts of *Venus Chastising Cupid* in which the goddess is modestly provided with a bit of foliage at midsection (for example, Metropolitan Museum, 26.260.90). One, in the sale of Prince Nicholas of Rumania (Galerie Stuker, Bern, May 21–30, 1964, no. 3402), was said to be signed and dated 1583, but the inscription was either misread or forged. Another of the type was again paired with *Venus Burning Cupid's Arrows* in a New York sale (Parke Bernet, November 3, 1971, no. 81), both standing on hillocks as in other late casts of the *Chastising* group.

JDD

FURTHER REFERENCES: Cat. 1767, p. 68, nos. 41–42; Fleischer 1910, p. 70; Tietze-Conrat 1918, pp. 9–16, 74–75, 84; Lucerne 1948, nos. 232–33; Landais 1949, no. 3, pp. 60–63; Bregenz 1967, nos. 152–53; Leithe-Jasper 1978, nos. 190a, 191a; Lombardi 1979, pp. 764–65.

45

Giovanni Francesco Susini
Florentine, ca. 1575–1653

FARNESE HERCULES
Florence, second quarter of 17th century
Bronze with reddish-golden lacquer patina; height 16½ in. (41.9 cm.)
Liechtenstein inv. no. 556

The colossal Hercules of marble, signed by Glycon, now in the Museo Nazionale in Naples, was one of the most admired of all antiquities during the Renaissance. By 1556 it was in Palazzo Farnese in Rome. Filippo Baldinucci (1772 ed., vol. 12, p. 193) relates that Antonio Susini, during a visit to Rome as the protégé

45

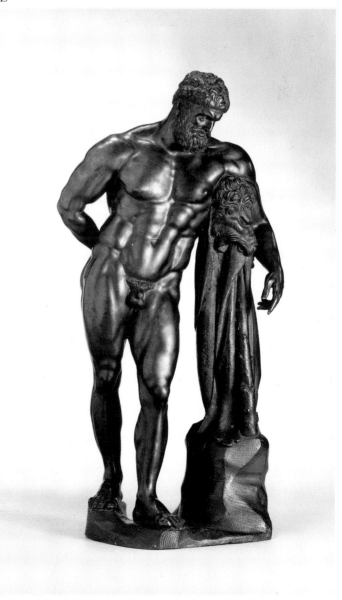

of Giovanni Bologna, produced five highly successful casts of the *Farnese Hercules*, one for Cardinal Scipione Borghese, one for Jacopo Salviati, and three that were to France. A private collector in Washington, D.C., owns what may be one of the Antonio Susini casts, paired with a *Mars* after Giovanni Bologna, both from the Corsini collections in Florence and both elegantly and closely chased, bearing fiery red-gold lacquer patinations. There are numerous differences between the Washington and Liechtenstein bronzes, the latter being generally more massive and slightly more generalized in its details, in character with bronzes by Giovanni Francesco. The dot punch used on the tree trunk of the Liechtenstein bronze matches that of the fighting animal groups (cat. nos. 40–41). There are good signs, here as elsewhere, that Giovanni Francesco rethought models used by his uncle Antonio. For example, there are casts of the multi-figured group known as the *Farnese Bull* signed by Antonio Susini and dated 1613 in the Galleria Borghese, Rome, and in the Hermitage, Leningrad. Yet the *Farnese Bull* was also one of the antiquities replicated by Giovanni Francesco, according to Baldinucci (1772 ed., vol. 12, p. 204). The Liechtenstein example of the *Farnese Bull* (Tietze-Conrat 1918, pp. 19–20, 95–96) is probably another cast by Giovanni Francesco.

It is just possible that the *Farnese Hercules*, comparable in height to the *Hercules and Antaeus* after Giovanni Bologna (cat. no. 39), was furnished as a pendant to it—even though their patinas are different and there is no indication of such a pairing in the early inventories. In fact, by the eighteenth century Fanti's guide (Cat. 1767, p. 86, no. 109) shows that the *Farnese Hercules* was paired with a bronze *Meleager*.

<div style="text-align:right">JDD</div>

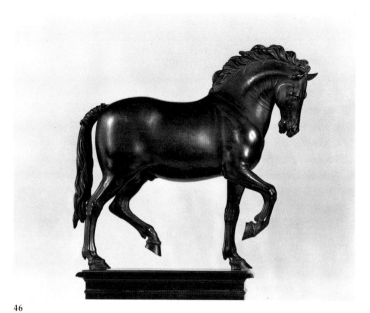

46

FURTHER REFERENCES: Fleischer 1910, p. 70; Tietze-Conrat 1918, p. 92 (as Antonio Susini); Lucerne 1948, no. 231; Bregenz 1967, no. 148 (as Antonio Susini).

46–47

After compositions by Giovanni Bologna
Flemish (act. in Florence), 1529–1608

Probably cast in the workshop of Giovanni Francesco Susini
Florentine, ca. 1575–1653

HORSE and BULL
Florence, mid-17th century
Bronze with red-brown lacquer patina; height 9¾6 in. (23.7 cm.) and 9¼ in. (23.5 cm.)
Liechtenstein inv. nos. 550, 553

These bronzes do not appear in the 1658 Liechtenstein inventory. They were acquired later, in 1696, as demonstrated by letters from the Antwerp dealer Marcus Forchoudt to his brother and

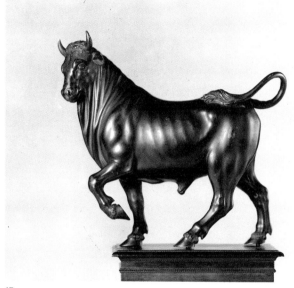

47

sister, stating that he was offering a "little horse" and a "little bull" by Giovanni Bologna to Prince Johann Adam Andreas for 90 rix-dollars in that year (Denucé 1931, vol. 1, p. 242). They may have been the same as bronzes listed in the Antwerp collection of Jan van Meurs in 1652 (Denucé 1932, vol. 2, p. 135).

The *Horse* is one of many statuettes produced in the wake of Giovanni Bologna's models for the equestrian monument to Cosimo I de' Medici in the Piazza della Signoria, Florence, which was finished in 1593. The *Bull* ensued somewhat later, clearly as a salable pendant. An early mention of a bull by the hand of Giovanni Bologna is a wax bull, conceivably a preliminary model, in the inventory of Benedetto Gondi in 1609. An animal heavier in its proportions in the Bargello, Florence, may reflect Giovanni Bologna's first thoughts. His followers streamlined the composi-

tion considerably, as in the Liechtenstein *Bull* and others. A horse and a bull, cast by Antonio Susini and seemingly intended as a pair, were among statuettes sent as a diplomatic gift to Henry, Prince of Wales, in 1612. Bulls of the Liechtenstein type are said by Avery (1978, nos. 177–78) to have been modeled after the antique. Ancient bovine sculptures survive in some quantity, but none seems likelier than another to have inspired the model directly (see Reinach 1909, vol. 2, pls. 730–36; Reinach's pls. 735.4 and 736.2 are obviously not antique but images derived from Giovanni Bologna). On the contrary, the *Bull* was occasioned by the success of Giovanni Bologna's *Horse*, responding rhythm for rhythm, a weightier but no less graceful counterpart.

The *Horse* has nicely articulated veins and a well-chased tail (separately attached, as in many examples), matched by the chasing of the *Bull*'s poll and eyes. Tietze-Conrat (1918, p. 82) suggested very plausibly that the *Bull* was cast in the workshop of Giovanni Francesco Susini; the same attribution should be extended to the *Horse*. JDD

FURTHER REFERENCES: Cat. 1767, p. 67, nos. 31–32; Tietze-Conrat 1918, p. 80.

48

SAINT SEBASTIAN
Probably Italian (Florentine), early 17th century
Bronze; height 21⅜ in. (54.4 cm.)
Liechtenstein inv. no. 557

The Liechtenstein *Sebastian*, one of the twenty-eight items listed in the 1658 inventory of "Statue von Metall" (Fleischer 1910, pp. 69–71; Tietze-Conrat 1918, pp. 74, 79), is the earliest documented example of this exceedingly popular composition. Its extraordinary appeal as an icon of the Counter-Reformation is underscored by the number of other examples which still exist and is surely due in part to its pose. In its limp pathos the composition eloquently evokes the suffering of Christ as expressed in contemporary versions of the Descent from the Cross or, for example, in Michelangelo's late Pietàs. This allusion to the Passion, however, is subverted by Sebastian's strongly characterized and modern face which, with its high-bridged nose projecting strongly between shallowly modeled eyes that squint with pain, departs decisively from the idealized image of Christ himself or of a martyr saint.

While it may not bear quite the resemblance to a "Marsyas" that Planiscig (1919, vol. 1, pp. 50, 52) had sensed in the example in the Este collection, still the Liechtenstein *Sebastian* does differ from the conventional iconography of the saint with re-

spect to his body as well as his face. It does not follow either the early mode of representing Sebastian's martyrdom, miraculously upright although shot through with arrows, nor does it resemble the bloody Counter-Reformation type (Kraehling 1938; Réau 1959, pp. 1190–99; Ascione 1973). Although he is collapsing, the suffering of this arrowless *Sebastian* is uncontaminated by gore, dramatically abstract. While related versions of this model show the saint's body with schematized arrow wounds and a loincloth, here it is ambiguously unmarked and unclothed.

48

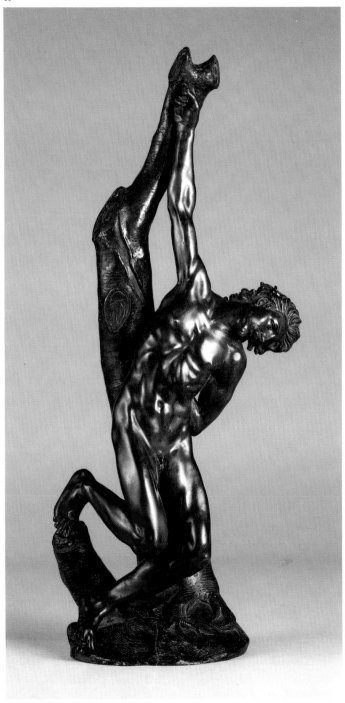

In this unwounded state Sebastian seems to anticipate his future suffering, his vulnerability heightened by his nakedness.

But one wonders if the Liechtenstein figure was in fact originally meant to be shown nude. Of the known examples, only two others are unclad: the example in Modena, documented in the Este collection in 1684 (Inventario 1880, vol. 3, p. 27), a weak version of the Liechtenstein model, and the powerful, uniquely rough, and model-like example in the Victoria and Albert Museum, London (Frankfurt 1982, pp. 262–63). All others, including the bronze in the Louvre (Paris 1904, no. 133) originally acquired by Louis XV (*Inventaire des diamans de la couronne* 1791, no. 208), feature a loincloth cast with the figure itself. Most tellingly, the plaster cast of the figure identifiable in the painting of a sculptor's studio dating from the early seventeenth century (Middeldorf 1978, fig. 9), a very early and apparently prototypical version, is depicted with the perizonium. It is conceivable that the elegant Liechtenstein version was originally clad in a separately formed (perhaps silver) loincloth, as was occasionally the case with small devotional sculptures. Certainly it may also once have had silver ropes attaching the body to the tree trunk. The 1658 inventory description, "an einem Baum S. Sebastian Angebunden" (Fleischer 1910, p. 70), appears to imply some form of attachment other than the highly visible bolt (perhaps later, certainly unique to this version) that rivets Sebastian's right foot to the stump; moreover all other examples are shown with ligatures of some kind.

The numerous examples of the bronze also vary enormously in the handling of surfaces: chasing of hair, facial features, and even tree and ground. The eloquently refined Liechtenstein bronze, with its delicately chased and stippled details, is one of the most beautiful. In a number of casts the torso of the saint is gilt (or silvered); in some the tree has been given an opaque black patina. All these variations in handling imply that more than a single workshop was involved in producing the bronzes, a factor which compounds the very real attributional difficulties posed by stylistic ambiguities inherent in the basic composition. Indeed, seldom have variants of a single model been so variously catalogued as have the examples of this bronze. What may have been another very early example, described "St. Sebastien, attaché à un arbre. 1½ pieds de hauteur," was in a German collection formed before 1616 by the astute and discriminating Nürnberg collector Paul Praun (Murr 1797, p. 232, no. 7). Praun had attributed it to Giovanni Bologna together with a number of other bronzes by the same sculptor. While no modern scholar concurs with such an attribution of the present bronze, some observers in this century have tended to view it as the work of one of Giovanni Bologna's followers (Planiscig 1919). Suggestions have included Pietro Tacca (Metropolitan Museum in-house catalogue) and Gianfrancesco Susini (Woeckel 1964, p. 33, and 1967, p. 469).

Others, however, have been uncomfortable with a straightforward Italian attribution for any of the examples. The conjunction, common to all of them, of sleek flickering torso, pointed ogival ribcage and loins, and the broken outline of loosely knit but awkwardly constricted muscular limbs with blunt and fleshy extremities has inclined some scholars to posit a Northern strain in the composition. A broad range of permutations has developed from this latter school of thought; attributions include: a Flemish associate of Ferdinando Tacca (Weihrauch 1967, pp. 234, 507 n. 272); a Netherlandish-Italian artist close to François Duquesnoy (Tietze-Conrat 1918, p. 79); German-Netherlandish, about 1650 (Bregenz 1967, 1st ed., no. 25); Italian-Netherlandish, 1620–50 (Bregenz 1967, 2d ed., no. 57a). Duquesnoy himself has been proposed (Schlegel 1974, p. 134 n. 12), as has Georg Petel (Middeldorf 1978, pp. 49–64); the only completely misconceived attribution is to the Italian-born Giovanni Giuliani (1663–1744) (Amsterdam 1973, p. 404), whose terracotta version of the composition is in the Heiligenkreuz Monastery, Austria. (Since the present statuette is documented in the Liechtenstein collection in 1658, Giuliani, who worked for Prince Johann Adam, must have copied the bronze, not invented it.)

Some observers have wondered whether the composition was originally meant to be cast in bronze at all. One of its more curious aspects is that, despite its complex frontal outline, when viewed in profile the figure is seen to be compressed in a single shallow plane. Its flatness suggests that another more confining medium, such as ivory or boxwood, may have been involved in its conception. This alternative is implied by Middeldorf's attribution to the Augsburg carver Georg Petel (1601/1602–1634). Middeldorf suggested that the original model for the bronze was a product of the youthful Petel's travels in Italy and dated it to his stay in Genoa, about 1622. He saw precedents in paintings by the Genoese G. B. Paggi and G. C. Procaccini and found additional support for his theory in another painting, now in the Statens Museum for Kunst, Copenhagen, showing two men (hypothesized as Petel and Duquesnoy) with sculptural models. However, while one of the models clearly represents this composition (with loincloth), the others seem to derive from too many different sources for this identification to be convincing. In addition to a plaster cast of this *Saint Sebastian*, the models include Alessandro Vittoria's earlier version of the theme; the bust of a child (conceivably of the Duquesnoy type); and a rather fragmentary female torso. The last, held by the putative Duquesnoy, appears to represent an antique figure of Venus or perhaps one of Giovanni Bologna's numerous variations on that theme (for example, *Astronomy* or the *Standing Venus Drying Herself*), a composition about as far as could be imagined from Duquesnoy's own style.

Yet another painting, long known to be related to the bronze composition, may prove to be more enlightening. Usually cited as examples of the bronze's *Nachleben* are two versions of a picture showing the martyred saint in a pose identical to that of the statuette. Both are oil on copper panel. One (height 15 in. [38 cm.]), belonging to the Bayerische Staatsgemäldesammlungen, Munich, has been called the work of Matthias Gundelach (Munich 1972, p. 396, no. 780). The other (height 14 in. [35.5

cm.]), formerly on the art market (Paris 1974, no. 22), had for years been in French private collections where it was attributed to Adam Elsheimer (1578–1610). Its most recent cataloguer (Malcolm Waddingham?) seemed less confident about this attribution than the previous owners had been but still placed it roughly in the German painter's circle.

Recently published documents (Cropper and Panofsky-Soergel 1984, pp. 473–88) now lend support to the old Elsheimer attribution. According to these documents, there were among the pictures listed in the collection of the Flemish painter Karel Oldrado no less than seventeen that had been attributed to Adam Elsheimer by their owner, an avid collector of his fellow Northerner's work. One of them, described in an inventory made at the time at Oldrado's death at Rome in 1616 as "un altro quadretto di San Bastiano in rame" (another picture of Saint Sebastian on copper) and in a later inventory as "un San Bastiano frezzato alto un palmo e mezzo in circa . . . di mano d'Adamo pittore" (a [picture of] Saint Sebastian shot with arrows, about a palm and a half high (ca. 14⅝ in. [37.8 cm.] . . . from the hand of the painter Adam [Elsheimer]), corresponds precisely to the panels which match the bronze Sebastian. It is thus tempting to conclude that these two panels are not merely from Elsheimer's circle but are, at the very least, copies of one of his own compositions.

If this is the case, we are compelled to draw one of two conclusions regarding the bronze. Either it served as a model for Elsheimer—in which case it would date before 1610 (the year of his death)—or it is derived from the Elsheimer composition. The second alternative still allows for an attribution to the young Petel, who is certainly known to have followed models by painters (such as Rubens) in other instances. However, all of Petel's work in this category is recognizably "Petelish" in style, robust and fleshy, which is not at all the case with the Sebastian bronze. It is in fact more likely to have been modeled by another, quite possibly older, artist who was attempting to replicate this two-dimensional model.

Adherence to such a prototype would account for much of the peculiar flatness of the bronze composition as well as its broken outline; it would also explain such inconsistently awkward passages as the rubbery right foot, more consonant with Elsheimer's style than with that of any known bronze sculptor. Aside from these eccentric features, Sebastian's torso appears to be modeled in a late Mannerist–early Baroque style quite close to that of Pietro Tacca's Crucifix in the Duomo, Prato (Torriti 1975, no. 59), as well as to two crucifixes that were once attributed to Giovanni Bologna (Venturi 1937, 10, III, figs. 651–52); the first of these is probably also the work of Tacca and the other that of Felice Palma (Watson 1983, fig. 60). Their sleek and astringently modeled torsos, angular pelvic structures, and broken outlines all coincide with some of the more striking features of the Liechtenstein Sebastian. It is therefore not entirely unreasonable to conclude that the composition itself, as well as the Liechtenstein version of it (although certainly not all of the

others), belongs to the first quarter of the seventeenth century and is likely to have been modeled in Florence, in the workshop of one of the followers of Giovanni Bologna.

JH

FURTHER REFERENCES: Cat. 1767, no. 13; Cat. 1780, p. 259, no. 30; Munich 1972, p. 118, fig. 103; Middeldorf 1978, pp. 49–64 (contains a complete bibliography of previous material).

49

François Duquesnoy
Flemish (act. in Rome), 1597–1643

MERCURY
Rome, modeled ca. 1629–30 and cast probably ca. 1630–40
Bronze with light-brown lacquer patina; height 24⅞ in. (63 cm.)
Liechtenstein inv. no. 611

Mercury is shown leaning against a tree, as he gets ready to depart on his flight. His gaze is directed downward toward a now-missing small cupid, who sat at his feet, looking up at him as he tied a pair of wings to the god's right ankle. In his left hand, Mercury originally held a caduceus, now also missing.

The complete composition is known from a plate in the *Galleria Giustiniana* (vol. 1, pl. 84), a set of engravings issued in Rome about 1631–37, to illustrate the famous collection of antiquities assembled by Marchese Vincenzo Giustiniani (1564–1638) in his Roman palace. The plate, engraved by Claude Mellan and stating that the author of the statuette is François Duquesnoy, together with a passage by Bellori (1672; 1976 ed., p. 300) describing the statuette made for Giustiniani, allowed Tietze-Conrat (1918, pp. 47–52) to recognize this model as a work by the Flemish artist. In the Liechtenstein example two holes in the base show the exact spot where the missing Cupid was placed.

According to Bellori, Duquesnoy created the Mercury statuette as a companion piece to an ancient bronze statuette of Hercules in the collection of Marchese Giustiniani, to whom the sculptor was introduced in 1629 by his friend Joachim von Sandrart. Bellori's statement is confirmed by an unpublished inventory of the sculptures in the Giustiniani palace, compiled in 1638, shortly after the Marchese's death, in which the two bronzes are described standing as pendants on the same table (Rome, Archivio di Stato, Archivio Giustiniani, Busta 16, int. 20A, pte. 2, f. 9). The detailed description of the Hercules allows us, moreover, to identify this statuette in another plate engraved by Mellan for the *Galleria Giustiniana* (vol. 1, pl. 13) and to trace it to a fine Hellenistic bronze now in the Villa Albani, Rome (Helbig 1972, no. 3279; Bieber 1960, p. 37, fig. 79).

The Giustiniani–Albani *Hercules* is a variant of the famous *Farnese Hercules* type. It was probably treasured in Giustiniani's

collection for its exquisite quality which would demonstrate to a discriminating seventeenth-century collector that the bronze was a much-valued Greek original. Its smooth surfaces and crisp, highly finished details must have been especially appreciated by Duquesnoy who was a devoted admirer of the "maniera greca" (Passeri 1934 ed., p. 112). In designing the *Mercury*, the artist tried to meet the challenge of equaling and even surpassing in excellence the composition and workmanship of the ancient bronze. As a complement and contrast to the *Hercules*, he chose an equally paradigmatic ancient prototype: the much-studied and admired *Belvedere Antinoüs*, whose graceful, youthful figure offered an appealing counterpart to the powerful, mature physique of the Hercules model. But in emphasizing Antinoüs's contrapposto and transforming it into the sinuous open outline of his *Mercury*, he endowed the statuette with a neo-Mannerist elegance that was quite typical of his own style: a style that owed much to the study of Renaissance paintings as well as to the inspiring example of Poussin with whom he maintained a close friendship.

Surprisingly enough, the episode of Cupid tying Mercury's *talaria* does not seem to be based upon any ancient source, either literary or visual. Its direct precedent occurs, however, in one of the most famous works of another Flemish sculptor, Adriaen de Fries (1545–1626): the Mercury group of one of the fountains at Augsburg, completed in 1599 (Larsson 1967, p. 24, fig. 27) and engraved by Wolfgang Kilian in 1614 (Augsburg 1980, vol. 1, p. 262), where a small cupid crouching at Mercury's feet clearly served as a model for Duquesnoy's Cupid.

Several sources have been suggested for Duquesnoy's re-elaboration of the *Belvedere Antinoüs*. Nava Cellini (1966a, p. 42) has observed the similarity between Duquesnoy's *Mercury* and a figure of Bacchus–Apollo drawn by Poussin, possibly about 1626, on a sheet at the Fitzwilliam Museum, Cambridge. And more recently, Gaborit (1977, p. 60, no. 19) has noted that Duquesnoy might have based Mercury's backward tilt on a recollection of Parmigianino's figure of Adam in the Madonna della Steccata, Parma, and used the same motif for the restoration of an ancient statue of Adonis in the Louvre.

Considered in the context of Duquesnoy's other sculptures, the *Mercury* has a deep stylistic affinity with two of the sculptor's major works: the *Vryburch Epitaph* (1628–29) (Nava Cellini 1966b, pl. IX), which shows a similar recollection of Flemish and Mannerist precedents, and the *Santa Susanna* (1629–33) (Nava Cellini 1966b, pl. VIII), with which it shares the same lyrical reinterpretation of antiquity and a similar purity of "light and sweet movement" (Bellori 1672; 1976 ed., p. 290). Modeled thus, we believe, about 1629–30, Duquesnoy's *Mercury* was probably one of his first works for Vincenzo Giustiniani, who cherished it to the point of including it in his Galleria Giustiniana, on a par with the famous antiquities in his collection.

The origin and dating of the Liechtenstein cast is, however, somewhat different. Although it has been suggested that this bronze may be identical with the Giustiniani statuette (Pope-Hennessy 1970b, p. 441), its description in the 1638 inventory of the Giustiniani collection makes it highly unlikely that it was sold so soon thereafter. The Liechtenstein bronze is, in fact, described as early as 1658 in the inventory of the "Statue von Metall" kept in the "Guardaroba" of Prince Karl Eusebius (1611–84) in his palace at Feldsberg, Lower Austria (Fleischer 1910, p. 70).

Although cast in three separate sections, the statuette is of exceptionally fine quality. The freshness and suavity of its chasing and the attention to light values and surface modulations have so much in common with the surfaces of some of Duquesnoy's marbles that one must believe that it was executed in Rome under the artist's own supervision. Duquesnoy himself, as we know from Bellori (1672; 1976 ed., p. 301), was proficient in cleaning and chasing some of his sculptures cast in silver and other metals, and although none of the reliquary heads or the silver busts of *Christ* and the *Virgin* which he finished himself has survived, one wonders whether he may not have been personally responsible for the chasing of this bronze.

No document has come to light concerning Karl Eusebius's acquisition of this piece or of its companion, the *Apollo* (cat. no. 50), but we know that the Prince was familiar with Duquesnoy's works quite early, since a silver relief with three boys eating grapes, by "Francisco Fiamengo," is described in a 1633 inventory of the Liechtenstein silver (Haupt 1983, Quellenband, p. 304, no. 253). In the following years Karl Eusebius often used his agents to obtain works of art in Italy, and more than once in Rome (Fleischer 1910, p. 36), making it therefore most likely that the *Mercury* and the *Apollo* were among these purchases.

Numerous bronze replicas of the *Mercury* were made in the eighteenth century either alone or together with the *Apollo*, since both statuettes were thought to be of classical origin. The earliest of them seem to be a *Mercury and Cupid* in the Louvre (Gaborit 1977, fig. 4) and another one, paired with an *Apollo*, at the Huntington Art Gallery, San Marino, Calif. (Bode 1910, vol. 2, p. 29, no. 214, pl. CLI; Weihrauch 1967, p. 369, fig. 448). In Vienna the Liechtenstein bronze served as inspiration for one of the sculptures formerly attributed to Giovanni Giuliani (1663–1744), executed about 1716 for one of the niches in the staircase of the Daun-Kinsky palace (Grimschitz 1944, pl. 52).

OR

FURTHER REFERENCES: Cat. 1767, p. 67, no. 36; Cat. 1780, p. 268, no. 136; Tietze-Conrat 1918, p. 82, fig. 35; Laurent 1923, p. 303; Pigler 1929, pp. 42–43, fig. 36; Fransolet 1942, pp. 86–90, 180–81, pl. XIIa; Nava Cellini 1966a, pp. 46–47; Nava Cellini 1966b, pp. 3–5, fig. 4; Bregenz 1967, pp. 32–33, no. 29, pl. 83; Weihrauch 1967, p. 512, no. 380; Woeckel 1967, p. 469; Gaborit 1977, pp. 57–60; Wilhelm 1976, p. 18, no. 30.

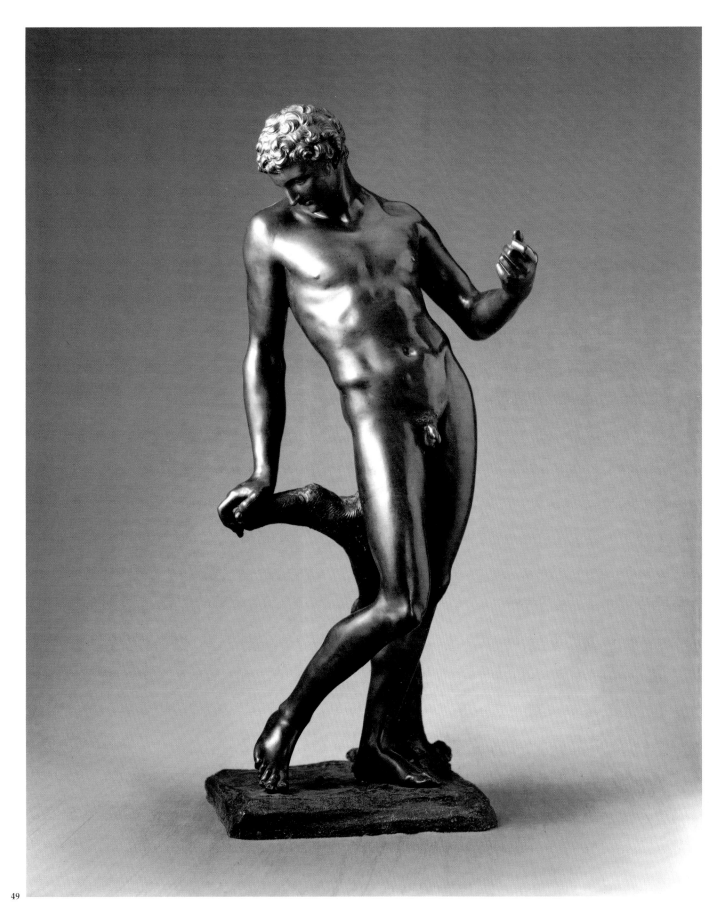

49

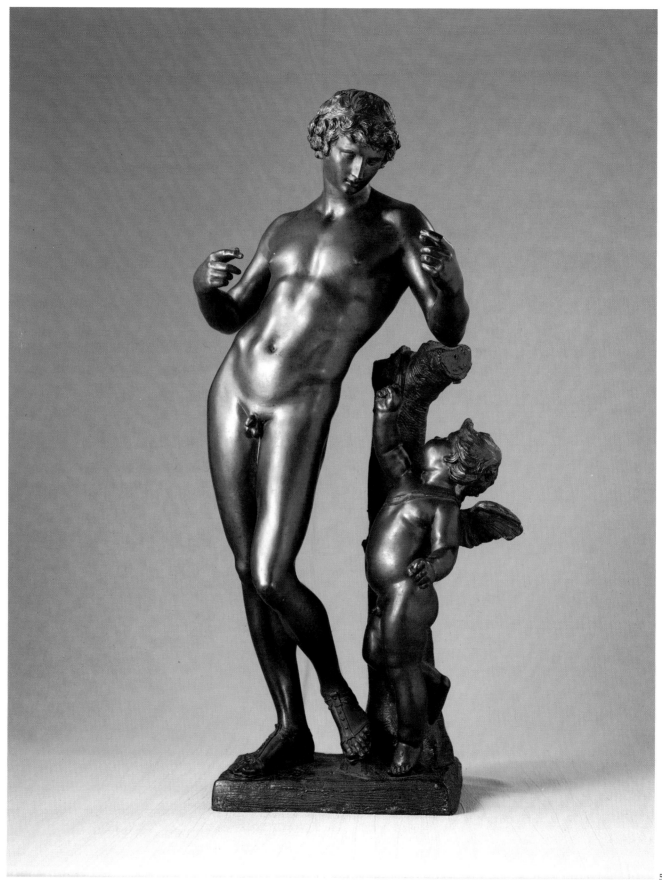

50

François Duquesnoy
Flemish (act. in Rome), 1597–1643

APOLLO TEACHING CUPID HOW TO USE A BOW
Rome, modeled and cast probably ca. 1635–40
Bronze with light-brown lacquer patina; height 26 in. (66 cm.)
Liechtenstein inv. no. 610

The young god stands beside a tree, in a graceful contrapposto that echoes that of the *Mercury* (cat. no. 49), but without its backward tilt. His left hand originally held a now-missing bow; with his right hand he gestures as if pulling a bowstring and demonstrating how to shoot an arrow. Cupid leans eagerly toward him, intent on learning this skill.

Duquesnoy's authorship of this statuette is based upon a passage in Bellori (1672; 1976 ed., p. 300), who, after describing the Giustiniani *Mercury*, adds that "later on" the sculptor modeled a figure of Apollo as a pendant to it. Bellori's very condensed passage has been generally understood to mean that both figures were made for Vincenzo Giustiniani. Since no bronze *Apollo*, however, appears in the 1638 inventory of the Giustiniani collection, where the *Mercury* is described (see cat. no. 49), it seems much more likely that Duquesnoy modeled the statuette not for Giustiniani, who paired the *Mercury* with an ancient *Hercules*, but for a different patron several years later.

A distance in date between the design of the two statuettes is also suggested by their stylistic differences. Composed on the frontal plane and defined by the strictly vertical line of the tree trunk, the *Apollo and Cupid* is more classical in design than the *Mercury*. Although the gently feminine traits of Apollo's face are but a variant of those of the *Santa Susanna* (1629–33), the vigorously modeled, robust Cupid is extremely close to the putti of the *Epitaph of Ferdinand von den Eynde* (1633–40), as well as those of the Filomarino frieze (1640–42) in Santi Apostoli, Naples (Nava Cellini 1966b, pls. IX, XIII, XIV–XV). On the basis of these similarities one must assume that the model of the *Apollo* was created by Duquesnoy somewhat later than the Giustiniani *Mercury*, most likely about 1635–40. Its surface, regularly and smoothly chased, shows the same delicacy of touch, the same attention to surface modulations and light values as the *Mercury*, while the god's hair, the figure of Cupid, and the tree trunk are even sharper, livelier, and more pictorial in their treatment.

Although the exceptional quality of this bronze suggests that, like the *Mercury*, its surface might have been finished by Duquesnoy himself, one may wonder whether the slight differences between the two casts may not be due to a distance in time between their execution. Duquesnoy may have kept a cast after his Giustiniani model in his studio and decided to pair it with an *Apollo* only after receiving a special commission. This is most likely to have come directly from Prince Karl Eusebius

(1611–84), who in the years following 1633, after his return from his study trip abroad, frequently commissioned and purchased works of art in Italy and Rome through his agents (Fleischer 1910, p. 38). Like the *Mercury*, the Liechtenstein *Apollo* is described for the first time in the 1658 inventory of the bronzes of Karl Eusebius at Feldsberg (Fleischer 1910, p. 70).

Several bronze replicas and variants of the *Apollo*, either alone or together with the *Mercury*, were made in the eighteenth century. One of the best replicas is at the Huntington Art Gallery, San Marino, Calif. (Bode 1910, vol. 2, no. 215, pl. CLII). On the other hand, Georg Raphael Donner (1693–1741) combined both Duquesnoy compositions in *Mercury*, a lead statuette executed about 1732–33 (Pigler 1929, p. 42, fig. 35).

In the course of the eighteenth century, memory of Duquesnoy's authorship was lost, and both statuettes were considered of classical origin. The *Apollo* is so described by Fanti in 1767 (Cat. 1767, p. 68, no. 37).

OR

FURTHER REFERENCES: Cat. 1780, p. 267, no. 134; Tietze-Conrat 1918, pp. 47–52, 82–83, fig. 36; Laurent 1923, p. 303; Pigler 1929, pp. 42–43, fig. 37; Fransolet 1942, pp. 86–90, 180–81, pl. XIIb; Mezzetti 1962, p. 367; Nava Cellini 1966a, pp. 48–49, pl. 32; Nava Cellini 1966b, pp. 3–5; Bregenz 1967, pp. 32–33, no. 28, pl. 82; Weihrauch 1967, p. 512, no. 380; Woeckel 1967, p. 469; Pope-Hennessy 1970b, p. 441; Wilhelm 1976, p. 18, no. 31.

51

Philipp Heinrich Müller (or Miller)
German, 1650/54–1718/19

MEDAL OF PRINCE JOHANN ADAM ANDREAS VON LIECHTENSTEIN (1657–1712)
Gold; diameter 2⅞ in. (7.2 cm.)
Obverse: IOANNES AD [AM] · D [EI] · G [RATIA] · DVX · OPPA [AVIAE] · ET CAR[NOVIAE] · PRINC[EPS] · ET GVBER[NATOR] · DOMVS DE LICHTENSTEIN✱ *(Johann Adam, through the grace of God, Duke of Troppau and Jägerndorf and Prince and Ruler of the House of Liechtenstein.) The Prince is shown in profile to the right, in a long full peruke, wearing contemporary armor, decorated on the shoulder with a battle scene, and over it a lace jabot and the collar of the Order of the Golden Fleece.*
Signed and dated below: P. H. Muller, 1694.
Reverse: DOMINVS ILLVMINATIO MEA *(The Lord is my light). An eight-pointed star shines on a rock emerging from a turbulent sea.*
Liechtenstein inv. no. M.133

This medal commemorates the tenth anniversary of Johann Adam's assumption of the rule of the House of Liechtenstein in 1684 and, parenthetically, celebrates his reception of the Golden Fleece in 1693. Despite the impression of martial valor conveyed by the parade armor he wears, his reputation rested not on his military achievements (which were insignificant) but on

51

The portrait on the obverse, however, is entirely representative. Müller designed dies for coins and medals for a whole gamut of states, cities, principalities, and ecclesiastical entities that were authorized to operate mints. His style shows a clear-cut evolution from a rather stiff manner to a more fluent and graceful one. The portrait of Johann Adam shows Müller at a turning point. The stiff and dryly delineated details of wig, jabot, and armor are unrelieved by the soft swag of drapery that he would later adopt in his more Frenchified medals. Although the imperious forward thrust of the right arm was a motif Müller did occasionally utilize, it is not a conventional gesture in medallic portraiture of the period.

It is perhaps ironic that shortly after this medal was struck, Johann Adam began his long patronage of the Italian sculptor and medallist Massimiliano Soldani, who sent the Prince an example of the medal he had made of the Duke of Lorraine (Tietze-Conrat 1918, pp. 63–64, fig. 46; Lankheit 1962, p. 327), one of the heroes of the Turkish war. One wonders why he himself never commissioned a medal from Soldani.

The present example, retained by the Prince himself, contains 100 carats of gold. Another, in the imperial collection during the nineteenth century (Missong 1882, no. 133), contained only about half as much. An unknown number of less precious examples were struck in silver and bronze for wider distribution (Missong 1882, no. 134; Forster 1910, no. 690). An ivory replica of the medal was carved by Jean Cavalier and is now in the Kunsthistorisches Museum, Vienna (Missong 1882, no. 137).

JH

FURTHER REFERENCES: Missong 1882, pp. 61–63; Forrer 1909, vol. 4, pp. 197ff.; Forster 1910, p. 96.

his enormously successful conduct of the family's financial affairs. As can be seen from the legend, the medal antedates the Prince's acquisition of the territories of Vaduz and Schellenberg which occurred in 1699 and 1712, respectively.

The minute scene depicted on his armor must represent a battle in the recently concluded war against the invading Turks; the combatants are clearly the troops of Austria on one side and the Ottoman forces on the other. Such representations abounded in the period, in a variety of media (Munich 1976; Vienna 1983); the particular source of this battle scene has not been identified. It would have been more usual to show this scene on the reverse of the medal where it could occupy the entire field. Here, however, the motto on the reverse, taken from Psalm 27, is illustrated by an emblem that forms a rebus on the family name —starlight (*Licht*) shining down on a rock (*Stein*). The device goes back to the medals of Karl I who was the first in the family to obtain the privilege of minting his own coinage.

The use of such a design for the reverse of a medal recalls contemporary Italian practice and is not typical of Müller's work.

52

Massimiliano Soldani
Tuscan, 1656–1740

PEACE AND JUSTICE
Florence, 1694
Bronze with yellow-gold lacquer patina; height 24 in. (61 cm.);
 width 17½ in. (44.5 cm.)
Liechtenstein inv. no. 540

The relief is the first of the works executed by Soldani for the Prince Johann Adam Andreas von Liechtenstein (1657–1712). In his first letter to the Prince, on December 11, 1694, Soldani mentions that it had just been finished and shipped to Vienna; he adds that he did not include its black pearwood frame since it would have cost more to ship it than it was worth and that he would later make a bronze cartouche to fasten it to a frame

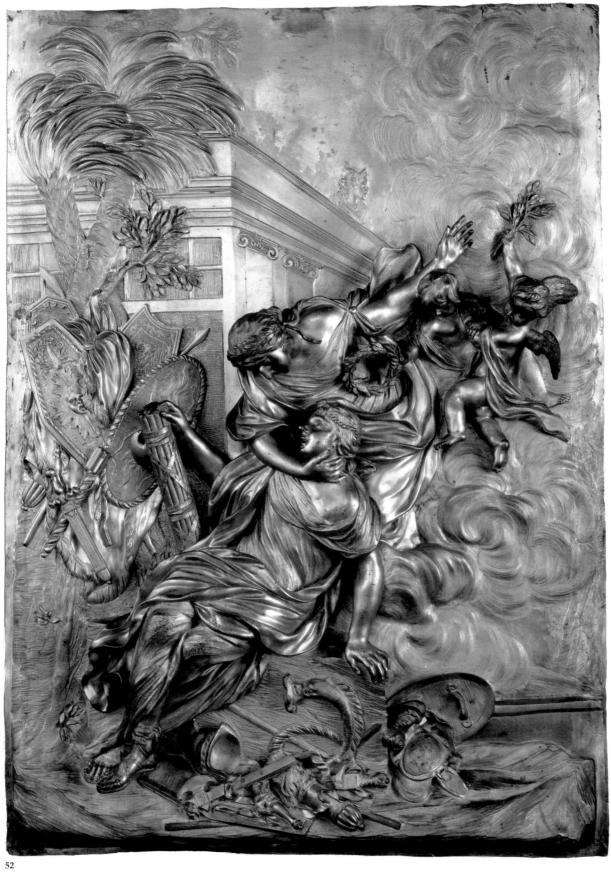

52

(Lankheit 1962, doc. 635). From this context it is clear that Soldani regarded the relief not as part of an architectural whole but as an independent picture: this concept inspired his devotional reliefs as well as the allegorical reliefs of the Seasons which he was to execute a few years later for the Gallery of the Elector Palatine Johann Wilhelm at Düsseldorf (Lankheit 1962, pp. 131–32, figs. 95–99).

Soldani had been trained as a medallist, and after 1688 he held the post of master of coins and custodian of the mint in Florence. But in spite of his specialized and highly successful activity in this field, he was ambitious to work on larger-scale reliefs and freestanding sculpture. The Liechtenstein relief, which was one of the earliest of Soldani's works for a private client, was surely meant to show his familiarity with the true *gusto romano* that he had acquired from the teachings of Ercole Ferrata and Ciro Ferri, during the years of his apprenticeship in Rome (1678–82). Perhaps based upon the design of one of the many *bassorilievi d'invenzione* that he did in those early years, the relief shows Soldani's attentive study of Algardi's works: *The Meeting of Leo I and Attila* (Heimbürger Ravalli 1973, pl. LXXIII), from which the two putti hovering on the right are a literal quotation, and the stucco relief of the *Miracle of Saint Agnes* (Heimbürger Ravalli 1973, pl. LXXXI), with its pictorial animation, abundant clouds, and lively interplay of diagonals. The decorative nature of the scene is further underlined by the elaborate chasing of the surfaces, sharply defined and differentiated in the smallest details, treated throughout with the virtuoso exactitude of the steel engraver, and further enhanced by the richness of the translucent golden patination.

The subject of the allegory represented is never mentioned in the correspondence between Soldani and the Prince, who does not seem to have been very much interested in such matters. Fanti (1767, p. 82, no. 405), Tietze-Conrat (1918), and Lankheit (1962) described the relief as "Glory" or "Fame crowning Virtue." But more recently, Montagu (1981, p. 34, ill.) rightly recognized it as a depiction of the familiar theme of the Reconciliation of the Virtues, based on the words of the Psalmist: "Mercy and Truth are met together, Righteousness [*Iustitia* in the Vulgate] and Peace have kissed each other" (Psalms 85:10). Justice, seated and holding the fasces, symbol of her slow but uncompromising punishing power, is embraced by Peace, who wears an olive wreath in her hair, while a winged cherub carries aloft an olive branch. Appropriately, the scene takes place in front of the closed temple of Janus. This building with its wide latticed window is based upon depictions on the reverse of several coins of Nero (Mattingly 1923, vol. 1, no. 112, pl. 41.1, no. 163, pl. 42.6, no. 164, pl. 42.7), while the motif of the Janus heads may have been borrowed from an engraving in du Choul's *Discours de la Religion . . .* (1556, p. 21). The scattered weapons in the foreground and the billowing clouds of smoke rising behind them seem to evoke the burning of the arms frequently associated with representations of Peace in ancient, Renaissance, and Baroque art (Baumstark 1974, pp. 132–33).

Although these allegorical elements are consistent with the traditional depictions of the meeting of Peace and Justice, there are other details that point to a further layer of symbolic meaning. While Justice is usually represented wearing a golden crown, as in the frescoes of Domenichino (Spear 1982, vol. 2, fig. 334) and Gaulli (Enggass 1964, fig. 16), she is here about to be crowned with a laurel wreath, a symbol of military victory rather than of royal prerogative. And a further allusion to victory is made by the arms hanging like a votive trophy from the two palm trees and an olive branch on the left side of the scene.

These references to victory—and a victory due to divine intervention, as the broad gesture of Peace pointing to heaven seems to imply—may easily be understood as an allusion to the victorious war conducted by Emperor Leopold I and the Holy League against the Turks between 1683 and 1699. A conflation of the theme of the meeting of Peace and Justice with that of the victory of Christendom, the relief must have been thought of by Soldani as an especially appropriate and timely compliment for a Prince of the Holy Roman Empire. It was also meant to be an example of his ability in composing an elaborate allegorical scene on a scale larger than on the reverse of his medals.

After Soldani's death many models and molds of his works were left in his studio. These were sold in 1744 by his son Ferdinand Soldani Benzi to Marchese Carlo Ginori, founder of the Porcelain Manufactory at Doccia. A wax related to the Liechtenstein relief, described as "Un bassorilievo rappresentante la Pace," is listed as no. 68 of the *Inventario de' Modelli*, compiled about 1780, and is in the Museo delle Porcellane at Doccia (Lankheit 1982, p. 133, fig. 173).

OR

FURTHER REFERENCES: Wilhelm 1911, pp. 102–105; Tietze-Conrat 1918, pp. 70–71, 96, fig. 55; Lankheit 1962, pp. 128–29, 375, no. 102, fig. 102, docs. 635ff.

53

Massimiliano Soldani
Tuscan, 1656–1740

TIME REVEALING TRUTH
Florence, 1695-97
Bronze with reddish-gold lacquer patina; height 25¼ in. (64 cm.);
* width 17¾ in. (45 cm.)*
Liechtenstein inv. no. 536

The first relief executed by Soldani for the Prince Johann Adam Andreas von Liechtenstein in 1694 (cat. no. 52) satisfied his new patron so much that three months later, in March 1695, the artist was asked to cast a companion relief, the subject to be devised to suit his own pleasure (Lankheit 1962, doc. 638). Soldani hastened to assure the Prince that the second relief would be an

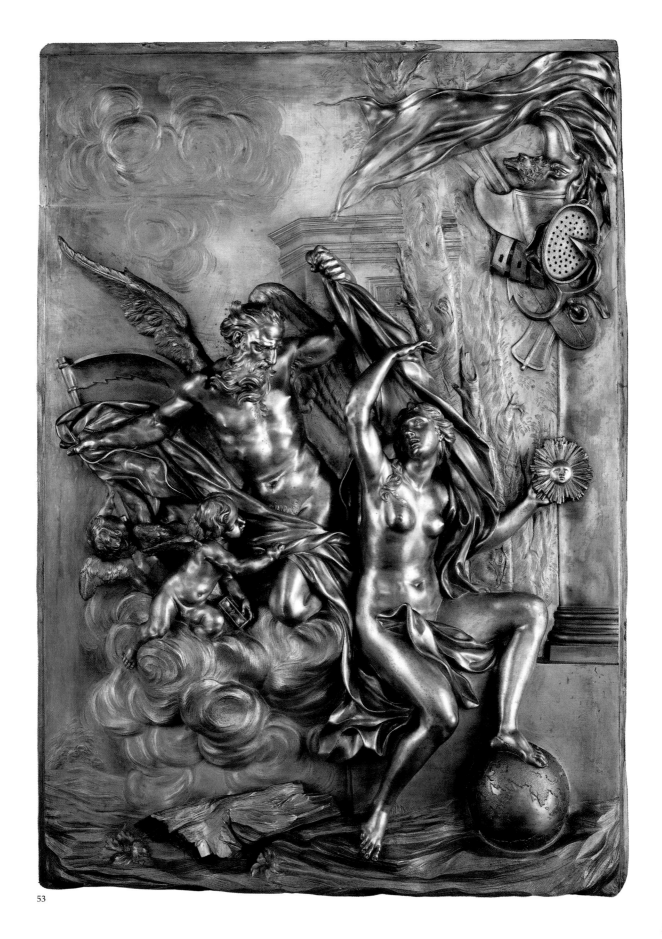

53

entirely personal creation ("tutto di mio genio") as well as "di miglior maniera" than the first one (Lankheit 1962, doc. 639). The finished composition was sent to Vienna in November 1697 (Lankheit 1962, doc. 656).

Time Revealing Truth is not only a more successful composition, more freely and vigorously modeled than *Peace and Justice*; it also shows how deeply affected Soldani was by the Baroque masters he had studied in Rome and how he was able to adapt a variety of sources to create a personal, decorative, and courtly style. The figure of Truth, literally borrowed from Bernini's famous *Veritas* (Wittkower 1981, pl. 76), is skillfully combined with an energetic figure of Time based on Algardi's Saint Paul in his relief *The Meeting of Leo I and Attila* (Heimbürger Ravalli 1973, pl. LXXIII); these elements were transformed into a narrative relief, full of those allusive details that were so much to the taste of Soldani and of his Florentine patrons.

The soaring clouds and the pictorial details on the right—the column with its naval trophies and its triumphal banner, the group of trees and the temple in the distance—correspond to the parallel elements in *Peace and Justice*, ensuring the visual and allegorical unity of the two scenes. If the first one was meant to signify the peace and justice which, under divine guidance, was brought about by the imperial victories against the Turks, then *Time Revealing Truth* must have been intended to convey the idea of the Triumph of Christian Truth as a result of the same victories. In this context, the naval trophies and banner may have been devised as an allusion to the successes of the Christian fleet, to which the Grand Duke of Tuscany, Cosimo III, as an ally of the Emperor and a member of the Holy League against the Turks, had contributed several galleys.

On Soldani's death, among the molds in his house at Borgo S. Croce, Florence, was one representing Time (Lankheit 1962, doc. 351). A wax cast related to the Liechtenstein relief is described as no. 98 in the *Inventario de' Modelli*, compiled about 1780 at the Porcelain Manufactory at Doccia, and is in the Ginori collection, Florence (Lankheit 1982, p. 137, fig. 171). A version in porcelain, made at Doccia about 1745–55, is in the collection of Marchese Roberto Venturi Ginori (Lane 1954, p. 38, fig. 56).

OR

FURTHER REFERENCES: Cat. 1767, p. 82, no. 406; Wilhelm 1911, pp. 102–105; Tietze-Conrat 1918, pp. 70–72, 96, fig. 55; Lankheit 1962, pp. 128-29, 375, no. 103, fig. 103, docs. 638ff; Bregenz 1967, p. 75, no. 127; Montagu 1981, p. 34, ill.

54

Massimiliano Soldani
Tuscan, 1656–1740

BACCHANAL
Florence, 1695–97
Bronze with reddish-gold lacquer patina; height 22¼ in. (56.5 cm.);
width 30½ in. (77.5 cm.)
Liechtenstein inv. no. 827

Bacchus and Ariadne have alighted from their triumphal chariot to rest in a wooded grove, not far from a herm of Priapus. Absorbed in each other, they recline and drink, oblivious of the riotous crowd of their followers. In the foreground a faun tries to separate two fighting putti, while the drunken Silenus, who has toppled off his donkey, lies prostrate on the grass. Behind them, the revelers surround the god of nature, while in the distance the maenads conduct their frenzied dance.

This exceptionally large and elaborate composition was created by Soldani in response to the Prince of Liechtenstein's wish to have "qualche scherzo baccanale" from the sculptor. In his first letter to the Prince, on December 11, 1694, Soldani announced that he had just sent him a wax *modello* of a Triumph of Bacchus, in which the god rests with Ariadne amid other figures and symbols referring to bacchic festivals.

In a recent article on the Liechtenstein bronzes, Montagu (1981) noted that the elderly satyr on the left surely derives from the satyr on the *Patera Martelli*, which in Soldani's time was still in Florence and generally believed to be by Donatello (Pope-Hennessy 1964, pp. 325–29, figs. 350–51). To this observation she rightly added that "something too, of the Mirror's exaltation of Nature is repeated in the complex iconography of Soldani's piece" (Montagu 1981, p. 35). Soldani has indeed filled the relief with bacchic as well as amatory symbols, culled from many sources, visual and literary, ancient and modern: vines, grapes, and vases, kissing snakes and mating doves, a maenad dancing to the sound of her cymbals, putti playing with a billy goat, one of them with a snake wrapped around his neck (as in Catullus, *Carmina* 64.258), an infant Pan dancing in drunken frenzy over the rump of one of Bacchus's unharnessed leopards, and, at the center of the relief, a maenad raising high her sistrum, the instrument of Isis, goddess of nature, as if to proclaim the triumph of Nature's power as the true meaning of the whole festive scene.

Although the wax *modello* of the relief arrived broken "in a thousand pieces," the Prince felt that it would be "una cosa molto bella," and in March 1695 he asked Soldani to cast it in bronze (Lankheit 1962, doc. 638). The finished relief was shipped to Vienna in 1697, and Soldani took special pride in a work that he considered "among the best to have been made in his day in Florence" (Lankheit 1962, docs. 653–54). The most ambitious of the works undertaken by Soldani in those years, the *Bacchanal*

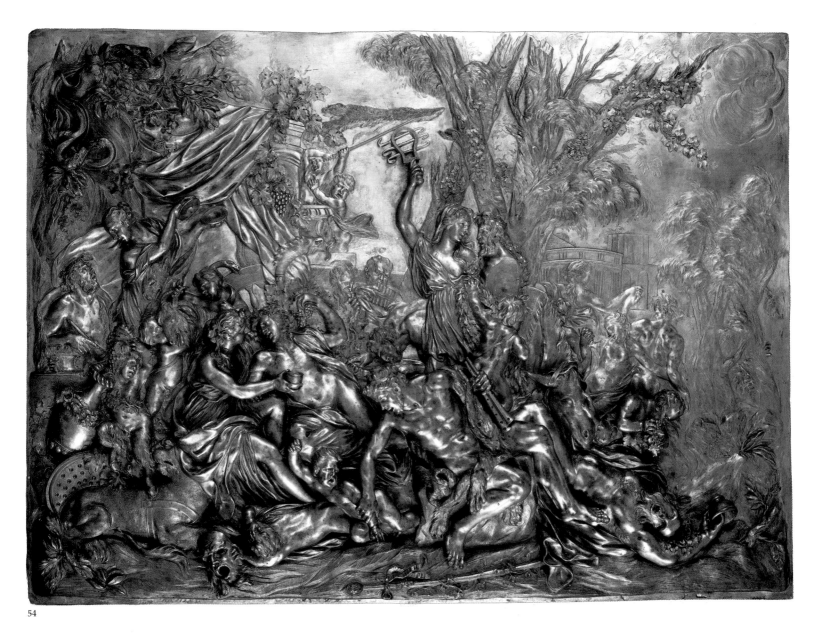

54

Fig. 19 Detail from cat. no. 54

is indeed something of a virtuoso display of all the artist had learned about the art of relief from classical as well as modern sources, both in Rome and Florence. The Cortonesque density of the composition and the pictorial complexity of the design were meant to express the ideal of richness that was considered appropriate for a princely collection. Throughout the work, Soldani's exacting chiseling technique displays his unique ability to achieve a whole gamut of sharply differentiated textures and a luminous vibration of surfaces, enhanced by the application of his typically translucent reddish-gold patination.

The painterly exuberance of Soldani's *Bacchanal*, clearly meant to be read as a "picture in bronze," must have been admired in Florence, especially in the circle of Grand Prince Ferdinando,

one of Soldani's most enthusiastic patrons. But its brash "modernity" did not please the more conservative, classicizing taste of Prince Johann Adam Andreas, who from 1697 on preferred to ask Soldani for bronze copies after Michelangelo or after well-known antiquities (Lankheit 1962, doc. 655).

<div align="right">OR</div>

FURTHER REFERENCES: Cat. 1767, p. 82, no. 404; Wilhelm 1911, pp. 102–105; Tietze-Conrat 1918, pp. 70, 96, fig. 56; Lankheit 1962, pp. 106, 129, 375, no. 104, fig. 104, docs. 635ff.; Bregenz 1967, p. 75, no. 128, fig. 88; Detroit 1974, pp. 23, 28; Montagu 1981, pp. 33–36, ills.

55–62

Massimiliano Soldani
Tuscan, 1656–1740

EIGHT BUSTS AFTER THE ANTIQUE
Florence, 1695

In 1680 the young Prince Johann Adam Andreas took his Grand Tour through Holland, England, France, and Italy. During his visit to Florence, he was so impressed by Michelangelo's sculptures in the Medici Chapel that, fourteen years later, when he asked Soldani to supply bronzes for the decoration of his palaces, one of his first wishes was to have bronze casts from the heads of "the Times of the Day."

Soldani, who discusses this order in his first letter to the Prince, on December 11, 1694, explained, however, that because of their bent attitudes, Michelangelo's heads could not be used to create independent busts. He suggested instead casting a series of bronze busts after the best antique marble busts of Roman emperors, philosophers, and ladies that were in the Gallery of the Grand Duke in the Uffizi. These he proposed to mount on small socles of colored marble, with a small bronze cartouche affixed to it with the name of the subject. Such bronze busts, he added, would indeed turn out to be "cose nobilissime, e da galleria" (Lankheit 1962, doc. 635).

Soldani's suggestion was accepted by the Prince, and by November 1695 the eight busts listed below were completed and shipped to Vienna (Lankheit 1962, doc. 649). In a letter to the Prince written shortly after he had completed the busts, Soldani proudly told of the care he had taken in chasing and finishing them, "sparing neither time nor money to make them as close as possible to the originals" (Lankheit 1962, doc. 650). To us, however, they appear as elegant variations, carried out with the exquisitely decorative taste that was so characteristic of Soldani's personal style.

<div align="right">OR</div>

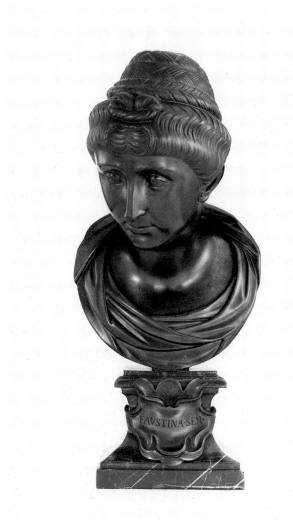

55

BUST OF FAUSTINA THE ELDER
Bronze with red-gold lacquer patina; height, including socle, 23⅛ in. (58.5 cm.)
Inscribed: FAVSTINA SEN.
Liechtenstein inv. no. 548

This bust was cast after a marble bust in the Uffizi, then supposed to represent Faustina, wife of Emperor Antoninus Pius, but no longer considered to be of ancient manufacture (Mansuelli 1961, vol. 2, p. 141, no. 189, ill.).

The Uffizi marble bust and another one representing Faustina the Younger (cat. no. 56) were the first pair proposed by Soldani to the Prince of Liechtenstein on the strength of their being "di vera maniera greca." The chasing of the elaborate coiffures, the elliptic design of the abbreviated drapery, and especially the bright "modern" patina transformed the two uninspired marble originals into decorative late Baroque objects.

<div align="right">OR</div>

FURTHER REFERENCES: Cat. 1767, p. 87, no. 114; Cat. 1780, p. 267, no. 124; Tietze-Conrat 1918, pp. 53, 92, fig. 73.

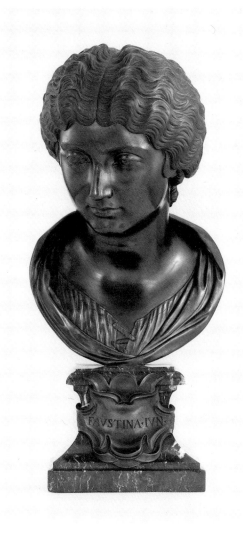

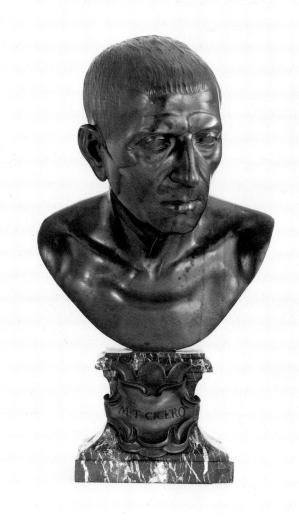

56

57

BUST OF FAUSTINA THE YOUNGER
Bronze with red-gold lacquer patina; height, including socle, 22⅞ in. (58 cm.)
Inscribed: FAVSTINA. IVN.
Liechtenstein inv. no. 529

This bust was cast after a Roman second-century A.D. marble bust of Faustina, wife of Emperor Marcus Aurelius, in the Uffizi (Mansuelli 1961, vol. 2, p. 103, no. 124, ill.).

For comments see cat. no. 55.

OR

FURTHER REFERENCES: Cat. 1767, p. 87, no. 115; Cat. 1780, p. 267, no. 134; Tietze-Conrat 1918, pp. 53, 92, fig. 74.

BUST OF CICERO
Bronze with red-gold lacquer patina; height, including socle, 23⅜ in.
(59.5 cm.)
Inscribed: M. T. CICERO
Liechtenstein inv. no. 554

This bust was cast after a Roman first-century B.C. marble bust in the Uffizi which is one of the most famous classical portraits, believed since the fifteenth century to represent Cicero (Mansuelli 1961, vol. 2, p. 46, no. 34, ill.). The outline of the Liechtenstein bust is an exact replica of that of the marble original and might have been used by Soldani as the prototype for designing the small-bust format of the whole series. Both *Cicero* and *Seneca* (cat. no. 58) were chosen by Soldani as pendants to the busts of *Faustina the Elder* and *Faustina the Younger*.

OR

FURTHER REFERENCES: Cat. 1767, p. 85, no. 96; Cat. 1780, p. 266, no. 110; Tietze-Conrat 1918, pp. 53–54, 89, fig. 38.

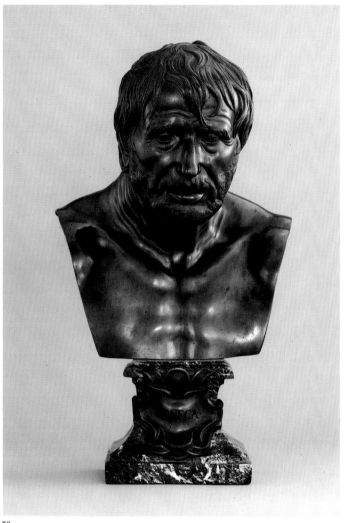

58

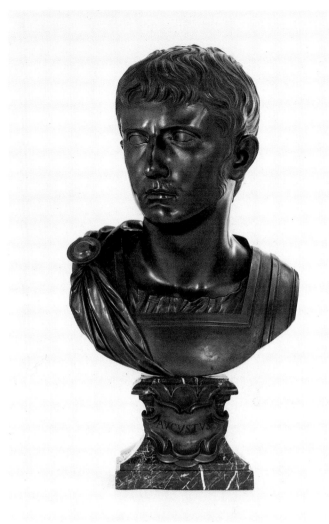

59

BUST OF SENECA

Bronze with red-gold lacquer patina; height, including socle, 23⅜ in. (59.5 cm.)
Inscribed: SENECA
Liechtenstein inv. no. 560

This bust was cast after a Hellenistic marble portrait in the Uffizi, long believed to represent the Roman philosopher Seneca (Mansuelli 1961, vol. 2, p. 26, no. 10, ill.)

Soldani's bronze, perhaps the most successful of these busts, reproduces faithfully the cut of the marble bust, while the sensitive, linear chasing of hair and beard contributes to the work's Baroque animation. OR

FURTHER REFERENCES: Cat. 1767, p. 85, no. 97; Cat. 1780, p. 267, no. 122; Tietze-Conrat 1918, pp. 53–54, fig. 39, p. 89; Lankheit 1962, p. 140; Bregenz 1967, pp. 77–78, no. 133, fig. 89.

BUST OF AUGUSTUS

Bronze with red-gold lacquer patina; height, including socle, 24⅜ in. (62 cm.)
Inscribed: AVGVSTVS
Liechtenstein inv. no. 513

This bust was cast after a Roman first-century B.C. marble bust in the Uffizi, a portrait of Octavian before the establishment of the principate in 27 B.C. (Mansuelli 1961, vol. 2, p. 51, no. 39, ill.). Soldani's bust is one of a group of four busts of Roman emperors proposed by the sculptor to the Prince of Liechtenstein in June 1695 to complement the first four busts (cat. nos. 55–58). It is clear from the heterogeneous character of the set, and from the correspondence between Soldani and the Prince, that no strict thematic consistency was ever intended, such as in the canonical group of the Twelve Caesars, so often used in Italy in the sixteenth and seventeenth centuries for the decoration of formal halls or galleries. OR

FURTHER REFERENCES: Cat. 1767, p. 84, no. 91; Cat. 1780, p. 266, no. 111; Tietze-Conrat 1918, pp. 59, 89, fig. 42; Lankheit 1962, p. 140, fig. 142; Gazola and Hanfmann 1970, p. 260, fig. 24; Lankheit 1980, pp. 275–76, pl. 55,7.

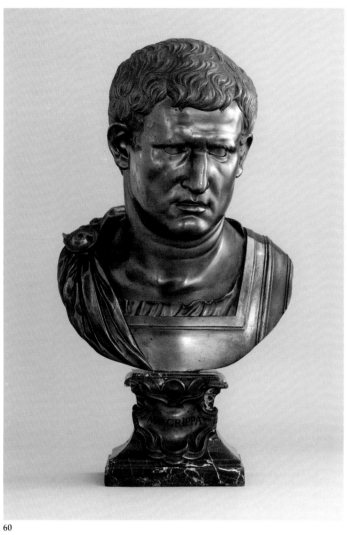

60

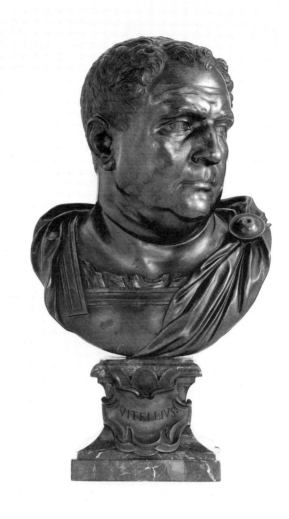

61

BUST OF AGRIPPA

Bronze with red-gold lacquer patina; height, including socle, 24¹³⁄₁₆ in. (63 cm.)
Inscribed: M. AGRIPPA
Liechtenstein inv. no. 504

This bust was cast after a Roman first-century B.C. marble bust in the Uffizi (Mansuelli 1961, vol. 2, p. 52, no. 41, ill.). According to Mansuelli, only the head of the Uffizi marble is ancient. Although Agrippa was never invested with the imperial dignity, his portrait was often included among those of the first Caesars.

<div align="right">OR</div>

FURTHER REFERENCES: Cat. 1767, p. 86, no. 106; Cat. 1780, p. 266, no. 119; Tietze-Conrat 1918, p. 90, fig. 70.

BUST OF VITELLIUS

Bronze with red-gold lacquer patina; height, including socle, 23¼ in. (59 cm.)
Inscribed: VITELLIVS
Liechtenstein inv. no. 563

Although Tietze-Conrat (1918, p. 90, fig. 69) has suggested that the model of this bronze is a pseudo-antique marble bust of Vitellius in the Uffizi (Mansuelli 1961, vol. 2, pl. 138, no. 180), Zadoks and Jitta (1972, p. 10, fig. 9) have rightly pointed out that Soldani's spirited portrait is much closer to a famous late Roman marble bust in the Museo Archeologico, Venice, known as the "Pseudo-Vitellius."

The bust in Venice, bequeathed by Cardinal Domenico Grimani in 1523 to the Venetian Republic, was traditionally believed to be a portrait of the Emperor Vitellius. It was greatly admired in the Renaissance for its vigorous modeling and its lifelike expression, and in the sixteenth as well as in the seventeenth century it was often used as a model for portraits of Vitellius. Such was the case with the pseudo-antique bust in the Uffizi, although its flabby modeling and frontal position are

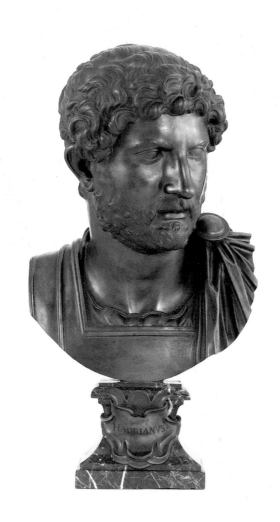

62

far removed from the liveliness and energy of its ancient prototype.

Since Soldani's bust returns to the energetic sideways twist of the Venetian portrait and captures some of its energy and realism, it is likely that he had access to a plaster cast after it. An example of such a cast is still in the Museo di Scienze Archeologiche e d'Arte, Padua (Zadoks and Jitta 1972, p. 7, fig. 5), and others must have existed in artists' studios in Florence and in Rome to serve as models for the many copies made after them (Faldi 1954, figs. 11m,n).

In the Liechtenstein bust, which is one of the most successful of the series, Soldani's surface chasing is especially effective in achieving the quality of softness in contours and modeling that was so much appreciated by his princely patron.

<div align="right">OR</div>

FURTHER REFERENCES: Cat. 1767, p. 85, no. 105; Cat. 1780, p. 267, no. 121; Lankheit 1962, p. 141, fig. 143; Leithe-Jasper 1976, p. 69; Lankheit 1980, pp. 275–76, pl. 55, 8.

BUST OF HADRIAN

Bronze with red-gold lacquer patina; height, including socle, 26⁹/₁₆ in. (67.5 cm.)
Inscribed: HADRIANVS
Liechtenstein inv. no. 571

This bust was cast after a Roman second-century A.D. marble bust of Hadrian in the Uffizi (Mansuelli 1961, vol. 2, p. 86, no. 91, ill.). The somewhat bland features of the Roman marble have been transformed by Soldani into a sensitive and almost lyrical likeness, its main decorative effect being achieved by the contrast between the smoothness of the face and the crisp and precise chasing of the beard and hair of the Emperor.

<div align="right">OR</div>

FURTHER REFERENCES: Cat. 1767, p. 84, no. 90; Cat. 1780, p. 266, no. 113; Tietze-Conrat 1918, p. 59, fig. 41, p. 89.

63

Massimiliano Soldani

Tuscan, 1656–1740

BACCHUS, after Michelangelo

Florence, 1699–1701
Bronze with reddish-brown lacquer patina; height 78 in. (198 cm.)
Liechtenstein inv. no. 573

In 1556, Ulisse Aldrovandi (1556, p. 172) described Michelangelo's *Bacchus* as he saw it standing in the garden of Paolo Galli in Rome. About 1570 the statue was bought by Grand Duke Francesco de' Medici and shortly thereafter installed in the eastern corridor of the new Granducal Gallery at the Uffizi, along with the most venerated Medici antiquities and a series of ancient portrait busts. Its presence in the midst of these works confirmed the traditional Florentine view that some of the great modern masters—Donatello, Sansovino, and, above all, Michelangelo—could and should be considered the true heirs of the ancients.

Following the same thinking, when in the 1680s Louvois sought to obtain copies of the most famous antiquities in Florence for Louis XIV, Michelangelo's *Bacchus* was included in the choice proposed to him. Grand Duke Cosimo III allowed the *Bacchus* to be copied in marble by Giovanni Battista Foggini, and by 1695 a signed and dated replica was installed in the gardens of the royal château at Marly (Alazard 1924, pp. 133, 145; Rosasco 1984, p. 122, no. 83). It is not surprising therefore to read that when in the same year Soldani proposed to the Prince of Liechtenstein that he cast a full-size bronze after the *Bacchus* to accompany bronzes after two famous Florentine antiquities, the *Medici Venus* and the *Dancing Faun* (Liechtenstein inv. nos. 537, 541), his offer was eagerly accepted (Lankheit 1962, doc. 641–43).

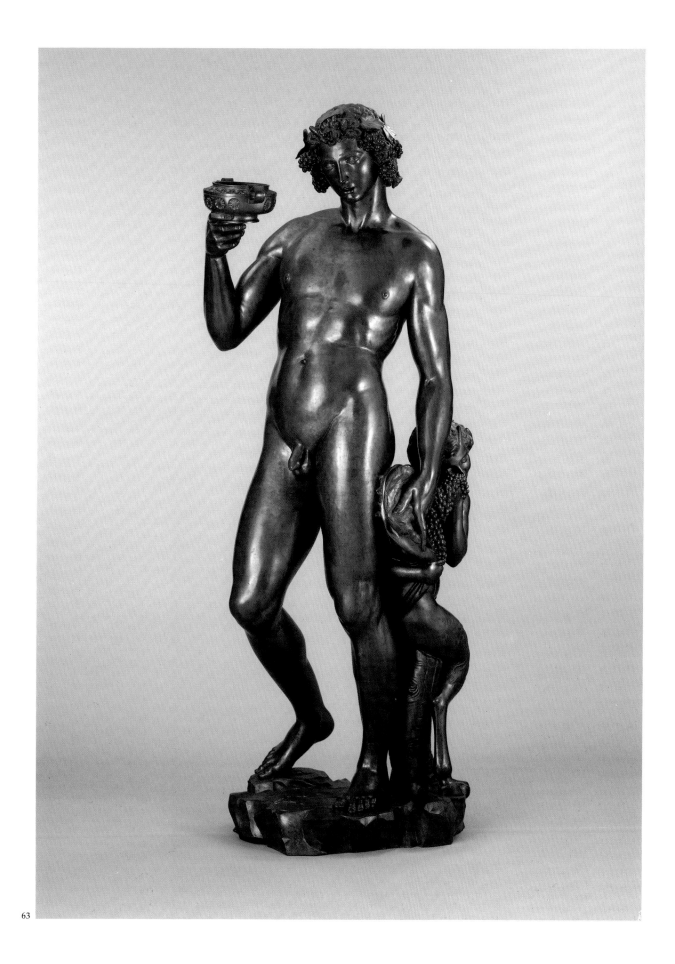

63

Soldani's cast after Michelangelo's *Bacchus* was the largest and most ambitious work he had yet attempted. But in dealing with a masterpiece so universally admired, the artist felt obliged to maintain a measure of fidelity to the original that proved, in the end, to work against him. The very plasticity of Michelangelo's *Bacchus*, the powerful spiraling of its composition, and the *quattrocentesque* spareness of its modeling, so well preserved in Soldani's cast, were all qualities deeply alien to the classicizing Baroque taste of Prince Johann Adam Andreas.

When the bronze *Bacchus* reached Vienna in 1703, the Prince was deeply disappointed: both he and the painters and sculptors he had consulted found the sculpture "a badly designed, poorly conceived and dry work" (*una cosa mal dissegnata . . . un' attitudine cattiva, idea pessima, e seccha*). The Prince truly regretted that Soldani had not used his talent in a better way (Lankheit 1962, doc. 673).

<div align="right">OR</div>

FURTHER REFERENCES: Cat. 1767, p. 48, no. 23; Cat. 1780, p. 257, no. 14; Tietze-Conrat 1918, pp. 81–82; Lankheit 1962, p. 144; Haskell and Penny 1981, p. 60.

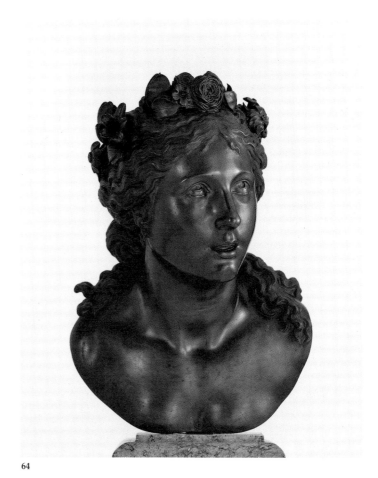

64

64

Massimiliano Soldani

Tuscan, 1656–1740

ANIMA BEATA, after Bernini
Florence, 1705–1707
Bronze with red-gold lacquer patina; height, including socle, 15⅛ in. (39 cm.)
Liechtenstein inv. no. 516

In 1705 Soldani proposed to the Prince of Liechtenstein that he make casts for him after two heads by Gian Lorenzo Bernini, both of them "cose di bellissima maniera" (Lankheit 1962, docs. 681–82, 684). Bernini's originals were two marble busts, the so-called *Anima Beata* (Blessed Soul) and *Anima Dannata* (Damned Soul), which in Soldani's time were in Rome in the church of San Jacopo degli Spagnoli (Wittkower 1981, pls. 6–7). Two admirable psychological and physiognomical studies, Bernini's marbles must have been especially appreciated by late Baroque artists for the ease with which they lent themselves to be reused as expressive formulas. Soldani, who probably owned plaster casts taken after them during his study years in Rome, was quick to exploit the decorative aspect of the *Anima Beata*. He adapted it as an ornamental element, surrounded by an elaborate cartouche, for the bronze decorations he designed about 1696 for the main altar of Santa Maria di Carignano, Genoa (Lankheit 1962, p. 151, figs. 67–68). And for Prince Johann Adam Andreas he turned it into a prettified Flora, lavishing his craftsmanship on the chasing of her flowers and her hair.

The bust was completed, together with its pendant, by 1707 (Lankheit 1962, doc. 686). They were still together in the Liechtenstein Palace in Vienna when described by Fanti in 1767 (Cat. 1767, p. 78, no. 71). The *Anima Dannata* was sold in 1920. It reappeared in a Berlin auction in 1929 (Berlin 1929, p. 26, no. 37, pl. 26).

<div align="right">OR</div>

FURTHER REFERENCES: Cat. 1780, p. 266, no. 109; Tietze-Conrat 1918, pp. 60–61, 88, fig. 44; Lankheit 1962, pp. 140–41, 151; Bregenz 1967, p. 78, no. 135, fig. 90; Wittkower 1981, p. 177; Montagu 1981, p. 37.

Workshop of the Master of the Reliefs of the Martyrdom of Saint Sebastian
Austrian, ca. 1657

FIGURE OF A CAPTIVE
Ivory; height 4¼ in. (10.8 cm.)
Liechtenstein inv. no. 308

The identity of this powerful but somewhat mysterious figure has never been successfully resolved. At first glance it appears to represent a captive, perhaps a Turkish prisoner. The assumption had been that it once cowered at the foot of some larger group representing an imperial triumph, comparable, for example, to Christoph Maucher's *Triumph of the Emperor Leopold* in the Kunsthistorisches Museum, Vienna (Vienna 1983b). However, Braun-Troppau (1940, pp. 92ff., fig. 3), who first published it as the work of Matthias Rauchmiller, suggested that it was an allegory of Madness or a literal depiction of a madman,

seeing parallels with Pieter Xavery's 1673 wood carving of *Two Madmen* in the Rijksmuseum (Amsterdam 1973, no. 328). Such representations are not uncommon in German sculpture; a related creation is David Heschler's boxwood *Allegory of Sickness* in the Victoria and Albert Museum, London (Schädler 1973, no. 101). In fact, the sculptural depiction of madness reached its apogee in Vienna, a century later, in the work of Franz Xaver Messerschmidt.

An explanation on a somewhat higher metaphysical level has been sought by Theuerkauff (1983, pp. 195–96), who proposed that the *Captive* be viewed as an "Allegory of Damnation" or as the "Powerlessness of the Vanquished." However, its abruptly sheared-off base does suggest that it had once been embedded in a larger composition, the precise allegorical function of which remains to be convincingly explained.

Braun-Troppau's attribution to Rauchmiller was accepted for many years. He had suggested that the *Captive* was one of the items referred to in a document in the Princely Archive (Wilhelm 1914, p. 37) recording Johann Adam Andreas's purchase in January 1699 of two undescribed Rauchmiller sculptures, one of

65

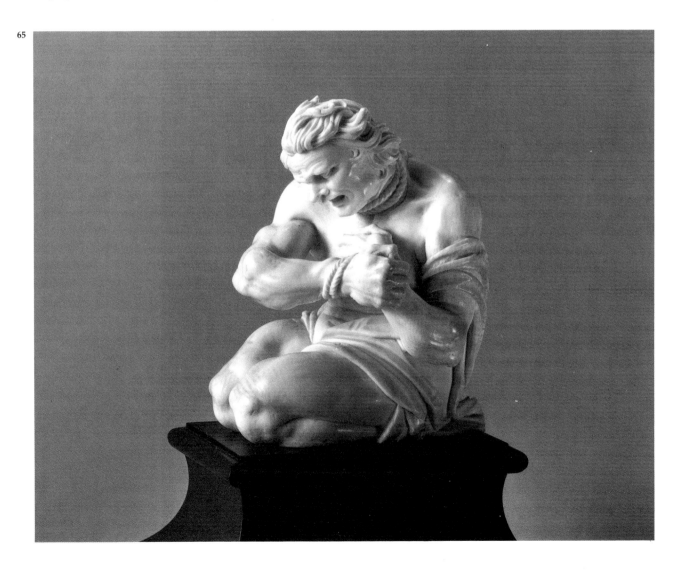

them ivory ("zwey Stukh von Rauchmuller, als eines von Helffenbein"). His identification was supported by a comparison between the *Captive*'s contorted features and one of the faces carved on Rauchmiller's signed ivory tankard, still in the Liechtenstein collection (cat. no. 67).

In 1973 Philippovich (p. 48, figs. 3–5) published the *Captive* as the work of Johann Caspar Schenck. He observed that it particularly resembled the figure of an archer in the *Martyrdom of Saint Sebastian*, the ivory relief in the Oberösterreichisches Landesmuseum, Linz, which, in the course of his analysis, he also attributed to Schenck. Birke (1974, p. 247, and 1981, pp. 26–27, 85, figs. 13–14) sustained this attribution, pointing out, correctly, that the Liechtenstein *Captive* diverged substantially from what we know of Rauchmiller's style. The figure's short and compressed athletic body type, with bulging, overdeveloped musculature and sharply protruding individual sinews, is nowhere to be found in Rauchmiller's oeuvre. Similarly foreign to Rauchmiller are the close-fitting, inactive drapery, adhering to arms and legs, and the centripetal energy of the composition.

Most recently, Theuerkauff (1983, pp. 195–96), while conceding the *Captive*'s close resemblance to the Linz relief, rejected the theory that Schenck was their author. He attributed both, rather, to an anonymous master who, he suggested, undoubtedly influenced Schenck, and Rauchmiller as well. He pointed out, however, that while the Sebastian Master's work exceeds theirs (or for that matter, any other contemporary Viennese carver's) in the ferocity of its expressiveness and precision of detail, stylistic variations within the Vienna and Linz reliefs do suggest that more than one person worked in his shop.

The Liechtenstein *Captive*, when compared directly with the Sebastian Master's *Man Struggling with a Serpent* (cat. no. 66), is clearly from the same family. But it is not apparent that they are the work of the same hand. The *Captive* is more softly carved and far less obsessive in its focus on anatomical details than the other, strongly undercut figure. It is, moreover, so tightly compressed that its form seems incompletely liberated from the block of ivory from which it was carved, even given the limitations that may have been imposed by the size and shape of the original material. Finally, the abruptly angled drapery does not so much cling to as bandage the body; its flattened, mechanically scooped-out folds seem almost as ropelike as the cords that bind his neck and wrists. We must conclude that while the *Captive* was almost certainly conceived by the Master of the Reliefs of the Martyrdom of Saint Sebastian, probably at a point quite close in time to the creation of the 1657 relief in Linz, its handling indicates that it was actually carved by a different hand. Clearly, many questions regarding this master and his circle remain to be elucidated.

JH

FURTHER REFERENCES: Theuerkauff 1964, pp. 45, 309; Bregenz 1967, p. 65, no. 102; Birke 1974, figs. 171–74, no. A2; Philippovich 1982, p. 146; Vienna 1983b, no. 20/9, pp. 258–61 (with further references).

66

Master of the Reliefs of the Martyrdom of Saint Sebastian
Austrian, ca. 1657

MAN STRUGGLING WITH A SERPENT
Ivory; height 9 in. (22.8 cm.)
Liechtenstein inv. no. 325

This vividly carved figure was acquired at the Brummer sale in 1979 (Zurich 1979, no. 99). It was a particularly appropriate addition to the distinguished group of ivories assembled by Princes Karl Eusebius and Johann Adam Andreas in the last decades of the seventeenth century. Not only is its provenance Viennese (during the nineteenth century it was in the collection of Anselm von Rothschild; Schestag 1872, no. 93) but it relates significantly to another ivory figure, a *Captive*, which has been in the Liechtenstein collection for many years (cat. no. 65). Both are key members of a group of controversial ivories, considered by some (Philippovich 1973, pp. 47–51; Philippovich 1982, p. 172; Birke 1974, no. A2; Birke 1981, pp. 26–27) to be from a single workshop and by others (Theuerkauff 1973, pp. 245–86, and 1983, p. 195, fig. 5; Draper 1984, pp. 175–76) from a somewhat more diffuse circle. The group includes some of the most serious and ambitious endeavors in this medium to have been generated in Austria in the period of revived artistic activity following the Thirty Years' War (1618–48).

The group centers around two spectacular reliefs depicting the Martyrdom of Saint Sebastian. Most (but not all) observers hold at least these two compositions to be the work of one artist (see Zoege v. Manteuffel 1969, vol. 2, pp. 471–72, 494–95, for a dissenting view). The earliest, dated 1655, is in the Kunsthistorisches Museum, Vienna (Philippovich 1982, p. 303, fig. 255); it includes twelve figures, most of them carved in very high relief. The other, dated 1657, is in the Oberösterreichisches Landesmuseum, Linz (Philippovich 1982, p. 304, figs. 256, 256a); it includes only three figures in high relief; the remainder of its highly pictorial composition is composed of shallowly carved figures and landscape. The *Man Struggling with a Serpent* strongly resembles the figures in the Sebastian reliefs; like them, it displays an exaggerated approach to the depiction of anatomical detail, a fondness for less-than-ideal bodies caught up in tense, contorted movement, and a penchant for snub-nosed, ropy-featured, fiercely expressive physiognomies.

A number of other works have recently been associated with the Linz and Vienna reliefs; clearly related to them, and to the *Man Struggling with a Serpent*, is the *Hercules and Antaeus* in the Metropolitan Museum, also from the Anselm von Rothschild collection (Schestag 1872, no. 99). Among other candidates are two standing covered cups in the Kunsthistorisches Museum, Vienna (Philippovich 1982, p. 173), a tankard in the Tiroler Landesmuseum Ferdinandeum, Innsbruck (Philippovich 1973,

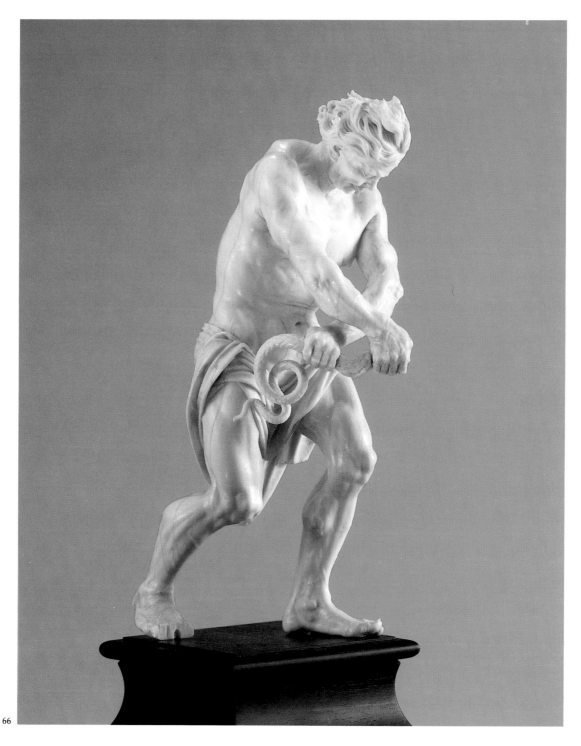

66

fig. 7), a relief depicting the Judgment of Solomon in the Hessisches Landesmuseum, Darmstadt (Philippovich 1973, fig. 6), and a diverse group of other pieces, signed ICS (Philippovich 1973 and 1982; Theuerkauff 1973 and 1983). This signature is believed to be that of Johann Caspar Schenck, a member of a family of ivory carvers from the Bodensee region. Schenck served the imperial court in Innsbruck for two years; in 1666 he was appointed *Kaiserliche Hofbeinstecher* (imperial ivory carver) in Vienna, a position he held until his death in 1674.

Philippovich and Birke have sought to identify Schenck as the anonymous Master of the Reliefs of the Martyrdom of Saint Sebastian (and, by analogy, of the *Man Struggling with a Serpent*) as well as of the other unsigned ivories mentioned above. Theuerkauff and Draper have, justifiably, resisted this attempt at consolidation. Schenck was evidently a member of the Sebastian Master's circle (perhaps even of his workshop) for their work has much in common (as do, to one degree or another, all the ivories in this group). However, comparisons between them

revolve primarily around their shared repertoire of facial and physical types, a repertoire that probably derives in large measure from an older German carving tradition.

There are, moreover, significant differences between Schenck and the Sebastian Master. Proponents of their common identity attempt to account for these differences in terms of an alleged stylistic development on Schenck's part, or even as the product of two manners practiced simultaneously. This hypothesis is difficult to accept. In the work of the Sebastian Master, the accidents of flesh take on a significance equivalent to that of underlying form; in Schenck's signed work they are almost always far more sketchily indicated. His facial features are less ropy, his drapery patterns more mechanical, and, as Theuerkauff has noted, his carving style is softer and drier. Even in his most robustly carved work, the signed Bacchic tankard in the Kunsthistorisches Museum, Vienna (Philippovich 1973, figs. 9–10), Schenck shows little of the relish in depicting anatomical detail that is displayed by the carver of the Sebastian reliefs (and of the *Man Struggling with a Serpent*). His style never approaches the Sebastian Master's increasingly firm command of anatomical structure whose development is apparent between the Vienna and Linz reliefs; nor does it display the accomplished draughtsmanship visible in their shallowest relief carving. Even when obsessed with minutiae of surface and musculature, as in the Liechtenstein statuette and the Metropolitan's *Hercules and Antaeus*, the Sebastian Master conveys a firm sense of his figures' underlying balance and structure and their tightly wound, coherent movement; Schenck's figures, on the other hand, are diffuse and fluid in their movement.

The *Man Struggling with a Serpent*, with its somewhat broader and softer (although still abruptly angled) folds and more gently waving hair, may suggest a date closer to the 1657 Linz relief than to the earlier one in Vienna. Its subject has been disputed; in the Rothschild catalogue (Schestag 1872) it was described as a "Hercules" and in the Brummer sale catalogue (Zurich 1979) as "Laocoön." Neither identification seems particularly convincing. It certainly features none of the attributes of Hercules (club and lionskin) which the Metropolitan ivory depicts so faithfully; on the other hand, the relationship of the struggling figure to the serpent appears more dominant than Laocoön's is usually shown to be. It is possible that the figure's significance is allegorical, as has been suggested of the Liechtenstein *Captive*, and that he was once part of a larger group. A serpent is one of the attributes of Heresy whose extirpation is frequently a featured motif in representations of Counter-Reformation triumphs. Snakes also serve as attributes of Discord. Without a more specific literary or visual context, however, its identification must remain a matter of speculation.

<div style="text-align:right">JH</div>

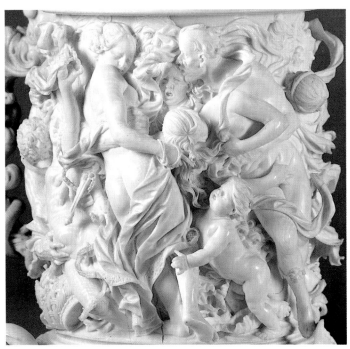

Fig. 20 Detail from cat. no. 67

67

Matthias Rauchmiller
Austrian, 1645–86

TANKARD WITH THE RAPE OF THE SABINE WOMEN
Vienna, 1676
Ivory; height 13¾ in. (34.9 cm.)
Inscribed (on base): MATHIAS/RAVCHMILER/FECIT/ANNO/1676; *(on cover):* MARS/STERNIT/PRATA/SED/HIC/VIC/TOR/IA/PARTA
Marks (on silver-gilt liner): EB
Liechtenstein inv. no. 326

This tankard is considered by many to be the single most important piece of German High Baroque ivory carving. Its allegorical and pictorial complexity, the extraordinary subtlety of its modeling, and the virtuosity of its carving are unrivaled in the medium. Indeed it provides us with a more vivid sense of Rauchmiller's style than do the three angels that constitute his contribution to the Pestsaule, the monument to the Holy Trinity he was commissioned to create in Vienna's Graben and which, had he lived to complete it, would have been the major achievement of his career.

The ivory was included among a group of *Raritäten* purchased by Prince Johann Adam Andreas in 1707 from Karl Lebzelter, a physician who was rector of the University of Vienna. Fanti devoted somewhat more attention to it than to many of the objects described in his 1767 catalogue (Cat. 1797, p. 87, no.

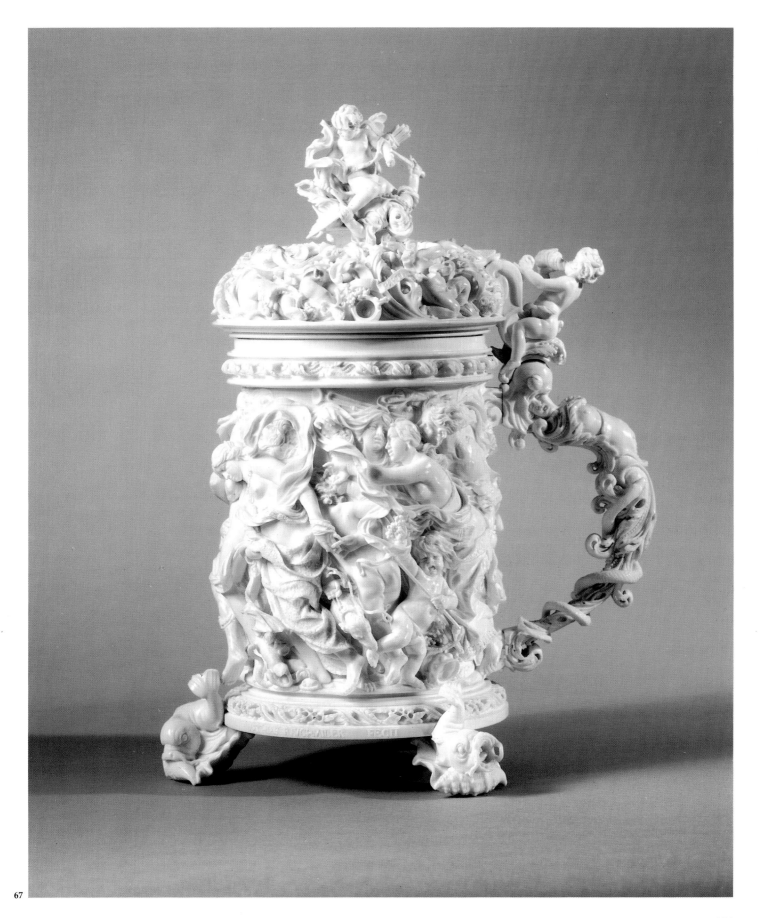

113), although there is some ambiguity in his comment: "E'desso lavoràto a Basso Rilievo, che rappresenta una infinità di figure, bene ordinate, il Ratto delle Sabine. Questa è un'opera molto rara, che palesa una verità troppo evidente." (It is worked in high relief which represents an infinitude of well-arranged figures [showing] the Rape of the Sabine Women. This is a very rare work which reveals a too-evident truth.) It is difficult to decide whether by "una verità troppo evidente" Fanti means that the carving style is overly realistic or that the subject has been handled in too mundane a fashion or that there is too obvious a message conveyed.

That the ostensible subject is indeed the Rape of the Sabine Women was established virtually at the moment of the tankard's creation in a poem "Herrn Matthias Rauchmillers Künstlich erhöheter Raub der Sabinen in Helffenbein" (Herr Matthias Rauchmiller's artfully carved Rape of the Sabines in ivory) by a friend and admirer of Rauchmiller's, the Silesian poet, dramatist, and statesman Daniel Casper von Lohenstein (1635–83). His identification has in fact precluded any real discussion of the subject or its iconography. These are handled in a manner so far from conventional, however, that more than one casual writer has described the tankard in other terms. Scherer (1905, p. 75), for example, called it simply a Bacchic scene.

Compositionally, the first section of the two-part main frieze does indeed recall a *thiasos* more than a traditional scene of abduction. But this Bacchanal is infused with elements of anguish and fury that distinguish it from even the most frenzied versions of the classical theme. The tangled web which starts to the left of the handle depicts a complex pursuit: a satyrish old man, whose arm and scalp are fiercely grasped by a haggard old woman behind him, seizes at the garments of another younger woman; she in turn lunges ahead and links one hand with that of a youth whose back is toward us; he, with his left hand, pulls at the collar of a hunting dog turning back to the right to bite the leg of a crying child; this child, fleeing in counterpoint also to the right, holds a bunch of grapes in one hand and a staff with a ribbon tied to it in the other. Leading them all is another woman, who links hands behind the back of the youth with the woman who brings up the rear. The procession leader lunges forward, her head lowered as if in shame, and gazes at the portrait medallion hanging from her neck; at the same time she clutches desperately at the brocaded garment that falls around her hips.

Behind her, in lower relief, are the heads of three grimacing furylike figures; to the right, behind the youth with the dog, a woman shelters an infant in her shawl; and behind the pursuing man, still in low relief, the soldier plays a trumpet. While the elaborately interlaced figures in the foreground seem to be following the steps of some intricate dance, reminiscent of those depicted in such paintings as Rubens's *Dance of the Peasants* (Prado, Madrid), the many discordant elements—the fearful (and fearsome) expressions, the bitten child, the protective mother —preclude any such direct comparison.

The second part of the main frieze, which depicts the violent capture of several other young women by a motley assortment of men, is also somewhat anomalous. While two of the captors are apparently youthful armed warriors, others are, again, aging and battered. The melee is accompanied by a tangle of swirling hair and drapery, chains and straps and strings of pearls, dangling swords and overturned vessels (a basket from which grapes spill and a capsized metal bowl). And, again, there are incongruously victimized squalling children tangled beneath the adult feet; all of them are also accompanied by elements which seem to resonate with deeper meaning—one spills a handful of roses as a snake bites his leg, another clutches a poppy.

The moldings above and below the main frieze take the forms of coiled foliage: the one below represents olive or laurel branches (peace and/or victory), the upper one a seeded acanthus (procreation?). The handle—a double-faced female terminal figure—is still more elaborate. The figure's lower half, rather than terminating in snakes as is more common, is composed of seeded acanthus; the snake twines around this foliage and bites the figure's right hip. On the left side her tormented face is completely visible; on the right her eyes are concealed within the bulbous dolphin's-head helmet that forms the cover's hinge. Mounting the hinge as a sort of thumbpiece, a child faces the cover blowing a conch shell. Three more conch shells surmounted by dolphins form the feet.

The cover itself is carved with a frieze of putti performing a comical gloss on the main frieze. In the center are two groups of infant boys energetically embracing baby girls; flanking them are babies enacting parodies of martial behavior—putti blaring horns and pounding drums, putti forging and bearing arms, putti wielding scepters. They are intertwined in Neo-Gothic turmoil with swirling foliage and ribbons, as well as more fallen bowls and spilled grapes. On the ribbons are blazoned Latin texts "Mars sternit prata," "Sed hic victoria," and, apart from the others, the single word "prata." These evidently relate to the subject matter although no entirely convincing translation has yet been offered. *Sternit* in this context could mean either strews or flattens; in either case it would seem to imply the more or less destructive presence of war in the ordinarily peaceful context of meadows (*prata*). The second part of the epigrammatic inscription appears to mean: "But here Victory is born," or somewhat less obviously, "But here are the benefits of Victory." The implication is that the brutal act of Romulus's followers had the redeeming benefit of giving birth to the Roman people. Rauchmiller's portrayal of the theme, however, is not flattering to the origins of Rome, and it is hard to imagine a contemporary dynast wishing to borrow such questionable luster. Crowning the cover a triumphant winged Eros surmounts a sprawling, wailing baby Mars. Eros brandishes a bow in his right hand while his left is formed in the vulgar gesture of contempt known as the *fico*: a fist with the thumb held between the first two fingers. This is scarcely an admirable triumph.

Casper von Lohenstein's poem, more encomium than expla-

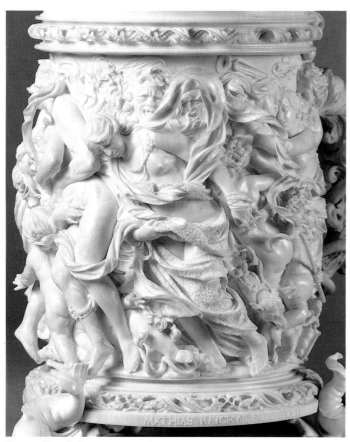

Fig. 21 Detail from cat. no. 67

gruous with traditional versions as are the aged faces in the background, with their wild hair and grimaces.

Although the original story was a violent one, its baleful aspect was tempered in the accounts of Roman mythographers by the element of justice in the Romans' act; they had been thwarted in their more peaceful attempts to acquire wives. This was abduction not rape, and the abductors were tribal heroes. In Rauchmiller's version of this essentially ambiguous ancestral legend, too many of the suitors are ignoble while the havoc portrayed is the brutal and mindless violence of war rather than the neat stratagem recounted by Livy and Plutarch.

A more comical version of the story (which interestingly also features spilling roses and loosened girdles as emblems of the loss of innocence) is to be found in the slightly earlier painting by Jan Steen in the Ringling Museum (Sarasota, Fla.). In this case, the more grotesque aspects of the portrayal have led scholars to question its connection with the Roman legend. In Rauchmiller's tankard, discordant notes incline the viewer to seek a more private and intricate interpretation than the blandly classical one that has been attached to it.

Attempts to find the specific source for the composition have understandably turned to Rubens, but this line of inquiry, while superficially plausible, has not been fruitful. Certainly, many individual motifs—the tumbling headlong movement, the body types, the style of dress, the arrangement of hair and jewels —recall the Flemish painter's manner. Isolated parallels can also be proposed: the old woman grasping at the hair of her daughter's assailant in the *Rape of Sabines* in Osterreith House, Antwerp, could be seen as the model for the similar scene to the left of the tankard handle; another striking resemblance is to be found to the left in the same painting, where Rubens depicts the back of a warrior who stretches out his right arm to enfold one woman while with his left he fends off her father. On Rauchmiller's tankard, the flattened back belongs to a man in armor clutching at a female figure with his right arm. But significantly, he uses his left arm not to fend off an outraged parent, but to snare another victim.

In this and other details it becomes clear that the overall impact of the composition and the expression of Rauchmiller's theme is completely antithetical to the spirit of the older artist's work. It is, in fact, a somewhat bitter and cynical reversal of one of Rubens's noblest preoccupations. For in all his numerous paintings which revolve around the theme of love and war, Rubens is primarily concerned with demonstrating the redeeming and softening aspect of Venus, opposing the aggressive and violent nature of her lover Mars. In Rauchmiller's carving, on the other hand, war and love are indeed juxtaposed, implicitly in the main body of the tankard and explicitly on the cover, but the implications of this juxtaposition are quite different. While the cover, for example, demonstrates the triumph of love over war, this love is aggressive and even contemptuous rather than elevating. This is emphasized most graphically by the vulgar gesture of the triumphant Eros surmounting the composition.

nation, offers little assistance in the decipherment of this provocative iconography, and the title he offers may be (as in the case of Giovanni Bologna's better-known version of the theme in the Loggia dei Lanzi, Florence) purely arbitrary or, perhaps, an attempt to put a good face on a tactless or (and this could have been Fanti's view) too true-to-life visual image.

One of the more curious aspects of the iconography revolves around the role played by the children: are they primarily a compositional convention, inappropriately carried over from the classical bacchanal, with its counterpoint of frolicking children underfoot? Is their function essentially dramatic, a chorus echoing the anguish of the main protagonists? Or are they intended as bearers of a specific iconographic message?

Children are, indeed, occasionally depicted in the more conventional versions of the Rape of the Sabine Women. Here, however, they seem not so much incidental presences or even distraught onlookers as equal victims. One is initially tempted to see them as the children of the victimized women (who in the literary sources, however, are represented as unmarried). Still the portrait medallion around the neck of the leader of the fleeing women indicates that she has a husband or lover, and surely at least one of the other women is a mother with a babe in arms. The other children add to the mood of blind violence as incon-

Rauchmiller's tankard embraces two disparate styles: the nervous linearity of local South German and Austrian Mannerism (as exemplified in the work of the Master of the Martyrdom of Saint Sebastian and Johann Caspar Schenck) as well as the robust classical vigor of the Flemish Baroque. The presence of the local elements is not surprising. Rauchmiller was born in the Bodensee region, which was also the home of the Schenck family, and it is not remarkable that his style should show many connections with their contorted and angular expressionism. The handling of the low-relief background figures, the heightened expressions, and the obsessive attention to details are all hallmarks of their style. But Rauchmiller's work will always be distinguished from theirs by the effortless classicism of the articulate and firmly modeled figures beneath his swirling ribbons of drapery. Like the bruised romantic idealism that lies behind the cynicism and brutality of this theme, this classical underpinning invests the tragicomic manner of Schenck and the Sebastian Master with the dignity and nobility of high art.

Seeking a source for the highly Rubensian stylistic quality in Rauchmiller's tankard, scholars have suggested a period of training in Flanders, perhaps in the workshop of Artus Quellinus. Closer to home are the various tankards with Bacchic themes carved in Augsburg earlier in the century and attributed to Georg Petel, Ferdinand Murmann, and others (Schädler 1973, nos. 19, 91–92). While there are undoubtedly both general and specific resemblances, these probably owe more to their derivation from a common Rubensian repertoire. Although Rauchmiller's frieze seems not to be as obviously related to specific Rubensian compositions as the Augsburg vessels are, the influence of the Fleming's work is too evident to be ignored and was probably exerted directly through paintings and prints rather than filtered through the eyes of another German sculptor.

Like both Rubens and Petel, Rauchmiller was capable of infusing the inherently decorative theme of the Bacchic processional with deeply resonant and powerful implications. But although he was too young to have had the direct contact with Rubens that Petel is known to have had, on a compositional level Rauchmiller's work captures more of the dynamic horizontal sweep of Rubens's paintings than do the more static ivories of the older sculptor and may reflect his training as a painter. This training is also implied in the pictorialism of the tumultuous plunging figures that form the tankard's deeply undercut frieze. Sustained only by their own momentum and airborne loops of cloth, these figures envelop the thin walls of Rauchmiller's cup in a lacy cage quite unlike the solid, sculpturally modeled vessels of the earlier Augsburg carvers.

This sweepingly horizontal effect may be attributable not only to his painterly manner but also to the striving for unified decorative effect that Rauchmiller shared with other major Baroque artists. He was not the first ivory carver to substitute ivory for the silver handle, cover, and base with which such tankards were then more commonly mounted, but his evident desire to merge these attachments into a visual unit with the cylinder of the tankard itself is particularly striking. Not only has he carved the "mounts" in an elaborate ajouré style reminiscent of the Late Gothic, so that they dance to the same frenzied rhythm as the main frieze, but he has worked into the frieze itself compositional elements that incorporate the form of the handle. This impulse to achieve a unified decorative ensemble reminds us of those multifaceted projects in which Rauchmiller demonstrated that his mastery extended beyond ivory carving or even monumental sculpture and into architecture and painting.

Ironically, although he was acknowledged by contemporaries as an ivory carver, and it would appear that he found his true métier in this medium, the tankard is the only surviving work in ivory presently associated with Rauchmiller's name. It was, however, purchased almost a quarter of a century after his death; of the sculptures in ivory or stone that Prince Johann Adam is known to have acquired directly from Rauchmiller himself (Wilhelm 1914, p. 35), none can any longer be identified.

Lebzelter, the collector from whom Prince Johann Adam purchased the tankard, was evidently too young to have been the client for whom it was originally carved. However, the suggestion that it was created for the imperial court seems to have little foundation. Its eccentric and complex quasi-literary theme in fact suggests that it may have been carved to follow a specific program suggested to the artist by an unusually erudite patron, and given Rauchmiller's close association and professional interaction with Casper von Lohenstein, it is not impossible that it was actually made for him.

JH

FURTHER REFERENCES: Casper von Lohenstein 1680; Cat. 1780, p. 262, no. 74; Nagler 1842, p. 310; Haendcke 1902, p. 89; Glück 1905, pp. 73–79; Höss 1908, p. 129; Pelka 1920, p. 256; Tietze-Conrat 1920, pp. 7–8, pl. 8; Berliner 1926, no. 211, p. 59; Feulner 1928, pp. 553–57, ill.; Cat. 1931, p. 19; Braun-Troppau 1940, vol. 9, and 1942, vol. 10; Decker 1943, p. 70, fig. 47; Gessner 1948, p. 77; Lucerne 1948, no. 255; *Burlington Magazine* 1954, p. 129; Philippovich 1961, p. 254, fig. 190; Theuerkauff 1962, pp. 96–129; Bregenz 1964, no. 123, figs. 36–37; Theuerkauff 1964, pp. 45, 308, 309 n. 145; Hempel 1965, pp. 79–80, 104; Munch 1966, pp. 51–62; Bregenz 1967, p. 66, fig. 99; Schikola 1970, p. 101; Theuerkauff 1973, pp. 245–86, fig. 32; Birke 1974, pp. 169–71, figs. 171–74 and p. 247, cat. A2; Birke 1976–77, pp. 164–75; Reber 1976–77, pp. 176–78; Sarasota 1980, no. 120; Birke 1981, pp. 23–25, 59–61, figs. 8–11; Philippovich 1982, p. 337, fig. 286; Aschengreen-Piacenti 1983, pp. 273–77; Theuerkauff 1983, pp. 194–208.

68

Ignaz Elhafen

Austrian, 1658–1715

THE RAPE OF PROSERPINA

Vienna, ca. 1690
Ivory; 4¾ × 7¼ in. (12 × 18.4 cm.)
Signed (on dog's collar): I.E.I. [Ignaz Elhafen Innsbruck?]
Liechtenstein inv. no. 510b

This relief and the following six (cat. nos. 69–74) were among a group of eighteen ivories described together by Fanti (Cat. 1767, pp. 42–43, no. 199), although without attribution. That they were framed and wall-mounted is clear from their context; in the same room in the Liechtenstein City Palace, Vienna, hung numbers of other miniatures in a variety of media: small parchment paintings, pietre dure, bronze plaquettes, boxwood reliefs, and more ivories. Of the total of thirty-three reliefs in boxwood and ivory hanging in this gallery, twenty-three (some of them now in the Kunsthistorisches Museum, Vienna) have been attributed to Elhafen, with varying degrees of certainty, by Scherer (1897, pp. 7, 9, 12), Tietze-Conrat (1920–21, pp. 166, 174), and most recently Theuerkauff (1964, pp. 146–47, 339, no. 63; 1968,

p. 133, no. 63). Although no documentation confirms the belief, it is probable, judging from the number of related reliefs in both the Liechtenstein and the imperial collections, that Elhafen worked for both Prince Johann Adam Andreas and the Emperor Leopold before departing Vienna to attach himself to the Düsseldorf court of Johann Wilhelm von der Pfalz.

It is from his Vienna work that Elhafen's major stylistic development can best be understood; in fact two of the boxwoods still in the Liechtenstein collection (Theuerkauff 1964 and 1968, nos. 14–15) may constitute his earliest identifiable work. Directly based on Matthaeus Merian's engravings of the Rape of the Sabines (*Hist. Chronica* 1657, p. 65), they show the artist at his least inventive. By contrast, in the *Rape of Proserpina*, Elhafen demonstrates a somewhat greater degree of independence from his source, in this case the 1605 engraving by Lukas Kilian (Le Blanc 56) after Josef Heintz's painting of the same subject for Rudolf II, now in the Gemäldegalerie, Dresden (Zimmer 1976, p. 254, no. A20; Gröhn 1966, vol. 3, p. 130).

The Heintz (like the Kilian) is dominated by the horses drawing Pluto's chariot, careening over the nymphs clustered in the foreground. The steeds seem about to burst from the canvas. Ovid (*Metamorphoses* 5.391ff.) described all the animals as black, but for his horse-loving patron, Heintz chose to portray two black and two white stallions. In Elhafen's rendering they are,

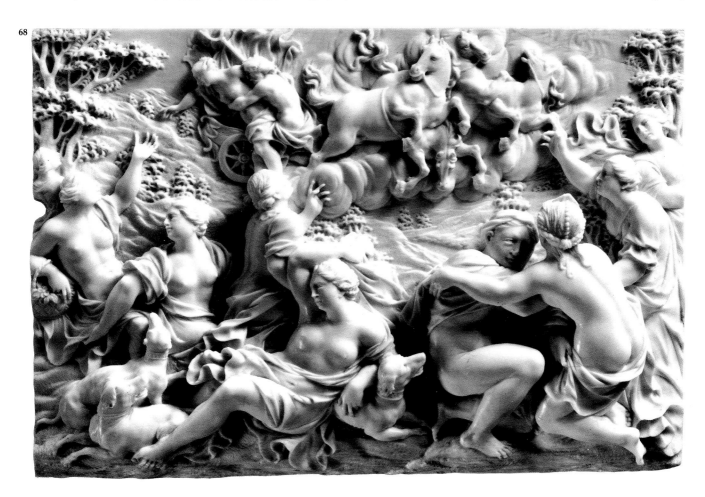

68

by virtue of the medium, less various and also considerably smaller; far greater emphasis is placed on the voluptuous nudes in the foreground. (It should be noted that Elhafen focuses on feminine beauty at the expense of plausibility.) Even while radically decreasing the chariot's scale, he retains its forward motion, thus giving the four-in-hand the appearance of approaching rather than departing the scene of the abduction. Still, as her pathetic gesture confirms, Proserpina's cause is a lost one; indeed, her desperate plight is not in the making, as in Elhafen's sources, but is a fait accompli. Her abduction is relegated to the distance and the past; the concern of the ivory composition is with her earthbound companions.

A certain indifference to the drama of the nominal subject is further revealed through changes Elhafen has made in the handling of the nymphs themselves. Although he has eliminated several of their number in order to enlarge the scale of those that remain, in one critical spot he has added an entirely new figure. In the midst of the nymphs, where Heintz had left a dramatic gap, graphically emphasizing the fact of the abduction, Elhafen has inserted the reclining figure of the goddess Diana. One of his favorite motifs (whose source has never been convincingly identified), it was also used in his relief of the *Abduction of Orithyia* in the Kunsthistorisches Museum, Vienna (Theuerkauff 1964 and 1968, no. 62), and in *Diana Resting After the Hunt* in the Markgräfliche Sammlungen, Baden-Baden (Theuerkauff 1964 and 1968, no. 60).

This repetition and recombination of motifs is characteristic of Elhafen, who would customarily rework his themes and alter the respective scales of his images over the course of time. The *Abduction of Orithyia* shows what is probably a later stage in Elhafen's revision of his elaborate Rudolfine source. Although the *Orithyia* still retains much of the Heintz composition, its cast of characters is even more changed. Here Elhafen has replaced the large pair of figures in the right foreground of the Proserpina relief, which derived from Heintz's composition, with a group taken from an altogether different source: J. de Bry's engraving of P. Moreelse's *Diana and Callisto* (Tietze-Conrat 1920–21, no. 27, p. 117, fig. 17). Orithyia's abduction is also rendered more plausible than Proserpina's as Boreas now moves more emphatically away from the cluster of nymphs below.

The *Rape of Proserpina* may have been paired, as were most of the ivories in the original Liechtenstein group of eighteen. Another single (now lost) relief, described by Fanti (Cat. 1767, p. 42, no. 195) as "Diana con diverse Ninfe, che cantano," although it would seem to have borne no thematic relation to the Proserpina relief, was close to it in size. Most of the Elhafen reliefs which compositionally resemble the Proserpina relief also appear to have been grouped. Three of these, now in a private collection in California, were together in the Max Strauss collection in Vienna at the beginning of this century (Theuerkauff 1964 and 1968, nos. 39–40, 43) and may relate to the Liechtenstein collection. One of them, *Diana and Callisto*, is, like the *Proserpina*, signed I.E.I.; the possibility that the two were paired should not be

ignored. Certainly, the *Abduction of Orithyia* may similarly have been paired with another *Diana and Callisto* in the Kunsthistorisches Museum, Vienna (possibly the earliest of Elhafen's essays on this theme), of the same format as the *Orithyia* and, like it, originally from Schloss Laxenburg (Tietze-Conrat 1920–21, pp. 129, 131, 170, no. 27, fig. 16; Theuerkauff 1964 and 1968, no. 42).

Theuerkauff (1964 and 1968) has assigned various overlapping spans to the reliefs which comprise this group, allowing the *Proserpina* a range of 1688 to 1695 and the *Orithyia* a somewhat wider one of 1685 to 1697; the California reliefs are called 1690 to 1695 while the Vienna *Diana and Callisto* is placed between 1690 and 1700. Criteria for dating them more narrowly are difficult to establish, for the reliefs have much in common. In addition to their closely related approach to landscape they share a similar, highly pictorial compositional technique. This results in a split in focus between the prominently carved figures in the foreground and the often narratively distracting situations carved in shallow relief in the middle ground. In his later work, in Düsseldorf, Elhafen resolved this conflict by unifying his entire subject matter in the foreground. However, his later work displays less interest in the warm textural possibilities of the ivory medium, exploited to such ravishing effect in several of the Liechtenstein group.

JH

FURTHER REFERENCES: Tietze-Conrat 1920–21, p. 139, figs. 56–57, pp. 147, 173, no. 49; Cat. 1931, p. 54; Zimmer 1967, no. A20e.

69–70

Ignaz Elhafen
Austrian, 1658–1715

PAIR OF MYTHOLOGICAL RELIEFS
Mars, Venus, and Vulcan Before an Assembly of the Gods
Orpheus and Hercules in the Underworld
Vienna, ca. 1690
Ivory; 4¾ × 6¾ in. (12.2 × 17.3 cm.); 4¾ × 7 in. (12.2 × 17.7 cm.)
Liechtenstein inv. nos. 510a, c

Both scenes, described by Fanti (Cat. 1767, pp. 42–43, nos. 194, 198) as the Assembly of the Gods, are somewhat odd compositions which Theuerkauff (1964 and 1968, nos. 65–66) cautiously accepted as Elhafen's work but found somewhat lacking in coherence. They are not comprehensive representations of Olympus but, rather, narrowly selected gatherings in which the characters appear chosen to represent particular themes; inv. no. 510a, for example, singles out for emphasis the players in the well-known Olympian love triangle of Mars, Venus, and Vulcan. The grouping depicted in its pair, inv. no. 510c, is less obvious in its principle of association; in fact it represents two mytho-

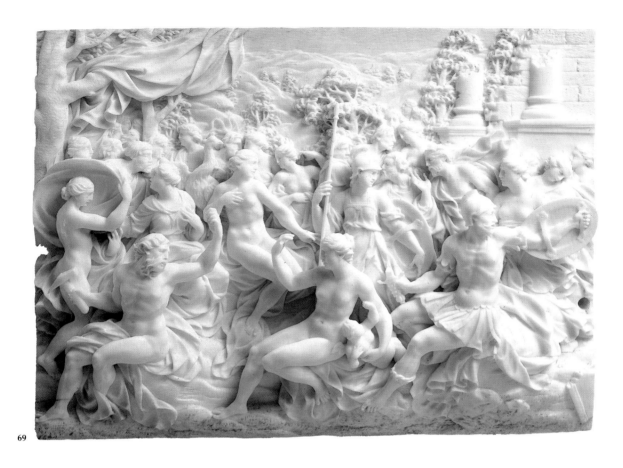

69

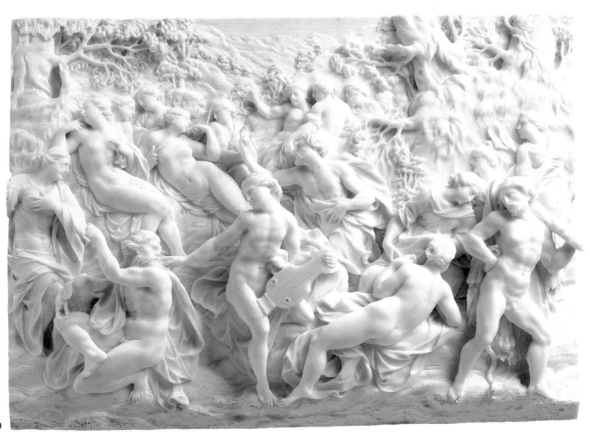

70

logical episodes not ordinarily conjoined (the separate descents by Hercules and Orpheus to the Underworld). The figure on the right of the relief is clearly Hercules; that on the left, sometimes identified as Vulcan, is more likely to be Pluto (although Cerberus is shown with only one head). While the central figure holding a lyre has always been thought to be Apollo, an identification with Orpheus would seem to make better sense in the context.

Orpheus and Hercules, here shown in attitudes of supplication and poignant appeal, were among the few mortals believed to have reemerged from a descent into Hades and therefore to have triumphed over death: Orpheus on his failed mission to retrieve Eurydice; Hercules in his final labor (borrowing Cerberus from the Underworld) and again in his rescue of Alcestis. Following this line of thought, the old man behind Orpheus could be Charon; to the far left, Proserpina looks down behind Pluto and Cerberus; the two women between Orpheus and Hercules may represent Eurydice and Alcestis. These images of immortality, as Cumont (1942, pp. 30, 304, 480) has documented, date back to Roman funerary symbolism (where, curiously, the amorous adventures of Mars and Venus are also featured on sarcophagi).

Supporting this interpretation is the disposition of the figures in a ravine-like landscape not commonly found in Elhafen's work but meant, perhaps, to represent the Elysian Fields. This setting, beneath the very roots of trees, was a common Northern Mannerist landscape motif generally rejected by Elhafen even when his graphic source included it. When, for example, he appropriated Lukas Kilian's engraving after Joseph Heintz's *Venus and a Satyr with Cupid* for his relief *Jupiter and Antiope* (Theuerkauff 1968, no. 64, figs. 107–8), he changed just that particular detail. Rather than nestling his figures within the rocky outcropping from which Kilian's gnarled tree springs, he set them upon a classically conceived block of stone. In the *Underworld* relief, Elhafen makes use of the more outdated picturesque device not once but twice, at both sides of the composition; it not only provides him with the opportunity for a particularly lush and sensual exploitation of the ivory medium but, when taken together with the mountainous background, creates the sense of an idyllic subterranean world.

Scherer (1897, p. 7 n. 1) did not include either of these reliefs in his list of Elhafen's work, and he specifically excluded from the artist's oeuvre the very similar pair in the Kunsthistorisches Museum, Vienna (Theuerkauff 1964 and 1968, nos. 67–68). Theuerkauff, while acknowledging the unusual density of the compositions, thought they were either very early works by Elhafen, close in carving style to his wood reliefs, or works done by a close follower. In our opinion, however, in addition to their style of carving and handling of foliage and landscape, the reliefs include typical examples of background motifs found in a group of compositions that are considered autograph and dated by Theuerkauff (1964 and 1968) between 1690 and as late as 1705. The *Mars and Venus* includes, to the left of Minerva's spear, a figure raising her veil behind her head with her left hand. This motif appears in both the background of the *Jupiter and Antiope* as well as in *Pan and Syrinx* in a California private collection (Theuerkauff 1964 and 1968, no. 40). In this same California relief the small figure is juxtaposed with two other figures that appear again in the left background of the *Underworld*: the turning seated female nude with right hand raised to her cheek and the veiled woman turning her head over her right shoulder. This couple appears again in the *Jupiter and Antiope* and in the *Diana After the Hunt* in the Markgräfliche Sammlungen, Baden-Baden (Theuerkauff 1964 and 1968, no. 60). The reclining figure in the *Underworld* also appears to fill a place in the composition quite similar to that of the central figure of Callisto in the *Diana and Callisto* in the Kunsthistorisches Museum, Vienna (Theuerkauff 1964 and 1968, no. 42; Tietze-Conrat 1920–21, no. 27, fig. 16). That same relief includes a draped overhanging tree branch like the one in the Liechtenstein *Mars and Venus*, a motif which appears again in the California *Pan and Syrinx*.

The two Liechtenstein reliefs, probably framed when Fanti described them, have been variously mounted over the course of time. Some of the mounting holes are now truncated at the right and left margins, showing that at one time the reliefs may have been wider. The missing(?) section of scroll at the lower right corner of *Mars and Venus* may have carried a signature.

JH

FURTHER REFERENCES: Theuerkauff 1964, pp. 101–3, 340; Theuerkauff 1968, pp. 99–100, 133–34.

71–74

Ignaz Elhafen
Austrian, 1658–1715

PAIR OF BATTLE RELIEFS
Alexander the Great Defeating Darius at the Battle of Arbela
Constantine Defeating the Forces of Maxentius at the Milvian Bridge

Vienna, ca. 1688–95
Ivory; 5⅝ × 10 in. (14.5 × 25.4 cm.); 5½ × 10 in. (14 × 25.4 cm.)
Signed: I.E.
Liechtenstein inv. nos. 533, 546

PAIR OF BATTLE RELIEFS
Scene from the Roman Wars
Scene from the Turkish Wars

Vienna, ca. 1688–95
Ivory; 5⅝ × 9 in. (14.2 × 23.1 cm.); 5½ × 9 in. (14.1 × 23.1 cm.)
Signed: I.E.
Liechtenstein inv. nos. 568, 558

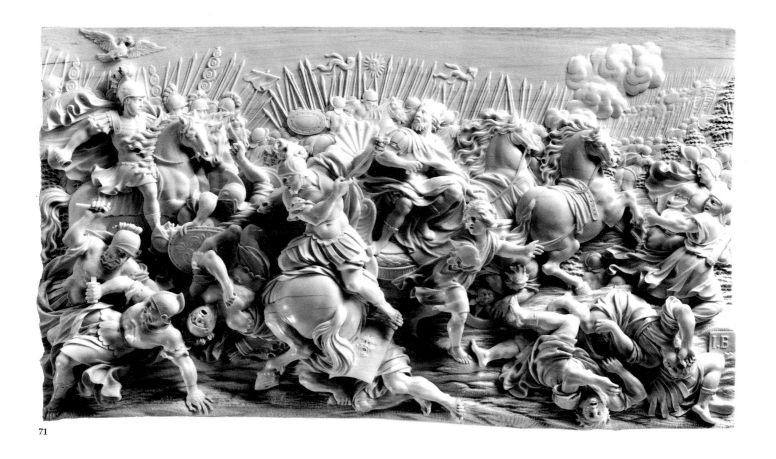

71

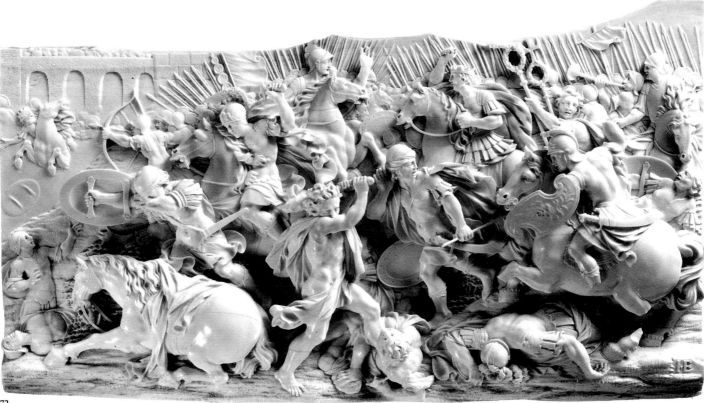

72

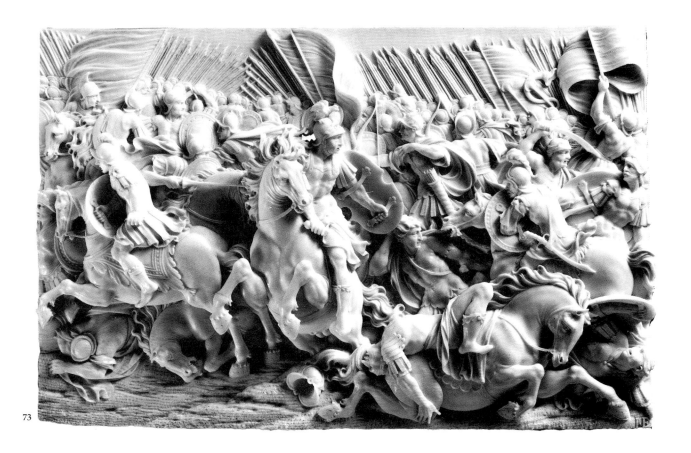

73

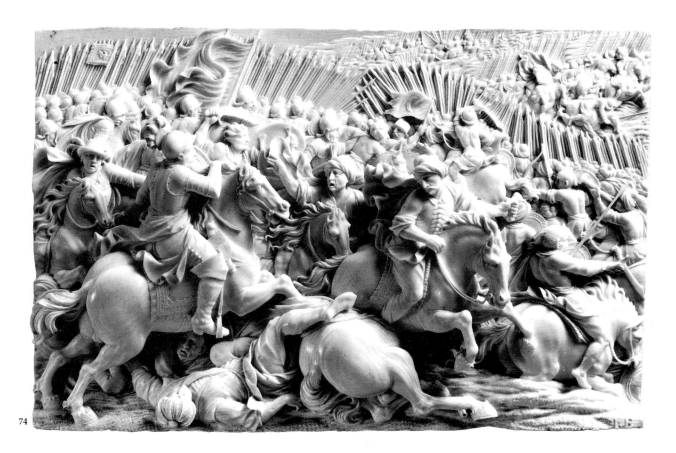

74

All four reliefs, similarly signed I.E. in the lower right corner, may have been commissioned by Prince Johannes Adam Andreas, as Theuerkauff (1968, p. 103) has suggested. They seem, however, to fall rather naturally into two pairs; this is not so much on the basis of their subjects (three ancient battles and one modern), but with respect to size, quality of ivory, and the nature of their compositions.

On the most obvious level, inv. nos. 533 and 546 are wider than the other pair (slightly wider in fact than any of the reliefs described by Fanti [Cat. 1767, p. 42, nos. 188–91]); their signatures also differ from those of inv. nos. 568 and 558, being placed on small, arbitrarily contrived, flat surfaces. Closer inspection also reveals a thematic coherence in the first pair of reliefs, each depicting a battle between a crowned warrior and a helmeted one. In inv. no. 533, which represents the Battle of Arbela, the helmeted figure of Alexander the Great, in the left middle ground, is the hero; the crowned figure, the Persian King Darius, is the fleeing victim. In inv. no. 546 it is the crowned figure who represents the victorious hero, Constantine the Great, in combat with the forces of his rival Maxentius. Maxentius himself is visible only in the very background—the minute, crowned figure seen drowning in the Tiber near the Milvian Bridge, the site of Constantine's vision of the Cross.

Compositionally a link between these two battle scenes can also be shown. In the Arbela relief, despite the fact that the ostensible movement is to the right background, the immediate effect is quite different. Faithful to its source, Robert de Mol's engraving (Tietze-Conrat 1920–21, fig.59) after Pietro da Cortona's

Fig. 22 Detail from cat. no. 71

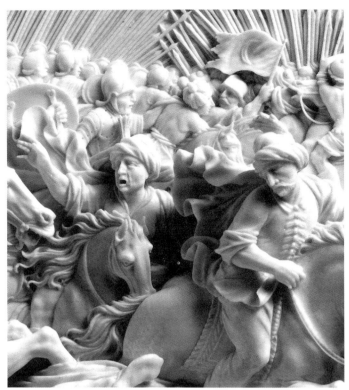

Fig. 23 Detail from cat. no. 74

broadly panoramic canvas of Alexander and Darius in the Palazzo dei Conservatori, Rome (Briganti 1982, no. 64), the movement sweeps across the surface of the ivory. The frieze of thematically subordinate, but sculpturally vivid combatants in the foreground, carved virtually in the round, zigzags across the picture plane; behind are the nominally central but plastically somewhat remote and flatter Alexander and Darius who, due to the inherent nature of the relief form, are relegated to sculpturally minor roles.

In the Constantine relief, the nominal subject is also pushed back, this time into the third rank; the drowning Maxentius himself is barely noticeable. At the center of interest is the group of figures including the soldier falling forward over his collapsing horse and the enigmatically nude club-swinging Hercules-like figure, his foot planted on his victim's throat. Some of these figures derive from engravings by Antonio Tempesta (B. XVIII, 156, 834, 837) and appear to have been pieced together from disparate sources to form a compositional pendant to the Cortonaesque relief. Like the anonymous combatants in the foreground of that one, they form a pattern that moves in and out of the picture's frontal plane. Both reliefs have lost some of their more strongly projecting elements, which would have emphasized this pattern even more.

In terms of subject, the rationale for pairing the other two reliefs, an anonymous classical battle and a contemporary battle between imperial and Turkish forces, is less apparent. However, the heavily striated ivory of this pair appears to come if not from the same tusk, then from two lots carefully selected

to be compatible; more significantly, the two reliefs also follow similar, more focused compositional formulas.

This pair lacks much of the headlong horizontal drive that characterizes the Alexander and Constantine reliefs. In the classical scene, as Tietze-Conrat (1920–21, pp. 138–41) pointed out, Elhafen has combined two different Tempesta engravings; he has inserted the vaulting figure of "Aemilius" from one (B. XVII, 156, 853), into the friezelike background of the other, a unidirectional cavalry charge (B. XVII, 156, 830). The ivory focuses, sculpturally and thematically, on the few figures in the foreground; behind them troops flock in the direction indicated by converging lances and upraised banner. Between the central group in front and the closely massed ranks of spears and the swaths of banners which form a decorative wall of pattern behind, the armies recede in gradual perspective with no vivid subject to interfere.

Nothing is known regarding the specific source of the Turkish battle. If not invented by Elhafen, it was selected by him, as a pendant to the Roman scene, from among the myriad depictions of such battles that commemorated the wars against the Ottomans between 1683 and 1699. As in the "Aemilius" relief, its friezelike format is broken in the center—here by the opening created by the falling Turkish soldier, through which one of his supplicant comrades is viewed facing forward. Again, between this main group and the retreating serpentine eddy of massed lances are only unified movements of troops in the background. As in its pair, but unlike the Alexander and Constantine reliefs, the focus is on a few thematically central foreground figures.

Considering the two pairs to be a group, Theuerkauff (1964, pp. 132–33) dates them all between 1693 and 1697; it is, however, not obvious that they do postdate Elhafen's Baden-Baden cylinder of 1693 (Markgräfliche Sammlungen; Theuerkauff 1968, p. 103, no. 17), as he maintains. The imperial victory at Mohács, which turned the tide of the Turkish invasion, took place in 1687, and the second pair, which includes the Turkish scene could date not too long after that. Whether these four reliefs simply represent two simultaneous manners of working or a stylistic progression of the artist is not at present possible to say; comparisons with the artist's earlier equestrian battle reliefs in Dresden, Vienna, and Vaduz (Theuerkauff 1964 and 1968, nos. 72–76), dated before 1685, are inconclusive. That they were conceived in two different modes, however, is quite clear.

JH

FURTHER REFERENCES: Scherer 1897, p. 7, nos. 16–19; Tietze-Conrat 1920–21, pp. 148, 174, nos. 45–47, figs. 25, 58; Theuerkauff 1964, pp. 130–33, 345–47, nos. 78–81; Bregenz 1967, no. 33, fig. 100 (Battle of Arbela); Theuerkauff 1968, pp. 103, 136–37, nos. 78–81.

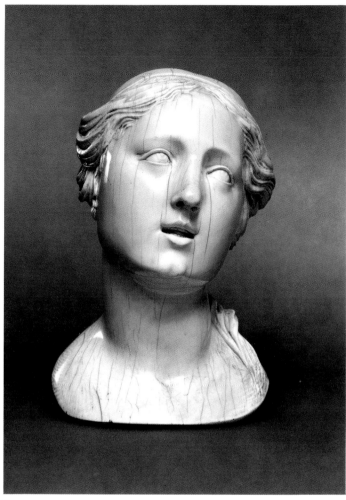

75

75–76

TWO FEMALE HEADS

Probably French, early 18th century
Ivory; height 8⅝ in. (21.8 cm.) and 8½ in. (21.6 cm.)
Liechtenstein inv. nos. 307, 303

These extraordinary and massive (for the medium) ivory heads, neither portraits, allegories, nor even *têtes d'expression*, were first described by Fanti (Cat. 1767, p. 106, nos. 134–35) simply as "Due teste di Donne di Avorio; alte once 7½." In modern times Sobotka has attributed them to François Duquesnoy (Thieme-Becker, vol. 10 [1914], p. 192), while the Liechtenstein house records refer to them as the work of Alessandro Algardi. This last attribution was based partly on the presence of a penciled monogram AL; this was said to be inscribed on the underside of the neck of inv. no. 303 but is no longer visible. The rationale for both old attributions is obvious. The more classicizing of the two heads with its demure expression, modestly downcast eyes, pursed mouth, and heavy nose recalls the manner of

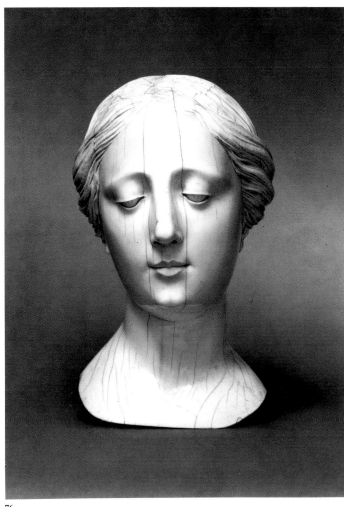

76

Furthermore, the studied arrangement and neatly ridged delineation of the compact masses of hair do not particularly put one in mind of Lenckhardt's more fluent, calligraphically rendered coiffures. Even less do the sleek and precisely outlined features, somewhat inorganically related to the faces, recall the evocative shorthand that characterizes his handling of detail. To account for these discrepancies, an advocate of Lenckhardt's authorship would have to rely on the absence of any other such extravagantly proportioned Lenckhardt ivories with which to compare them.

In fact, the affinities between these heads and Lenckhardt's Italianate carvings are essentially generic in that all of them refer back to the earlier seventeenth-century Roman exemplars cited above. That this expressive type was very broadly disseminated, however, is underscored by the close resemblance between inv. no. 307 and the face of an ivory bust in Milan (Zastrow 1978, pp. 47–48, no. 96, figs. 254, 256). Smaller than the Liechtenstein version, and with a separately carved coiffure, the Milan head is set into a highly ornamented, elaborately draped bust that justifies its cataloguer's attribution to a seventeenth-century Italian artist.

Still more explicit ivory replicas of antique and contemporary Italian marble sculptures in Italy are known, among them the ivory reductions acquired by Cardinal Leopoldo de' Medici before 1675 from the Nürnberg ivory-worker Balthasar Stockhamer (Aschengreen-Piacenti 1963, pp. 99–110). But in actuality the Liechtenstein heads are more classical in their mien than any of Stockhamer's carvings. Even the more ecstatic of the pair betrays a degree of abstract blandness and (in profile particularly) a heaviness that points toward a later, more staidly classicizing and antiquarian version of the Roman Baroque; the evolution of the style in the hands of the French comes particularly to mind. Indeed the sleek and slightly glacial aspect presented by these heads can also be discerned in a French ivory crucifix in Milan, formerly in the Durini collection (Zastrow 1978, p. 59, no. 144, figs. 361–62). While this was a gift to Cardinal Durini from Louis XV in 1747, there is no reason to believe that it was new at that time. It may well date to the earlier part of the century.

We are unfortunately less well informed than we might wish concerning specific stylistic developments in French ivory carving during the postmedieval era. Nonetheless beyond these stylistic parallels between the heads and the Durini crucifix, other more circumstantial evidence supports the notion of their French origin. The interest in Duquesnoy, so obviously displayed by the carver of these heads, was a salient aspect of French taste. The persistent reverence for the Flemish sculptor's work, for example, is one of the notable features of the collection of the French court sculptor François Girardon, revealed not only in his inventory but also in the idealized engravings of his gallery which were published in 1709 (Souchal 1973, pp. 1–94). Also pointing to an origin around this time is the striking *all'antica* quality presented by these isolated undraped heads.

Duquesnoy's much reproduced bust, *Madonna* (Schlosser 1910, vol. 1, pl. xli, p. 16). The beribboned one, with transfixed upward gaze and parted lips, clearly emulates an ecstatic Baroque model frequently found in seventeenth-century Roman sculpture: Bernini's *Anima Beata* and *Santa Bibiana*, Algardi's *Magdalen*, and Ercole Ferrata's *Santa Agnese* are only a few examples of the type, which has its most obvious precedent in the paintings of Guido Reni.

More recently, scholars have attempted to associate the Liechtenstein heads with the work of the Würzburg ivory-carver Adam Lenckhardt (1610–61), partly, it would seem, on the basis of the inscription. However, the pair are not among the ivories by Lenckhardt described in seventeenth-century Liechtenstein inventories (Fleischer 1910, pp. 26–37, 225–26). Moreover, they do not present the impression of Lenckhardt's personal style that infuses even the most Italianate of his carvings, cited by Sandner (Bregenz 1967, pp. 52–53) and Theuerkauff (1971, pp. 35–37) as parallel (among them the *Deposition* in the Metropolitan Museum, acc. no. 24.80.87). The Würzburg carver's work lacks the striking geometry of form so prominent in these heads.

In the Liechtenstein palace they were exhibited in an assembly of eight small "teste" of like size. The six others were alabaster, four of them representing Roman Emperors. They appear to have served as miniaturized equivalents of the antique busts that would have decorated the walls of a late seventeenth-century "gallery" (much as the bronze versions of antique heads supplied to Prince Johann Adam Andreas by Massimiliano Soldani [cat. nos. 55–62] were intended to function). Charpentier's suite of engravings, characterized by the proliferation of sys-tematically paired antique marble busts, testifies to the fact that by the early eighteenth century the interest in such display extended to France. It is entirely possible that Joseph Wenzel, who served as imperial ambassador to the court at Versailles, could have acquired these small heads during his tenure there.

JH

FURTHER REFERENCES: Cat. 1780, p. 261, nos. 70, 72; Cat. 1931, p. XIX (?); Fransolet 1942, p. 110; Bregenz 1967, nos. 72–73; Theuerkauff 1965, pp. 59ff; Theuerkauff 1971, figs. 13–14.

II

Princely Splendor

FIREARMS

The Princely Collections of Liechtenstein include one of the last great armories in Central Europe to have survived in the possession of the family who were its original owners. The armory comprises plate armor and edged weapons, and firearms and artillery, but it is the hand firearms (guns and pistols) that are of the greatest historical and artistic interest. The collection, one of the largest extant, includes more than one thousand firearms, ranging in date from the sixteenth through the nineteenth century, with examples from every corner of Europe —France, the Netherlands, Spain, England, Denmark, Italy, and the territories of Central Europe that constituted the Holy Roman Empire. While the Liechtenstein armory contains fewer decorated firearms than are found in the major dynastic collections in Vienna, Munich, Dresden, Copenhagen, and Stockholm —all now state-owned public museums—it nevertheless presents a more accurate picture of the *Gewehrkammern* (cabinets of arms) assembled by the high nobility in Central Europe during the Baroque period.

Most of the Liechtenstein firearms are sporting weapons—for the hunt and for target shooting—that the Princes of Liechtenstein collected for themselves and for their families, retainers, and guests to use at hunting parties on their estates in Austria, Bohemia, Moravia, and Silesia. Designed as luxury arms, they were technically efficient and aesthetically pleasing, and many bear the names of the finest gunmakers of the time. Some are so richly embellished—the target rifle by Johann Michael Maucher (cat. no. 83), for example—that they appear to have been created solely as works of art. Such weapons required the skills not only of a barrelmaker, lockmaker, and gunstocker, but of specialized designers and decorators as well, and they were therefore collected and appreciated as virtuoso demonstrations of craftsmanship. The possession of such skillfully made, elaborately ornamented, and invariably costly firearms reflected the taste, wealth, and social status of their owners.

Weapons, either as instruments of attack or for self-defense or food gathering, were respected and prized by their possessors and were actively collected as souvenirs of past wars, mementos of illustrious ancestors, and examples of human ingenuity and workmanship. The symbolic value of weapons is underscored by the fact that a monarch frequently presented them to his subjects in recognition of political or military services rendered or as tokens of esteem. The Princes of Liechtenstein were also givers and recipients of firearms, and several guns included here seem to have been acquired as gifts (cat. nos. 78, 84, 87). Certainly, the most splendid of gifts was the magnificent garniture of Spanish fowling pieces (cat. nos. 94–100) presented to Prince Joseph Wenzel by his sovereign, Emperor Joseph II, in 1767.

The Princely Archive is rich in documents pertaining to the firearms commissioned or purchased by the various Liechtenstein Princes, from Karl I to Joseph Wenzel. Most important are the numerous inventories of the princely *Gewehrkammer* which, in the seventeenth and eighteenth centuries, contained mainly hunting arms. Many of the present firearms can be recognized in one or more of these inventories, thereby establishing the weapon's ownership and the date by which it had been acquired. The survival of so extensive a series of documents is without parallel and, indeed, almost miraculous. Once these documents are transcribed and analyzed, they will provide insight into the size, scope, and diversity of the Liechtenstein *Gewehrkammer*, shedding light on trends in firearms collecting in Central Europe in the seventeenth and eighteenth centuries.

The selection of firearms for this exhibition was made for two distinct reasons. The first twenty-four items (cat. nos. 77–100) were chosen as works of art from among the most beautiful arms in the Liechtenstein collection. They attest to the skill of their makers and to the taste of their princely owners. In a broader sense, they also reflect the technical innovations and artistic developments of the period and, specifically, of the geographic centers in which they were produced. The three panoplies, numbering one hundred wheellock and flintlock firearms (cat. nos. 101–3), provide an idea of the sheer number of weapons assembled by the Princes for use in the hunt, the chief aristocratic pastime in the seventeenth and eighteenth centuries. The Liechtensteins were vigorous and enthusiastic hunters, and one member of the family, Prince Hartmann (1666–1728), even served as grand master of the hunt (*Oberstjägermeister*) under Emperor Charles VI. In spite of the practical uses for which these weapons were intended, they are handsomely decorated.

Whereas war, political turmoil, and neglect have led to the destruction or scattering of most of the great hereditary arms collections in Central Europe, the survival of the Liechtenstein *Gewehrkammer* can be attributed, in part, to the esteem in which the firearms were held by successive generations of Princes. Beginning with the testament of Prince Johann Adam in 1712, the princely art collections—including the *Gewehrkammer*—were legally protected from dispersal under the terms of a *Fideikommiss*, or entailed estate. In this manner, the collections passed intact, by inheritance, through a long line of Princes with the result that the arms collection today comprises the aggregate of their holdings. Because firearms played a functional role in the daily life of the Princes, and in their activities as military leaders and aristocratic huntsmen, they represent a more personal aspect of the collection than do the Princes' famous paintings and sculpture.

Stuart W. Pyhrr

PAIR OF WHEELLOCK PISTOLS

German, ca. 1580–90
Steel, wood, staghorn, gold; length overall 20⅛ in. (51.2 cm.); length of
* barrels 12⁹⁄₁₆ in. (32 cm.); caliber .56 in. (14 mm.)*
Liechtenstein inv. nos. 142–43

The heavy barrels are octagonal at the breech, changing to round, with slightly flaring muzzles. Three panels of etched arabesques, completely gilt, decorate the breech, center, and muzzle. Each barrel is stamped with a maker's mark—a shaped shield enclosing the letters WM above a cogwheel (not in Støckel)—and is incised with the inventory numbers 142 and 143, respectively. The latter pistol is also stamped on the side of the barrel with the crowned CL cipher of the Liechtenstein collection.

The wheellocks are of conventional construction. The lockplates are completely etched, with gilt borders of scrolling foliage on a dotted ground framing a center panel of bright strapwork and scrolls on a blackened ground. The solid domed wheelcovers are etched and gilt with two eagles. The flat faces of the cocks are engraved with a bull, a ram, and, on the jaws, a dragon's head. The clocksprings, pans, and safety springs are blued; the push-button pancover release and pivoting safety catches are gilt.

The stocks are completely overlaid with a marquetry composed of tiny pieces of staghorn forming a dense pattern of stylized foliate scrolls and with large horn plaques engraved with figural and foliate motifs, the incised lines blackened for contrast. The decoration of each pistol is identical and includes: behind the lockplate, a couple seated at a table singing to the accompaniment of a lute-player; on the left side (that opposite the lock), male and female river-gods, birds, a griffin, a lion, and a bear and, around the lock screws, satyrs and dogs;

on the back of the grip, an allegorical figure labeled ɪVRɪSPRVDECE (on inv. no. 142) and THEOLOGIE (on inv. no. 143); around the barrel tang, nude male and female figures emerging from the mouths of sea monsters; and on the underside of the forestock, interlaced strapwork enclosing male and female figures, masks, fruit, and foliage and, at the center, the infant Hercules strangling a snake. The staghorn ramrod pipe is engraved with equestrian battles with nude figures, with Hercules battling the Trojans on inv. no. 142, inscribed HERCVLES MVLTIS BELLIS LACESSIT TROIAM (Hercules provoked Troy in many battles), and with Hercules abducting Iole on inv. no. 143, inscribed EVRYTI REGIS FILIAM IOLAM OCCISO PATRE ABDVXIT HERCVLES (Hercules abducted Iole, the daughter of King Eurytus, after having slain her father). The fore-end caps are of staghorn engraved with satyrs peering through strapwork. The wooden ramrods (replacements) have engraved horn tips. The baluster-shaped triggers (that of inv. no. 143 is a replacement) and triggerguards are gilded iron.

This pair belongs to a large class of wheellock pistols with large spherical pommels made principally in Germany and also in parts of Western Europe during the last third of the sixteenth century. Known in German as *Puffer*, this type of pistol was primarily intended for use on horseback and was carried in pairs in holsters suspended from the front of the saddle. The massive pommel somewhat counterbalanced the heavy barrel and thus allowed a better grip on the weapon and an easier withdrawal from the holster. The thick-walled barrel and large lock mechanism, with sturdy mainspring attached directly to the interior of the lockplate (the conventional wheellock construction used throughout Europe, except in France and its neighboring territories; see cat. no. 80), dictated the cumbersome

77

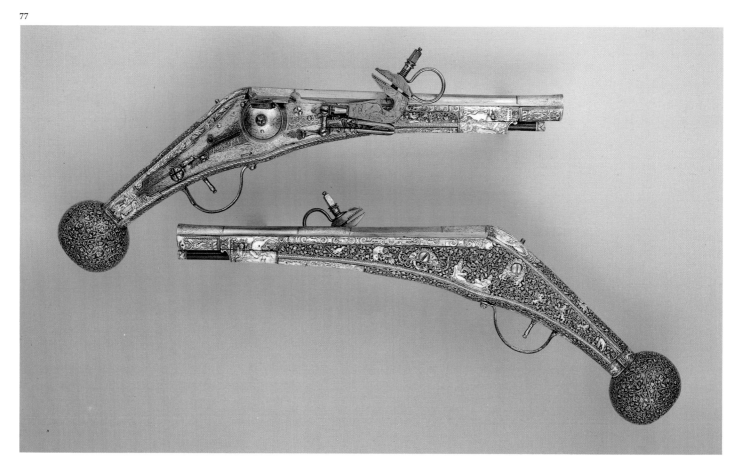

size and proportion of the stocks. These pistols were the standard armament for cavalry and were also used for hunting on horseback at close range.

These pistols rank among the most elaborately decorated and beautiful of the *Puffer* type and are more likely to have been intended for display in a *Kunstkammer* than for actual use. Their manufacture required not only the skills of a barrelsmith, a lockmaker, and a stocker, but also the talents of an etcher and a gilder for the metal parts and of specialized woodworkers and engravers for the decoration of the stock. The figural decoration on the stock is particularly noteworthy for its ambitious variety and skillful engraving. Many of the motifs can be traced to the ornamental prints issued by engravers in Paris, Antwerp, and Nürnberg that were used by arms decorators before the advent of specialized firearms patternbooks. (The same prints were used by other craftsmen, among them goldsmiths, jewelers, enamelers, and cabinetmakers.) The decorator of these stocks had before him a variety of prints. The equestrian battle scenes with Hercules on the ramrod pipes are copied from two engravings for the *Labors of Hercules*, a series by Hans Sebald Beham (1500–1550, act. in Frankfurt from 1531) issued between 1542 and 1548 (Hollstein n.d., vol. 3, pp. 67–69, nos. 105, 107). The decorator must also have possessed the series of grotesques with allegorical figures by the Parisian engraver Étienne Delaune (1518/19–1583), as the personifications of Jurisprudence and Theology on the grips of the stocks and the river-gods and the dogs framing the lockplate screws on the left side of the stock derive from this undated series (Robert-Dumesnil 1865, vol. 9, pp. 103–4, nos. 341–45). The motif of the infant Hercules within an elaborate strapwork frame on the plaque beneath the stock recalls the style of Virgil Solis (1514–62) of Nürnberg, and the satyrs in strapwork on the fore-end caps recall a motif frequently used by the Flemish engraver Cornelis Bos (act. 1540–d. 1556).

The finest wheellock pistols of this type were made in the South German cities of Nürnberg and Augsburg. Indeed, the etched lockplates on the Liechtenstein pistols are particularly close in appearance to those on several Nürnberg pistols in the collection of the Metropolitan Museum (14.25.1406a,b; 14.25.1430; 14.25.1434). However, the stock decoration is so similar to that on a matchlock target rifle of distinctly Nürnberg type in the Bayerisches Nationalmuseum, Munich (inv. no. W1447; see Schalkhausser 1966, pp. 7–8), which is inscribed in German "Wolf Lucz, gunstocker at Mergendthal 1584," as to have been made by the same craftsman. "Mergendthal" presumably refers to the town known today as Bad Mergentheim, (formerly Merghenthal), south of Würzburg (and probably not a town of that name in Bohemia, as was suggested by Schalkhausser). On the strength of their strong stylistic similarities to the gun in Munich, the Liechtenstein pistols must be attributed to the otherwise unrecorded firearms decorator Wolf Lucz.

These pistols (as well as cat. nos. 81, 84, 91, 93) were part of the *Gewehrkammer* kept in the Liechtenstein palace at Kromau, in Moravia, in the nineteenth century. They were included among the group of arms lent by Prince Karl Rudolf (1827–99) to the important exhibition of arms and armor held in Brünn (now Brno, Czechoslovakia) in 1885 (Prokop and Boeheim 1886, p. 20, pl. xv, fig. 2 [pistol no. 142]).

SWP

FURTHER REFERENCES: Cat. 1952, p. 51, no. 264; Blair 1979, fig. 15.

78

WHEELLOCK CARBINE

German, ca. 1600
Steel, wood, staghorn; length overall 26⁷⁄₁₆ in. (67.8 cm.); length of barrel 16⁷⁄₈ in. (42.9 cm.); caliber .48 in. (12 mm.)
Liechtenstein inv. no. 3603

The barrel of bright steel is octagonal at the breech, changing to round, with a turned molding between the sections and at the breech and muzzle ends. The backsight is chiseled with a series of grooves and ridges; a bead-shaped foresight is welded to the muzzle ring. A maker's mark in the shape of a pomegranate (not in Støckel) is stamped into each of the upper three facets at the breech.

The wheellock of bright steel is fitted with an enclosed wheel and push-button pancover release. The neck of the cock, the base of the cocking ring, the finials of the cockspring, and the pancover are chiseled with close-set ring moldings.

The full-length stock of walnut terminates in a scroll-shaped butt. The planes of the stock and the spiral of the butt are outlined in strips of staghorn, and both sides, as well as the underside, are inlaid with staghorn plaques engraved with the insignia of the Order of the Golden Fleece (crossed ragged staves, flints, and fire-steels striking flames); the flames extend around the grooved spiral channels of the butt. A staghorn plaque on the underside of the stock behind the ramrod is engraved with the cipher of Archduke Matthias of Austria (1557–1619) surmounted by the archducal crown. The mounts are of bright steel. The trigger has an adjustable pressure screw; the triggerguard is shaped to accommodate three fingers. The rear lock screw on the left side of the stock also secures a ring, presumably for attaching the gun to a bandolier. The wooden ramrod has an engraved staghorn tip.

This carbine was made for Archduke Matthias of Austria. The prominence of the emblems of the Order of the Golden Fleece suggests that the gun was made in 1596, the year in which Matthias became a member of that order, or shortly thereafter. In any case, the carbine must date before 1612, when Matthias became Holy Roman Emperor and assumed the imperial crown. The same monogram found on this gun is also included in the decoration of the three series of halberds made for Matthias's bodyguard corps in 1578, 1595, and 1612.

The Liechtenstein carbine is one of five wheellock firearms associated with Archduke Matthias—each having a scroll-shaped butt and a stock inlaid with emblems of the Order of the Golden Fleece—that were apparently made for his personal use. Three of the guns are virtually identical, measuring 45¼ in. (115 cm.) long, with rifled barrels of .59 in. (15 mm.) in caliber; these are in the Musée de l'Armée, Paris (inv. nos. M.89, M.90) and in the

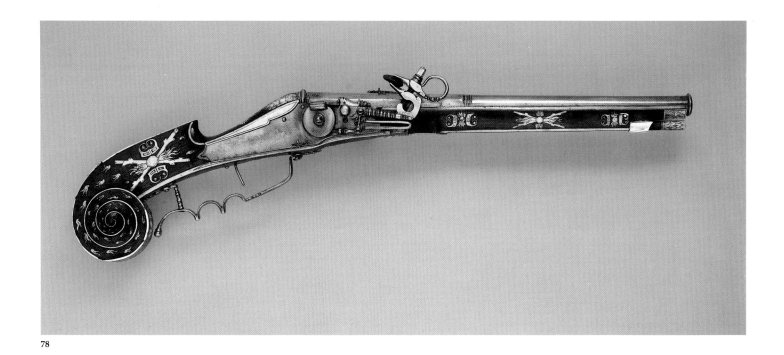

78

Museum für Deutsche Geschichte, Berlin (D.D.R.). The fourth example, also in the Musée de l'Armée (inv. no. M.88), is much longer, measuring 57 ⅟₁₆ in. (145 cm.) long, with smoothbore barrel having a caliber of only .35 in. (9 mm.). Unlike the others, the last gun has a gilded barrel and lockplate; it does not, however, bear the Archduke's monogram. All five guns appear to have been made for the Archduke's personal use rather than for his bodyguard, which would have been equipped with less decorative arms of uniform size.

The scroll or volute-shaped butt, so characteristic of Matthias's firearms, is a particularly felicitous decorative design that was, however, seldom repeated again. It differs dramatically from the two basic shapes of butts of that period: the straight, so-called German cheek-stock, which, as the name implies, was held against the cheek and was mostly used for wheellock rifles in Central Europe; and the triangular, shoulder-held stock favored throughout Europe for military muskets. However, in the years around 1600, German stockers experimented with single and double volute-shaped butts, mostly for military-type arms with combined wheellock and matchlock mechanisms, whose decorative profiles may reflect the influence of the scrollwork ornament of Mannerist inspiration that was prevalent in the decorative arts of the time (Krenn 1983, pp. 42–53). The example closest to Matthias's gun is a beautiful Nürnberg wheellock hunting rifle, dated 1599, in the Nationalmuseum, Kraków (inv. no. v–1390), whose scroll-shaped butt is inlaid with figures and grotesques in staghorn and mother-of-pearl. A scroll-shaped butt is also found on a German crossbow of about the same date in the Tower of London Armouries (inv. no. XI–16). Outside of Germany the scroll butt was used at least once—again for purely decorative effect—on an early flintlock gun dating

about 1610–20, made for Louis XIII of France by Pierre Le Bourgeois (d. 1627) of Lisieux, Normandy (Metropolitan Museum, 1972.223).

None of Matthias's guns are recorded prior to the nineteenth century, and it is likely that they were kept in the Vienna arsenal until 1805, when French troops removed quantities of arms and armor as booty (Thomas 1941, pp. 189–94). Two of the Paris guns entered the Musée de l'Armée as gifts of Baron Marbot (1859) and Colonel Pernety (before 1862) (Robert 1893, vol. 4, p. 41) while the provenance of the third gun appears to be unrecorded. The Berlin gun can be traced to the collections of the Earl of Londesborough in England (sold at Christie's, London, July 4–11, 1888, lot 375) and Richard Zschille of Grossenhain, Saxony (sold at Christie's, January 25–February 1, 1897, lot 314). Wilhelm (1970, p. 423, figs. 1–2) has suggested that the Liechtenstein gun may have been a gift from Matthias to Prince Karl I von Liechtenstein (1567–1627), but as this distinctive weapon cannot be recognized among the Liechtenstein *Gewehrkammer* inventories of the seventeenth and eighteenth centuries, it is possible that it entered the collection at a later date. The carbine is, however, recognizable in Rudolf von Alt's watercolor showing the display of firearms in the Liechtenstein palace at Feldsberg, painted in 1845.

SWP

FURTHER REFERENCES: Cat. 1952, p. 51, no. 261; Blair 1979, p. 50, fig. 12.

WHEELLOCK RIFLE

German (Nürnberg), ca. 1610–20
Steel, ebony, staghorn, mother-of-pearl, brass, gold; length overall 39¾ in.
(101 cm.); length of barrel 29½ in. (75 cm.); caliber .52 in. (13 mm.)
Liechtenstein inv. no. 3822

The rifled octagonal barrel of bright steel is engraved at the breech, center, and muzzle with scrolling foliage and at the center with a mask; it is fitted with a brass bead foresight and a notched steel backsight. Five different marks are found at the breech: on the top facet, a shaped shield enclosing a bugle (Støckel no. 5966) and above this an incised N (similar to Støckel no. 1601); on the facets to either side, the initials A and K (Støckel no. 1895); and, on each side of the barrel, the Nürnberg mark, composed of the city arms in a shield surmounted by an N (similar to Støckel nos. 1581–85).

The wheellock of bright steel is of conventional construction, with push-button pancover release. The lockplate is engraved with a bird and foliate scrolls matching the decoration of the barrel; the cock is engraved with masks and a dragon's head. The openwork wheelcover is of blued steel. The lockplate is stamped with the Nürnberg mark and the maker's mark, a shaped shield enclosing the letters LH above two tassels (Støckel nos. 3770–73).

The straight stock of German form is completely covered with a marquetry of ebony veneer, white and green-stained staghorn, and mother-of-pearl. At the top of the stock, behind the barrel tang, the ebony is twice stamped with the letter N (Nürnberg). The mother-of-pearl plaques are cut out and incised to represent human figures in various domestic and pastoral settings, as well as hunters, dogs, deer, rabbits, and ducks. On the cheekpiece is a domestic group seated around a table with musicians and refreshments; the tiled floor beneath is executed in green-stained staghorn. Other figures include a musician playing a viola da braccio and several couples drinking and singing. On the underside of the stock is a male figure in Eastern European (Hungarian or Polish) costume holding a *fokos* (combined axe–walking stick). Between the pearl plaques the ebony veneer is incised with scrolls, formerly inlaid with gold leaf. Strips of white staghorn engraved with geometric and foliate ornament outline the planes of the stock. Staghorn plaques to either side of the barrel tang are engraved with busts of a European and a Turk, and a hunter in contemporary European costume is engraved upon the horn-veneered sliding butt-trap cover. The buttplate, also of staghorn, is engraved with a turbaned Turkish warrior holding a mace. The set-trigger and triggerguard are bright steel. The original wooden ramrod has an engraved horn tip.

The wheellock rifle was the principal sporting arm used in Central and Eastern Europe, with relatively little change in its basic appearance from the mid-sixteenth to the mid-eighteenth century. Barrels rifled (from the German *riffeln*, "to groove") with spiral grooves imparted a spin to the ball and thus ensured a straighter trajectory. Rifled barrels were the specialty of German craftsmen, whereas smoothbore barrels, which were less difficult and less expensive to manufacture, were favored by gunmakers and hunters in Western and Southern Europe. German wheellock rifles have a peculiar form of stock, straight in shape—the right side of the butt is carved with a recess to hold pyrites and wadding, with a sliding spring-held butt-trap cover; the left side is concavely shaped to fit against the hunter's cheek. The recoil was thus absorbed by the shooter's arms and by the heavy barrel and stock typical of these weapons. Other features of these rifles include a set-trigger mechanism with two triggers with adjustable pull, and a large triggerguard with indentations for the fingers that promoted a steadier grip when aiming.

The colorful decoration of the stock, with its marquetry of ebony and incised plaques of staghorn and mother-of-pearl, is characteristic of a large and well-known group of South German firearms dating to the first third of the seventeenth century. Many of the wheellock rifles, smoothbore carbines, and pistols that make up this group bear Nürnberg marks, as does this example, and it is likely that this famous arms-producing city in Southern Germany was also the home of the stock decorator.

79

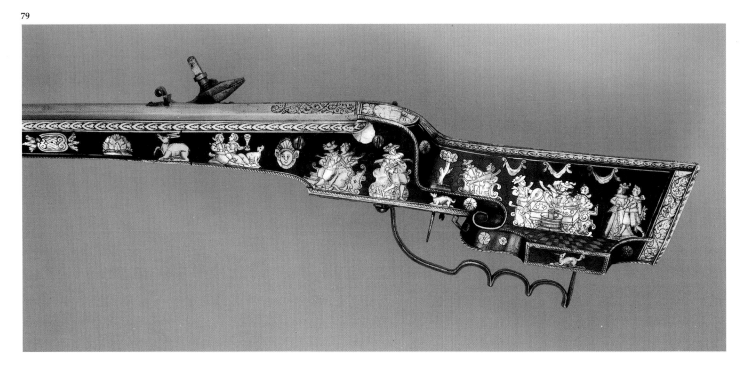

As none of the stocks is signed, Boccia (1974, p. 86) has assigned the name "Master of the Castles" to this workshop because of the castles that are frequently incorporated in the decoration. Although this decorator often represented scenes from ancient history, usually with warriors dressed in classical armor, his hunting scenes and bucolic open-air banquets, peopled by figures in contemporary costume, are even more appropriate for sporting weapons. The figures in Turkish and Eastern European dress reflect the European fascination with peoples in distant lands and were probably copied from popular costume books of the time. The figural subjects on some of these guns are said to be inspired by the late sixteenth-century engravings of Jost Amman and Hendrik Goltzius, though Boccia (1974, p. 86 n. 18) has pointed out that the costumes appear to be of early seventeenth-century date. This dating is generally corroborated by the only dated piece from this workshop, a powderflask of 1616 in the Tower of London (inv. no. XIII–17). The figural scenes on the present rifle have a homespun, folk-art quality of great charm.

The marks on the barrel, lock, and stock leave no doubt as to the Nürnberg origins of this rifle. The initials AK on the barrel have been identified by Schedelmann (1972, p. 89) as those of the well-known Nürnberg barrelsmith Augustinus Kotter (act. ca. 1616–35), who appears to have specialized in the manufacture of barrels with bores of square, triangular, or rose shapes. However, these initials do not occur on the guns inscribed with Kotter's full name and are frequently found on barrels drilled with the usual circular bore, thus leaving this attribution in doubt. A pair of Nürnberg wheellock rifles in Skokloster Castle, Sweden (Meyerson and Rangström 1984, pp. 104–5) has barrel markings similar to those of the Liechtenstein rifle, and this pair is also tentatively attributed to Kotter. The two Skokloster rifles, which are approximately contemporary with the present example (rather than ca. 1630–40, as suggested by Meyerson and Rangström 1984, pp. 84–110), have their locks and barrels decorated with the same foliate ornament and bird as the Liechtenstein rifle; all three were presumably decorated in the same workshop.

The N's stamped into the ebony veneer of the stock may indicate the custom of the Nürnberg cabinetmakers' guild (as was the practice in Augsburg) of applying to their productions the town mark as a guarantee of genuine ebony, though gunstocks of mahogany are occasionally also stamped with the town mark (Meyerson and Rangström 1984, pp. 134–35, 159–60). The Liechtenstein rifle is the only recorded example of the Master of the Castles group to have its stock stamped with Nürnberg marks and thus is important in reaffirming the Nürnberg origins of this anonymous gunstocker.

SWP

FURTHER REFERENCES: Stockerau 1902, p. 41, no. 275; Feldkirch 1971, no. 107.

80

PAIR OF WHEELLOCK PISTOLS

French, ca. 1620
Steel, fruitwood, brass, silver, gold; length overall 24 15/16 in. (63.9 cm.);
* length of barrel 16 13/16 in. (42.7 cm.); caliber .50 in. (12.5 mm.)*
Liechtenstein inv. nos. 865–66

The slender, slightly tapering octagonal barrels of dark gray color (formerly blued?) are chiseled at the breech, center, and muzzle with trophies of arms and foliage against a stippled ground, with traces of gilding. Between these areas are foliate scrolls formed of punched dots, with a cross-shaped ornament of five silver studs set into the top of the barrel between the breech and center areas. The breech and muzzle ends have shallow filed moldings, and the short squared tangs are decorated with close-set file lines, with traces of gilding.

The wheellocks are of French construction. The flat lockplates with beveled edges are blued and terminate at the back with a baluster-shaped finial. The exposed wheels of bright steel are secured by gilded baluster-shaped wheelguides. The cocks, also of bright steel, are plain; the cocksprings are chiseled with foliage. The pancovers, cocksprings, and bridles retain traces of gilding. Stamped on the lockplates between the wheel and cock is an unidentified gunmaker's mark, a crowned fleur-de-lis within a shaped cartouche (not in Stöckel).

The fruitwood stocks are profusely inlaid in brass and silver wire forming a continuous strapwork interlace (in silver) enclosing foliate scrolls, laurel branches, and, on the left side around the bearingplate, trophies of arms and musical instruments (in brass). One of the pistols (inv. no. 866) retains its oval escutcheon of silver sheet, worked in relief with trophies of arms. The ovoid pommels are octagonal in section and are inlaid with brass and silver wire en suite with the rest of the stock. Longitudinal bands of silver sheet of alternating widths are set into recesses in the pommels: the narrow bands are stamped with a repeated foliate design, the wider bands with crossed branches of palm and laurel, vases of flowers, and trophies of arms beneath a canopy against a diagonally cross-hatched ground. A large rosette of stamped silver sheet forms the terminal of the pommel, while a narrow collar of silver sheet, stamped with repeated circles, covers the join between the grip and pommel (the collar on inv. no. 866 is missing). The holes in the forestock, through which the barrel pins pass, are framed by six-petaled rosettes of silver sheet. The fore-end cap on each stock is of silver sheet worked in relief, on either side of the ramrod, with trophies of arms. Another plaque of silver sheet was formerly attached to the underside of the stock at the base of the ramrod, but it is missing from both pistols. The strap beneath the grip, the offset trigger, the triggerguard, and the tubular ramrod pipe on each pistol are gilded iron. The V-shaped bearing plates are chiseled and gilded with foliage en suite with the barrels. One of the original ramrods, inlaid with silver wire and fitted with a gilded iron tip, is preserved.

By the middle of the sixteenth century French gunmakers had devised a distinctive form of wheellock construction, the main features of which are evident on these pistols. On the French wheellock the spindle of the wheel passes completely through the stock and rotates in a hole drilled through the bearingplate that is screwed to the left side of the stock. The mainspring is independent from the lockplate and is fitted into a recess within the grip. The tip of the mainspring passes through a steel strap on the underside of the stock; this strap also supports the triggerguard. This construction differs markedly from wheellocks made elsewhere in Europe: in those the mainspring is attached directly to the massive lockplate, and thus a larger, heavier stock is needed to accommodate it. As a result of these technical differences, the French wheellock firearms tend to be more slender and graceful, with a distinctive bulge in the profile of

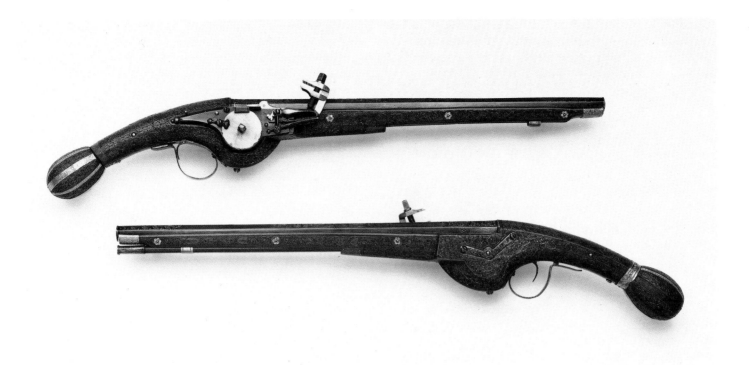

80

the stock beneath the wheel. On the French wheellock pistol, whose narrow, partially hollow grip (accommodating the mainspring) was especially vulnerable to breaking, a reinforcing steel strap was almost invariably added along the top, from the barrel tang to the pommel, with a second strap added on the underside; curiously, the upper strap was not utilized on these pistols.

The decoration of the pistols is distinctly French and of the highest quality. A large number of French wheellock firearms dating from the first quarter of the seventeenth century are embellished with brass and silver (or pewter) wire in designs covering the entire surface of the stock. This extremely precise and painstaking technique required the cutting of grooves in the wood into which metal wire (or ribbon) was set flush with the surface. The intricate designs usually incorporated entwined strapwork, branches of laurel and palm, and trophies of arms. This combination of motifs is typical of the etched decoration of French armor from ca. 1550 to ca. 1620; the same ornament, encrusted in gold and silver on a darkened ground, appears on a well-known group of early seventeenth-century French (or French-style) firearms, hunting spears, and at least one partisan (Norman and Barne 1980, p. 362). The same ornamental vocabulary, known as the fanfare style in bookbinding (Hobson 1970), was also employed in goldsmiths' work, furniture, and enamels.

The stocks of the Liechtenstein pistols are virtually identical to those of two French wheellock pistols in the Historisches Museum, Dresden (inv. nos. J.270–71; Ehrenthal 1899, p. 131, nos. F.281, F.283), and presumably they were decorated in the same workshop. The stocks of the Dresden pistols are inlaid with similar designs in the fanfare style and are mounted with the same stamped silver bands in the pommel and at the base of the grip. Both pistols have silver plaques behind the ramrod on the underside of the stock, and inv. no. J.271 has a short barrel tang and an oval escutcheon decorated with trophies (though in wire inlay, not silver sheet) as on Liechtenstein inv. no. 866. The Dresden pistols, which are not a pair, have lockplates struck with different marks—IP above a star on inv. no. J.270; PP below a crown on inv. no. J.271—that are usually found on French wheellock guns and pistols dating from the end of the sixteenth century or the first years of the seventeenth century (Kennard 1956, pp. 22–24). The forms of the barrels and locks (the lockplates are of characteristic late sixteenth-century form, with a notch cut out at the back) confirm a dating around 1600. The Liechtenstein pistols may be dated somewhat later than this, perhaps around 1620. By this date there was a noticeable tendency for octagonal barrels to be substituted for round ones and for barrels to become shorter and larger in caliber. The moldings at the ends of the barrels on the Liechtenstein pistols are vestiges of the more sculptural treatment of the ends of barrels dating around 1600.

The Dresden pistols have been associated by Lenk (1965) with a group of firearms whose decoration employs the same roller-die-stamped silver bands. The best known among this group is the famous gun by Jean Henequin of Metz, dated 1621, in the Bayerisches Nationalmuseum, Munich (inv. no. W.1933). The silver band of ornament around the butt of the Henequin gun and the six-petaled silver rosettes used in the decoration of its

123

stock are generally similar to those on the Liechtenstein pistols, but the wire inlay of the Henequin stock is quite different from that on the Dresden and Liechtenstein pistols and is more typical of the group of Rhineland and Dutch firearms of the 1620s (Hoff 1978, pp. 33–34). The firearms assembled by Lenk around the Henequin gun, while sharing similar decorative treatment, appear to date over a considerable period (1600–1630) and come from different areas in Western Europe (Eastern France, Western Germany, Holland). While this heterogeneous group requires further study, there is no reason to doubt that the Liechtenstein pistols and the related examples in Dresden, with their French wheellock construction and French style of decoration, are indeed of French manufacture.

SWP

FURTHER REFERENCES: Cat. 1952, p. 52, no. 271; Blair 1979, p. 52, fig. 16.

81

WHEELLOCK RIFLE

Austrian, ca. 1640
Steel, walnut, brass, silver; length overall 41⅜ in. (105.1 cm.); length of
* barrel 31 in. (78.8 cm.); caliber .52 in. (13 mm.)*
Liechtenstein inv. no. 170

The octagonal rifled barrel is cross-hatched and counterfeit-damascened in silver along its entire length; the iron surface is darkened for contrast. The decoration consists of symmetrical foliate ornament with large rosette-shaped flowers and scrolling tendrils on the top facet of the barrel and meandering foliate scrolls on the facets to either side. The notched steel backsight has a folding leaf, formerly gilt; the bead foresight is brass. The top of the barrel near the breech is incised with the inventory number 170, and the left side of the barrel is stamped with the crowned CL cipher of the Liechtenstein collection.

The wheellock, which is of conventional construction, has an external wheel, a manually closed pancover, and a cock engraved with scrolls. The forward portions of the flat lockplate are darkened, cross-hatched, and counterfeit-damascened in silver with foliate scrolls en suite with the barrel; the rear third of the lockplate, formerly decorated in the same manner, is now polished bright. The circular brass wheelcover is pierced and engraved in the form of animal-head scrolls.

The full-length stock of dark reddish-brown walnut is carved in low relief with a dense pattern of foliate scrolls, from the ends of which emerge naturalistic and fantastic birds and animals, including dogs and apes, with figures of dogs chasing foxes and hares within cartouches, all against a background of punched circles and leaves. On the cheekpiece is a circular medallion of uncarved wood laid with pierced and engraved brass wire and sheet incorporating animal-head scrolls en suite with the carved stock. An oval recess at the center of the medallion is now filled with red wax. The underside of the stock beneath the butt is carved with a pattern of closely set overlapping scales. The planes of the stock are outlined with brass wire set flush into the surface, and the tip of the forestock and the front ramrod pipe are reinforced with brass; the buttcap is missing. The set-trigger and triggerguard are bright steel; the latter was once damascened, almost all traces of which are obliterated. A wooden ramrod with horn tip is present.

The distinctive carved decoration of the stock, with its dominant motif of scrolling vines ending in grotesque beasts and animal heads, is characteristic of a well-known group of firearms attributed to the so-called Master of the Animal-Head Scroll (*Meister der Tierkopfranke*). This group has been studied in great detail by Hans Schedelmann (1973), who identified fifty-one firearms (the majority of them wheellock sporting rifles) with stocks carved by this still-unidentified craftsman. The place of manufacture is unknown, but the presence in the decoration of the imperial eagle or personal emblems and ciphers of the Hapsburg family and the preservation of the largest single group of these guns in the former imperial *Gewehrkammer* (today the Waffensammlung of the Kunsthistorisches Museum, Vienna) suggest that this master worked for the Emperor and his court. An origin in Austria, if not the capital itself, is indicated by the presence of barrels made by craftsmen in Vienna (Hans Faschang) and Salzburg (members of the Klett family). Most of the guns by this master are datable to the second quarter of the seventeenth century, with the earliest dated example from 1624 (Odescalchi collection, Rome, inv. no. 1526) and the latest from 1659 (Aitken collection, New York), though one rifle has recently been dated on stylistic grounds as late as 1670 (Gusler and Lavin 1977, no. 56). The decoration of these gunstocks, while ambitious in character and handsome in appearance, has a folk-art character. The scrolls terminating in whimsical beasts or animal heads, some of them wearing tall pointed hats with brims, are in many respects closer in feeling to the drolleries found in the margins of medieval manuscripts than to Baroque ornament, though the source of these motifs has not been identified.

The Liechtenstein gun is a particularly fine example of this group. The tight scrolls are carved in crisp, rounded relief that gracefully flows over the surface. The repetition of the animal-head scrolls on the brass-inlaid cheekpiece and on the wheelcover and the use of the same damascened ornament on the barrel, lock, and triggerguard indicate that the decoration was created as a carefully worked-out ensemble. The use of brass wire to outline the planes of the stock adds highlights to the wood and is a subtle aspect of this stock-decorator's work. Additional color was originally imparted by the use of an oval mother-of-pearl plaque that formerly occupied the center of the brass-inlaid cheek-medallion and that was still present when this gun was exhibited in Brünn (now Brno, Czechoslovakia) in 1885 (Boeheim 1886, pl. VI, fig. 2). Only an approximate date, about 1640, can be assigned because of the traditional character of the decoration, which was in use for over half a century. The damascened decoration of the lock and barrel is very similar to that found on guns dated 1631 (Waffensammlung, Vienna, inv. no. A2282; Schedelmann 1973, no. 5) and 1648 (Waffensammlung, Vienna, inv. no. D98; Schedelmann 1973, no. 17), and the stock carving finds its closest parallel in an undated wheellock rifle of this master in the State Hermitage Museum, Leningrad (inv. no. Z.O.5811; Schedelmann 1973, no. 11).

The Master of the Animal-Head Scroll is well represented in the Liechtenstein collection. In addition to this rifle, the collec-

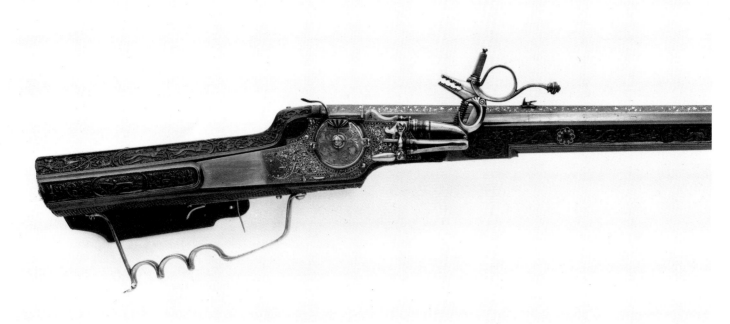

81

tion includes another rifle (inv. no. 157; Schedelmann 1973, no. 38) with silver-damascened barrel and lock. The barrel of the gun is stamped GF and dated 1641, and it carries the damascened initials of the decorator(?) HHP; the cheek of the stock is carved with a figure of Saint George slaying the dragon between two heraldically posed beasts, a lion and a griffin. There is also a wheellock pistol (inv. no. 3621; Schedelmann 1973, no. 39), whose octagonal barrel and buttcap are counterfeit-damascened in silver with an imperial eagle.

SWP

FURTHER REFERENCES: Stockerau 1902, p. 37, no. 260, ill.; Blair 1979, p. 52, fig. 10.

82

WHEELLOCK RIFLE

Bohemian (Eger), ca. 1670
Steel, fruitwood, brass; length overall 40⅜ in. (102.5 cm.); length of barrel
29⁵⁄₁₆ in. (74.5 cm.); caliber .41 in. (10.5 mm.)
Liechtenstein inv. no. 861

The octagonal barrel has a bore lined with a brass sleeve, which is rifled with eight grooves. The bright surface is engraved with foliate scrolls at the breech and muzzle, and a wreath is engraved around the muzzle opening. The notched steel backsight has a front extension pierced and engraved with scrollwork; the bead foresight is brass.

The flat lockplate is pierced around the internal wheel and engraved with a dense pattern of flowers against a recessed, blackened ground. Engraved near the back of the lockplate is a wreath enclosing a coat of arms: a shield with a fess, surmounted by a helm with mantling, the crest comprising a tall pointed hat flanked by two wings, the hat and wings also emblazoned with a fess; around the arms are the initials ·G·P·V·/·D·H·O· The neck of the cock is pierced

and engraved in the form of a dolphin issuing flowers; the foliage extends across the top jaw and its extremely long pierced cocking-lever. The cockspring is concealed behind a flat plate, pierced and engraved en suite. The pan and pierced flashguard, the pancover and its push-button release, and the jaws of the cock and cockspring retain traces of blueing.

The ebonized fruitwood stock is carved in high relief on the butt with heavy acanthus foliage, fruit, and shells on a stippled ground; the butt-trap cover is carved en suite. Carved on the cheekpiece is a landscape in which dogs pursue a stag, followed by a hunter dressed in mid-seventeenth-century costume and armed with a spear, who blows a horn. The steel buttplate is engraved with a wreath in the center and is fitted with a steel ball to protect the butt when it is placed on the ground. The rear trigger (of a double set-trigger) is pierced, and the triggerguard is engraved with scrolls similar to those on the barrel. The forestock is undecorated and has a steel fore-end cap; the tip of the ramrod and ramrod pipe are also steel.

Though lacking a gunsmith's mark or signature, this sporting rifle may be attributed on stylistic grounds to the Bohemian town of Eger. Situated in the German-speaking Sudetenland, Eger (now Cheb, Czechoslovakia) was an important gunmaking center in the seventeenth century. A number of wheellock rifles and pistols signed by the leading Eger gunsmiths—Kaspar Keiser, Hans Keiner, and Hans Reiner—have lockplates and sometimes the entire length of the barrels decorated with the same dense floral ornament as found on the Liechtenstein gun. On another distinctive group of Eger wheellocks, the lockplates are engraved with trophies of arms around the wheelcover, which is often elliptical in shape. Elaborately pierced cocks and cockspring plates, with excessively long pierced cocking-levers, are also hallmarks of the Eger style. The technique used in decorating the lockplates and barrels of Eger wheellocks is unusual: the background of the design was apparently eaten away with acid, leaving a design in low relief on which the details were engraved. Hayward (1962–63, vol. 2, p. 127) has

125

suggested that such decoration is characteristic of guns by Hans Keiner (act. ca. 1656–72), but as similar embellishment is found on guns signed by other Eger masters, it is likely that it was the specialty of a single decorator's workshop serving the gunmakers of the town. Lockplates etched in the same manner as that of this gun are found on wheellock sporting rifles in the Waffensammlung, Vienna (inv. no. D214, by Kaspar Keiser, dated 1664), in the Historisches Museum, Dresden (inv. no. GG484, by Karl Keiner), in the Deutsches Jagdmuseum, Munich (inv. no. W5721, by Kaspar Keiser, dated 1666), in the Bayerisches Nationalmuseum, Munich (inv. no. W.626, dated 1681, the barrel by Michael Lein or Lem, Arzberg; the lock unsigned), and a pair of pistols in the State Historical Museum, Moscow (by Hans Reiner). A group of similarly decorated wheellocks by Hans Keiner was published by Schedelmann (1940–44, pp. 149–51).

The stock of this gun, stained black in imitation of costly ebony, is also decorated in a style typical of Eger. In the seventeenth century this town was famous for writing cabinets and other furniture decorated with plaques carved in relief on a stippled ground with scenes from ancient history, representations of the planets and continents, allegorical figures, and scenes of contemporary life (Sturm 1961). Many of the stocks of Eger firearms are carved in a manner similar to that found on Eger cabinets and presumably come from the same workshops. The above-mentioned rifles in Dresden and Vienna, a rifle by Hans Keiner in the Museum für Deutsche Geschichte, Berlin, D.D.R. (Müller [1980]), and a number of Eger rifles and pistols, formerly in the collection of the Princes Lobkowitz in Schloss Raudnitz (now Roudnice, Czechoslovakia) (Dvorak and Matejka 1910, p. 190, nos. 196–97, 206, figs. 119–20) have stocks carved in this manner. The subject matter utilized for furniture by the Eger cabinetmakers was frequently copied from engraved sources, and the motifs were often repeated from one cabinet to another. The same is true for the gunstocks, in which hunting themes were most commonly used. For example, the stag hunt carved on the cheekpiece of the rifle in Berlin is the same as that on a rifle in Schloss Raudnitz (Dvorak and Matejka 1910, fig. 120 left). The stag hunt carved on the cheekpiece of the Liechtenstein gun is repeated on two other examples: a wheellock rifle with a barrel dated 1684, formerly in the W. R. Hearst collection (sold at Galerie Fischer, Lucerne, on three different occasions: May 10, 1939, lot 91; December 1, 1971, lot 269; and June 25, 1975, lot 124a); and another wheellock rifle (or pair of rifles) at Schloss Raudnitz (Dvorak and Matejka 1910, fig. 120 right). These stocks appear to have been carved by the same craftsman. Similar hunting subjects are found on a cabinet in a private collection in Florence (Kreisel 1968, vol. 1, figs. 556–57).

As there is very little stylistic change in the decoration of Eger guns dated between 1664 and 1681, a mean date of about 1670 is suggested for this gun. It has not been possible to identify the coat of arms on the lock, which presumably belongs to an Austrian or Bohemian family; the initials around the arms may stand for the owner's name, title, or motto.

SWP

FURTHER REFERENCES: Cat. 1952, p. 42, no. 200; Feldkirch 1971, no. 98.

82

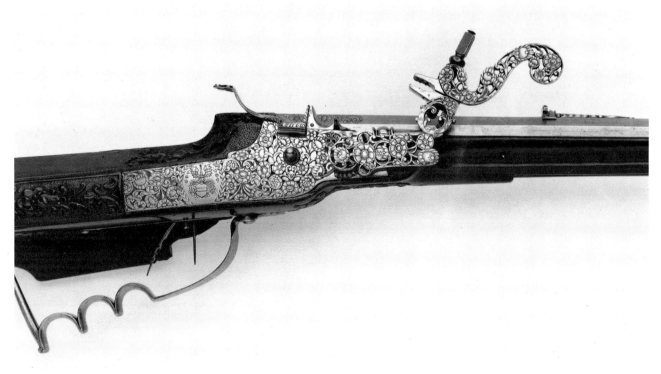

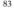

83

WHEELLOCK RIFLE

German (Schwäbisch-Gmünd), ca. 1670
Steel, cherry wood, ivory, staghorn, mother-of-pearl, brass, silver, copper;
length overall 47½ in. (120.6 cm.); length of barrel 36⅛ in. (91.7 cm.);
caliber .51 in. (13 mm.)
Liechtenstein inv. no. 859

The octagonal rifled barrel of dark blue-gray steel is engraved with narrow bands of geometric ornament at the breech and muzzle and around the muzzle opening. It is fitted with an adjustable folding-leaf backsight and a copper blade foresight. A single mark in the form of a clump of vegetation (not in Støckel) is stamped deeply into the top facet of the barrel near the breech.

The wheellock, which is of conventional construction, has a manually closed pancover. The flat lockplate is engraved behind the wheel with a stag attacked by three dogs. The wheelcover is engraved with two confronted lions and a cartouche at the top inscribed GOT (SIC) MIT UNS (God with us). The neck of the cock is pierced and engraved with a mermaid. The lockplate, cockspring, and bridle (pierced and engraved with a mermaid and two fishes), the pan and flashguard, and the top jaw of the cock are blued in contrast to the rest of the lock, which is bright steel.

The stock of cherry wood is carved in low relief over most of the surface with scenes of boar and lion hunts, a cherub's head, monkeys, fruit, and acanthus foliage. A grotesque mask with mother-of-pearl eyes and ivory teeth is carved on the underside of the stock in front of the triggerguard, and a dog's head with

eyes and teeth of ivory is carved on either side of the stock in front of the lock. Staghorn plaques engraved with fruit and flowers are inlaid on either side of the barrel tang and along the top of the butt. The sliding butt-trap cover is fashioned from a single piece of ivory carved in high relief with the figure of Fortune—a nude female figure holding a wind-filled sail and traveling across the waters on a winged globe—with a grimacing, mustached mask above. Numerous thin plaques of ivory, pierced and carved in low relief, are set into recesses in the stock and include representations of Diana and Actaeon on the right side of the butt above the butt-trap cover, the vision of Saint Hubert (or Saint Eustace) on the left side, and scenes of dogs chasing rabbits on the forestock along the barrel. Some of the ivory plaques are now broken, and others are missing. The cheekpiece is inlaid with a crowned double-headed imperial eagle of engraved mother-of-pearl, one talon clutching a sword and scepter (in silver), the other an orb and a laurel branch (in staghorn); the halos around the eagles' heads are of copper wire. Flowers (including tulips) of engraved staghorn and mother-of-pearl surround the eagle, and a mother-of-pearl plaque behind the sideplate is engraved with a mermaid combing her hair. The fore-end cap is formed of a thick ivory plaque carved on either side of the ramrod with eagles devouring their prey. The wooden ramrod has an engraved ivory tip and was formerly secured to the stock by two carved ivory ramrod pipes, now lost. The brass buttplate, fitted with a ball, is secured to the stock by numerous nails along the edges. The set-trigger and triggerguard are blued steel. The underside of the stock behind the triggerguard bears the incised inventory number 20.

This richly decorated rifle, one of the most important in the Liechtenstein collection, can be attributed with virtual certainty to the Swabian stockmaker Johann Michael Maucher. Born into a family of wood, ivory, and amber carvers in Schwäbisch-Gmünd in 1645, Maucher worked in his native city until 1688. After a brief stay in Augsburg, he settled in Würzburg in about 1693 and died there in 1701. Maucher's specialty was richly decorated gunstocks of intricately carved wood into which were set plaques of ivory and mother-of-pearl, worked in relief. On several occasions Maucher signed his stocks in full, describing himself as *Bildhauer und Bixenschifter* (sculptor and gunstock-maker), and many of the ivory plaques found on his guns, and in particular the butt-trap covers carved in high relief such as the Fortune on this gun, have the quality of independent sculptures. Maucher is known to have made other objects in ivory, including several large pitchers and basins that are carved in the same manner and use much of the same iconography as that employed on his firearms—hunting themes, scenes from Ovid's *Metamorphoses*, biblical subjects, and allegorical figures. Vessels fashioned from this precious medium were intended as luxury goods solely for display on the sideboard in a noble house or in the *Kunstkammer* of a Prince. In the same way Maucher's firearms, decorated in ivory and mother-of-pearl, presumably were valued more for their artistic virtuosity than for their practical use as sporting weapons.

About thirty firearms by Maucher are preserved, some of them signed and dated. The earliest recorded guns, a pair of wheellock rifles in a German private collection (Bistram 1978), are dated 1668, the latest being a wheellock rifle made in Würzburg in 1693. Throughout this period Maucher employed many of the same decorative themes—the figure of Fortune, scenes of Diana and Actaeon, the vision of Saint Hubert, boar and lion hunts, and the imperial double-headed eagle. Some of the subject matter has been traced to prints, such as the engravings of Jost Amman, Adriaen Collaert, and Johann Wilhelm Baur (Berliner 1926; Petrasch 1960), but Maucher rarely copied his sources exactly and always combined elements in a new and different way, thus demonstrating his skill and imagination as a designer. In form and decoration the Liechtenstein gun finds close parallels in three dated examples by Maucher in the Bayerisches Nationalmuseum, Munich—one of them dated 1670 (inv. no. w633) and the other two dated 1671 (inv. nos. w624, w631)—and therefore can be assigned to the same early period of Maucher's career, about 1670.

Maucher's fame appears to have been limited to German lands, but there he counted among his patrons the Dukes of Pfalz-Zweibrücken and of Württemberg. He is reported to have presented Emperor Leopold I (reigned 1658–1705) with a richly decorated gun in 1688, but this apparently no longer exists. Prince Johann Adam Andreas von Liechtenstein (1657–1712) must also be included among the aristocratic collectors of Maucher's firearms. The present gun is portrayed in exact detail in a still life painted for the Prince by Dirk Valckenburg

in 1698–99 (cat. no. 189), which demonstrates the great importance placed on this gun by the Prince. This is the only known contemporary illustration of a Maucher gun. The gun can be identified among the firearms at Feldsberg in the inventory of 1712, following the death of Johann Adam Andreas, where it was described as follows (Princely Archive, Karton 356, Inventory 1712, fol. 44v, no. 18): *Scheibenröhr mit einen wohlgeschnüttenen schafft aufn schubladl die Fortuna von helffenbain geschnitten, blau angeloffen* (target rifle with a carved stock; on the butt-trap cover Fortune in carved ivory; [with a] blued barrel). The gun later passed into the possession of Prince Emanuel von Liechtenstein in Vienna, in whose inventory of 1753 it is again described (Princely Archive, ms. 2032, fol. 5v, no. 1): *Ein Scheiben-Rohr, auf dem schloss die innschrift: gott mit uns, der schafft mit perl-mutter und helffen-bein eingelegt, und mit verschiedenen figuren gezieret* (a rifle, on the lock an inscription "Gott mit Uns," the stock inlaid with mother-of-pearl and ivory and decorated with various figures). The inventory number 20 incised beneath the stock does not correspond to any of the existing Liechtenstein inventories.

SWP

FURTHER REFERENCES: Wilhelm 1970, pp. 434, 444 n. 74, figs. 11–14; Blair 1979, p. 50, fig. 11.

84

PAIR OF FLINTLOCK BREECH-LOADING PISTOLS

Austrian (Vienna), ca. 1675–80
Steel, walnut, silver, gold; length overall 20⅞ in. (53.1 cm.); length of barrel 14³/₁₆ in. (36 cm.); caliber .51 in. (13 mm.)
Liechtenstein inv. nos. 283–84

The turnoff barrels of blued steel are each formed in two parts, with the barrel proper unscrewing immediately in front of the breech. The short breech section is octagonal, changing into sixteen facets, and has a projection at the front filed with an interrupted thread. The facets of the breech are outlined in gold. At the base of the breech is engraved and gilded a foliate frame enclosing a figure—Mars on inv. no. 283, Minerva on inv. no. 284—wearing classical armor, holding a lance and shield, and standing amid trophies of arms. The barrel proper is of three sections—round, octagonal, and round—separated by moldings, with a series of moldings at the muzzle. A steel bead foresight is on the most prominent muzzle ring. The end of the barrel screws onto the breech section by means of a so-called bayonet lock. Each facet of the octagonal barrel section is fluted; the recesses are gilded. Directly in front of the octagonal section is an engraved and gilded band with fruit, foliage, and masks. The barrel is attached to the stock by an extensible, rotating silver-covered iron rod, which slides into a socket at the front of the stock. The rod is attached to the barrel by a silver ring on which is cast the U-shaped backsight. This ring is stamped with the letter F within a parallelogram, the tax stamp used in Brünn, Moravia (now Brno, Czechoslovakia), in 1806–1807 (Rosenberg 1928, vol. 4, p. 578, no. 9242).

The bright steel locks, which are of conventional flintlock construction, have convex plates and swan's-neck cocks of identical form and decoration. Each lockplate is engraved with foliage, a male half-figure emerging from tendrils,

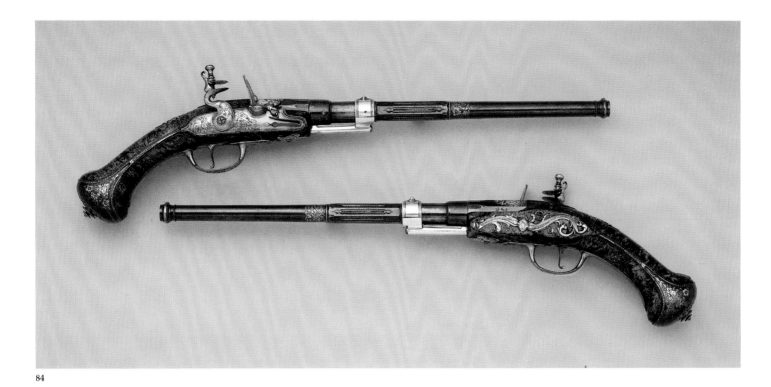

84

and a dragon and is inscribed LA MARRE A VIENNE; the cock is engraved with foliage.

The half-stocks of burled walnut are carved with simple moldings and are inlaid with scrollwork of silver wire and nailheads behind the breech and around the mounts. The cast-silver escutcheons are inset with heart-shaped centers of steel (formerly engraved?), surmounted by an imperial crown of engraved silver sheet. Each of the silver sideplates of serpentine form is inset with a similarly shaped steel plate engraved with an emperor's head in profile; the sideplate screwheads are engraved as flowers. The rounded buttcaps of blued steel have long spurs that extend up the sides of the grip to the lock and sideplate. The edges are counterfeit-damascened with gold dots, and the sides are engraved and gilded with female masks, fruit, and foliage. To the end of each buttcap is applied a pierced oval plate of steel, engraved with foliage issuing human and bird heads and set against a gilded plate below; a baluster-shaped finial projects from the center. The bright steel triggerguards are pierced and chiseled at the center with the letter L surrounded by the collar of the Order of the Golden Fleece, with an imperial crown above; the triggerguard finial is pierced with foliage. Applied to the underside of each stock in front of the triggerguard is a cartouche-shaped silver plaque, engraved with foliage (possibly a later addition). The Brünn assay mark of 1806–1807 is stamped on the silver sideplates, escutcheons, and plaques beneath the stock. The buttcaps bear the incised inv. nos. 288 and 289, respectively.

These magnificent pistols, made by a Parisian gunsmith working in Vienna, epitomize what has been termed the "classical Louis XIV style" of gunmaking (Lenk 1965, pp. 93–108). French firearms of this period, like French art in general, set the standard for the rest of Europe. Characteristic of firearms in this style are flintlocks with convex surfaces, delicate openwork mounts of silver or steel, and barrels of changing faceted and round sections. The ornament is classically inspired, with frequent use of allegorical figures and traditional decorative imagery. The French style of gunmaking was disseminated in several ways. French firearms were avidly collected abroad, and Louis XIV

made a practice of giving gifts of richly decorated firearms to foreign sovereigns and diplomats. In 1673, for example, he presented Charles XI of Sweden with a large number of firearms made by the leading gunsmiths of Paris. French styles were also spread by means of engraved gunsmiths' patternbooks —those by Marcou (ca. 1657), Jean Berain the Younger (1659), Thuraine and Le Hollandois (1660), Claude Simonin (1685, with later editions in 1693 and 1705, the last edition with supplementary plates by De Lacollombe), Guérard (ca. 1700–1710), De Lacollombe (1730), and De Marteau (editions of the 1730s and 1749)—that profoundly affected the appearance of firearms from Scandinavia to Italy, from England to Bohemia. With the revocation of the Edict of Nantes in 1685, French Protestant (Huguenot) gunsmiths were forced to flee their homeland to seek work abroad, and they carried the French style with them.

Jacques Lamarre (also spelled La Marre), the maker of these pistols, was a French craftsman who sought his fortune abroad. He is first recorded in 1657 when his father-in-law, the gunmaker Philippe Thomas, died at "la rue des petit champs" in Paris (documentary information communicated by E. Heer, November 1984). Lamarre's name is next found among the twenty-six leading Parisian gunmakers listed in the famous patternbook of Thuraine and Le Hollandois, published in 1660. An inventory of firearms belonging to the Duke of Richmond at Cobham Hall, Kent, made in 1672, includes a number of French firearms, among them a pair of pistols, a breech-loading gun, and "a very fine birding gun" by Lamarre, which indicates that this craftsman's guns had already acquired an international reputation (Hayward 1962–63, vol. 1, pp. 216–17). Probably for reasons of business rather than religion (he appar-

129

ently was not a Huguenot), Lamarre presumably left Paris by the mid-1670s and is recorded working in Prague in 1674/75 and in Vienna by 1675/76 (Heer 1978–82, vol. 1, p. 674). Lamarre married in the Cathedral of Sankt Stephan, Vienna, in 1682 and is recorded as *Hofbüchsenmacher* (court gunmaker) to the Holy Roman Emperor Leopold I (reigned 1658–1705). He died in Vienna in 1700/1701.

The present pistols were made for Leopold I, as is clear from the decoration of the triggerguard, which bears the Emperor's initial and collar of the Order of the Golden Fleece surmounted by an imperial crown, and from the escutcheon (now blank but probably formerly engraved), which is surmounted by the same crown. Stylistically the Liechtenstein pistols date to Lamarre's early years in Vienna, as they are very similar in the forms of their barrels, locks, and mounts of the stocks to Parisian firearms made in the late 1660s and early 1670s. Comparisons may be made to a pair of pistols by Des Granges, ordered by a Swedish nobleman in Paris in 1668; to a pair of pistols by Thuraine, dated 1669; and to a series of pistols by various gunsmiths presented by Louis XIV to Charles XI of Sweden in 1673, all of which are now in the Livrustkammaren, Stockholm (Lenk 1965, especially pls. 66, 68–69, 73–74). On this basis, the Liechtenstein pistols may be dated to the period 1675–80. Several firearms from Lamarre's stay in Vienna are still preserved in the Waffensammlung, Vienna, among them a flintlock gun (inv. no. D180), whose decoration includes a portrait of Leopold I, his patron.

It is not clear when or under what circumstances the present pistols, which in the nineteenth century were in the Liechtenstein castle at Kromau, Moravia, entered the family's possession. It is known, however, that firearms by Lamarre were collected by the Princes Liechtenstein from an early date and that the gunmaker was employed at various times by the Princes. The 1678 inventory of Prince Karl Eusebius's arms (Princely Archive, ms. 352, fol. 82) records a pair of guns and a pair of pistols by Lamarre, and a pair of pistols by the same master were included in the armory of Prince Anton Florian in 1686 (Princely Archive, Inventory 1686, fol. 13). Payments to Lamarre are recorded in the family accounts for 1695, when he repaired the guns acquired by Prince Johann Adam Andreas from Count Brandis, and in 1698, when he restored two Spanish barrels and mounted them with locks and stocks of his own making. The inventory of the *Gewehrkammer* at Feldsberg, made after the death of Prince Johann Adam Andreas in 1712, records a pair of flintlock guns with Spanish barrels (probably those mounted by Lamarre in 1698), another flintlock gun, and a pair of pistols (Princely Archive, Karton 356, Inventory 1712, fol. 37, nos. 3–4; fol. 41, no. 49; fol. 47, nos. 9–10; see also Wilhelm 1970, pp. 6, 8, 12, 19). Three flintlock guns—one with a Spanish barrel by (Alonso?) Martínez and the other two a pair of silver-mounted flintlock pistols—are described in the 1727 inventory of arms collected by Prince Hartmann von Liechtenstein (1666-1728) at his castle at Niederabsdorf as being "by Lamarre, the French

master, but made in Vienna" (Princely Archive, ms. 682, p. 13, no. 50; p. 16, no. 61; p. 24, no. 102; p. 36, no. 157; see also Schedelmann 1944, pp. 67–69). Prince Joseph Wenzel's *Gewehrkammer* inventories in 1761 and 1766 record five flintlock guns by Lamarre, but no pistols. Unfortunately none of the pistols recorded in the inventories is described in sufficient detail to be identifiable as the pair under discussion.

The pistols are not without technical interest. They are constructed as screwed turnoff breechloaders, in which the barrel could be unscrewed immediately in front of the chamber to facilitate loading. Unlike muzzle-loading firearms, breechloaders offered the advantage of loading the weapon with greater precision and with a tighter fit of the ball in the chamber, thereby assuring a more dependable projection of the ball, with minimal escape of gas. Breech-loading guns and pistols were used throughout Europe from the middle of the seventeenth century and continued to be used in England until the middle of the eighteenth century. French breech-loading pistols of this period are rare, though a pair of breechloaders by Des Granges of Paris were included in the French gift to Sweden in 1673 (Livrustkammaren, Stockholm, inv. nos. 1699–1700). The device connecting the barrels to the stock, which on the Lamarre pistols is fashioned of silver, prevented accidental loss of the barrels and facilitated the loading of such holster pistols while on horseback.

SWP

FURTHER REFERENCES: Cat. 1952, p. 55, no. 287; Wilhelm 1970, p. 447 n. 95; Blair 1979, p. 52, fig. 18.

85

PAIR OF FLINTLOCK PISTOLS
Italian (probably Brescia), late 17th century
Steel, gold; length overall 13 1/16 in. (33.2 cm.); length of barrel 7 13/16 in.
 (19.8 cm.); caliber .50 in. (12.5 mm.)
Liechtenstein inv. nos. 3622, 4140

The barrels are round, with flattened sides at the breech and a flat sighting rib down the center ending in a chiseled bead foresight. At the breech is chiseled a leafy mask issuing foliate scrolls. The touchholes are gold-lined.

The convex lockplates are chiseled behind the hammer with foliage and are inscribed VILLALONGA beneath the pan. The round-faced cock, cockscrew, pan, and steel are chiseled with masks and foliage, and the tips of the lockplate screws are engraved as rosettes. The top jaw of the cock on inv. no. 3622 is a replacement, as are the cock-jaw screws on both pistols.

The all-metal stocks are engraved on the grips with scrolling foliage issuing flowers and snakes. On the back of the grips is a nude winged putto holding a banderole, that on inv. no. 3622 inscribed *Villa*, that on inv. no. 4140; *Longa.* The forestocks are embossed with scrolls and are engraved with foliage. The applied sideplate is pierced and chiseled with foliage issuing a female half-figure and dolphin-like monsters and is fitted with a belt-hook retained by the rear sideplate screw. Similar pierced and chiseled plates are applied to the stock behind the barrel tang and on the underside of the stock around the triggerguard. The separately formed buttcaps are chiseled with leafy masks and snakes at the sides and with a classical male profile bust, crowned with

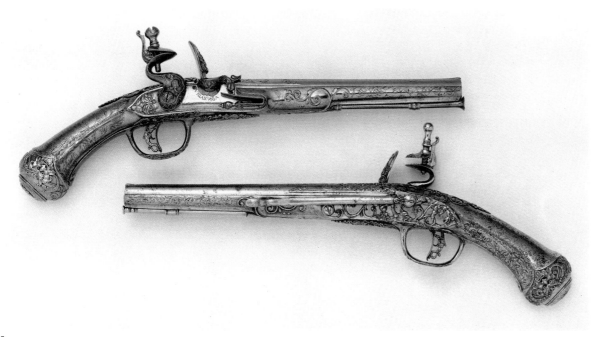

85

laurel, at the center. The trigger is pierced and chiseled in the form of a dolphin, and the triggerguard is chiseled with a female profile bust within a wreath at its center. Two baluster-shaped ramrod pipes retain the steel ramrod. Inv. no. 4140 differs from its mate in that it has suffered considerable corrosion and its sideplate screws, ramrod, and both ramrod pipes are replacements.

In the seventeenth century the gunmaking town of Brescia, in the area of Lombardy then under Venetian suzerainty, was internationally famous for the thin-walled, light-weight barrels and the pierced and chiseled steel mounts of its guns and pistols. Few hunting cabinets in Europe were without Brescian firearms, and the eighteenth-century inventories of the *Gewehrkammer* of the Princes of Liechtenstein record large numbers of Brescian firearms, many of them with barrels by members of the famous Cominazzo family of Gardone, near Brescia. The present pistols, notable for their all-metal construction and the splendid quality of their decoration, are by far the most important of the Italian firearms that remain in the Liechtenstein collection.

All-metal pistols have the advantage of great strength, as there is little danger of the steel stock breaking through heavy use. Hollow stocks formed of iron sheet were frequently employed by German gunmakers in the sixteenth century particularly for heavy multishot pistols having two or even three barrels and locks. In the seventeenth and eighteenth centuries all-metal stocks were occasionally used for lighter flintlock pistols produced in Northern Europe, often of turnoff breech-loading type; and a distinctive type of all-metal pistol, made first of brass, later of iron, was the specialty of Scottish gunmakers for over two hundred years, beginning about 1625. Iron-stocked guns and pistols were also produced by Brescian gunmakers. The majority of these are signed by Stefano Scioli (Cioli, Sioli), who seems to have specialized in all-metal firearms, though the names of other Brescian gunsmiths, such as Hieronimo Zucolo, Francesco

Garatto, and Pietro Fiorentino, are also encountered. The all-metal Brescian stocks generally follow the form of conventional guns and pistols; the iron surfaces are embossed in relief, engraved with ornament, or applied with pierced mounts comparable in style to that of the carved or silver-inlaid wooden stocks.

The pistols by Villalonga are outstanding examples of this Brescian tradition. Virtually nothing is known about Villalonga; his recorded work is limited to the Liechtenstein pistols and an almost identical pair of short belt pistols in the Museo Poldi Pezzoli, Milan (inv. nos. 2213, 2214), which are inscribed with Villalonga's name on the barrels, locks, and stocks (Boccia 1972, p. 73; Collura 1980, vol. 2, p. 167, no. 933). Gaibi (1978, figs. 430–31) identifies the maker of the Poldi Pezzoli pistols with a Pietro Villa of Brescia, born in 1591, but also refers (p. 261) to a firearms decorator named Villalonga who was recorded in Reggio Emilia. Boccia (1972, p. 73) has noted, however, that the gunmaker's name may refer to his (or his family's) birthplace in the town of Villa Lunga (in dialect Longa) near Reggio Emilia. N. di Carpegna (personal communication, April 1984) has also noted several other towns of this name in Venetian territory, including Villalonga S. Alessandro and Villalonga S. Silvestre in the region of Bergamo. An origin in Central Italy, perhaps near Reggio Emilia, is most probable, however, as Villalonga's pistols have been strongly influenced by Central Italian firearms, from which they have borrowed the male bust on the buttcaps and the female bust with disproportionately small head on the triggerguards. Given the profusion of signatures on Villalonga's pistols, it is likely that the gunsmith may have been both lockmaker and decorator as well.

A comparison to similar all-metal pistols by Scioli (Wallace Collection, London, inv. nos. A1229–30) or Pietro Fiorentino (Kunstgewerbe Museum, Frankfurt, inv. no. 1414) demonstrates

131

the superior quality of Villalonga's iron chiseling. The foliate ornament on the sides and ends of the buttcaps is particularly fine, and its effectiveness is emphasized by undercutting. The engraved decoration is also commendable for its graceful design and logical distribution over the surface. Gusler and Lavin (1977, pp. 180–81, fig. 71), who published one of these pistols when it was in the Bedford collection, noticed the influence of French patternbooks in the decoration of these pistols. The classical profile bust on the buttcaps, for example, may have been inspired by a laurel-wreathed emperor's head on a pistol butt found in pl. 1 of the famous patternbook *Plusieurs Models des plus nouvelles manières qui sont en usage en l'Art d'Arquebuzerie* (Paris, 1660), which was based upon designs by the Parisian gunmakers Thuraine and Le Hollandois and engraved by Jacquinet. However, the face on the Villalonga buttcaps is distinctly more youthful, with a receding chin and a large ear, and might be a portrait. The flying putti holding the banderoles inscribed *Villa* and *Longa* on the grips of the pistols are, on the other hand, literal borrowings from the same patternbook. They have been copied from a plate on which the names of the leading Parisian gunmakers are inscribed on banderoles carried by putti (Grancsay 1970, p. 29), with Villalonga substituting his name for that of a French gunmaker.

The Villalonga pistols can be traced to the inventory of Prince Emanuel von Liechtenstein (1700–1771), begun in Vienna in 1753 (Princely Archive, ms. 2032, fol. 17v, no. 11), where they are described: *Item ein paar pistolen völlig mit eysen montirt von Villalonga* (Item: a pair of pistols, mounted completely in iron, by Villalonga). At some unrecorded date one of the pistols (inv. no. 4140) left Liechtenstein possession; it reappeared in recent years in the collections of M. Lemon, Brussels, and Clay P. Bedford, Scottsdale, Ariz., and was acquired again for the Princely Collections in 1982.

SWP

FURTHER REFERENCES: Cat. 1952, p. 51, no. 266; Blair 1979, p. 50, fig. 22.

86

FLINTLOCK GUN

German (Düsseldorf), ca. 1710
Steel, maple; length overall 58⅛ in. (147.7 cm.); length of barrel 43⅛ in. (109.6 cm.); caliber .63 in. (16 mm.)
Liechtenstein inv. no. 3863

The bright steel barrel is round with flat sides at the breech and a flat sighting rib along its front half. The base of the breech is chiseled with a series of decorative moldings, a mask, and foliage. Above this is a pedestal decorated with antique arms, with bound captives at its base. At the apex of the pedestal sits a male figure, wearing a classical cuirass and crowned with a wreath; he holds a trumpet in his right hand while his left hand raises branches of laurel and palm overhead; under his left foot is a rooster. The base of the sighting rib is chiseled with foliage and a mask. The breech plug and tang screw are probably replacements.

The bright steel lock has a flat-faced lockplate and cock. The lockplate is chiseled in low relief with a grotesque mask and foliage behind the cock; in front of the cock is a male figure in classical costume, a laurel wreath on his head, who holds a trumpet and is seated amid trophies of arms. The plate is inscribed behind the cock BONGARDE/A DVSSEL/DORP. The cock is chiseled with foliage and a winged monster; the cock screw is chiseled with a grotesque mask; the face of the steel is chiseled with foliage and a bearded mask.

The half-stock of burled maple has been shortened from its original full length. The stock is carved with foliage around the bright steel mounts, and its butt of German fashion has a pronounced cheekpiece and a flat underside. The sideplate is pierced and chiseled with scrolls (some terminating in dragon heads), bound captives, trophies of arms, and putti holding trumpets; in the center a garland-framed medallion encloses a classical warrior's head in profile. The pierced escutcheon is chiseled with a profile head of a male wearing a wig of late seventeenth-century fashion, with trophies of arms below and two putti above blowing trumpets and holding aloft a classical helmet. The buttplate extension at the top of the stock is chiseled with a mask and foliage ending in dragon heads, bound captives seated amid trophies of banners, the whole surmounted by an eagle with branches in its beak. The triggerguard is chiseled with moldings and a mask and has foliate finials. The wooden ramrod is attached by two faceted octagonal ramrod pipes; the forward pipe is brazed onto the barrel, and the rear one attached to the stock. The tip of the forestock is fitted with a ribbed and beaded steel band.

Armand Bongarde, the maker of this beautiful fowling piece, was the leading German gunmaker working in the classical French style. Born in Süchteln, near Krefeld, Bongarde is first documented in 1678, the year of his marriage. In 1690 he is recorded in Düsseldorf as armorer (*Rüstmeister*) and court gunsmith (*Kurfürstlicher Hofbüchsenmacher*) for the Elector Johann Wilhelm, Count Palatine of Neuburg and Duke of Jülich-Berg (1658–1716, Elector after 1690), and he continued to serve the electoral court until his death in 1727. Bongarde's firearms are distinguished by virtuoso iron chiseling whose exquisitely minute detail suggests that he may have been trained as a medalist. His patronage was of the highest order, and his firearms are often

86

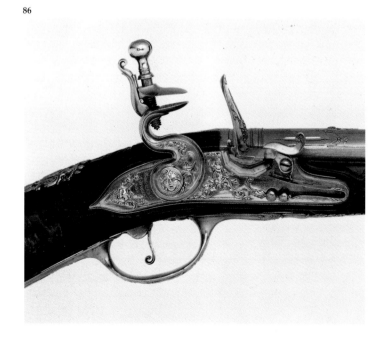

decorated with motifs especially designed for their owners. His finest arms consist of a garniture comprising a fowling piece and a pair of pistols, made before 1690 for Charles V Leopold, Duke of Lorraine (1643–90), now in the Waffensammlung, Vienna (inv. nos. A1636–38), and a second garniture made about 1690 for the Elector Palatine, comprising a fowling piece, two pistols, and a smallsword, now in the Bayerisches National-museum, Munich (inv. nos. 13/583, 1031–32, 129; the set origi-nally included a cane, now lost). On both garnitures the mounts are chiseled with tiny figures in classical costume or contempo-rary dress, with imagery referring to triumph and fame, and with portraits of the owners. Doubtless the iconography and complex figural compositions were supplied to Bongarde by court artists. These firearms can be compared favorably to the finest deluxe firearms made in Paris in the 1680s and 1690s by the gunmakers Bertrand Piraube and Pierre Gruché, both of whom worked for Louis XIV, and are among the most beautiful firearms ever produced outside of France. Despite the classical imagery used in the embellishment of Bongarde's firearms and the fashionable French spelling of his name (he is referred to as Herman Bongard in German documents), there is no evidence that he traveled to France. He was conversant, nevertheless, with French ornament, probably through prints and drawings, and he probably had seen French firearms at the electoral court. Bongarde's firearms, while in the mainstream of Parisian style, do not slavishly copy the French firearms patternbooks upon which so many German gunmakers relied. A contemporary chronicler records that Bongarde's garniture for the Elector Pala-tine (that now in Munich) was kept in the treasury (not the armory) of the electoral residence in Düsseldorf and could only be handled while wearing gloves; this account demonstrates that Bongarde's firearms were recognized and respected by his patrons as works of art (Stöcklein 1922, p. 95).

The Liechtenstein gun belongs to a later period of Bongarde's career than the garnitures in Vienna and Munich. It reflects the new styles that first appeared in Paris in the 1690s and that spread rapidly throughout Europe in the first years of the eigh-teenth century with the issuance of the patternbooks of Guérard and De Lacollombe. The new fashion (the so-called Berain style) prescribed flat surfaces for the lock and mounts where formerly they had been convex; the long serpentine extension of the buttplate became shorter; and the ramrod pipes, formerly round, were now faceted. These features are present on this gun, as well as on an analogous gun and matching pair of pistols made for Margrave Ludwig Wilhelm of Baden (the so-called Türken-louis, 1655–1709), now in the Waffensammlung, Vienna (inv. nos. A1639–41). This splendidly decorated garniture has mounts of chiseled iron that are by the same hand as those on the Liechtenstein gun, and many of the same figural and ornamental motifs are repeated on both. The Vienna garniture is unsigned and was formerly ascribed to the medallist Philipp Christof Becker of Koblenz (Karlsruhe 1955, p. 53, no. 61, pls. 12–15), but has more recently been attributed to Bongarde

on stylistic grounds (Hayward 1962–63, vol. 2, p. 333). The signed Liechtenstein gun confirms the Bongarde attribution. The Vienna garniture must have been made shortly before 1709, the year of the Margrave's death. The Liechtenstein gun is of contemporary date, but not earlier than 1705, the year in which Simonin's patternbook of 1684 was republished along with four supplementary plates of the new Berain style by De Lacollombe. Bongarde borrowed from De Lacollombe's pl. 11 the shape of the buttplate extension, with its foliate finial and lion mask, and perhaps the profile bust of the Roman warrior on the sideplate (pl. 10).

Though not as elaborate in decoration as some of Bongarde's works, the Liechtenstein gun demonstrates the same high qual-ity of iron chiseling. The trumpet-bearing figures symbolic of fame and the bound captives and trophies are motifs found on most of Bongarde's firearms, though the figure of the warrior on the barrel—dressed à l'antique and with what may be the Gallic cock under his feet—is surely a reference to the ongoing War of the Spanish Succession, between the allies of France and the Holy Roman Empire. The portrait on the escutcheon is not specific enough to make a positive identification with any of the Liechtenstein princes. While no guns by Bongarde are listed in the *Gewehrkammer* inventory of Prince Johann Adam Andreas (1657–1712), made in 1712 (Wilhelm 1970), several Bongarde firearms do, however, appear in later Liechtenstein inventories. That of Prince Emanuel (1700–1771) dated 1753 records a pair of flintlock guns by Bongarde mounted in iron, and a single gun mounted in brass, the barrel with the mark of Ferdinand Daz (Princely Archive, ms. 2032, fols. 7v, 16v). Joseph Wenzel, Emanuel's elder brother and Reigning Prince, possessed a garniture by Bongarde comprising a gun and two pistols mounted in iron, which are listed in the *Gewehrkammer* invento-ries of 1751 and 1766 (Princely Archive, ms. 1649, pp. 15, 62; ms. 1616, pp. 33–34, no. 126, and p. 77, no. 61). The present gun may be the remnant of this garniture.

SWP

FURTHER REFERENCES: Cat. 1952, p. 46, no. 229; Blair 1979, p. 50, fig. 13.

87

FLINTLOCK GUN

French (Paris), ca. 1730–40
Steel, walnut, silver, gold, fabric; length overall 56 3/16 in. (142.7 cm.); length of barrel 44 1/4 in. (112.3 cm.); caliber .65 in. (16.5 mm)
Liechtenstein inv. no. 3618

The Spanish barrel is in three stages, separated by transverse moldings and chiseled foliage; the entire surface is deeply blued and richly decorated in gold and silver. The octagonal breech is stamped with the gold mark of I. P. Esteva and the arms of Barcelona as a countermark below (similar to Støckel nos. 331–32), with three silver-damascened flowers to either side and a silver-damascened cross above. At the center of the breech section is engraved and

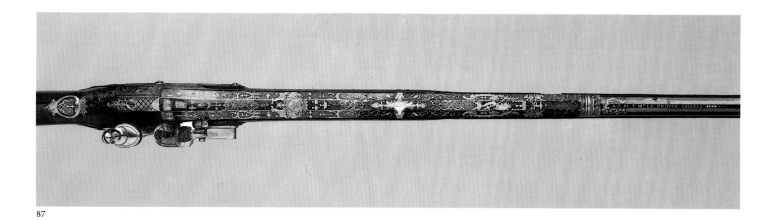

87

gilded the coat of arms of Lorraine-Armagnac, encircled by the French orders of Saint Michel and Saint Esprit and surmounted by a ducal crown; to either side is a crowned eagle with a Lorraine cross hanging around its neck (the traditional supporters of the Lorraine arms) and a sword entwined with a swordbelt, symbol of the *Grand Écuyer de France.* Above the arms are three gold birds (*alérions*)—the original arms of Lorraine—with a pair of similar birds to either side, beneath swags of drapery from which hang Lorraine crosses. The remainder of the octagonal section is embellished with Lorraine crosses, a crossed sword and flaming torch, palm branches, all in gold, and scrolls in silver damascene around the backsight. The U-shaped backsight of silver gilt, pierced and chiseled with foliage, is attached with a barrel ring. The next section of the barrel is polygonal, chiseled with palm and laurel branches and inscribed in gold on the top facet ·A. S. AL. T. M.^G LE. PRINCE. CHARLE· The muzzle section is round and has a silver bead foresight surrounded by silver-damascened scrolls. The barrel tang is blued and decorated in gold with a shell and diaper ornament; the bright tang screw is a replacement.

The bright steel lock has flat surfaces engraved with Rococo scrolls and shells within zigzag borders. The lockplate is inscribed in script in front of the cock *Languedoc A Paris.*

The full stock of dark walnut is carved in relief with foliage behind the tang and has mounts of blued steel chiseled in low relief and gilded. The flat sideplate is decorated with a fallen stag attacked by dogs. The escutcheon is emblazoned with two swords, entwined with sword belts, with a Lorraine cross between them and a ducal crown above. The triggerguard has foliate ends and is chiseled at the center with a trophy. The buttplate is blued and gilt en suite, with a hunting trophy on the extension on top of the stock. The top of the butt is cut away to accommodate a blue-velvet-covered cheekpad with gilt borders. Four faceted ramrod pipes, decorated with a gold diaper pattern, hold the steel-tipped wooden ramrod.

Laurent le Languedoc, whose name is on the lock, was one of the most famous Parisian gunmakers during the reign of Louis XIV (1643–1715). Languedoc is first recorded in the famous patternbook engraved by Claude Simonin, *Plusieurs Pièces et Ornements Darquebuzerie Les plus en Usage tiré des Ouvrages de Laurent le Languedoc Arquebuziers Du Roy et Dautres Ornement Invente et gravé Par Simonin . . .* , Paris, 1685. The book's title indicates that Languedoc was already a mature craftsman with the title of royal gunsmith. The engraver Simonin is presumed to have worked for Languedoc, and the patternbook therefore reflects the collaboration of the two craftsmen. Such was the value of the patternbook in advertising Languedoc's name throughout Europe, that the gunmaker himself issued a new edition of the patternbook in 1705, which included four supplementary sheets

engraved by De Lacollombe showing firearms ornament in the new Berain style (Lenk 1965, pp. 109–20). Remarkably little else is known about Languedoc, whose family name appears to have been Laurent, and there is considerable confusion concerning his name and working dates in firearms literature. French documents record both a François and a Jean Laurent le Languedoc active in the year 1717 (Heer 1978–82, vol. 1, p. 170; Jarlier 1976–81, vol. 1, col. 159; Jarlier 1981, col. 163), and both appear to have been referred to in separate documents as *arquebusier du roy* (gunmaker to the king) (Jarlier 1976–81, vol. 3, col. 163). In this respect, Heer (1978–82) may be correct in his assumption that there was only one gunmaker in question, Jean François Laurent le Languedoc. The last record of the name of Laurent le Languedoc (his Christian name is not given) is found in the expense accounts of the "Petites Écuries du Roy" for the period 1728–30 (Wackernagel 1976, vol. 2, p. 253), though a pair of double-barreled turnover flintlock guns in the Liechtenstein collection (inv. nos. 3815, 3935), dated 1732 and 1733 on the buttplates, appear to be his latest dated firearms. These bear the name Laurent le Languedoc engraved on the lockplates and the gold monogram JL (for Jean Laurent?) on the barrels.

This question—whether there were one or two gunmakers using the name Languedoc—must be raised again with regard to the Liechtenstein gun under consideration, as it appears to date to the years around 1730–40. This dating is based upon the slender arched shape of the butt and upon the inclusion of Rococo shells, scrolls, and panels of diaper ornament upon the lockplate, barrel tang, and mounts. Some of these motifs can be found in De Lacollombe's patternbook issued in 1730, but some of the most elaborate shell motifs of advanced Rococo style (on the lockplate, steel, and barrel) appear in the sheets of firearms ornament issued by De Marteau in the 1740s, though they already existed in the decorative arts in the previous decade. In light of the late dating of this gun, Languedoc either worked to a very advanced age (Georg Keiser, the Viennese gunsmith, signed his last known piece at the age of ninety-three), or there were in fact two gunmakers, possibly father and son, of the same name.

The magnificent barrel is by one of the Peresteva (usually, and incorrectly, called Esteva) family of Barcelona, who were active as barrelsmiths throughout the eighteenth century. J. D. Lavin (personal communication, June 1984) has suggested that the mark is that of Joan Peresteva, chief inspector of the Barcelona arsenal from 1716 to 1737. The silver backsight and silver-damascened scrolls around the barrelsmith's marks and backsight and at the muzzle appear to be the original Spanish decoration, whereas the engraved and gilded ornament was probably added in Paris, presumably in Languedoc's workshop. The coat of arms and the French inscription (To His Highness Prince Charles) identify the original owner of this gun as Charles of Lorraine, Count of Armagnac (1684–1751). The seventh son of Louis of Lorraine, Count of Armagnac, Charny, and Brionne and *Grand Écuyer* (1641–1718), Charles had a long and distinguished military career. Beginning as a musketeer in 1697, he became captain of cavalry in the regiment of Prince Camille of Lorraine in 1701 and lieutenant general of the armies of the King in 1712. He served during the War of the Spanish Succession (1701–1714) and saw action in Germany at Kehl and Höchstädt in 1703/1704 and in the Netherlands at Malplaquet in 1709, at Arleux in 1711, at Denain in 1712, and at Douai and Le Quesnoy in 1712. He succeeded his elder brother Henri, Count of Brionne, as *Grand Écuyer de France* (Grand Master of the Royal Stables) in 1712 and was bestowed with the orders of Saint Michel and Saint Esprit in the chapel at Versailles on June 3, 1724. He was named governor of Picardy, Artois, and Montreuil-sur-mer in 1748. Married to Françoise Adélaïde de Noailles (1704–1776) in 1717, he died without heirs. The biographical information, largely derived from the contemporary account of Père Anselme and Du Fourny (vol. 3 [1728], pp. 500–501; vol. 8 [1733], p. 510), establishes that the gun could not have been made before 1724, when Charles of Lorraine received the royal orders.

The Liechtenstein inventories do not indicate exactly when this gun entered the collection. It is clearly described in the inventory of Prince Joseph Wenzel dated 1761 (Waffensammlung Library, Vienna, ms. 339181, fol. 11v) and again in 1766 (Princely Archive, ms. 1616, fol. 9). It may have been presented to Prince Joseph Wenzel in the years 1737–40, when he was imperial ambassador in Paris. Certainly he would have known the *Grand Écuyer*, whose military interests paralleled his own.

SWP

FURTHER REFERENCES: Cat. 1952, p. 44, no. 215; Blair 1979, p. 52, fig. 14; Vienna 1980, p. 569, no. 143.08.

88

FLINTLOCK GUN

French (Versailles), ca. 1770–80
Steel, walnut, horsehair, fabric, whalebone, horn, gold; length overall 50 in.
* (126.9 cm.); length of barrel 35 7/16 in. (90 cm.); caliber .60 in. (15 mm.)*
Liechtenstein inv. no. 3609

The barrel is in three stages—octagonal, polygonal, and round—with transverse moldings separating the latter two. A gilt panel at the breech is stamped with three oval marks; on the top facet is the mark of barrelsmith Jean-Baptiste Leclerc of Paris (a crown and two crossed palms above the letters I.L.C.; Støckel no. 180), and a fleur-de-lis proofmark (Støckel no. 5454) appears on the facet to either side. The remainder of the barrel is blued and ornamented with chiseled and gilt trophies of arms and foliage, with a sunburst around the silver blade foresight and gilt bands at the muzzle. The top facet of the barrel is inscribed DE SAINTE A VERSAILLES. The silver backsight, cast and chiseled with scrolls, is attached to the barrel by a ring; the sight is hallmarked with an A within a square, the tax stamp used in Vienna in 1806/1807 (Rosenberg 1922–28, vol. 4, p. 435, no. 7877). The false breech of bright steel is engraved with trophies and foliage. The flintlock of bright steel has a convex lockplate en-

88

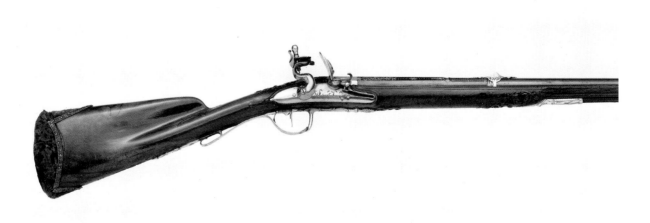

graved DE SAINTE ARQUEBUSIER/OᴰᴿDU ROY A VERSAILLES; the lock is otherwise unornamented, with the exception of oak leaves chiseled in low relief on the front of the steel.

The slender walnut stock is carved with foliage around the brightly polished steel mounts. The sideplate is engraved with fruit and flowers; the triggerguard is engraved with a trophy of arms and chiseled with foliate ends. The end of the butt is fitted with a horsehair pad upholstered with green velvet; the silver border of this pad is attached to the stock by gilt nailheads. The ramrod of dark flexible whalebone has a steel-capped horn tip. Stamped into the underside of the butt is the number 315 and the numeral v.

Pierre de Sainte (act. 1747–88), the maker of this gun, held the title "gunmaker in ordinary to the King at Versailles" under Louis XVI from 1763. This gun is one of a set of twelve ladies' sporting guns by De Sainte that are recorded in the imperial *Gewehrkammer* inventory of 1819, no. 315: *Französische Flinten in braunem Schaft mit grün samtenem Anschlag, die Läufe reich mit gold eingelegt, und silbernen Absehen und Fliegen auf einem Goldstern[.] De Sainte a Versail . . . 12. Der Kaiserin Ludovica von Herzog Albert zum Präsent* (French flintlocks with brown stock with green velvet-covered pad, the barrels richly inlaid with gold, and [with a] silver backsight and [a] foresight on a gold star. De Saint a Versailles . . . 12. A present from Archduke Albert to Empress Ludovica). From this we learn that the guns had belonged to Maria Ludovica Beatrix d'Este (1787–1816), third wife of Emperor Franz II (1768–1835, reigned from 1792), who had received them as a present from her uncle Archduke Albert of Sachsen-Teschen. It has been suggested that the set of twelve guns may have been sent to Vienna by Queen Marie Antoinette

of France (Gamber and Beaufort-Spontin 1978). The twelve guns remained together in the Waffensammlung, Vienna, until 1925, when two were sold from the collection (Dorotheum 1925, nos. 19–20, pl. 2); one of these, the present gun, passed into the Liechtenstein collection, while the other was acquired by the French collector Georges Pauilhac and is now in the Musée de la Chasse et de la Nature, Paris (inv. no. 962). It is interesting to note that, in addition to the imperial *Gewehrkammer* number (315) stamped into the stock, all parts of this gun are marked on their interior with the number five, either as the Roman v or the Arabic 5, as an indication that this is the fifth of a series. Presumably each of the twelve guns was similarly marked with its respective serial number to facilitate proper assembly.

The slender proportions of this gun, the return to convex surfaces for the lock and mounts, the form of the triggerguard with its additional loop at the back for the fingers, and the delicate floral ornament evoking the Rococo are characteristic elements of gunmaking style in the second half of the eighteenth century.

De Sainte is perhaps better known as the father-in-law of Nicolas-Noël Boutet (1761–1833), director of the National Arms Factory at Versailles from 1793 to 1818 and the foremost gunmaker in France during the Napoleonic era. De Sainte's title of royal gunmaker was valued at 10,000 francs when he ceded it to Boutet in 1788 as part of the marriage contract.　　SWP

FURTHER REFERENCES: Cat. 1952, p. 47, no. 236; Feldkirch 1971, no. 114.

VIENNESE FIREARMS

With the establishment of a gunmakers' guild in Vienna in 1661 and the subsequent flowering of that craft in the late seventeenth century, the imperial court acquired a highly skilled local source for the great numbers of hunting arms it demanded. By the beginning of the eighteenth century, a distinctive style of Viennese firearm had developed. The walnut stocks were mounted with gilt-brass furniture, cast in elaborate patterns of Baroque foliage and strapwork. The locks were typically engraved with scrolls and often included a hunting scene in the manner of the prints by Johann Elias Ridinger (1698–1767). Spanish barrels were highly prized by the Austrian nobility and seem to have been imported in great numbers for mounting in Vienna with locally made locks and stocks. The pervasive Spanish influence also affected the appearance of the barrels made by Viennese masters, which were finished and signed in

emulation of barrels imported from Madrid and Barcelona. The overall effect of eighteenth-century Viennese firearms is colorful, with the brilliant gilt-brass mounts contrasting against dark red walnut stocks and blued barrels damascened in gold or silver. Viennese firearms were technically among the finest ever made and only secondarily served as a decorative adjunct to the brilliant green-and-gold hunting costumes of the court.

The finest assembly of Viennese firearms is preserved today in the former *Hofgewehrkammer* (arms cabinet of the imperial court), now in the Waffensammlung of the Kunsthistorisches Museum, Vienna. However, the Liechtenstein collection contains more than three hundred Viennese guns, rifles, and holster pistols, of which cat. nos. 89–93 are among the most important.　　SWP

PAIR OF FLINTLOCK HOLSTER PISTOLS

Austrian (Vienna), ca. 1690–1700
Steel, walnut, silver, horn; length overall 23¼ in. (59 cm.); length of barrel
16⅛ in. (40.9 cm.); caliber .64 in. (16.5 mm.)
Liechtenstein inv. nos. 3432–33

The bright steel barrels are round, chiseled with shaped moldings at the breech, and have a flat longitudinal sighting rib that terminates at the silver blade foresight. The breeches are stamped with the gold mark of Georg Keiser (Støckel nos. 569–70), and the sighting ribs are engraved with foliage and inscribed A VIENNE. The engraved barrel tangs incorporate a U-shaped backsight.

The bright steel locks are of conventional flintlock construction. The convex lockplates are engraved behind the cock with a putto, seated among trophies of arms, who holds aloft a circular shield(?); in front of the cock there is a running warrior armed with shield and sword; the lockplates are inscribed GEORG KEISER/ A VIENNE. The cocks are engraved with foliage. The top cock jaw and jaw screw of inv. no. 3433 are now missing.

The full stocks of dark walnut are carved with foliate scrolls behind the barrel and rear ramrod pipe; the fore-end caps are of dark horn. The polished steel mounts, engraved with zigzag ornament and foliage, include serpentine sideplates, bulbous pommels with long spurs, triggerguards with foliate terminals, and rounded ramrod pipes. The silver escutcheons are engraved with the Liechtenstein coat of arms, with crossed branches below and a princely bonnet (*Fürstenhut*) above, and are inscribed around the edge: PHILIPVS ERASMVS FIRST VON V ZV LICHTENSTEIN. Below the escutcheon is a cartouche-shaped silver plaque inscribed: *Diese Pistol Seÿnd mit den Sterb:pferd 1704 nach der action beÿ Cast:novo: alwo mein Vatter gebliben, den Comend: General guido (sic) Starenberg in Italie geben worden, der mir diese 1732 zur gedaechtnus verehret* (translation given below). The wooden ramrods have tips of dark horn and steel.

These robust pistols with their sparsely decorated steel mounts were designed to be carried in the saddle holsters of a cavalry officer or nobleman. Their importance is historical rather than aesthetic, as they were a memorial to Prince Philipp Erasmus

von Liechtenstein (1664–1704). Philipp Erasmus served with the imperial army during the Turkish Wars in the years following the Siege of Vienna (1683). He participated in the rout of the Ottoman army at the Battle of Harsan Mountain, in Hungary, on August 12, 1687; at the Siege of Belgrade in September 1687; and in the Hungarian campaigns under Prince Eugene of Savoy in 1697. During the War of the Spanish Succession (1701–1714) he commanded a regiment, with the title of Lieutenant Field-Marshal. Wounded at the Siege of Mantua in August 1703, he returned to the field at the Battle of Castelnuovo in the Bórmida Valley, in the Piedmont region of Italy, where he was killed in action on January 9, 1704. This event is recorded on the plaque attached to the grip of each pistol: "These pistols, together with the funeral horse, were given in 1704, after the action near Castelnuovo at which my father died, to the commanding General Guido Starhemberg, who gave them to me as a memorial in 1732." The son responsible for this plaque was undoubtedly Prince Joseph Wenzel in whose *Gewehrkammer* inventories of 1751 (Princely Archive, ms. 1649, p. 60), 1761 (Schedelmann 1944, p. 71), and 1766 (Princely Archive, ms. 1616, pp. 73–74, no. 48) the pistols are described.

Johann Georg Keiser, the maker of these pistols, was one of the founders of the Viennese school of gunmaking and was its leading craftsman for over half a century. Born in the Bohemian gunmaking town of Eger in 1647, he became a master in the Viennese gunmakers' guild in 1674. His extraordinarily long life is documented by a number of guns made late in his career, each proudly inscribed with his age: a gun in the Princely Collections (inv. no. 3883), inscribed *alt 93 Jahr* (93 years old), establishes that he was still working in 1740. A large number of firearms of all types were made by Keiser for the Emperor and his court. For the Princes of Liechtenstein he made the six

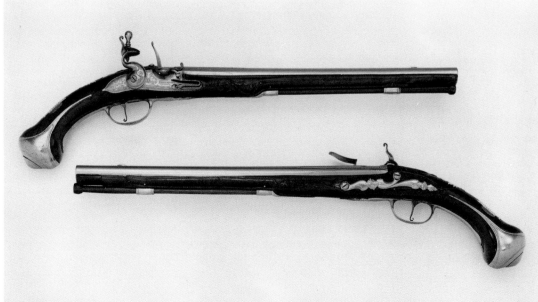

89

Fig. 24 Detail from cat. no. 89

wheellock rifles, seven flintlock guns, and thirty pistols (mostly pairs) remaining in Vaduz today. The Princely Archive contains many references to Georg Keiser, beginning in 1688, when he was paid for mounting a Turkish barrel for Prince Maximilian Jacob Moritz (Liechtenstein ms. 469, p. 14, no. 30). These pistols are Keiser's earliest datable firearms in the Liechtenstein collection. The running warrior on the lockplates appears to have been adapted from a similar figure on a lockplate engraved on pl. 8 of Simonin's patternbook *Plusieurs Pièces et Ornements Darquebuzerie* of 1685. This French influence observable in Keiser's work in the seventeenth century disappears after 1700, when his firearms became more distinctly Viennese.

SWP

90

PAIR OF FLINTLOCK PISTOLS

Austrian (Vienna), ca. 1720–30
Steel, walnut, brass, gold, silver; length overall 22³⁄₁₆ in. (56.3 cm.); length of barrel 15⅛ in. (38.5 cm.); caliber .61 in. (15.5 mm.)
Liechtenstein inv. nos. 3798–99

The blued barrels are round, with side-flats at the breech and a flat longitudinal sighting rib that ends at the silver blade foresight; the touchholes are gold-lined. The breech is stamped with the gold mark of the Madrid barrelsmith Alonso Martínez (a variant of Støckel no. 745), with three gold-stamped flowers and a cross above (similar to Støckel nos. 747–48). The bright barrel tangs incorporate V-shaped backsights and are engraved with foliage on a horizontally hatched ground.

The brightly polished lockplates have a stepped profile behind the cock and are chiseled with scrolls on a gilt matte ground. A panel behind each cock is blued and gold-damascened with strapwork, and a blued panel in front of the cock is inscribed in gold FELIX MEIER/IN WIENN. The cock and steel are chiseled with scrolls on a gold matte ground; the cock screw is of engraved gilt brass.

The dark walnut stocks are carved with strapwork and foliage behind the barrel tang and rear ramrod pipe and are mounted in gilt brass chiseled and engraved with strapwork and foliage. The sideplates are pierced with foliate scrolls which incorporate, on inv. no. 3799, a rider, armed with a pistol, and his dog; and, on inv. no. 3798, a rider thrown to the ground, his saddleless horse galloping off, with a parrot above mocking him. The escutcheon is emblazoned with the Liechtenstein arms surrounded by the collar of the Order of the Golden Fleece and surmounted by a princely bonnet (*Fürstenhut*). The buttcaps are chiseled in relief with strapwork, with a mask at the center. The bronze fore-end cap is made in one with the front ramrod pipe. The wooden ramrods have tips of horn and brass.

Felix Meier (master from 1702–d. 1739) was one of the finest Viennese gunmakers and is best known for his successful recreation of damascened barrels in the Turkish style. Meier was married to Georg Keiser's daughter, and the two masters appear to have worked together closely, apparently even sharing some commissions: in the Liechtenstein collection there are

90

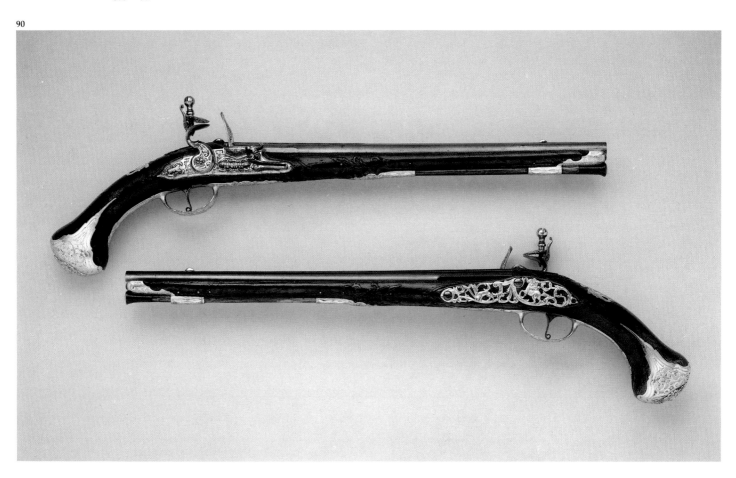

what appear originally to have been a dozen flintlock holster pistols with Spanish barrels and identical brass mounts; of the remaining six pistols, five have locks signed by Keiser, the sixth by Meier. The present pistols are typical of the superb finishing of Meier's firearms. The locks are unusually colorful in combining relief-chiseled scrollwork of bright steel against a ground of matte gold and blued steel; similarly decorated locks are found on pistols made by Georg Keiser, Meier's father-in-law. The gilt-brass mounts are exceptional among Viennese firearms for the graceful strapwork design on the buttcaps and the anecdotal subject on the sideplates. The strapwork motif is repeated in the carving of the stocks and in the decoratively shaped outline of the lockplates. The shape of the cock, which has a scroll at the point where the neck springs from the body, is typically Viennese.

The Liechtenstein coat of arms engraved on the escutcheons of these pistols consists of the quartered arms of Silesia, Kuehnring, Troppau, and East Frisia, with Jägerndorf at the point and the ancient Liechtenstein arms as the inescutcheon. This is the coat of arms of the Gundaker branch of the family, named after Gundaker von Liechtenstein (1580–1658), the younger brother of the first Prince, Karl I (1559–1627). With the death of Karl's grandson Prince Johann Adam Andreas in 1712, the so-called Caroline branch of the family (i.e., the direct descendants of Karl I) became extinct and was replaced by the Gundaker branch from which all subsequent Princes descend. The Gundaker coat of arms thus remains the blazon of the Reigning Prince and, since 1719, of the Principality of Liechtenstein itself. The presence of the collar of the Order of the Golden Fleece in conjunction with the arms on the escutcheons suggests that the pistols were made for Prince Joseph Johann Adam (1690–1732; reigned from 1721), who received the Fleece in 1721. The pistols are not likely to have been made for Joseph Wenzel (1696–1772; reigned 1712–18, 1748–72), who received the Fleece in 1740 (the year of Felix Meier's death), unless the escutcheons were added after that date. Nevertheless, the pistols are recorded in Joseph Wenzel's *Gewehrkammer* inventories of 1751 (Princely Archive, ms. 1649, p. 70), 1761 (Schedelmann 1944, p. 71, no. 26), and 1766 (Princely Archive, ms. 1616, fol. 60, no. 3), where they are described: *Ein paar pistollen von Martinez, die schlösser vom Felix Mayer mit gold eingelegt, gelb montirt mit fürstlichem wappen schield* (A pair of pistols by Martínez, the locks by Felix Mayer [sic] inlaid with gold, mounted in yellow [metal], with the princely coat of arms). A similar pair of pistols, also with barrels by Martínez and locks by Meier, are described in the same inventories and are still in the Liechtenstein collection (inv. nos. 3661–62).

SWP

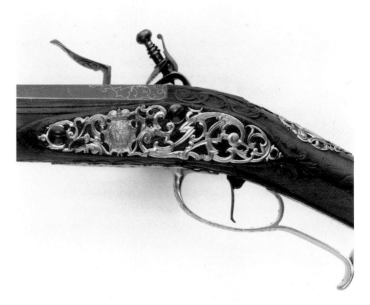

91

91

FLINTLOCK GUN
Austrian (Vienna), ca. 1720–30
Steel, walnut, brass, gold, silver, horn; length overall 59 in. (149.8 cm.);
* length of barrel 43¾ in. (111.1 cm.); caliber .68 in. (17.5 mm.)*
Liechtenstein inv. no. 188

The deeply blued barrel is of two sections, octagonal and round, with transverse moldings and chiseled foliage; a silver bead foresight is mounted at the slightly flared muzzle. The breech is damascened in gold with interlaced strapwork and is stamped with the gold mark and countermark of gunsmith Joseph Hamerl (Stöckel nos. 467–68), with three gold flowers on the facet to either side and four above. The bright steel tang is engraved with strapwork and the number 1. The touchhole is gold-lined.

The flintlock is unusual in that the cock and its flat retaining screw are recessed flush with the lockplate; the steel spring is mounted inside the lockplate. The flat lockplate is engraved overall with a stag hunt within a landscape. The lockplate is inscribed around the cock IOSEPH HAMERL IN WIENN. The cock and steel are engraved with scrollwork.

The half-stock of walnut is carved with interlaced foliage and has a horn fore-end cap; the inventory number 188 is incised on the top of the butt. The mounts are of gilt bronze, chiseled with strapwork and engraved with figures appropriate to the hunt, notably Diana and two dogs on the buttplate extension and a seated hunter in eighteenth-century costume on the rearmost of the pierced barrel rings. The pierced sideplate includes a medallion engraved with the Liechtenstein coat of arms surrounded by the collar of the Order of the Golden Fleece and surmounted by a princely bonnet (*Fürstenhut*). The escutcheon is blank. The trigger is blued steel; the triggerplate and triggerguard are gilt bronze. The wooden ramrod has a dark horn tip and is held by three bronze ramrod pipes. On the buttplate is engraved the inventory number 10.

This gun is discussed in the text for cat. no. 92.

SWP

FLINTLOCK GUN

Austrian (Vienna), ca. 1730
Steel, walnut, brass, gold, silver, horn; length overall 57¾ in. (148.8 cm.);
 length of barrel 42⁹⁄₁₆ in. (108 cm.); caliber .63 in. (16 mm.)
Liechtenstein inv. no. 3856

The blued steel barrel is octagonal, changing to round, with transverse moldings between, and is mounted with a silver bead foresight. The breech is stamped with the gold mark and countermark of Hamerl, as is cat. no. 91. The bright steel tang is engraved with a stag.

The flintlock is of conventional construction. The gilt-brass lockplate is engraved behind the cock with a seated huntress (Diana?) and a cupid holding two doves; in front of the cock, a huntress is approached by a shepherd, at whom the cupid aims his bow. The lockplate is inscribed IOSEPH HAMERL beneath the pan and IN WIENN behind the cock. The cock of blued steel is damascened with gold strapwork and is secured by a gilt-brass screw. The steel is polished bright and engraved with a huntress; the steel spring is blued.

The dark walnut half-stock is chiseled with interlaced foliate strapwork and is mounted in gilt brass, pierced, chiseled, and engraved with scenes related to the hunt, including a figure of Diana on the butt. The wooden ramrod has a dark horn tip.

The maker of cat. nos. 91 and 92—which are not a matched pair—is Joseph Hamerl (1678–1738), a Munich-trained gunsmith who became a master in the Vienna guild in 1710. Besides producing richly decorated firearms for the Vienna court, Hamerl held the title of *herzoglich-lothringischer Hofbüchsenspanner* (gun-winder to the ducal court of Lorraine) to Francis Stephen, Duke of Lorraine (1708–1764), who reigned from 1748 as Emperor Francis I. The two guns show a particularly imaginative treatment of the locks. One of them, cat. no. 91 (inv. no. 188), has a countersunk cock and an internal steel spring, which reflects the trend toward streamlining the appearance of the lockplate in the second quarter of the eighteenth century. This also served to provide a large surface on which to engrave elaborate hunting scenes in the manner of the hunting prints by Johann Elias

Ridinger (1698–1767). The lock of the second gun, cat. no. 92 (inv. no. 3856), combines a gilt-bronze lockplate with a blued and gold-damascened cock, a white steel, and a blued steel-spring for a rich, colorful effect.

Both guns reflect the trend in Viennese gunmaking to emulate Spanish fashions. Hamerl's mark, countermark, and surrounding foliate motifs directly imitate those of Madrid barrelmakers, as does the use of rings to secure the barrel to the stock. On the other hand, the triggerguard, with the projection behind for the fingers, is a feature generally found on Central European firearms dating from 1725 to 1775. During this period the full stock, which was subject to damage owing to the thinness of the wood, was often replaced by a half-stock, as seen on these two examples.

Cat. no. 91 (inv. no. 188) was originally one of a pair of sporting guns. Its mate (formerly inv. no. 189) was sold from the Liechtenstein collection (American Art Association, New York, November 19–20, 1926, no. 77); it was later in the collection of Clarence H. Mackay, Roslyn, New York (sale catalogue, Christie's, London, July 27, 1939, no. 26). In recent years it was in the W. Keith Neal collection, Warminster, England, but its present location is unknown. The presence of the Liechtenstein coat of arms and the collar of the Order of the Golden Fleece on the sideplates of cat. no. 91 indicates that it was probably made for Prince Joseph Johann Adam, who became a knight of the order in 1721. The inventories of Prince Joseph Wenzel include the description of "a flintlock gun, the barrel and lock by Joseph Hamerl, with gilded mounts," which may refer to this gun (Princely Archive, ms. 1649 [inventory of 1751], p. 18; Schedelmann 1944 [inventory of 1761], p. 69, no. 120; and Princely Archive, ms. 1616 [inventory of 1766], p. 35, no. 131).

SWP

FURTHER REFERENCES: Stockerau 1902, p. 55, no. 328 or 329 (inv. no. 188); Cat. 1952, p. 44, no. 214 (inv. no. 3856).

92

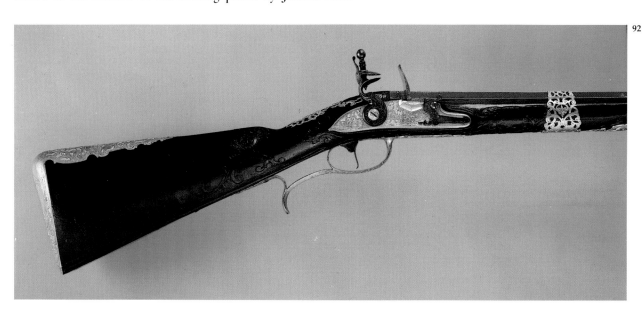

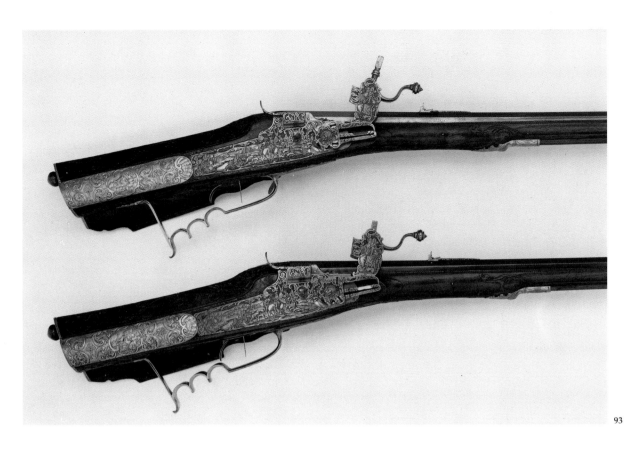

93

93

PAIR OF WHEELLOCK RIFLES

Austrian (Vienna), ca. 1740
Steel, walnut, brass, gold, horn; length overall 42¼ in. (107.4 cm.); length of
 barrel 30¹¹⁄₁₆ in. (77.9 cm.); caliber .54 in. (14 mm.)
Liechtenstein inv. nos. 164–65

The heavy octagonal barrels, formerly blued, are rifled with seven grooves.
Each is mounted with a brass bead foresight and a brass backsight having two
folding leaves and an extension along the barrel pierced with scrolls. The breech
is damascened in gold with scrolls and the gunmaker's name MARCUS ZELNER.
The bright barrel tangs are engraved with strapwork and the numbers 1 and 2,
respectively.

The wheellocks, with concealed wheel, are of late form. The flat lockplates
of bright steel are each engraved with the same boar-hunting scene with figures
in eighteenth-century costume. The cocks with flat hoods concealing the jaws
are engraved with figures of Venus and Cupid accompanied by a dog, and the
bridles of the cock springs are engraved with a boar.

The walnut stocks are carved with foliate scrolls, and each is mounted with
gilt-brass furniture, comprising a sideplate, sliding butt-trap cover, buttplate
with blued steel ball, decorative panels on top of the butt and on the cheek,
triggerguard, ramrod pipes, and fore-end cap. The mounts are cast and chis-
eled with foliate scrolls, allegorical figures, and scenes from the hunt; Diana
(goddess of the hunt) and a dog are represented on the sideplates and butt-trap
covers. The buttplates are engraved with scrolls, a female bust, and the number
45. On the top of the butt of each rifle is incised an inventory number (164 and
165, respectively). The set-triggers are steel. The wooden ramrods have horn
and brass tips.

Wheellock rifles were the favorite weapon for stag hunting and
target shooting in Central Europe where they continued to be
made well into the eighteenth century, long after they had been
abandoned elsewhere in favor of smoothbore flintlock guns. As
luxury weapons, the finest wheellocks were often made in pairs,
allowing the shooter a second shot from a matching rifle.

In the early eighteenth century the Vienna gunmakers' guild
still required each applicant to submit a "masterpiece," that is,
a wheellock rifle made in its entirety (lock, stock, and barrel).
Marcus Zelner (also spelled Zellner) the maker of the present
rifles, would have submitted such a masterpiece when he ap-
plied for entrance to the guild in 1726 (Schedelmann 1944, pp.
20–21). Zelner (master 1726–58) was one of a large family of
Viennese gunmakers who originally came from Salzburg, all of
whom are represented in the Liechtenstein collection. Like other
Viennese gunmakers, Marcus Zelner was equally at home mak-
ing wheellock and flintlock firearms, and the Liechtenstein col-
lection contains not only this pair of rifles but also three pairs
of flintlock fowling pieces and two pairs of flintlock holster pistols,
most of them made for Prince Joseph Wenzel. The present rifles
presumably also belonged to this Prince and may be identifiable
in his inventories of 1751 (Princely Archive, ms. 1649, p. 52)
and 1761 (Schedelmann 1944, fol. 4, no. 3). In the nineteenth
century these rifles were kept in the Liechtenstein castle at
Kromau in Moravia.

SWP

FURTHER REFERENCES: Stockerau 1902, p. 46, nos. 298–99, ill.; Cat. 1952, p. 43,
no. 212, or p. 47, no. 235; Feldkirch 1971, no. 110; Blair 1979, p. 52, fig. 4.

A GARNITURE OF SIX SPANISH GUNS

These six guns (cat. nos. 94–99) are listed in the *Gewehrkammer* inventory of Prince Joseph Wenzel begun in 1766 (Princely Archive, ms. 1616, p. 21), where they are recorded as having been presented to that Prince by his sovereign, Emperor Joseph II (reigned 1765–90), on October 30, 1767. Preserved in virtually pristine condition, they retain their cheekpads, tampions (barrel storage-rods), and storage boxes (cat. no. 100). They are representative of the best Spanish gunmaking in the eighteenth century, and as a group they are unique.

The guns are signed by six different Madrid masters, five of whom held the prestigious title of royal gunmaker. The earliest of these, Nicolás Bis (act. 1692–d. 1726), was also the most famous. He was a pupil of Juan Belen, gunmaker to Charles II (reigned 1665–1700) of Spain, and succeeded to that title in 1691. He was greatly esteemed by Charles's successor, Philip V (reigned 1700–1746), the first Bourbon monarch of Spain. In 1713 Bis became the first gunmaker in Spain to have his entire output reserved for royal use; he was also one of the first Spanish gunmakers to follow French fashions. On Bis's death in 1726, Juan Fernández (act. 1711–d. 1739) was named royal gunmaker. Francisco Antonio Baeza y Bis (act. 1730–d. 1765), represented here by a splendidly decorated gun (cat. no. 96), was the grandson of Nicolás Bis, whose name he adopted and whose countermark he copied for his own firearms. Appointed honorary gunmaker to the King in 1735, he succeeded Fernández as royal gunmaker in 1739. Gabriel de Algora (act. 1733–d. 1761) was appointed gunsmith to Ferdinand VI (reigned 1746–59) in 1749, but the superbly decorated Liechtenstein gun (cat. no. 97) is an example of his work prior to that date. Joaquín de Zelaia (also spelled Zelaya or Celaya) (act. 1747–d. 1760) was honorary gunmaker to Ferdinand VI from 1747 and became royal gunmaker, together with Algora, in 1749. Juan Santos (act. 1721–ca. 1756), maker of cat. no. 98, was a commercial gunmaker, the only master represented here who was not employed by the King.

These guns exhibit many of the characteristic features of Spanish firearms. The barrels are smoothbore (rifled Spanish barrels are virtually unknown) and are generally formed in two stages, octagonal and round, with finely chiseled moldings and foliage between. The surfaces are fire-blued and damascened in gold, often with a profusion of foliate decoration along the entire length of the barrel. The gunsmith's marks (one with his name, the countermark with his emblem) are deeply stamped into the breech, each mark covered with a piece of gold foil; these marks are often accompanied by decorative flowers (or other devices) and a cross in gold. An inscription in gold-damascened letters giving the maker's name, the city in which he worked, and the date of manufacture is often present. The barrel is attached to the stock by rings held in place by spring-catches (this method

is different from that common in firearms produced elsewhere in Europe; in those guns, pierced lugs were brazed to the underside of the barrel, and transverse pins were passed through the stock and lugs). The backsight is also attached by a ring fitting over the barrel and is often elaborately decorated to match the mounts of the stock.

The Spanish lock is also highly distinctive. From the early seventeenth century until the introduction of the percussion system in the nineteenth century, the vast majority of firearms made on the Iberian Peninsula were fitted with a flint-fired snap-lock mechanism known in Spain as a *patilla* lock, to which the modern term "miquelet" is commonly applied. Characteristic features of the miquelet lock include: a mainspring mounted on the outside of the lockplate; a horizontally moving sear which provides the cock with two positions: safety (half-cock) and firing (full-cock); and a combined steel and pancover of distinctive L-shape. The strong mainspring necessitated a heavy lockplate of irregular shape quite unlike that found on the typical European flintlocks. Yielding to the pressure of French influence under the Bourbon monarchy, the conservative Spanish gunmakers adapted the miquelet lock to the foreign style. The type of miquelet lock utilized on the gun by Santos (cat. no. 98) was known as the *tres modas* type, miquelet in construction but with the lockplate, cock, and steel of French shape. The other guns of this group are also equipped with miquelet locks but of the *a la moda* type, which have the outward appearance of French flintlocks, with internal mainspring, but which retain the inner constructional features of the miquelet. In both types of locks the cock retained the distinctive ring screw.

French influence also changed the appearance of the stock and the decoration of the gun as a whole. All six of these guns show the abandonment of the traditional fluted form of Spanish stock in favor of a full-length stock of the French shape (*a la francesca*), constructed of burled maple, with mounts of brightly chiseled and gilt steel. The decoration generally followed French gunmakers' patternbooks, especially the various editions of Claude Simonin's *Plusieurs Pièces et Ornements Darquebuzerie* (1685, 1693, and 1705).

The history of this remarkable set of guns before their presentation to Joseph Wenzel in 1767 is not known. They presumably were once part of the stock of the imperial *Gewehrkammer*, but none of the guns bears any heraldic devices or emblems to indicate that they were originally made for presentation to the Emperor. There is some evidence that they were refurbished in Vienna, as the present green velvet-covered cheekpads and tampions match the interiors of the two guncases and show little sign of wear. Green was the color traditionally associated with the hunt in German lands and was used for hunting costumes and accessories. The inventory of the imperial *Gewehrkammer* of

1785 lists "a green hunting coat for his majesty" and "a pair of flintlock guns and two pair of pistols, [with] sacks of green velvet with gold borders" (Schedelmann 1944, pp. 66–67, nos. 82, 122). Several sporting guns by the Viennese gunmaker Joseph Früwirth, fitted with green velvet cheekpads, are still in the Waffensammlung, Vienna, and green velvet was also used for the De Sainte gun from the imperial collection (cat. no. 88). J. D. Lavin (personal communication, June 1984) has indicated, however, that the long triangular form of the present cheekpads is Spanish and that cheekpads (called *almohadillas*) were used on Spanish firearms from the time of Nicolás Bis to about 1770.

The present green velvet pads thus may be Viennese-made replacements for the original Spanish pads that became worn out. The red-and-gold covering of the boxes may refer to the Liechtenstein house colors and, if so, proves that they were constructed (or at least refurbished) on the occasion of the Emperor's gift.

<div align="right">SWP</div>

FURTHER REFERENCES: Prokop and Boeheim 1886, p. 12, pl. III (inv. no. 3611); Stockerau 1902, pp. 53–54, nos. 322–27; Cat. 1952, pp. 46, 48, nos. 231–33, 242–43, 247; Feldkirch 1971, nos. 113 (inv. no. 3607), 115 (inv. no. 3611); Blair 1979, p. 52, fig. 6 (inv. no. 3611); Vienna 1980, pp. 568–69, nos. 143.02–07, 143.09.

94

MIQUELET-LOCK (A LA MODA) GUN

Spanish (Madrid), ca. 1710
Steel, maple, ivory, fabric, gold, silver; length overall 57¼ in. (145.9 cm.);
* length of barrel 42⅛ in. (107 cm.); caliber .65 in. (16.5 mm.)*
Liechtenstein inv. no. 3608

The barrel is deeply blued and damascened in gold with foliage at the breech, moldings, and muzzle. The touchhole is gold-lined. The breech is stamped with the gold mark and countermark of Nicolás Bis (Støckel nos. 60–61), with a gold-damascened cross and four fleur-de-lis above (Støckel nos. 62–63). The U-shaped backsight is chiseled steel; the bead foresight is silver. The brightly polished barrel tang is engraved with foliage.

The flat lockplate has a countersunk rear section chiseled with foliage on a stippled ground; in front of the cock is engraved a dog attacking a boar. The lockplate is stamped with the gold mark of Nicolás Bis (Støckel no. 60) and is inscribed NICOLAS BIS MAD[RID]. The flat cock is engraved with foliate scrolls on a stippled ground; the steel is chiseled and engraved with foliage.

The full-length stock of figured maple is carved with simple moldings around the polished steel mounts. The flat sideplate (a later eighteenth-century replacement?) is sparsely engraved with foliage, the butt-plate extension with a trophy of arms. The triggerguard is engraved with strapwork, a shell, and foliage, and it terminates in foliate finials. The top of the butt is partially cut away to accommodate a green velvet-covered horsehair cheekpad, with a border of gold galloon, secured by gilt nails. The two barrel rings are pierced, chiseled, and engraved. The wooden ramrod has a turned ivory tip.

By the first decade of the eighteenth century the firearms of Nicolás Bis, the first royal gunmaker under the new Bourbon dynasty, show the influence of the "Berain" style of firearms decoration. The lock surfaces are flat and are engraved with ornament copied from the 1705 edition of Simonin's famous patternbook, which included four supplementary plates in the new fashion by De Lacollombe, a copy of which Bis is known to have possessed (Lavin 1967). This gun is a relatively plain work, but the engraved decoration, especially the foliate scrolls on the lock and the trophy on the buttplate, reflect the influence of De Lacollombe. Few complete guns by Bis are known, the majority of his barrels having been remounted at a later time in Spain or elsewhere in Europe. This is one of only two guns by Bis to retain its original stock (J. D. Lavin, personal communication, June 1984).

<div align="right">SWP</div>

94

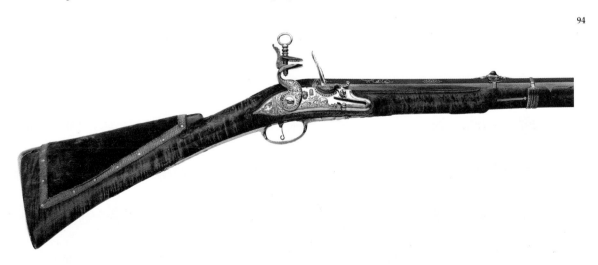

MIQUELET-LOCK (A LA MODA) GUN

Spanish (Madrid), dated 1729
Steel, maple, fabric, gold, horn; length overall 56¹¹/₁₆ in. (144 cm.); length of
barrel 41⁷/₁₆ in. (105.3 cm.); caliber .67 in. (17 mm.)
Liechtenstein inv. no. 3615

The blued barrel is stamped at the breech with the gold mark and countermark of Juan Fernández (Støckel nos. 369–70); in front of these marks are three gold-damascened flowers and a cross, and the inscription, within a cartouche, EN MADRID AÑO 1729. Gold-damascened foliage and trophies of arms are found on the sides of the breech, at the barrel moldings, and at the muzzle. The touchhole is gold-lined. The U-shaped backsight is of elaborately pierced and chiseled steel; the bead foresight is gold. The barrel tang is chiseled with bright foliage on a gold-stippled ground.

The lock is bright steel, chiseled with foliate scrolls on a stippled gold ground. The flat lockplate is stamped with the gold mark of Juan Fernández (Støckel no. 372) and is inscribed JUAN/FERNANDEZ/MD.

The maple stock, carved with foliage around the barrel tang, is mounted with chiseled and gilded steel mounts. The pierced serpentine sideplate is decorated with foliage, a monster, and an emperor's head in profile; the extension of the buttplate is chiseled with a hunting trophy, now partially covered by the green velvet-covered cheekpad. The barrel rings are blued steel, pierced and engraved. The wooden ramrod has a horn tip.

SWP

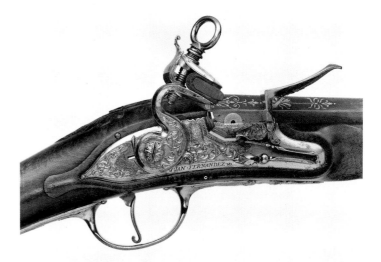

95

MIQUELET-LOCK (A LA MODA) GUN

Spanish (Madrid), dated 1732, 1734
Steel, maple, ivory, silver, gold; length overall 56³/₈ in. (143.2 cm.); length of
barrel 41¼ in. (104.8 cm.); caliber .67 in. (17 mm.)
Liechtenstein inv. no. 3611

The round barrel is blued, chiseled, gilded, and gold-damascened; the decoration is divided into four sections by transverse moldings and chiseled foliage. The breech section is stamped with the mark and countermark of Francisco Baeza y Bis (Støckel pl. 1), surmounted by four gold-damascened fleur-de-lis and a foliate cross. In front of these marks Bellona (or Minerva) stands below a canopy with trophies of arms at her feet; the figure is chiseled in relief against a stippled gold ground with banners to either side emblazoned with a fleur-de-lis (France) and a quadruped (a lion, for León?). Farther forward is an engraved and gilded figure of Hercules wearing a lionskin, holding aloft in his left hand the scales of Justice; a slain hydra lies at his feet; a banderole above is inscribed HERCULES AUDIT (Hercules hears [acts as a judge]). The backsight consists only of the base, the U-shaped sight (of silver?) having been lost; the base is chiseled with strapwork, foliage, birds, a grotesque mask, two harpies, and a cartouche inscribed FRANCº BIS. The touchhole is gold-lined. The short second section of the barrel is decorated with scrolls and a vase supporting a classical wreath-crowned bust surrounded by emblems of learning and flanked by lamps of wisdom. The decoration of the third section includes a phoenix rising from flames with Apollo's radiant head above and strapwork inhabited by birds to either side. The long muzzle section has a flat sighting rib in two parts, the first inscribed in gold FRANCº · BIS EN MADRID 1734, the second SIC FAMA CIRCVIT ORBEM (Thus Fame encircles the globe). The muzzle is gold-damascened around the gold bead foresight. The barrel tang is chiseled and gilt en suite.

The lock is chiseled in relief with figures, trophies, and strapwork on a stippled gold ground. The flat lockplate is countersunk at the back where there is a trophy of a boar's head and arms; in front of the cock a hunter on horseback shoots a pistol at a boar. A gold cartouche behind the pan is stamped FRANº BIS, and the lower edge of the lockplate is engraved EN MADRID 1732. The cock is chiseled with foliate strapwork; the upper cock jaw carved with a putto holding a boar's head. On the face of the steel is a grimacing grotesque mask. The lock interior is engraved with foliage on a stippled gold ground.

The stock of burled maple is inlaid with scrolling foliage of silver wire, some of the scrolls terminating in dragon heads in engraved silver sheet. The mounts are of bright chiseled steel on a stippled gold ground. The pierced sideplate incorporates foliate scrolls, winged heads, and a mask inscribed FRANCº BIS MD 1732 (MD = Madrid). At the center of the escutcheon is a heart-shaped medallion of gold, inscribed FRANCº BIS, with two putti above holding aloft a French royal crown; the inside band of the crown is inscribed MD 1732. The buttplate extension is chiseled with two river-gods, the bust of a warrior in classical armor, a mask, trophies, a radiant sun, and a cartouche inscribed FRANCº BIS. The triggerguard is chiseled with trophies, foliage, a figure of Bellona (or Minerva) holding a lance and a palm, and a banderole inscribed FRANCº BIS. Of the three faceted ramrod pipes, the forward two are made in one with the barrel rings, and all are chiseled en suite with the other mounts. The two barrel rings are inscribed FRANCº BIS MD. The wooden ramrod has a turned ivory tip.

This gun by Francisco Baeza y Bis is remarkable for the exceptional quality of its decoration. It is the only one of the six not to have been fitted with a shoulder pad, presumably because such a pad may have damaged the silver inlays of scrolls issuing dragon heads on the butt (these heads are closely copied from pl. 13 of the 1705 Simonin/De Lacollombe patternbook). The escutcheon with royal crown (the closed French crown was also used by the Bourbon monarchs in Spain) is copied from pl. 12 of the 1693 edition of Simonin's patternbook, with the substitution of the gunmaker's name in place of the French arms. The bust on the buttplate extension is also copied from that edition (pl. 6). The embellishment of the lock can be traced to two sources:

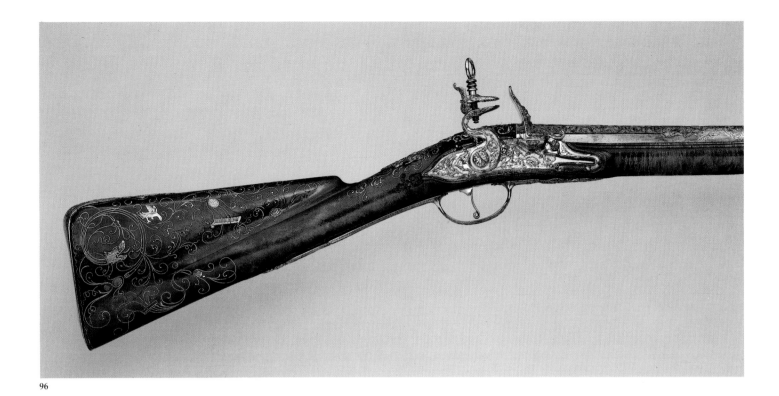

96

the stag's head trophy at the rear of the lock, the foliage on the cock, and the putto holding a boar's head on the top cock jaw are copied from the 1705 Simonin/De Lacollombe patternbook (pl. 11 by De Lacollombe); while the mounted hunter shooting a boar on the lockplate in front of the cock is adapted from the more elaborate boar hunt scene in pl. 12 of the 1693 edition of Simonin's patternbook.

SWP

97

MIQUELET-LOCK (A LA MODA) GUN

Spanish (Madrid), dated 1743
Steel, maple, ivory, fabric, gold; length overall 56⅛ in. (142.5 cm.); length of
barrel 40¾ in. (103.6 cm.); caliber .65 in. (16.5 mm.)
Liechtenstein inv. no. 3614

The barrel is octagonal at the breech and round at the muzzle with a short polygonal section between. The entire surface is blued and gold-damascened with foliage, trophies of arms, masks, birds, and, at the breech, figures of a male and female peasant. The breech is stamped with the gold mark and countermark of Gabriel de Algora (Støckel nos. 4–5), followed by four gold heads and a cross below a royal crown; in front of these marks the barrel is inscribed in gold EN MADRID/GABRIEL ALGORA/ANO DE 1743. The touchhole is gold-lined. The U-shaped backsight is chiseled and gilt steel; the bead foresight is gold. The barrel tang is chiseled and gilded en suite.

The lock is chiseled in relief on a stippled gold ground. The lockplate is chiseled behind the cock with a seated Minerva in armor, surrounded by dogs and holding aloft a bow on which sits an owl (her symbol). In front of the cock a dog chases a stag, the latter having been wounded by an arrow; an oval

medallion above the stag is inscribed G.EL/ALGO/RA/MD. On the cock is chiseled a putto with a bow; the faces of the steel are chiseled with a huntress (Diana?) with bow and two dogs. The lock interior is sparsely engraved.

The stock of burled maple is carved with foliage at the breech and behind the ramrod and with moldings at the neck of the butt. The stock shows signs of repair and has been extended at the end of the butt by the addition of a piece of wood about ¾ in. (2 cm.) wide. The mounts of chiseled and gilded steel include a pierced sideplate with a dog chasing a boar and a medallion enclosing a female bust in armor; the triggerguard and buttplate extension are chiseled with trophies, busts, and foliage en suite. A green velvet-covered pad, like that of other guns in this group, covers much of the butt. The barrel rings are blued, engraved, and gold-damascened. The wooden ramrod has a turned ivory tip.

SWP

97

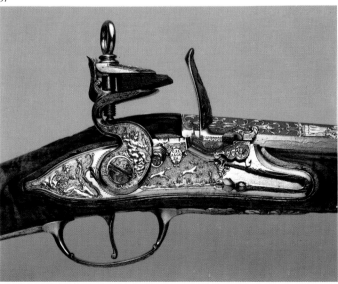

MIQUELET-LOCK (TRES MODAS) GUN

Spanish (Madrid), dated 1744
Steel, maple, gold, silver, horn; length overall 57³⁄₁₆ in. (145.2 cm.); length of
* barrel 42 in. (106.3 cm.); caliber .68 in. (17.5 mm.)*
Liechtenstein inv. no. 3619

The barrel has three stages—octagonal, sixteen-sided, and round—blued and damascened in gold with foliage; the facets of the polygonal section are alternately engraved and gilt. The breech is stamped with the gold mark and countermark of Juan Santos (Støckel nos. 985, 987), with three flowers and a cross above (Støckel nos. 988–89). The upper three facets of the breech are inscribed in gold EN. MADRID/JUAN. SANTOS/AÑO. DE. 1744. The touchhole is gold-lined. The U-shaped backsight is chiseled with foliage on a stippled gold ground; there is a gold bead foresight. The breech tang is chiseled with foliage on a gold ground.

The lock is chiseled with foliage against a stippled gold ground and is stamped behind the pan with the gold mark of Juan Santos (Støckel no. 985); the plate is engraved JUAN. SANTOS behind the cock and EN MADRID AÑO DE 1744 along the bottom edge. The cock and steel are decorated en suite. The full-length maple stock is constructed in two pieces and is inlaid with silver wire behind the barrel tang and in front of the triggerguard; the butt has a green velvet-covered pad. The bright steel mounts are chiseled and gilt en suite with the lock; the buttplate extension is ornamented with a trophy of arms. The pierced barrel rings are of bright steel. The ramrod has a dark horn tip. There is extensive damage to the butt around the pad.

SWP

98

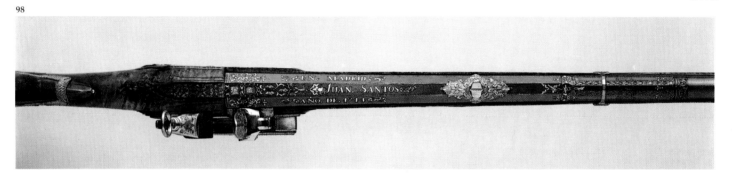

MIQUELET-LOCK (A LA MODA) GUN

Spanish (Madrid), dated 1753
Steel, maple, fabric, gold, ivory; length overall 53⁷⁄₈ in. (136.8 cm.); length of
* barrel 38⁷⁄₈ in. (98.8 cm.); caliber .65 in. (16.5 mm.)*
Liechtenstein inv. no. 3607

The barrel is blued and damascened in gold with foliate scrolls. The breech is stamped with the gold mark and countermark of Joaquín de Zelaia (Støckel pl. 1), surmounted by a stamped fleur-de-lis and a gold-damascened cross; these marks are followed by the inscription EN MADRID,/JOACHIN DE ZELAIA,/AÑO DE 1753. The backsight is chiseled with fleurs-de-lis, bright on a gold-stippled ground; the foresight is a gold bead. The touchhole is gold-lined. The bright barrel tang is chiseled with a trophy and classical bust against a gold ground.

The lockplate has a recess at the rear chiseled in relief with Rococo scrolls, flowers, and trophies, bright on a gold-stippled ground. In front of the cock the plate is engraved with a female figure (Fame) holding two trumpets and is inscribed in script *Joachin de Zelaia en Madrid*; Zelaia's gold mark (as on the barrel) is stamped below the steel. The cock is chiseled in high relief with Rococo scrolls, and the face of the steel with a lion. The interior of the lock is also chiseled and gilt.

The stump maple stock is fitted with a green velvet-covered buttpad and has mounts of chiseled and gilt steel. The sideplate is embellished with Rococo scrolls, a cornucopia, and a female bust; the buttplate extension is decorated with trophies of arms beneath a canopy. The barrel rings are blued and damascened with foliage. The wooden ramrod has a turned ivory tip.

SWP

99

100

TWO GUNCASES

Austrian (Vienna), mid-18th century
Wood, velvet, iron, gold; length 58¾ in. (149.2 cm.); width 10 in.
(25.3 cm.); height 9⅞ in. (25 cm.)

The boxes are constructed of wood and are covered with red velvet with gold borders and bands. The hinges, locks, and carrying handles are gilded iron. The interior of each is fitted with compartments for three guns (which traveled upside down), lined with green velvet with gold bands and equipped with a stuffed and tufted cushion of green velvet with gold tassels to cover the guns.

<div align="right">SWP</div>

100

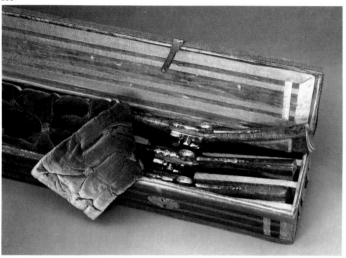

101

PANOPLY OF VIENNESE FLINTLOCK FIREARMS

This panoply is composed of fourteen flintlock guns or rifles and ten flintlock holster pistols made by Viennese gunmakers active during the eighteenth century. The majority of them were made by the prolific master Georg Keiser (1647–ca. 1740/41), who was employed by various Princes of Liechtenstein (see cat. no. 89). Keiser's work is represented here by a pair of smoothbore fowling pieces (inv. nos. 3828, 3869), three pair of rifles (inv. nos. 3910–11, 3914–15, 4024–25), and five pair of pistols (inv. nos. 254–55, 256–57, 3447–48, 4062–63, 4077–78). As this long-lived gunmaker grew ever more venerable, he proudly inscribed his age on the barrels of his guns, a practice that allows them to be accurately dated. Several examples in this panoply were made by Keiser in 1734/35 when he was eighty-seven years old (inv. nos. 3914–15), in 1735/36 when he was eighty-eight (inv. nos. 3828, 3869), and in 1738/39 when he was ninety-one (inv. nos. 4062–63). Most of these are listed in the inventories of Prince Joseph Wenzel (1696–1772). Simon Penzneter (act. 1695–1724) is represented by a pair of rifles dat-

ing from the early eighteenth century (inv. nos. 3832–33), and Anton Klein (act. 1753–82) by a pair of fowling pieces dating from about 1760 (inv. nos. 206–7). Johann Lobinger (act. 1745–88), court gunmaker to Prince Joseph Wenzel, made another pair of guns dating about 1770 mounted with Italian barrels by Beretta (inv. nos. 426, 430).

The firearms in this panoply are generally similar in appearance, with blued barrels, walnut stocks, and gilt-brass mounts, including escutcheons engraved with the Liechtenstein coat of arms. The guns by Klein and Lobinger have wooden triggerguards, a feature frequently found on Central European flintlocks of the eighteenth century.

<div align="right">SWP</div>

102

PANOPLY OF WHEELLOCK FIREARMS

This panoply, composed of fifty-two wheellock rifles and pistols, represents a cross-section of the great collection of wheellock arms in the Liechtenstein *Gewehrkammer*. The majority are hunting rifles made by gunmakers in Austria, Bohemia, Moravia, and Silesia, where the Liechtensteins had their estates. The most distinctive of these is the type of wheellock birding rifle known as the *Tschinke* (or *Teschinke*), a name derived from the Silesian town of Teschen in which many of the gunmakers worked. Characteristic of the *Tschinke* are the small caliber barrel, a lock with external mainspring and push-button operated sear, and a "hind's foot"-shaped butt. The stock of the *Tschinke* is typically decorated with a colorful mix of staghorn, mother-of-pearl, and brass in an exuberant and decidedly folkloristic style. Perhaps also Silesian in origin are the enormously long (over eight feet) *Karrenbüchsen* (cart guns), also known as duck or swan guns (nos. 1–2), whose decoration, including pierced brass plaques backed by red felt, recalls that of a small group of *Tschinke*-style firearms. As the name *Karrenbüchsen* implies, these cumbersome guns were mounted on carts rolled into the fields. Exceedingly rare firearms, these cart guns may be compared to very similar examples in the Bayerisches Nationalmuseum, Munich (inv. nos. 996–97), and in the Odescalchi collection, Rome (inv. no. 145).

Austrian gunmakers are well represented, especially those of Vienna (Jacob Koch, Caspar Zelner, and his nephew Marcus Zelner) and Salzburg (Matthias and Michael Mätl and Johann Neyreiter). The earliest of the Austrian guns, a carbine (no. 52), is one of a series of identical weapons carried by the guard of Wolf Dietrich von Raitenau (1559–1617), Prince-Archbishop of Salzburg from 1587 to 1612. This short gun makes an interesting comparison to another example in the Liechtenstein collection, the carbine made for Archduke Matthias (cat. no. 78).

The little-known Moravian gunmaker Heinrich Reimer of Tropatze can best be studied in the Liechtenstein collection. He appears to have worked extensively for Prince Johann Adam Andreas (1657–1712), whose *Gewehrkammer* inventory lists thirteen examples by Reimer, all but one of them wheellocks (see Wilhelm 1970). The nine rifles by Reimer included in this panoply were presumably made for this Prince. The most interesting of these is the pair of rifles with the Liechtenstein arms inlaid in staghorn on the cheekpiece of the butts. As nothing is yet known of Reimer's life, and none of his recorded firearms are dated, the Liechtenstein guns must be dated on stylistic grounds, most of them to the period 1670–80.

This panoply includes arms of outstanding quality and beauty. Mention should be made of the pair of wheellock rifles by Samuel Scheffel, a gunmaker active in Unterwiesenthal, Saxony, in the period 1660–90. The pale fruitwood stocks are inlaid with hunting scenes and scrolls in staghorn, and the staghunt inlaid on the cheekpiece of one of the rifles bears the initials BZ, presumably those of the stock decorator. The decoration of the lockplates, signed by the engraver AB, includes the figure of the goddess Diana with a stag, copied from the gunmakers' patternbook of Thuraine and Le Hollandois, published in Paris in 1660, and demonstrates the far-reaching influence of French patternbooks in the seventeenth century.

SWP

1. Wheellock gun (*Karrenbüchse*)
Silesian(?), mid-17th century
Length overall 98 13/16 in. (251 cm.); inv. no. 4098

2. Wheellock gun (*Karrenbüchse*)
Silesian(?), mid-17th century
Length overall 98 13/16 in. (251 cm.); inv. no. 4099

3. Wheellock rifle by Heinrich Reimer
Moravian, ca. 1670–80
Length overall 41 11/16 in. (105.8 cm.); inv. no. 3628

4. Wheellock rifle (*Tschinke*)
Silesian (Teschen?), mid-17th century
Length overall 50⅜ in. (128 cm.); inv. no. 3837

5. Wheellock rifle by Samuel Scheffel
German (Unterwiesenthal, Saxony), late 17th century
Length overall 43⅛ in. (109.6 cm.); inv. no. 3632

6. Wheellock rifle by Matthias Mätl
Austrian (Salzburg), late 17th century
Length overall 44½ in. (113 cm.); inv. no. 3633

7. Wheellock rifle by Heinrich Reimer
Moravian, ca. 1670–80
Length overall 44⅛ in. (112 cm.); inv. no. 3638

8. Wheellock rifle by Franz Heintz
Moravian (Sternberg), ca. 1730–40
Length overall 44 in. (111.7 cm.); inv. no. 4150

9. Wheellock rifle (*Tschinke*)
East European (Teschen), mid-17th century
Length overall 46⅞ in. (119 cm.); inv. no. 153

10. Wheellock rifle by Heinrich Reimer
Moravian, late 17th century (cock ca. 1720)
Length overall 44 3/16 in. (112.2 cm.); inv. no. 3636

11. Wheellock rifle by Johann Neyreiter
Austrian (Salzburg), early 18th century
(Barrel by Caspar Zelner of Vienna; lockplate engraved by
Johann Christoph Stengl of Freising, Bavaria)
Length overall 47 3/16 in. (119.8 cm.); inv. no. 3938

12. Wheellock rifle by Heinrich Reimer
Moravian, late 17th century
Length overall 46⅞ in. (119.1 cm.); inv. no. 3657

13. Wheellock rifle by Michael Städt
Austrian(?), dated 1658
Length overall 46 9/16 in. (118.3 cm.); inv. no. 3987

14. Wheellock rifle by Jacob Koch
Austrian (Vienna), ca. 1700
Length overall 46⅛ in. (118.5 cm.); inv. no. 3643

15. Wheellock rifle (*Tschinke*)
Silesian (Teschen), mid-17th century
Length overall 49 15/16 in. (126.8 cm.); inv. no. 845

16. Wheellock rifle by Jacob Koch
Austrian (Vienna), ca. 1700
Length overall 44⅞ in. (114 cm.); inv. no. 3649

17. Wheellock rifle by Marcus Zelner
Austrian (Vienna), ca. 1730
Length overall 46 9/16 in. (118.3 cm.); inv. no. 857

18. Wheellock rifle by Caspar Zelner
Austrian (Vienna), early eighteenth century
Length overall 43 11/16 in. (111 cm.); inv. no. 168

19. Wheellock rifle by Caspar Zelner
Austrian (Vienna), early 18th century
Length overall 46⅛ in. (118.5 cm.); inv. no. 3644

20. Wheellock rifle (*Tschinke*)
Silesian (Teschen), mid-17th century
Length overall 50⅜ in. (128 cm.); inv. no. 848

21. Wheellock rifle by Caspar Zelner
Austrian (Vienna), early 18th century
Length overall 43 11/16 in. (111 cm.); inv. no. 3801

22. Wheellock rifle
German, ca. 1630–40
Length overall 47 9/16 in. (120.8 cm.); inv. no. 158

23. Wheellock rifle by Caspar Zelner (pair to no. 21)
Austrian (Vienna), early 18th century
Length overall 43 11/16 in. (111 cm.); inv. no. 3839

24. Wheellock rifle (*Tschinke*) by TR (Thomas Ritter?)
Silesian (Teschen), mid-17th century
Length overall 45⅞ in. (116.5 cm.); inv. no. 849

25. Wheellock rifle by Caspar Zelner (pair to no. 19)
Austrian (Vienna), early 18th century
Length overall 46⅞ in. (119 cm.); inv. no. 3645

26. Wheellock rifle by Caspar Zelner
Austrian (Vienna), ca. 1720
Length overall 41 11/16 in. (105.9 cm.); inv. no. 166

27. Wheellock rifle by Marcus Zelner (pair to no. 17)
Austrian (Vienna), ca. 1730
Length overall 42½ in. (108 cm.); inv. no. 3803

28. Wheellock rifle by Jacob Koch (pair to no. 16)
Austrian (Vienna), ca. 1700
Length overall 45 7/16 in. (115.4 cm.); inv. no. 3648

29. Wheellock rifle (*Tschinke*)
Silesian (Teschen), mid-17th century
Length overall 46½ in. (118.2 cm.); inv. no. 850

30. Wheellock rifle by Jacob Koch (pair to no. 14)
Austrian (Vienna), ca. 1700
Length overall 46 5/16 in. (117.7 cm.); inv. no. 3642

31. Wheellock rifle by Matthias Städt (pair to no. 13)
Austrian(?), dated 1659
Length overall 46 9/16 in. (118.3 cm.); inv. no. 3658

32. Wheellock rifle
German, ca. 1675
Length overall 46 in. (116.8 cm.); inv. no. 3974

33. Wheellock rifle by Johann Neyreiter (pair to no. 11)
Austrian (Vienna), early 18th century
*(Barrel by Caspar Zelner of Vienna; lockplate engraved by
Johann Christoph Stengl of Freising, Bavaria)*
Length overall 43⅛ in. (109.6 cm.); inv. no. 3650

34. Wheellock rifle by Heinrich Reimer (pair to no. 10)
Moravian, late 17th century (cock ca. 1720)
Length overall 44⅛ in. (112.1 cm.); inv. no. 3637

35. Wheellock rifle
Silesian (Teschen?), mid-17th century
Length overall 46 11/16 in. (118.6 cm.); inv. no. 3826

36. Wheellock rifle by Heinrich Reimer
Moravian, ca. 1670–80
Length overall 44½ in. (113 cm.); inv. no. 3639

37. Wheellock rifle by Heinrich Reimer
Moravian, ca. 1670–80
Length overall 40⅜ in. (102.6 cm.); inv. no. 3937

38. Wheellock rifle by Michael Mätl
Austrian (Salzburg), late 17th century
Length overall 44½ in. (113 cm.); inv. no. 3634

39. Wheellock rifle by Samuel Scheffel (pair to no. 5)
German (Unterwiesenthal, Saxony), late 17th century
Length overall 43⅛ in. (109.6 cm.); inv. no. 3635

40. Wheellock rifle (*Tschinke*)
Silesian (Teschen), mid-17th century
Length overall 46¾ in. (118.8 cm.); inv. no. 3836

41. Wheellock rifle by Heinrich Reimer (pair to no. 3)
Moravian, ca. 1670–80
Length overall 41 11/16 in. (105.8 cm.); inv. no. 3629

42. Wheellock belt pistol (barrel signed "Lazari Cominaz")
Italian (Brescia), ca. 1620–30
Length overall 15⅝ in. (39.7 cm.); inv. no. 3574

43. Wheellock belt pistol (barrel signed "Lazari Cominaz")
Italian (Brescia), ca. 1620–30
Length overall 15 11/16 in. (39.8 cm.); inv. no. 3575

44. Wheellock pistol by Johann Stifter
Bohemian (Prague), ca. 1680
Length overall 20⅜ in. (51.8 cm.); inv. no. 4071

45. Wheellock pistol by Johann Stifter (pair to no. 44)
Bohemian (Prague), ca. 1680
Length overall 20 5/16 in. (51.6 cm.); inv. no. 4072

46. Wheellock pistol
Probably Flemish, ca. 1610–20
Length overall 22⅝ in. (57.5 cm.); inv. no. 3430

47. Wheellock pistol (pair to no. 46)
Probably Flemish, ca. 1610–20
Length overall 22⅝ in. (57.5 cm.); inv. no. 3431

48. Wheellock pistol
Dutch, ca. 1640–50
Length overall 27⅛ in. (69 cm.); inv. no. 862

49. Wheellock pistol (pair to no. 48)
Dutch, ca. 1640–50
Length overall 27¼ in. (69.3 cm.); inv. no. 3980

50. Wheellock pistol
French, ca. 1600
Length overall 27 in. (68.5 cm.); inv. no. 3930

51. Wheellock pistol (pair to no. 50)
French, ca. 1600
Length overall 29 5/16 in. (74.5 cm.); inv. no. 3931

52. Wheellock carbine for the guard of Prince-Archbishop Wolf Dietrich von Raitenau (reigned 1587–1612)
Austrian(?), ca. 1590–1600
Length overall 35 in. (89 cm.); inv. no. 869

103

PANOPLY OF VIENNESE FLINTLOCK FIREARMS

This panoply, the pendant to cat. no. 101, is also composed of brass-mounted flintlock fowling pieces and pistols made by the leading Viennese masters of the eighteenth century. It is largely made up of parts of three now-incomplete hunting garnitures. One of these comprises eight fowling pieces made about 1760 for Prince Joseph Wenzel (1696–1772) by his court gunmaker Johann Lobinger (inv. nos. 3829–30, 3888, 3897–3901). The guns are mounted with blued Italian barrels stamped with the gold marks of the Leoni family of barrelsmiths active in Pistoia, Tuscany, and have full walnut stocks with wooden triggerguards. Each has an oval escutcheon engraved at the center with the Liechtenstein coat of arms surrounded by the collar of the Order of the Golden Fleece and inscribed around the edge with the name of Prince Joseph Wenzel. Another hunting garniture, originally composed of eight or more guns, is represented by four fowling pieces by Augustin Scheffl (or Scheffel), a master from 1731 to about 1759 (inv. nos. 3850, 3891–93). The barrels are stamped with the gold mark and countermark of Egidio Leoni and are inscribed ROSINA IN TOSCANA (that is, Ruosina, a barrel-making center in northwest Tuscany near Massa). The brass buttplate is engraved on the top extension with the arms of Prince Joseph Wenzel, in whose inventory of 1761 some of these guns are recorded (Schedelmann 1944, p. 69, inv. nos. 96–97).

Six pistols made about 1720–30—five by Georg Keiser (inv. nos. 4050–54) and one by his son-in-law Felix Meier (inv. no. 4049)—belong to a garniture originally consisting of twelve pistols. Each has a Spanish barrel stamped with the gold mark "Coma," identifying it as the work of the Coma family of Ripoll barrelsmiths. These pistols document the close association of Keiser and his son-in-law Meier, who appear to have shared the work on this garniture. (A pair of pistols in the Bayerisches Nationalmuseum, Munich, inv. nos. 13/1052–53, are actually inscribed "Keiser und Meier in Wienn"). The pistols have escutcheons engraved with the Liechtenstein coat of arms surrounded by the collar of the Order of the Golden Fleece, which suggests that they were made for Prince Johann Joseph Adam von Liechtenstein (1690–1732), the only member of the family to belong to this order at a time compatible with the apparent date of these pistols.

The other firearms in this panoply are a pair of guns by Lobinger with Spanish barrels made in Barcelona (inv. nos. 3828–29) and four pistols by Keiser (inv. nos. 3612, 4055–56 [a pair], 4057).

SWP

THE GOLDEN CARRIAGE OF PRINCE JOSEPH WENZEL

European noblemen of the Baroque Age took very careful stock of their public appearance—the insignia of their power and dignity, the ranking order of their cortege, and the various functions of their servants—and they made use of architecture to provide the backdrop for their ceremonial activities. In a world so thoroughly planned and staged, the carriages used by the nobility and their representatives had great significance. Particular attention was given to the entrée (entry) of a ruler or a ruling couple into the city of their coronation or residence. The entrée of a victorious Prince into a conquered city was also an important event, but this ceremony was traditionally carried out on horseback.

In the late Middle Ages, Queens and Princesses and their retinues were the first to be granted the use of carriages, for it was usually the long journey of a royal bride that ended with a ceremonial entrée (*entrée solennelle*) into a city. In the sixteenth century special emphasis was placed on the luxurious and splendid adornment of official carriages used on the occasion of princely visits or ambassadorial entrées. During the first half of the seventeenth century, carriages became a fixed component of an ambassador's entrée. These state coaches were subject to luxury laws, and the right of entry by carriage (*droit de carrosse*) into the palace grounds was granted as a royal favor. Large streets, squares, and above all the principal palace courtyards were used for ceremonial occasions.

The ranking order—court carriage, royal carriage, state carriage, and finally the coronation carriage—was fully developed at the court of Louis XIV and was adopted by all the European courts, from Portugal to Russia, around 1665. From then on, these carriages were an indispensable part of every ceremony.

In the second half of the seventeenth century a new type of carriage, prized for its lightness and maneuverability, was developed. This was the berlin, with a chassis consisting of two lateral poles connected by parallel leather straps, upon which the body of the coach was placed—a different construction from that of the state coach, whose body was suspended by straps from the front and back frames. The external contours of the bodies are also markedly different: the berlin has a slightly curved bottom; the state coach, on the other hand, has a rather flat bottom and long door panels designed to conceal the steps into the body. The berlin was soon used as a city carriage, and from about 1730, it was employed as a stylish suite carriage for official occasions. It was for the latter purpose that the Golden Carriage was built. When the Emperor Charles VI appointed Prince Joseph Wenzel von Liechtenstein ambassador to the French court, the renowned general and courtier applied for a suitable *hôtel* (mansion) in Paris and began the preparations for his official entrée into the city. When he arrived in Paris in December 1737, these extensive efforts, including the construction of five carriages (two state coaches, a chaise, and two berlins), were far from completed. The *entrée publique* in Paris did not take place until a year later, on December 21, 1738; a second procession, watched by Louis XV, the Queen, and the entire court, took place two days later in Versailles.

The ambassador was not only presenting himself as an envoy of the highest ruler of Christendom, the Holy Roman Emperor; he was also displaying the splendor and renown of his own house, unquestionably one of the most distinguished families at the Viennese court at that time. The entrée into Paris proceeded according to the strict regulations of French ceremonial. The procession was headed by the two carriages of the *introducteur*, a court official charged with the task of calling for the ambassador at his residence. These were followed by the *introducteur* himself and Prince Joseph Wenzel in a royal carriage, which in turn was followed by fifteen ceremonial carriages of the royal Princes and Princesses, who were represented by their equerries. Only then, in the second section of the procession, did the ambassador's own carriages appear. The first and the second were splendid state or parade coaches; each was drawn by eight horses from the Eisgrub stud (see cat. nos. 106–7). Both of them were empty. The third carriage was a *carrosse-coupé*; the fourth was the Golden Carriage, a berlin à la mode carrying a secretary and the Prince's page-steward; the fifth was another berlin à la mode. While the state coaches represented the ambassador's ceremonial rank, the Golden Carriage showed the Prince to be a man of taste who knew how to distinguish the best among the newest.

The *Mercure de France* described the two state coaches—the first one red and gold, the second blue and silver—as well as the mighty horses from the Liechtenstein stud and the *livrée* (the splendidly clad members of the princely household) in terms expressive of the highest admiration.

The crafting of these carriages and the materials used—the velvet and silk and leather, the gold- and silver-plated bronze mountings, the cords and tassels—are all described in detail. Thanks to the *Mercure de France*, we know the names of several of the contributing artists. However, the name of the architect Nicolas Pineau, who supplied the designs for each of the ambassador's five carriages, is not mentioned there. His genius has fortunately lived on in the Golden Carriage, the only surviving example of the elegant French Rococo coach.

Georg Kugler

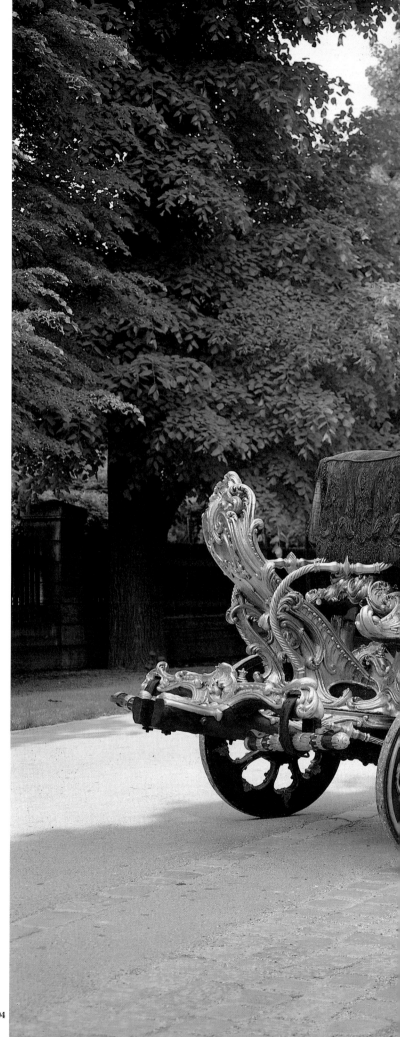

THE GOLDEN CARRIAGE
Paris, 1738
Gilt and painted wood, gilt bronze, steel, fabric; length 20 ft. (610 cm.);
greatest width 83⅞ in. (213 cm.); greatest height 10 ft. 5⅝ in. (319 cm.);
approximate weight 3100 lbs. (1400 kg.)

The Golden Carriage, a berlin à la mode, was built as a modern gala carriage for the suite of Prince Joseph Wenzel, the ambassador of the Holy Roman Empire to the French court. All five of the ambassador's carriages—which were called by the traditional name *carrosse d'ambassadeur*, even though two of them were not *carrosses* (that is, state coaches) but berlins—were designed by the architect and *sculpteur-ornemantiste* Nicolas Pineau (1684–1754). The carriage was used for the first time on December 21, 1738, the day of the ambassador's official entrée into Paris; it was used a second time for a procession in Versailles two days later; and on May 4, 1739, it served as an official carriage on the occasion of the audience of Princess Anna Maria, Joseph Wenzel's wife, with the Queen. When Prince Joseph Wenzel's term as ambassador came to an end, he took the five French carriages with him to Vienna, a decision that can only be explained by their fine quality and by the extraordinary amount expended on their construction. Such transport of coaches was generally avoided; the carriages were usually sold to a local agent who would then sell or rent them to less wealthy ambassadors.

The French carriages were probably put to occasional use during the two decades that followed, but they are not mentioned again until 1760, when Prince Joseph Wenzel was sent to Parma as the bridal ambassador of Empress Maria Theresa. He took the Golden Carriage with him, offering the blue-and-silver state coach, the second of the five he had commissioned in Paris, to the imperial court as a carriage for the bride's entrée. Twenty-two years after they were built, the French carriages were still incomparable, and evidently nothing of equal value could be found in Vienna.

In 1760 the Golden Carriage was used twice in short succession in official functions: on September 3, the splendor-loving Joseph Wenzel made his entrée into Parma, where he celebrated the marriage by proxy of Princess Isabella of Parma and the future Emperor Joseph II, and on October 6 he made his entrée into Vienna, escorting the Princess to the court church.

Employed as a royal coach on these occasions, the carriage underwent an elevation of its ceremonial rank. Four years later, in January 1764, Joseph Wenzel, who was then almost seventy, was sent to Frankfurt as Joseph II's election ambassador. His assignment there was to engage in the negotiations which traditionally preceded the election of every Holy Roman Emperor and which provided an opportunity to demonstrate the power and wealth of the imperial candidate as well as the splendor of the ambassador's own house. In its function as princely gala

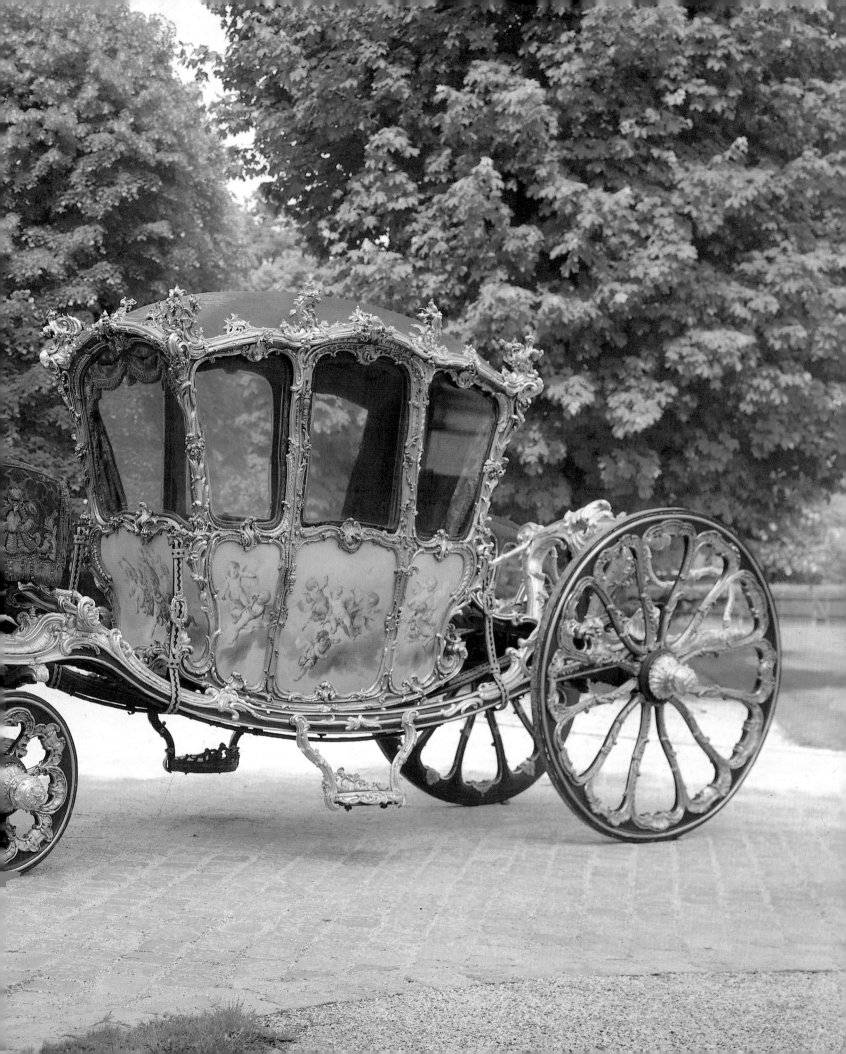

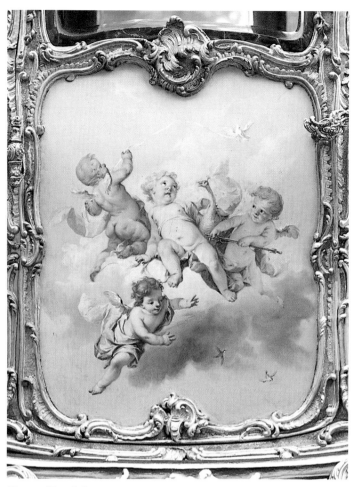

Fig. 25 Detail from cat. no. 104 Fig. 26 Detail from cat. no. 104

carriage, the Golden Carriage now assumed a prominent position. Its rise from a berlin *de suite* (1738) to the Prince's personal gala carriage (1760 and 1764) demonstrates the Golden Carriage's importance.

It is no less significant as a work of art. It is the most beautiful French berlin of the Rococo period still in existence and represents Parisian carriage making at the peak of its development. The design was created by Nicolas Pineau, and among those who participated in its execution were the sculptor Jacques-Louis Herpin and Guillaume Martin the Elder, who was famed for his lacquerwork. The elegant bronzes of the roof ornamentation were almost certainly by the *bourreliers/bronziers* Legrand and Mouront. Pierre de Neufmaison, a *peintre-doreur* who had contributed his skill to Louis XV's coronation carriage in 1722, is mentioned, along with many other artists, in newspaper reports and itemized bills; it is not possible, however, to ascertain the degree to which each artist contributed to a particular carriage among the five commissioned by Joseph Wenzel. Nor do we know the name of the master of the panel paintings that decorate the Golden Carriage, but their style points to the atelier of François Boucher. The amoretti on the four larger panels—those on the doors and on the front and

back of the body—represent a cycle of the Four Elements; those on the four smaller side panels represent the Four Seasons.

The name "Golden Carriage" was first used in the nineteenth century, probably to distinguish this example from the great number of princely gala carriages which, since the early 1800s, were painted in dark colors, usually black.

In the beginning of the twentieth century, the Golden Carriage was exhibited for the first time as a work of art in a museum in Vienna. It was kept in Vienna for a time and was then moved to Feldsberg in Lower Austria; in 1944 it was evacuated to Vaduz. In 1977–79, after years of restoration, it was the focus of an exhibition in the Schönbrunn Palace, Vienna.

GK

FURTHER REFERENCES: Wackernagel 1966, pp. 184–203; Wilhelm 1975, pp. XXIX–XLVIII; Vienna 1977b; Kugler 1978–79, pp. 9–42; Kugler 1980, pp. 60–69.

HORSE TRAPPINGS
Vienna, 1760
Velvet, silk, silver, gold; each 69 × 63 in. (175 × 160 cm.)

The two horse trappings in this exhibition belong to a set of twelve made for the entrée of Prince Joseph Wenzel into Parma in 1761 (see cat. no. 112). Known in German as *Handdecken* (literally "hand blankets"), these were decorative coverings draped over the back of horses that were led by hand in the procession (the animals were known as *Handpferde*, or "hand horses"). Such trappings were usually decorated with the owner's coat of arms in rich gold and silver embroidery.

The present trappings are made of deep-red velvet decorated with raised embroidery and with gold fringe. The silver and gold embroidery is worked in low relief and appliquéd; there is shaded polychrome silk embroidery. Four trophies of arms are depicted among the leaves and flowers along the border, and in the center of each is the Liechtenstein coat of arms, surrounded by the collar of the Order of the Golden Fleece and set among flags, cannons, weapons, and kettledrums.

Surmounted by the princely bonnet (*Fürstenhut*) and surrounded by a mantling of purple and ermine, the Liechtenstein coat of arms consists of a shield with inescutcheon: quarterly, of Silesia (or, an eagle sable, armed and crowned of the field, charged on the breast and wings with a crescent argent, treflé at the ends, supporting in the center a cross), Kuenring (a barry of eight, or and sable, a crown of rue arched in bend vert), Troppau (per pale, gules and argent), East Frisia (or, an eagle-maiden sable, the face argent, armed and crowned of the field), with a point of Jägerndorf (azure, a hunting horn or, with string of same), the inescutcheon with the ancestral family arms (per fess, or and gules).

The twelve trappings were commissioned from Peter Anton Dierckes, an embroiderer in Vienna. Nine are still preserved in the Princely Collections.

GK

105

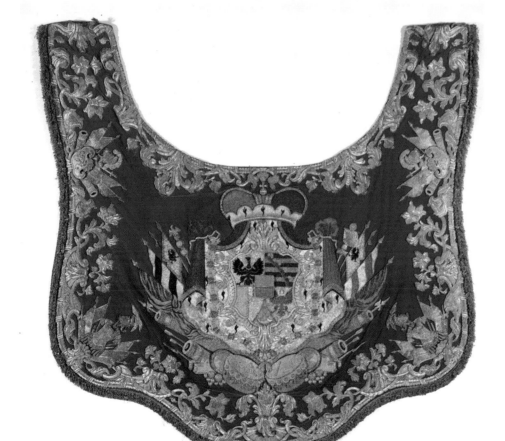

106–107

Johann Georg von Hamilton
Flemish (act. Vienna), 1672–1737

PORTRAIT OF A PIEBALD HORSE FROM THE EISGRUB STUD
Oil on canvas; 101⅝ × 82⅝ in. (258 × 210 cm.)
Liechtenstein inv. no. 3699

PORTRAIT OF A HORSE FROM THE EISGRUB STUD
Oil on canvas; 102⅜ × 79½ in. (260 × 202 cm.)
Liechtenstein inv. no. 3702

In Feldsberg, the magnificent early Baroque palace on the Austrian-Moravian border, a gallery was set up during the nineteenth century for a large number of equine portraits that had been originally commissioned for the Garden Palace in Vienna. In Fuhrmann's 1770 book about Vienna, he remarks that among the paintings exhibited in the first room on the ground floor of the Garden Palace are: "No. 50. A very beautiful horse with black spots, a copy of an original from the princely stud of Liechtenstein at Eisgrub, painted by Ferdinand Hamilton. [No.] 51. Another similar horse with large spots by the same painter" (vol. 3, p. 169). Though Fuhrmann mistakenly attributes the paintings to the brother of Johann Georg von Hamilton, he is accurate in asserting that the horses depicted are famous stallions from the Eisgrub stud. Eisgrub horses attracted great attention when they were used to draw the ambassadorial carriages in Prince Joseph Wenzel's entrée into Paris. These imposing, high-stepping animals were of Italo-Hispanic origin and had beautiful long manes and tails and handsome Roman noses.

Pictures of this kind are actual portraits of particular horses—individuals or, as Fuhrmann puts it, "originals." The high regard in which horses were held in the Baroque Age was evident not only in their ceremonial ranking and their equipment with precious harnesses, blankets, and ornaments for mane and tail, but also in the custom of having their portraits painted.

Some of Hamilton's invoices still survive, and from these it can be determined that the artist was paid for six equine portraits in 1700 and that the background landscapes were added by the Viennese painter Anton Faistenberger in 1707. Apparently in great demand, Hamilton limited himself to animal portraiture.

GK

106

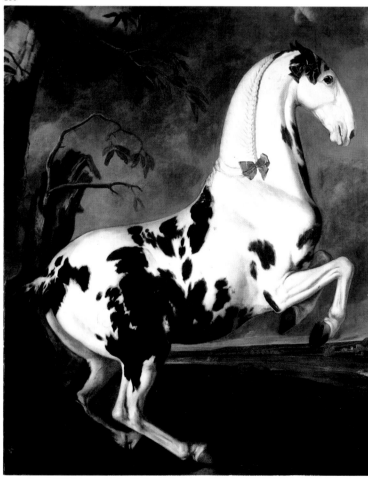

107

156

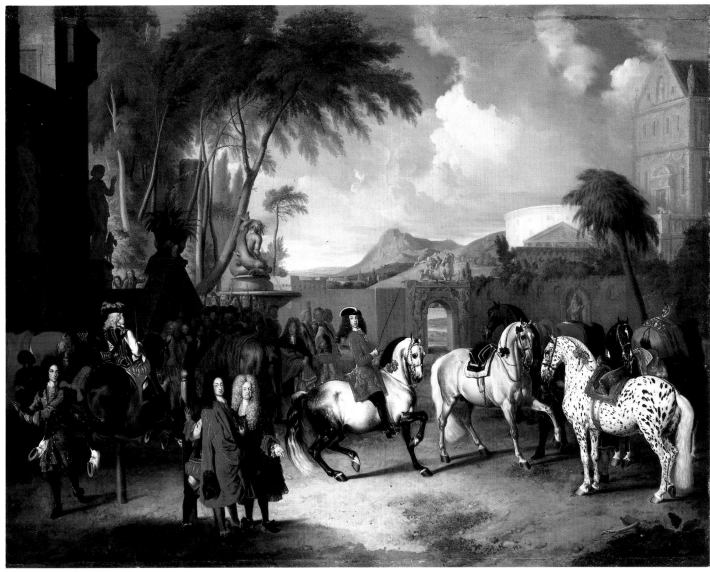

108

FURTHER REFERENCES: Cat. 1767, no. 50, p. 97; Wilhelm 1914, p. 37; Wilhelm 1976, pp. 74, 110, 126; Vienna 1977b, pp. 69–70, no. 14, pl. 39; Baumstark 1980, no. 138.

108

Johann Georg von Hamilton
Flemish (act. Vienna), 1672–1737

THE IMPERIAL RIDING SCHOOL IN VIENNA
Oil on canvas; 27⅛ × 35 in. (69 × 89 cm.)
Liechtenstein inv. no. 759

In 1702 Leopold I had been Holy Roman Emperor for forty-four years. His older son, Joseph, was twenty-four; he had been crowned King of the Romans (the title of the heir apparent) in 1690 and would succeed to the imperial throne in 1705. His younger son, Charles, was seventeen, and as heir of the Spanish line of the Hapsburgs, he was destined to become the King of Spain. It was this issue of the right to succession to the Spanish throne that was being contested among the European powers in the War of the Spanish Succession. Just a year later, in 1703, the young Archduke Charles would travel to Spain via England and Portugal, together with his mentor and High Steward, Prince Anton Florian von Liechtenstein (1656–1721), and would remain there until his brother's death in 1711. On his return to Vienna, he became Emperor Charles VI, while Prince Anton Florian acceded to the office of Imperial High Steward.

In this picture two noblemen are engaging in one of the most elegant of princely pastimes, horseback riding. In the center Archduke Charles is leading his Spanish stallion through the

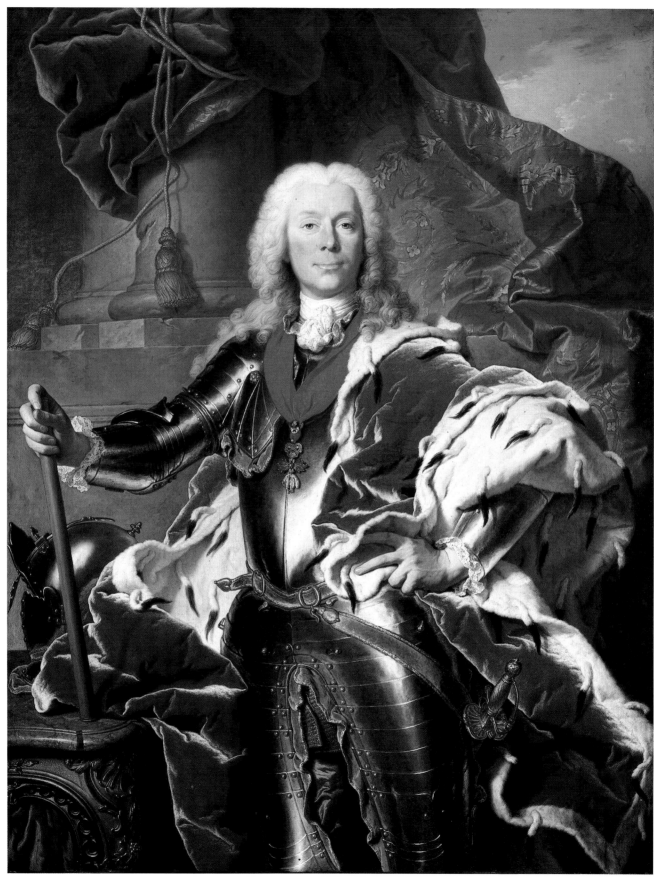

piaffe, one of the classic haute-école movements. Prince Anton Florian and Count Cobenzl stand in the left foreground; behind them a stallion is performing a capriole.

The horse was highly valued in the courtly aristocratic world. When used for riding, it was the faithful companion of the knight and the hero; in processions and parades, it was an indispensable participant in the festivities. Its stables bore comparison with palaces, and its appearance was preserved in portraits. The Liechtenstein collection included a number of paintings of horses, all of them created between 1700 and 1720; there were numerous paintings of horses in the imperial collection as well.

Two of the most important contemporary painters of animals were the brothers Johann Georg and Philip Ferdinand (1664–1750) von Hamilton, both of whom came to Vienna from the Low Countries around 1700. They worked for the court, especially for Emperor Charles VI. No doubt this representation of the Riding School includes "portraits" of riding horses from the Liechtenstein stable, so we may infer that they were bred in a variety of colors, such as piebalds, tigers, isabelles, and so on. Pure white and pure black horses became fashionable in England in the middle of the nineteenth century. After this vogue spread to the Continent, the imperial Lippizaners were almost exclusively bred to be a pure white, achieving the appearance that is so familiar today.

GK

109

Hyacinthe Rigaud
French, 1659-1743

PORTRAIT OF PRINCE JOSEPH WENZEL VON LIECHTENSTEIN

Oil on canvas; 57½ × 45¼ in. (146 × 115 cm.)
Inscribed (on the reverse): Peint à Paris par Hyacinthe Rigaud, / Chevalier
de l'ordre de S. Michel en 1740
Liechtenstein inv. no. 1496

Joseph Wenzel von Liechtenstein (1696–1772) was one of the most illustrious Princes in the history of the House. First as a soldier, then as a statesman, and always as a connoisseur and collector of art, he achieved the highest excellence in the three arenas in which his family had traditionally been distinguished. He is depicted here in his forty-fourth year, at a highpoint in his career. From 1737 until 1741 he served the Holy Roman Emperor Charles VI as imperial ambassador to the French court, a post to which he brought all the wealth and prestige of his family in honor of the House of Hapsburg. On December 21 and 23, 1738, he made his *entrée solennelle* in Paris and Versailles, the ceremonial arrival that occasioned the commis-

sioning of the Golden Carriage (cat. no. 104). His mission was to conclude the Vienna Peace of 1738 and to secure confirmation of the Pragmatic Sanction, which assured the Austrian succession through the female line, and thus to Maria Theresa, the Emperor's daughter, whom he had named his successor in 1713. On December 29, 1739, recognizing Joseph Wenzel's success, Charles VI named him to the Order of the Golden Fleece, into which he was received on February 15, 1740, eight months before the Emperor's death.

It is not surprising that upon his knighthood, Joseph Wenzel, a great patron of art, should have wanted to commemorate the honor by commissioning a portrait. His choice of artist, though conservative, is also not surprising. In Paris, the Prince availed himself of the most celebrated portraitist living in that world capital of art: Hyacinthe Rigau y Ros, who went by the surname Rigaud. The eighty-one-year-old artist's career as a court portraitist had been launched more than half a century earlier in 1688 with a well-received portrait of Louis XIV's brother. His renowned portrait of the King himself (Louvre, Paris), painted in 1701, became the paradigm of French Baroque portraiture.

What does seem somewhat surprising is that, in addition to this portrait in which the Prince wears the badge of the Order suspended from a crimson ribbon around his neck, he should also have had painted a full-length portrait in which he sports the full regalia of the Order (cat. no. 110), and that this second painting, in many respects the grander image, should be on so small a scale. It is apparent from both the pictorial evidence and surviving documentation that the larger painting preceded the smaller, and it is suggested here that the commissioning of the smaller portrait may have been a subsequent idea, perhaps prompted by the artist himself.

This is the order in which the two portraits are entered into Rigaud's ledger, his *livre de raison* (see Roman 1919, p. 218). The entries deserve full quotation as they provide interesting insight to the artist's working method. Under the heading 1740 is written:

> Mʳ le prince de Lichtenstein, ambassadeur de l'empʳ. En grand, figure jusqu'aux genoux, habillement répété d'après celui du portrait de Mʳ le duc d'Antin.
> Autre en petit, figure en pié en habit de cérémonie de la Toison d'or. Entièrement original.
> Ces deux portraits ont été paiés un grand prix, et de plus le prince gratifia Mʳ Rigaud d'une superbe tabatière d'or enrichie de diamants estimée 5 à 6.000 l.

> (The Prince of Liechtenstein, ambassador of the Emperor. Large scale, three-quarter length, apparel repeated after that of the portrait of the Duc d'Antin.
> Another, small scale, full length wearing the full regalia of the Order of the Golden Fleece. Entirely original.
> These two portraits were paid for at a high price, besides which the Prince bestowed upon Mr. Rigaud a superb gold

snuffbox embellished with diamonds and estimated to be worth five to six thousand livres.)

Apparently Rigaud was too embarrassed by what must have been an exorbitant payment to record his fee as he usually did. However, modesty did not prevent his mention of a gratuity in the form of a snuffbox estimated to be worth five to six thousand livres. He was paid six hundred livres (his usual fee at that time) for the only other portrait he recorded as having painted that year.

Of greater interest is the artist's notation that the large, knee-length portrait repeats the apparel of his portrait of the Duc d'Antin. The archetype of the portrait of Louis-Antoine de Pardaillan de Gondrin, Duc d'Antin, is not registered in the artist's ledger, but it must have been painted before 1710 since in that year the first of many copies of it is recorded. It is not clear which, if any, of the numerous versions of it that survive is the original (the best is in the Musée National de Versailles), however, it was engraved by, among others, Nicolas-Henri Tardieu in 1720 (the plate is in the Chalcographie du Louvre). It is evident from that engraving that the Liechtenstein portrait does not repeat the attire so much as the pose of the d'Antin portrait. Such was common working practice with Rigaud. The arrangements of draperies and the backgrounds differ. In the positioning of hands and in the depiction of armor the Liechtenstein portrait is closer still, in fact identical to Rigaud's portrait of Claude-Louis-Hector, Duc de Villars and Maréchal de France. According to the artist's ledger, the original portrait of the Maréchal de Villars was painted in 1704. It may be identical with the portrait of a field marshal by Rigaud sold by Wildenstein & Co., New York, to a U.S. private collector in 1946 (see New York 1946, no. 45, ill.). Later versions of the Villars portrait (the best surviving is in a private collection, Paris) and engravings after the portrait (a fine example is that made by Pierre Drevet in 1714) all show the Duke wearing the badges of the Order of the Holy Spirit, which he received in 1705, and/or of the Order of the Golden Fleece (Bourbon branch), which he received in 1714. Neither order is in evidence in the ex-Wildenstein portrait. (The author would like to thank Mary O'Neill, Georges de Lastic, and Joseph Baillio for their consideration of his questions about the works mentioned above.)

This portrait of Joseph Wenzel combines two of the artist's standard formulas appropriate to the dual nature of the sitter's calling. In his military portraits, Rigaud usually depicts the sitter three-quarter-length in armor, often with one hand resting on a field marshal's baton, set against a background that features a battle scene. Indeed, this is exactly the format of the Maréchal de Villars portrait. In his state portraits, the subject is usually represented in an imaginary palace setting that features the bases of columns about which are wrapped billowing draperies that aggrandize the sitter's appearance and allude to his high social position. The two schemes are joined in the portrait of Joseph Wenzel, who was both a soldier and a diplomat.

Though there is little original in the conception of the larger Liechtenstein portrait, it is of the highest caliber in execution. The sumptuously elaborated ermine-lined mantle and highly finished armor are worked up to a degree that surpasses any of the extant portraits of the Duc d'Antin or of the Maréchal de Villars.

GCB

FURTHER REFERENCES: Höss 1908a, pp. 19, 137, 221; Frimmel 1908a, p. 112; Frimmel 1913, pp. 7–8; Roman 1919, p. xxii; Vienna 1930, pp. 30–31; H. V[ollmer] in Thieme-Becker, vol. 28 (1934), p. 350; Cat. 1948, no. 4; Cat. 1965, no. 84; Wilhelm 1976, p. 122; Baumstark 1980, frontispiece and pp. 311–12; Vienna 1980, no. 51.01.

110

Hyacinthe Rigaud
French, 1659–1743

PORTRAIT OF PRINCE JOSEPH WENZEL VON LIECHTENSTEIN IN FULL REGALIA OF THE ORDER OF THE GOLDEN FLEECE

Oil on canvas; 32¼ × 25⅝ in. (82 × 65 cm.)
Inscribed (on reverse): Peint à Paris par Hyacinthe Rigaud/Chevalier de
 l'ordre de S. Michel en 1740
Liechtenstein inv. no. 670

Joseph Wenzel von Liechtenstein (1696–1772) was named to the Order of the Golden Fleece by the Holy Roman Emperor Charles VI on December 29, 1739, and received into it on February 15 of the following year. Founded by Philip the Good, Duke of Burgundy, in 1430, the *Toison d'or* is one of the oldest and most distinguished chivalric orders. Charles VI was the first grand master of the Hapsburg branch of the Order, which he instituted in 1713 at the close of the War of the Spanish Succession when the crown of that country passed from the Hapsburgs to the Bourbons, his claim to it having been defeated. Joseph Wenzel was not the first nor the last Prince of Liechtenstein to be so honored. Karl von Liechtenstein, who in 1608 became the first Prince of the House, was named to the Order in 1622, and to date some twenty-five other members of the family have followed him.

The events that led to this honor have been presented in the entry for the three-quarter-length portrait by Rigaud that the Prince commissioned in the same year as this work. In that painting (cat. no. 109), Joseph Wenzel wears the badge of the Order suspended from a crimson ribbon around his neck. Though it is a superb example of Rigaud's portraiture, Joseph Wenzel must have felt or have been persuaded that it alone was insufficient pictorial record of the full splendor of the award's honor and hence commissioned the smaller portrait as well. The Prince was surely familiar with the portrait painted by Rigaud in 1729

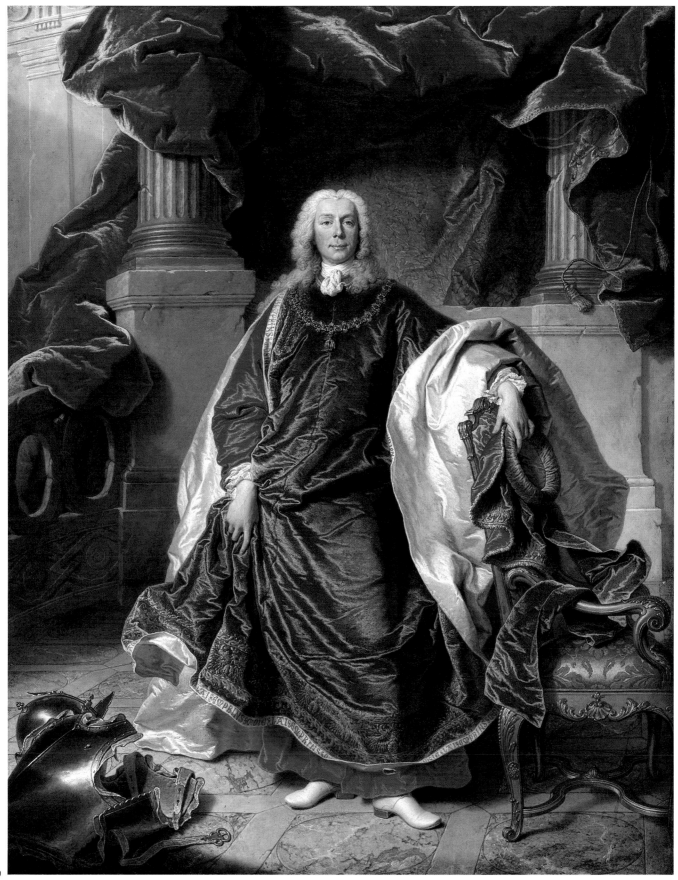

161

of Count Philipp Ludwig Wenzel von Sinzendorf in full regalia of the Order of the Golden Fleece (Kunsthistorisches Museum, Vienna). The Count served as envoy extraordinary from the Hapsburg court to Versailles from 1699 to 1701.

The custom of the Order was for a knight himself to have the badge of the Order made up. The badge remained the knight's personal property, but the collar and robes were his only on deposit and reverted to the Order at his death, to be passed on successively. Having decided to have this second portrait executed, Joseph Wenzel evidently found it necessary to secure the proper costume. On July 21, 1740, he wrote a formal request from Compiègne to his brother-in-law Count Friedrich August von Harrach, asking to have sent to him the full regalia of the Order. The letter (in the Harrach family archives, Österreichisches Staatsarchiv, Vienna) deserves quotation:

> J'ai pris la liberté le 6. courant d'écrire à Vtre Ex.^ce pour la prier de m'envoyer un habillement complet de chevalier de la Toison d'or, avec le chapeau et tout ce qui appartient audit habillement, je n'en ai pas reçu de reponse ce qui me fait soupçonner que ma lettre ne sera pas parvenüe à V. E., le peintre Rigault à son ordinaire ne veut cependant pas continuer le portrait qu'il a commencé avant qu'il n'ait ledit habillement, c'est pourquoy je prie V. E. en cas qu'il soit possible d'en avoir un de me l'envoyer le plutôt que faire le poura...

> (I took the liberty of writing to Your Excellency on the 6th of this month to ask you to send me the complete apparel of a knight of the Golden Fleece, with the hat and everything else that belongs with it, [but] I received no reply, which causes me to suspect that my letter may not have reached Your Excellency. The painter Rigaud does not want to continue the portrait that he has begun until he has [seen] it, as is his custom. Therefore I ask Your Excellency, in the event it would be possible to have one, to send me it as soon as it could be done...)

From this we learn not only that Joseph Wenzel did not yet possess the appropriate attire, but also that he was eager to accommodate the artist, who apparently had impressed upon the Prince his need of it in order to complete in his usual practice the portrait which already had been started. Where the letter was sent is not recorded, but it must have been Brussels since Count Harrach was imperial Gouverneur-Général des Pays-Bas (modern Belgium). Although the Count himself was not to be made a knight of the Golden Fleece until 1745, Brussels was until 1794 the seat of the Order, and Joseph Wenzel surely supposed that his brother-in-law was in a position to expedite the shipment of the necessary apparel.

Apparently Joseph Wenzel's request was met, for Rigaud was able to render in detail his noble attire, which imparts to the image much of its splendiferous effect. The jeweled gold collar chain consists of alternating steels in the form of interlocking

B's (for Burgundy) striking flints from which sparks emit. From this is suspended the insignia of the Order, a ram's fleece. In his left hand, Joseph Wenzel holds a biretta to which is attached an embroidered neckcloth and a trail of fabric down one side. The design of the headgear, like the collar, dates back to fifteenth-century fashion. The Prince wears a carmine velvet tunic beneath a purple velvet mantle reverse-lined in white satin and embroidered in gold along its border with steels, flints, fleeces, and the repeated motto of the Order: JE L'AI EMPRINS (I have taken the risk). A cuirass and helmet, parts of his armor extraneous to the costume, lie at his feet, alluding to his military career.

As he recorded in his ledger (see cat. no. 109), Rigaud delivered an entirely original composition. It should be noted, however, that the head appears to have been copied curl-by-curl of the wig, fold-by-fold of the knotted scarf, and line-by-line of the facial expression from the large portrait which must have preceded it. And though the composition of the picture is original, it follows the standard format of many of Rigaud's state portraits. Though much smaller in scale, it is quite similar to the portrait he painted in 1730 of Louis XV in coronation costume (Musée National de Versailles). In encouragement of a second commission, this portrait might have been suggested by Rigaud to the Prince as a model. The poses are not dissimiliar—particularly in the positions of the feet, in both portraits identically clad in fashionable court shoes of white kid with red heels—and the portraits display spatial arrangements of greater similarity still. In addition to his regal mantle, Louis XV wears the sixteenth-century costume of the Order of the Holy Spirit, including its collar and the distinctive *culotte bouffante*. The Saint Esprit was instituted by Henry III in 1578 as the supreme order in France. It was intended to supplant the Order of Saint Michael, founded by Louis XI in 1469, which had by then fallen into such low esteem that it was known as the *collier à toutes bêtes*. Yet by the eighteenth century the Order of Saint Michael had regained some of its former prestige. Of special interest here, though hardly an isolated occurrence, is the form of the inscription on the backs of both portraits of the Prince of Liechtenstein: "Peint à Paris par Hyacinthe Rigaud, Chevalier de l'ordre de S. Michel en 1740."

GCB

FURTHER REFERENCES: Cat. 1780, no. 294; Cat. 1873, no. 962; Cat. 1885, no. 670; Bode 1895c, p. 113; Höss 1908, pp. 19, 137; Frimmel 1908a, p. 112; Frimmel 1913, pp. 7–8; Roman 1919, p. 218; Cat. 1931, no. 670; H. V[ollmer] in Thieme-Becker, vol. 28 (1934), p. 350; Strohmer 1943a, no. 27; Baumstark 1980, no. 156; Vienna 1980, no. 20.01.

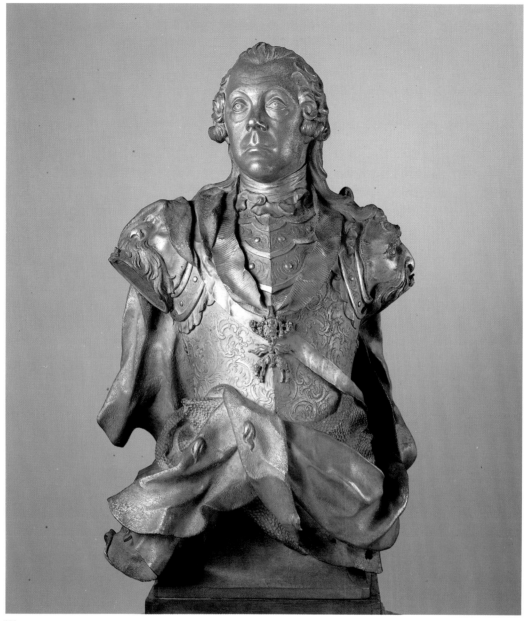

111

111

Balthasar Ferdinand Moll
Austrian, 1717–85

BUST OF FIELD MARSHAL JOSEPH WENZEL, PRINCE OF LIECHTENSTEIN

Vienna, 1758
Gilt bronze; height 35⁷⁄₁₆ in. (90 cm.)
Lent by the Österreichisches Barockmuseum, Vienna (inv. no. 4245)

Prince Joseph Wenzel (1696–1772) relished portraits of himself in the prevailing Rococo style of the day, as witness the two paintings by Rigaud (cat. nos. 109–10) and this bust, no less opulent, created almost twenty years later. However, the bust was not the Prince's personal commission. A signal honor, in acknowledgment of his high achievements as General Director of the imperial artillery (since 1744) and Field Marshal (since 1745), the bust was commissioned by Maria Theresa and Francis I to ornament the Kaisersaal of the Imperial Arsenal. Once Moll's model had received imperial approval, he produced the cast. Moll was assisted by his student Johann Georg Dorfmeister (1736–86), as we know from the latter's autobiography (1785). In the context of learning sculpture and especially metalwork under Moll's paternal guidance during a three-year period, Dorfmeister wrote: "The most noteworthy thing on which I collaborated with Moll was the monument to Prince Wenzel Lichtenstein [sic] in the imperial Armory" (Tietze-Conrat 1910,

p. 240). The seizing upon detail and the overall surface of the *Joseph Wenzel*, with its mellow fire-gilt sheen, are indeed beyond praise, but one can only guess at the extent of Dorfmeister's share in the finishing.

The bust's setting in the Kaisersaal is known from a variety of sources including a watercolor (see introduction, fig. 4). With its billowing drapery of lionskin, the bust dominated the central niche, bedecked with military trophies, in the left wall. It stood upon a tall carved pedestal, with a semicircle of cannon ranged in front of it. The display was appropriate to the dignity of this soldier-prince, who was himself an important collector of firearms. The socle bore the Prince's coronet and arms as well as a Latin inscription relating his titles and virtues and the date 1758.

The *Joseph Wenzel* offers a synthesis of various elements dear to Moll. As to the manifestly acute perception of detail, it could well be that his memory traveled all the way back to his native Innsbruck and the over-life-size early-sixteenth-century bronze statues of the Hapsburgs in the Hofkirche, with their intensely realistic graphic touches. For the generally militant flavor and imagery, as Baum (1980, vol. 1, pp. 448–50, no. 299) points out, he undoubtedly researched Renaissance bronze busts in imperial possession, such as those by Leone Leoni and Adriaen de Fries. One aspect that recalls Renaissance usage, apart from the subject's proud bearing, is the pair of fanciful leonine masks with flowing whiskers that serve as shoulder pieces. This cannot be actual parade armor, but a neo-Renaissance garb intended to create an automatic association of Joseph Wenzel with the illustrious past of Charles V (Leoni) and Rudolf II (de Fries). Equally fundamental, as regards both the arched and rounded modeling of the facial features and the air of pride, was the critical example of Georg Raphael Donner (1693–1741), the central genius of Austrian eighteenth-century sculpture. Oval bronze relief portraits of Counts Althann and Pálffy in the Österreichisches Barockmuseum, Vienna, long attributed to Donner himself, are now believed to be by Moll, based on Donner's designs, and to date from 1739–40. Moll's actual teacher in the Vienna Academy was Matthaeus Donner, Georg Raphael's younger brother, a medallist from whom he gained the technical means to achieve his firmly detailed surfaces. Moll had most recently proven his ability at merging Rococo costume, delineated with medallic sharpness, into a traditional iconography, in the splendid lead funerary monument to Maria Theresa and Francis I in the crypt of the Kapuzinerkirche, Vienna (1754). One need only compare his lead equestrian monuments to Joseph II (Waffensaal of the Franzensburg, Laxenburg, 1778) and Francis I (Burgring, Vienna, 1781), with their relatively frozen immobility, to appreciate the vibrant charm of Moll's works of the 1750s.

Two years after his bust was made, as a return favor Prince Joseph Wenzel commissioned busts of his sovereigns from Franz Xaver Messerschmidt to adorn the same room of the Arsenal. Also of gilt bronze, Messerschmidt's imperial busts, like Moll's, have features so exactly rendered as to seem hyper-realistic,

while their attire is equally giddily, unrestrainedly Rococo. Messerschmidt's debt to Moll is obvious, especially in the graphic attention to features and dress. Moll, professor of sculpture in the Vienna Academy during Messerschmidt's youth (1751–54), bears no small share in Messerschmidt's artistic formation. The three busts of Joseph Wenzel, Maria Theresa, and Francis I have been reunited in a room of the Lower Belvedere, today's Österreichisches Barockmuseum.

JDD

PROVENANCE: Imperial Arsenal, Vienna; Heeresmuseum, Vienna; in the Österreichisches Barockmuseum since 1923.

FURTHER REFERENCES: Fleischer 1932, pp. 26–27, 78, no. 184; Diemer 1977, pp. 87–88; Krapf 1980, pp. 281–82, no. 51.11.

112

THE ENTRY OF PRINCE JOSEPH WENZEL VON LIECHTENSTEIN INTO PARMA ON SEPTEMBER 3, 1760
Italian, 1761/62
Oil on canvas; 81⅛ × 100⅞ in. (206 × 256 cm.)
Liechtenstein inv. no. 3496

After lengthy political and diplomatic negotiations, Emperor Francis I and Empress Maria Theresa decided on the Bourbon Princess Isabella of Parma as the future wife of their oldest son, Archduke Joseph. Isabella was the daughter of Duke Philip of Parma, and through her mother, Elizabeth of Bourbon, she was a granddaughter of King Louis XV of France.

Ceremonial etiquette required that the bride be courted with the utmost formality and with an impressive display of luxurious splendor, not by the groom but by an ambassador. For this supreme honor, Maria Theresa elected Prince Joseph Wenzel von Liechtenstein. In addition to its primary purpose, this mission was also intended to demonstrate the power of the imperial house of Austria, which was embroiled in the Seven Years' War with Prussia. Hence the extravagance of this journey and the magnificence of the entrée into Parma. The Parisian gala carriages were refurbished at great expense. Some of the commissions and invoices for this work, which are preserved in the Princely Archive, read like modern restoration reports. Four of the Parisian carriages were disassembled, and the parts were carefully packed for transport. New liveries were made for all the pages, and the horses were given splendid new harnesses.

At the end of August 1760, the Prince departed for Parma with his retinue and more than a hundred traveling and luggage carriages. The trip through Styria, Carinthia, and the South Tyrol to Milan and finally Parma took eighteen days, including five days of rest. The painting depicting the processional entrée

112

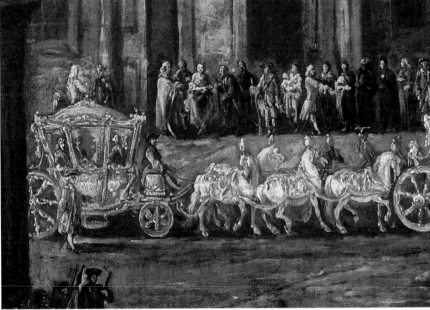

Fig. 27 Detail from cat. no. 112

was no doubt commissioned by the Prince, but probably a year or two after the ceremony; consequently there are a few incongruities between the depiction and the actual event.

At the right of the picture is the *livrée*—the members of the Prince's household—in their new attire. These are followed by hand-led horses with their splendid blankets (see cat. no. 105) and cavaliers on horseback. In the middle of the picture, in the lead, is a court carriage of the Duke of Parma, in which Prince Joseph Wenzel was escorted by the Marchese Roma Pallavicini. Following immediately behind, shining brightly, is the ambassador's empty parade carriage—undoubtedly the red-and-gold Parisian state coach. According to ceremonial regulations as well as contemporary reports, this carriage was followed by a procession of court carriages, and only then, at an appropriate distance, did the ambassador's suite appear, and with it the Golden Carriage.

Most likely, the Prince asked the artist to have the three Liechtenstein suite carriages follow immediately after the empty parade carriage, so as to be able to include them in the picture. If this assumption is accurate, the French berlin, the Golden Carriage, is the last one to the left in this row.

The date of the painting—1761/62—can be inferred from the history of the construction of the buildings on the Piazza Grande (today the Piazza Garibaldi). The church of San Pietro Apostoli in the background (on the west side of the square) did not receive its classicistic facade (designed by Ennemond Petitot) until 1761. The same architect built the Palazzo del Governatore with the clock tower on the right in 1760. The empty niche in the facade is still awaiting the statue of the Madonna, which was installed in 1762.

GK

FURTHER REFERENCES: Wackernagel 1966, p. 202; Vienna 1977b, no. 12.

PORCELAIN

In 1683, for the second and last time in Vienna's history, the city was besieged by the Turks. Kara Mustafa was driven back, and although the Ottomans lingered in Hungary and Lower Austria for another thirty years, the threat to Vienna was over, and the city could assume its new role as the capital of the Hapsburg court. Vienna was ready: most of the great collection formed by Rudolf II in Prague had been transferred to Vienna before the end of the Thirty Years' War in 1648; in 1662 Leopold I inherited nearly 1,400 paintings in the Netherlands acquired by his uncle, Archduke Leopold Wilhelm; and a wave of church building in mid-century introduced the architecture of the Italian Baroque into the cityscape. What had been lacking were the peace and stability to encourage a flowering of court life, with its attendant society, wealth, and patronage. With the defeat of the Turks this changed quickly, and Vienna was transformed from a medieval, defensive town on the eastern edge of Europe to a modern cosmopolitan center of renewed imperial vigor. Almost at once, the city was altered by the proliferation of wide-fronted Italianate palaces built for the princely families that clustered around the imperial court. The Liechtenstein City Palace, begun in the 1690s, was among the first of these, and Prince Johann Adam was the first to signal Vienna's expansion outside the old city walls by building a summer, or garden, palace. These huge palaces required extensive furnishings, and the luxury with which they were outfitted struck an English visitor in 1716. On her way to Constantinople, accompanying her husband as ambassador to the Porte, Lady Mary Wortley Montagu noted the magnificence of these new palaces with "furniture such as is seldom seen in the Palaces of sovereign Princes in other Countrys: the Hangings the finest Tapestry of Brussells, prodigious large looking glasses in silver frames, fine Japan Tables, the Beds, Chairs, Canopys and window Curtains of the richest Genoa Damask or Velvet, allmost cover'd with gold lace or Embroidery—the whole made Gay by Pictures and vast Jars of Japan china, and almost in every room large lustres of rock chrystal" (Halsband 1965, pp. 260–61). Lady Mary was not describing a particular palace, but a prevailing taste that was to reach one of its most exuberant expressions at Schönbrunn, where furniture, lacquer, gilded woodwork, and porcelain were integrated with exceptional felicity.

Porcelain was an essential element of these settings. Rooms were enlivened not only with "vast Jars" but with vases, bowls, and chargers of oriental porcelain often mounted in gilt bronze, while smaller objects were assembled in centerpieces and dessert services for the dining table. In the previous century porcelain, still a curiosity, had belonged to the *Kunstkammer*: in 1613 the inventory of Prince Karl I of Liechtenstein listed eight pieces of Chinese porcelain, three of which—as if to emphasize their rarity—were fitted with silver or silver-gilt mounts

(Haupt 1983, p. 190). But in the eighteenth century, access to the China trade routes encouraged the acquisition by imperial and princely collectors of large quantities of Chinese and Japanese porcelains, giving porcelain a new social importance (cat. no. 113): for example, it was regularly included among the prizes for the crossbow shooting contests held annually in Vienna (Hayward 1952, p. 15). Early in the century, this meant oriental porcelain, but after about 1720 the prizes were more often of porcelain from the two newly established European factories in Meissen and in Vienna. The rediscovery of hard-paste porcelain in Dresden, and the founding of the Meissen factory by Augustus II in 1710, created a demand and a competition for porcelain that swept across the Continent in the eighteenth century. It is a measure of Vienna's newfound importance as an artistic center that Europe's second hard-paste factory was established there, by Claudius Innocentius Du Paquier, in 1718. Nothing definite is known of the interest taken by the Princes of Liechtenstein in Du Paquier's enterprise, but the presence in the Liechtenstein collection of rare models from the factory's earliest years suggests that the Princes were not behindhand in their support (cat. nos. 114–15).

European porcelain quickly came to symbolize aristocratic fashion. The majority of the Continental factories, following the precedent set by Meissen, were founded and supported by heads of state or by the nobility for national and personal prestige, and nowhere was this more apparent than on the eighteenth-century table. In 1716 Lady Mary Wortley Montagu admired the "taste and Magnificence" of Viennese dining customs, the fifty or more meat courses served in silver, and the dessert "in the finest china." At this early date she can only have been referring to bowls and dishes of oriental porcelain, but it was not long before Meissen began to produce the great sculptural services—of which J. J. Kändler's candelabra, decorated for Prince Joseph Wenzel, are so characteristic (cat. no. 119). Porcelain table services became a necessary accoutrement of court life, gradually replacing those in silver and attaining equal importance as a royal or diplomatic gift. As in so many aspects of eighteenth-century taste, the French led the way: just as the silver table service had been a coveted gift of the French King at the end of the seventeenth century, so a service of Sèvres—such as that presented to Maria Theresa in 1758—was equally desired in the eighteenth. Thus, the King of Prussia, proud of his new Berlin factory and anxious to demonstrate its success, chose a table service as a gift for his old friend Prince Joseph Wenzel in 1763 (cat. no. 120); with its shimmering glaze and lively colors, the porcelain was perfectly suited to the lightness and elegance of Viennese court life—of which the Princes of Liechtenstein were so prominent a part.

Clare LeCorbeiller

Thirty-two Chinese porcelains mounted in gilt bronze

PAIR OF LONG-NECKED BOTTLES
Transitional period (1620–83); the mounts possibly French, ca. 1720
Height 17¾ in. (45.1 cm.)
Liechtenstein inv. nos. 1748–49

TWO PAIRS OF COVERED JARS MOUNTED AS POTPOURRIS
Transitional period; the mounts probably Viennese, 18th century
Height 14 in. (35.5 cm.), 14¼ in. (36.2 cm.)
Liechtenstein inv. nos. 1743, 1746; 1745, 1747

PAIR OF COVERED JARS MOUNTED AS POTPOURRIS
Transitional period; the mounts probably Viennese, 18th century
Height 13 in. (33 cm.), 13¼ in. (33.6 cm.)
Liechtenstein inv. nos. 1829a,b

TWO BEAKER VASES
Transitional period; unmounted
Height 17⅜ in. (44.1 cm.), 17⅝ in. (44.7 cm.)
Liechtenstein inv. nos. 538, 540

DISH
K'ang-hsi period (1662–1722), early 18th century; unmounted
Diameter 19⅛ in. (48.5 cm.)
Liechtenstein inv. no. 1367

PAIR OF CYLINDRICAL VASES
Transitional period; the mounts probably Viennese, ca. 1760–70
Height 21¼ in. (54 cm.)
Liechtenstein inv. nos. 1358a,b

PAIR OF CYLINDRICAL VASES
Transitional period; the mounts probably Viennese, ca. 1760–70
Height 23½ in. (59.7 cm.)
Liechtenstein inv. nos. 1358c,d

Liechtenstein inv. no. 1748

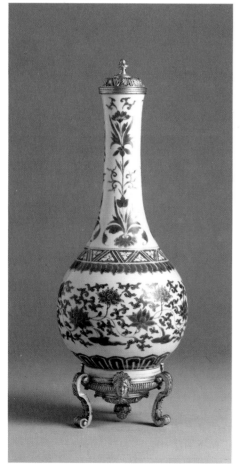

Liechtenstein inv. no. 1358a

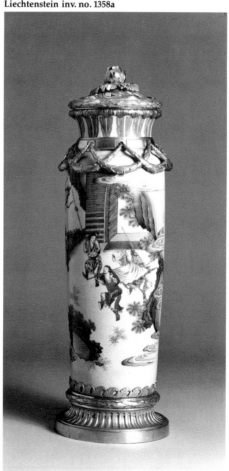

Liechtenstein inv. no. 1358b

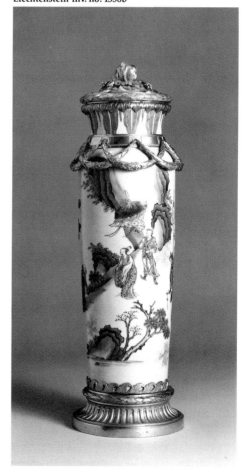

FOUR CYLINDRICAL VASES MOUNTED AS FOUR-LIGHT CANDELABRA

Transitional period; the mounts probably Viennese, ca. 1760–70
Height 18½ in. (47 cm.)
Liechtenstein inv. nos. 2012–13, 2018–19

PAIR OF DISHES

K'ang-hsi period, first quarter of 18th century; the mounts probably Viennese,
 ca. 1760–70
Diameter 19⅝ in. (49.9 cm.)
Liechtenstein inv. nos. 1365, 702

PAIR OF COVERED BOWLS MOUNTED AS POTPOURRIS

K'ang-hsi period, early 18th century; the mounts probably Viennese,
 ca. 1760–70
Height 18½ in. (47 cm.)
Liechtenstein inv. nos. 1822a,b

PAIR OF VASES MOUNTED AS EWERS

Ko ware, mid-18th century; the mounts possibly French, ca. 1750
Height 27 in. (68 cm.)
Liechtenstein inv. nos. 1832a,b

BALUSTER VASE WITH CELADON GLAZE

Mid-18th century; the mounts probably Viennese, ca. 1760–70
Height 28 in. (71 cm.)
Liechtenstein inv. no. 1848

PAIR OF COVERED BOWLS WITH CELADON GLAZE

18th century; the mounts probably Viennese, ca. 1760–70
Height 13¼ in. (33.6 cm.)
Liechtenstein inv. nos. 1850a,b

PAIR OF BALUSTER VASES WITH CRACKLED CELADON GLAZE

Mid-18th century; the mounts probably Viennese, ca. 1770
Height 11½ in. (29 cm.)
Liechtenstein inv. nos. 1854a,b

PAIR OF CYLINDRICAL BLUE-GROUND VASES WITH GOLD DECORATION

First half of 18th century; the mounts probably Viennese, ca. 1770
Height 14 in. (35.5 cm.), 14¼ in. (36.2 cm.)
Liechtenstein inv. nos. 1824a,b

The porcelains are fitted with mounts associated with the two periods in which the fashion for such a practice was at its height: the first quarter of the eighteenth century, when palaces were being filled with blue-and-white wares brought to Europe by the Dutch, and the third quarter of the century, when French taste and the skill of the Parisian *bronziers* had great influence.

Blue-and-white porcelains of the Transitional period (1620–83) figure in both categories, indicating that they were probably acquired all together early in the century, being fitted with mounts at successive periods. Later additions among the porcelains are the *ko* and celadon pieces of the mid-eighteenth century,

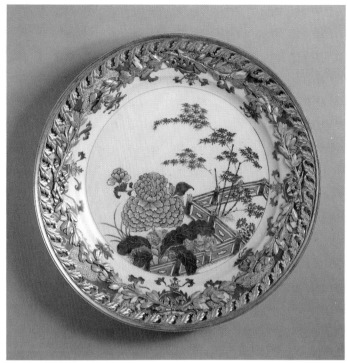

Liechtenstein inv. no. 1365

Liechtenstein inv. no. 1822a

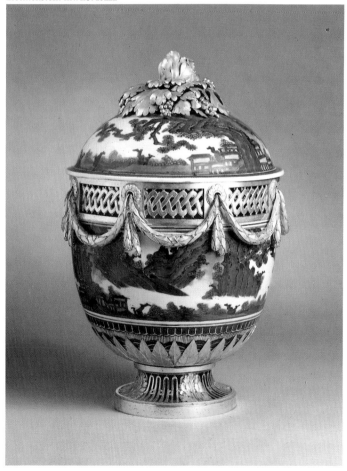

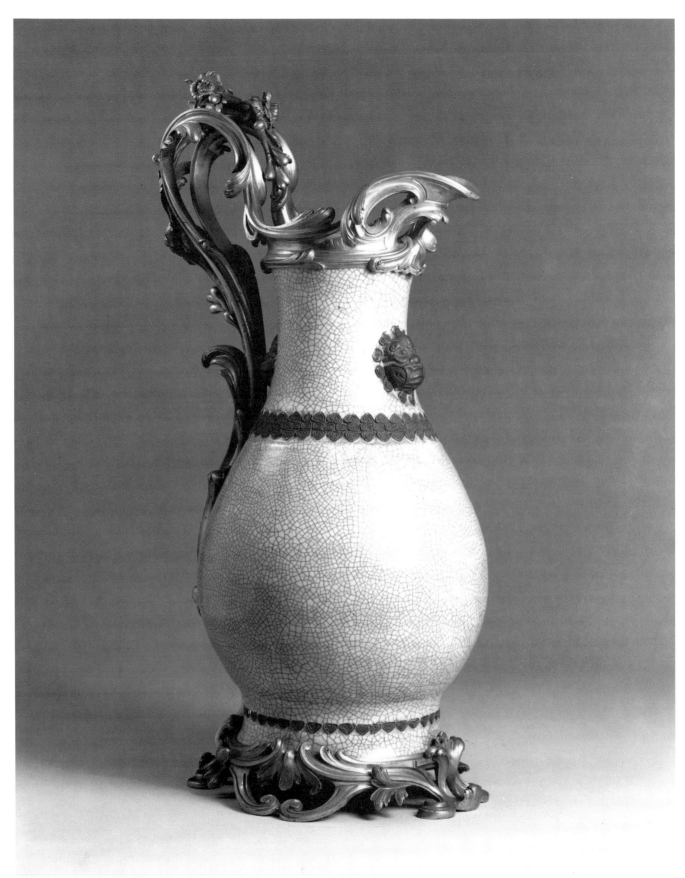

Liechtenstein inv. no. 1832c

so favored by the French as a foil for the bravura of their mounts.

Although the mounts of both periods are in the French style, most were probably made in Vienna. The porcelains themselves would not have come from Paris but from Amsterdam or Ostend by way of Prague. The most active period for the acquisition of oriental porcelains in Vienna is likely to have been between 1722 and 1731, when Charles VI's own Ostend Company, a multinational assortment of private traders, was in operation. While little is known of Viennese bronze workers, there is no reason not to assume at least a modest industry, and there is evidence of such in the second half of the century. In 1770 the goldsmith Anton Domanöck (1713–79) furnished the steel and gilt-bronze mounts for a gueridon delivered later that year to Marie Antoinette at Versailles by his son, who was also to learn bronze gilding while he was in Paris (Baulez 1978, p. 367; Thieme-Becker, vol. 9 [1913], p. 397); and a steel urn made by Domanöck in 1770 shares some stylistic mannerisms with the later mounts on these porcelains (Leisching 1912, p. 557). Ten years later, in 1780, Ignaz Joseph Würth, a member of a prominent Viennese family of goldsmiths, signed the gilt-bronze mounts of a pair of urns of petrified wood sent by the Emperor Joseph II to his sister, Marie Antoinette, in Paris (Baulez 1978, p. 368).

These indications of local manufacture, taken into consideration with a somewhat provincial freshness of style of the mounts themselves, point to Vienna as the place of their origin.

CLC

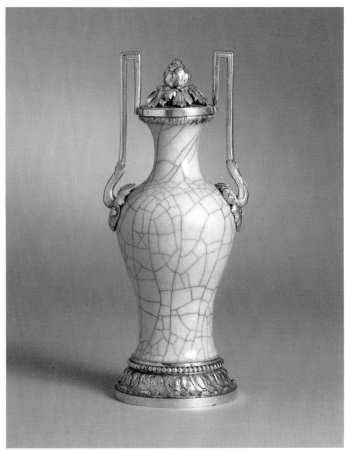

Liechtenstein inv. no. 1854a

VIENNESE PORCELAIN OF THE DU PAQUIER PERIOD (1718–44)

Vienna's porcelain factory was founded in 1718 by Claudius Innocentius Du Paquier (d. 1751), a minor official at the court of the Emperor Charles VI, who is said to have spent several years attempting to reproduce Meissen's formula for hard-paste porcelain. That he was ultimately successful was due to the help of two Dresden workmen: C. K. Hunger who, although not a Meissen employee, was able to bring with him to Vienna in 1717 some knowledge of clay and colors; and Samuel Stölzel who in 1719 provided Du Paquier with the necessary techniques of kiln structure and manufacture.

Outside of this practical assistance Du Paquier borrowed little from Meissen, creating a style which, while making use of much of the same Baroque and oriental vocabulary of decoration, was remarkably independent and original. The decoration of early Du Paquier porcelains reflects the contemporary fascination with the oriental style, but whereas at Meissen a deliberately stylized manner of flower painting lasted well into the 1730s, Vienna moved quickly from *indianische blumen* (cat. no. 115) to a graceful, naturalistic style in a subtle palette in which muted gradations of rose and purple were effectively offset by slightly astringent tones of green, blue, yellow, and iron-red (cat. no. 114).

Also original, and unique, to Vienna were two types of decoration exemplified here by the Jagd service (cat. no. 118): decoration in black line in imitation of engraving; and *Laub- und Bandelwerk* border patterns composed of intricate and highly disciplined arrangements of strapwork, foliage, and diapered cartouches chiefly

171

derived from engravings published in Augsburg in 1711 by Paul Decker. Painterly versions of the *Schwarzlot* technique were common among the independent porcelain decorators in the 1720s, and it is possibly due to their influence that it made its appearance the following decade in the factory's repertoire. As Hayward (1952, p. 45) has observed, the distinction between factory and *Hausmaler* work during the Du Paquier period is not always obvious; differentiating between the two is made more difficult by an apparently complete absence of factory records. Nothing is known of Du Paquier's own role in the creation of the factory's style, and the names of only a few decorators have been recorded. The authorship of the models themselves is also unknown. Conspicuous for an idiosyncratic—and not always resolved—combination of European and oriental motifs, architectural and sculptural elements, the models are curiously authoritative. Relatively little attention was paid to freestanding sculpture in the early years of the period, figural work being limited to a supporting role. A consistency of naive stiffness and charm of these figures points to a single, not very experienced modeler. About 1740, beset by financial difficulties, Du Paquier began to produce copies of Meissen figures and groups which, though derivative, perpetuate the naive attractiveness of the earlier models (cat. no. 117). But Du Paquier was unsuccessful in competing with Meissen and in May 1744 relinquished the factory to the Austrian State, retiring as director later the same year.

CLC

114

FOUR DISHES

Austrian (Vienna), Du Paquier period (1718–44), 1725 and ca. 1725
Hard-paste porcelain; diameter 14⅞ in. (37.8 cm.), 16¼ in. (41.2 cm.), 17 in. (43.2 cm.)
Liechtenstein inv. nos. 1, 78, 100–101

Although the model of these dishes (conspicuous for an atypical sharp-edged rim molding) and their scheme of decoration are the same on all four, they are not a set, one differing markedly from the other three in size, simplicity of painting, and lightness of palette. This single dish (inv. no. 78) is ambiguously inscribed *Viennae 17 5*, which has been interpreted to signify 1725 (Hayward 1952, p. 45), although there is no trace of any numeral between the 7 and 5. Mrazek, who dates the four dishes about 1720 (1970, nos. 3–6), has suggested that the numerals be read as the seventeenth day of the fifth month, the year being omitted (or now missing). The substitution of a numeral for the name of a month would be unusual for this period, however, and the inscription on the Liechtenstein dish is thus here read as an incomplete 1725. It is a date entirely consistent with the rather naive and stylized painting of orien-

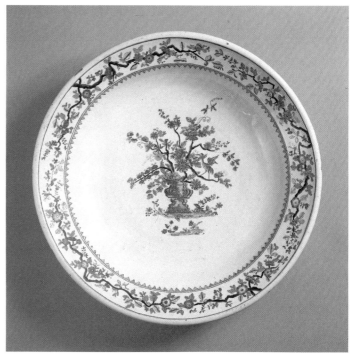

Liechtenstein inv. no. 1

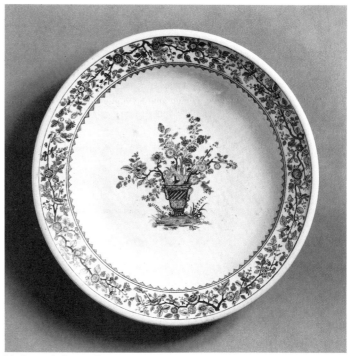

Liechtenstein inv. no. 78

Fig. 28 Signature
from inv. no. 78

tal flowers, such as is found on a clock case similarly painted with *indianische blumen* and clearly dated 1725 (Hayward 1952, pl. 10).

The three other dishes, all larger, are painted with more sophistication in the same palette but in richer and more modulated tones and with a less crowded border composition. They are nonetheless so close in style to the inscribed dish that they must either be the work of the same decorator at two different (and rapidly matured) stages or examples painted by another artist following the dated model. Another pair of dishes, apparently of this second type, is in the Just collection, Prague (Just 1961, p. 32, fig. 27).

The central motif of a flower-filled urn (different on each dish) has been associated (Mrazek 1970, p. 77) with an illustration in the *Treatise of Japanning and Varnishing* by John Stalker and George Parker, published in Oxford in 1688. Only the urn on the inscribed dish corresponds at all closely to pl. 14 in Stalker and Parker, leaving open the probability that individual illustrations of the English book—which is not known to have been subsequently published elsewhere—were freely adapted by an engraver on the Continent.

CLC

FURTHER REFERENCE: Vienna 1904, nos. 1, 3.

115

TUREEN

Austrian (Vienna), Du Paquier period (1718–44), ca. 1725
Hard-paste porcelain; length 14¼ in. (36.2 cm.); height 6½ in. (16.5 cm.)
Liechtenstein inv. no. 1878

The tureen is one of several models in a "service," evidently composed exclusively of tureens, traditionally said to have been made for an unidentified Prince de Rohan.

Table services and tureens were not in common use in the early eighteenth century. Silver services composed of a variable assortment of serving and eating vessels evolved in Paris in the last quarter of the seventeenth century to meet the needs of court life and Louis XIV's penchant for making grand diplomatic gifts. But the first porcelain service to include different types of objects with similar decoration was apparently one made only in 1732 at Meissen for Adolf Frederick I of Sweden. A "complete table or dessert service" of Japanese porcelain was among the prizes for the annual crossbow competition in Vienna in 1719, but it was merely an assemblage of twenty-one bowls or cups and plates, presumably more or less matched in their decoration, rather than a planned, stylistically unified ensemble. Similarly, the tureen, although it existed in fact and in name by 1684, did

115

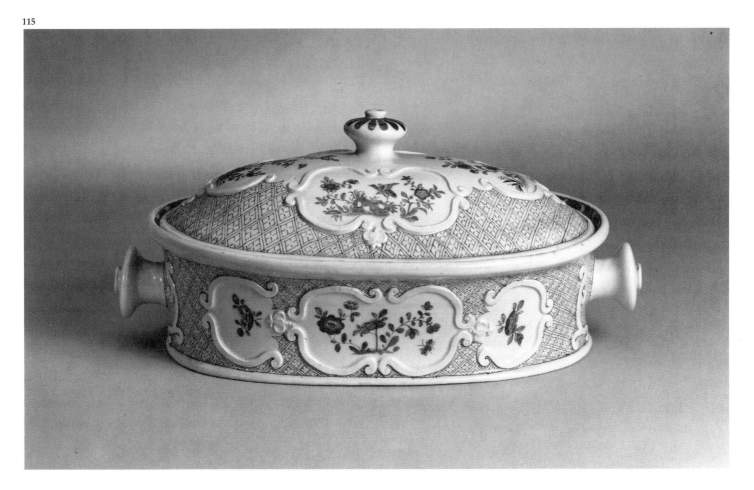

not become an essential element in dining services until nearly the 1740s. The Rohan tureens are therefore among the first to have been made in any material. The existence of two even earlier Du Paquier tureens is premised on the survival of two white covers of appropriate size, dating about 1720, in the Museum für angewandte Kunst, Vienna (Mallet 1968, figs. 10–11). Of fluted oval form, with grotesque lizard-form handles recalling those on *blanc de chine* export porcelain, they—as do the Rohan tureens—exemplify Du Paquier's dependence on oriental prototypes in the early years of his proprietorship.

Other shapes of tureens in the Rohan service are a very large circular one with handles similar to those of the Liechtenstein tureen (Syz collection, National Museum of American History, Washington, D. C.) and small circular ones with loop handles, of which two are in the Metropolitan Museum (1982.60.246a,b– 247a,b).

CLC

Fig. 29 Detail from cat. no. 116

116

COFFEEPOT
Austrian (Vienna), Du Paquier period (1718–44), ca. 1725–30
Hard-paste porcelain; height 11¼ in. (28.6 cm.)
Liechtenstein inv. no. 71

The model is at several removes from one originating in Chinese porcelain, at Dehua, ca. 1675–1725, of which numerous versions had reached Europe by 1721 when they are recorded in the Dresden inventory of that year (Donnelly 1969, p. 188, pl. 60). One version, which Vienna repeated with variations, was a straight-walled hexagonal tea or wine pot with raised handle, the sides being molded with oriental figures in low relief. Here the polygonal form and the relief decoration of oriental figures have been adapted to a pear-shaped body of European origin and combined with an exaggerated mask spout and

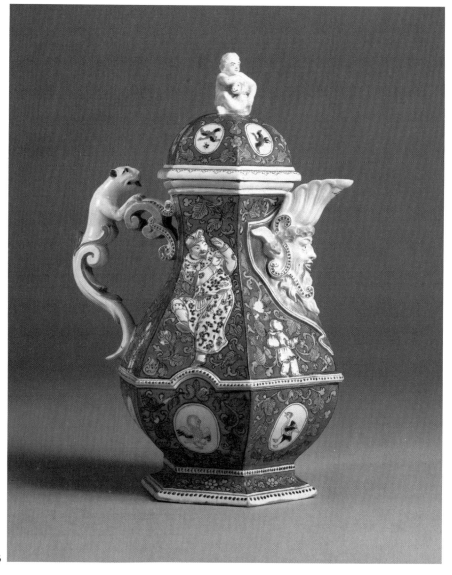

116

leopard handle. The model of the handle is based on an engraving by Jacques Stella, published in 1667 in his *Second Livre des Vases* (pl. 26). Stella's designs were widely known and used by porcelain manufacturers, and Du Paquier may well have been familiar with this particular one, but he is just as likely to have been aware of a much more recent parallel, the dramatic springing-leopard handle on a silver-gilt ewer of 1697 by the French court silversmith Nicolas Delaunay. The spout has a longer tradition in Continental goldsmiths' work, reaching back to ewers of the early seventeenth century.

While little freestanding sculpture was produced by Du Paquier during his early years as proprietor of the factory, there was considerable use of figures in relief and as semiattached elements in his architectural compositions. The large figures on either side of this coffeepot recur, differing only in minor details of size and costume, on three other early Du Paquier pieces: a straight-walled hexagonal teapot in the Museum für angewandte Kunst, Vienna (possibly a literal translation from the Chinese), a vigorous and rather crude milk jug in the Metropolitan Museum (1977.216.36), and a wall sconce of slightly later date (ca. 1735), also in Vienna. The same two figures are closely related to, and were perhaps the inspiration for, two compelling fully modeled white figures in the Victoria and Albert Museum, London (Mallet 1968, pp. 117–27), belonging, like the milk jug and teapot, to the first five years of the factory. The association of the relief sculpture on the Liechtenstein coffeepot with the other figures implies a comparable dating: Mrazek (1970, no. 10) has suggested a dating of ca. 1720 for the coffeepot, but this seems to the writer a little early in view of the fully developed form of the model and the highly controlled dramatic color scheme of iron-red, rose-purple, and green.

CLC

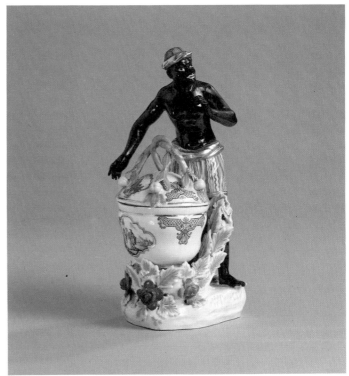

117

117

MOOR WITH SUGAR BOX

Austrian (Vienna), Du Paquier period (1718–44), ca. 1741–44
Hard-paste porcelain; height 9⅛ in. (23.2 cm.)
Liechtenstein inv. no. 2022

This is one of three variant models, of which the other two are in the Metropolitan Museum (Hayward 1952, pl. 67b) and the Fitzwilliam Museum, Cambridge. The moor of the Cambridge version is clothed in a feather skirt and headdress, the conventional costume used to symbolize the American continent, inviting the suggestion that the turbaned moor of the other two models might be taken to represent Africa. It is not certain that the two figures were so conceived, however. Both derive from models by Johann Friedrich Eberlein at Meissen in 1741, and at the time the turbaned moor was described simply as a "figure of a moor which stands by a sugar box" (Berling 1910, p. 44). Contemporary description of the feather-dressed moor is appar-

ently lacking, and there is no evidence of the production of companion models which could be considered as symbols of America and Asia.

The two Meissen models, and the Du Paquier variants, would have been elements of a centerpiece for a dessert course. Figural tablewares in porcelain originated at Meissen in 1737 in a *plat de ménage* or centerpiece designed for Count Heinrich von Brühl, and from this period dates the evolution of porcelain sculpture as table decoration, with centerpieces of elaborate thematic composition incorporating both freestanding figures and combination pieces such as this for sugar or sweetmeats.

Of the three Du Paquier examples, only the Metropolitan's is decorated entirely in black and gold. The bowls of all three, and the covers of the Liechtenstein and Cambridge versions, are painted with cartouches enclosing figural landscapes. The cartouches of this piece are considered by Mrazek (1970, no. 169, pl. 29) to be probably by Anton Franz Josef Schulz. Recorded as an employee of the factory in 1726 and 1736, Schulz left between 1740 and 1741, apparently working as an independent decorator for two years before moving to Fulda. He is last mentioned in 1768. A coffeepot and a cup and saucer in the Museum für angewandte Kunst, Vienna, both signed Schulz and dated 1740, are guides to his work, with which the painting here compares closely. But Schulz had left the factory by the time this piece could have been made: it is possible, but unlikely, that the decoration of a new and rather important model would have been assigned to a *Hausmaler*, even if a former employee, so an attribution to Schulz can only be considered tentative.

CLC

DISH FROM A HUNTING OR JAGD SERVICE
Austrian (Vienna), Du Paquier period (1718–44), 1730–40
Hard-paste porcelain; height 19⅛ in. (48.6 cm.)
Liechtenstein inv. no. 1702

The term "Jagd service" has by long usage subsumed not one but at least four distinct groups of Du Paquier porcelains decorated in black line with scenes of wild animals, in most compositions being attacked by hounds. The services share a common pictorial source in the engravings of Johann Elias Ridinger (1698–1767), although they have not all been identified and may include the work of other artists as well. They are distinguishable from each other by variations in their *Laub- und Bandelwerk* borders, but only one service—represented by a tureen and platter in the Metropolitan Museum (Hayward 1952, pl. 41)—appears to be the work of a single artist.

The border pattern of this dish is the same as that on others of the same model in the Museum für angewandte Kunst, Vienna (Hayward 1952, pl. 39). The Viennese service has a traditional history of having been made for the Benedictine cloister of Saint Blasius near Freiburg, whence it passed into the monastery of Saint Paul in Lavanttal and eventually (1925) into the collections of the Vienna museum (Mrazek 1970, p. 93). Hayward (1952, p. 104) has suggested that the Liechtenstein Jagd service may have originated not independently but as part of the Vienna one, having become separated from it at an early date. This is unverifiable either through factory or Liechtenstein account books, as both are missing. Nor can a distinction between the Vienna and Liechtenstein services be determined by their decoration, as the hand of more than one artist is discernible in both. One is the painter of this dish, whose style is recognizable by a rather dark firm line, simplified foliage, and the use of wash to create shadow. Another is the painter of a dish and two platters in the Liechtenstein collection, en suite with

118

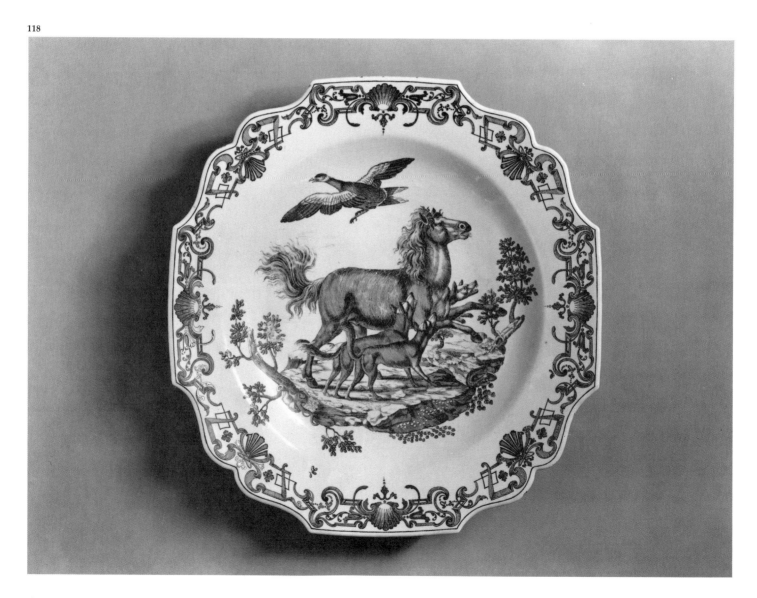

this dish, identifiable by a lighter fine line, shading defined by cross-hatching, a greater variety of strokes, and more naturalistic foliage.

The name of Jakob Helchis has been linked with all the recorded Jagd services. Of him, little is known. Only one record of his presence at Vienna is known, variously dated 1741 and 1746 (Mrazek 1970, p. 38; Hayward 1952, p. 131); in it he is described as a painter living at the factory. According to Hayward, in 1741 Helchis left Vienna for Turin, returning by 1746 and leaving Vienna for good the following year for the Neudeck (later Nymphenburg) factory. His confirmed work consists of two fully signed covered bowls (Hayward 1952, pls. 58a, 59), both decorated in a thin, soft gray-black line with Italianate landscapes and putti. To Helchis, also, have been tentatively attributed some half-dozen pieces signed with the initials JH, ranging in style and subject matter from chinoiseries painted boldly in black or iron-red to a Jagd dish differing from the others in its border pattern and in the pastoral character of its composition (Hayward 1952, pl. 40a).

This last piece has been instrumental in the attribution of the other Jagd pieces to Helchis, but whether Helchis and JH are one and the same artist and whether Helchis was the decorator of any of the Jagd services are still open questions. His signature suggests that he was a *Hausmaler*, anonymity being the rule for factory painters, and as such he would not normally have been employed in the decoration of what was clearly an important factory commission. We may speculate that he was at one time hired by Du Paquier, thereby adding his pseudo-engraving technique to the factory's repertoire of decorative styles, which would account for the variations among the several Jagd services. It is here suggested only that this dish, by comparison with his signed work, is not by Helchis, while the other three pieces remaining in Liechtenstein, clearly by a different hand, are much closer in style to Helchis's two signed bowls.

CLC

119

Fig. 30 Detail from cat. no. 119

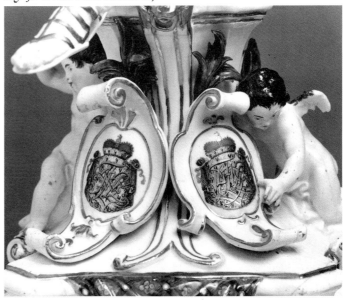

119

Johann Joachim Kändler
German, 1706–1775

PAIR OF FIVE-LIGHT CANDELABRA
German (Meissen), ca. 1737–40, after a model of 1736
Hard-paste porcelain; height 24⅛ in. (62 cm.)
Liechtenstein inv. nos. 1995a,b

The model originated as part of a table service ordered by Saxony's Prime Minister, Count Alexander Joseph von Sulkowsky (Rückert 1966, no. 489). It was the first of several services in which Kändler was to explore the integration of sculpture with functional tablewares. Here the seated nymph remains somewhat

independent of the rest of the design, and in its generous and imposing proportions the figure recalls the large-scale sculptures on which Kändler had been engaged since his employment at Meissen in 1731. Kändler subsequently reworked the model for Count Heinrich von Brühl's Swan Service (1737–41) and, by adding and repositioning figures and enlivening the pedestal with rippling scrollwork and shellwork, transformed it into a purely Rococo composition (Walcha 1981, pl. 95).

The Meissen records do not mention the repetition of the Sulkowsky candelabrum, but the practice was not unknown, Kändler having modified his Brühl version for Marshal de Belleisle in 1741 (Rückert 1966, no. 518).

The cartouches on the front of the pedestal enclose two ciphers. On the left are the initial letters of Prince Joseph Wenzel's name and titles: FJWVZL (Fürst Joseph Wenzel von und zu Liechtenstein). The right-hand cipher, which has been read as PAFGVL, must be accepted as referring to his wife, Princess Anna Maria, although the G remains unexplained.

CLC

120

Thirteen pieces from a table service
German (Berlin), 1765–66
Hard-paste porcelain

THREE OVAL PLATTERS WITH HANDLES
Length 21½ in. (54.6 cm.)
Marks on each: scepter (underglaze blue); 14 4 (impressed)
Liechtenstein inv. nos. 952, 1060–61

TWO CIRCULAR DISHES
Diameter 13¾ in. (35 cm.)
Marks on each: scepter (underglaze blue); 03 (impressed)
Liechtenstein inv. nos. 1145, 1151

SIX DESSERT PLATES
Diameter 10½ in. (26.7 cm.), 10⅝ in. (27 cm.)
Marks: scepter (underglaze blue, on each); Λ (impressed, on 956, 1121, 1124, 1141); o (impressed, on 1026); oo (impressed, on 956, 1123); 0-0-0-3 (impressed, on 1121)
Liechtenstein inv. nos. 956, 1026, 1121, 1123–24, 1141

Liechtenstein inv. no. 1060

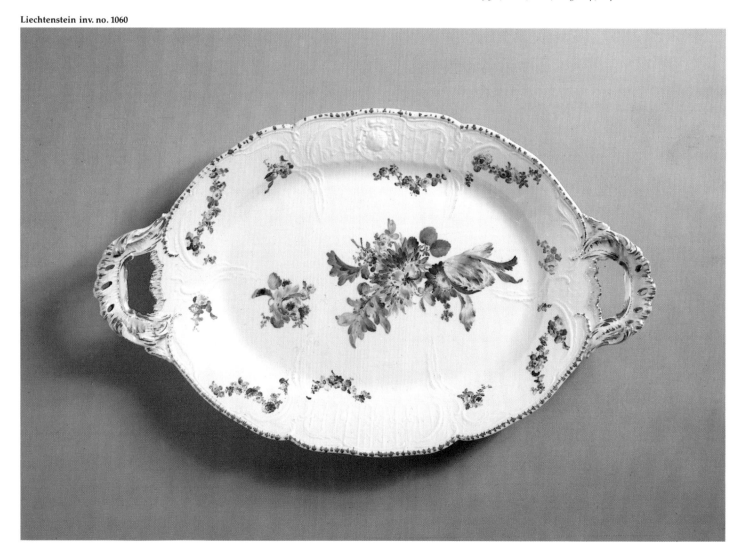

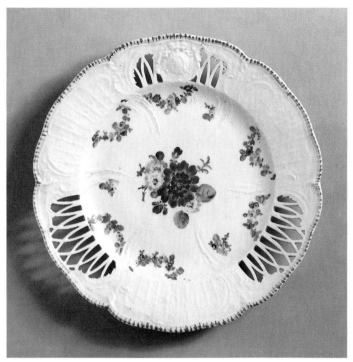

Liechtenstein inv. no. 1141

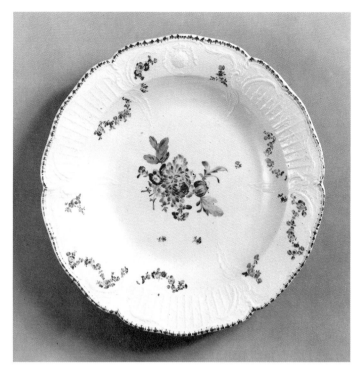

Liechtenstein inv. no. 1145

PAIR OF CANDLESTICKS
Height 10 in. (25.4 cm.)
Mark on each: scepter (underglaze blue)
Liechtenstein inv. nos. 1517–18

In 1766 Frederick the Great, renewing an old friendship with Prince Joseph Wenzel, sent him a table service of Berlin porcelain accompanied by a letter. "Do not think," the King wrote on February 27, "that the sentiments of esteem and friendship which I have for you are as little durable as the fragile bagatelles I send you."

In making this gesture Frederick was following a well-established custom. His rival monarch, Louis XV, had for several years used the state-owned Sèvres factory as a source for his royal and diplomatic gifts, commissioning large services for such recipients as the Empress Maria Theresa, the Duchess of Bedford, and the Kings of Denmark and Sweden. These gifts carried with them the combined weight of royal authority and the prestige of the factory, considerations certainly appealing to the Prussian King. Frederick had long wanted a porcelain manufactory of his own and had spent some time in Dresden during the Seven Years' War, hoping to transfer the Meissen works to Berlin. Failing in this, he purchased the Berlin factory in 1763. He had in fact supported its original establishment in 1751, granting a monopoly to the wool merchant Johann Caspar Wegely, who gave it up in 1757. Four years later, at Frederick's instigation, the factory was bought by a Berlin businessman, Johann Ernst Gotzkowsky, from whom Frederick acquired it on August 24, 1763.

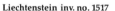
Liechtenstein inv. no. 1517

The new owner was a generous patron of his own factory, and in 1765 ordered the first of twenty-one table services for his personal use. This so-called First Potsdam Service, made for Sanssouci, served as the model for the Liechtenstein service which he ordered immediately afterward, on April 17, 1765. The Potsdam service was designed by Friedrich Elias Meyer, who had been lured to Berlin from Meissen in 1761. It incorporated a motif of flower sprays entwined with palings in low relief (*Reliefzierat mit Stäben*). Introduced at Berlin in 1763 during Gotzkowsky's proprietorship, this pattern was an adaptation of one originated for Gotzkowsky himself at Meissen between 1741 and 1744. The pierced latticework panels with which the flower work is alternated likewise hark back to a Meissen pattern of 1742, also borrowed by Gotzkowsky in 1763.

The principal difference between the Potsdam and Liechtenstein services is the insertion, in the latter, of a cartouche in a pierced section of the rim, molded with the Liechtenstein arms.

The service has been described as having been made for twenty-four people (Köllman 1966, vol. 1, p. 46) and, if so, may have comprised as many as two hundred pieces, including tureens and dish covers such as are found in Frederick the Great's own service. Forty-seven pieces survive, and from them it is apparent that it was a combination dinner and dessert service. There are six oval platters of graduated size, fourteen circular dishes in two sizes, eight dessert plates of two models, a pair of candlesticks, fourteen pierced oval and circular baskets in several sizes, two fragmentary fruit stands, and a single small scoop.

CLC

III

The Collection of Paintings

COLLECTING PAINTINGS

The collections of the Reigning Princes of Liechtenstein culminate in an extensive body of paintings that allows one to study the development of art from the fifteenth to the nineteen century—the Early Renaissance to the Romantic period—with special emphasis on seventeenth-century Baroque art. The flowering of the Flemish and Dutch schools is represented by an abundance of masterworks; there are characteristic examples of Italian and German art, but relatively few French paintings and almost none from Spain. The Princes of Liechtenstein never entertained the encyclopedic ambitions of many public museums. What passes for homogeneity in the collection is purely a product of gradual accretion, according to highly individual and quite varied aesthetic ideals. While all the acquisitions reflect, to a degree, the dominant tastes at the time that they were made, they are above all a personal expression of the collector's passion, which—as evinced by these pictures—was always indulged for its own sake. Each of the great princely collectors put the unique stamp of his own personality on the Liechtenstein gallery.

The core of the Liechtenstein collection, consisting primarily of family portraits—such as Hans Mielich's portrait of the Count of Haag (cat. no. 153)—can be traced to the sixteenth century, but a regular program of collecting paintings did not begin until the reign of Karl Eusebius (1611–84). In his *Treatise on Architecture*, the Prince had expressed the view that tapestries rather than paintings were to be used to decorate the walls of the Liechtenstein palaces. Paintings, he said, should be exhibited in a specially designed long gallery, where their beauty and significance could be properly appreciated. Prince Karl Eusebius was probably influenced by the example of the Italians for, in the sixteenth century, the gallery as an independent building reserved for the display of paintings had become a feature of Italian residences. The Prince's advice is all the more remarkable for his strict insistence on separate galleries for painting and sculpture. This emphatic distinction constituted a break with tradition. The *Kunstkammer*, with its wide assortment of extraordinary curiosities and artifacts, was replaced by the gallery, in which each work of art on display was granted independent status.

Prince Karl Eusebius housed the collection in a special vaulted chamber in his main residence, the castle at Feldsberg, "so that the paintings would be safe from fire." Since Feldsberg was substantially rebuilt in the eighteenth century, the original appearance of this room can no longer be precisely ascertained. There exists, however, a nearly complete record of the Prince's acquisitions between 1669 and 1684, providing an indication of the contents and the extent of the picture collection. Although only a portion of this initial group of paintings can still be identified today, these sources yield a reliable image of the Prince

as a collector. He was confident in his judgment, making his selections after careful deliberation and frequently returning paintings to their owners. He favored small, delicately executed pictures, which made him partial to the works of the minor masters of the Flemish and Dutch schools.

His son and successor, Prince Johann Adam (1657–1712), introduced something more than the taste of a new generation to art collecting; he revolutionized its very standards, which affected all aspects of the process from the level of the Prince's personal involvement in acquisitions to the appearance and quality of the objects that he obtained. Karl Eusebius's preference for the more reserved forms of artistic expression gave way to an enthusiastic espousal of powerful objects and pictures with grandiose compositions. Now, in place of landscapes and genre subjects that demanded painstaking appreciation by the connoisseur, paintings of historical narratives were commissioned and collected. The cabinet picture, of modest dimensions, was superseded by life-size figure paintings that dominated the space in which they were hung. Prince Johann Adam had found that the requirements of a collector of Baroque art were most adequately met by Italian art—especially by Bolognese painting. The Prince also showed a preference for the great Flemish masters, such as Rubens and van Dyck. With his acquisition of the Decius Mus cycle in 1693, he laid the foundation for the famous collection of works by Rubens, which grew steadily in the years that followed. The compelling imagery of this series of paintings lent an unprecedented splendor to the Liechtenstein gallery. Toward the end of the seventeenth century, with the demise of the second generation of buyers who had enjoyed a personal relationship with Rubens and van Dyck, a large group of works by these Flemish masters became available in Flanders. Three collectors seized this unique opportunity: Elector Palatine Johann Wilhelm, Elector Maximilian II Emanuel of Bavaria, and Prince Johann Adam von Liechtenstein. While the two Electors' collections were later united in the Alte Pinakothek, Munich, the works by Rubens acquired by Prince Johann Adam are still preserved in the Liechtenstein gallery. Wilhelm von Bode's appraisal in 1896 of the high rank of this Rubens collection still pertains: "When the Liechtenstein gallery is named, everyone even slightly acquainted with the fine arts will immediately think of Rubens, remembering the abundance of glorious paintings of all sizes and kinds by this master that are distributed throughout a whole row of rooms in the palace. We might say that the terms 'Liechtenstein gallery' and 'Rubens' are intrinsically connected: the gallery cannot be conceived without its Rubens collection, nor can a complete knowledge of the great Flemish master be acquired without having seen his works in the Liechtenstein gallery." Next to the Alte Pinakothek, the Museo del Prado, and the Louvre, the private collection of the

Prince of Liechtenstein has to be considered one of the finest collections of great works by Peter Paul Rubens.

A network of trade relations extending throughout Europe supplied Prince Johann Adam with offerings from which he made selections, based entirely on his personal taste. For his acquisitions he frequently made use of the firm established by the Forchoudt brothers in Antwerp, dealers who also had a branch in Vienna. Some of the Forchoudt correspondence has been preserved, furnishing valuable insights into the nature of the art market at that time and indicating that only autograph and exceptionally well-preserved works were to be sold to the Prince of Liechtenstein. Besides the Forchoudts, the Bolognese painter Marcantonio Franceschini was the source of many of the Prince's acquisitions. The correspondence between the artist and the Prince has been preserved; unique for its time, it contains critical evaluations of various artists and of the condition and quality of their works, along with records of tenacious negotiations concerning the prices of a great number of acquisitions and questions of transport. On October 1, 1706, Prince Johann Adam wrote to Franceschini that he had then filled a total of eight rooms with pictures, adding "Niente dimeno non tralasciaremo di fare novi acquisiti, ma devono essere delli autori della prima classe e die bonissimo gusto" (Nevertheless we will not fail to make new acquisitions, but these must be by artists of the first order and of excellent taste). The rooms of which the Prince speaks were situated in the Liechtenstein City Palace in Vienna; the Liechtenstein gallery had been transferred from its original home at Feldsberg Castle to the capital of the Holy Roman Empire, where it played a decisive role in the city's cultural life for two hundred years.

The order imposed by the Prince on his collection appears to have impressed his immediate successors, for there is no documentation of any changes, rearrangements, or noteworthy additions until the late eighteenth century. In the first printed catalogue of the Liechtenstein gallery, dated 1767, its director, Vincenzo Fanti, lists over five hundred paintings, displayed in ten rooms and gives their actual sequence as if for an imaginary tour. With the help of his text, we can reconstruct the position of the pictures room-by-room, thereby experiencing the juxtaposition of specific works intended by Prince Johann Adam. In the course of two generations, a collection had thus been assembled that was impressive for the clarity of its conception as well as for the range of its contents. The Liechtenstein gallery could compare favorably with the imperial collection and with that of Prince Eugene of Savoy.

Prince Johann Adam ensured that his collection would be preserved for future generations: his will and testament of 1712 designated the City Palace, including the gallery, as the inalienable property of the Reigning Princes of Liechtenstein, in perpetuity. When an inventory of the gallery was made in 1733, the family seal was impressed on all the paintings bequeathed by Johann Adam. Many pictures still bear this mark, indicating that they were a part of the great collector's gallery.

In the course of the eighteenth century, the rapid growth of the Liechtenstein gallery subsided, and the gallery's successive owners restricted themselves, in the main, to preservation, arrangement, and occasional enlargement. When major changes next occurred, they stemmed from the spirit of a new age and were initiated by Prince Johannes I (1760–1836). In 1807 he had the contents of the art gallery in the City Palace transferred to the Liechtenstein Garden Palace outside the gates of Vienna and arranged according to conservatorial criteria. What had once been an intimate, private collection of treasures gained a life of its own as an independent institution. Although the general public did not yet have access to the collection—in his 1816 description of Vienna, J. Pezzl noted that anyone wishing to visit the gallery had to apply for permission to the House of Liechtenstein—the first step had been taken toward the formation of a museum. Such a step could not have occurred outside of the context of intellectual developments in Europe, which had led to the opening up of private collections in the late eighteenth century and had contributed to the founding of the Louvre just a few years before the relocation of the Liechtenstein gallery. A particularly impressive example had been set in Vienna by Emperor Joseph II, who, in 1777, ordered the imperial collection of paintings removed from the Stallburg and installed in the Upper Belvedere of Prince Eugene, to provide a pedagogical institution for the public.

Because of the astuteness shown by Johannes I in reorganizing and adding to the gallery, he must be counted among the great collectors of his family. An inventory of works acquired by him, drawn up after his death, comprises a total of 711 paintings—the largest increase in the collection since the days of Prince Johann Adam. Prince Johannes I favored Dutch historical scenes and portraits, genre pictures and still lifes, and especially landscapes, and he acquired them in extraordinary quantities. These works were evocative of the golden age of seventeenth-century Dutch painting; this romantic collector found a meaningful connection between the Dutch depictions of nature and his own passion for gardens and parks. That the history of collecting art is inseparable from general cultural history is well illustrated by another aspect of this Prince's acquisitions: a small but significant number of early German paintings that probably appealed to him because they documented the German past. Johannes I seems to have regarded them with the same reverence that led him to acquire and restore medieval castles as monuments to his family's heritage.

Only one other Prince of Liechtenstein was comparably active in adding to the collection. Throughout the more than seventy years of his reign, Prince Johannes II (1840–1929), the grandson of Johannes I, devoted himself to the scholarly study of art history, which flourished in his time. Three years before Johannes II began his reign, Jacob Burckhardt had published his *Cicerone*—with its "instructions for the enjoyment of Italian works of art"—which would provide guidance for the Prince's activities as a collector. As a result of his efforts, Italian art of

the Early Renaissance, which had been rather sparsely represented in the gallery, was expanded into a significant focal point of the collection.

Prince Johannes II not only contributed substantially to the Liechtenstein gallery but made generous donations to public museums in Prague, Troppau, Bozen, and especially Vienna. In 1873 Jacob von Falke, the historian of the Princely House and director of the gallery, published a new catalogue of the collections, comprising 1,451 paintings, but in 1885 a revised edition was issued after the Prince removed a large number of pictures alien to his taste. It was Prince Johannes's wish that his collection be made available to scholars, and he also funded numerous research projects. Occasionally, Wilhelm von Bode, General Director of Museums in Berlin—who, in 1896, published the first comprehensively illustrated volume on the Princely Collections—served as Prince Johannes II's adviser. The Liechtenstein gallery had become the equal of the great European museums; with its venerable tradition and its unusual aristocratic status, it had entered the modern age.

Reinhold Baumstark

ITALIAN AND FRENCH PAINTINGS AND WORKS OF ART

121

French Artist (Provençal?)
1456

PORTRAIT OF A MAN

Parchment on wood; 20⅛ × 16½ in. (51 × 41.8 cm.)
Inscribed (on reverse): No. 120 Von Mantenio erkaufft vom Spilenberger
Liechtenstein inv. no. 729

Undoubtedly one of the glories of the Liechtenstein collection, this renowned portrait is one of those mysterious works that continue to raise a multitude of questions. Flanking the face of the sitter, only the date 1456—almost certainly that of the picture's execution—is sure. We know nothing about the identity of the subject, or of the creator of this remarkable likeness, nor even the school of painting to which it belongs. Since it has been rarely shown in public, and is known to scholars principally through black-and-white reproductions, there have been erroneous assessments of its state of preservation. However, even technical examination yields no specific determinator for locating more precisely the *Portrait of a Man*. The parchment upon which it was, from all indications, originally painted is a support that was more widely employed in Northern Europe than in the South, but there are too few surviving examples of this technique to make any definitive judgment. This parchment is affixed to a panel of fir (*Abies alba*), a species common throughout Europe; however, there is no proof that the parchment was originally glued to a panel, despite the mention of such a wood backing in the 1780 catalogue. It is unlikely that the artist himself mounted his work on this fir backing; the theory of a later alteration is supported by a number of elements: the trimming of the parchment's edges evidenced by the cropped numerals that—because of the clumsiness of its execution—distorts the image at the levels of the parapet and of the date; the choice of a poor-quality wood; and the faulty manner by which the parchment is glued to it. In any event, we know nothing about the work's appearance in 1677, the year Prince Karl Eusebius von Liechtenstein purchased it in Vienna from the Emperor's dealer and painter, Johann Spilberger. The Princely Archive contains no record of a reinforced support or of the addition of the notorious overpainting that was removed in the 1938 restoration (Strohmer 1943, pp. 25–29), that is, the black cap mentioned in the 1780 catalogue and the brooch and white shirt visible in several old photographs of the work. Did Spilberger make such alterations the better to sell his "Mantegna"?

It should, however, be pointed out that, contrary to what is sometimes maintained, the present picture's state of preservation does not prevent us from truly appreciating its style. Both the background, once perhaps enlivened with a decorative motif that is now barely discernible on the left, and the hair have obviously suffered. But, although the edges of the parchment support have unquestionably been trimmed, a careful reading of the X-ray (fig. 31) reveals that it is on the whole well preserved, excepting an old repair in the lower-left corner and slight losses at the upper right and left center. The uneven surface discernible in the sitter's left cheek and the vertical split that traverses the picture are due to irregularities in the panel to which the parchment is glued. There are no traces of old restoration or major lacunae in the paint surface. The X-ray confirms the existence of the pentiment in the position of the fingers, which is faintly visible to the naked eye. The use of light which so characterizes the finished picture is even more striking in the X-ray, where one sees a vigorous modeling of the face and hand through strong contrasts of light and dark. The striking use of light may seem somewhat more heavy-handed

than it was originally, owing to the loss of glazes on the flesh tints (under the chin and around the nostrils and the contour of the sitter's left eye). In the same area, the surface of the parchment has suffered minute losses, although at a certain distance this does not diminish the overall effect. On the other hand, the sitter's right cheek, neck, hand, and above all the ear have lost nothing of their strength or of their admirable modeling. In short, as confirmed by a technical examination undertaken by Hubert von Sonnenburg—to whom the author is most grateful—the picture is in satisfactory condition for one of its period.

Several of this portrait's features are surprising: the protuberance and marked cast of the sitter's left eye contribute to the odd fixity of the youth's gaze, so unlike the familiarity encountered in Flemish portraits. The exuberance of the numerals' Gothic calligraphy contrasts strongly with the severity of the composition. Even the presentation of the sitter is extraordinary for its milieu in the mid-fifteenth century. At this date in Italy, even such innovators as Filippo Lippi and Piero della Francesca were still following the "Gothic" tradition of the profile portrait, while Northern European painters were gaining fame for their skill at three-quarter portraits, for their emphasis on individual features, and for strikingly lifelike impressions. Whatever the debt owed by the painter of the Liechtenstein portrait to the example of Jan van Eyck—especially to his *Timotheos*, dated 1432 (National Gallery, London)—he moved away from it to a different approach. The neutral background, the truncation below the shoulders, the physiognomical individualization, the forward gaze, and the parapet on which a hand rests: all attest to the painter's probable Northern training. This is the only example known to the author in fifteenth-century European painting of an independent, nearly full-face portrait using a shoulder-length format in which the breadth of the body is so lifelike, the shoulders so broad. The horizontal effect is strengthened by the period taste for padded clothing with voluminous sleeves and heavy pleats. We sense that, behind the parapet, the body of the model is normally proportioned and not unduly short and narrow in the Flemish manner. This figure is distinguished from the more inventive masterpieces of Jean Fouquet—for example, the *Portrait of Charles VII* (Louvre, Paris), with which it shares a sense of monumentality—by stylistic differences (which are treated in greater detail below, since attribution to the French master continues to find favor with some scholars) but also by the fact that it is not extended in length to the waist and that it is clearly less than life-size. Nevertheless, it should be noted that the Master of 1456 chose the strong, almost squared format dear to Fouquet and that he gave the parchment—later cut down on both sides—dimensions notably larger than those of Northern panels.

Is this work a self-portrait? Friedländer (1896, p. 213), following Falke's attribution to Fouquet (Cat. 1873, no. 270), compared the Liechtenstein work to Fouquet's self-portrait, the enamel medallion in the Louvre. This comparison ignores the differences in physiognomy between the two men—incontestable

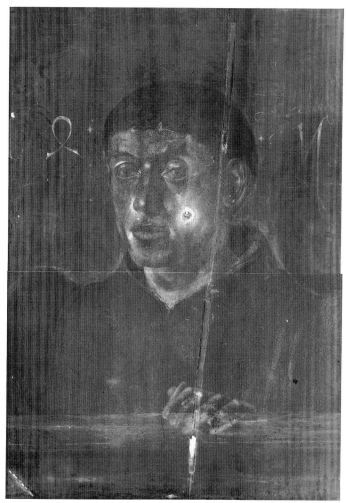

Fig. 31 X-ray of cat. no. 121

to this author—Fouquet's ovoid head and the straight stare of his apparently light eyes versus the pronounced bone structure and the skewed gaze of the present dark-eyed subject. Nonetheless, the notion that the present work is a self-portrait is reiterated by Künstler (1975, pp. 29–35, pls. 6, 8–9), who also perceived an object, perhaps a piece of charcoal or red chalk, between the young man's fingers. X-ray examination of the picture reveals this "object" to be nothing more than pentiment, an alteration of the position of the fingers. As for the frontal gaze—which Künstler likens to that of a painter looking at himself in a mirror—it does not, in this author's opinion, constitute any further evidence in favor of the *Portrait of a Man* being a self-portrait, since the works of van Eyck himself provide several examples that do not fall into this category, for example, the *Portrait of Margaretha van Eyck* (Groeningemuseum, Bruges). Rare, if not unique, for the period is the depiction of a hatless sitter who is neither a donor at prayer nor, until contrary evidence is forthcoming, a man of high station.

The most thorny element in discussions about the Liechten-

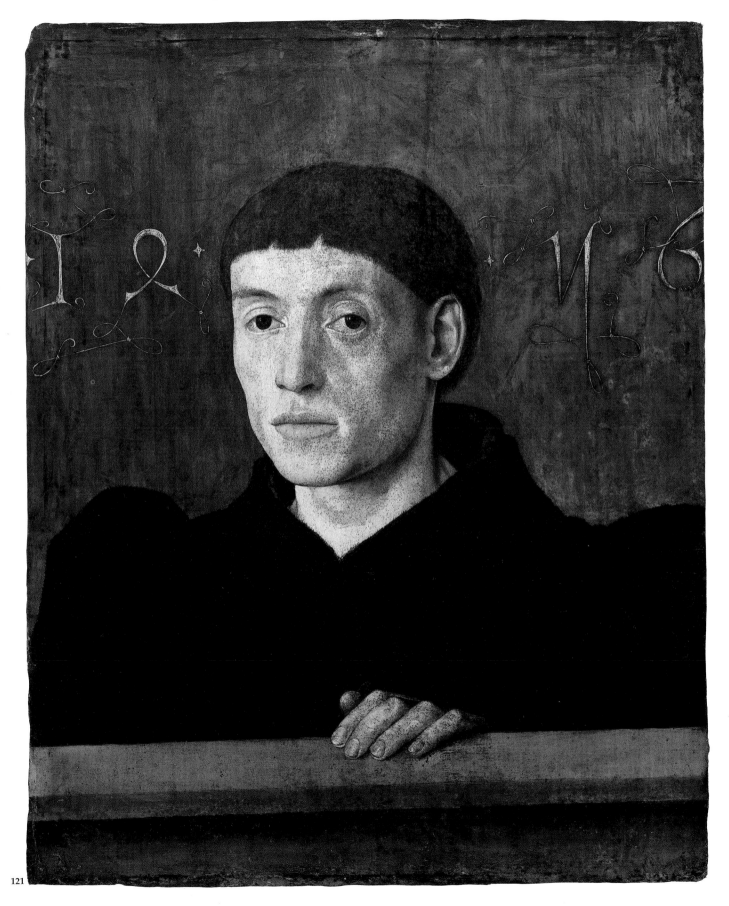

121

stein portrait is the continually debated question of its attribution. It would be pedantic to list all the suggestions put forward, from Andrea Mantegna to Hans Burgkmair the Elder, from Colin d'Amiens to the Master of Jouvenal des Ursins. Three proposals, however, deserve consideration, particularly as they still have their supporters. According to the first, advanced by Falke (Cat. 1873, no. 270) and adopted by such eminent authorities as Bode (1895c, pp. 109–12), Friedländer (1896, p. 213)—although the latter abandoned it in 1912—and more recently by Künstler (1975, pp. 32–35), the portrait is a masterpiece by Fouquet himself. This hypothesis is based on the picture's exceptional quality, on stylistic arguments, and on the subject's purported resemblance to the Louvre self-portrait. It is true that one is struck in Fouquet's works, as in the present portrait, by the stability of the image, by the compelling modeling of the individual, and by a certain expressive reserve that overrides the evident concern for realism. In the work of Fouquet, however, "for the first time a portrait is composed as a 'picture per se,' the object of a research in overall placement that gives it its monumental authority" (Reynaud 1981, p. 15). The Liechtenstein portrait is less inventive and closer to Flemish models than are works by Fouquet, and it does not evince that artist's formal preoccupation. In the *Portrait of Charles VII*, the work by Fouquet most comparable formally and stylistically to the present painting (although the *Charles VII* is a *présentation de majesté*), the artist's imposition of a geometrical pattern on the composition is manifest. Thus, the small head of Charles VII is reduced to a smooth, rounded volume, whereas in the present picture an energetic use of light forcefully brings out the head's irregular internal structure. Hulin de Loo (1904, pp. 31–34) and Leprieur (1907, pp. 18–27) note that two of Fouquet's usual devices do not appear in the Liechtenstein painting: his way of "almost always orienting the faces of his sitters toward the right and of regularly and methodically lighting them from the most visible side"—unlike van Eyck, who lit the foreshortened side—and his habit of finishing the hands "with oval nails each highlighted with a single lengthwise stroke" (both quotations from Leprieur, p. 15).

Reinach (1910, pp. 236–42) suggested the present portrait to be a work by the Portuguese painter Nuño Gonçalves, together with the *Man with a Glass of Wine* (Louvre, Paris), which, since Friedländer (1902, p. 30), had been considered by many critics to be inseparable from it. Although the attribution to that master was not very convincing, the attribution of both paintings to the Portuguese school gained the support of a number of scholars, most notably Sterling (1938, pp. 86–87). Sterling (1965, p. 21) later conceded that the two portraits could not be by the same hand, but they were nevertheless linked by date and by a common artistic origin, an opinion he maintains (written communication, 1983; 1984, p. 168). Indeed, analogies between the two portraits are apparent: similar palettes with the same brownish-orange background, perhaps slightly lighter in the Liechtenstein portrait; the same dark clothing that stands out

strongly; the same characteristic markings on either side of the face; and a shared dependence on Eyckian prototypes in their concern for individualization of character and in the device of a parapet upon which a hand is rested. (The ancient Viennese provenance of both works should also be noted.) However, the relationship becomes less striking if the original format of the Louvre work is reconstructed by visually suppressing the 1⅝ in. (4 cm.) additions to the right and left side; it was particularly vertical. The monumentality that distinguishes the *Portrait of a Man* thus vanishes from the *Man with a Glass of Wine*, and the fidelity of the latter to the Flemish aesthetic becomes more pronounced. In the Louvre picture there is a certain slackness in the rendering of the hands and clumsiness in the presentation of the planes of the face and neck, passages that in the Liechtenstein portraits are handled with remarkable energy and mastery. Beneath the heavy varnish of the Louvre painting, thick brushstrokes are discernible in certain areas (the eyes, the creases in the neck, elements in the still life); such impasto brushwork is not present in the Liechtenstein picture. This use of paint, along with the oddity of the narrow, sad, and resigned face, do indeed evoke Gonçalves's *Polyptych of Saint Vincent* (Museu Nacional de Arte Antiga, Lisbon). Sterling (1941, pp. 56–57) viewed the Master of 1456, to whom he then still attributed both the Louvre and Liechtenstein portraits, as more faithful than Gonçalves to the example of van Eyck, who was in Portugal in 1428 and 1429, and hence surmised that he might have been the Portuguese painter's senior and master. In any event, the walnut support of the *Man with a Glass of Wine*, quite common at the time, does not contradict an Hispanic origin.

Hulin de Loo (1904, p. 30), who considered the Liechtenstein picture "a first-class work, perhaps the finest of all that were seen in the exhibition [of French primitive paintings in 1904]," opened a third avenue of exploration for determining the origins of the present work, by far the most convincing in this author's opinion. Categorically refuting the attribution to Fouquet adopted by the organizers of that exhibition, he identified the Master of 1456 as a painter of Flemish origin, essentially Eyckian, whose career evolved in Burgundy or Provence. Following Hulin de Loo's suggestion, Wescher (1945, p. 57), Ring (1949, no. 143), Sandner (Cat. 1965, no. 39), and for a time Sterling (1946, pp. 129–30) cautiously associated the artist of the Liechtenstein portrait with the Master of René of Anjou, who painted the miniatures in several manuscripts made for that sovereign, particularly in *Le Coeur d'Amour épris*, the artist's masterpiece (Nationalbibliothek, Vienna, ms. 2597). There is also good reason to believe that the Master of René of Anjou is identical with the master in Aix-en-Provence who painted the Annunciation of Aix Triptych between 1443 and 1445 (the central panel, the *Annunciation*, is in the church of La Madeleine, Aix-en-Provence), as well as for identifying that mysterious anonym with Barthélémy d'Eyck, *peintre et varlet de chambre* to King René, documented in Provence and Anjou from 1444 to 1470 (see Sterling 1983, pp. 173–83). Admittedly, the connec-

tion between the Liechtenstein portrait and Barthélémy d'Eyck depends more on an intellectual process than on physical evidence. If we recognize, however, that with the 1456 *Portrait of a Man* we are confronted with one of the great masters of the fifteenth century, that he was trained in the North, as indicated by certain iconographic peculiarities as well as by his sense of realistic observation and his sensual rendering of fabrics, but that he is also set apart from his Flemish predecessors by his more synthetic approach, a greater psychological distance from his subject, and, above all, by a masterful use of light to model form, traits that are more specifically French, then we have also described the Master of the Annunciation of Aix. The relationship of the present portrait with the Annunciation of Aix Triptych was stressed early on by Hulin de Loo (1904, p. 39): "It is not impossible that they were produced by one and the same artist." As in the case of the Annunciation Triptych, echoes of the Master of Flémalle and the van Eyck brothers mingle: a pronounced taste for contrasts of dark and light and sharp three-dimensionality. In spite of the modernity of vision and verisimilitude that the artist of the Liechtenstein portrait applies to his subject and that comprise his personal concept of portraiture, he does not share with his contemporary Fouquet the Italian concern for *grande forme*. Compared with the manuscript illuminations by Fouquet, there is something archaizing about those of the Master of René of Anjou, their refinement of execution and their knowledge of color and light notwithstanding. Various disconcerting similarities of detail also attest to this commonality of culture between the René Master and the Master of 1456. For instance, there are the "large planes of the bony cheeks, the bitter expression of the tight lips, the eyes set in narrow and deep-set lids" (Sterling 1941, p. 48), words that describe the face of Isaiah in the left panel of the Annunciation Triptych (Museum Boymans–van Beuningen, Rotterdam) as well as that of the young unknown subject of the Liechtenstein picture. The fingers of the hand of Jeremiah in the right panel of the Annunciation Triptych (Musées Royaux des Beaux-Arts, Brussels) and, on the back of the same panel, those of Christ the Gardener terminate in the same short, square nails highlighted with a touch of white and ringed with a dark line. The lower eyelids of the man portrayed here and of the figures in the Annunciation Triptych are marked by identical white lines. The miniatures in *Le Coeur d'Amour épris* manuscript, clearly later in date, furnish numerous examples of such strongly lit faces "portrayed with an almost cubist determination" (Sterling 1941, p. 48).

We are, of course, well aware that there is no way to prove categorically the Liechtenstein portrait's origin in Provence, or even in Anjou—the regions between which the activity of the René Master is divided. Nonetheless, no other painter at this time managed with such distinction and authority to transfigure the painstaking realism of the Flemish painters by infusing it with the light of the South.

DT

FURTHER REFERENCES: Cat. 1767, no. 420 (as Burgkmair); Cat. 1780, no. 591 (as Burgkmair); Waagen 1866, p. 286 (as Andrea Mantegna?); Cat. 1885, no. 729 (as Jean Fouquet); Woltmann and Woermann 1887, p. 55; Suida 1890, p. 118, ill. p. 119 (as Jean Fouquet); Leprieur 1897, pp. 347–48, ill. p. 349; Bouchot in Paris 1904, no. 51, pp. 23–24; Vitry 1904, pp. 292–93, ill. p. 293; Lafenestre 1905, p. 40, ill. p. 39; Höss 1906, pp. 66–67; Fleischer 1910, p. 55, no. 20; Durrieu 1911, pp. 730–31; Friedländer 1912, pp. 157–58, ill.; Friedländer in Thieme-Becker, vol. 12 (1916), p. 253; Willis in Thieme-Becker, vol. 14 (1921), pp. 366–67; Hausenstein 1923, pp. 16, 27–28, pl. 36; Gluck 1923, no. 7, pl. 7; Cat. 1931, no. 729, p. 144, ill. (as Jean Fouquet); Lemoisne 1931, pp. 78–80, pl. 62; Perls 1935, pp. 313–18, pl. 3; Perls 1940, no. 284, pl. 285; Strohmer 1943, p. 94, pl. 25 (as Master of 1456); Vollmer in Thieme-Becker, vol. 37 (1950), pp. 366–67; Panofsky 1953, vol. 1, pp. 307–8, 488; Châtelet and Thuillier 1963, p. 55; Sterling 1972, no. 64, pl. 64; Sterling 1973, pp. 518–24; Wilhelm 1976, p. 54, pl. 4 (as French Painter, 1456); Baumstark 1980, no. 153 (as Jean Fouquet); Laclotte and Thiébaut 1983, p. 92, ill. p. 74, and no. 55, p. 232, ill.

122

Naddo Ceccarelli

Sienese, act. second quarter of 14th century

CHRIST AS THE MAN OF SORROWS

Tempera on wood, gold ground; 24 × 14⅛ in. (61 × 36 cm.) excluding engaged frame; 28 × 19¾ in. (71 × 50 cm.) with frame
Signed (on the sarcophagus): NADDUS CECCH [ARELLI] DESENIS MEPINX[IT]
(Naddo Ceccarelli of Siena painted me)
Liechtenstein inv. no. 862

The half-length figure of the dead Christ is shown erect, emerging from his tomb, with his head inclined toward his right shoulder and his two arms crossed at the wrists so that the wounds in his hands and side are fully visible. The unusually elaborate frame, which is original, is made up of raised gesso decoration (*pastiglia*) and painted roundels that show, from the upper left, Saint Paul holding his epistles, the dove of the Holy Ghost (damaged and visible only in part), Saint Peter, Saint John the Baptist gesturing to Christ and holding a scroll inscribed ECCE AG[NUS DEI] (Behold the Lamb of God), a female martyr saint with a palm, Saint Agnes (holding a lamb?), a female saint, and Saint Andrew holding his cross. The reverse side has a *faux-marbre* design.

Paintings of Christ as the Man of Sorrows were common in Italy from at least the late thirteenth century, and they enjoyed a special popularity in Siena, where they occur as the center element of predellas of altarpieces, as a diptych with a companion image of the Madonna and Child, and, more rarely, as the center of an altarpiece. Ceccarelli's image seems to be based on Simone Martini's depiction of the Man of Sorrows in the predella of his altarpiece at Pisa, of 1320, where the motif of the winding sheet draped over the front and back edges of the sarcophagus is also found. Ceccarelli has increased the hieratic quality of this prototype by adding a crown of thorns to Christ's head and by treating the winding sheet as though it were a brocaded cloth of honor. The artist has achieved an ingenious effect by partly hiding his signature behind this cloth,

189

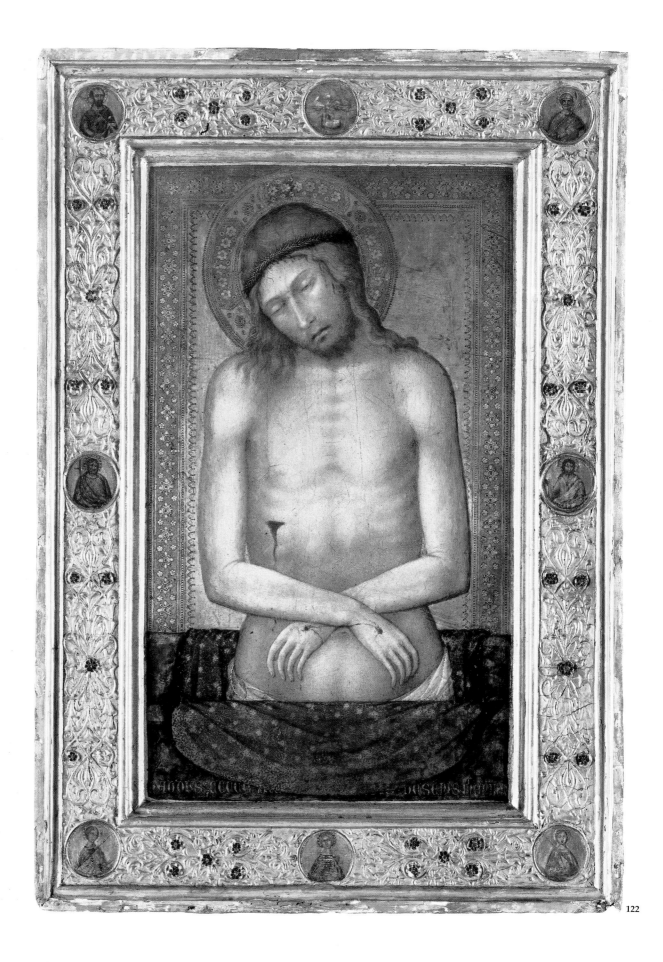

122

making the signature appear as if it were inscribed on the sarcophagus itself.

Although the Liechtenstein picture has generally been considered a wing of a diptych and is frequently associated with a *Madonna and Child* formerly in the Cook collection (sale, Christie's, London, November 25, 1966, no. 62), the first assumption is probably wrong and the second demonstrably incorrect. The frames of both pictures are more elaborate than those normally found on diptychs. Moreover, the three roundels at the base of the frame of the *Madonna and Child* show figures of the Virgin and Saint John to either side of Christ as the Man of Sorrows, and the center roundel at the top shows Christ blessing. The panel was clearly conceived as an isolated image with its own self-contained iconography. In all probability the Liechtenstein picture, which shows no trace of hinge marks along its vertical edges and, again, has a self-contained iconography, was also an independent work for private devotion.

Aside from the Liechtenstein *Man of Sorrows* and the ex-Cook *Madonna and Child*, which is signed and dated 1347, virtually nothing is known about Ceccarelli. With a single exception, the paintings that can be attributed to him with any certainty are relatively small in scale, consisting mostly of images of the Madonna and Child. The exception is an altarpiece in the Pinacoteca, Siena, showing the Madonna and Child with Saints Anthony Abbot, Michael, John the Evangelist, and Stephen; this was probably painted for the altar of Sant'Antonio in the church of the Ospedale di Santa Maria della Scala, inasmuch as a predella of exactly the requisite dimensions in the Art Museum at Princeton bears the arms of the hospital and an altarpiece dedicated to Saint Anthony is cited in the pastoral visit of 1575. The predella is of interest in that, at its center, is a roundel with Christ as a Man of Sorrows that stands midway between Simone's predella panel and the Liechtenstein picture.

To judge from these works, Ceccarelli must have been associated for a time with the workshop of Simone Martini—without doubt the largest and most influential shop in Siena. It has been suggested that he accompanied Simone to Avignon in 1339 and returned to Siena following Simone's death in 1345, but this is no more than conjecture. A number of Sienese artists, including Simone's brother Donato, his brother-in-law Lippo Memmi, Lippo's brother Federico, and a "Petrus Ciccarelli de Senis" (conceivably a brother or relation of Naddo's), are known to have painted works for Avignon, and relations between the papal city and Siena must have been close. Ceccarelli's work is closer to the so-called Master of the Palazzo Venezia Madonna and the Master of the Strauss Madonna, sometimes identified with Federico Memmi and Donato Martini, respectively, than to Simone himself. No work is datable earlier than about 1335 or later than about 1350. The Liechtenstein picture is among the latest of the pictures by Ceccarelli and may be considered his masterpiece. It is first mentioned in the Ciseri collection in Florence in 1885 and was acquired for Liechtenstein in 1892.

KC

FURTHER REFERENCES: Crowe and Cavalcaselle 1885, pp. 324–26; Perkins 1909, p. 6; Bernath 1912, p. 253; Frimmel 1912, p. 97, ill. p. 98; Nicola 1921, pp. 243–44, ill. p. 245; van Marle 1924, vol.2, p. 303, fig. 201; Perkins 1931, p. 21; Cat. 1931, p. 171, no. 862; Berenson 1932, p. 143; Lucerne 1948, p. 5; Bregenz 1965, no. 17; Berenson 1968, p. 85, fig. 321; Stubblebine 1969, pp. 8, 13 n. 42; Cat. 1972, p. 13, fig. III; Benedictis 1974, pp. 142, 152, 153 n. 31, fig. 17; Benedictis 1979, pp. 40–41, 83; Boskovits 1979, pp. 207–8; Baumstark 1980, no. 1; Polzer 1981, p. 569, fig. 19; Lonjon 1983, pp. 191–92.

123

Piero di Cosimo
Florentine, 1461/62–1521

MADONNA AND CHILD WITH THE INFANT SAINT JOHN THE BAPTIST
Oil and gold on wood; 28⅜ × 21¼ in. (72 × 54 cm.)
Liechtenstein inv. no. 264

According to the thirteenth-century *Meditationes vitae Christi*, the infant Christ and John the Baptist first met following the Purification of the Virgin and before the Flight into Egypt. Seven years later, when the Holy Family was returning from Egypt, the two met again in the desert. However, in Florence, where Saint John the Baptist was the patron saint, the infant Baptist was commonly included in representations of the Nativity from the middle of the fifteenth century and in devotional images of the Madonna and Child from the late fifteenth century. (The principal study on the devotion to the infant Saint John is that of Lavin 1955, pp. 85ff.) In these scenes, as in the Liechtenstein picture, he is shown about six months older than the Christ Child, in conformity with the narrative of the Gospel of Luke (1:26).

The present picture, which is beautifully preserved, seems to have been purchased by Prince Johann Adam Andreas von Liechtenstein before 1712, probably as a work by Perugino, to whom it is ascribed in the eighteenth-century catalogues of the collection. It is listed by Waagen (1866, p. 283), rather surprisingly, as a work by Gaudenzio Ferrari, and Bode (1892, pp. 96–97, ill. p. 96) attributed it to Giuliano Buggiardini under the influence of Piero di Cosimo. However, following Knapp's careful analysis (1899, pp. 83ff., 114, fig. 25) the painting has been almost universally accepted as a late work by Piero di Cosimo. Nonetheless, Bacci (1966, pp. 108–9, no. 58, fig. 58) has found the spatial and psychological relationship between the figures unsatisfactorily defined and the landscape monotonous and lacking in Piero's customary refinement; she suggests that the picture may be an early copy of a lost work by Piero or a workshop production in which his part was limited to the head of the Virgin. If the term of comparison is Piero's *Immaculate Conception* in the Uffizi, Florence, or the luminous *Madonna and Child with Angels* in the Fondazione Cini, Venice—two of his

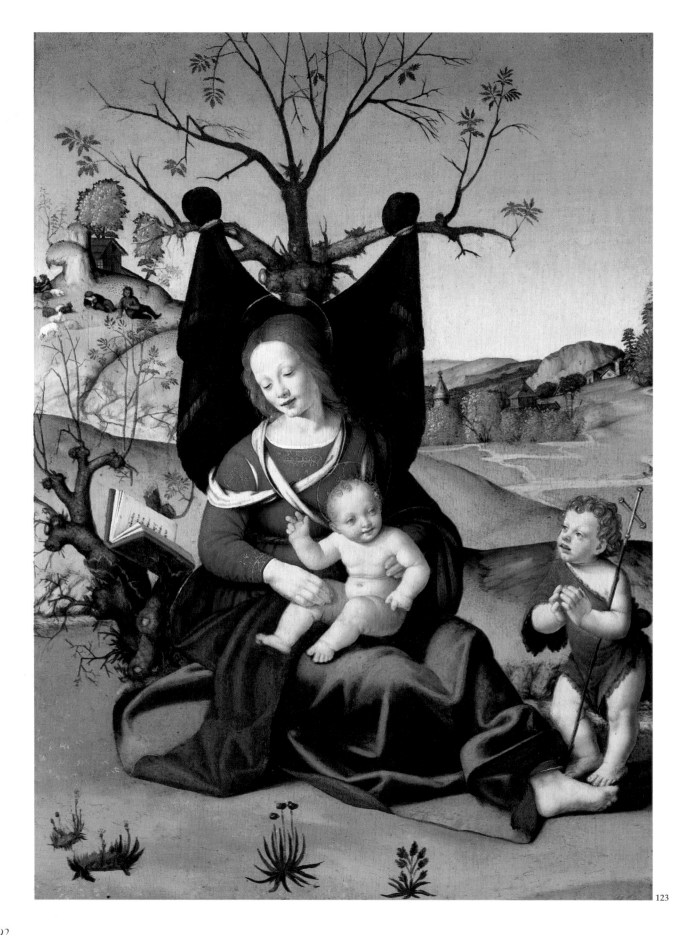

greatest masterpieces, both dating from about 1505–1507—then these observations may seem to carry some weight. However, it is not with these two pictures that the Liechtenstein painting should be compared but with a group of smaller, somewhat later paintings, in which the High Renaissance compositions and idealized types of Raphael and Fra Bartolommeo are transposed by Piero into his own homespun, eccentric idiom (Zeri 1959, p. 44). The Liechtenstein picture is certainly the finest of this group of paintings, not all of which, however, are likely to be by Piero, and it is worth recording that a study by Piero of the Madonna and Child on a sheet in the British Museum (no. 1946-7-13-4 r.; ill. in Bacci 1966) generically relates to it, although the direction of the figures is reversed.

The manner in which the coarsely textured, woolen shawl has been suspended from the pruned tree behind the Virgin—a parody of the traditional, richly brocaded cloth of honor—and the way the devotional book has been propped in the gnarled branches of a half-dead stump (whether this is a symbol of rebirth or simply a motif Piero selected for its pictorial properties is uncertain) are typical of his imaginative approach. So also are the two shepherds: one shown in a steeply foreshortened pose, fast asleep, and the other playing a rustic pipe; their presence is an indirect reference to the Nativity. Moreover, a cleaning carried out in 1983 has greatly enhanced the rich, brilliant palette and the subtle use of glazes to describe the features of the Virgin's face, which recalls especially the work of Fra Bartolommeo in the late 1490s.

As is so often the case with Piero, the architecture of the buildings in the background shows a sympathy with Flemish painting. Perhaps the closest parallel for the landscape details occurs in his earlier altarpiece in the Spedale degli Innocenti, Florence. The type of the Virgin's face, however, recurs in the figure of Andromeda being reunited with her father in the *Story of Andromeda* in the Uffizi, Florence. Bacci (1966) has also questioned the attribution of that work to Piero, though, as Vasari acutely recognized, it represents one of Piero's most singular achievements. The *Andromeda* seems to have been painted for Filippo Strozzi the Younger in 1510 (Craven 1975, p. 575; but see Berti 1980, p. 163, no. 370, for a later dating, ca. 1513). The most probable date for the Liechtenstein picture, which is certainly earlier, is about 1507–1510. Knapp (1899) identified a possible source for the pose of the Virgin in Luca Signorelli's tondo of the Virgin and Child in the Uffizi, a work painted almost two decades earlier than Piero's.

KC

FURTHER REFERENCES: Cat. 1767, no. 127; Cat. 1780, no. 111; Cat. 1873, no. 641; Cat. 1885, no. 264; Schaeffer 1897; Haberfeld 1900, pp. 108–110; Cartwright (Ady) 1906, p. 310; Venturi 1911, p. 713 n. 1; van Marle 1931, vol. 13, p. 356, fig. 244; Cat. 1931, no. 264; Berenson 1932, p. 455; Degenhart 1933, p. 16; Berenson 1936, p. 390; Douglas 1946, pp. 77, 119, pl. LXII; Lucerne 1948, no. 53; Morselli 1957, p. 147, fig. 9; Morselli 1958, p. 85; Freedberg 1961, p. 74, fig. 65; Berenson 1963, p. 177, fig. 1200; Grassi 1963, p. 112; Bregenz 1965, no. 22; Abbate 1968, p. 77; Cat. 1972, pp. 264–65, no. 22, fig. XXIV; McKillop 1974, p. 8 n. 35, pp. 24, 33 n. 49, p. 126; Bacci 1976, p. 100, no. 73, fig. 73; Baumstark 1980, no. 4.

124

Attributed to Raphael

Umbrian, 1483–1520

PORTRAIT OF A MAN

Oil on wood; overall: 21½ × 17½ in. (54.6 × 44.5 cm.); painted surface: 18¾ × 14⅝ in. (47.5 × 37.2 cm.)
Liechtenstein inv. no. 36

This beautiful bust-length portrait of a man in three-quarter view before a landscape was purchased in 1823 from the Marchese Bovio collection in Bologna, where, according to a label on the back, it was considered to be a portrait of a Duke of Urbino by the young Raphael (GALLERIA/DEL MARCHESE BOVIO/in Bologna/in Strada S. Stefano./Ritratto di un Duca di Urbino di prima/maniera di Raffaele Sanzio di Urbino). The basis of this identification is likely to derive from an association of the picture with a passage in B. Baldi's *Vita e fatti di Guidobaldo I di Montefeltro, Duca d'Urbino* of about 1615 (1821 ed., vol. 2, p. 237) describing the Duke's costume on his tomb in the church of San Bernardino, Urbino: "a black damask coat with a cap on his head, as was the custom in those days, similar to that worn in the portrait of him by an excellent master" (un giubbone di damasco negro, con un berrettone in capo, com'era costume di quei tempi, simile a quello col quale d'eccellente mano egli si vede ritratto). Although the identification has been argued at length, especially by Filippini (1925, pp. 213ff.), it is certainly incorrect. Not only do the sitter's features differ considerably from those of the Duke, but the portrait of Guidobaldo mentioned by Baldi and listed in ducal inventories in Urbino in 1599, 1609, and 1623/24, is in the Uffizi (see Sesti 1983, p. 248; Florence 1984, pp. 64ff.). Equally unconvincing is Becherucci's identification (1968, pp. 38–39, pl. 26) of the sitter as a member of the Albizzi family on the basis of superficial similarities with one of the bystanders in Raphael's *Marriage of the Virgin* in the Brera, Milan. The matter would not be worth comment were it not that the identifications have carried with them implied dates for the execution of the picture.

No less problematic is the attribution of the portrait. As early as 1839 Passavant questioned both the identification of the sitter as Guidobaldo and the attribution to Raphael, and in 1866 Waagen suggested that Francesco Francia was its author. Attributions both to Raphael and to Francia have found supporters. Cavalcaselle (1882), Bode, Berenson, Longhi, Camesasca, Vecchi, Becherucci, Baumstark, Carli, and Cuzin have ascribed it to Raphael, while Cavalcaselle (1871), Williamson, and Dussler have attributed it to Francia. Venturi proposed Marco Meloni, a mediocre follower of Francia, as its author, while Suida ascribed it to Perugino. Filippini ingeniously suggested that Raphael was responsible for the design and Francia the execution. In light of what we now know, an ascription to Meloni, Perugino, or Francia may be excluded.

The picture was thoroughly examined and cleaned by Hubert von Sonnenburg in 1981–82. It is painted on two vertically grained panels. Originally it had an engaged frame (the support has not been cut). An old repainting—evidently carried out about 1800 (Naples yellow was found in the previously highly detailed hair)—had much altered the hair. Interestingly, Cavalcaselle's initial attribution of the picture to Francia was based on "the finish and minuteness of the hair and other parts, in which the clean touch of the goldsmith is apparent" (Crowe and Cavalcaselle 1871, vol. 1, p. 571). In its present state this arèa has an unfinished appearance (which is also true of the balustrade behind the sitter, in which the black is exceptionally thin). This is due to abrasion and possibly to the portrait's not having been brought up to a uniform degree of finish. The trees on the left have also suffered from minor abrasion. On the whole, however, the state is good. X-ray radiography reveals a number of minor changes. The red lapel extending outward below the chin originally had a more varied, less straight edge. The mass of hair to the right and left of the head was extended over the landscape. The shape of the hat was also altered so that the turned-up rim to the right and the protruding rim at the left were enlarged. The contour of the sitter's left shoulder was also simplified. Examination under infrared reflectography revealed virtually no underdrawing or traces of a transfer from a cartoon by pricking. Nonetheless, there can be no doubt that the design for the picture was worked up first in a cartoon. Proof of this is provided by a detailed drawing in the Isabella Stewart Gardner Museum, Boston, of the head and neck of the sitter in which the hat and lapel conform with the initial rather than the executed design of the portrait. The drawing is of exactly the same scale. However, despite its undeniable relationship to the present picture, it differs both in effect and in quality—it lacks any sense of volume and all of the features are much flattened—and was certainly copied from the lost cartoon. Not surprisingly, it shows no stylus marks or pricking for transfer. None of the technical evidence weighs either for or against an attribution to Raphael: though the absence of any underdrawing would be unusual in his portraits, it is not unparalleled.

An attribution to Raphael necessarily implies an early date. This was recognized by Berenson, who categorized the picture as a youthful work; by Longhi, who dated it between 1503 and 1505—prior to Raphael's Florentine period; and, most recently, by Cuzin, who dates it about 1503–1504 and compares it with the Brera *Marriage of the Virgin* of 1504. Indeed, Dussler's rejection of the portrait as by Raphael, despite what he correctly perceived as its high quality, was based on a fallacious comparison with works of about 1505–1506. The matter of Raphael's early portrait style is still speculative. The Uffizi portraits of Elisabetta Gonzaga and Guidobaldo I da Montefeltro, for example, are far from universally accepted despite their provenance from the ducal collection of Urbino (see Florence 1984, pp. 58ff., 64ff.). If the Elisabetta Gonzaga is an autograph work,

as its ravishing landscape would seem to suggest, it would clearly be an extremely early painting of about 1502. The Liechtenstein portrait, with its three-quarter rather than frontally viewed sitter and the more animated, smaller featured face, would date from a subsequent moment. There are suggestive analogies between the sitter and the figure of Saint Peter in the Vatican *Coronation of the Virgin* of 1502–1503. The landscape in the Liechtenstein portrait compares with that in both the Vatican *Coronation* and the Mond *Crucifixion* in the National Gallery, London, of 1503. As in these two pictures, the portrait would mark the ascendance of Perugino's influence in the brilliant local color and the strongly Flemish character of the landscape (the buildings may, in fact, derive from a specific Flemish prototype).

While any analysis of the Liechtenstein portrait must make allowance for the difference in preservation between, on the one hand, such intact areas as the nose and eyelids of the sitter and the bluffs at the left, which are painted with the delicacy of an autograph work by Raphael, and, on the other hand, the red cloak and the most distant range of hills, which lack any strength of execution but are also less well preserved, the weak conception of the torso and the unsatisfactory relationship of the head to the balustrade and landscape are inherent to the design, though not irreconcilable with the young Raphael's work.

KC

FURTHER REFERENCES: Passavant 1839, vol. 2, p. 61; Passavant 1860, vol. 2, p. 46; Waagen 1866, vol. 1, p. 260; Cat. 1873, p. 10, no. 67; Crowe and Cavalcaselle 1882, vol. 1, p. 334; Cat. 1885, p. 7, no. 36; Bode 1892, p. 94; Bode 1895a, p. 128; Williamson 1901, p. 135; Frizzoni 1912, pp. 85–86, pl. XIX; Lipparini 1913, p. 128, ill. p. 127; Venturi 1913, p. 479; Venturi 1914, p. 1094, fig. 827; Glück 1923, no. 10, fig. 10; Cat. 1931, p. 14, no. 36, ill.; Suida 1934–36, p. 164 n. 2; Fischel 1935, p. 435; Berenson 1932, p. 483; Golzio 1936, p. 365; Stix and Strohmer 1938, p. 92, no. 13, fig. 13; Ortolani 1945, p. 23; Lucerne 1948, p. 25, no. 101; Longhi 1955, p. 22; Camesasca 1956, pp. 36–37, no. 21, pl. 21; Vecchi 1966, p. 90, no. 26, fig. 26; Dussler 1966, pp. 72–73, no. 129; Berenson 1968, p. 355; Cat. 1972, p. 17, no. 23, fig. VI; Vecchi 1981, p. 258; Baumstark 1980, no. 5; Carli 1983, p. 36; Cuzin 1983, pp. 42, 45, fig. 38.

125

Francesco di Christofano, called Franciabigio
Florentine, 1484–1525

PORTRAIT OF A MAN

Oil on canvas; 21⅝ × 15¾ in. (55 × 40 cm.); there is an added vertical strip, ⅜ in. (1 cm.) wide, at the left
Inscribed and dated (at left, on cartel): A·D·M·D·X·VII / D·X·/ S
Liechtenstein inv. no. 254

This beautiful portrait was purchased in Florence in 1879 from the estate of Marchese Gino Capponi, in whose collection it was seen by Burckhardt a quarter of a century earlier. Burckhardt

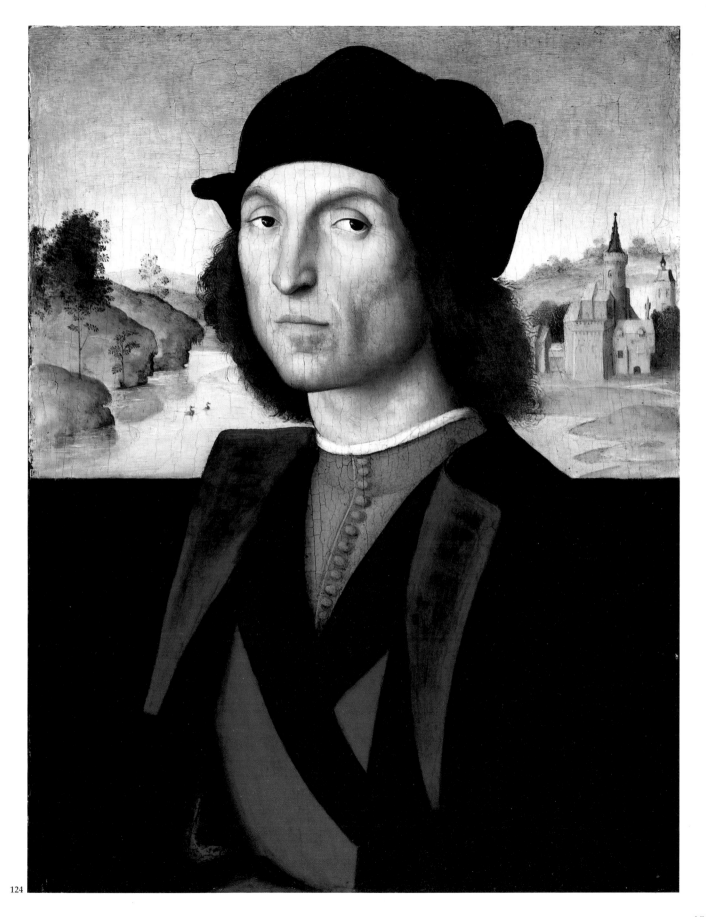

124

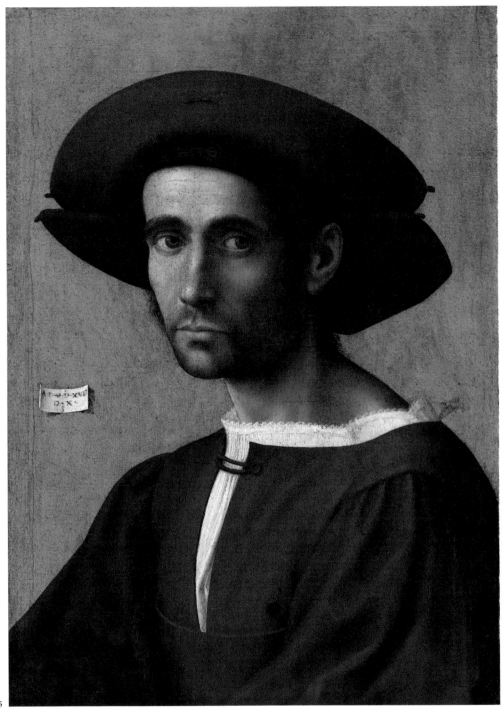

125

(1869, p. 900) attributed the picture to Franciabigio and suggested that it might be a self-portrait. There is, however, little physiognomic resemblance between this sitter and the Saint John the Baptist in Franciabigio's altarpiece of 1516 (now in San Salvi, Florence), which, according to Vasari, is a self-portrait. (Vasari's portrait of Franciabigio in the 1568 edition of the *Lives* is clearly based on the Saint John.) It cannot be excluded that the sitter is a member of the Capponi family, although there is no evidence one way or the other.

According to McKillop (1974, p. 214), the attribution of the painting to Franciabigio was questioned (verbally) by Freedberg sometime after 1961. McKillop herself has rejected the attribution, implausibly suggesting that "the work may not be Italian." She concludes her analysis by noting that the portrait might conceivably be by Franciabigio's younger compatriot Tommaso di Stefano "under the influence of a Flemish visitor, or by a Northerner taken with the Florentine portrait style. A difficult picture to attribute."

196

This untenable conclusion derives from an insufficient understanding of the technical properties peculiar to this work, for whereas every other portrait (indeed, every other portable painting) by Franciabigio was painted in oil on wood, this one is executed in a thin oil medium on a finely woven canvas—an unusual but certainly not unparalleled technique. As a result, the surface has a dry appearance that accounts for what McKillop saw as a "two-dimensional treatment," quite different from the richer appearance and the fatty medium frequently encountered in Franciabigio's work. However, there is a compensating delicacy in such details as the embroidered collar and the definition of the eyebrows and eyelashes that is completely characteristic of the artist. Although the picture is quite well preserved, it has suffered from abrasion, especially on the crown of the weave. The background may originally have been glazed with a dark green that turned brown and has been reduced.

There are no grounds for believing this to be the work of a Northern artist, and the picture is qualitatively vastly superior to Tommaso di Stefano's unique signed and dated portrait, of 1521, in the Metropolitan Museum. Indeed, it is difficult to imagine who other than Franciabigio could have painted this distant, melancholy figure who confronts the viewer in stark simplicity, without the embellishment of either a landscape or a writing table. The closest compositional analogy within Franciabigio's oeuvre is the portrait, signed with his monogram, in the Detroit Institute of Arts, where the sitter is shown against a plain background, although posed in a more lively fashion and with one hand raised. As so frequently with Franciabigio, the immediate prototype was a work by his friend and associate Andrea del Sarto. The closest parallel is perhaps Sarto's contemporary portrait of a man, sometimes identified as Baccio Bandinelli, in the Uffizi, Florence, which, like the Liechtenstein *Portrait of a Man*, is also painted on a fine canvas. There is an exact parallel for the treatment of the white collar in Franciabigio's portrait of a young man in the Uffizi of 1514, and the drawing of the bow by the left sleeve may be taken practically as a signature of the artist.

In the absence of any alternative interpretation, it may be suggested that the last three enigmatic letters of the inscription on the cartel were intended to be read as part of the date: D[IE] X S[EPTEMBRIS].

KC

FURTHER REFERENCES: Morelli 1890, p. 126; Bode 1892, p. 95; Berenson 1904, p. 116; Berenson 1909, p. 135; Gronau 1916, vol. 12, p. 326; Venturi 1925, vol. 9, p. 442, fig. 328; Cat. 1931, no. 851; Berenson 1932, p. 211; Berenson 1936, p. 181; Lucerne 1948, p. 8, no. 31; Freedberg 1961, p. 483, fig. 585; Berenson 1963, p. 66, fig. 1368; Sricchia Santoro 1963, p. 14; Cat. 1972, no. 13; Baumstark 1980, no. 6.

126

Francesco di Christofano, called Franciabigio
Florentine, 1484–1525

MADONNA AND CHILD WITH THE INFANT SAINT JOHN THE BAPTIST

Oil and gold on wood (the panel is slightly thinned); 48 ⅜ × 35 ⅞ in.
(123 × 91 cm.)
Signed, on hem of Virgin's mantle, with artist's monogram
Inscribed (on scroll held by Christ): ECCE AGN [US DEI] *(Behold the Lamb of God)*
Liechtenstein inv. no. 254

Despite the presence of Franciabigio's monogram on the hem of the Virgin's mantle and the picture's exceptional quality, this beautifully preserved painting, purchased in 1790 from the painter Johann Adam Braun, was incomprehensibly attributed to Giuliano Buggiardini. Berenson (1909, p. 135) was the first to ascribe it to Franciabigio (but see Knapp [1911, p. 208] and Venturi [1925, pp. 425, 427, fig. 307] who maintained the attribution to Buggiardini). It is Franciabigio's grandest and most fully evolved composition of the Madonna and Child and arguably his masterpiece in this genre. The Virgin, seated on a grassy knoll in an open landscape, fills the foreground with her ample, broad-shouldered body in a way that is unprecedented in Franciabigio's work. The arc formed by the gesture of her arms envelops the Christ Child, to the left, and Saint John the Baptist, to the right, in a carefully articulated, cohesive group.

Raphael's Florentine paintings of the Madonna and Child had a formative influence on Franciabigio's early pictures of the theme, and it is not surprising that the point of departure for this work should be the *Madonna dell'Impannata* (Galleria Palatina, Palazzo Pitti, Florence), which, according to Vasari, Raphael painted in Rome—probably about 1514—for Bindo Altoviti, who sent it to Florence (for the most recent information on this picture, see Florence 1984, pp. 166ff.). From that work Franciabigio has taken over the relative positions of the two children to either side of the Virgin and the general pose of Saint John, who turns to address the viewer. He has also maintained the same age difference between the infants seen in Raphael. However, Raphael's picture shows the Virgin, her mother, and a female saint grouped together in an interior, whereas the theme of Franciabigio's picture is the meeting of the Christ Child and Saint John upon the Holy Family's return from Egypt (the figure in the distant landscape is Saint Joseph, who may be searching for nuts or berries). This change in theme necessitated a number of compositional changes, the most important of which are the placement of the figures in an outdoor setting and the transfer of the Christ Child's attention from the attendant female figures to his mother, to whom he playfully shows the scroll inscribed with words foretelling his sacrifice. In effecting this change, Franciabigio seems to have turned to

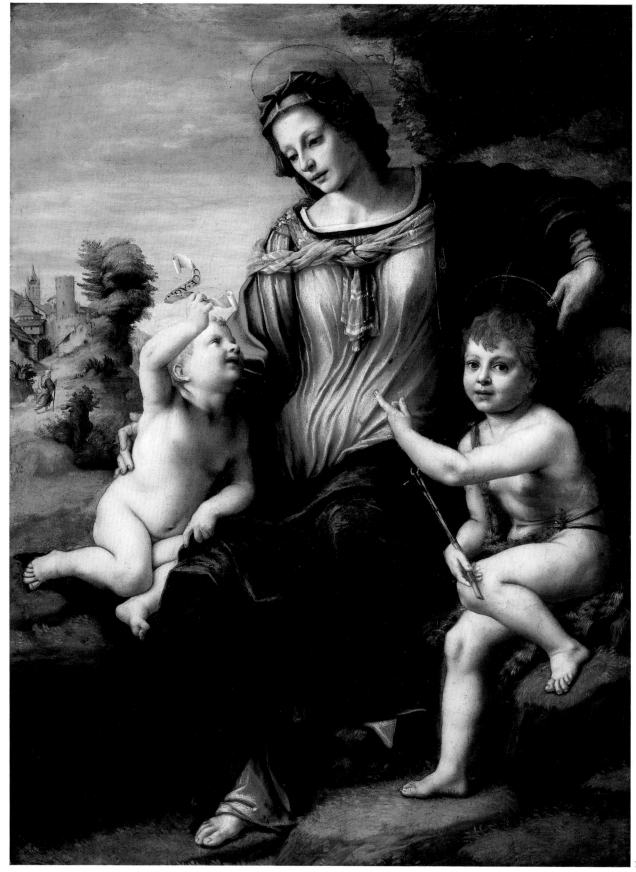

another Raphaelesque source, Agostino Veneziano's engraving, dated 1516, of Venus and Cupid, a composition based upon Raphael's contemporary frescoed decoration in the bath of Cardinal Bibbiena in the Vatican. The pose of Franciabigio's Virgin derives from that of the Venus, and the idea of setting the figures off-center, to the right, balanced by a landscape on the left also depends from the engraving. However, in place of Agostino Veneziano's view of a Venetian lagoon, Franciabigio painted a wooded hill crowned by a Northern-looking city; it is uncertain whether the buildings were freely based on a print like Lucas van Leyden's *Hagar* or whether they represent an interpretation *alla fiamminga* of a variety of sources (the circular building with biform windows recurs in Piero di Cosimo's portrait of Francesco Giamberti in the Rijksmuseum, Amsterdam). The closest analogies for the headdress of the Virgin and the folds of her dress, which create a beautiful, abstract pattern and, at the same time, accent her breasts and abdomen, occur in the contemporary work of Sarto, Pontormo, and Il Rosso.

McKillop (1974, pp. 85–86, 90, 167, 169–70, 172, no. 33, fig. 94) has argued at some length that Franciabigio made a trip to Rome in 1520 in the company of Andrea del Sarto and Jacopo Pontormo, with whom he was then working in the Medici villa at Poggio a Caiano, and that the influence of Sebastiano del Piombo may be discerned in the present picture. However, any similarities between the Liechtenstein *Madonna and Child with Saint John the Baptist* and a work by Sebastiano like the *Holy Family with a Donor* in the National Gallery, London, are more casual than real. And although it is possible that Franciabigio made a trip to Rome, it is worth recalling that Vasari explicitly states that the artist never left Florence. Moreover, the primary sources for this picture were apparently available to Franciabigio in Florence.

The picture has been dated by Sricchia Santoro (1963, p. 16, fig. 16) to about 1518 and by McKillop to about 1521–22. The two fixed points of Franciabigio's late work are the *Portrait of a Man* in Berlin, dated 1522, and the *David and Bathsheba* in the Gemäldegalerie, Dresden, dated 1523. There is no doubt that the Liechtenstein *Madonna and Child with Saint John the Baptist* belongs with these two works, which mark the culmination of his career. Indeed, there is no reason that the Liechtenstein picture should not date as late as 1524 (McKillop's interpretation of Franciabigio's last two years of activity as a period of decline and a relapse to an earlier style is unconvincing). The picture is, in a sense, Franciabigio's response, via Raphael, to the work of his younger compatriots Pontormo and Il Rosso. Franciabigio worked with Pontormo not only at Poggio a Caiano, but also in the decoration of a room for Giovanni Benintendi in Florence, for which he painted the Dresden *Bathsheba*.

McKillop has tentatively associated a black chalk drawing in the Albertina, Vienna (no. 27472), of a head of a woman as a preliminary study for the Virgin, and she has incorrectly interpreted a pentiment on the left cheek of the Christ Child as a later addition. KC

FURTHER REFERENCES: Cat. 1873, no. 254; Cat. 1885, p. 36, no. 254; Bode 1892, p. 96; Berenson 1904, p. 113; Borenius 1914, p. 132 n. 5; Cat. 1931, p. 70, no. 254; Berenson 1932, p. 211; Berenson 1936, p. 181; Berenson 1963, p. 66, fig. 1372; Freedberg 1971, p. 156; Cat. 1972, p. 14, no. 12, fig. XIV.

127

North Italian
Ca. 1515–30

APOLLO AND THE MUSES
Oil on wood (pine); overall: 6⅞ × 46⅞ in. (17.5 × 119.2 cm.); painted surface (excluding border): 5⅝ × 46¼ in. (14.2 × 117.5 cm.)
Inscribed (at center, on hillock): POLYDOR CARVI/1520
Liechtenstein inv. no 207

At the center of the composition, seated on a hillock midst a grove of trees, is Apollo, who plays a viola da braccio. To his right are a lira da braccio and two cornetts, while to his left is the Castalian font, identifying the setting as Parnassus. To either side of him are the Muses, Pegasus (the horse of the Muses), and Pan, who plays his pipes. Upon comparison with the famous series of Ferrarese *tarocchi* of the mid-fifteenth century (for which see Levenson 1973, pp. 100ff.), the Nine Muses may be identified by the instruments they play. Urania carries a celestial globe in one hand and a compass in the other. Erato beats a timbrel and dances. Calliope blows into a sackbut (in the *tarocchi* series she plays a trumpet). Melpomene plays a cornett. Polymnia is seated at an organ, whose bellows are operated by a winged putto and against which is propped a harp. Clio, seated on a swan, sings. Thalia plays a fiddle. Terpsicore plays a lute. Euterpe plays an aulos.

According to Hesiod (*Theogones* 52–76), the Muses were the daughters of Zeus and Mnemosyne. They came to be associated with poetry, the arts, and the sciences and were each given a specific attribute. For example, Clio, the muse of history, was shown with a scroll, while Melpomene, the muse of tragedy, carried a tragic mask. Raphael observes these distinctions in his fresco of Parnassus in the Vatican *stanze*. In the present panel, as in the *tarocchi* series, only Urania, the muse of astronomy, Erato, the muse of amorous poetry and the dance, and Euterpe, the muse of lyric song, bear their appropriate attributes. Seznec (1953, pp. 140–41) explains that in the *tarocchi* series the Muses and Apollo express the Harmony of the Universe, and he points out that this idea is taken up in Franchinus Gaffurius's *Practica Musicae*, first printed in Milan in 1496 with a dedication to Ludovico il Moro (for various later editions see Gaffurius 1968 ed., p. 9). The same meaning is certainly intended here as well.

The picture is one of a pair, and was so noted in the 1780 catalogue of the Liechtenstein collections. The second panel

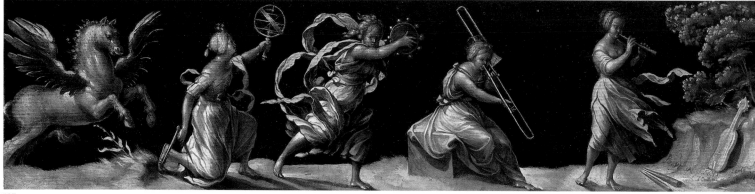

127

(fig. 32), also at Liechtenstein and cleaned in 1984 with revealing results, depicts an allegory of Music. At the center of a Bramantesque arcade with simple pilasters, seated on an architectural throne, is a personification of Music, holding in her left hand a lyre and in her right an open book (the figure has been taken over from an engraving after Raphael's celebrated tondo of Poetry on the ceiling of the Stanza della Segnatura). On the dais in front of her lie a lute, a case for a set of recorders, and an open book with a musical score. Under her feet is a recorder, while a diatonic harp is propped against the front of the dais. To either side of Music three putti hold a tablet. That on the left is a diagram of the *Introductorium* of Guido d'Arezzo illustrating his diatonic system; that on the right diagrams the application of solmization syllables to notes of the gamut. Both diagrams seem to have been adopted from Gaffurius's *Practica Musicae*. On the left side of the panel are the ancient and Old Testament "inventors" of music, Pythagoras and Jubal (or Tubal, as he was sometimes called through a conflation with Tubalcain, the Old Testament counterpart to Vulcan). Pythagoras, whose name is inscribed on the background of the arch behind him, is seated at a table diagramming, presumedly, the arithmetical relations of the musical scale, which he is said to have discovered by listening to the various sounds produced by hammers of different weight striking an anvil. Next to him three children are shown engaged in precisely this activity. It is worth noting that the story was illustrated and explained in the eighth chapter of Gaffurius's *Theorica Musicae* (Naples, 1480), which dealt with musical consonance. A number of musical instruments, including an organ, a lute, three cornetts, and two crumhorns, are on the table before him, and a harp, a viola da braccio and bow, what may be a regal, and a shawm lie on the floor. Jubal (the name "Tubal" is inscribed on the background of the arch behind him), "the father of all such as handle the harp and pipe" (Genesis 4:21), is seated on a marble bench playing a portative organ with a cornett at his side. On the right side of the panel is shown a figure evidently copying from an open book on a stand before him onto a large sheet of paper or parchment. Only the last four letters of his name can be clearly

read on the background above his head: . . . INVS. In the event that his two counterparts represent the Greek and Hebrew inventors of music, it seems likely that this person is intended to show their modern counterpart (the contemporary hat he wears would also suggest this). The most obvious person would be Guido d'Arezzo—or Guido Aretinus, the founder of the modern notational system whose work is illustrated on the tablets to either side of Music. An organ, lute, recorder case, and book lie on the table before him. On the floor are an assortment of instruments: a dulcimer or hackbrett, a tromba marina, a tambourin à cordes, a drum, a cornett, a sackbut, and an organ. On the continuous plinth of the arcade are a lute and clavichord. (My thanks to Laurence Libin, who has kindly checked the identification of the instruments and generously discussed the intricate iconography of the panel with me.)

That the two pictures are companions cannot be doubted. Not only are the subjects complementary—one illustrating harmony in mythological terms, and the other offering a synopsis of musical history and theory—but the grisaille technique employed is identical. It can, moreover, be demonstrated that while the panels had different heights, their painted surface was originally the same length. Both panels have been cut at the right. On the reverse of the panel showing Apollo and the Muses are two vertical slits—⅜ in. (1 cm.) wide, ⅝ in. (1.6 cm.) long, and 3/16 in. (.5 cm.) deep—1 13/16 in. (4.6 cm.) from the left edge and ⅜ in. (1 cm.) from the right. Presumedly, then, the panel was cut 1⅜ in. (3.5 cm.), of which 11/16 in. (1.7 cm.) would have been occupied by the plain border visible on the other three sides. The total length of its painted surface would, therefore, have measured 46 15/16 in. (119.2 cm.). The second panel has two notches on its bottom edge: one 2⅛ in. (5.3 cm.) from the left edge and the other 1¾ in. (4.5 cm.) from the right. It has presumedly been cut 5/16 in. (.8 cm.). Since this panel seems to have had a painted border only along the top (that on the left is false), the total length of its painted surface would also have been 46 15/16 in. (119.2 cm.). The fact that the height of the painted surface on the second panel (29.5 cm. minus the .7 cm. border at the top) is almost exactly twice that of the *Apollo and the Muses*

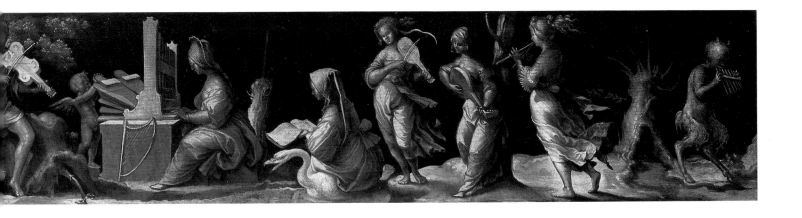

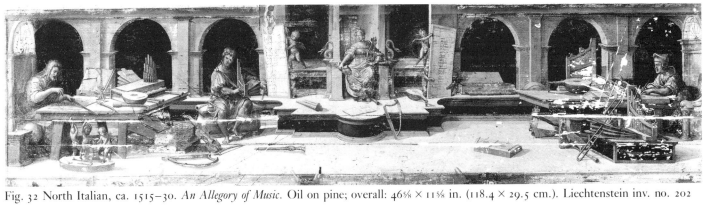

Fig. 32 North Italian, ca. 1515–30. *An Allegory of Music.* Oil on pine; overall: 46⅝ × 11⅝ in. (118.4 × 29.5 cm.). Liechtenstein inv. no. 202

Fig. 33 Detail from cat. no. 127

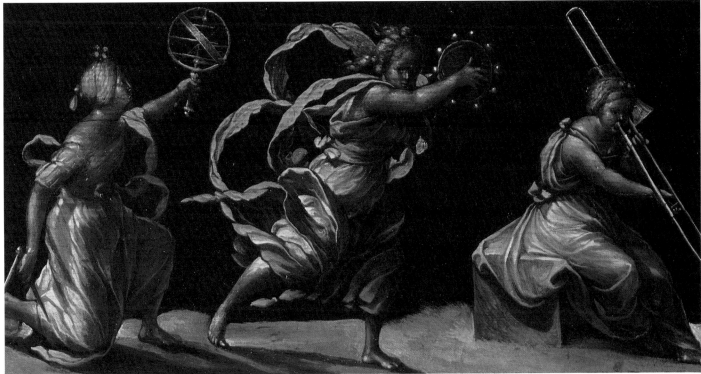

is surely not coincidental. Yet, this said, it is clear from the considerable damage sustained by the second panel (the *Apollo and the Muses* is in excellent condition), as well as from the fact that one panel has notches at the bottom while the other has slits on the reverse, that the two panels occupied quite different positions in their original setting.

Since 1885 it has been repeatedly stated that the two panels may have decorated a clavichord or other keyboard instrument, and this idea is certainly not contradicted by their iconography. Indeed, a spinet made in Venice in 1566 and now in the Germanisches Nationalmuseum, Nürnberg, shows on the inside of its cover Apollo and the Muses on Mount Parnassus. Nonetheless, the proportions of the two panels are difficult to reconcile with their function as lids to a keyboard instrument (for examples, see especially the double virginal of 1580 in van der Meer 1983, fig. 117), and neither panel seems to have been painted on its reverse or bears the trace of any hinge marks. While the proportions of the two panels might suggest their possible use above the keyboard of a harpsichord (for the *Apollo and the Muses*) and as the front of an outer case, their dimensions exceed those of comparable sixteenth-century Italian keyboard instruments. Geronimo da Bologna's harpsichord of 1521, for example, has a length of only 29½ in. (75 cm.) and a height of 7⅝ in. (19.5 cm.) (including the keys), and a harpsichord of 1574 by the Venetian Giovanni Baffo has a length of 32⅝ in. (83 cm.) and a height of 7½ in. (19 cm.) (Russell 1968, pp. 28–29, 33). It should, finally, be noted that along the bottom edge of the panel with an allegory of Music are two further inscriptions, one of which reads *Contratenor*. These inscriptions suggest that even if the panel had not been cut on the bottom, it must have been contiguous with a further painted panel. That they were overdoors (Venturi 1926, pp. 452f., fig. 384) is extremely unlikely.

The attribution of both works is problematic. The inscription with Polidoro's signature and the date 1520 is clearly old and cannot, on technical grounds, be faulted. However, it is difficult to believe that Polidoro could have painted these pictures at any time in his career (the closest point of comparison is the series of small panels at Hampton Court, for which see Shearman 1983, pp. 196ff.; these are carried out in a completely different style). Interestingly, in the 1767 catalogue (nos. 97, 300), both pictures were attributed to Raphael and no mention is made of the inscription. Venturi's tentative attribution of them to Marcantonio Raimondi makes no sense either. It is, in fact, difficult to make any satisfactory attribution. The two pictures appear to be by a North Italian master and to date from about 1515–30—the earlier terminus is provided by the derivation of the personification of Music from a print after Raphael's *Poetry* in the Stanza della Segnatura. The artist was obviously familiar with and interested in Northern prints by Dürer and Lucas van Leyden: the hat of the muse Polymnia depends from a print like Dürer's engraving of a young couple threatened by Death of about 1498; Clio's costume derives from a print like Lucas van Leyden's woodcut of a spinner of 1513; and the figure

here identified as Guido d'Arezzo wears the sort of scholar's hat found in a number of Northern prints.

There is a temptation to identify the artist with Lorenzo Leombruno (active between 1499 and 1537), Isabella d'Este's favored court painter at Mantua between the death of Mantegna in 1506 and the arrival of Giulio Romano in 1524 (see Gamba 1906, pp. 65ff., 91ff.; Perina 1961, pp. 392ff.; and Pasetti 1978, pp. 237ff.). Leombruno is known to have painted mythological or allegorical pictures simulating bronze. Among the decorations he was paid for in 1523 in Isabella's new suite of rooms in the *Corte Vecchia* of the ducal palace were four such pictures in the vault of the *Camera della Fama* (see the documents in d'Arco 1857, vol. 2, p. 91). One such work has survived and is now in the Brera, Milan. Gamba has related its iconography to Leombruno's personal reversals after the arrival in Mantua of Giulio Romano and plausibly dated it about 1524. Although the technique is roughly the same as that employed in the Liechtenstein pictures, the execution is drier and a dependence on both Mantegna and Giulio is evident. This does not exclude the possibility that the two Liechtenstein panels may be by Leombruno, but the case is not compelling. Venturi (1926, p. 393), followed by Gamba, has also attributed to Leombruno another grisaille (on canvas) formerly in the Spitzer collection, Paris. What is almost certainly the same picture, cut into three pieces and somewhat made up, has subsequently been published as a work by Mantegna and associated—incorrectly—with paintings done to simulate bronze over the two doors of Isabella's studiolo (Zimmermann 1965, pp. 17ff.; Béguin 1975, p. 30). They do not seem to be by Leombruno. Although an attribution to Leombruno cannot be advanced with any degree of confidence, the popularity of this sort of technique in Isabella's decorative enterprises is suggestive, as is her well-documented interest in music and musical instruments (see her ample correspondence with the celebrated instrument builder Lorenzo da Pavia in Brown 1982). Leombruno is known to have painted a large picture of Apollo and the Muses in 1512, and his mastery of an *all'antica* style is amply documented in his frescoed vault of the *Scalcheria* in the ducal palace, for which he was paid in 1523.

KC

FURTHER REFERENCES: Inventory 1712, no. 213; Cat. 1767, p. 32, no. 97; Cat. 1780, p. 153, no. 538; Cat. 1873, no. 446; Cat. 1885, p. 30, no. 207; Bode 1892, p. 97; Schubring 1915, p. 409, fig. 847; Cat. 1931, p. 64, no. 207.

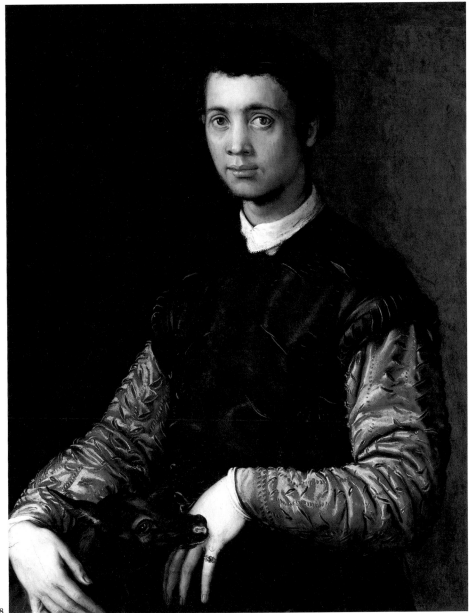

128

128

Francesco Salviati
Florentine, 1510–63

PORTRAIT OF A YOUNG MAN
Oil on wood; 34⅞ × 27⅛ in. (88.5 × 69 cm.)
Liechtenstein inv. no. 848

When this fine portrait was acquired in 1894 by Prince Johannes II from the Palazzo Torrigiani in Florence, it was considered to be a portrait of Alessandro de' Medici by Agnolo Bronzino (1503–1572), the Florentine painter whose riveting portrayals of elegant and aloof aristocrats, notably of the Medici, are the most widely known exponents of Italian Mannerist portraiture. The features of the present sitter have no more than general resemblance to those found in authenticated portraits of Alessandro, and there is no sound basis for the traditional identification of the subject; it is not recognized by Langedijk (1981, vol. 1, pp. 221–42).

Nor has the traditional attribution found general acceptance; this portrait is excluded from Baccheschi's *L'opera completa del Bronzino* (1973). Though the painting has some affinities to the work of Bronzino, and though his authorship of it has been accepted by Bode (1895a, p. 128), Schulze (1911, p. 31), Venturi (1933, vol. 9, pt. 6, p. 32), and Baumstark (1980, no. 14), the strongly recessive features and nervous expression seen here are more closely related to portraits by Francesco Salviati. The

203

possibility of Salviati's authorship was first put forward by McComb (1928, p. 128) and was taken up by Berenson (1932, p. 197), who found it probable.

Francesco de Michelangelo de' Rossi, known as Salviati, was born in Florence, where he received his principal training in the workshop of Andrea del Sarto during the years 1527–30. In 1531 he was called to Rome by Cardinal Giovanni Salviati, who desired an artist in his personal employ and who evidently considered him the most promising young painter of the time. Francesco subsequently appropriated the surname of his patron. In Rome, Salviati attracted the notice of Pier Luigi Farnese, son of Pope Paul III, and was employed on commissions for frescoes, notably in San Giovanni Decollato, where his reputation was made by a *Visitation* painted in 1538 for the oratory.

From 1539 until 1541, the artist worked in Venice and afterward returned to Rome. He worked in Florence for five years between 1543 and 1548. During these two periods of activity in North Italy, Salviati came under the influence of Parmigianino, whose style is reflected in the present work. No portrait by Salviati is securely datable, but a group of portraits which includes those of Pier Luigi Farnese (Palazzo Reale, Naples) and of a gentleman of the Santacroce family (Kunsthistorisches Museum, Vienna) is ascribed by Cheney (1976, p. 418) to the years 1542–43. The present work is very similar to the portrait of a gentleman of the Santacroce family, particularly in its treatment of the sitter's right hand which is especially close to that in the Vienna picture. The style of these paintings merges imperceptibly into that of portraits executed in Florence later in the same decade, and there is, on the evidence of style and costume, no means of establishing whether the present painting was produced early in the 1540s in Rome or later in the same decade in Florence.

Bode associates with the Liechtenstein painting a drawing of the head of an unknown youth formerly in the Quincy A. Shaw collection, Boston, which it has not been possible to trace. Another drawing, by Salviati, of the head of a youth (Victoria and Albert Museum, London, inv. no. Dyce 186) appears also to be intimately related to the present work. It reportedly belonged to the Medici in Florence, which suggests that the present work may date from Salviati's years in Florence as well.

The animal fondled by the sitter here is described by McComb as a dog. There can be no doubt, however, that a young deer is represented. Though the man caresses the animal with one hand and his other is nuzzled by it, its significance is likely to be emblematic or heraldic, though it is not related to the coat of arms of the Torrigiani.

JP-H

FURTHER REFERENCES: Höss 1908, p. 41 (as Bronzino); Cat. 1931, no. 848 (as Bronzino); Strohmer 1943, pl. 15; Cat. 1948, no. 51 (as Bronzino); Zurich 1956, no. 41 (as Bronzino); Emiliani 1960, p. 72; Cat. 1965, no. 14 (as Bronzino); Cat. 1972, no. 6 (as Bronzino).

129

Copy after Raphael
Flemish, late 16th century (?)

SAINT JOHN THE BAPTIST IN THE WILDERNESS

Oil on wood; 70½ × 61 in. (179 × 155 cm.)
Inscribed (on scroll): A[GNUS] DEI·
Liechtenstein inv. no. 22

Saint John the Baptist is shown seated on a rocky ledge, his body partly draped in a leopard pelt rather than the biblical camel skin, his right hand raised toward a reed cross from which emanates a supernatural light. Behind him, to the left, is a spring of water. To the right of the grotto-like rock formation, the darkness of which offers a foil for the saint's illuminated torso, is a distant landscape with a river and waterfalls. Crowe and Cavalcaselle (1885, vol. 2, p. 483) have explained the spring as an emblem of the purity of the Christian faith, but it is also an obvious symbol of baptism. The light-giving cross toward which Saint John gestures is "the light that shineth in darkness" and "the true Light" to which he bore witness, as described in John 1:5–9, and it is intended as a contrast to the tree stump to which it is fastened. The allusion is to Luke 3:9—

129

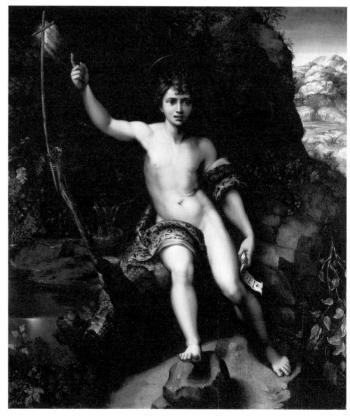

"Every tree therefore which bringeth not forth good fruit is hewn down, and cast into the fire." Indeed, at the point where the cross is fastened to the stump, a new branch has sprung to life.

This beautiful picture is probably identifiable with "Une grande pièce de figure dela main de Rafael Ourbin" that was offered for sale to Prince Karl Eusebius von Liechtenstein by the dealer Peter Bousin in February 1680 and was purchased by the Prince that December (Fleischer 1910, pp. 67–68). Despite the ambitious attribution to Raphael, the picture must, from the outset, have been recognized as an excellent copy of the celebrated canvas in the Tribuna of the Uffizi, Florence. Bousin, in fact, lowered his initial asking price of 1,500 florins to 800, and in the 1767 catalogue of the collection (Cat. 1767, p. 95, no. 476) the picture is attributed to Giulio Romano, thereby confirming its status as a copy after Raphael.

The picture in the Tribuna of the Uffizi seems to be identical with the painting described by Vasari as painted by Raphael for Cardinal Colonna and subsequently owned by the Florentine Francesco Benintendi. It is first mentioned in the Tribuna in 1589 as by Raphael; present opinion tends to ascribe it to either Giovan Francesco Penni or Giulio Romano working from Raphael's design (for the most recent discussion of the matter, see Florence 1984, pp. 222ff.). The Uffizi picture is slightly smaller than the Liechtenstein painting and is on canvas rather than on panel. This is curious, considering that almost all of the known copies are also on panel. While both compositions are extremely close, there are a few differences. For example, the end of the scroll held by Saint John in the Liechtenstein picture curls back differently (the scroll in the Uffizi picture was originally considerably longer and fluttered down). The foliage at the left in the Liechtenstein picture departs significantly from that in the Uffizi painting, as do Saint John's face and hair. The fact that the rock on which Saint John's right foot rests in the Uffizi picture originally had a somewhat different shape and that the present form is repeated in the Liechtenstein painting would seem to confirm that the Uffizi painting is almost certainly not only the prime version but the model for the Liechtenstein copy.

In his study of the Uffizi picture, Rosselli del Turco Sassetelli (1925, pp. 17, 39, pl. 14) maintained the attribution of the Liechtenstein painting to Giulio Romano, and Krönfeld (1931, pp. 7–8, no. 22) continued to believe that it might be a replica from Raphael's own workshop. It is, however, difficult to believe that the picture could date from the first quarter of the sixteenth century. The cursory brushwork—especially on the foliage and in the distant landscape—the brilliant reflections of the supernatural light, and the idiosyncratic manner of describing the Baptist's curls suggest that the picture is by a considerably later artist—possibly a Fleming working at the very end of the sixteenth century. It is worth noting that another copy of the Uffizi picture, of inferior quality, in the Pinacoteca Nazionale, Bologna, has been ascribed to a Flemish artist by Zeri (see Emiliani 1967, no. 118). Nonetheless, of all the known copies, that at Liechtenstein is without doubt the most accomplished and beautiful. **KC**

FURTHER REFERENCES: Cat. 1780, no. 546; Cat. 1873, no. 340; Cat. 1885, p. 4, no. 22; Bode 1892, p. 97.

130

Bertoldo di Giovanni
Florentine, ca. 1440–1491

SHIELDBEARER
Florence, ca. 1470–75
Bronze with remains of fire-gilding; height 8⅞ in. (22.5 cm.)
Liechtenstein inv. no. 258

The statuette was bought in 1880 from the Florentine dealer Stefano Bardini, from whom it probably acquired the fanciful Neo-Renaissance soapstone base on which it has consistently been exhibited. Published in Bode's initial essay (1895b) on the sculptor Bertoldo di Giovanni, the statuette has ever since been recognized as one of the few bronzes attributable on secure stylistic grounds to Bertoldo. Bertoldo was a pivotal figure, a follower of Donatello, as he stated in a letter of 1479 to Lorenzo de' Medici—a letter celebrated for its jocular and familiar tone. According to Vasari, Bertoldo was in turn a mentor of the young Michelangelo, and this report is amply verified by the appearance of Bertoldesque traits in the younger artist's juvenilia. Bertoldo's own work, at least as much of it as survives, is much slighter in scope than that of Donatello or Michelangelo, for his artistic personality was most freely expressed in the form of small bronze reliefs and statuettes.

A statuette of a satyr with a club, now in the Frick Collection, New York, was recognized by Bode (1905, p. 134) when in the collection of J. P. Morgan to be a companion to the Liechtenstein piece. Eventually, by 1910, it acquired a shield in imitation of the Liechtenstein one (Bode 1910, vol. 1, pp. vi–vii, no. 9). According to Bode (1908, vol. 1, p. 15), "the remainder of the drawing on the shield of the Liechtenstein figure" corresponded to the coat of arms of the Este family. The oldest photograph (Bode 1895b, p. 149) shows no arms on the shield and no traces are visible today. Certainly arms were intended to be displayed on the shield; it is more likely, however, that the arms appeared on an enamel insert (there are small holes on the plane of the shield through which the insert would have been pinned). Este arms would have suited Bode's theory (1908, introduction) that the two figures originally formed a group with the *Hercules on Horseback* in the Galleria Estense, Modena, and that because of the Estense provenance of the latter, and a pronounced Estensian flavor in the three pieces, they would have been produced together for Ercole d'Este, Duke of Ferrara. The earliest notice

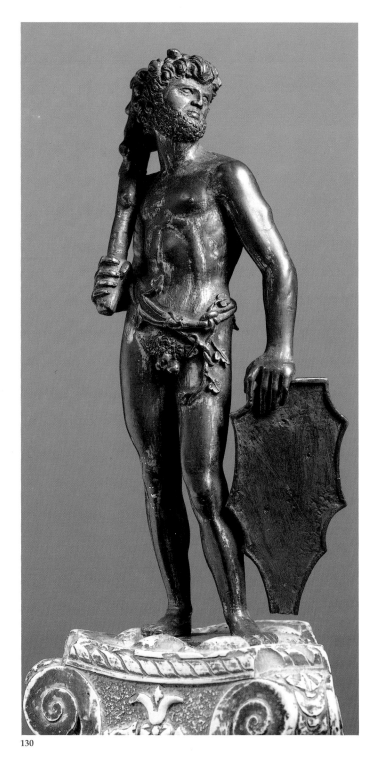

130

The Modena horseman is often described as a wild man on horseback because of his fierce urgency and his garlands of greenery. However, the lionskin with which he is furnished and his largeness in proportion to his mount suggest that he is Hercules, albeit a Hercules in an unfamiliar guise. Lisner (1980, p. 316) has established that Hercules mounted on a horse was a uniquely Ferrarese phenomenon, represented on tapestries, now lost, that decorated the rooms of Ercole d'Este. Ercole himself, whose name and power occasioned a great surge of Herculean imagery at Ferrara, was a noted equestrian.

The Liechtenstein figure is a bearded muscular nude girt with vine leaves, his tumbling locks crowned with a wreath of foliage. He does not have a tail, as Bode (1908) implied, and is more Herculean in proportion than the Frick statuette, who is slighter is his physiognomy and sports both a tail and tiny horns. The two seem to mix the trappings of wild men with those of Hercules and of Bacchic lore. Wild men too were employed in various fashion at the court of Ercole d'Este: they adorned silver flasks and performed as dancers in nuptial masques. The conflation of wild men with Hercules has also been noted in two panels with shieldbearers in Groningen, probably from a wedding cassone. The bronze *Shieldbearers* under discussion similarly framed some element, probably the Modena horseman. Their gilding would have offset it nicely, and the general appearance might have been that of a miniature equestrian monument. Andrea del Castagno's famous fresco of Niccolò da Tolentino in Florence Cathedral shows the rider flanked by shieldbearers of comparable litheness.

A date for the Modena horseman close to 1469 has been proposed by Pope-Hennessy (1963, p. 17), because in it Bertoldo employs a chunky, "primitive" steed similar to those in his earliest medal, that of Emperor Frederick III, while the horses in his later medals and in his statuette *Bellerophon and Pegasus* (Kunsthistorisches Museum, Vienna) are more flowing in their linearity. Figural analysis suggests an identical dating for the *Shieldbearers*—their movements are rather abrupt, expressed in simple S-curves rather than the supple intertwined forms of the elongated *Bellerophon* or the unfinished *Apollo* (Bargello, Florence). All in all, the Liechtenstein–Frick–Modena bronzes, Bertoldo's earliest statuettes, seem to belong together. Olga Raggio raised the possibility that they were made on the occasion of the wedding of Ercole d'Este and Eleonora Gonzaga, which took place in 1473 (Freytag 1974, p. 112). She also pointed out that the Ferrarese court celebrated the *Maio*, a spring revel akin to May Day, in which young cavaliers strew branches of greenery at the doors of maidens; a contemporary records that Ercole d'Este led the *Maio* in 1478 (Zambotti 1935, p. 7). Although Ercole's features are not reflected in those of the rider, it is very likely his valor and a vernal occasion such as the *Maio* that are commemorated in the leafy bronze figures.

Balogh (1982, no. 265a) suggested a resemblance to bronze statues of nude shieldbearers made for Matthias Corvinus, King of Hungary. With axes and swords, they stood near a bronze

of the Modena bronze, in an inventory of 1684, mentions the equestrian Hercules and its pedestal (Ministero della Pubblica Istruzione 1880, vol. 3, p. 27) but makes no reference to additional figures. Pope-Hennessy (1970a, vol. 3, p. 38) did not think the three necessarily belonged together, because the Liechtenstein and Frick pieces are gilt, while the Modena piece is ungilt. However, several considerations vindicate Bode's theory in general outline if not in detail.

Hercules, but their description, written before 1488 by Antonius de Bonfinis, does not convey the pungent woodland flavor of the Liechtenstein and Frick statuettes.

JDD

FURTHER REFERENCES: Bode 1925, pp. 94–97; Planiscig 1930, fig. 15; Bernheimer 1952, p. 208 n. 94; Bregenz 1967, no. 12; Pope-Hennessy 1971, p. 303; Treffers 1974, pp. 100–101; Draper 1985, no. 88.

131

Francesco di Giorgio Martini

Sienese, 1439–1501

SAINT ANTHONY ABBOT

Siena or Urbino, ca. 1470–80
Bronze; diameter 7¹¹/₁₆ in. (19.5 cm.)
Liechtenstein inv. no. 583/11

The hermit saint is recognizable by his tau cross and bell, the only extra elements in this spare design. It was made en suite with three other roundels. Two with Saints Sebastian and John the Baptist are in the National Gallery, Washington, D.C., and one with Saint Jerome is in the sculpture collections at Berlin-Dahlem. The four were displaced from their original situation and dispersed during the nineteenth century. *Saint Anthony Abbot* was bought from the dealer Bovardi in 1881. Planiscig (1921, p. 104) ascribed it to Bartolomeo Bellano. Bange (1922, no. 17) first realized that the four roundels belonged together, and Ragghianti (1938, p. 182) first made the association with Francesco di Giorgio. Ragghianti supposed that the roundels embellished a book, a cross, or a reliquary. Pope-Hennessy's idea (1965, nos. 72–74) that they were inset in a frame, such as that of an altarpiece, is more likely. Their alignment would have been Jerome and Anthony Abbot above (left and right) with Sebastian and John the Baptist below (left and right). The concave, parenthetical shapes of the last two suggest this relationship, as does the Forerunner's gesture—it is familiar enough, but in this instance his index finger would have pointed up toward the central composition instead of away from it.

All four roundels were covered at a later date by a pitchy dark-brown lacquer. This lacquer largely masks the textural excitement of the underlying metal and diminishes the force of the compositions. Where exposed, the reddish-brown bronze of the Liechtenstein roundel shows surfaces that are almost unreworked apart from the slight use of a rasp in vertical strokes to relieve the background.

The *Saint John the Baptist* in Washington adheres fairly closely to the rugged type of Francesco's wood statue of the Baptist at Fogliano (documented 1464). The figural types and exploration

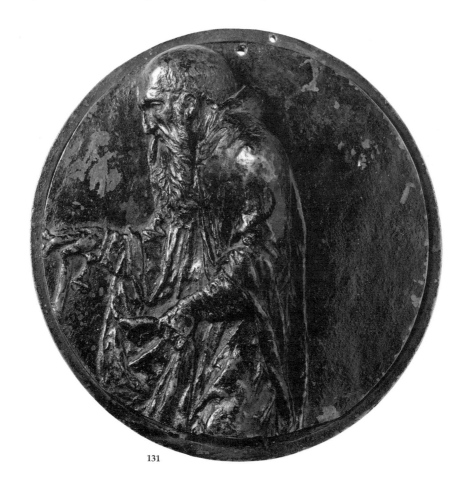

131

of space in all four roundels are akin to bronze reliefs by Francesco in Santa Maria del Carmine, Venice, and the Galleria Nazionale, Perugia (the *Deposition* and the *Flagellation*, respectively). The *Deposition* was presumed by Weller (1943, p. 168) to date around 1474–75, as it contains donor portraits of Federigo da Montefeltro, the Duke of Urbino, and his son Guidobaldo who, born in 1472, appears to be little more than three years old in the relief. Francesco's architectural activity at Urbino is undocumented before 1477, but the *Deposition* portraits give reason to think that he had already been working for Federigo as a sculptor.

Both the Venice and Perugia reliefs evince a penetrating study of Donatello's late narrative style as it emerged in the bronze reliefs for the pulpits of San Lorenzo, Florence (unfinished at Donatello's death in 1466). The four roundels show Francesco paying equal attention to Donatello's bronze doors in the Old Sacristy of San Lorenzo (ca. 1440), whose paired saints exhibit extremes of tension arising from their subtly asymmetrical deployment against bare backgrounds. Francesco's appreciation of these calculated expressive measures is manifested most radically in the present roundel, where Saint Anthony is tilted and pulled well to the left of center.

<div align="right">JDD</div>

FURTHER REFERENCES: Carli 1949, p. 36; Bregenz 1967, no. 44a.

132

Antonio Lombardo
Venetian, ca. 1458–1516

RELIEF WITH INSCRIPTION AND EAGLES
Ferrara, ca. 1508
Marble; height 14 in. (35.6 cm.); width 41½ in. (105.5 cm.)
Liechtenstein inv. no. 146

Antonio Lombardo belonged to an important dynasty of Venetian sculptors. He was the son of Pietro Lombardo (ca. 1435–1515), a pioneer of Renaissance style, and the brother of Tullio Lombardo (ca. 1455–1532), whose characteristic manner dominated sculpture of the Venetian High Renaissance. In 1505 Antonio was still in Venice but was already executing orders for the Este at Ferrara, where he moved the following year, bringing with him the profoundly neoclassical ideals which he shared with Tullio.

This relief was bought at Modena in the ninteenth century by one Signor Marcato and sold in 1887 to the Liechtenstein collection by the Florentine dealer Stefano Bardini. In the words of Venturi (1935, vol. 10, p. 400), the frieze is "among the most perfect expressions of Antonio Lombardo's distinguished manner, delicate and precise in the gradations of relief, most

pure in modeling, guided by a medallic sense of measure." The crisply delineated eagles are borrowed from the imagery of Jupiter. Here they signify the reign of Alfonso d'Este, third Duke of Ferrara, whose name appears, abbreviated, in the inscription on the tablet: ET QVIESCENTI/AGENDVM EST/ET AGENTI QVI E/SCENDVM ALᶠ.D. III (He who is indolent should work, and he who works should take rest. Alf[onso] third Duke). This is a quotation from Seneca's *Moral Epistles* to Lucilius (1965 ed., vol. 1, p. 5; citation provided by E. R. Knauer).

The frieze belongs to a large series of reliefs executed by Antonio Lombardo and assistants for the *camerino d'alabastro* and an adjacent *studio di marmo*, rooms erected over the Via Coperta in Ferrara to connect the Este Palace with the Castle. At least thirty-two reliefs survive from these rooms which, though chief among the glories of High Renaissance art, were later disassembled and their contents dispersed. Thus Ferrara lost masterpieces of painting, Giovanni Bellini's *Feast of the Gods* (National Gallery, Washington, D.C.) and three works by Titian, including his *Bacchus and Ariadne* (National Gallery, London). Around 1609 the marble carvings were removed to the Belvedere of the Estense palace of Sassuolo, later owned by the Finzi, who sold the reliefs to the Comte d'Espagnac, who in turn took them to France. The Liechtenstein relief had apparently already been separated from the group. In 1875 thirty-seven of the reliefs, comprising nineteen friezes and eighteen upright reliefs, were sold at auction by the heirs of P. Couvreur (Hôtel Drouot, Paris, May 26–28, 1875, no. 1) and bought by the dealer-collector Frédéric Spitzer. Spitzer gave one frieze to the Louvre and exhibited eighteen others at the Trocadéro in 1878. Twenty-eight pieces figured in Spitzer's sale (33 rue de Villejust, Paris, April 17–June 16, 1893, vol. 1, no. 1270), after which they went to Russia, belonging successively to Count Polotzoff in Moscow, the Stieglitz Museum in St. Petersburg, and finally to the Hermitage. In addition, two minor upright panels with figures, not part of the Spitzer group, are in the Bargello in Florence.

The Hermitage reliefs include two large mythological scenes, *The Forge of Vulcan* and *The Contest Between Minerva and Neptune*. Goodgal, author of the best-documented survey of the Ferrara decorations (1978), assumes that the two scenes were in the *camerino d'alabastro*, a richly paved room that also contained the paintings of Bellini and Titian. The ornamental reliefs with classical inscriptions, according to Goodgal, were more suitable for the *studio di marmo*. Two of the Hermitage reliefs are inscribed in Latin: "In 1508 Alfonso, third Duke of Ferrara, established this for his leisure and tranquility." Another inscribed relief in the Hermitage has a partial quotation from Cicero's *De officiis* (3.1) to the effect that a leader is never less idle than when idle, never less alone than when alone: "A magnificent saying in truth and worthy of a great man, showing that even in his leisure his thoughts were occupied with public business" (see Goodgal 1978, p. 165). The sentiments on the Liechtenstein relief are a perfect echo of the need for thoughtfulness alternating with action and would have been entirely appropriate for the

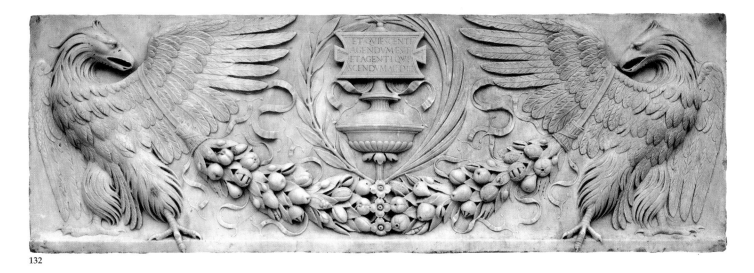

132

study of a man such as Alfonso, a warrior with humanist leanings.

The *studio di marmo* was built between 1508 and 1511. Antonio Lombardo had been sent to Venice in 1507 to engage several stonecarvers. During the same period he was at work on the Palace chapel. The date of 1508 on one of the Hermitage friezes suggests that Antonio's forces were marshaled and the work carried out with due speed and considerable help. Documents of 1508–1515 show that stone and other materials for the *studio*, the chapel, and the *camerino d'alabastro* were carried to and from Antonio's house. While the controlling designs must be his, it cannot be said that Antonio's own hand is visible in all the purely ornamental carvings. The chaste classical design of the Liechtenstein frieze, so aptly praised by Venturi, certainly originated with Antonio. The eagles resemble that in the right corner of *The Forge of Vulcan* in Leningrad. But the carving is a bit drier than in the purely figural reliefs, and it would be fairest to consider a specialist in ornamental carving among Antonio's helpers as the sculptor who was responsible.

JDD

FURTHER REFERENCES: Paoletti di Osvaldo 1893, vol. 1, p. 211, fig. 125; Nicola 1917, p. 174; Pope-Hennessy 1964, vol. 1, p. 356; Pope-Hennessy 1971, p. 343.

133

Antico (Pier Jacopo Alari-Bonacolsi)
Mantuan, ca. 1460–1528

BUST OF A YOUTH (possibly HERCULES or SCIPIO AFRICANUS)

Mantua, ca. 1520
Bronze with dark-brown lacquer patina, silvered eyes, and oil-gilt lionskin and fillet; height 22¼ in. (56.5 cm.)
Liechtenstein inv. no. 535

It is not known when this bust entered the Liechtenstein collection. Hermann J. Hermann, the scholar most responsible for reintegrating Antico's oeuvre, first published it, naming it the artist's single most beautiful work (1910, p. 279). This claim is fully supported by the sheer poetry of the youth's idealized countenance, his head tilted and gaze lowered, and by the perfection of the fastidiously delineated details, enriched with gilding and silvering. Particularly to be admired is the truant curl edging over the gilt fillet above the left brow.

The subject has traditionally been identified as Antinoüs, the Bithynian favorite of the Emperor Hadrian, who had Antinoüs deified after his early death and raised quantities of statues in his memory. However, the bust does not have the broad facial planes or the ample coiffure that characterize portraits of Antinoüs. Further, there are no clear signs that the features of Antinoüs were well known in artistic circles at this stage; the earliest mention of Antinoüs by a Renaissance artist may be that by Benvenuto Cellini in his autobiography.

There are other possibilities. In the first place, this work is likely to be identical with a bust in the 1627 inventory of Ferdinando Gonzaga, where it was known as Hercules. The entry names together "three heads of bronze with busts, to wit, a Hercules with a lionskin, a lady with two crowns and another with a wreath of grapes" (Hermann 1910, p. 219). This could be a matter of the recorder's interpretation rather than of Antico's intention, for in his numerous other representations of Hercules, statuettes as well as reliefs, the artist gave a squarer shape to the head. The features in this bust derive from a cumulative perception of the noblest antiquities available, such as the *Apollo Belvedere*, which Antico copied in three statuettes.

An unbearded Hercules is rare but not without precedent. The ancient travel-writer Pausanias (*Description of Greece* 7.24.4) described a bronze Hercules by Ageladas at Aigion as representing a beardless youth. It is quite possible that Antico's imagination was fired by ancient literary descriptions, especially of Hercules at the Crossroads, as the subject became known, in

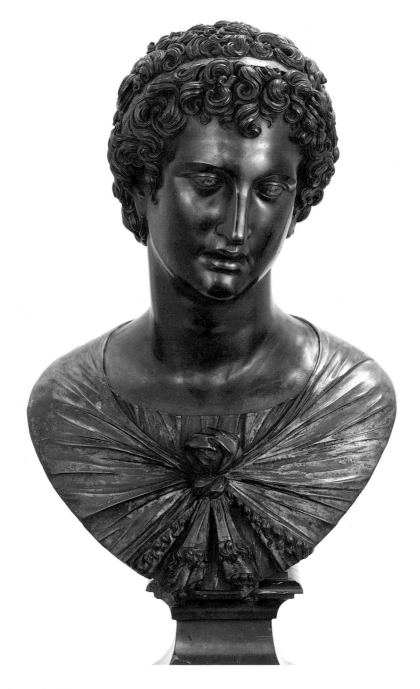

133

which Hercules chooses the path of virtue over vice, a subject whose morality and mystery endeared it to the courts of Italy. The conflicts between virtue and vice were a substrain in the decorations by Mantegna, Perugino, and other painters in the *studiolo* of Isabella d'Este, Antico's chief patron at Mantua. A lost painting of 1507 by Lorenzo Costa in Palazzo San Sebastiano, Mantua, showed Marchese Francesco Gonzaga "led by Hercules along the path of virtue" (Vasari-Milanesi 1906, vol. 3,

p. 134). In any case, our youth, with the athlete's fillet in his hair and the skin tied across his chest, could sensibly reflect Cicero's recounting of "the experience of Hercules, as we find it in the words of Prodicus in Xenophon: 'When Hercules was just coming into youth's estate (the time which Nature has appointed unto every man for choosing the path of life on which he would enter), he went out into a desert place. And he saw two paths, the path of Pleasure and the path of Virtue, and he sat

down and debated long and earnestly which one it were better for him to take'" (*De officiis* 1.32.118; 1913 ed., p. 121). Antico's bust contains the requisite sense of isolated introspection.

The chamois-like skin is reversed and ends in tufts of hair rather than paws, so it is not necessarily a lionskin. An imagist might freely adapt Hercules's gear and attitude to other heroes, such as Alexander the Great. In a classical source consulted more often in the Renaissance than now, the *Punica* of Silius Italicus, the author adapts the story of Hercules at the Crossroads to celebrate the valor of the young Scipio Africanus, whose "anxious thoughts" over the choice between virtue and vice he describes vividly (15.10–34; 1934 ed., vol. 2, pp. 325–27). Silius Italicus also specifies a "beardless" Scipio. The Choice of Scipio, visualized as a dream, is the actual subject of Raphael's famed *Vision of a Knight* (National Gallery, London), as pointed out by Panofsky (1930). Roman art does not record the features of Scipio in his youth, and an artist would have had license to invent them, as did Raphael, who supplied "antique" armor and helmet. It may be worth noting in this connection that the first bust which Antico is documented as making was one of *Scipio* for Bishop Ludovico Gonzaga in 1499, as is known by a letter from the Bishop, who undertook to provide the casting materials.

In the present bust the corkscrew curls are even more tightly wound than in other works by Antico, who made this treatment of hair a trademark. He might originally have found inspiration for such curls in Hellenistic coinage, but the usage came to him easily through his training as a goldsmith and finally as a matter of predilection. The slightly parted lips were a device of Hellenistic portrait sculpture, but the "bean-shaped" double drill holes in the pupils, which contribute equally to the sense of a "speaking likeness," made their appearance in Roman busts of the second and third centuries. Through helping to restore ancient sculptures in the Gonzaga collections and elsewhere, Antico observed at close range a variety of ancient practices, here merging them in an intensely lyrical embodiment of late adolescence.

There have been successful attempts at proposing dates for Antico's statuettes, which he made from at least 1496. For example, Legner (1967, pp. 103–118) showed that the roughest of the *Apollo Belvedere* statuettes, in the Liebieghaus, Frankfurt, is the earliest of the three. The few busts for which Antico was responsible have escaped the same close scrutiny.

In 1499, as noted, he was at work on a *Scipio* for Bishop Ludovico Gonzaga; his activity for the Bishop was intermittent, lasting from 1498 to the Bishop's death in 1511. A letter from Antico to Isabella d'Este in 1519 states that he had found "a way of having them [bronze busts] made which will make them even more beautiful than those busts which were made for the Bishop" (Stone 1982, p. 96). The letter implies at least two main phases in Antico's production of busts and a possibility of replication, while assistance in their making is implicit in the letter. His documented collaborators in casting were, in 1499, Gian Marco Cavalli, who died around 1508, and, in 1519, one Maestro Iohan, mentioned in the same letter to Isabella d'Este.

Only six or seven surviving busts can be said to be autograph on the basis of comparison with Antico's statuettes. They are probably datable in the following order.

Marcus Aurelius (Bayerisches Nationalmuseum, Munich) is a relatively rigid frontal portrait but with a sideward glance that will become typical of Antico's busts. The cuirass is decorated similarly to the bronze *Gonzaga Vase* in the Galleria Estense, Modena, made soon after the marriage of Giovanfrancesco Gonzaga and Antonia del Balzo in 1479.

The *Marcus Aurelius* was probably followed by the *Bacchus* and the *Ariadne* (both Kunsthistorisches Museum, Vienna). The *Bacchus* is rather simplistically volumetric, in the way of *Marcus Aurelius*, and may date slightly earlier than the companion *Ariadne*, which offers a subtler and more withdrawn personality. (*Ariadne* could be the other bust of a lady "with a wreath of grapes" in the 1627 inventory mentioned above.)

Antoninus Pius (Metropolitan Museum, 65.202) exhibits greater fluency in the handling of curly hair. A copy, possibly made under Antico's supervision, is in the Louvre.

The Liechtenstein youth, extremely assured in handling and more profound in psychology than the above-mentioned busts, presumably dates later (if it does represent Scipio, it may, however, improve upon an earlier model).

Cleopatra (Museum of Fine Arts, Boston), with a tiara in two registers that led to her description in the 1627 inventory as "a lady with two crowns," shares with the Liechtenstein youth a compelling, introspective air and has the most sophisticated complexity of drapery patterns in this group. Sheard (1979, nos. 68–69) dates *Cleopatra* earlier than *Bacchus* and *Ariadne*, sensing that it has properties in common with Venetian art of the earliest sixteenth century. It is difficult, however, to see the Liechtenstein and Boston busts as anything other than progressions toward fuller spiritual characterization in which points of technique have been gradually refined. Other busts associated with Antico do not approach these two in finesse of detail or psychological involvement. The *Menander* (Walters Art Gallery, Baltimore), technically like Antico's busts in many respects, has a hard finish and feathered curls somewhat resembling those of a bust of an unknown Roman in the Metropolitan Museum (68.141.22). Heads of four Caesars discovered by Allison (1976, pp. 213, 218) in the Seminario in Mantua offer yet another direction in Mantuan portraiture, the hair being worked in broad waves except for the Seminario's *Antoninus Pius*, where the curls lack Antico's tight control.

Two small holes in the back of the present bust offered a means of attachment, possibly to a niche of circular form. An architectural situation would have been animated by the finely modulated radiations in the folds of the skin. The *Ariadne* has a deeply downward glance, and the draperies of the Vienna busts curve, round upon round, suggesting that the forms of the busts were calculated to appear to best advantage at some height,

their draperies perhaps echoing circular settings. A high position for at least some of Antico's busts is indicated by the wording in the 1542 inventory of the second *grotta* of Isabella d'Este. On one level above the cornice molding were placed bronze statuettes, several identifiably by Antico. Yet higher, seventeen sculptures were ranged, described as "figures and half-length figures and ancient and modern heads of bronze" (Hermann 1910, p. 216).

JDD

FURTHER REFERENCES: Lucerne 1948, no. 238 (as bust of a girl); Bregenz 1967, no. 6.

134

Ludovico Lombardo
North Italian (b. Venice), ca. 1509–1575

BUST OF A ROMAN
Rome or Recanati, mid-16th century
Bronze with dark-brown lacquer patina; height including base 33¼ in. (84.5 cm.)
Inscribed (on back in stamped capitals, mirror-fashion): LVDOVICVS·DE· / LONBARDIS·/·F·
Liechtenstein inv. no. 538

134

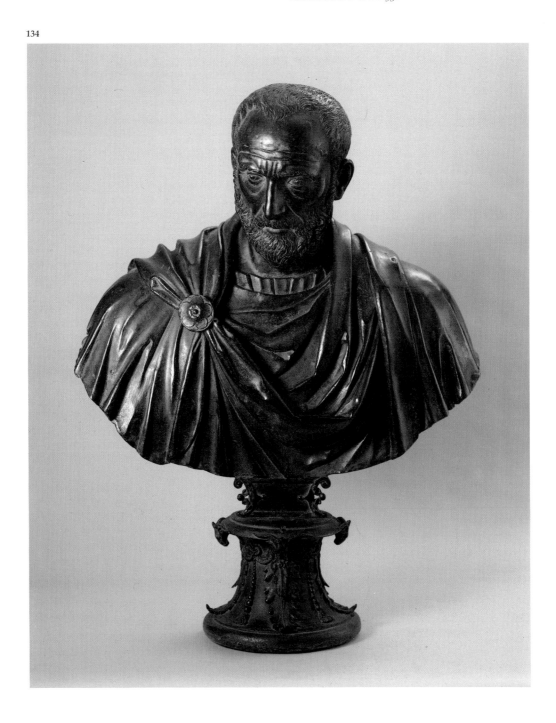

212

Fig. 34 Detail from cat. no. 134

Ludovico Lombardo, the youngest son of Antonio (cat. no. 132), was active chiefly as a bronze founder. He created a bronze faldstool for Paul III in Rome in 1546; the decoration of this bust's base suggests that if the faldstool was ornamented, it must have been a splendid piece. Around 1550 Ludovico joined his older brothers Aurelio and Girolamo at Recanati in the Marches, where their foundry was responsible for large-scale sculptural projects at the Santa Casa di Loreto and elsewhere. Ludovico seems to have been the most peripatetic and business-minded of the brothers. Among lesser tasks, in 1551 he was an intermediary for Lorenzo Lotto in selling some antiquities belonging to the painter. In Rome in 1559 he made "a base for a young Caesar" (Pauri 1915, p. 21 n. 3). It would not have related to the present composition, whose subject is far from youthful. This stay in Rome probably had to do with the brothers' commission for a bronze tabernacle in the Duomo, Milan, ordered by Pius IV. Afterward, Ludovico worked in Recanati and as an artillery founder in the pontifical city of Ancona.

The Liechtenstein bust, bought from the Florentine dealer Stefano Bardini in 1894, is the only signed example of the composition, which exists in two other versions, one in the Louvre (RF 787) and another that once belonged to Count Pourtalès in Berlin. A marble replica is said by Bergmann (1981, p. 189) to be in Villa Albani, Rome. In each of the bronze busts, Ludovico changed the delicate ornamentation of the bases, which all resemble inverted capitals. The pendent goats' heads of the Liechtenstein example were replaced by more fanciful beasts' heads in the ex-Pourtalès base, which lacks the Liechtenstein base's vertical beading. The Louvre base has a more chaste decoration of leafy fluting. There is no immediate explanation for the mirror-written signature on the back of the Liechtenstein bust, unless it was meant for display against a mirror or was simply enigmatic in keeping with the Mannerist ornament.

Bergmann (1981, p. 189) corrected an earlier impression (Haarløv 1975, pp. 13–14) that the features are those of the Emperor Pupienus, demonstrating instead that they are those of another third-century Roman, as yet unidentified, in a mar-

ble head now in the Ny Carlsberg Glyptothek, Copenhagen. Ludovico, no doubt believing that the marble represented an important ancient statesman or philosopher, took the liberty of amplifying this portrait, giving it a massive mantle. The play of the brooding features, chin drawn in, against the broad spread of drapery, recalls somewhat Daniele da Volterra's bust of Michelangelo—the best example of which (and the one with the most opulent base) is in the Bargello, Florence.

JDD

FURTHER REFERENCES: Bode 1899, pp. 96–97; Planiscig 1921, pp. 323–24; Vitry 1922, vol. 1, no. 683; Lucerne 1948, no. 236; Bregenz 1967, no. 74.

135

Pierre Courteys
French, act. 1544–81, d. before 1591

THE JUDGMENT OF PARIS
French (Limoges), mid-16th century
Enamel, partly gilded, on copper; 17 × 21¼ in. (43 × 54 cm.)
Signed (in gold, beneath feet of Paris): CORTEYS ·
Liechtenstein inv. no. 220

The Judgment of Paris belongs to a group of seven enameled plaques of extraordinary size illustrating the Legend of Troy. This one shows Paris, son of the Trojan King Priam, awarding the golden apple for being the fairest of three competing goddesses to Aphrodite in return for her promise of the beautiful Helen, wife of the Greek King of Sparta, Menelaus. The goddess, attended by Eros and flanked by Athena in the act of disrobing and Hera attended by the god Hermes, stands before Paris, who is seated under a tree in a pastoral landscape peopled by nymphs and a river-god.

The enameled plaque is an almost exact copy of an etching that Bartsch attributed to an anonymous School of Fontainebleau printmaker (Bartsch, vol. 16, pt. 2 [1876], p. 404, no. 72, or *The Illustrated Bartsch*, vol. 33 [1979], p. 347), but Herbet recognized it as part of a Trojan War cycle by Jean Mignon after designs by Luca Penni (Herbet 1900, pt. 4, p. 336, no. 21). Penni (1500–1556) was born in Florence; about 1530 he emigrated to France, where he was employed as a painter for the decoration of the Château de Fontainebleau. Little is known about Mignon other than that the Comptes des Bâtiments records payments to him between 1537 and 1540 as a painter at Fontainebleau. Of his work as an etcher, two signed prints are known, and the six etchings of the Legend of Troy have been firmly attributed to him on the basis of their stylistic similarities to the signed works (Zerner 1969, pp. 26–30).

Mignon's print copies a signed drawing by Penni in the Cabinet des Dessins, Louvre (inv. no. 1396), except that the etching is

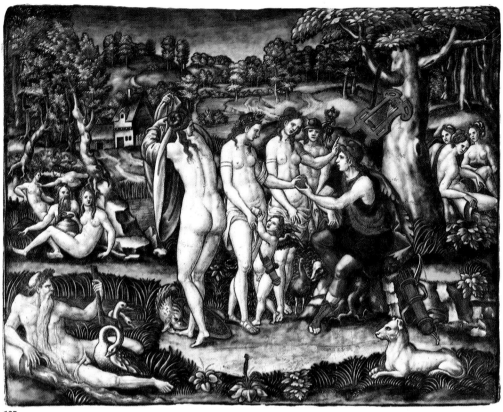

135

reversed, omits a winged genius who holds a wreath above the head of Aphrodite, and substitutes a pastoral background for the sky-gods of the drawing. The date of the drawing is not known, although it has been suggested that it was part of a stock brought to Paris from Italy by the young artist about 1530 (Golson 1957, p. 26). Penni's drawing was undoubtedly adapted from the well-known engraving by Marcantonio Raimondi (Bartsch, vol. 14, pt. 1 [1867], p. 197, no. 245), in turn based on a lost drawing by Raphael. (For a concise summary of the relation of the Marcantonio print to surviving Raphael designs, see Shoemaker 1981, pp. 146–47, no. 43.) That the Mignon etching rather than the Marcantonio engraving was the source for Courteys's enamel is evident from the inclusion in the enamel of details found in the Mignon but not in the Penni drawing or the Marcantonio print.

Marcantonio's engraving also served as the source for several surviving Limoges enamels, notably by Léonard Limosin and Jean II Pénicaud, but it was Mignon's version that was used by another of the great Limoges enamel painters, Pierre Reymond (1513–d. after 1584). Reymond used Mignon's design on the back of a casket formerly in the Charles Mannheim collection in Paris (Molinier 1898, p. 49, no. 179, fig. 179) and, in abbreviated form, on a tazza in the Walters Art Gallery, Baltimore (Verdier 1967, pp. 267–68, no. 148).

Few biographical details about Courteys are recorded, but it

has often been suggested that he may have been trained in Reymond's workshop. There is little agreement, however, about whether he was, in fact, the "Pierre Courteys, le petit" mentioned in a Limoges document of 1529. His first known work is a cup in the Herzog Anton Ulrich-Museum, Brunswick, which is signed and dated 1544. In the following year he is said to have been commissioned by the French King Francis I (1497–1547) to make a series of colossal enameled reliefs for the Château de Madrid in the Bois de Boulogne in Paris, but these were not completed until 1559. Nine of them, depicting the gods Jupiter, Saturn, Mars, Mercury, and Apollo, the demigod Hercules, and the personifications of Roman Charity, Justice, and Prudence, each measuring nearly five and a half feet (about one and a half meters) in height but made in four separate pieces (still, like the Liechtenstein Trojan War cycle, in this intractable medium, a technical tour de force), entered the collection of the Musée de Cluny, Paris, after their presumed removal from the Château de Madrid during the French Revolution. Courteys also painted the sixteen enameled plaques after engravings by Albrecht Dürer incorporated in an altarpiece that was in the chapel at the Château d'Écouen and is now in the Louvre. His last known work is a cross-shaped assemblage of five enameled plaques in the Walters Art Gallery, dated by Verdier about 1581 (1967, pp. 282–85, nos. 154–58).

None of the seven plaques belonging to the Liechtenstein

Trojan War cycle is dated, and it is not known who commissioned them. Jacob von Falke (1882, vol. 3, p. 168) states that they were purchased by Prince Joseph Wenzel (1696–1772), the imperial ambassador to France between 1737 and 1741, while he was living in Paris. Paper labels attached to the backs of five of the seven, evidently in the eighteenth century, identify them in French as belonging to "Prince Joseph Wenceslau de Lichtenstein."

The enamels were not displayed in the Liechtenstein gallery in the eighteenth century, but a watercolor of 1852 by the Austrian artist Rudolf von Alt (1812–1905), in the Princely Collections at Vaduz, shows several of them embedded in the window reveals of a room in Seebenstein Castle in the vicinity of Vienna. A contemporaneous description of the Liechtenstein-owned castle notes the presence of all seven in the room referred to as the anteroom of the *Schatzkammer*.

The back of this plaque is covered with transparent counter-enamel.

CV

FURTHER REFERENCES: Leber 1856, vol. 1, p. 174; Falke 1882, vol. 3, p. 168; Cat. 1931, p. XVI; Lucerne 1948, p. 68, no. 281; Wilhelm 1976, p. 121.

136

Pierre Courteys
French, act. 1544–81, d. before 1591

THE ABDUCTION OF HELEN
French (Limoges), mid-16th century
Enamel, partly gilded, on copper; 17 × 21¼ in. (43 × 54 cm.)
Signed (in gold, lower right): ·P·CORTEYS·
Liechtenstein inv. no. 221

There are several versions of the Abduction of Helen, but according to Dares the Phrygian, whose *Fall of Troy, A History* was far better known to medieval Europe than the Homeric version of the war between the Greeks and Trojans, Paris sailed to the Greek island of Cythera as commander of the royal Trojan fleet. On Cythera he met Helen, who had come from Sparta to worship in the temple of Diana and Apollo at the seaport of Helaea. That evening the Trojans seized Helen in the temple and, after a heated battle with the Cytherans, carried off both Helen and the temple treasures. The mountainous seacoast in this enamel probably represents Cythera; therefore, the battle is presumably between the Cytherans and Trojans. The unhappy woman in the foreground is, without doubt, Helen, who is being dragged to a small boat waiting to carry her to the Trojan ships anchored along the coast.

136

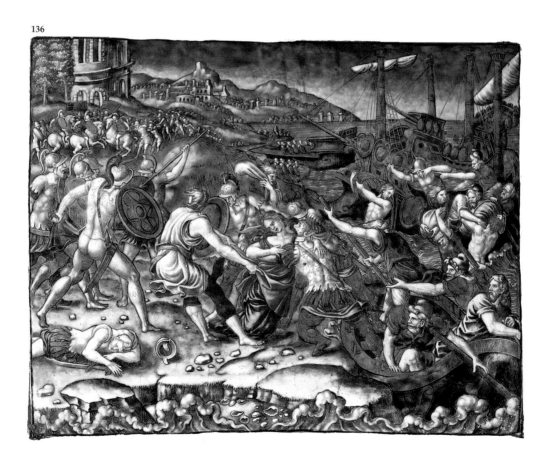

Like *The Judgment of Paris*, *The Abduction of Helen* is based on a School of Fontainebleau etching by Jean Mignon (Herbet 1900, pt. 4, p. 335, no. 12; Bartsch, vol. 16, pt. 2 [1876], p. 393, no. 42, or *The Illustrated Bartsch*, vol. 33 [1979], p. 318) after a drawing by Luca Penni. The subject also appears in a better-known engraving by Marcantonio Raimondi (Bartsch, vol. 14, pt. 1 [1867], p. 170, no. 209, or *The Illustrated Bartsch*, vol. 26 [1978], p. 208), but in this case a great many more changes have been made in the composition. The Penni–Mignon Abduction of Helen focuses more directly on Helen and the group of Trojans who are abducting her, and a rather romantic-looking ruin has been substituted for the porticoed temple of Diana and Apollo in the Marcantonio version. Marcantonio's engraving has long been believed to be based on a lost Raphael drawing, but there exists a pen-and-ink design of the same composition made for a circular plate which has been attributed to Giulio Romano (Northampton, Mass., 1941, no. 49).

Courteys's enamel is an almost exact copy of the Mignon print; although a few details have been changed, largely to accommodate the difference in shape between the two. It is painted in shades of blue, green, brown, and gray enamel, with the figures in white but modeled in flesh tones and boldly outlined in dark brown. The bright color and extensive use of gilding to highlight details of the armor, ships, clothing, and especially the hair of Helen create a richly decorative effect akin to that of painted miniatures.

Courteys also probably used the Penni–Mignon etching as a model for the large circular plaque that is in the Révoil collection in the Louvre, Paris (Laborde 1852, vol. 1, p. 246, no. 376, where it is described as by Pierre Courteys after Primaticcio).

The back of the Liechtenstein plaque, covered with transparent counterenamel, bears the label: 217 No. Tablau Appertinent au Prince Joseph Wenceslau de Lichtenstein.

CV

FURTHER REFERENCES: Leber 1856, vol. 1, p. 174; Falke 1882, vol. 3, p. 168; Cat. 1931, p. XVI; Wilhelm 1976, p. 121.

137

Pierre Courteys
French, act. 1544–81, d. before 1591

A WOMAN RESTRAINING A WARRIOR FROM KILLING A YOUNG MAN
French (Limoges), mid-16th century
Enamel, partly gilded, on copper; 17 × 21¼ in. (43 × 54 cm.)
Signed (in gold, lower left, on rock): ·P·/CORTE/YS·
Liechtenstein inv. no. 223

The scene, laid in a pastoral setting with a ruin in the background, shows an armed soldier, presumably a Greek warrior, being restrained by a kneeling woman from killing a kneeling man with his sword. Several of the onlookers, who are in varying states of agitation, wear the Phrygian caps associated throughout this cycle with Trojans. Two of them hold what appears to be a cradle. The scene has never been identified with a specific event in any of the Greek or Latin versions of the Trojan War. That it belongs to Jean Mignon's Trojan War cycle, however, seems unquestionable (Bartsch, vol. 16, pt. 2 [1876], p. 394, no. 46, or *The Illustrated Bartsch*, vol. 33 [1979], p. 322; Herbet 1900, pt. 4, p. 335, no. 15; Zerner 1969, p. 27, fig. J.M. 43). Like the rest of Mignon's Trojan War etchings, it is copied in reverse from a drawing by Luca Penni, which is in the Cabinet des Dessins, Louvre (inv. no. 1397).

The back of the Liechtenstein plaque, covered with transparent counterenamel, bears the label: No. 163 Tablau Appertinent au Prince Wenceslau de Lichtenstein.

CV

FURTHER REFERENCES: Leber 1856, vol. 1, p. 174; Falke 1882, vol. 3, p. 168; Cat. 1931, p. XVI; Wilhelm 1976, p. 121.

138

Pierre Courteys
French, act. 1544–81, d. before 1591

BATTLE SCENE
French (Limoges), mid-16th century
Enamel, partly gilded, on copper; 17 × 21¼ in. (43 × 54 cm.)
Signed (in gold, bottom left, on rock): ·P·/CORTE/YS·
Liechtenstein inv. no. 222

The scene is a cavalry battle beneath the walls of Troy. At the lower left appear the extremities of a warrior being dragged by the feet from the tail of the charger in the center foreground. This seems to be an allusion to the death of Hector as described in book XXII of Homer's *Iliad*, where the Trojan hero is killed in single combat by the Greek Achilles, who then fastens Hector's body to his chariot and drags him by the heels three times around the walls of Troy while the Trojans inside the city watch in horror.

The engraving from which this enamel was copied was long known to have been based on a drawing attributed to Luca Penni; Herbet, author of the earliest specialized catalogue of School of Fontainebleau prints, however, accepted H. A. G. Destailleur's attribution of the engraving to Master L. D. (Herbet 1900, pt. 1, p. 85, no. 75), and it was only recently recognized by Zerner

137

138

as being part of Jean Mignon's Trojan War cycle (1969, p. 27, fig. J.M. 42).

Although by no means exact copies, certain figures in the Penni–Mignon composition, notably the warrior on a charger from whose tail the feet of Hector are suspended and the dead horse in the right foreground, are similar to those of another engraving by Marcantonio Raimondi, which Bartsch called the Battle with a Cutlass (Bartsch, vol. 14, pt. 1 [1867], p. 171, no. 211, or *The Illustrated Bartsch*, vol. 26 [1978], p. 210). The print, now known as the Triumph of Scipio, is probably based loosely on a drawing by either Giulio Romano (1499–1546) or Luca Penni's brother, Giovanni Francesco Penni (1496–1528), for a series of tapestries illustrating the battles and triumphs of the Roman general Scipio Africanus (237–183 B.C.) woven in Brussels between 1532 and 1535 for the French King Francis I (Jestaz and Bacou 1978, pp. 5–24, 94–97). Bacou thinks that a drawing destroyed in 1871 and known only from a photograph may have been the original of this subject (pp. 21–22, 95), but she also discusses and illustrates two drawings of the same subject (pp. 96–97), both in the Cabinet des Dessins, Louvre (inv. nos. 3717–18), the first of which has been attributed at various times to Giulio Romano, Giovanni Francesco Penni, or simply to the School of Raphael. Bacou also mentions the existence of still another drawing of the subject in the Albertina, Vienna (inv. no. 14198). The two drawings in the Louvre contain similar figures of a warrior on a charger, as well as the dead horse in the right foreground of the print.

The Penni–Mignon Battle Scene may have been based in part on the Marcantonio Triumph of Scipio, or the finished tapestry of the Battle of Zama in the collection of Francis I, the King by whom both Penni and Mignon were employed, or on one of the drawings. The central figure of the warrior on horseback in the Penni–Mignon version is, however, far closer than all the other versions to Raphael, and specifically to a figure in the right foreground of *The Repulse of Attila*, one of the frescoes in the Stanza d'Eliodoro in the Vatican, Rome, indicating that Luca Penni probably drew, at least in part, upon direct observation and not entirely upon intermediate sources.

A second version of the Triumph of Scipio engraving by either Marco Dente (d. 1527) or Agostino Veneziano (1490–1540) also exists (Bartsch, vol. 14, pt. 1 [1867], p. 172, no. 212, or *The Illustrated Bartsch*, vol. 26 [1978], p. 211). It is almost identical to the Marcantonio version, but reversed. This second version probably served as the model for several Limoges enamelists of the second half of the sixteenth century. A plaque attributed to Pierre Pénicaud (act. 1555–90) in the Louvre employs the Marcantonio horseman in reverse (Marques de Vasselot 1914, p. 90, no. 505, pl. XLII). Another plaque based on the same image by Master K. I. P. (act. mid-16th century) is in the Walters Art Gallery, Baltimore (Verdier 1967, pp. 143–44, no. 72). The trappings of the horse in this plaque are inscribed "Hector," a circumstance that implies a deliberate borrowing of the Scipio Africanus iconography for the imagery of the Trojan War.

The back of the Liechtenstein plaque, covered with transparent counterenamel, bears the label: 215 [Tablau Appertinent au Prin]ce Joseph [Wenceslau L]ichtenstein.

CV

FURTHER REFERENCES: Leber 1856, vol. 1, p. 174; Falke 1882, vol. 3, p. 168; Cat. 1931, p. XVI; Wilhelm 1976, p. 121.

139

Pierre Courteys
French, act. 1544–81, d. before 1591

THE TROJAN HORSE
French (Limoges), mid-16th century
Enamel, partly gilded, on copper; 17 × 21¼ in. (43 × 54 cm.)
Signed (in gold, lower center): · P · CORTEYS ·
Liechtenstein inv. no. 224

Book V of the *Journal of the Trojan War* by Dictys of Crete, another of the ancient chroniclers of the Trojan War, relates that the Trojans received the wooden horse from the Greeks, believing it to be a sacred peace offering to the goddess Athena. The Trojans came out to welcome it but soon saw that the horse was too big to pass through the city gates. Throwing caution to the winds, they began to tear down the city walls, accomplishing what years of siege by the Greeks had failed to achieve.

Courteys's *The Trojan Horse* is, like the first three enamels, a close copy of a Jean Mignon etching (Bartsch, vol. 16, pt. 2 [1876], p. 394, no. 45, or *The Illustrated Bartsch*, vol. 33 [1979], p. 321; Zerner 1969, pp. 26–28, fig. J.M. 44). Mignon's print, like the other five in his Trojan War cycle, is taken from a drawing by Luca Penni, which is in the Louvre (inv. no. 1399). Penni's drawing is illustrated by Dimier (1904, pl. opp. p. 116).

The back of the Liechtenstein plaque is covered with translucent counterenamel.

CV

FURTHER REFERENCES: Leber 1856, vol. 1, p. 174; Falke 1882, vol. 3, p. 168; Cat. 1931, p. XVI; Wilhelm 1976, p. 121.

140

Pierre Courteys
French, act. 1544–81, d. before 1591

THE BATTLE IN PRIAM'S PALACE
French (Limoges), mid-16th century
Enamel, partly gilded, on copper; 17 × 21¼ in. (43 × 54 cm.)
Signed (in gold, lower right): · P · CORTEYS
Liechtenstein inv. no. 225

139

140

The Latin poet Vergil tells the story of the Trojan Horse somewhat differently from Dictys of Crete (see cat. no. 139). The second book of the *Aeneid* relates that once the horse was inside Troy the Greeks stole out of its hollow interior, signaled their army outside the walls, and flung open the gates of the city. Vergil continues with the description of the scene in this enamel, the storming of the royal palace, where King Priam, wearing his crown and armor, his queen, Hecuba, and their daughters took refuge at the foot of the altar to their household gods. But Priam was soon killed by Pyrrhus, Helen retaken, and Troy utterly destroyed.

Again, this enamel is an almost exact copy of Jean Mignon's etching of the Luca Penni drawing (Bartsch, vol. 16, pt. 2 [1876], p. 393, no. 44, or *The Illustrated Bartsch*, vol. 33 [1979], p. 320; Zerner 1969, pp. 26–27, fig. J.M. 45). Courteys also used a variant of this scene, but including the Trojan Aeneas carrying his father, Anchises, on his shoulders, in a circular plaque now in the Louvre (Darcel 1891, p. 279, no. 522).

The back of the Liechtenstein plaque, covered with translucent counterenamel, bears the label: Nʳ: 164 Tablau Appertinent au Prince Joseph Wenceslau de Lichtenstein.

CV

FURTHER REFERENCES: Leber 1856, vol. 1, p. 174; Falke 1882, vol. 3, p. 168; Cat. 1931, p. XVI; Wilhelm 1976, p. 121.

141

Pierre Courteys
French, act. 1544–81, d. before 1591

AENEAS RESCUING ANCHISES FROM THE BURNING TROY

French (Limoges), mid-16th century
Enamel, partly gilded, on copper; 17 × 21¼ in. (43 × 54 cm.)
Signed (in gold, lower left): · P · CORTEYS ·
Liechtenstein inv. no. 226

At the end of the second book of the *Aeneid*, the Trojan nobleman Aeneas describes his departure from the burning city carrying his aged father, Anchises, on his back. The description fits the central group in this enamel, a nude male carrying an older, bearded, and equally unclothed man, set against the background of a walled city in flames from which numerous others are also fleeing with whatever possessions they can carry. If the two men are indeed Aeneas and Anchises, then the child hugging a small dog to his chest is presumably Aeneas's son Ascanius, who also survived the sack of the city.

Preceding the central group is an equally prominent pair, a nude male carrying an old woman on his back. These figures

have no prototypes in the *Aeneid*. The old woman cannot be Aeneas's mother, the goddess Aphrodite, who was never an old crone and hardly in need of rescue. Neither can she be his wife Creüsa, who perished in the confusion of the sack predicting her husband's eventual destiny as the founder of Rome.

This discrepancy can be accounted for, however, by the fact that the enamel does not belong to the Penni–Mignon Trojan War cycle but has been borrowed instead from a fresco in the Galerie François I at Fontainebleau by Giovanni Battista di Jacopo di Gaspare, called Rosso or Il Rosso Fiorentino (1495–1540). According to Béguin and Pressouyre (1972, pp. 134–35), there is a tradition as old as the first quarter of the seventeenth century that the fresco represents the Burning of Troy. This identification was apparently given up at the suggestion of the eighteenth-century French engraver and collector Pierre-Jean Mariette in favor of another subject, the Destruction of Catania, depicting two brothers, Amphinomous and Aenapias, rescuing their parents from the burning city. Until recently most of the literature has identified Il Rosso's fresco as the Destruction of Catania, but this title also has been questioned and the fresco renamed Filial Piety. Whatever its meaning in Il Rosso's cycle of frescoes at Fontainebleau, the subject of the Liechtenstein enamel was clearly chosen to complete a Trojan War cycle, and *Aeneas Rescuing Anchises from the Burning Troy* seems the most appropriate title for the enamel, despite the anomalies in its iconography.

Barocchi (1950, pp. 141–43, fig. 130) related the central figures of Il Rosso's fresco to the inevitable prototype by Raphael, this one belonging to a group in the left foreground of *The Fire in the Borgo*, a fresco in the Stanza dell'Incendio in the Vatican, Rome. Barocchi went on to note the existence of two prints of Il Rosso's fresco. The first print (Bartsch, vol. 16, pt. 2 [1876], p. 413, no. 93, or *The Illustrated Bartsch*, vol. 33 [1979], p. 368) was included by Herbet in his catalogue of the work of Antonio Fantuzzi (ca. 1508–ca. 1550), who was employed as a painter under Primaticcio for work at Fontainebleau but, like Mignon, also became one of the best printmakers of the School of Fontainebleau (Herbet 1900, pt. 2, p. 279, no. 33). Herbet's attribution has been rejected, however, by Zerner (1969) in his study of School of Fontainebleau printmakers. The second print, signed by the French engraver René Boyvin (ca. 1525–ca. 1580/98), is catalogued by Robert-Dumesnil (vol. 8 [1850], p. 25, no. 17). Both are illustrated by Béguin and Pressouyre (1972, p. 137, figs. 198–99) along with several drawings, at least one of which is believed to be a copy of a lost Il Rosso original.

Although neither print has been precisely dated, it was probably the first print that Courteys copied. He made minor adjustments, as he did in the other enamels, but the small boy with the dog in the Liechtenstein plaque may have been quite deliberately moved from the head of the procession of refugees in Il Rosso's version to the feet of the Aeneas–Anchises group in order to suggest that he is the young Ascanius. At least one other Limoges enamelist, Pierre Reymond, employed this image

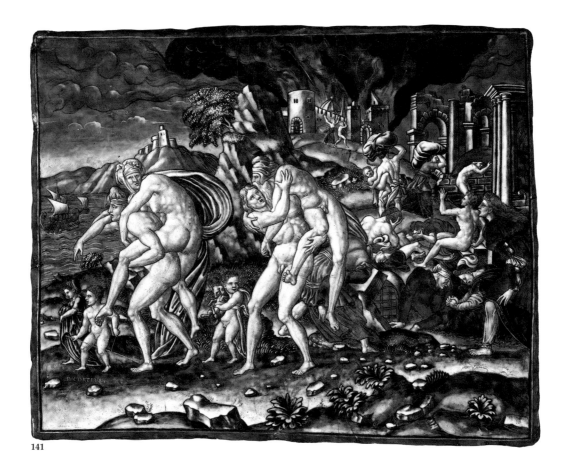

141

as part of a Trojan War cycle. It occurs on the enameled casket mentioned in cat. no. 135 in the former Charles Mannheim collection (Molinier 1898, p. 49, no. 179, fig. 179). According to Béguin and Pressouyre, there is a third Limoges enamel version of the subject in the Musée Municipal, Limoges (1972, p. 134).

The back of the Liechtenstein plaque, covered with transparent counterenamel, bears the label: N^r: 216 Tablau Appertinent au Prince Joseph Wenceslau de Lichtenstein.

CV

FURTHER REFERENCES: Leber 1856, vol. 1, p. 174; Falke 1882, vol. 3, p. 168; Cat. 1931, p. XVI; Lucerne 1948, p. 68, no. 282; Wilhelm 1976, p. 121.

142

Sebastiano Ricci
Venetian, 1659–1734

THE RAPE OF THE SABINES
Oil on canvas; 78 × 119¾ in. (198 × 304 cm.)
Liechtenstein inv. no. 245

The story of the rape of the Sabine women is told by Livy (1.9) and by Plutarch (*Romulus* 14). The present picture follows Plutarch's account. Romulus's newly founded city of Rome had been settled by foreigners, all men, who had no success in finding wives. In despair at this situation, Romulus conceived a ploy whereby word was spread that an altar of a god had been discovered. A celebration to which all the inhabitants of the surrounding countryside were invited was organized, "and many were the people who came together, while [Romulus] himself sat in front, among his chief men, clad in purple. The signal that the time had come for the onslaught was to be his rising and folding his cloak and then throwing it round him again. Armed with swords, then, many of his followers kept their eyes intently upon him, and when the signal was given, drew their swords, rushed in with shouts, and ravished away the daughters of the Sabines."

Ricci has kept closely to the text. The city, still unfinished, is dominated by a circular temple at the center and the ground floor of a palace under construction. To the right of the temple portico is Romulus—standing, with his cloak spread around him, giving the signal—accompanied by his soldiers. The rape takes place in the foreground. Ricci painted the subject on at least three occasions. One picture, described minutely by Pascoli in 1736 (vol. 2, pp. 383–84), is lost, while another, earlier treatment of the theme is in the Palazzo Barbaro-Curtis, Venice. The Palazzo Barbaro picture has been dated about 1700–1701 (see Daniels 1976a, p. 138) and differs considerably from the present picture in its darker tonality, its more densely packed composition, and its obvious dependence on the work of Pietro da Cortona and Luca Giordano. Giordano's *Rape of the Sabines*, formerly at Dresden (see Ferrari and Scavizzi 1966, fig. 590), offers, perhaps, the closest parallel for the compact grouping of figures close to the picture plane and the pronounced lateral movement of the composition from left to right.

In the Liechtenstein picture both the action and the setting are more carefully articulated, and the palette is considerably lighter than in the Palazzo Barbaro picture. The composition has been compared to that of Pietro da Cortona's famous canvas in the Pinacoteca Capitolina, Rome. The relationship be-

tween the two is not, however, very close, though the group on the left—a Roman soldier viewed from the back carrying off a Sabine woman—probably derives from the somewhat similar group in Pietro da Cortona's composition. Ricci would have known Pietro da Cortona's picture from his stay in Rome between 1691 and 1694. The central group may depend from Bernini's *Abduction of Proserpina* in the Galleria Borghese, though if this is so, Ricci has treated his source with remarkable freedom. It is worth pointing out that the central temple, with chapels and a pedimented facade attached to the circular core in a totally nonarchitectural way, seems to derive from no actual building but, instead, is an interpretation of Roman architecture *alla veneziana* (the high drum and steeply inclined dome).

The attribution of the picture to Ricci has been doubted by Derschau (1922, p. 163, no. 21a, fig. 151), and it has been suggested by Natale (1978, pp. 144f., no. 105, ill.) that the background figures were executed by an assistant. Neither contention has any basis. This is one of Ricci's most brilliant and beautifully painted large canvases. Daniels (1976a, p. 138, no. 1, p. 152, no. 527a, fig. 362) has plausibly dated it to about 1702–1703, when Ricci was working for the King of the Romans in Vienna, and suggests that it and its pendant (cat. no. 143) may have been among the "varie cose" Ricci is said by Pascoli (1736, vol. 2, p. 380) to have painted for him. Given the nature of the subjects and the fact that the two pictures were

Fig. 35 Detail from cat. no. 142

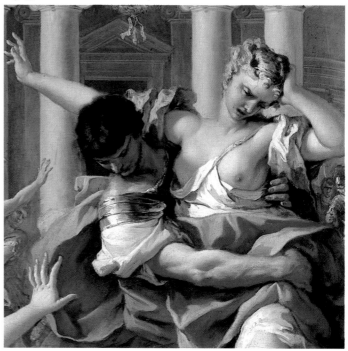

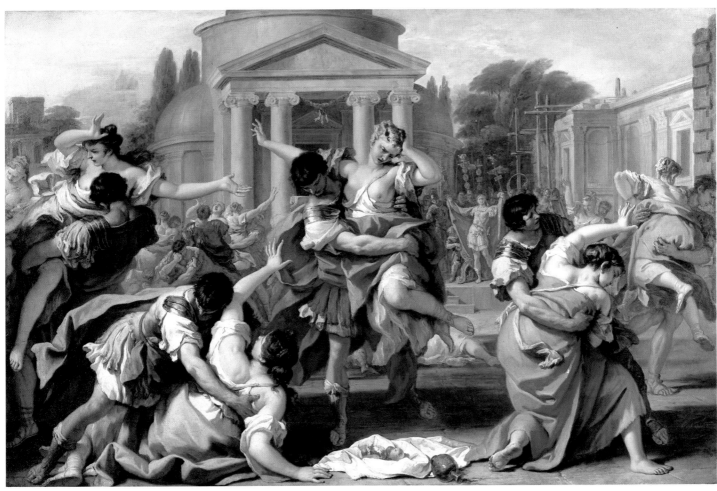

142

purchased in Vienna in 1819 from the dealer Querci, this also seems plausible but not demonstrable. When they were painted, these two pictures would have been among the most advanced compositions of their sort, establishing the foundation for Tiepolo's later achievement. The figures in the background are a tour de force of impressionistic handling, and the overturned picnic of one of the Sabine women in the foreground has rightly been singled out by Baumstark (1980, no. 23); it is one of Ricci's most beautiful still-life details.

KC

FURTHER REFERENCES: Cat. 1873, no. 420; Cat. 1885, p. 35, no. 245; Daniels 1976b, p. 98, no. 126, fig. 126; Baumstark 1980, no. 23.

143

Sebastiano Ricci
Venetian, 1659–1734

BATTLE OF ROMANS AND SABINES
Oil on canvas; 78 × 119¾ in. (198 × 304 cm.)
Liechtenstein inv. no. 243

The event represented is the celebrated intervention of the Sabine women—resigned, after three years of captivity, to their fate as wives of the Romans who had carried them off—between the Roman and Sabine armies. According to Plutarch (*Romulus* 19), at the height of battle "the ravished daughters of the Sabines were seen rushing from every direction, with shouts and lamentations, through the armed men and the dead bodies, as if in a frenzy of possession, up to their husbands and their fathers, some carrying young children in their arms, some veiled in their disheveled hair, and all calling with the most endearing names now upon the Sabines and now upon the Romans." At the left a Roman charges into battle; to the right a Sabine soldier is confronted by one of the Sabine women carrying her

223

Roman child. In the background a Sabine woman, probably Hersilia, makes her plea before the Sabine general Tatius and the Roman leader Romulus, whereupon a truce is concluded.

Although the event is intimately linked to the Rape of the Sabines, it was represented far less frequently. This is indeed the only picture of the subject by Ricci. The composition is less focused and less centralized than that of the pendant *Rape of the Sabines* (cat. no. 142), but there is a compensating dynamism in the movement of the figures parallel to the picture plane which is played off against the receding walls of Rome. The group of the woman and her child at left is brilliantly conceived, and the Sabine who has rushed in to stop her compatriot with one hand while she holds her frightened baby with the other fully justifies Pascoli's praise of the artist for his "inventiveness, facility in execution, his harmonious compositions, and his strength of color" (1736, vol. 2, p. 379).

KC

FURTHER REFERENCES: Cat. 1873, no. 422; Cat. 1885, p. 35, no. 243; Derschau 1922, p. 163, no. 21b, fig. 152; Daniels 1976a, p. 138 n. 1, p. 152 n. 527b, fig. 363; Daniels 1976b, p. 98 n. 127, fig. 127; Natale 1978, pp. 144–45, no. 107, ill.; Baumstark 1980, pp. 61–62.

144

Pompeo Girolamo Batoni
Roman, 1708–1787

HERCULES AT THE CROSSROADS
Oil on canvas; 39 × 29⅛ in. (99 × 74 cm.)
Monogrammed and dated (on tambourine, lower right): P·B·1748·
Liechtenstein inv. no. 161

The allegorical story of the choice of Hercules was invented by the Greek Sophist Prodicus of Ceos and is recounted by Xenophon in the *Memorabilia* (2.1.21–33) as an incitement to Virtue. Xenophon writes that the young Hercules "went out into a quiet place, and sat pondering which road to take"—the path of virtue or the path of vice—when "there appeared two women of great stature making towards him. The one was fair to see and of high bearing . . . her limbs . . . adorned with purity, her eyes with modesty. . . . The other was plump and soft, with high feeding . . . and dressed so as to disclose all her charms." Each tried to induce Hercules to follow her path; the first promised an arduous but virtuous life crowned by true happiness,

143

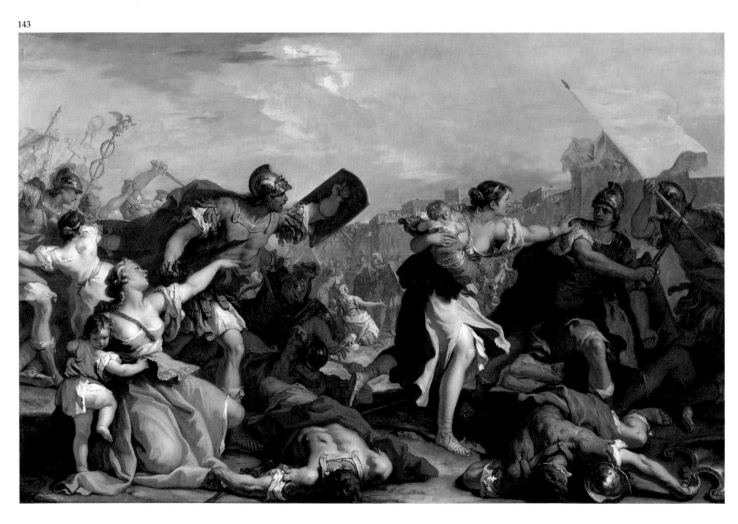

while the second held out the prospect of an easy life filled with pleasure and vice.

Batoni shows Hercules seated on a rock, his head resting on his right hand while he gazes dreamily at Virtue, who is dressed in military garb and holds a shield and spear. At his side sits the voluptuous figure of Vice, her hair falling loosely on her bare shoulders. She leans toward Hercules, enticing him with a blossom, the traditional symbol of transient pleasures, while in her left hand she holds a mask. The latter attribute has been identified by Panofsky (1930, p. 125) as symbolizing fraud (see also Ripa 1613). At her feet lie coins, dice, a tambourine, an oboe, and an open musical score, symbolizing infamy (Panofsky 1930, p. 125) or reprehensible amusements (see Martin 1965, p. 25, where Ripa's description of Scandal is cited). The two infants at Virtue's feet amuse themselves with Hercules's lionskin and club. In the distance a temple stands atop a rugged slope which Virtue urges Hercules to scale.

The subject of Hercules at the Crossroads enjoyed enormous popularity in the seventeenth and eighteenth centuries. Batoni himself treated it no less than four times. The earliest version, now in the Uffizi, Florence, was painted in 1742 for the Marchese Gerini. There are, additionally, the painting in the Galleria Sabauda, Turin, which adapts the Liechtenstein composition to a horizontal format, and the canvas in the Hermitage, Leningrad, dated 1765, which is also dependent to some extent on the present picture. Of the four known paintings, that in the Uffizi is the most closely related to Annibale Carracci's canonical treatment of the subject—his canvas of about 1595 for the ceiling of a study in the Farnese Palace in Rome (the picture is in the Museo Nazionale di Capodimonte, Naples). From Annibale's picture Batoni took over the general pose and position of Hercules, whose features were based on classical statues of the hero. He also followed Annibale in flanking Hercules with the two female personifications; but while Annibale shows Virtue and Vice standing, Batoni shows Vice seated on the ground, and he clothed Virtue in the guise of Minerva (see Panofsky 1930, p. 105). These differences are further refined and the composition given greater coherence in the Liechtenstein picture, which can bid to be Batoni's most beautiful rendition of the subject.

In 1787 Boni, Batoni's first biographer, contrasted Batoni with his great contemporary Anton Raphael Mengs, noting that while philosophy had made the latter a painter, nature had made Batoni one. He went on to remark that "Batoni had a natural taste that directed him, unconsciously, to the beautiful, while Mengs achieved beauty only with study and reflection. . . . Batoni was perhaps more a painter than a philosopher . . . less profound, but more natural." The figure of Vice in the Liechtenstein picture seems to bear out this judgment, for seldom has the personification of an abstract idea been so seductively conceived. There is a red chalk drawing, squared, for the two infants and for the right arm and sleeve of Vice in the Stiftung Ratjen, Vaduz (Dreyer 1978, p. 242, ill.), and another

for the figures of Virtue and Vice is in the Yale University Art Gallery (see Haverkamp-Begemann and Logan 1970, pp. 165–66, fig. 24).

KC

FURTHER REFERENCES: Cat. 1873, no. 612; Cat. 1885, p. 25, no. 161; Frimmel 1913, vol. 1, p. 159; Voss 1924, pp. 648–49, ill. p. 415; Panofsky 1930, pp. 131, 133, fig. 82; Cat. 1931, p. 60, no. 161; Emmerling 1932, pp. 53, 125, no. 152; Clark 1959, p. 235; Belli Barsali 1965, p. 200; Bregenz 1968, p. 90, no. 116, fig. 54; Gabrielli 1971, p. 68; Baumstark 1980, p. 64; Bowron 1980, p. 46; Clark 1985, pp. 243, 386, 389, no. 123, pl. 120.

145

Pompeo Girolamo Batoni
Roman, 1708–1787

VENUS PRESENTING AENEAS WITH ARMOR FORGED BY VULCAN
Oil on canvas; 39 × 29⅛ in. (99 × 74 cm.)
Monogrammed and dated (lower right): P·B·1748·
Liechtenstein inv. no. 163

The subject of the picture, first correctly identified by Voss (1924, pp. 648–49, ill. p. 415), is taken from the eighth book of the *Aeneid*. Aeneas is shown just prior to his battle with Turnus, the King of the Rutuli, as his mother Venus gives him arms forged by Vulcan. According to Vergil, Venus, "bearing her gifts through the clouds of heaven . . . laid the armor glittering under an oak" near the river of Caere, which Batoni symbolizes in the river-god in the left foreground. Behind the river-god is the she-wolf who suckled Romulus and Remus. Vergil does not mention the wolf, and Batoni has obviously included her as an allusion to Aeneas's role in the founding of Rome. Bowron (1980, p. 38) has demonstrated that the composition derives from an etching of the same subject by Pietro Testa (in reverse). Testa includes four putti, two holding the shield and the other two holding the helmet and sword. In Batoni's picture one putto holds the shield while the other lifts the helmet.

The artist has been at pains to recreate the shield described at length by Vergil—the shield that told "the story of Italy and the triumphs of Rome," showing "every generation that had sprung from the stock of Ascanius, and the wars they had fought one by one." In the bottom compartment Batoni depicts "the she-wolf couched after the birth [of Romulus and Remus] in the green cave of Mars; round her teats the twin boys hung playing, and fearlessly mouthed their foster mother." (Batoni shows the wolf on the banks of the Tiber, in obvious reference to the river-god and the wolf depicted in the foreground of the picture; the she-wolf is based on the ancient bronze statue in the Museo Capitolino, Rome, while the river-god is based on the colossal

225

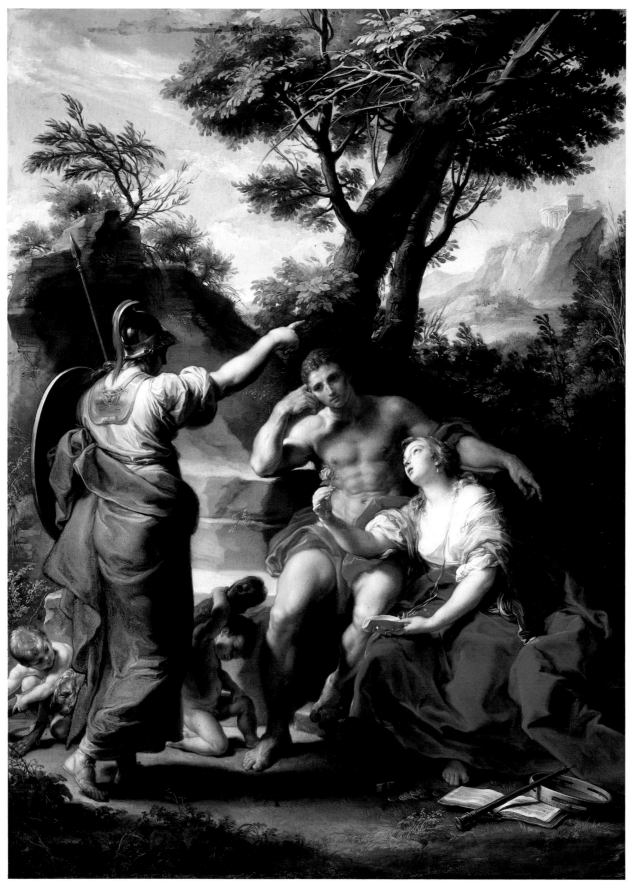

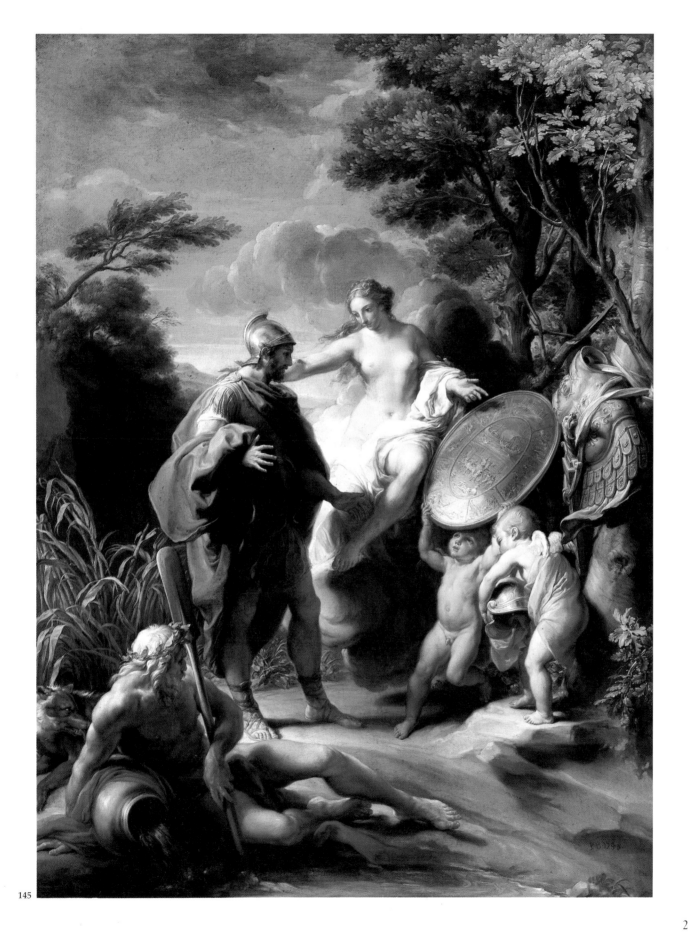

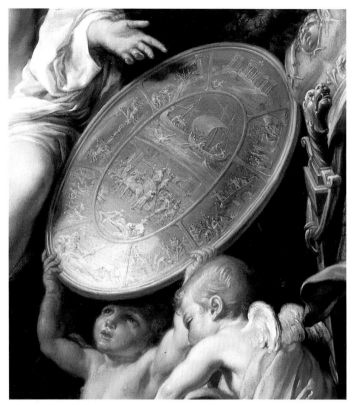

Fig. 36 Detail from cat. no. 145

statue of the Tiber on the Capitoline.) In the compartment to the right of this is shown the Rape of the Sabines. Departing from Vergil's description, Batoni omits the ensuing battle between the Romans and Sabines. The next episode shows how "these same kings laid down their mutual strife and stood armed before Jove's altar with cup in hand, and joined treaty over a slain sow"; Batoni presents this scene in the compartment to the left of that with the she-wolf and river-god. In the adjacent space he shows Mettus Curtius torn apart by two horse-drawn chariots for his treachery to the Romans. In the rectangular compartment opposite, Horatius Cocles defends the Sublician bridge against the army of Lars Porsena while his companions tear the bridge down, barring passage to Porsena's army. In the upper left compartment Marcus Manlius defends the Capitoline against the Gauls, at whose coming "the silver goose, fluttering in the gilded colonnades, cried." The identification of the remaining two scenes around the periphery is more problematic. In the trapezoidal compartment in the upper right are apparently depicted the sacred rites of the Lupercalia, although with the sacrifice of a bull rather than a goat or dog (the composition derives, in part, from an ancient relief in the Uffizi, Florence), and in the top compartment is shown either the Capitoline or the Gates of Dis with Catiline "hanging on a frowning cliff" (the temple is based on a Roman fresco). Vergil's description of the scenes decorating the center field of the shield makes little allowance for pictorial limitations, and Batoni has necessarily both selected and condensed from his source. Omit-

ting some of the battle scenes, he shows Anthony and Cleopatra in their barge battling Octavian and, below, Octavian's subsequent triumphal entry into Rome (the composition of the latter is based on *The Triumph of David* in the *logge* of Raphael in the Vatican). There is a drawing for the shield, viewed straight on, in the Philadelphia Museum of Art, which differs somewhat in the sequence of the scenes as well as in details (see Bowron 1980, p. 38, who identifies the subject of three of the scenes differently).

In his youth Batoni drew incessantly after ancient statues and reliefs, and shortly after his arrival in Rome in 1727 he was employed as a copyist by the British collector Richard Topham. It is, therefore, not surprising that the scenes on the shield have an authentically classical appearance. However, their archaeological character only emphasizes the inherently unclassical quality of the picture as a whole, with Venus's voluptuous, curving body supported by swirling clouds at its center. Still, as Clark (1959, p. 235) points out, the composition is more restrained than in the pair of pictures in the collection of Brinsley Ford, London, of *Achilles Comforted by Thetis* and *Aeneas Abandoning Dido*, painted the preceding year. Of particular beauty is the open landscape, with its dispersed light, as noted by Emmerling (1932, pp. 53, 124, no. 144). Just how important this effect was to Batoni can be surmised from the fact that the *Aeneas* is painted on a warm, pale brown ground while the companion *Hercules* (cat. no. 144), with its more staid composition, is painted on a dark gray ground.

By 1748, when this picture and its companion were painted, Batoni's history paintings were much in demand throughout Europe, and it is probable that the Liechtenstein pair was commissioned directly from the artist by Prince Joseph Wenzel von Liechtenstein (1696–1772), who in 1748 succeeded his cousin, Johann Nepomuk Karl, as ruler of the House of Liechtenstein. They are known to have hung in his private palace on the Herrengasse in Vienna, where they are listed in an inventory of 1805. They were incorporated into the Liechtenstein gallery only two years later. Certainly the themes of the two pictures —one dealing with a great military hero and the other extolling the choice of virtue over pleasure—would have been deemed appropriate for the Prince.

Clark (1985, pp. 243, 388, no. 122, pl. 117) cites, in addition to the drawing for the shield, a study for the river-god in the Rijksprentenkabinet, Amsterdam.

KC

FURTHER REFERENCES: Cat. 1873, no. 614; Cat. 1885, p. 25, no. 163; Cat. 1931, p. 60, no., 163; Belli Barsali 1965, p. 200; Dreyer 1978, p. 68; Baumstark 1980, no. 26.

Hubert Robert

French, 1733–1808

ARCHITECTURAL COMPOSITION WITH THE PANTHEON

Oil on canvas; 40 ⅛ × 57 ½ in. (102 × 146 cm.)
Signed and dated 1761 (see text below)
Liechtenstein inv. no. 511

This painting, one of the prolific artist's most accomplished and a key early work in his oeuvre, was painted in 1761 for Étienne-François de Stainville, Duc de Choiseul (1719–75). Robert's father was the *valet de chambre* of the Duke's father, the Marquis de Stainville. No doubt it was by grace of the Marquis that the aspiring artist was able to attend the prestigious Collège de Navarre. He apprenticed with Michel-Ange Slodtz and in 1752 and 1753 exhibited in the Salons de la Jeunesse. Having become a protégé of the Marquis's son, then the Comte de

Stainville, the artist went with him to Rome in 1754 after the Count had been appointed French ambassador to that city. Stainville secured lodgings for Robert in the French Academy's Palazzo Mancini, despite the fact the artist was not a Prix de Rome recipient. At the Academy, Robert may have studied with Gian Paolo Pannini (1691–1765) who from 1732 was professor of perspective there. The Italian artist became the principal formative influence affecting the young artist's subsequent specialization—imaginary and topographical architectural landscapes. Robert also became acquainted with the younger Italian artist Giovanni Battista Piranesi (1720–78), who had probably studied under Pannini at the French Academy as well and who, after the elder artist, had the greatest impact on Robert's development.

In 1757 the Comte de Stainville left Rome and was made ambassador to Vienna, but he maintained a close interest in Robert's career. In 1758 he rose to the all-powerful position of Minister of Foreign Affairs and was elevated to the title Duc de Choiseul. In 1759, through Choiseul's influence with the Marquis de Marigny, the Surintendant des Bâtiments, Robert was made

146

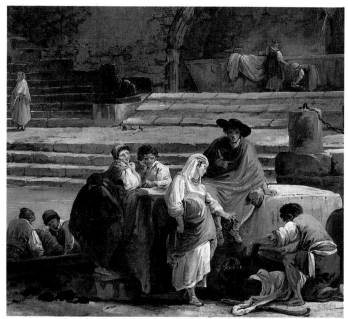

Fig. 37 Detail from cat. no. 146

a full pensionnaire of the French Academy in Rome. Earlier that year the artist had painted for Choiseul a picture which the Duke presented to Marigny, after having arranged for the Marquis to see it side by side with one of the same size that he had commissioned from Robert (see Montaiglon and Guiffrey 1901, vol. 11, pp. 281, 293, 298–301).

In 1765, after an eleven-year Roman sojourn, Robert returned to Paris in triumph. The following year he submitted to the Académie Royale de Peinture et de Sculpture a number of paintings to support his *agrément*, one of which was a nearly identical replica of the present painting dated 1766 (École Nationale Supérieure des Beaux-Arts, Paris). On the merit of this replica, the artist was simultaneously *agréé* and received as a member of the Academy—an exceptional honor that had been conferred before upon Pannini in 1732. It is not clear whether Robert realized that this painting would become his *morceau de réception*, but from what is recorded in the proceedings of the Academy, it may be surmised that he prepared for the event. The secretary wrote that "s'étant trouvé dans le nombre des ouvrages qu'il a présentés, un tableau d'architecture *dont il pouvoit disposer*, l'Académie, sans tirer à conséquence, l'a accepté pour sa réception" (as there was found among the number of works he presented an architectural composition *with which he could part*, the Academy saw fit on this occasion to accept it as his reception piece [author's translation; italics added]) (see Montaiglon 1886, vol. 7, p. 334). Robert exhibited the École des Beaux-Arts replica in the Salon of 1767, when it drew the particular praise of Denis Diderot (see Roland-Michel 1984, p. 343–46).

If Robert anticipated the action of the Academy, his decision to paint a replica of the picture belonging to the Duc de Choiseul is partially explained. Choiseul might well have lent his picture in support of the artist's *agrément*, as he lent its pendant (see

below) to the Salon in 1769, but he would not have wanted to part with it, and presentation to the Academy of the reception piece was required. No doubt the artist chose to repeat this composition because he found it so appropriate a summary of all he had learned during his years in Rome and so consummate a demonstration of his skill in effectively arranging in a complex perspective diverse architectural elements rendered in an atmospherically convincing light.

Employing prominent monuments ancient and modern, the composition suggests an ideal survey of Roman architecture. The convex wall of the esplanade flanked by sphere-mounted columns and projecting into a cascade of steps is modeled directly after the quay of the Ripetta, the upstream city port of Rome once in the Campo Marzio. The Ripetta, or "little bank," as opposed to the downstream port in Trastevere, the Ripa Grande, was renovated during the papacy of Clement XI in 1703–1704. Designed by Alessandro Specchi, it was dismantled in 1889–90 (see Marder 1980, pp. 28–56). Where at the Ripetta the church of San Girolamo dei Schiavone would be seen, Robert has substituted the Pantheon, though he has taken the initiative of restoring it by continuing as attached pilasters around the rotunda the columns of the portico, and by removing before the fact the bell towers added to the pediment by Bernini. With implied axial symmetry, the central structure is embraced from behind by a semicircular colonnade that derives from Bernini's portico at Saint Peter's, and a modified version of Michelangelo's Palazzo dei Conservatori at the Campidoglio is included at the left. In the then-popular manner of the painter Joseph Vernet (1714–89), the artist has introduced staffage comprising longshoremen, merchants with their cargo, and vendors in the foreground, and sundry representatives of the Roman populace beyond, including washerwomen and a cleric.

A red chalk drawing by Robert of around 1758–59 (Uffizi, Florence, inv. no. 117625), which records his *primo pensiero* for the Liechtenstein painting, provides most interesting insight into the artist's working method. The drawing presents a somewhat awkward combination of but two architectural sites. The foreground depicts an only slightly modified view of the Ripetta, preserving its undulating steps, its long straight wharf, and its customhouse at the left. Robert's raked-angle view of the quay may have been influenced by Piranesi's 1753 engraved view of the site, with which the French artist must have been familiar, though Robert's vantage is from the south, not the north. Above this in the background is represented the seventeenth-century church of Santa Maria dell'Assunzione in Ariccia, Bernini's adaptation of the Pantheon. As in Ariccia, it is closely flanked by semicircular structures, visible at both the left and the right, though the artist has here already thought to cast them in a form like that of Saint Peter's colonnade rather than as palaces.

Two later drawings preliminary to the Liechtenstein painting record the subsequent development of Robert's idea. The earlier, in red and black chalk (Musée des Beaux-Arts, Rouen,

inv. no. 964.4.1), is signed and dated ROBERTI/1760. The second, in pen and watercolor (private collection, New York), is signed ROBERTI/D. ROMAE and presumably was made after a counter-proof of the first that was once in the University Library, Warsaw, but was destroyed during World War II. In both, the church of Ariccia has been replaced by an archaeologically accurate rendering of the Pantheon and the lateral palaces at Ariccia have taken the form of ruined colonnades modeled after the Pantheon's portico. The undulating steps of the quay at the Ripetta have been made straight, and a basin-like port has been introduced in the foreground.

In the final solution, represented by the present painting, the artist has elevated the vantage point and opened up the space around the Pantheon, the result of which is that the structure at the right drops out of view and the central building is shifted to that side. For the lateral structure that remains, the artist has returned to his first thought, which incorporated the appearance of Saint Peter's colonnade, and has introduced the Palazzo dei Conservatori where in the Uffizi drawing is situated the building inspired by the Ripetta customhouse.

In the convex wall where at the Porto di Ripetta a plaque was installed with an inscription in Latin that began with the name of the patron for whom the quay was built, Clement XI, and that ended with the year of its completion, 1704, Robert has represented a plaque inscribed in Latin:

D CHOISEUL

H. ROBERTI . . .

. . . ACADEMIAE . . .

QUADR 1761

The meaning of this only partially legible text is far from clear. The artist's signature and the identification of his patron, D[ux] Choiseul, are apparent, but the rest is open to interpretation. The final date is presumably that of the composition's execution, the year it was put into its final shape (QUADR[ATUS EST?]). Roland-Michel (1984, p. 348) asks whether the phrase "of [or to] the academy" might not indicate that the inscription was added after Robert's induction in 1766 into the Royal Academy in Paris, since the replica of this picture was his reception piece. She suggests that the painting may not have been made immediately for Choiseul but possibly was acquired by him later. These proposals run counter to probability. It is suggested here that the reference is to the French Academy in Rome, of which the artist was in 1759 made a full pensionnaire, a position secured through the influence of Choiseul.

Robert may have presented the Liechtenstein picture to the Duc de Choiseul as a token of gratitude, apparently together with a painting that depicts a harbor with classicizing architecture (Musée des Beaux-Arts, Dunkerque). The Dunkerque picture is not dated, probably because its pendant is, but it has exactly the same dimensions as the present painting and in the Choiseul sale of 1772 (Paris 1772, no. 141), the pictures sold as a pair. Evidently they were bought by or for Vicomte Jean-Baptiste-Adolphe du Barry, son of Vicomte Jean-Baptiste du

Barry, called Le Roué, who in 1768 arranged the marriage of his brother to the mistress of Louis XV. They are catalogued again as a pair in the 1774 sale of Adolphe's collection (Paris 1774, no. 102).

One might ask why these two pictures were conceived as pendants: in what way do they relate to one another? Each has as its subject an imaginary harbor scene alluding possibly to the position to which Choiseul had recently been named when they were painted—Ministère de la Marine. Yet their spatial arrangements differ widely. Architecture encloses a central void in the Dunkerque picture, whereas it radiates about an imposing central structure in the present painting. It can be argued that the creative approach by which the artist arrived at the composition for one differs from that for the other. In the Dunkerque painting Robert applies a broad architectural vocabulary to invent a visionary architectonic space; in the Liechtenstein painting he combines a number of known monuments to create an evocative architectural landscape. Roland-Michel (1976, p. 314) has demonstrated that the Dunkerque composition depends directly from designs by Piranesi. Correspondingly, the Liechtenstein picture clearly displays the compositional working method of Pannini—it is as Pannini-esque as the former is Piranesian. It is suggested here that together the pendants comprise Robert's homage to his principal masters in Rome.

The Duc de Choiseul was an important patron of Pannini as well. In 1756 he commissioned pendant paintings from the Italian artist: *Ancient Rome* (National Gallery of Scotland, Edinburgh) and *Modern Rome* (Museum of Fine Arts, Boston). Slightly variant replicas of these paintings at the Metropolitan Museum of Art, which are signed by Pannini and dated 1757, have been identified by Arisi (1961, pp. 215–16) as the ones which appeared in the posthumous sale of Hubert Robert's own collection, and Arisi proposes that the young Robert himself had a hand in their execution. Their subjects together are very similar in conception to the subject of the Liechtenstein painting, the replica of which was exhibited at the Salon of 1767 under the title *Le Port de Rome, orné de différens Monumens d'Architecture antique & moderne*.

From 1793 to 1809 the present picture was reportedly in the (Nicolas?) Reber collection in Basel. Subsequently it was acquired by Grand Duke Ludwig I von Hessen, whose collection devolved to the Hessisches Landesmuseum, Darmstadt. It was deaccessioned by the museum in 1951, when it was acquired by Prince Franz Josef II von Liechtenstein.

GCB

FURTHER REFERENCES: Basan 1771, no. 108 (etching by B. A. Dunker); Blanc 1857, p. 199; Frimmel 1908b, pp. 180–82; Dacier 1910, p. 28; Pannier 1910, p. 94; Back 1914, no. 160; Sentenac 1929, p. 21; Sterling 1933, p. 35; Cat. 1965, no. 85; Rosenberg 1968, p. 73; Bregenz 1968, no. 402; Guilmard 1974, p. 146; Cailleux 1975, p. v of advertisement supplement; Roland-Michel 1976, p. 311; Carlson 1978, p. 68; Baumstark 1980, no. 158; Rosenberg and Bergot 1981, p. 83; Roland-Michel 1984 (this catalogue includes extensive bibliographies for the École des Beaux-Arts replica and for the Dunkerque pendant).

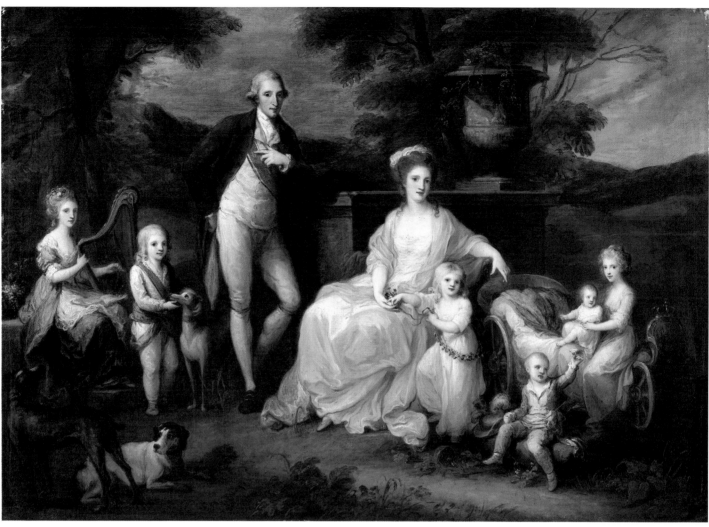

147

147

Angelica Kauffmann
Swiss, 1741–1807

FERDINAND IV, KING OF NAPLES, AND HIS FAMILY

Oil on canvas; 28 × 39 in. (71 × 99 cm.)
Signed (on stone step to left): A. K. pinx.
Liechtenstein inv. no. 2070

Kauffmann, "a Tyrolese with an Italian training and a gay and charming personality" (Waterhouse 1962, p. 185), painted this engaging group portrait in preparation for the very large version (122⅛ × 167¾ in.[310 × 426 cm.]) which is now in the Museo di Capodimonte, Naples. Both the *modello* and the final work were carried out in Rome in 1783.

Although women—being barred from life drawing classes —rarely aspired to become history painters, this was Kauff-

mann's goal when she first went to Rome in 1763. Between 1766 and 1781 she enjoyed a successful career in London, where she was a founding member of the Royal Academy and a friend of its president, Sir Joshua Reynolds. The few portraits that Kauffmann painted in England are not as impressive as her decorative figure compositions and, to a lesser extent, her mythological and historical subjects.

Thus, the portrait of Ferdinand's family marks an important moment in her career. History painters and decorators were not in short supply in Italy; this competition, and the expectations of patrons, would have made portraiture more important in the artist's oeuvre. Kauffmann refused Ferdinand's offer to be his court painter in Naples, where, in September and October 1782, she made a pen drawing (now in the Liechtenstein collection) of the present composition and oil sketches of individual figures (see Bregenz 1968, nos. 22–23, 85). The artist herself, in a letter dated December 22, 1782, states that "having finished all the likenesses at Naples, I shall finish the rest at Rome, the residence of the Arts" (Bregenz 1968, p. 55).

She soon inherited the position of Pompeo Batoni (1708–1787) as Rome's principal portraitist of traveling Englishmen. This specialty, her friendship with Goethe, and her graceful sociability made Kauffmann's studio one of the most favored stops on the Grand Tour.

While Naples was a cosmopolitan cultural capital, Ferdinand himself (1751–1825) was not a man of great taste, ability, or even maturity. He succeeded his father, Charles Bourbon, as King of Naples and Sicily when the latter was crowned Charles III of Spain in 1759. The boy's ambitious guardian and regent, Bernardo Tanucci, saw to it that the King grew up as accustomed to sports and the pursuit of pleasure as he was lacking in learning and manners. In 1768 Ferdinand married Maria Carolina (1752–1814), daughter of the Empress Maria Theresa. The Queen was clever, beautiful, and treacherous; she dismissed Tanucci and with her favorite, Sir John Acton, reduced the kingdom's government to a corrupt and often cruel system of political patronage and espionage.

Goya is the first artist of whom one might expect some intimation of the dark side of Bourbon rule (as in his portrait in the Prado of Ferdinand's older brother, Charles IV of Spain, and his family); Kauffmann is one of the last. She conceived the present picture as a family, not a state, portrait, and in its warm, harmonious, innocent mood, as well as in color and brushwork, it generally recalls Nicolas Lancret's conversation pieces and some later English examples. The scale and style of execution in the Liechtenstein *modello* are admirably suited to this approach. In the final version (Detroit 1981, fig. 10), by contrast, the scale is monumental and the handling dry. The figures appear vapid and prim; they betray—they almost confess—their illegitimate descent from Apollo and the Muses in the famous *Parnassus* (1761) by Anton Raphael Mengs in the Villa Albani, Rome (see Clark 1968, p. 7, and Detroit 1981 on patrons and painters, including Mengs, at Ferdinand's court).

The children, from left to right, are: Princess Maria Theresa (1772–1807), later Empress of Austria; Crown Prince Francesco (1777–1830), later King of the Two Sicilies; Princess Maria Christina (1779–1849), later Queen of Sardinia; Prince Gennaro (1780–89); the infant Princess Maria Amelia (1782–1860), later Duchess of Orleans and Queen of France; and Princess Maria Luisa (1773–1802), later Archduchess of Tuscany. In the carriage, beneath overpainted drapery which has become transparent, is an image of the infant that the Queen was expecting when Kauffmann began painting but that was stillborn.

The authors of the Bregenz catalogue suggest that the Liechtenstein picture may be identical with a canvas sold by the artist in January 1786 to the Russian Count Rossomersky (see also Manners and Williamson 1924, p. 154, and, on the document cited, Roworth 1984).

WL

FURTHER REFERENCES: Cat. 1931, no. 2070; Bregenz 1968, p. 54; Irwin 1968, p. 534; Baumstark 1979, pp. 62–65, no. 21; Baumstark 1980, no. 139.

GERMAN PAINTINGS

148–149

Bernhard Strigel
German, 1460–1528

PORTRAIT OF A MAN
Oil on wood; 16½ × 11½ in. (42 × 29 cm.)
Liechtenstein inv. no. 712

PORTRAIT OF A WOMAN
Oil on wood; 16½ × 11½ in. (42 × 29 cm.)
Liechtenstein inv. no. 714

These portraits of a man and his wife, traceable since 1805 in the Princely Collections, are among the finest painted by Bernhard Strigel. A member of the third generation of a family of artists in the Swabian town of Memmingen, Strigel is documented as artistically active there throughout his life, as well as holding various civic offices. Yet by the late 1490s his reputation as a painter of excellence must have extended well beyond his small hometown, since by 1499 at the latest he seems to have been in the occasional employ of Maximilian I, who was proclaimed Holy Roman Emperor in 1508. In 1515 the artist was summoned to Vienna to paint a dynastic group portrait of Maximilian and his heirs, his best-known work (Kunsthistorisches Museum, Vienna). The commission may be regarded as one of the most prestigious of its day. In 1520 the picture belonged to Maximilian's advisor, the renowned humanist Johannes Cuspinian, who, in that year, commissioned Strigel to paint as a pendant to it a group portrait of his own family (Wilczek collection, Seebarn Castle, Lower Austria).

The Liechtenstein portraits passed as the work of Holbein until the middle of the nineteenth century, when Waagen (1862, pp. 187–89) attributed them to Bartholomaeus Zeitblom, a painter with whom Strigel is known to have collaborated and whose style influenced his own. Eisenmann (1874, p. 156) was the first to group the portraits correctly with a body of work at that time given to the anonymous Master of the Hirscher Collection, so-called because a number of his paintings, now mostly in the Staatliche Museen Preussischer Kulturbesitz, Berlin-Dahlem, were then in that Freiburg private collection. Bode (1881, p. 61) discovered an old inscription on the reverse of the portrait of the Cuspinian family mentioned above that made possible the identification of Strigel as the artist responsible for these works.

Opinion about the date of the Liechtenstein portraits varies. Baum (in Thieme–Becker, vol. 32 [1938], p. 188) first proposed a date of about 1513, associating the portraits with one of Sibylla von Freyburg (Alte Pinakothek, Munich) that, on external evidence, is thought to be of that date. Strohmer (1943a, p. 102)

suggests 1510. Stange (1957, p. 149), who sees aspects of Strigel's late style in the portraits, puts them in the early 1520s, and his opinion seems to have been followed by Otto (1964, p. 106), who, judging by their placement in her catalogue, assigns them to a period between 1523 and 1526. From Strigel's dated portraits, it appears that his style in this genre developed from sharply delineated, markedly plastic forms to softer, flatly rendered ones. The modeling of the Liechtenstein faces indicates that the pictures are not so late as Stange believed. They are close to the portrait dated 1517 of Conrad Rehlinger (Alte Pinakothek, Munich) and probably date from about that time, not long after Strigel's trip to Vienna in 1515.

148

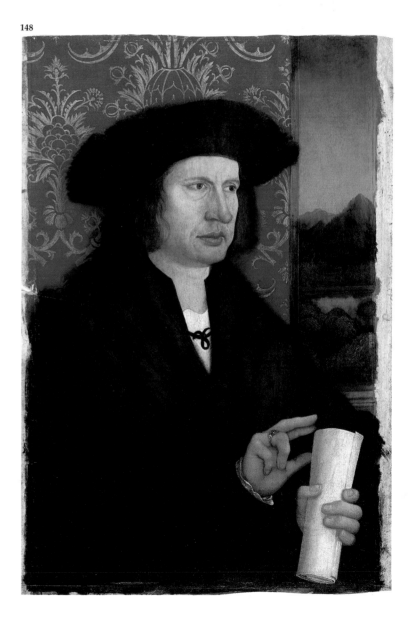

The likelihood that the man portrayed is one of the humanists who were in Cuspinian's circle at Maximilian's court in Vienna led Dworschak (1962) to identify him as Dr. Georg Tannstetter (1482–1535), physician in ordinary to the Emperor and an astrologer of repute. The basis for this identification, a box-wood relief portrait of Tannstetter dated 1521 in the Benedictine Abbey at Melk, Austria (illustrated in Cat. 1979, p. 26), is somewhat equivocal. In the Melk relief the sitter is viewed full-face frontally. Though his dress is similar and his features do not differ markedly from those of the man in the Liechtenstein portrait, he is much more corpulent.

It has been suggested, too, that the arrangement of the man's hands in the Liechtenstein portrait—with his fingers of his right hand raised over a scroll held in his left—can be interpreted as a gesture of taking the Hippocratic oath and provides circumstantial evidence supporting the identification. However,

this is also problematic since there is evidence that at least the man's left hand has been repainted, though it is not yet clear to what extent.

In the wife's portrait it is clear to the naked eye that her beringed right hand has been repainted. It was originally positioned upward and held a rosary with small coral Ave Maria beads and large gold Paternosters. On the evidence of what appear to be the parts of two similarly painted coral beads at the right of the lower edge of the man's portrait, he too must have held a rosary. Technical examination confirms that the alterations were made not long after the panels' completion. A probable reason for these changes in composition would be the sitters' desire, if they subsequently converted to Lutheranism, to suppress evidence of their earlier Catholic practices. This rationale, however, argues further against their identification as Dr. Tannstetter and his wife, of whom such a conversion is not to be suspected.

It is of interest to note that these panels have been cut down. Instead of having framed each first and then laying on its gesso ground, the artist prepared the entire panel and then scored its borders to establish the limits of his composition. The perimeters of both pictures are painted loosely, extending beyond these guidelines. It is clear from these margins and also from rough-cut edges that the portrait of the man has been cut at the top and that of the woman at the top and bottom. When the windowsills in the portraits are aligned, it appears that the woman is taller than her husband. The adjustment made by the modern framing "corrects" this situation.

GCB

FURTHER REFERENCES: Waagen 1866, pp. 277, 278 (as Zeitblom, under Holbein?); Cat. 1873, nos. 1053, 1057 (as Zeitblom); Cat. 1885, nos. 712, 714 (as Zeitblom); Woltmann and Woermann 1887, vol. 2, p. 196; Janitschek [1890], p. 442; Suida 1890, vol. 2, p. 117; Bode 1895a, p. 124; Mayer 1929, ills. pp. 2–3; Cat. 1931, nos. 712, 714; Lucerne 1948, nos. 61–62; Otto 1964, pp. 77, 80; Sankt Florian 1965, pp. 16, 196; Cat. 1979, nos. 3–4; Baumstark 1980, nos. 125–26.

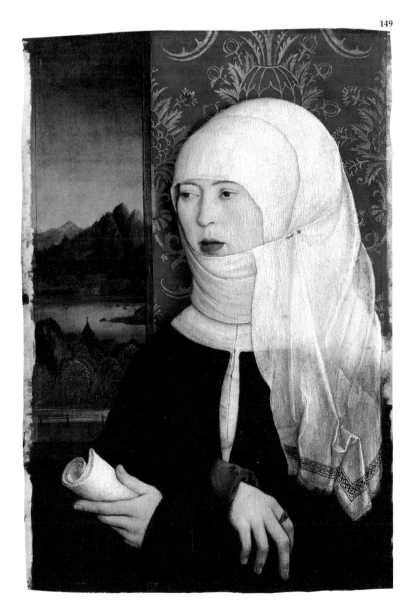

149

150

Hans Schäufelein
German, act. by 1503–d. before Nov. 11, 1540

THE VISITATION
Oil on wood; 30¾ in. × 25⅝ in. (78 × 65 cm.)
Liechtenstein inv. no. 934

Schäufelein was one of the leading secondary masters of German painting in the first third of the sixteenth century. Probably born in Nürnberg around 1480/85, he worked in Albrecht Dürer's shop from about 1503/1504 until about 1506/1507. In 1505 he was assigned by Dürer to execute the Ober Sankt Veit

235

Altarpiece (Dom- und Diözesanmuseum, Vienna), a work that shows how thoroughly dependent Schäufelein's style was upon that of his master. By 1508 he seems to have come into his own as a competent painter of modest individuality, much less progressive and original than Dürer. His work is characterized by an emotional piety and a flair for narrative subjects. He distinguished himself more in the graphic arts, particularly as a designer of woodcuts, in which capacity he worked for the Holy Roman Emperor Maximilian I in 1512 in Augsburg.

In 1515 Schäufelein became a citizen of Nördlingen, his father's hometown fifty miles (eighty kilometers) southwest of Nürnberg, and he resided there for the rest of his life. That year he was engaged to decorate the town hall of Nördlingen with paintings still in situ. A prolific artist, Schäufelein appears to have headed a substantial workshop in Nördlingen.

He was patronized particularly by the Counts of Oettingen, just to the north of Nördlingen, who commissioned various works for their religious foundations, the most important being an altarpiece for the Carthusian monastery of Saint Peter at Christgarten (Alte Pinakothek, Munich).

The Liechtenstein panel is one of six from an altarpiece for the church of Hohlheim near Nördlingen. It was the donation of several local aristocratic families, but its principal patrons were apparently two members of the Oettingen household. Two of the panels—the *Annunciation* and the *Nativity*, both the same size as the present picture—are still in the church of Hohlheim. Two others—*Saint John the Baptist* and *Saint John the Evangelist*, both wider and over twice as high as the present picture (each about 78 × 35 in. [200 × 90 cm.])—were at the church of Hohlheim in 1935, but their whereabouts are now unknown.

150

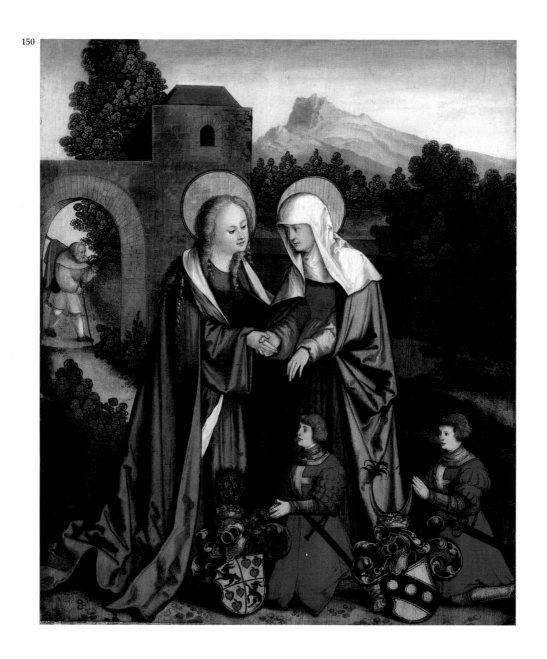

The fifth panel from Hohlheim, the *Adoration of the Magi*, was in the Schwartz collection, Bocholt, in 1935 and also corresponds in size to the Liechtenstein picture.

The original appearance of the altarpiece is not known, and it is possible that it included other panels. However, as Oppolzer (1906) suggests, these six panels probably formed the wings of a folding triptych with a carved central section, perhaps, and with the two Saint John panels on the exterior. Thieme (1892, p. 92) notes that such an arrangement would be the most likely one but unnecessarily rejects it because the combined dimensions of the four narrative panels are considerably less than those of the two Saint Johns. This discrepancy might easily have been accommodated by the framework.

The four interior panels of the altarpiece must have been distributed as follows: in the left wing, the *Annunciation* above and the *Nativity* below; in the right wing, the *Visitation* above and the *Adoration of the Magi* below. This makes the most sense visually, and it is the arrangement that has been preserved in copies of the panels in the Nördlingen town hall by Friedrich Wilhelm Doppelmayr (1776–d. after 1833).

Three of the narrative scenes include devotional portraits of donors with their coats of arms. However, that of "Johann Konradt von Rosenbach" (the only one whose name is inscribed below his coat of arms) in what would be the lower left panel, the *Nativity*, is clearly a seventeenth-century overpaint and breaks the symmetry of the arrangement. Four donors are distributed across the two panels in the upper register. In the *Annunciation*, at the left (the position of honor), are generalized portraits of two youthful members of the Oettingen household, perhaps Count Ludwig XV zu Oettingen (d. 1557) and his brother Karl Wolfgang (d. 1549), though this is not certain. In the Liechtenstein *Visitation* two other local nobles are represented, identifiable by their coats of arms: a member of the Bodmann family on the left and a member of the Wernau family at the right (see Siebmacher 1605, pp. 111 and 110 respectively; in editions from 1734 onward the coat of arms of the second family is identified as Werzola).

Modern (1896, p. 367) expresses the opinion that "in all [of the works for the Counts of Oettingen], the collaboration of assistants can unmistakably be detected. The Hohlheim altarpiece nearly has the appearance of a routine shopwork [*Alltagsschablone*]" (author's translation). Granted, the handling of paint in the Liechtenstein picture is dryer and flatter than in Schäufelein's best works, though it is in a good state of preservation. But the deftness of execution and the sensitivity of expression argue for the recognition of the master's hand. The rigidity of the draughtsmanship leads one to suspect that the composition derives from a print, though it has not been possible to find a source in Schäufelein's or Dürer's graphic oeuvre. Modern (1896, p. 364) dated the Hohlheim altarpiece to the years 1518–19. Buchner (1935, pp. 558, 559) implies a date between 1525 and 1532. It is difficult to identify the artist's later paintings because of a lack of securely dated comparative works.

It seems most prudent to assign a date of about 1520 to the Liechtenstein picture.

The *Visitation* was acquired by Prince Johannes II in 1906, in the sale of the Oppolzer collection (Munich 1906, no. 14) which also included the *Adoration of the Magi* from the Hohlheim altarpiece. According to a previous owner, the two paintings were in the estate of the Munich painter Joseph Schlotthauer (1789–1869).

<div align="right">GCB</div>

FURTHER REFERENCES: Thieme 1892, pp. 93, 170; Höss 1908, pp. 44–45; Cat. 1931, no. 934; Winkler 1941, p. 249; Lucerne 1948, no. 63; Cat. 1965, no. 95; Cat. 1979, no. 7; Baumstark 1980, no. 128.

151

Lucas Cranach the Elder
German, 1472–1553

SAINT EUSTACHIUS
Oil on wood; 34 × 12¾ in. (86.5 × 32.5 cm.)
Liechtenstein inv. no. 1036

Lucas Cranach's earliest known paintings date from the years just after 1500. In Vienna about 1501–1503, he achieved a new, emotive style incorporating strikingly naturalistic landscapes and laid the foundation for what has come to be known as the Danube school of painting. After 1505, when he became painter at court to the Electors of Saxony in Wittenberg, whom he served for the remainder of his life, the intensity of Cranach's art relaxed, and his paintings became increasingly elegant and stylized.

There is no reason to question the dating of this picture to about 1515–20, first put forward by Friedländer and Rosenberg (1932, p. 48, no. 95). The naturalistic conception of landscape and foliage seen here is not far removed from that developed by the artist in Vienna and agrees with that found in dated works from this period, for instance, the 1518 *Reclining Water Nymph* (Museum der Bildenden Künste, Leipzig). A drawing by Cranach (Museum of Fine Arts, Boston, acc. no. 53.5) with the same subject as the present painting, in which the composition is reversed and the figures are set in an expansive, more open space, is some ten to fifteen years later in date.

The composition of the present painting derives loosely from Albrecht Dürer's renowned engraving of about 1501 depicting Saint Eustachius, as do various details—particularly the mountain with castles at the upper left and the positions of several of the whippets. Though the print has often been said to represent Saint Hubert, Dürer himself, who recorded in his journal having given several copies of it as gifts during his trip

to the Lowlands, refers to its subject as Saint Eustachius. The saint in Cranach's painting was also thought to be Hubert until Rosenberg (1954, p. 282) identified him as Eustachius because of the Dürer engraving.

The legends of these two saints are, in part, identical. Both converted to Christianity while hunting, when confronted with a miraculous apparition of the crucified Christ between the antlers of a pursued stag. The Eustachius legend is primary. Eustachius was a second-century Roman who changed his name from Placidus at his baptism; he was subsequently martyred under Hadrian. He is revered in Germany, especially, as one of the fourteen helpers in need (*Vierzehnheiligen*). Hubert, first Bishop of Liège, lived in the eighth century. In Northern Europe, the cult of the Teutonic saint came to supplant that of the Italian around the year 1000. Believed to be of noble family, he was revered especially as patron of the hunt, and because of the association with hunting dogs, his name was invoked against hydrophobia.

The somewhat rabid action of the dog that menacingly bares his teeth at the holy stag in Cranach's painting might be interpreted as an indication that the saint represented here is Hubert. The saint's aristocratic attire further supports this idea. Lacking documentation, the question of identification cannot be resolved.

The proportions of this panel indicate that it probably was once the wing of a folding triptych. In fact, it has been cut at the top edge and would, thus, have originally been even more vertical in format. When it was first catalogued in the Liechtenstein collection (Cat. 1873, no. 1036), it was listed as having a pendant (Cat. 1873, no. 1038) depicting "a bishop saint reviving a dead man in a landscape, with other figures behind him." Waagen (1866, p. 268) describes the subject as "a bishop saint healing a sick man in the presence of two lookers-on." The bishop saint in question is probably Saint Valentine, a subject treated by Cranach and his workshop on at least three other occasions (see Friedländer and Rosenberg 1978, no. 2, sup. 1, and sup. 6B).

It is possible that this second panel was from the other wing of the same altarpiece, or it may have been originally the verso of the present panel. The second possibility seems more likely since the wood support of the Eustachius panel has been shaved very thin and attached to another panel—evidence that it may once have been part of a thicker panel that was divided in half. It has not yet been possible to trace the whereabouts of the second panel, which was sold from the Liechtenstein collection in Paris in 1880.

Though the present picture has always been catalogued as by Cranach in the Liechtenstein collection, the assertion of Waagen (1862, p. 247) that this attribution is erroneous deserves clarification. At a time in art-historical studies when the artistic personality of Matthias Grünewald was not clearly defined (Waagen believed the Isenheim Altarpiece in Colmar to be by Hans Baldung Grien), he attributed the two wings in the

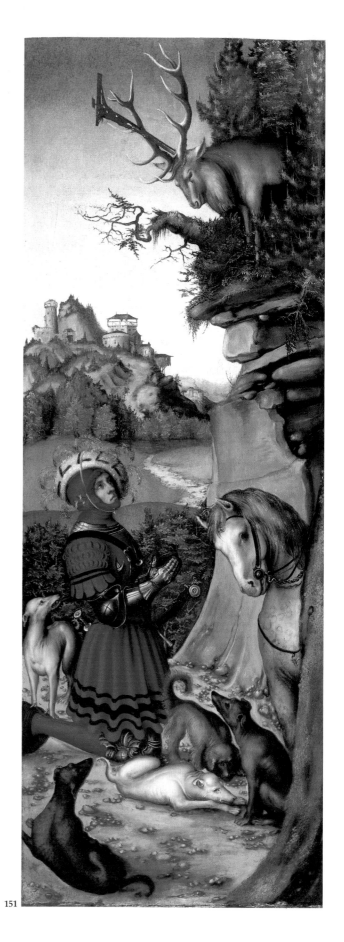

151

238

Liechtenstein collection to this master. In Waagen's view, Grünewald's principal work was a *Lamentation* then in the Esterházy collection (now Szépművészeti Múzeum, Budapest). The Budapest work is very close in style and date to the present painting and is today accepted without question as by Lucas Cranach the Elder. It provides a clue to the appearance of the lost pendant of the *Saint Eustachius* for it includes at its lower left a standing bishop saint that presumably is similar to that picture—hence Waagen's attribution.

Bode (1895a, p. 126) believed he recognized the hand of Lucas Cranach the Younger (1515–86) in the Liechtenstein panel. Presumably his judgment was based on the sweetness of expression evident in the head of the horse that coyly engages the viewer's glance. However, the apparent date of the painting precludes the participation in its creation of Cranach's younger son, and a horse with similar expression is found in the elder master's earliest work, the *Crucifixion* (Kunsthistorisches Museum, Vienna).

The *Saint Eustachius* is seen in New York for the first time since its cleaning and restoration in 1984. One of several works by Cranach in the Liechtenstein collection, less well known than the *Sacrifice of Abraham* dated 1531, it was acquired by Prince Johannes I, possibly in 1819 from the collection of Count Collowrat in Prague. The attraction it held for the Prince was, no doubt, twofold. Besides its distinction as an exemplary work by one of the leading artists of the so-called Danube school, the association of this subject with the noble pastime of hunting would have appealed to Prince Johannes, whose enthusiasm for this sport is well documented. GCB

FURTHER REFERENCES: Flechsig 1900, p. 118; Cat. 1931, no. 1036; Friedländer and Rosenberg 1978, p. 91, no. 108; Posse 1942, p. 56, no. 39; Lucerne 1948, no. 71; Cat. 1971, no. 5; Koepplin and Falk 1974, p. 247; Cat. 1979, no. 5.

152

Monogrammist AG
German, act. second quarter of 16th century

PORTRAIT OF A YOUNG MAN BEFORE A BROAD LANDSCAPE

Oil on wood; 23¼ × 20⅛ in. (59 × 51.2 cm.)
Signed and dated (at left, on tablet): AG/1540
Liechtenstein inv. no. 699

This painting, traceable since 1805 in the Princely Collections, depicts in full-face a young man whose identity is not known. To judge by the falcon and gear of falconry, an aristocratic pastime, in the tree at the right, he was a nobleman. In his right hand he holds a carnation—generally recognized as a token

of betrothal in fifteenth- and sixteenth-century Northern European portraits. In his left hand he holds an early type of rosary, before its form had been standardized. His figure looms large in the foreground, elevated above a panoramic landscape vista, painted in cool gray-greens and blues, that spreads out behind him, reinforcing his silhouette.

One of the most impressive of mid-sixteenth-century German portraits, the picture has nevertheless eluded all attempts to determine the identity of its painter. The rubric for the master to whom it is assigned derives from this picture, which is signed with the monogram AG and dated 1540 on the tablet at its upper-left corner. Until as recently as 1931 it was given to Heinrich Aldegrever (1502–d. 1555/61), an artist best known as a printmaker who, in imitation of Dürer, signed his works with a monogram very similar to the one seen here. Aldegrever's activity as a painter was then less well known. In early literature this portrait was always grouped with two others that bore similar monograms: one in Berlin that bore the date 1551 and the other, once in Breslau, thought to be dated 1535. The monogram and date on the first were discovered to be false, and the picture is now universally recognized as a work by Bartholomäus Bruyn the Elder (Staatliche Museen Preussischer Kulturbesitz, Berlin-Dahlem). The other picture, a portrait of Count Philipp III zu Waldeck (Prince zu Waldeck und Pyrmont collection, Arolsen, West Germany) is in fact dated 1537 and is an authentic work by Aldegrever. There is no relationship whatsoever in style between it and the present work. The only inference is that the Liechtenstein picture is by a contemporary painter who employed the same monogram.

Indeed, there were various other sixteenth-century German artists who did so. Because this picture is closely related to works by painters from Augsburg, Benesch (1933, pp. 252–53) draws attention to Andreas Giltinger, a painter from that town (see Nagler 1858, vol. 1, no. 584), but is forced to reject the possibility of his authorship since that artist obtained his trade rights only in 1563.

The circumstances surrounding the attribution of the Liechtenstein portrait are best set out early on by Bode (1895a, pp. 124–26), who initially questioned the Aldegrever designation, and much ink has since been unnecessarily spilled over it. Bode was the first to ensure that the authenticity of the inscription had been verified by technical examination; this was done anew by Benesch and again for the 1965 Danube school exhibition (Sankt Florian 1965, no. 250). Although Bode noted the painting's relation to ones by an artist called the Master of the Holzhausen Portraits—today identified as Conrad Faber von Creuznach—several of whose pictures are signed on the reverse with the monogram ɔvc, he stopped short of assigning the Liechtenstein portrait to that master; that is, he all but suggested the Monogrammist AG designation. Nevertheless, Baldass (1922, pp. 84–85) and Pauli (1931/32, p. 46) mistakenly believing the Liechtenstein inscription to be false, attribute the picture to that master; and Buchner (1928, pp. 374–78) attributes it to

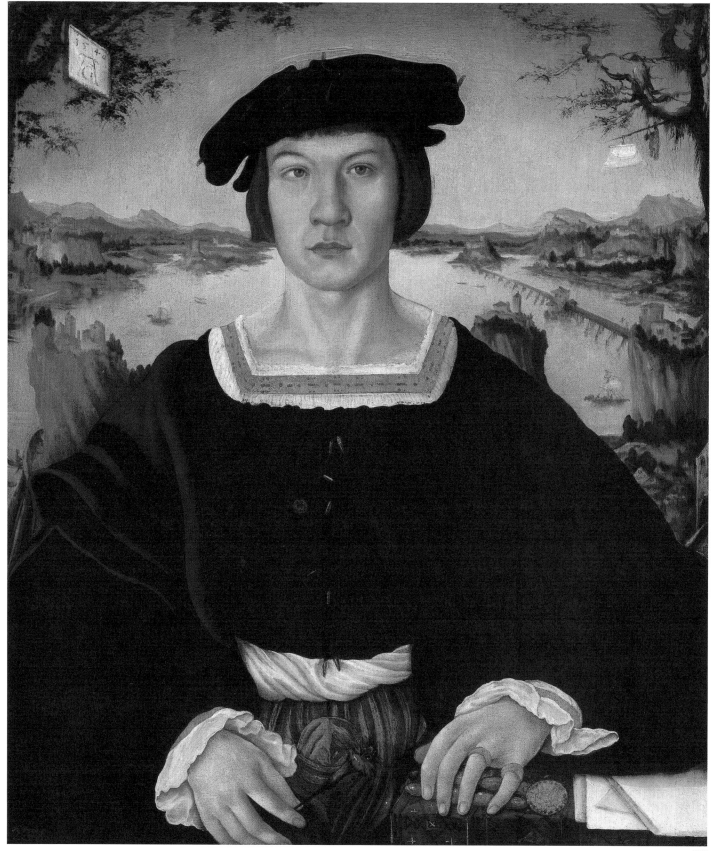

Jörg Breu the Elder, a prominent Augsburg painter.

Voss (1907, pp. 156–57) draws attention to a portrait (Niedersächsisches Landesmuseum, Hannover; there attributed to Jörg Breu the Elder) that apparently portrays the same individual as here, evidently about a decade later. The Hannover sitter has the same narrow mouth and broad, pear-shaped nose, though he is less round-faced, and the distinctive squint in the left eye of the Liechtenstein subject—a feature that had been "corrected" by overpainting now removed—is not apparent in the later portrait. The Hannover picture is of mediocre quality and should be attributed neither to Breu nor to the Monogrammist AG, as often has been done.

A handful of other portraits have been attributed to the Monogrammist AG, none altogether convincingly. The strongest candidates are a portrait of a man (Staatliche Museen Preussischer Kulturbesitz, Berlin-Dahlem), portraits of a married couple (Iklé collection, Saint Gall, Switzerland, and Kunsthistorisches Museum, Vienna), and the portrait of Michel Agler dated 1529 (Germanisches Nationalmuseum, Nürnberg); however, the Liechtenstein painting is superior in quality to all of these. It seems to stand alone, an isolated masterpiece by an artist who was influenced by Breu and Faber, but whose sensitivity to nature attests also to an awareness of the work of painters from the Danube region.

GCB

FURTHER REFERENCES: Waagen 1862, p. 240; Waagen 1866, p. 279; Cat. 1873, no. 1072; Cat. 1885, no. 699; Woltmann and Woermann 1887, p. 234; Janitschek [1890], p. 530; Suida 1890, vol. 2, p. 117; Pauli in Thieme–Becker, vol. 1 (1907), p. 241; Friedländer 1908, p. 393 (as Master of the Holzhausen Portraits); Cat. 1931, no. 699; Deusch 1935, p. 28; Munich 1938, pp. 149–50; Strohmer 1943a, p. 103; Cat. 1943, no. 65; Thieme–Becker, vol. 37 (1950), p. 373; Fritz 1959, p. 81; Stange 1964, p. 153; Cat. 1979, no. 10; Baumstark 1980, no. 129.

153

Hans Mielich
German, 1516–73

LADISLAUS VON FRAUNBERG,
COUNT OF HAAG
Oil on canvas; 83⅛ × 43⅞ in. (211 × 111.5 cm.)
Signed and dated: ANNO DN·M·D·LVII·HANNS MIELICH Ā
 MONAC.FECIT
Liechtenstein inv. no. 1065

The ill-fated life of the man here portrayed makes this portrait a poignant illustration of a principal theme in sixteenth-century European portraiture—that of the vanity of all earthly pursuits. Ladislaus von Fraunberg, Count of Haag (1505–1566) was a direct vassal of Charles V and, after 1541, the last of his line.

Haag, a small town about 30 miles east of Munich, was the seat of his county, comprising about 115 square miles. Throughout his life (see Goetz 1889–90, pp. 108–65), he was obsessed by the fear that his county would be swallowed up by the much larger neighboring Duchy of Bavaria, which after 1550 was ruled by Duke Albrecht V, his powerful archrival.

As early as 1555, Albrecht negotiated clandestinely with Charles V for an expectancy—a claim on the county should Ladislaus die without having produced a male heir. The children from the Count's first marriage to Marie Salome von Baden all died in infancy, and she herself died in 1549. Thereafter, the Count's principal aim in life was to secure for himself a suitable wife and to have a son. This portrait is rife with allusions to this state of affairs. Yet its theme of vain pursuits can be seen as prophetic, since nine years after it was painted he died without an heir.

It is remarkable that the picture still belongs to a family related by marriage to that of the sitter. It probably entered the Liechtenstein collection in 1568, just two years after his death, when his niece married Hartmann II von Liechtenstein. Their child Karl became the first Prince of Liechtenstein in 1608. Mentioned in an inventory of 1613, it is today the earliest painting traceable in the Princely Collections.

Hans Mielich was Albrecht V's painter at court in Munich. He was trained in the workshop of Albrecht Altdorfer, but his style reflects the influence of Barthel Beham, his predecessor at the Bavarian court. Mielich may be regarded as the leading portraitist of his generation in Germany, and this painting is one of his most impressive achievements.

At the moment he stood for his portrait, Ladislaus was much more vulnerable than this grandiose portrayal leads one to suspect. It was executed during or shortly after a period when Ladislaus was illegally detained by Albrecht V. He was arrested on September 12, 1557, in Altötting, where he had gone to attend his sister's wedding. From September 28 to November 2 he was held in Munich, and for six weeks thereafter he was under house arrest at Haag Castle until he had paid off the large ransom that was extorted from him. To judge by the view of Haag Castle in snow, glimpsed through the open window at the painting's left, the painting was made in the winter of 1557. The inscription HANNS MIELICH Ā MONAC. FECIT most likely indicates that the portrait was painted in Munich, though it might also mean that the artist came from that city. If the inscription employs epigraphic abbreviation form, and it probably does, the "ā" is short for *apud* (at). The standard reference for Latin abbreviations does not list *ab* (from) as a possibility (see Cappelli 1973, p. 429).

A life-size standing portrait of Albrecht V with the Bavarian lion by his side (Kunsthistorisches Museum, Vienna), painted by Mielich in 1556, seems to have provided a model for the present picture, though the portrait of Ladislaus, surely to his gratification, surpasses in quality that of his rival. The format of both portraits derives from the renowned portrait of Charles

V, dated 1532 (Kunsthistorisches Museum, Vienna), by Jacob Seisenegger (1505–1567), court painter to Ferdinand I, whose daughter married Albrecht V.

The present portrait was painted not long after Ladislaus had returned in 1556 from Ferrara, where he had gone the year before, with great pomp and circumstance, to arrange a marriage with a member of the Este household. This project proved a total fiasco. On arriving, he learned that the bride promised him was the illegitimate daughter of Duke Ercole II's brother, Ippolito d'Este the Younger, Cardinal of Ferrara. When Ladislaus objected, a legitimate niece of the Duke was proffered, Emilia Roverella di Pio, whom he married. However, it became clear that the marriage contract would be financially and politically unfavorable for Ladislaus. His new mother-in-law had her daughter abducted to a convent, and her greed for the Count's wealth led to an attempted poisoning and the hiring of assassins. Ladislaus returned to Haag brideless and humiliated.

After an attempt to secure a papal dispensation for divorce failed, he converted to Lutheranism, apparently in hopes that his act would provide further grounds for the dissolution of his Italian marriage and also, perhaps, permit a Protestant one. In the summer of 1557, just before his arrest by Albrecht, Ladislaus began courting a local noblewoman, Margarethe von Trenbach, his sights set upon a new marriage. However, their union was made impossible by the fact that Ladislaus still had not been able to dissolve his marriage to Emilia. Apparently broken-hearted, Margarethe died shortly before 1566. At the time of his own death that year, Ladislaus was in the midst of arrangements to marry again, this time with a Protestant Saxon princess.

In the portrait the themes of the transience of life and the omnipotence of death are established by the hourglass standing on a skull inscribed MORS OMN[IA] RAPIT (Death takes all) on the ledge. Man's recourse to eternal spiritual values is represented by the crucifix. The illusory quality of human existence is introduced by the encased mirror hung on the wall beneath the ledge, paired with a triangular gold medal, suspended on a ribbon, that features a cross, the initials SM, and the date 1525. A memento, surely, of his greatest glory—the 1525 siege of Pavia where the twenty-year-old Count, fighting for the empire, first distinguished himself in battle and launched his military career—this object probably denotes the spiritual protection of the Holy Trinity and possibly of the Virgin (Santa Maria?). The military trophy on the rear wall, consisting of an ornamental shield of Italian design, a coat of mail, a rapier and mace crossed, a velvet-covered morion, and sprigs of evergreen, alludes to the Count's principal vocation but might also be regarded as representing vain glories.

Ladislaus had particular reason to be disillusioned about his glory in 1525. He was captured by the French and held for ransom, but his liege-lord, Charles V, declined to buy his freedom. Offended, he went over to the enemy and served the French monarch Francis I until 1529. In that year he was pro-scribed by Charles V and his possessions declared forfeit. Yet by 1531, he had managed to regain imperial favor, and by 1536 was able to consolidate under himself the entire earldom of Haag, half of which had been held by his brother.

For his service, Francis I had conferred upon Ladislaus the right in perpetuity to incorporate in his coat of arms those of the French monarch. Indeed, Ladislaus's coat of arms, labeled with his name and title, is shown in stained glass in the painting, and it has as its crest the figure of France. His motto, included here on a banderole, is *Cum labore et Deo juvante* (With work and God's help). The illusionistic frame enclosing his arms features the four cardinal virtues.

The Count's coat of arms is reversed, a detail kindly brought to the author's attention by Helmut Nickel. This was done when a man's coat of arms was paired with that of his wife's, here significantly absent. Other allusions to a missing wife are evident. On the table covered with a Turkish rug in front of the open window, a glass vase holds a single carnation stem. In sixteenth-century Northern European portraits, the carnation is commonly recognized to be a token of betrothal.

There is other evidence of the Count's former marriages. The painting's most striking and exotic element, the collared leopard on a leash, is not imaginary. We know from a letter written in 1640 by Hartmann II's son (Princely Archive) that the animal was a gift from one of the Count's Ferrarese brothers-in-law. He writes that "like a dog, it was always by his side," and mentions that the Mielich portrait was then housed at the Liechtenstein residence at Feldsberg. The conjoined letters LS on the collar may be an unusual monogram for "Ladislaus," but it is conceivable too that, following the usual practice, they are an interlocking of the initials of Ladislaus and his first wife, Salome.

At the center of this constellation of content-charged imagery, Ladislaus stands proudly, sumptuously attired in Spanish costume, the fashionable dress of the day. Gripping his sword, he regards the viewer cautiously. Though the last Count of Haag failed to produce an heir, his portrait survives and ensures that his name will not be forgotten.

GCB

FURTHER REFERENCES: Fleischer 1910, p. 7; Braun 1925–26, pp. 78–80; Röttger in Thieme–Becker vol. 25 (1931), p. 212; Lucerne 1948, no. 64; Wilhelm 1976, p. 16; Cat. 1979, pp. 9–10; Baumstark 1980, no. 130; Munch 1980, pp. 169, 220; Munich 1980, no. 54.

242

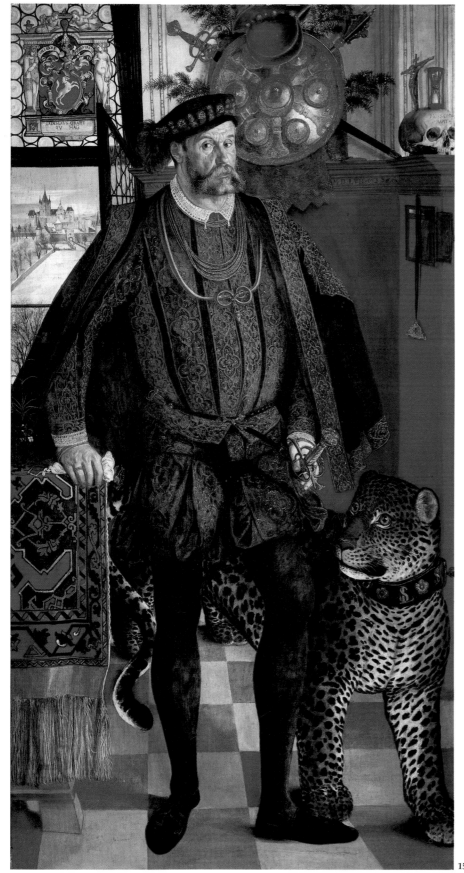

153

Fig. 38 Detail from cat. no. 153

154

Johann Heinrich Schönfeld
German, 1609–1684

THE OATH OF HANNIBAL
Oil on canvas; 42⅜ × 72¼ in. (107.5 × 183.5 cm.)
Signed (lower left): Schönfeldt Fecit
Liechtenstein inv. no. 1264

Schönfeld was the object of unrestrained admiration in Germany during his lifetime and through the eighteenth century. With the exception of Adam Elsheimer, few German artists of the seventeenth century are renowned today, but Schönfeld and Johann Liss have been the subjects of recent exhibitions and a flourish of scholarly literature.

During the turmoil of the Thirty Years' War (1618–48) the small, separate states of Germany did not provide painters with prospects nearly so promising as those in other European countries. No German artist of consequence could fail to spend some of his formative years studying abroad. Schönfeld, the son of a goldsmith and burgomaster of Biberach an der Riss, near Ulm in Upper Swabia, went to Rome around 1633 (Pée 1971, p. 12). He was active there during the first and last few years of his eighteen-year Italian period; from about 1637 to about 1648 he

worked in Naples. In May 1651 Prince Paolo Giordano II Orsini, Duke of Bracciano, granted Schönfeld leave from his obligations in Rome to attend to personal affairs in Germany. He obtained citizenship in Augsburg and married in July 1652.

Schönfeld's career thrived in the imperial heartlands from the mid-1650s. He painted religious pictures and historical and mythological subjects in Augsburg (where he had numerous commissions in the 1660s and 1670s), Regensburg, Salzburg, and probably Vienna. In 1666–67 he executed the ceiling paintings (now lost) for the Munich Residenz (Pée 1971, no. 109).

Schönfeld might be described as one of those Baroque painters who stand midway between late Mannerism and early Rococo. His provincial origin and an inclination toward stylish rather than weighty ideas made him open to a cornucopian assortment of sources during his early years. Of those usually mentioned, Jacques Callot's etchings are the most interesting for Schönfeld's figure style and his imaginary architecture (Voss 1964, pp. 11, 14; Pée 1971, p. 19). The Swabian's interest in French art should probably be given more attention than it has hitherto received: not only Callot and Abraham Bosse but Jacques Bellange and even Francesco Primaticcio and Niccolò dell'Abate are brought to mind by Schönfeld's tapering, twisting, balletic

figures, by his fantastic characters, and by his shallow spaces which resemble stage scenery. Such an orientation, or "occidentation," would also make the artist's enthusiasm for Hendrik Goltzius and his circle in Haarlem and for Nicolas Poussin and Cornelis van Poelenburgh in Rome seem less unexpected than it might at first appear.

Schönfeld's debt to Roman artists—but above all to the Frenchmen Poussin and Claude Lorrain—is clear in pictures dating from the 1630s. His later work was intimately involved with Neapolitan painting. Here again two artists from France, Simon Vouet and François de Nomé (called Monsù Desiderio), deserve special mention, the former with regard to Schönfeld's use of light and shade to enliven figures, the latter in respect to his visionary architectural views (London 1982, nos. 89, 164). The most important Italian painter for Schönfeld in Naples was probably Domenico Gargiulo (called Micco Spadaro), who himself had been strongly impressed by Callot's prints. Spadaro's master, Aniello Falcone, the latter's associate, Salvator Rosa, and other young artists in Naples, such as Domenico Cavallino, all contributed, and in some instances responded, to Schönfeld's style and imagery (see London 1982, on these painters and on Schönfeld). His manner of execution became bolder and more painterly, his compositions looser, and his colors more intense during this period.

The Liechtenstein collection is especially rich in pictures by Schönfeld, including the three exhibited here and two pendant paintings, *King Solomon Worshiping Pagan Gods* and *The Queen of Sheba Before Solomon*, of about 1665–66 (Pée 1971, nos. 104–5). All five paintings were acquired between 1677 and 1681 by Prince Karl Eusebius.

The subject of Hannibal, like the story of Solomon, was well suited to Schönfeld's taste for exotic settings and accessories. An earlier treatment of the theme, a large canvas painted around 1660 for the burgomaster of Augsburg, is now in the Germanisches Nationalmuseum, Nürnberg (Pée 1971, no. 93). The present picture dates from about 1670 and forsakes the dynamic and eccentric arrangement of the Nürnberg composition in favor of a symmetrical and much more monumental design. The impression of dramatic import, of solemnity and obsession, is thus intensified in this strangely still scene where the boy Hannibal (b. 247 B.C.), before the spectral figure of a high priest, swears eternal hatred of Rome (Livy, *Ab urbe condita* 21.1). His later crossing of the Alps at the head of the army of Carthage (in 218 B.C.), his occupation of parts of Italy throughout the subsequent sixteen years, and his political career from 202 B.C. to his suicide in 183 or 182 B.C. (in response to a Roman order of extradition) testify to Hannibal's relentless resolve.

Works by artists such as Callot, Cavallino, and Raphael, among others, have been cited in connection with this composition (Pée 1971, pp. 184–85); one might also mention Veronese in respect to the architecture and the Dutch Mannerists in regard to the figure groups. However, as the contemporary biographer Joachim Sandrart remarked, Schönfeld used borrowed ideas as

assuredly "as if they had flowed from his own invention" (quoted by Pée 1971, p. 26).

WL

FURTHER REFERENCES: Fleischer 1910, p. 55; Voss 1964, pp. 21, 34; Adriani 1965, p. 370; Ulm 1969, no. 77; Pée 1971, pp. 57, no. 118; Baumstark 1979, no. 15; Baumstark 1980, no. 132.

155–156

Johann Heinrich Schönfeld
German, 1609–1684

ARTILLERYMEN STUDYING A MAP
Oil on canvas; 42⅜ × 35⅝ in. (107.5 × 90.5 cm.)
Signed and dated (lower left): JHS *[in monogram] 1653*
Inscribed on the back: 656/ Vom Schönfeldt/ Erkaufft vom/ Megan/ 1679
Liechtenstein inv. no. 1231

SOLDIERS PLAYING DICE IN AN ENCAMPMENT
Oil on canvas; 42½ × 35 in. (108 × 89 cm.)
Signed and dated (lower left): JHS *[in monogram] 1654*
Inscribed on the back: Vom Schönfeld/ Erkaufft vom Megan/ 1679
Liechtenstein inv. no. 1235

These two canvases are evidently part of a set of four pictures of military life by Schönfeld that Prince Karl Eusebius von Liechtenstein bought from the Viennese dealer Regnier Megan in 1679 (Fleischer 1910, p. 65: "4 Schoene Stueck von Schoenveldt per 200/hoendert [sic] r̄y. [Reichstaler] ider Stueck maecht . . . 800 r̄y" [4 handsome pieces by Schönfeld at 200 Reichstaler for each picture total . . . 800 Reichstaler]). One of the other two paintings is very probably *Soldiers Fighting over a Game of Dice* (Pée 1971, no. 59, pl. 67), which was sold from the Liechtenstein collection in 1841 and was later in a private collection in Berlin; the picture is said to be signed and dated 1654, and in size, composition, and particular motifs (for example, the drum used as a gaming table, and two of the principal figures), it corresponds very closely to *Soldiers Playing Dice.* (The inscription cited by Pée as on the back of *Soldiers Fighting*, "Erkauft Vom Herrn Imstenrad" [Bought from Herr Imstenrad], may be mistaken or may be wrongly recorded; see Pée 1971, nos. V104–105 for "two pieces by Schönfeld in his best manner" which were acquired by Karl Eusebius from Frans von Imstenrad in 1678.) The fourth painting in the set must be *Soldiers Loading a Cannon* (Pée 1971, no. V103), which was sold in 1841 along with two mythological pictures by Schönfeld (Pée 1971, V101–102); its present location is unknown. Hitherto known only from the handwritten catalogue of the Liechtenstein gallery dating from 1805, this canvas may also be iden-

245

tified with item no. 109 in the 1712 inventory made after Prince Johann Adam's death. (In summary, Pée 1971, nos. 57, 58, 59, and v103 = 1712 inventory nos. 445, 446, 559, and 109, respectively.)

Though the four military scenes might be paired into pictures of dice players or of cannoneers, they appear to have been conceived by Schönfeld less in terms of pendant relationships than as a decorative ensemble. The two paintings illustrated here and old photographs of *Soldiers Fighting* all show a vertical element closing the composition on the left; three or four dramatically lit figures in the foreground; a distant landscape to the right; and similar sunlit skies.

The use of genre scenes, particularly those of military life, as large-scale decorative paintings was a concept essentially foreign to Northern Europe in the first half of the seventeenth century. Dutch and Flemish pictures such as Gerrit Honthorst's *Musical Companies* and Jacob Jordaens's illustrations of proverbs ultimately depend from Italian models, though their subjects are often indigenous to the Netherlands. Similarly, Schönfeld's large genre paintings of the 1650s are formally related to works by Italian masters such as Salvator Rosa, Micco Spadaro, and Domenico Cavallino (see discussion in cat. no. 154) and perhaps to the Roman street scenes of Pieter van Laer (Pée 1971, p. 131, no. 57). The German painter's military themes may also be associated, however, with many earlier Northern European images: sixteenth-century *Landsknecht* prints; Callot's etchings of the Miseries of War; battle and bivouac pictures by early seventeenth-century artists such as Sebastiaen Vrancx, Esaias van de Velde, and Pieter Snayers; and Dutch Guardroom paintings by Pieter Codde, Willem Duyster, Simon Kick,

155

and Jacob Duck. *Soldiers Fighting* also recalls the scenes of fighting peasants that were introduced by Pieter Brueghel the Elder and were continued by Pieter Brueghel the Younger and Adriaen Brouwer.

While the Thirty Years' War (1618–48) may have kindled interest in subjects such as these (Pée 1971, p. 131), Schönfeld's set of four pictures probably has much more to do with the artistic concerns of Schönfeld and of Karl Eusebius. The latter bought a considerable variety of Schönfeld's work and evidently was fascinated by his vigorous style and vivid inventions. The artist spent the war years in Rome and Naples, and his theatrical troops can be aligned with Rosa's romantic heroes (for example, the warriors in his approximately contemporary Figurine series of etchings) and with the colorful characters created by picaresque novelists such as Francisco de Quevedo. The idea of war as adventure appealed to painters, poets, and princes, who could imagine its supposed splendors, rather than to soldiers and ordinary citizens, who had experienced its reality.

WL

FURTHER REFERENCES: *Inv. no. 1231:* Cat. 1873, no. 656; Fleischer 1910, p. 65; Voss 1964, pp. 24, 34; Kosel 1967, p. 371; Pée 1971, pp. 39, 131, no. 57; Baumstark 1980, no. 133.

Inv. no. 1235: Cat. 1873, no. 652; Fleischer 1910, p. 65; Voss 1964, pp. 24, 34; Kosel 1967, p. 371; Ulm 1967, p. 38, no. 49; Pée 1971, pp. 131–32, no. 58.

156

157

Carl Ruthart
German, 1630?–1703?

LEOPARDS ATTACKING A LION
Oil on canvas; 37¾ × 29⅛ in. (96 × 74 cm.)
Signed (lower left): C RVTHART
Liechtenstein inv. no. 625

Ruthart, from the city of Danzig (now Gdánsk, Poland), was one of the most accomplished animal painters of the seventeenth century. Like Schönfeld (cat. no. 154), he led a peripatetic career; many of his pictures remain in rather out-of-the-way locations, such as Aquila in the Abruzzi, where Ruthart spent the last thirty years of his life. Although he was in Italy (Rome and Venice) during the 1650s, in 1663–64 he was listed as a member of the painters' guild in Antwerp. Between 1665 and 1667 Ruthart worked in Vienna for Prince Karl Eusebius von Liechtenstein. The artist was in Venice and Rome in 1672; in that year he entered the Celestine monastery of Sant'Eusebio in Rome, and shortly thereafter he withdrew to the monastery of Santa Maria di Collemaggio at Aquila.

Evidently, Ruthart was largely self-taught. Older specialists in animal painting such as Frans Snyders, Jan Fyt (cat. no. 187), and Giovanni Benedetto Castiglione have been cited as possible influences on Ruthart, but their works were clearly of no great importance for his subjects and style. Ruthart's eclectic inclinations encompassed antiquarian interests; however, his animals, including the then-exotic large cats, must have been based upon meticulous studies from life. In this respect Ruthart anticipates George Stubbs, but the arbitrary way in which his beasts are assembled and set beside other curious motifs (for example, the sculptures depicted here) is entirely within the late Renaissance tradition of *Wunderkammer* collecting and compares more closely with drawings by Jacob de Gheyn II and with the Paradise paintings of Roelant Savery (cat. no. 180). Both Ruthart and Savery would have had access to imported animals in the private zoos of princes such as Karl Eusebius and Emperor Rudolf II.

This picture provides ample evidence of Ruthart's acquaintance with Roman sculpture or at least with some of its odder forms. Lions, donkeys, stags such as the one seen in a pendant painting in the Liechtenstein collection (*Lynxes Stalking a Panther That Has Brought Down a Deer*; illustrated in Baumstark 1979, p. 59), and even foxes are found in similar poses in the ancient marble menagerie of the Sala degli Animali in the Vatican (Amelung 1908, pls. 30–39). Also relevant to Ruthart's central group is the familiar Roman motif of a lion attacking a horse, the most famous example of which was on the Capitoline Hill in his time (Haskell and Penny 1981, pp. 250–51, no. 54, fig. 128; see Amelung 1908, pl. 35, no. 195, for a similar piece). This monumental sculpture inspired the many small bronzes by Giovanni Bologna and his followers, such as Antonio Susini, that represent a lion attacking either a horse or a bull (Vienna 1978, pp. 252–58).

Ruthart's motif of a leopard on the back of a lion recalls, in the pose of the smaller cat, Susini's bronze after Giovanni Bologna of a lion attacking a horse; a version was in the Liechtenstein collection by 1658 (cat. no. 40; Vienna 1978, no. 172a). Also in Prince Karl Eusebius's possession was an apparently unique bronze from the Susini studio of a leopard, not a lion, attacking a bull (cat. no. 41). These likely models for Ruthart's undated composition suggest that the picture was painted during the artist's Viennese sojourn of 1665–67. However, the canvas entered the Liechtenstein collection only in 1786 when Prince Joseph I acquired it in Vienna from Freiherr von Bartolotti.

The connection with Susini may indicate that the other quasi-antique motifs seen here are merely reminiscent of sculptures that Ruthart could have encountered in Rome. Indeed, the herm is a pastiche of a head of Pan on a satyr's body; the circular base is probably the painter's invention. The marble vase adopts a form known from Roman glass, not sculpture, though the Triton relief is similar to figures found on sarcophagi (Maxwell Anderson of the Metropolitan Museum's Department of Greek and Roman Art made these observations). Finally, the entire composition, in which wild animals are set before a wall of rock, recalls a mosaic from Hadrian's Villa in which a lion attacks a bull and two stags are perched on the escarpment (Amelung 1908, pl. 33, no. 125a). However, this may well be a coincidental case of two artists both placing ferocious beasts in appropriately forbidding environments. Ruthart was not greatly concerned with geographical or archaeological accuracy; this picture, like many of his works, is a Northern reverie on the Roman and African worlds.

WL

FURTHER REFERENCES: Cat. 1873, no. 874; Frimmel 1886, p. 145; Cat. 1885, no. 625; Feldkirch 1971, no. 29; Baumstark 1979, pp. 52–53, no. 16; Baumstark 1980, no. 135.

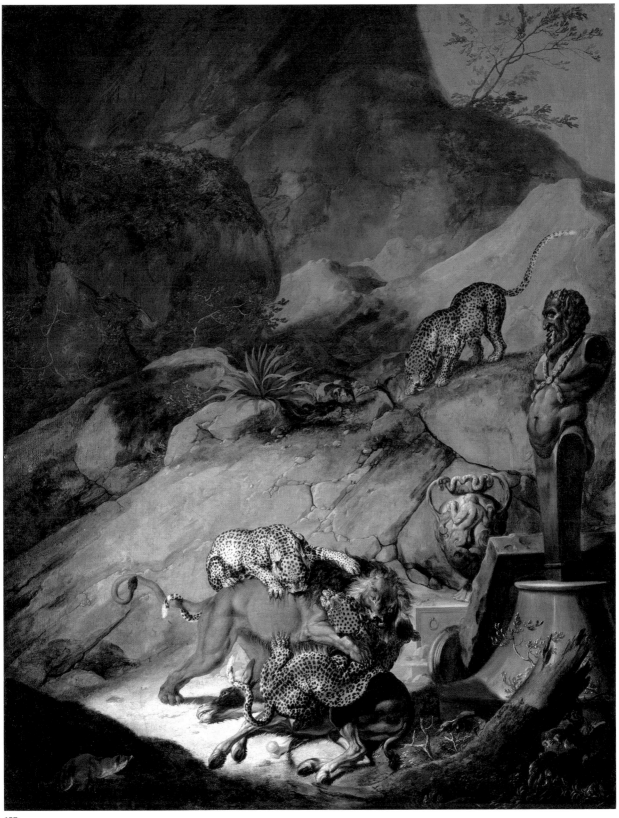

157

DUTCH PAINTINGS

158

Herman Posthumus
Dutch, act. by 1536–d. after 1542

FANTASTIC LANDSCAPE WITH ROMAN RUINS
Oil on canvas; 37¾ × 55¾ in. (96 × 141.5 cm.)
Signed and dated (right foreground, base of colossal foot): Hermañus Posthumus
pinge[ba]t 1.5.3.6.
Liechtenstein inv. no. 740

This recently discovered painting is the masterpiece of Herman Posthumus, a little-known, early sixteenth-century Dutch artist. Acquired in Vienna in 1983, this important and fascinating work is the latest indication of the continuing collecting interests of the Princes of Liechtenstein. The painting is dated 1536 and its subject—the advent of classical archaeology—is unprecedented. In this regard it is a handsome complement to the exactly contemporaneous painting by Herri met de Bles, *Landscape with Forge* (cat. no. 177), which has as its likewise unprecedented subject another of the most important developments of the Age of Discovery: the advent of industrial technology. The present painting will be the subject of two articles in the July 1985 issue of *The Burlington Magazine* by Nicole Dacos and by Ruth Rubinstein, who have generously made available here the results of their research.

The artist's signature and the date 1536 are found on the base of the colossal foot. Prior to the discovery of this painting, the artist's activity was known only for the period 1540–42. During those years he was recorded under the appellation "Meister Herman" as the second highest paid painter engaged by Duke William IV of Bavaria to decorate the new Italianate wing of the Residenz, his palace in Landshut, about forty miles northeast of Munich. Posthumus's only documented work there is an altarpiece for the chapel comprising a large panel with a nocturnal Nativity and a smaller predella panel with the Adoration of the Magi. The predella is signed "Herman Posthumus pinx." Though thoroughly influenced by contemporary North Italian painting, the style of the altarpiece reveals an artist of Northern European origin.

It is evident from what remains of the chapel decoration—a frescoed overdoor depicting the Resurrection that is painted by the same hand as the altarpiece—that Posthumus was responsible for the decoration of the entire room. To judge by his position in the records of payment, he must have painted many other rooms in the Residenz as well, though the documents do not specify which.

The decoration of the Italianate wing of the Landshut Residenz is modeled directly after the Palazzo del Tè in Mantua, which was designed for Federigo II Gonzaga by Giulio Romano. He and his assistants painted the interiors of the palace between 1527 and 1534. Apparently William IV, who was related by marriage to the Gonzaga family, imported from Mantua a number of Italian artists, recorded in the accounts of payment at Landshut, to decorate the Residenz. The influence of Giulio Romano, evident in the works at Landshut by Posthumus, suggests that he too spent time in Mantua before 1540.

The discovery of this painting dated 1536 has made it possible to establish the artist's presence that year in Rome. It reveals an apparently firsthand knowledge of archaeological remains found in that city and has led to the recognition of external evidence confirming the fact. The partially exposed subterranean corridors decorated with antique wall paintings in the foreground of the present picture form the earliest known Renaissance representation of the excavation of the Domus Aurea (Golden House of Nero), which was discovered around 1480. By the 1530s, the Domus Aurea had become a principal attraction for visitors to the Eternal City, who often left their names inscribed in the plaster of its walls and vaults. Dacos (1969, p. 157) transcribes the names found in the room called the *volta nera*. Among them are what appear to be the names of a party of Dutch artists who visited the site together, one of which, "HEMSKERC," must refer to Maerten van Heemskerck (1498–1574), who lived in Rome from 1532 to 1536. Below his name appears another —"HER POSTMA." In her forthcoming article Dacos convincingly proposes that this is the name of our artist, who would have subsequently latinized, as was then fashionable, his typically Frisian name "Postma." A Dutch origin for Posthumus is supported by the recent discovery in Landshut of the epitaph of his wife, Petronella, who died in childbirth in 1540 at the age of thirty (see Beckenbauer 1979, pp. 15–19). The inscription states specifically that she was Dutch. As he presumably was older than his wife and was probably close to Heemskerck's age, the year of Posthumus's birth can be estimated as around 1500.

In her forthcoming article Rubinstein draws attention to further possible documentation of Herman Posthumus's presence in Rome the year this picture was painted. In 1536, the year of Charles V's triumphal entry into that city, a "maestro Ermanno" was paid for decorating the Porta San Sebastiano, the gate through which the Emperor arrived. This "master Herman" could well have been Posthumus, and she suggests that reflections of the decoration for the gate, a theme of which was the conquest of North Africa, may be found in the background of the present picture, which includes various Egyptian antiquities.

The subject of the Liechtenstein painting—an imaginary landscape filled only with the remains of classical antiquity and sundry figures who study them—is distinguished by its modernity of vision. An exactly contemporaneous painting by Heemskerck that features ancient remains in a panoramic view,

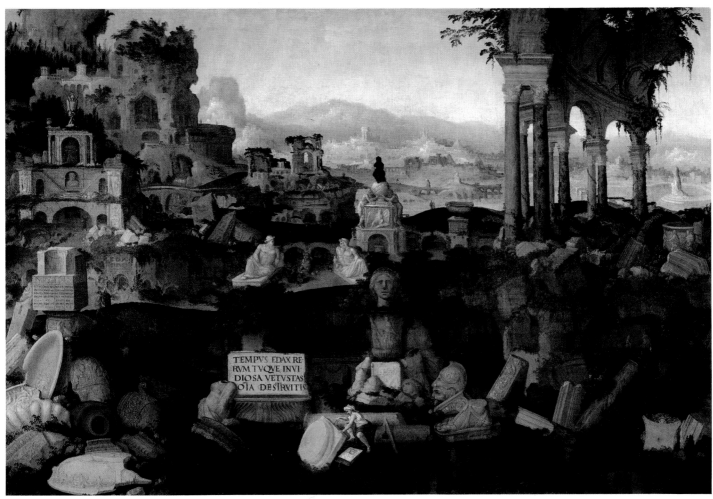

158

Fig. 39 Detail from cat. no. 158

the *Landscape with the Rape of Helen* dated 1535/36 (Walters Art
Gallery, Baltimore), offers a close parallel, but it has as its pri-
mary content a classical subject. The relationship between the
Vaduz and Baltimore paintings nonetheless attests to what must
have been a close association between two Dutch artists in Rome.
Further evidence of this is provided by Heemskerck's painting
of around 1536/37, *The Triumph of Silenus* (Kunsthistorisches
Museum, Vienna), which, just as here, is signed by its artist on
the base of a colossal sculpted foot fragment: "Martinus
Hemskerkius pingebat." Presumably Herman Posthumus
emerged, as did Heemskerck, from the workshop of the Utrecht
painter Jan van Scorel (1495–1562). This supposition is sup-
ported by the style of the panel signed with the monogram HP
that surfaced recently on the art market, a personification of
Temperance (see London 1984, no. 2).

Dacos identifies as drawings by Posthumus fifty-six
folios in the second of the two well-known albums that include
drawings by Heemskerck after antique Roman remains (Kup-
ferstichkabinett, Staatliche Museen Preussischer Kulturbesitz,
Berlin-Dahlem). The artist responsible for this group of
drawings, which includes a number from a sketchbook appar-

entently made in and around Mantua as well as a number in the style of Heemskerck after antique Roman remains, is designated the "Anonym A" by Hülsen and Egger (1916, vol. 2, pp. VII–XVIII).

The drawings with Roman subjects in the Berlin albums —some depict private collectors' sculpture gardens and courtyards—provide one of the largest single pictorial records of ancient Roman remains known in the early sixteenth century and offer numerous points of comparison to the archaeological remains seen here. In her forthcoming article Rubinstein gives a detailed catalogue of these in which she attempts insofar as possible to identify the artist's sources. Some are identifiable specifically, such as the Roman sundial and rustic calendar, the renowned *Menologium rusticum Vallense*, which was in the collection of the della Valle family in the sixteenth century but is lost today. The large female head at the center of the composition, known as the *Juno Ludovisi* after the family that acquired it in 1622, is today in the Museo Nazionale Romano, Rome. Posthumus would have known it in the famed collection of Cardinal Cesi. The same may be true of the cylindrical marble sculpture at the right, the *Albani Puteal*, today in the Villa Albani Torlonia, Rome. It too was in the Cesi collection in the sixteenth century, though Posthumus might have known it before that in the forum of Nerva where it is depicted in one of the Berlin album drawings by Heemskerck (Hülsen and Egger 1916, vol. 2, fol. 37r).

In other instances the artist seems deliberately to have obscured his sources by combining elements from similar statues—as in the two river-gods at the center which are a conflation of the pairs at the Campidoglio and at the Vatican Belvedere (one of the latter is now in the Louvre)—or by inventing composite monuments incorporating known antiquities. The fantastic funerary monument at the left is flanked by the pair of Egyptian basalt lions that were in front of the Pantheon in 1536 and are today in the Museo Gregoriano Egizio in the Vatican. The large altar dedicated to Jupiter just to the right of the river-gods is surmounted by a statue of the god that Posthumus would have known in the Villa Madama; a fragment of this statue survives today in the Museo Archeologico Nazionale, Naples.

Other recognizable monuments have been modified by the artist to appear as though in ruins. For instance, the fragment of a gadrooned basin with a relief of a Bacchic symposium below the sundial at the left is modeled after the *Torlonia Vase*, which by 1536 had been installed in the Cesi gardens where it was drawn intact by Heemskerck (Hülsen and Egger 1916, vol. 1, fol. 25v). Today it is preserved in the Museo Torlonia, Rome. The imposing architectural ruin overgrown with vegetation at the right is a free adaptation of the fourth century A.D. mausoleum of Constantia, which survives whole still as the church of Santa Costanza in Rome and which was popularly believed to be a temple of Bacchus in Posthumus's day.

The artist's reason for these modifications is made clear by the inscription from Ovid (*Metamorphoses* 15.234–35) that figures

prominently in the foreground: TEMPVS EDAX RERVM TVQVE INVIDIOSA VESTVSTAS OMNIA DESTRVITIS . . . (Ravenous Time and envious Age destroy everything . . .). The *vanitas* theme that it makes explicit has as its emblem the ancient timepiece at the left. However, as Rubinstein plausibly suggests, the implicit meaning of the painting points to the ways in which the ravaging effects of time can be counteracted. A turbaned artist in the foreground records the proportions of a column base. To the right explorers with torches descend into the grotto. In the middle ground another artist draws one of the river-gods; the arm of the other statue is measured by a man who has scaled it. These human figures are suggestive of Posthumus himself and of his view of the important role played by the artist in preserving the remains of antiquity. As Rubinstein notes: "Statues could be saved from the lime kilns by private collectors, while monuments *in situ* could be measured, drawn, and presented to scale in plan, elevation, and section, their missing parts restored on the drawing board, with the help of ancient texts, as Raphael pointed out to Leo X in his famous letter of 1519." She observes that Paul III's papal brief of November 28, 1534, appointing Latino Giovenale Manetti as Commissioner of Antiquities, describes the precarious state of Roman monuments and the dangers from which they must be protected. The *Fantastic Landscape with Roman Ruins* is best understood in this context, not merely as an illustration of the conquest of Time, but as an encouragement of classical archaeology with a plea to collectors for historical preservation.

GCB

FURTHER REFERENCE: Vienna 1983a, no. 2.

159

Abraham Bloemaert
Dutch, 1564–1651

MERCURY AND ARGUS
Oil on canvas; 31⅛ × 41 in. (79 × 104 cm.)
Signed and dated (lower center): A. Bloemart f. /1645
Liechtenstein inv. no. 349

This is one of the last and most elegant landscapes by Bloemaert, who painted it at the age of eighty-one. Throughout his long career in Utrecht, where he settled (after periods in Paris and Amsterdam) in 1593, Bloemaert was that city's most admired master. He received important commissions; he had distinguished visitors, such as Rubens and Queen Elizabeth of Bohemia; and his notable pupils included Hendrick ter Brugghen, Jan van Bijlert, Gerrit and Willem van Honthorst, Jacob Gerritsz. Cuyp, Nicolaes Knüpfer, Cornelis van Poelenburgh, Jan Both, and Jan Baptist Weenix.

This roster reflects Bloemaert's authority as a painter of figures and landscape. He frequently set biblical or mythological sto-

ries in a landscape, as did his teacher, Joos de Beer; the latter's mentor, Frans Floris; and Bloemaert's copupil under de Beer, Joachim Wttewael. However, the Italianizing tradition that linked Antwerp and Utrecht was less important for Bloemaert's landscape painting than was the Haarlem circle of Hendrik Goltzius, whose assistants, such as Jacob Matham and Jan Saenredam, engraved designs by Bloemaert as well as by Goltzius and other Haarlem artists. The evolution of Bloemaert's work broadly follows that of these Haarlem draughtsmen and engravers: his "Spranger style" Mannerism of the 1590s (seen, for example, in *Moses Striking the Rock* of 1596, in the Metropolitan Museum) was replaced by a classicizing approach and—in Bloemaert's drawings and in what might be called his farmyard scenes—by a study of motifs from nature (Delbanco 1928, pp. 27–28).

It was not until the 1630s, however, that Bloemaert, in response to younger artists (see the discussion in cat. no. 160), employed a more expansive space, realistic light and shade, and firmly modeled forms in his landscape (Müller 1927; Bodkin 1929, pp. 101–3; Fechner 1971, pp. 111–17). Occasionally a vista, like that at the right in *Mercury and Argus*, is reminiscent of works by Bloemaert's former pupils such as Both and Weenix

or by another artist of their generation. But no matter how naturalistic a figure, a tree, or any isolated passage may be, Bloemaert never abandoned his bright palette, sinuous contours, and decorative foliage—the qualities that, a century later, appealed to Boucher.

It is consistent with this predilection for stylized effects that the mythological figures in Bloemaert's landscapes, although more than mere staffage, do not disturb the langorous pastoral mood as they act out their story. In this picture, for example, Mercury lulls Argus to sleep; nothing suggests that in a moment Argus will be decapitated. Io, the lovely white heifer on the hill, was a maiden whom Jupiter had seduced and then transformed to hide her from Juno, his wife. The suspicious goddess had hundred-eyed Argus watch over the heifer, but Jupiter, feeling sorry for Io, sent Mercury to set her free (Ovid, *Metamorphoses* 1.589–751). This theme was popular with many Italian, Dutch, and Flemish artists of the time (for an incomplete list see Pigler 1974, pp. 175–78).

Bloemaert's own interpretation of the subject, and the connection to the Haarlem artists mentioned above, is clarified by a comparison with an engraving after Goltzius that may have inspired parts of the Liechtenstein painting (for instances

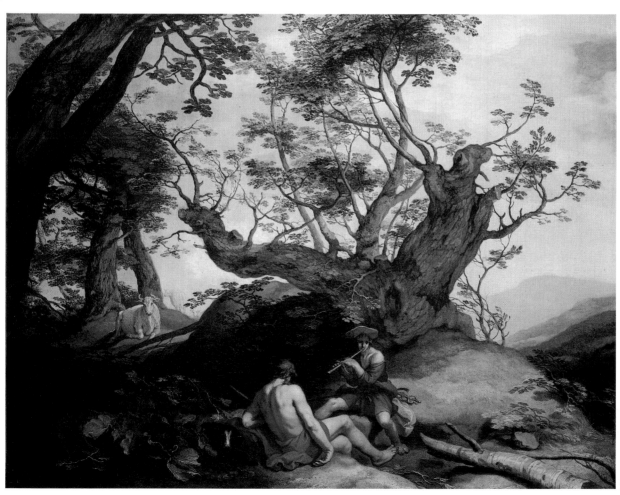

159

in which Bloemaert referred to the Ovid illustrations that Goltzius's students engraved in 1589–90, see Lavin 1965, p. 123). In both images, Mercury sits beneath an old, gnarled tree, his legs spread like the two trunks behind him. Goltzius's use of branches to fill in the design is taken further by Bloemaert, despite his more distant vantage point. The drama is diminished: Io has been herded off to the background, all of Argus's ugly eyes have been hidden from view, and he and Mercury look like nothing more than cowherds without a care in the world. To Bloemaert, it does not seem to matter: the figures seem to have been included simply to emphasize the beauty of the landscape.

Mercury and Argus was acquired by Prince Johannes I von Liechtenstein in 1836.

WL

FURTHER REFERENCES: Cat. 1873, no. 561; Cat. 1885, no. 349; Wurzbach 1906–1911, vol. 1, p. 110; Thieme-Becker, vol. 4 (1910), p. 126; Muller 1927, p. 208; Delbanco 1928, p. 77, no. 50; Cat. 1931, no. 349; Stix and Strohmer 1938, no. 52; Lucerne 1948, no. 154; Zurich 1953, no. 13; Stechow 1966, p. 25; Cat. 1970, no. 81; Baumstark 1980, no. 101.

160

Salomon van Ruysdael
Dutch, 1600/1603–1670

A COUNTRY ROAD NEAR A CASTLE
Oil on canvas; 45¼ × 61 in. (114 × 155 cm.)
Signed and dated (lower right): S. Rvysd . . . 1652
Liechtenstein inv. no. 914

In the eighteenth and nineteenth centuries Salomon van Ruysdael's reputation was totally eclipsed by that of his nephew Jacob van Ruisdael. During the past hundred years, however, he has become recognized as one of the most important Dutch landscapists of the seventeenth century. This change in appreciation is reflected in the history of Continental collections: to cite only three examples, the Rijksmuseum in Amsterdam received its first two pictures by van Ruysdael in 1870 and 1880 (the Metropolitan Museum bought three in 1871); the Mauritshuis

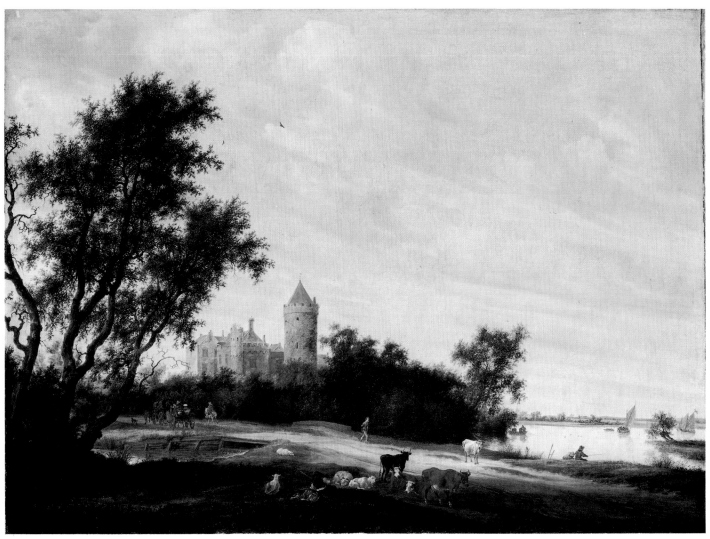

160

at The Hague purchased its first authentic painting by van Ruysdael in 1905; and Prince Johannes II von Liechtenstein acquired this picture in 1912.

With Jan van Goyen and Pieter de Molijn, van Ruysdael was a founder of realistic landscape painting in the late 1620s and the 1630s. These Haarlem artists drew upon the most advanced ideas of Esaias van de Velde, who worked in Haarlem around 1610–18 and was the first to extend the innovations he and other local artists made in landscape drawings and prints to the comparatively conservative medium of painting. Van Ruysdael, having shared with van Goyen a nearly monochromatic palette and diagonally arranged compositions during the 1630s, was more responsive than his colleagues to the richer color, stronger structure, and more heroic, perhaps more "classical" style of the younger generation that emerged about 1650 and that included Jacob van Ruisdael, Meindert Hobbema, and Aelbert Cuyp.

This new direction in van Ruysdael's mature work is wonderfully apparent in *A Country Road near a Castle*, which dates from the period in which he painted a number of his finest pictures. The main areas of the composition—the trees at the left, the sweeping clouds and bright blue sky, and the river and the road leading in a seemingly leisurely way into the background—are anchored at the castle, where the tall tower serves as a keystone in the dynamic design.

The castle is very similar to the Kronenburg near Nijmegen (Niemeyer 1959, p. 51), but van Ruysdael was not concerned with topographical accuracy (Niemeyer 1959, pp. 51–56; Stechow 1973, pp. 222–31). The building represents the life-style that appealed to patrician citizens of Amsterdam and The Hague, who traveled in carriages like those depicted here. The resting shepherd in the foreground, the man walking down the road, the fishermen, the boaters, and not least the weather remind one of the pleasures of country life, as do pastoral poems and plays of the period (Kettering 1983, chaps. 1–2). This aspect of the picture sets it apart from the approximately contemporary views of castles and country houses by Jan van der Heyden, David Teniers the Younger, and even Jacob van Ruisdael; the first two artists especially tended to treat châteaux as real estate rather than as empathetic places (in this sense, van Ruysdael's painting is a Dutch parallel to Rubens's *View of the Château "Het Steen"* in the National Gallery, London).

WL

FURTHER REFERENCES: Cat. 1931, no. 917; Beelaerts van Blokland 1935, p. 28; Ströhmer 1943a, no. 57; Lucerne 1948, no. 156; Zurich 1953, no. 138; Bregenz 1965, no. 91; Cat. 1970, no. 18; Stechow 1975, pp. 51, 150, no. 524, and p. 159, no. 660; Baumstark 1980, no. 94.

161

Aert van der Neer
Dutch, 1603/1604–1677

A CANAL WITH A FOOTBRIDGE BY MOONLIGHT
Oil on wood; 9¾ × 8¾ in. (25 × 22 cm.)
Liechtenstein inv. no. 479

Aert van der Neer, whose son was the more successful Eglon van der Neer (cat. no. 174), was a native of Gorinchem, which lies near the union of the Meuse and Waal rivers equidistant from Rotterdam to the west and Utrecht to the north. The biographer Arnold Houbraken reports that van der Neer began painting as an amateur while working as a steward for a wealthy family. He moved to Amsterdam around 1630, where two artists from Gorinchem, the Camphuysen brothers (Raphael Govertsz. and Joachim Govertsz.), were instrumental in van der Neer's early development as a landscape painter (Bachmann 1968, pp. 705–7; Bachmann 1970, pp. 243–50; Bachmann 1975, pp. 213–22). It has not been noted previously in this connection that the woman van der Neer married in Gorinchem bore the not very common name of Lysbeth Goverts (= Govert's daughter); van der Neer was probably the brother-in-law of Raphael and Joachim Govertsz. (= Govert's son) Camphuysen. This would help to explain his close association with these rather minor artists, which continued beyond his early years. In 1642 Raphael Govertsz. was a witness at the baptism in Amsterdam of van der Neer's child.

As one might expect of any artist active in Amsterdam, and particularly one who never studied under an important master, van der Neer gleaned ideas from a considerable variety of sources. His compositions are invariably related to those of earlier artists. Stechow (1966, p. 69) stressed the importance of the Fleming Alexander Keirincx, who moved to Amsterdam by 1636 after some years in Utrecht, for van der Neer's early landscapes of about 1635. Both Stechow and Bachmann mention Gillis d'Hondecoeter, who also moved from Utrecht to Amsterdam, and Bachmann (1975, pp. 213–14) maintains that the origins of van der Neer's style also may be traced, by way of the Camphuysens, to Roelant Savery in Utrecht. A comparison between the present painting and Savery's *Landscape with a Flock of Sheep* (cat. no. 180) does illuminate the eclectic quality of van der Neer's trees; for example, his tunnel-like recessions into the background are anticipated in the imaginary woodland views of Flemish artists such as van Coninxloo (cat. no. 179). This tradition trained the Dutchman's eye for the picturesque.

Van der Neer's more empirical effects, on the other hand, depend both on the pioneering works of Dutch painters and printmakers and on his independent observations. Among the most influential antecedents of van der Neer's nocturnal views were Hendrick Goudt's engraving of 1613 after Adam Elsheimer's

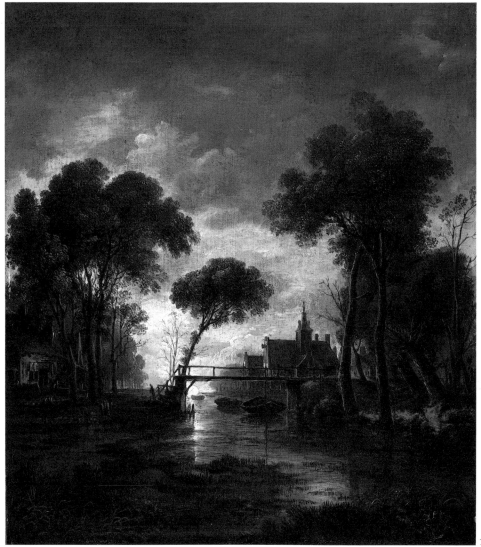

161

The Flight into Egypt, Jan van de Velde's etching of Willem Buytewech's *Ignis (The Element of Fire)*, and paintings of villages at night by Esaias van de Velde and his cousin Jan (Stechow 1966, chap. 10; van Gelder 1933, p. 112, no. v, fig. 77). Not only the night views but also the winter landscapes (Stechow 1966, pp. 92–95, figs. 181–85) and, in general, the compositional schemes of Esaias van de Velde and the slightly later Haarlem artists Jan van Goyen, Salomon van Ruysdael, and Pieter de Molijn determined van der Neer's development.

They do not, however, explain his remarkable achievement. Van der Neer's nocturnal and winter views, which, it is generally agreed, date from the late 1640s to the late 1650s, are now appreciated as individual and exceptional examples of Dutch landscape painting during its most mature period. His specialization in nocturnes may be explained partly by the demands of the art market: the great number of works van der Neer painted, the declining quality of his late work, and the fact that he died in poverty do not indicate that he chose his subject unwisely

but that he found it necessary to stay with whatever sold. At the same time, the nocturnes share with the winter views qualities of light, color, and atmosphere that the artist studied for their own sake (Kauffmann 1923, pp. 106–10; Stechow 1966, pp. 92–98, 178–79, 185). In his investigation of optical effects, he may be placed among such different but contemporary painters as Pieter de Hooch, Jan van de Cappelle, Willem Kalf, and Emanuel de Witte.

Although van der Neer's pictures are notoriously difficult to date, *A Canal with a Footbridge by Moonlight* is clearly a mature work and may be assigned to the late 1640s (Bachmann 1982, p. 67) or the early 1650s. In 1656 it was in the collection of Archduke Leopold Wilhelm of Austria; Prince Karl Eusebius von Liechtenstein acquired the painting in 1676.

WL

FURTHER REFERENCES: Cat. 1767, no. 333; Cat. 1780, no. 287; Cat. 1873, no. 725; Cat. 1885, no. 479; Hofstede de Groot 1908–1927, vol. 7, pp. 393–99, no. 310; Fleischer 1910, p. 49; Baumstark 1980, no. 89.

Philips Wouwerman
Dutch, 1619–68

ATTACK ON A COACH
Oil on wood; 23⅜ × 31⅛ in. (59.5 × 79.2 cm.)
Signed and dated (lower right): PH. W. A 1644 [PH in monogram]
Liechtenstein inv. no. 430

Wouwerman's paintings were so widely admired throughout the eighteenth century that no princely collector would have been likely not to have one or even several (consequently, the museums at Kassel, Dresden, and Leningrad each have several dozen of the artist's more than twelve hundred known works). The painter's popularity was surely enhanced by the publication of Jean Moyreau's suite of eighty-nine engravings (dated 1737–62) after Wouwerman's "meilleurs Tableaux qui sont dans les plus beaux Cabinets de Paris et ailleurs" (best pictures which are in the most beautiful collections in Paris and elsewhere), but Moyreau was already able to cite numerous "princes of the blood" among the owners of the original pictures as well as, more predictably, among the dedicatees.

A native of Haarlem, Wouwerman is said to have studied with Frans Hals and then to have eloped with a local girl to

Fig. 40 Detail from cat. no. 162

162

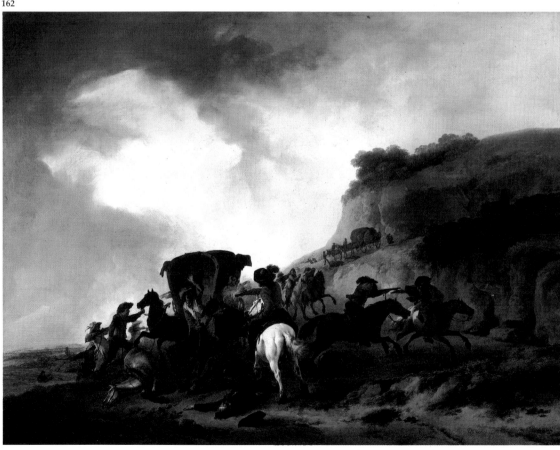

Hamburg at the age of nineteen (that is, in 1638 or 1639). He joined the painters' guild at Haarlem in 1640 and was one of its officers in 1645. His earliest dated works were previously considered to be those few inscribed 1646 (for example, the very large *Cavalry Making a Sortie from a Fort on a Hill*, in the National Gallery, London); however, a recent cleaning of the present picture has revealed a monogram and the date 1644.

Wouwerman, like other Dutch painters who exploited their personal talents and market demand (see cat. no. 161 on the nocturnes of Aert van der Neer), concentrated upon particular subjects that had already been explored, though less exhaustively and exclusively, by earlier artists. That Wouwerman appreciated the advantage of his work being readily recognized is suggested by the fact that he made the inclusion of a handsome white horse his virtual signature (white horses, to judge from remarks in the popular literature of the period, were especially esteemed). However, the motif was adopted by other painters, such as Adriaen van de Velde, and more frequently by Wouwerman's younger brothers Pieter and Jan.

Scenes of plunder, whether of towns, coaches, or unfortunate individuals on the open road, may be considered as among the happier by-products of the Eighty Years' War. The subject —often specifically that of coaches under attack—was treated repeatedly at the beginning of the seventeenth century by Dutch and Flemish painters such as Hans Bol, Sebastiaen Vrancx (sometimes in collaboration with Jan Brueghel the Elder or Alexander Keirincx), David Vinckboons, and Pauwels van Hillegaert. The theme gained a second wind with the end of the Twelve Years' Truce (1609–1621) and with paintings by the Haarlem landscapist Esaias van de Velde. In 1618 van de Velde moved to The Hague, where the local clientele, which would have included many military and courtly figures, evidently found war and plunder entertaining at certain geographic and aesthetic distances (see Keyes 1984, pp. 103–15, on van de Velde and his predecessors). The mostly mercenary troops (not to mention deserters) of both the Dutch and Spanish armies were unreliably paid, supplied, and disciplined; raids on the civilian population were routine in the more beleaguered parts of the Northern and Southern Netherlands until the Peace of 1648.

Van de Velde's example inspired younger Haarlem artists such as Gerrit Bleker, Pieter Post, Jan Martszen the Younger, Pieter van Laer, and ultimately Wouwerman (see Keyes 1984; Bol 1969, pp. 244–54). Early pictures by Wouwerman, like this one, are most closely related in composition, as well as in the subject, to the landscape paintings of van Laer. The latter artist was in Rome (where he was called "Bamboccio") from about 1625 to 1639 and died in Holland in 1642; however, it has been shown that his bucolic landscapes were sent back to the Netherlands during the 1630s, that they influenced artists such as Nicolaes Berchem, Karel Dujardin, Paulus Potter, Dirck Stoop, and Adriaen van de Velde, and that Wouwerman may have been (as his biographer Arnold Houbraken claimed in 1719) the first to examine the late van Laer's "chest filled with models, drawings,

and sketches, before anyone else stuck his nose in there . . . (one being dead is the other one's bread) . . . " (Blankert 1968, pp. 117–34; pp. 129–30 for the quotation).

Wouwerman's references to this particular iconographic tradition and to two of the most talented landscape painters of the day (Esaias van de Velde and Pieter van Laer) do not fully explain his achievement—especially that aspect of it that appealed to eighteenth-century connoisseurs. His prolific production, exceptional for its consistent level of quality even more than for sheer volume, was sustained by his remarkable mastery of figure drawing (equine no less than human); his command of composition (here, the energetic rhythms and foreshortenings of the figure group correspond both to the explosive event depicted and to the lay of the land); his sensitivity to color harmonies (usually cool); and his delicate, decorative touch (even in this very early work Wouwerman avoids not only the petty descriptiveness of, for example, Adriaen van Ostade but also Berchem's suave but superficial figure style). The fallen figure in the foreground, brilliantly placed, promises pictures of great artistic skill and expressiveness, if only rarely great in scale.

The many battle scenes by Wouwerman that date later than this painting exhibit the most extraordinary variety in their individual motifs as well as in their overall design; not one known to the writer comes close to being a variant of the Liechtenstein picture. A copy of the latter was in the Lachmann sale at Lepke's, Berlin, November 14, 1911 (no. 117, wrongly attributed to Pieter van Laer).

The present painting was presumably acquired for the Princely Collections before 1712.

WL

FURTHER REFERENCES: Cat. 1767, no. 327; Cat. 1780, no. 610; Smith 1829–37, vol. 1, p. 349, no. 502; Parthey 1863–64, vol. 2, p. 813, no. 5(?); Cat. 1873, no. 670; Cat. 1885, no. 430; Hofstede de Groot 1908–1927, vol. 2, pp. 553–54, no. 908; Cat. 1931, no. 430; Thieme-Becker, vol. 36 (1947), p. 267; Lucerne 1948, no. 1977; Cat. 1970, no. 80.

163

Philips Wouwerman
Dutch, 1619–68

LANDSCAPE WITH BATHERS
Oil on canvas; 21⅞ × 31⅞ in. (55.5 × 81 cm.)
Signed (lower right): PHILS· W *(the first character appears to be a monogram of all seven letters of the artist's first name, with the* P *and the* I *counting twice)*
Liechtenstein inv. no. 432

His enthusiasm for landscape and horses led Wouwerman to themes of either war or peace: on the one hand, scenes of battle and plunder (see cat. no. 162); on the other, pictures of leisurely pastimes set out-of-doors. The latter subjects, perhaps

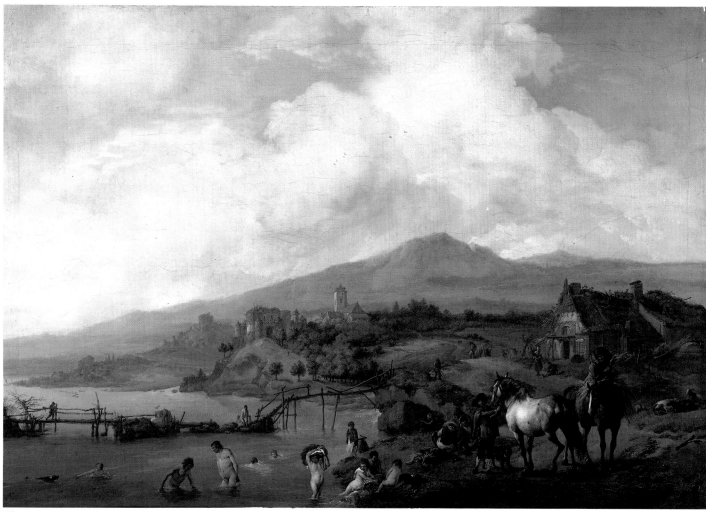

163

because of the painter's more mellow years—and certainly be-
cause of the happier times in the Netherlands (the greater part of
his career falls within the two most prosperous and peaceful de-
cades of seventeenth-century Dutch life, the 1650s and 1660s)—
predominate in his mature work. People with horses rest by
the open road, at the edge of the field in which they work, or at
the seashore, where a fresh catch of fish is frequently shown.
The more polite pursuits of hawking, dressage (in backyard
"riding schools"), and simply riding in elegant company are
also among the artist's picturesque preoccupations. It is not
surprising, then, that his paintings were so popular with aristo-
cratic connoisseurs of the eighteenth century, when society's
pleasures were much the same, but its problems—or so Pari-
sians especially would have thought—were much more complex.

One aspect, and one source, of Wouwerman's idyllic imag-
ery was Italianate landscape, where life was *dolce* in the
Northerner's view. Scenes of travelers and bathers in southerly
climes were evidently derived by Wouwerman principally from
pictures by Pieter van Laer (see Blankert 1968, especially figs.
13–14). Here, however, the extensive landscape itself is more

reminiscent of paintings by Karel Dujardin and by Jan Asselijn.
Wouwerman himself never went to Italy, but he captures
wonderfully well the warm light and sweeping space found in
the works of these Italianate landscapists and of others such as
Jan Both. Bathing scenes by other Dutch stay-at-homes, such
as Gabriel Metsu and Hendrick ten Oever, are set in local
landscapes and look as chilly as one might expect.

The present picture was presumably acquired for the Princely
Collection before 1712.

WL

FURTHER REFERENCES: Cat. 1767, no. 326; Cat. 1780, no. 611; Smith 1829–37,
vol. 1, p. 349, no. 501; Cat. 1873, no. 672; Cat. 1885, no. 432; Bode 1894a,
p. 99; Hofstede de Groot 1908–1927, vol. 2, p. 284, no. 92; Cat. 1931, no. 432;
Thieme-Becker, vol. 36 (1947), p. 267; Lucerne 1948, no. 176; Cat. 1970, no.
78; Baumstark 1980, no. 104.

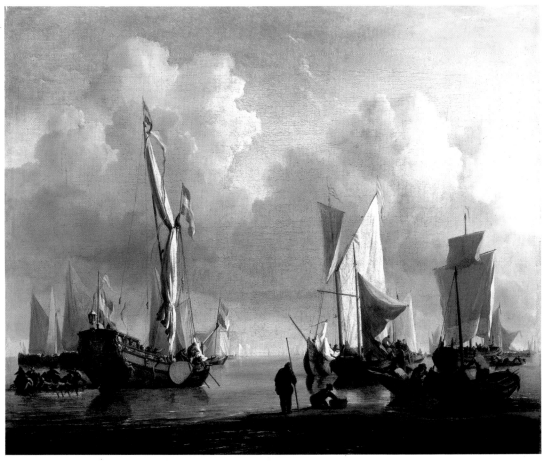

164

164

Willem van de Velde the Younger
Dutch, 1633–1707

SHIPS OFF THE COAST
Oil on canvas; 17½ × 21½ in. (44.5 × 54.5 cm.)
Signed and dated (lower center, on piece of wood): W. V. Velde 1672
Liechtenstein inv. no. 918

Willem van de Velde the Younger was the son of the marine painter and draughtsman Willem van de Velde the Elder (1611–93) and the brother of the landscapist and staffage painter Adriaen van de Velde (1636–72). The family lived in Amsterdam until 1672, when Adriaen died, the French invaded the Netherlands, and the elder van de Velde renounced his wife. Father and son went to London, where they received handsome pensions from Charles II and the Duke of York, in addition to payments for their pictures. The artists had studio space in the Queen's House at Greenwich (this building, designed by Inigo Jones, is now part of the National Maritime Museum, where a great number of paintings and drawings by the van de Veldes are preserved). Such knowledgeable contemporaries of Willem the Younger as the French critic Roger de Piles and the English

engraver and author George Vertue considered him to be the best marine painter of the period, an opinion that remains unrefuted.

The elder van de Velde was essentially a draughtsman. In the Netherlands he sometimes served the States General in an official capacity by stationing himself in the midst of important sea battles and sketching the action. These rapid records were complemented by meticulous drawings of ships and boats, some of which were prized possessions of the Dutch navy or of their occasional enemies (usually the English; see London 1982, introduction). The great majority of Willem the Elder's paintings are grisailles, that is, panels colored by monochromatic washes, upon which the ships and other details were precisely rendered with finely cut quill pens. Conventional easel pictures were left mostly to Willem the Younger, who collaborated with his father and also produced paintings of his own.

The paintings of the younger van de Velde, such as *Ships off the Coast*, are the work of an artist with rather different gifts from those of his father. As well as being a masterful and prolific draughtsman, Willem the Younger was very much a painter of the new generation that included Jacob van Ruisdael and Johannes Vermeer (the different styles of the two van de Veldes are approximately paralleled by those of the architectural painters Pieter Saenredam and Emanuel de Witte). The younger van

de Velde's approach to composition and his attention to subtle effects of light and atmosphere are attuned to a discriminating sense of pictorial values. Here, the use of highlights, silhouettes, and an unassertive scheme of horizontal and vertical elements achieves an impression of serenity, despite all the activity near the shore.

The central figure plays an important role in this respect: he draws the eye out over the water to the boats in the distance and to the horizon. One might compare the man with the pole to one of Claude Lorrain's shepherds and suggest that van de Velde, like Claude, comprehends eternity in nature by attending to its elements, here the sea and the sky. However, the extent to which a comparison to Claude seems inappropriate illuminates the Dutch artist's different understanding of experience.

Van de Velde's poetical qualities are his own, but his appreciation of the beauties of the sea and his command of appropriate artistic means were aided by Simon de Vlieger (ca. 1600–1653), with whom he probably studied around 1650. The older artist's paintings of ships lying on calm seas, sometimes with a strip of beach in the foreground (Stechow 1966, p. 104), were an inspiration not only to van de Velde but to his brother Adriaen and to the self-taught Amsterdam artist Jan van de Cappelle (1624/26–1679). These restful marines of the third quarter of the century provide a counterpoint to the stormy seascapes of van Ruisdael, Allart van Everdingen, and Ludolf Bakhuizen and are a complement to the quiet domestic world of such artists as Gabriel

Metsu and Pieter de Hooch. For the van de Veldes, at least, the year that is inscribed on *Ships off the Coast* was the last in which such a peaceful life could be found in the Netherlands.

This painting was acquired by Prince Johannes II von Liechtenstein in 1881.

WL

FURTHER REFERENCES: Bode 1894a, p. 94; Hofstede de Groot 1908–1927, vol.7, p. 98, no. 372; Willis 1911, p. 88; Cat. 1931, no. 918; Lucerne 1948, no. 188; Baumstark 1980, no. 96.

165

Matthias Stomer
Dutch, ca. 1600–ca. 1650

THE ADORATION OF THE SHEPHERDS
Oil on canvas; 46⅛ × 65⅜ in. (117 × 166 cm.)
Liechtenstein inv. no. 110

A follower of Caravaggio, Stomer is said to have studied under Gerrit van Honthorst in Utrecht. He must also have been in Flanders before traveling to Italy, where he spent most of his career, since Antwerp artists such as Rubens, Jordaens, and Abraham Janssens obviously influenced his work. Stomer's

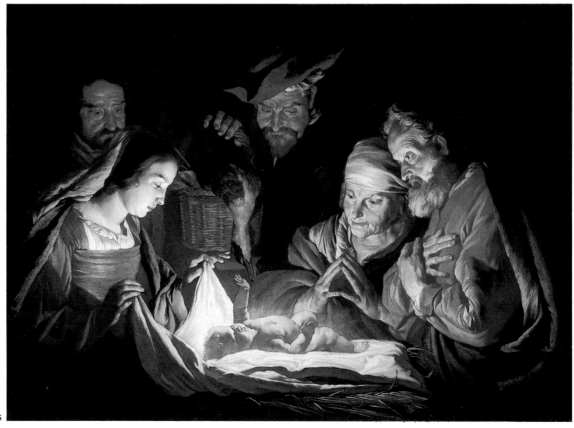

165

sources were entirely absorbed into a style that is at once personal and part of an international movement. The leathery look of his figures and the abrupt confrontations of light and shade are distinctive exaggerations of the Caravaggesque manner. Given his unvarying style, "a full-scale Stomer exhibition would be a catastrophe" (Nicolson 1977, p. 230), but the eccentric artist has the virtue, to which Rubens aspired in a different way, of not being confused with any other painter (see Rooses and Ruelens 1887, p. 145, for Rubens's remark of 1603).

Stomer usually managed to combine this assertive style with sensitive expressivity; both qualities probably account for his success in Rome (where he was recorded in 1630–32), in Naples, and (by 1641) in Sicily. Caravaggio had worked in the same centers some thirty years earlier, and other major artists, such as Jusepe Ribera in Naples, would have made local patrons receptive to Stomer's approach. He painted many religious pictures for churches and for private individuals (including the famous collector Antonio Ruffo) and a number of secular works (Pauwels 1953; Nicolson 1979).

Most of Stomer's subjects are set at night. In all his Adorations (Nicolson 1979, p. 93), the Christ Child is himself the source of light. The various half-length pictures of the Adoration of the Shepherds may, as a group, be traced back to a composition by Honthorst: the two most similar paintings by Honthorst and by Stomer are the former's *Nativity (The Holy Family with Two Angels)* in the Uffizi, Florence (Krönig 1968, fig. 4), and the latter's *Adoration of the Shepherds* in the Leeds City Art Gallery (Friedman 1977, fig. 1). In the Leeds canvas an old shepherd couple takes the place of Honthorst's angels, Joseph is shifted to the far right, a young shepherd with a chicken occupies the center of the composition, and the figures are aligned parallel, rather than obliquely, to the picture plane. The Liechtenstein painting essentially reverses the Leeds design; the viewpoint is somewhat lower and nearer, and the figures are more tightly grouped. The revelation of the Child has become a more intimate and moving experience. The central shepherd is older and more thoughtful; the bird is now dead. In form and expression, this appears to be Stomer's most mature rendering of the Adoration of the Shepherds. The picture must date from the last years of his life.

It has been recorded since 1805 in the Liechtenstein collection.

WL

FURTHER REFERENCES: Cat. 1873, no. 190 (as Honthorst); Cat. 1885, no. 110 (as Honthorst); Voss 1908, pp. 992–93, fig. 2 (as Honthorst); Schneider 1923–24, p. 29; Cat. 1931, no. 110 (as Honthorst); Schneider 1933, pp. 120, 140; Pauwels 1953, pp. 159, 189; Krönig 1968, pp. 293–94; Nicolson 1977, pp. 237, 242, no. 112; Nicolson 1979, p. 93; Baumstark 1980, no. 82.

166

Bartholomeus Breenbergh
Dutch, 1598–1657

CHRIST HEALING THE BLIND BARTIMAEUS
Oil on wood; 20⅜ × 26⅛ in. (51.7 × 66.4 cm.)
Monogrammed and dated (at left): BB / A° 163-
Liechtenstein inv. no. 664a

Breenbergh, with Cornelis van Poelenburgh, was a pioneer of Italianate landscape painting, those views of the Roman countryside, of cisalpine coasts and mountains, and of ancient history set in a timeless Italy. Later representatives of the genre include such Dutch artists as Jan Both, Jan Asselijn, Nicolaes Berchem, Karel Dujardin, and Adam Pijnacker. Born in Deventer in 1598, Breenbergh was supposedly in Amsterdam in 1619, and in that year or the next he went to Rome. He lived there for a decade and then returned to Amsterdam. Like the so-called Pre-Rembrandtists, such as Pieter Lastman and Jan and Jacob Pynas, Breenbergh was influenced by the small landscapes that were painted in Rome by Adam Elsheimer and Paul Bril. (In 1653 Breenbergh, in testifying to the authenticity of a painting by Bril, stated that he had known Bril in the years before his death in 1626, that he had seen Bril paint many of his pictures, and that he had copied some of them.)

The last digit of the date on the present painting has long been obscure (to this writer the date appears to read 1635). Rothlisberger argues that the most plausible date is 1634, on the basis of a comparison with such works as the *Landscape with the Preaching of Saint John the Baptist*, dated 1634, in the collection of Richard Feigen, New York (Rothlisberger 1981, no. 165). The same scholar observes that the architecture is derived from a drawing in the British Museum, London (Rothlisberger 1981, no. 161), which Breenbergh made during his last years in Italy; in the painting, the house has different openings, the tower is added, and the view through the archway (which includes a church closely based upon the Cathedral of Florence) is invented. This caprice of ancient, medieval, and Renaissance architecture serves to suggest the outskirts of Jericho, where Jesus, answering the pleas of the blind beggar Bartimaeus, restored his sight (Mark 10:46–52).

Breenbergh's composition recalls Pre-Rembrandtist inventions of the preceding two decades. Rothlisberger compares it to a painting by the obscure Johan de Wet which is dated 1618 and which is modeled directly on a drawing signed "Jan Pynas fe / Roma 1617" (Rothlisberger 1981, no. 160). Jan Pynas's *Christ Healing the Woman of Samaria* (now with Richard Feigen, New York) more closely anticipates Breenbergh's compact figure group. The energetic gestures of the men on either side of Christ and of the man above him on the bridge are strongly reminiscent of Lastman's demonstrative types, while the meticulous style in which the figures are painted is similar to that of con-

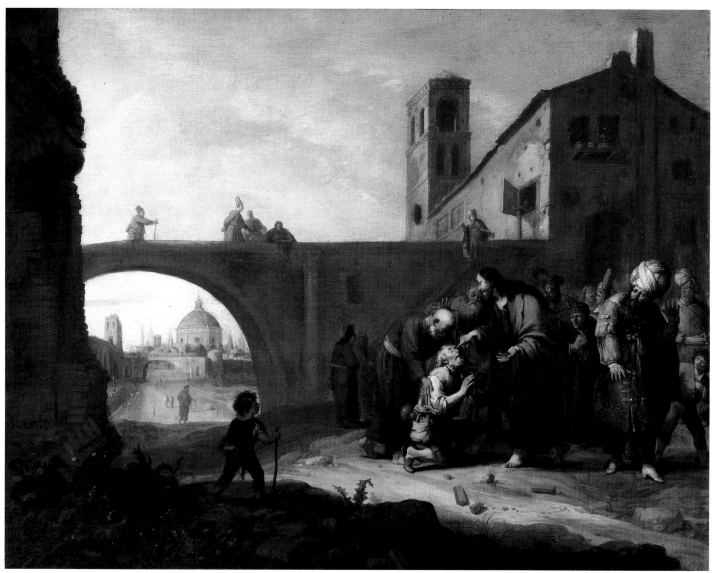

166

temporary works by Claes Moeyaert (see Rothlisberger 1981, no. 164) and, more broadly, to that of Rembrandt's religious figures dating from the early 1630s. It would not be unexpected, given these many links to artists active in Amsterdam, if a more immediate model for Breenbergh's picture were found. However, the suave but sturdy characters are distinctly his.

The same circle of Amsterdam painters produced a large number of biblical pictures; Old Testament stories and scenes from the life of Christ (often miracles) provided, in narrative form, examples of spiritual and ethical behavior. The subject of Breenbergh's painting concerns not only God's mercy but also the power of faith: it was this virtue, Christ said, that made the blind man well. The loss of sight is a sensitive subject for any artist, and in these years it was one of Rembrandt's most frequent themes (Held 1969, pp. 124–28).

This provides a background to the now-surprising circumstance that the present picture was recorded in the Princely

Collections before 1805 as a work by Lastman's pupil, Rembrandt. The painting was demoted to the oeuvre of Rembrandt's follower, Salomon Koninck, in the 1873 catalogue of the Liechtenstein collection; in his 1896 book, Wilhelm von Bode, the great German scholar of Dutch art, recognized the panel as one of Breenbergh's.

WL

FURTHER REFERENCES: Waagen, 1862, p. 287; Cat. 1873, no. 964 (as S. Koninck); Cat. 1885, no. 664 (as S. Koninck); Bode 1891, p. 11; Bode 1894a, p. 91; Bode 1896, pp. 61, 93; Höss 1908, p. 72; Hofstede de Groot 1927, p. 275 (as S. Koninck); Stechow 1930, p. 136; Cat. 1931, no. 664; Rothlisberger 1981, pp. 6, 9, 17, 67, no. 162; Roetlisberg 1985, p. 59.

167

167

Govaert Flinck
Dutch, 1615–60

DIANA AND ENDYMION
Oil on canvas; 55½ × 42½ in. (141 × 108 cm.)
Liechtenstein inv. no. 83

Although a merchant's son from Cleves, which belonged to Prussia at the time, Flinck was entirely an Amsterdam artist. He arrived there in the early 1630s, after training in Leeuwarden, and studied in Rembrandt's studio for a few years. A joint work, *Abraham's Sacrifice* (Alte Pinakothek, Munich), is inscribed

"Rembrandt verandert en overgeschildert 1636" (Rembrandt revised and overpainted 1636). Like his teacher, Flinck rarely left the city and never went abroad; Rembrandt's compositions, his manner of execution, and his figure types (even their homeliness) sufficed to fire the younger artist's imagination. He later turned, with such contemporary portraitists as Bartholomeus van der Helst and Ferdinand Bol, to a lighter, looser style based on Flemish models.

Flinck was already financially secure when he married in 1645. A few important public commissions and many portraits of prominent citizens date from this period. In his several pages on the artist, the biographer Arnold Houbraken records that Flinck had a valuable collection of ancient sculpture, of paint-

ings and drawings, and of armor and orientalia; that he moved in high social circles; and that he was a friend of the distinguished burgomasters Cornelis and Andries de Graeff (Houbraken 1719, vol. 2, p. 22). In 1656 Flinck, now a widower, wed a wealthy woman. Thus, Rembrandt's pupil enjoyed a career that the master might have envied, but his success had more to do with charm, fashion, good connections, and the readability of his history pictures than with his superficial command of Rembrandt's manner.

Diana and Endymion is one of the more entertaining works of the Rembrandt school, which most Continental courts did not collect until the early nineteenth century. (The false *Rembrandt* signature on the present painting was removed when the canvas was cleaned in 1980.) Diana was goddess of the hunt and of the moon. Her brother Apollo, the sun-god, would chase Diana and her companions (the bow-bearing figure in the background of this painting must be one of them) into darkness at the coming of dawn. Flinck must have had this in mind, since the swan, a sign of beauty, was one of Apollo's attributes. The swan appears in other tales of love, as in the escapade of Leda; it is also harnessed to the hovering chariot of Venus, as in Bartholomeus Breenbergh's *Venus and Adonis*, a panel of 1646 (Rothlisberger 1981, no. 219).

In any case, a story set on the edge of night and day is ideally Rembrandtesque. Endymion, despite evidence to the contrary here, was a remarkably handsome man whom Jupiter granted eternal youth through the practical expedient of everlasting slumber. Chaste Diana, moonstruck over Endymion, would kiss him while he slept. Sometimes he awoke, as in Poussin's painting of the early 1630s in the Detroit Institute of Arts. Conceivably, Flinck may have been aware that the story of Diana and Endymion was an ancient allegory for the sleep of death which was followed by a reawakening in paradise (Lawrence 1961, vol. 1, pp. 323–24; cited by Blunt 1967, p. 122).

It has been proposed that Flinck's composition and perhaps that of Bol's painting *Jacob's Dream* (Gemäldegalerie, Dresden) depend upon Rembrandt's drawing of that subject in the Louvre (Baumstark 1980, p. 238; Blankert 1982, pp. 91–92, no. 5, pl. 3, and fig. 19 for Gerbrand van den Eeckhout's panel, *Jacob's Dream*, dated 1642, in the Muzeum Narodowe, Warsaw). These images are of general interest for the Liechtenstein picture, but Bol's *The Angel Appearing to Gideon*, painted in or about 1642 (Dienst Verspreide Rijkskollekties, The Hague; Blankert 1982, pp. 94–95, no. 11, pl. 2), is much more likely to have been directly connected with the Liechtenstein painting (Gideon kneels at the lower right, with his back turned to the angel and his hands raised). Flinck himself had already depicted kneeling figures surprised by celestial visitors (see *The Annunciation to the Shepherds* of 1639 in the Louvre and *Manoah's Sacrifice* of about the same date [Moltke 1965, nos. 19, 44, pls. 10–11]). These comparisons support a dating of *Diana and Endymion* to about 1642–45, which is consistent with the picture's apparent place in Flinck's stylistic development.

As Reinhold Baumstark has observed in conversation, the figure of Endymion resembles Rembrandt, especially as he appears in the *Self-Portrait* in the National Gallery, London. In choosing such a model, Flinck wittily adopted Rembrandt's practice of making classical heroes look like plain Dutch types.

WL

FURTHER REFERENCES: Dutuit 1885, p. 50 (as Rembrandt); Cat. 1873, no. 172 (as Rembrandt); Cat. 1885, no. 83 (as Rembrandt); Suida 1890, p. 100; Bode 1891, p. 9; Frimmel 1913, p. 423; Thieme-Becker, vol. 12 (1916), p. 98; Hofstede de Groot 1908–1927, vol. 6, p. 460 n. 44; Cat. 1931, no. 83 (as Rembrandt); Lucerne 1948, no. 146; Benesch 1956, p. 201; Moltke 1965, pp. 84–85, no. 92; Cat. 1970, no. 36; Pigler 1974, vol. 2, p. 164; Baumstark 1980, no. 115.

168

Dirck Hals
Dutch, 1591–1656

A YOUNG COUPLE
Oil on wood; 11¼ × 8 in. (28.6 × 20.3 cm.)
Signed (at right, on tree trunk): D HALS *[DH in monogram] / 1624*
Liechtenstein inv. no. 455

Dirck Hals was the younger brother and pupil of Frans Hals (1580?–1666). With Willem Buytewech (1591–1624) and Esaias van de Velde (1591–1630), he was a pioneer of the Dutch conversation piece (*conversatiestuk*), which presents scenes of fashionable society. Unlike his two contemporaries, however, Dirck Hals specialized almost exclusively in this genre and, during the 1630s and 1640s, painted pictures of a few (sometimes only one or two) figures in middle-class interiors, as well as of more elegant companies (compare the examples in Sutton 1984, pp. 204–8). Dirck Hals was probably more important for the development of Dutch genre painting than he is generally thought to have been (Liedtke 1984b); the declining quality of his later works and his close association with such distinguished artists as those mentioned here have perhaps drawn attention away from this engaging minor master.

The Merry Company scenes and similar pictures painted in Haarlem had many sixteenth-century antecedents, as well as the more immediate precedents of prints and paintings by artists active in nearby Amsterdam, such as Dirck Barendsz., Hans Bol, and David Vinckboons. One may speak, nonetheless, of a new beginning in Haarlem, where a naturalistic style and more straightforward interpretations of the theme (most earlier examples are allegorical or religious, such as those representing the Prodigal Son) reflect an interest in the manners of middle-class society. Members of the younger generation, in particular, benefited from the political and material security that their

168

de Son after Johann Liss in which a similar couple strolls along with other pairs of lovers in a garden setting (Baumstark 1980, p. 235; Liedtke 1984a, fig. 45, for de Son's print). Hals's composition and such details as the tree to the right and the large feather in the man's hat also recall Dürer's well-known engraving *The Promenade* (Strauss 1981, no. 20).

Young couples and single figures in fashionable dress were the subjects of a number of drawings by Buytewech dating from about 1615; they inspired the droll costume studies that appear in prints after Jan van de Velde and, apparently, in one by Cornelis Kittensteyn after Dirck Hals (Haverkamp-Begemann 1959, pp. 120–21 under no. 62; see figs. 12–14, 18–21, 32–33, 38–44, etc.). The technique of Hals's panel is also closely related to that of Buytewech's paintings and even more closely to that of Frans Hals's works. These various influences clearly did much to sustain Dirck Hals's artistic efforts during the 1620s, the decade in which he produced his finest pictures (for example, the *Fête Champêtre*, Rijksmuseum, Amsterdam).

WL

FURTHER REFERENCES: Cat. 1873, no. 801; Cat. 1885, no. 455; Lucerne 1948, no. 203; Baumstark 1980, no. 111; Liedtke 1984a, p. 185 n. 45.

169

Jan Miense Molenaer
Dutch, ca. 1610–68

THE KING DRINKS
Oil on wood; 16⅜ × 21⅞ in. (41.5 × 55.5 cm.)
Signed (at far left, on chair): J miensen molenaer
Liechtenstein inv. no. 447

Twelfth Night Feast, also known as the Feast of the Epiphany and the Feast of the Kings, is celebrated on January 6 and commemorates the Adoration of the Magi. In the Netherlands the occasion was also called the Feast of the Bean, since whoever found the single bean hidden in a cake would be named king and preside over the festivities. The king received a paper crown printed with simple woodcut images of the Virgin and Child, Joseph, and the Three Kings; the only surviving example from the seventeenth century bears a close resemblance to the outer part of the crown seen here on the chair at the left (Kisch 1984, pp. 43–51, fig. 14). Also entrusted to the monarch of the moment were *koningsbrieven* or *billets du roi*, printed paper slips which bore the titles of the members of the court (queen, steward, chamberlain, jester, and so on) and in some cases quatrains describing the duties of these offices. Seven indecipherable *billets du roi* are seen here: on the cap of the old woman seated in the chair at the left (the queen), on the two smokers immediately behind the table, on the fiddler's hat, on the standing man behind

elders—many of whom, like the Hals family, were Flemish emigrants—had struggled for decades to achieve and, in their social ambitions, were unencumbered by traditional notions of nobility. Thus this painting of a young couple in modish attire should be considered, despite the striking formal similarity, as an image very different from Rubens's late (ca. 1639) self-portrait with his wife, Helena Fourment, and their son Peter Paul in the Metropolitan Museum (see Liedtke 1984a, pp. 176–85, and fig. 41, for the strolling couples in Rubens's *Garden of Love*, Prado, Madrid). Rubens's figures are presented as pillars of their society, whereas Dirck Hals's are merely ornaments of theirs, and amusing ones at that.

The comparison also illuminates the fact that Hals's little panel, which was painted about fifteen years before Rubens's family portrait, depends upon the venerable tradition of the Garden of Love and related images in Northern art. Baumstark, in stressing this point, describes the parklike setting; he observes that the panel has been cut down on the left and that a garden motif, such as a fountain or an arbor, may have been included in the composition, and he cites an engraving by Nicolas

him, and on the two boys at the right (on one's hat and on the pipe stuck in the hair of the other).

Whenever the king happened to drink, the entire company would cry out in unison, "Le roi boit!" Anyone who failed to shout loud enough or at the right time was subject to punishment, such as having soot smeared on his or her face. In Molenaer's picture no one runs the risk. The barmaid in the left background and the dog in the foreground are exempt from participation, if not from irritation.

The subject, which always features a male member of the party in the role of king, is best known from paintings by Jan Steen (for example, his canvas in the Staatliche Kunstsammlungen, Kassel, where the king is a little boy; Kisch 1984, fig. 16) and Jacob Jordaens (Liedtke 1982–83, pp. 289–90). Their figures and settings seem almost respectable compared to Molenaer's group of guzzlers (the chalk marks on the table record rounds served) and his tavern interior. The royal aspect of the king and queen, although they have pulled up proper chairs as thrones, is somewhat diminished by the king's displaced crown (which is forgivable, considering the size of the jug) and the queen's missing teeth.

Nothing is known of Molenaer's training, but he was a native of Haarlem, and his low-life scenes were inspired by those of Frans Hals and of Hals's supposed pupils, Adriaen Brouwer and Adriaen van Ostade. Unlike these artists, Molenaer tends to overestimate the viewer's appetite for loutish levity. Here, however, his humor is perfectly suited to the clamorous moment represented.

This painting has been dated to about 1637 because it "reveals traits of the Utrecht style"; because a knowledge of this manner would have come to Molenaer through his wife, the painter Judith Leyster; and because the couple married in 1636 (Baumstark 1980, p. 219). However, the vigorous modeling and energetic contrasts of light and shade do not, at this date, require any reference to the Caravaggesque genre scenes of Utrecht; Molenaer must have been familiar with them, and probably knew his wife, before 1636. A dating to the mid- to late 1630s is convincing, nonetheless, on the strength of comparisons with other works by the artist, such as *The Denial of Peter*, dated 1636 (Szépmüvészeti Múzeum, Budapest).

The King Drinks has been recorded in the Princely Collections since 1780.

WL

FURTHER REFERENCES: Cat. 1780, no. 613; Cat. 1873, no. 683; Cat. 1885, no. 447; Cat. 1931, no. 447; Lucerne 1948, no. 194; Bauch 1960, p. 37; Schnackenburg 1970, p. 168 n. 25; Baumstark 1980, no. 85; Sutton 1984, p. 265 n. 3.

169

170

170

Pieter de Bloot
Dutch, 1601–1658

CHRIST IN THE HOUSE OF
MARY AND MARTHA
Oil on wood; 18¼ × 26 in. (46.5 × 66 cm.)
Signed (on paper on shelf to right): P. de Bloot / 1637
Liechtenstein inv. no. 663

The story of Christ in the home of his friends Mary and Martha (Luke 10:38–42), with its comparison between spiritual and mundane matters, was a favorite theme of painters, and presumably of preachers, during the seventeenth century in the Netherlands. In this picture Martha has left the kitchen area (the live chickens suggest much labor ahead) and complains to Christ that her sister is not helping. He admonishes Martha for being absorbed in housework—the same view was taken of Dutch housewives by foreign travelers—and declares that Mary's more profound preoccupations shall not be denied her.

Contemporary authors, especially Jacob Cats, placed domestic diligence with cleanliness next to godliness. An opposite quality —negligence with moralistic implications—was attributed by Dutch artists to maidservants who allowed a cat to steal fish or meat (the motif occurs frequently in the works of Nicolaes Maes and Jan Steen). De Bloot's iconographic digression—the cat in

the foreground—is characteristically naive. So is his idea of an ancient dwelling, which, despite the classicizing desk and a wall hanging representing Moses' Tables of the Laws, looks entirely like a seventeenth-century peasant interior as painted by Teniers (cat. no. 193).

De Bloot was one of several artists in Rotterdam who depicted the interiors of barns and humble houses, often with extensive passages of still life (Heppner 1946). The most talented member of this group, Herman Saftleven, was evidently in Antwerp in the early 1630s and certainly knew Teniers (Klinge 1976). Pictures by Herman's brother Cornelis, by the Saftlevens' colleague Hendrick Sorgh, and by their follower François Ryckhals of Middelburg also reveal the influence of Teniers's early paintings of peasant interiors. De Bloot's composition conforms to a scheme that Teniers repeatedly employed: the L-shaped plan of the space, the still-life arrangement serving as a repoussoir, the placement of the figures in the back of the room, and the insistent attention to details, textures, and light effects in the still life are all strongly reminiscent of Teniers. De Bloot's colors, on the other hand, are more locally applied than in Teniers's pictures, where richer effects of light and atmosphere are usually achieved. The bold palette of this picture enhances the impression that de Bloot's still life of many fruits and vegetables was inspired by Flemish "kitchen" or "market" paintings, such as those by Frans Snyders. They, in turn, have origins in the large still lifes of Pieter Aertsen and

Joachim Beuckelaer, both of whom placed biblical subjects, including the present one, in the backgrounds of their pictures.

This panel, then, is of interest not only for its obvious charm but also as an example of the continuing ties between Dutch and Flemish artists after the end of the Twelve Years' Truce (1609–1621) and before the Peace of 1648 (see Duverger 1968). The picture is also, in its execution, one of the painter's finest works. Another treatment of the subject, signed by de Bloot and dated 1641, is in the Museu Nacional de Arte Antiga, Lisbon (Haverkorn van Rijsewijk 1910; Haak 1984, p. 408, fig. 884).

This painting is traceable in the Princely Collections since 1805.

WL

FURTHER REFERENCES: Cat. 1873, no. 960; Cat. 1885, no. 663; Bode 1894b, p. 88; Haverkorn van Rijsewick 1910, p. 138; Cat. 1931, no. 663; Heppner 1946, p. 17.

171

Hendrick Gerritsz. Pot

Dutch, ca. 1585–1657

PORTRAIT OF A SEATED WOMAN
Oil on wood; 17⅛ × 13⅜ in. (43.5 × 34 cm.)
Liechtenstein inv. no. 901

Like the two somewhat younger Amsterdam artists Thomas de Keyser and Pieter Codde, Hendrick Pot, who worked in Haarlem, specialized in small, finely finished portraits of upper-middle-class citizens. Codde and Pot also exploited their ability to depict fashionably dressed figures and modern manners by painting genre scenes. It was in the circle of Codde, Willem Duyster, and Pot that Gerard ter Borch, studying in Haarlem in 1634–35, began to produce his own exquisite small portraits, as well as pictures of everyday life.

Pot was at the peak of his career when he painted the *Portrait of a Seated Woman*, which dates, to judge by the costume and hairstyle (compare Rembrandt's *Portrait of a Lady with a Fan*, dated 1633, in the Metropolitan Museum), from about 1633–35. He served as dean of the painters' guild in Haarlem in 1626, 1630, and 1635 and as *hoofdman* of the guild in 1634. In 1632 he was in London, where he made small portraits of the King and Queen (White 1982, pp. 97–99) and reportedly portrayed many members of the court (Bredius and Haverkorn van Rijsewijk 1887, p. 163). The artist was back in Haarlem the following year; he appears as a lieutenant in Frans Hals's *Officers and Sergeants of the Saint Hadrian Civic Guard Company*, dated 1633, in the Frans Halsmuseum, Haarlem (Slive 1974, p. 48). Pot himself had the honor of painting the officers of the same company in 1630; his remarkably original composition is also in the Frans Halsmuseum.

Pot's style is in many ways typical of Haarlem, but it reveals a few peculiar qualities (best described by Bernstein in Thieme-Becker, vol. 27 [1933], p. 301). His interior settings are spacious and sparsely furnished; the background, as in this painting, is usually matte and unadorned. The figures, whether standing or seated, are almost always presented full-length, and props, such as a table, conform to well-established conventions; the bearing of the sitters, however, seems somewhat relaxed, and their amiable expressions temper the air of formality. Pot, although plainly a different painter from Frans Hals, was intimately familiar with his work, and he probably had the opportunity in England to appreciate contemporary portraits by van Dyck.

In Pot's *Portrait of Charles I, Henrietta Maria, and Prince Charles* (Buckingham Palace) and in a few other pictures, he separates the figures by an unexpected extent of interior space. The *Portrait of a Seated Woman* is another example of this compositional type. It was parted from a pendant portrait of a man when it was purchased for Prince Johannes II at the sale of the collection of Adrian Hope at Christie's, London, April 30, 1894 (nos. 52–53, both portraits listed as by Anthonie Palamedesz.). The male sitter is described as standing, with gloves in hand, by "a table covered with a crimson cloth, on which are his hat and two

171

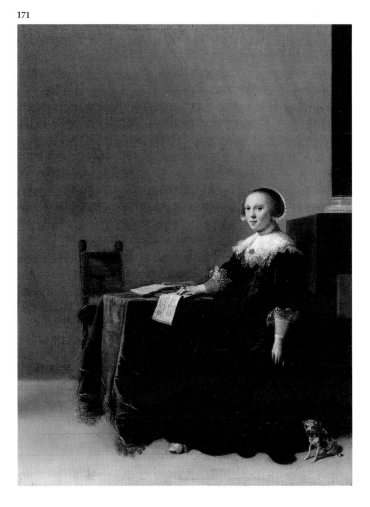

books." The gloves and books in both pictures, as well as the lady's pearls, brooch, and rings, are patrician appointments; the songbooks probably also suggest marital harmony. This reading is supported by the dog, a symbol of fidelity prevalent in Dutch portraiture (on the dog and on music, see Amsterdam 1976, pp. 66, 184).

WL

FURTHER REFERENCES: Bode 1894b, p. 87; Cat. 1931, no. 901; Bernt 1969, vol. 2, no. 933a; Cat. 1970, no. 4; Baumstark 1980, no. 109.

172

Godfried Schalcken
Dutch, 1643–1706

SELF-PORTRAIT
Oil on copper; 17 × 12⅝ in. (43 × 32 cm.)
Signed (lower right): G. Schalcken
Liechtenstein inv. no. 584

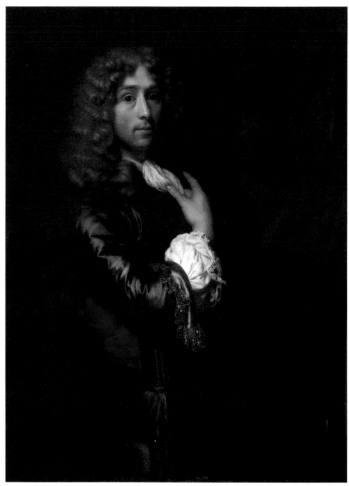

172

This superbly painted picture has never been recognized for what it is: a portrait of the artist himself, the finest example of those known to exist. The *Self-Portrait* and its pendant (cat. no. 173) were probably painted around the time of Schalcken's marriage to Françoise van Diemen on October 31, 1679, and may very well commemorate that event. At the time the artist was thirty-six years old, and his wife was almost eighteen.

Schalcken painted pendant oval portraits of himself and his wife in 1706, the last year of his life; these pictures were rediscovered twenty years ago in an Irish private collection (Roland 1963, pp. 10–11). The sitters are certainly the same as those in the Liechtenstein paintings, although they have aged a quarter century (their features may be somewhat idealized). Schalcken's appearance is also known from a number of other self-portraits; Hofstede de Groot cites fifteen, including: an early example on canvas, very much in the manner of Ferdinand Bol, in the Fitzwilliam Museum, Cambridge, since 1816 (Hofstede de Groot 1908–1927, no. 280; Gerson and Goodison 1960, pp. 116–17, no. 368, pl. 63); a canvas signed "G. Schalcken pinxit hanc suam effigiem Londini 4e 1694," in the Washington County Museum of Fine Arts, Hagerstown, Maryland (Larsen 1964, pp. 78–79, figs. 1–2); and a canvas in the Uffizi, Florence, known to have been painted in England for Cosimo III of Tuscany in 1695 (Crinò 1953, pp. 191–97, fig. 3; Crinò 1960, p. 259, fig. 40).

Roland (1963) suggests that the late pendant portraits of Schalcken and his wife might be identical with those recorded by Hofstede de Groot (nos. 284b, 284c) as sold at The Hague on July 19, 1822. However, Hofstede de Groot describes his no. 284b as "a study for Houbraken's engraving" and as sold for only "8 florins, with pendant." Neither the portraits in Ireland nor this *Self-Portrait* and its pendant would have brought such a

low amount (compare, for example, Hofstede de Groot, no. 313, a very small historical portrait by Schalcken sold in Amsterdam in 1800 for seventy-one florins); nor could either male portrait be described reasonably as a "study" for another work. Jacob Houbraken's engraving, published in the book by his father, Arnold Houbraken (1721, vol. 3, after p. 176), is a bust-length image based upon the portrait of 1694 in Hagerstown (see Hofstede de Groot, no. 285, where Houbraken's engraving should have been cited). The issue was somewhat confused by Hofstede de Groot when he suggested that his no. 284b might be identical to no. 280, the Cambridge picture, which was given to the Fitzwilliam Museum six years before the sale at The Hague of no. 284b, and which could not possibly be "a study for Houbraken's engraving."

Houbraken himself identified the figure in the foreground of Schalcken's genre scene *The Game of "Lady, Come into the Garden"* (Buckingham Palace) as a portrait of the artist (Amsterdam 1976, no. 57 on p. 223; White 1982, p. 118, no. 180, pl. 152; Sutton 1984, p. 301, no. 99, pl. 121). The painting is generally dated between 1675 and 1680, and it is thus approximately contemporary with the Liechtenstein *Self-Portrait*. The pendant portrait of Françoise van Diemen now allows us, at Houbraken's

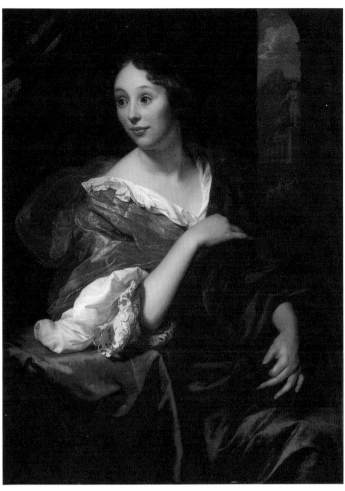

173

invitation (he states that the other figures in the London picture are also portraits), to propose that the other figure in the foreground of the Queen's picture is Schalcken's wife.

A second genre painting by Schalcken in Buckingham Palace, *A Family Concert*, also includes a portrait of the artist (White 1982, p. 117, pl. 155). The standing figure in the background appears younger than the painter in the Liechtenstein portrait, which supports a dating of the London picture to the later 1660s (White's suggestion) or the early 1670s.

The aristocratic image adopted by the artist in the present self-portrait, which conforms to international conventions of the period, may say more about the painter's ambitions (later realized) than it does about his social circumstances around 1679. Schalcken was one of six children of a parish minister, Cornelis Schalckius, who in 1654 became rector of the Latin School in Dordrecht. The artist studied in that town with Samuel van Hoogstraten and then, in the early 1660s, with Gerard Dou in Leiden. Schalcken worked mostly in Dordrecht between 1665 and 1692, when he went to London with his wife (on whether or not this was Schalcken's first trip to England, see White 1982, p. 116). He painted portraits of the monarchs William and Mary and of members of the English court; Houbraken remarks that

Schalcken made a great deal of money in England, and Thomas Platt, the unofficial English agent of the Grand Duke Cosimo III, described the artist as "un pittore olandese assai famoso" who painted large and small portraits, "night scenes," fruits, flowers, and so on wonderfully well (Platt also observed that Schalcken worked in the manner of Guido Reni) (Crinò 1953, p. 192). From 1698 Schalcken lived mainly at The Hague, where he must have had courtly clients (see his *Portrait of the Stadholder-King William III*, dated 1699, in the Mauritshuis, The Hague). He evidently worked for the Elector Palatine at Düsseldorf in 1703; Schalcken wears the medal of the Elector in the *Self-Portrait* of 1706.

A figure of Diana, in the form of a garden sculpture, appears in the portrait of Schalcken's wife (cat. no. 173) and represents the virtue of chastity. Following a long-standing tradition in French portraiture, young women were often represented as Diana; approximately contemporary examples in France by Pierre Mignard and in England by Peter Lely (*Jane Kelleway as Diana*, ca. 1668, Hampton Court Palace) are well known. It seems likely that the garland of fruits and vegetables (evidently carved on a column) and the picture of a sleeping nude woman, which appear indistinctly in the background of Schalcken's self-portrait, are also symbolic elements appropriate to marriage rather than to the painter's profession. The first motif must refer to fertility. The second is more obscure; if intended as a sleeping Venus, it might have been considered as a kind of counterpart to Diana and as an appropriate symbol for the same virtue, chastity, in a portrait of a man.

In any case, the painting within the painting probably refers to the joys of love. The warm expressions of the figures in this painting and its pendant, along with the extraordinary refinement of the execution and the care with which the compositions were conceived as a pair, indicate that, to the sitters, these pictures were special and personal treasures.

The present picture and its pendant (cat. no. 173) were acquired in 1821.

WL

FURTHER REFERENCES: Cat. 1873, no. 860; Cat. 1885, no. 584; Hofstede de Groot 1908–1927, vol. 5, p. 403, no. 339; Cat. 1931, no. 584.

173

Godfried Schalcken
Dutch, 1643–1706

FRANÇOISE VAN DIEMEN, THE ARTIST'S WIFE
Oil on copper; 17 × 12⅝ in. (43 × 32 cm.)
Signed, falsely (lower right): G. Schalcken.
Liechtenstein inv. no. 588

Françoise van Diemen (1661–after 1706) was baptized in the Grote Kerk (Great Church) in Breda on August 29, 1661. Her father, Christoffel van Diemen, was an ensign (later major) in

the army; her mother, Cornelia Beens, was the daughter and granddaughter of butchers, as the family name (*been* = bone) suggests. (This information was provided by M. W. van Boven, Keeper of the Records at the city archives of Breda.) Françoise was engaged to Schalcken by July 3, 1679, and she married him on October 31 of that year. They had eleven children, but only one, their daughter Françoise (b. 1690), lived beyond childhood. Both his wife and his daughter survived the artist. For further details concerning the subject and date of this picture, see cat. no. 172.

WL

FURTHER REFERENCES: Cat. 1873, no. 864; Cat. 1885, no. 588; Hofstede de Groot 1908–1927, vol. 5, p. 409, no. 360; Cat. 1931, no. 588.

174

Eglon Hendrik van der Neer
Dutch, 1634?–1703

A YOUNG WOMAN WITH A PLATE OF OYSTERS
Oil on wood; 12½ × 10½ in. (30.8 × 26.8 cm.)
Signed (at right, on tabletop): E. van der Neer 1665 f.
Liechtenstein inv. no. 475

As in the case of his contemporary Godfried Schalcken (cat. no. 172), Eglon van der Neer's first independent works date from the prosperous period in the Netherlands of the 1660s, and they respond to the demand, which was strongest in the artist's native Amsterdam, for little luxuries like this exquisitely executed image of a modish young woman. She offers oysters to an imaginary gentleman with whom the purchaser of the picture might have identified, but, despite this delicacy's reputation as an aphrodisiac, the woman and the viewer seem uninvolved (compare Jan Steen's *Girl Eating Oysters* in the Mauritshuis, The Hague). She holds her pose in the manner of a model in a fashion photograph, and indeed, van der Neer's small painting is essentially a still life of her stunning satin dress and appropriate accessories. Those scholars who have spoken of a tendency toward "aestheticization" in Dutch genre painting during the second half of the seventeenth century might find a perfect example in this painting (Sutton 1984, pp. LXI, LXVI n. 133; Liedtke 1984b, pp. 166–67, 176 n. 48).

The biographer Arnold Houbraken states that van der Neer was a pupil of his father, the landscapist Aert van der Neer (cat. no. 161), and of Jacob van Loo. The latter was a successful Amsterdam portraitist and history painter who, like Gerbrand van den Eeckhout, painted scenes of stylish young couples and companies during the 1650s (Sutton 1984, nos. 43, 64). Perhaps through van Loo's connection with Constantijn Huygens, the connoisseur and secretary of the Prince of Orange, Eglon van der Neer, at about the age of twenty, became painter to Count

van Dona, the Dutch Governor of the principality of Orange in Southern France. In February 1659 van der Neer was married in Rotterdam; he and his wife lived in Amsterdam until about 1664. The couple then moved to Rotterdam, where the artist's wife died in 1677. He went to Brussels, remarried there in 1681, and in 1687 was named a court painter to Charles II of Spain. Van der Neer must have served in this capacity without leaving Brussels; he moved from there to Amsterdam in 1689. In the following year he was appointed court painter of the Elector Palatine, Johann Wilhelm, in Düsseldorf. Van der Neer married for the third time there, and he died in Düsseldorf on May 3, 1703. His aristocratic patrons, and perhaps his many children (sixteen by his first wife, nine by his second), indicate that van der Neer had a very prosperous career.

The artist took his subjects and compositions mostly from the oeuvre of Gerard ter Borch, whose rendering of fine materials, along with Gabriel Metsu's manner in Amsterdam (compare, for example, Metsu's *Musical Company* in the Mauritshuis, The Hague), were emulated by van der Neer. The origin of the Liechtenstein painting's composition—that is, of the woman's pose and expression and of the placement of the table and chair in the picture field—may be located precisely in a lost painting by ter Borch that is known from a few copies, one of which is in the Metropolitan Museum (Gudlaugsson 1959–60, vol. 1, p. 304, fig. 147; vol. 2, p. 161, no. 147b). Gudlaugsson claims that the execution of the New York canvas "indicates decisively" that Eglon van der Neer is the copyist. This may not be immediately evident: the work is a much more modest undertaking than the Liechtenstein picture and lacks all the fine materials that would allow a closer comparison. Nonetheless, Gudlaugsson appears to be right; the quality of the little-known work in New York is higher than one would be led to expect from published photographs, and the description of, for example, the facial features is consistent with the Liechtenstein painting and with other works by van der Neer.

He made, then, a copy of a composition by ter Borch, probably around 1665, and then painted *A Young Woman with a Plate of Oysters* and another picture (sold at Sotheby Parke Bernet, New York, January 22–23, 1976, no. 22; later at the Richard Green Galleries, London; a canvas measuring 14½ × 11 in. [37 × 28 cm.]), both of which are signed and dated 1665. The version on canvas is closer to van der Neer's copy after ter Borch in that the woman's head and shoulders are modestly covered, and she looks up from a book (the other objects on the table differ). In the Liechtenstein painting, finally, the dress, which was already more elaborate in the first of the two independent works, has become exceedingly sumptuous; strings of pearls and an extraordinary ribbon have been added; and an entirely different class of objects is on the table. It is almost as if, in her progress from a book and writing implements in the copy after ter Borch, to the book, the face powder, and the mirror in van der Neer's first rethinking of the theme, to the wine, the oysters, and the elegant attire in the Liechtenstein picture, the young

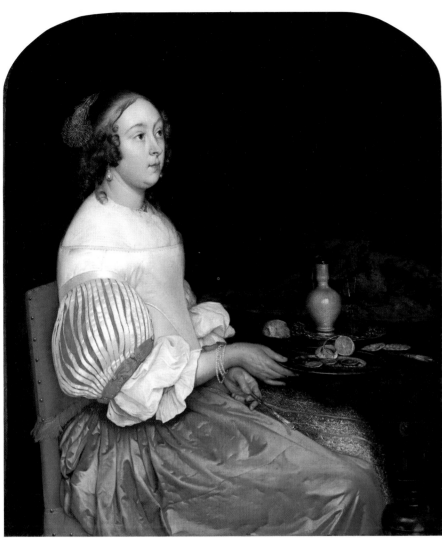

174

woman has made her way into society: a girl from ter Borch's Deventer is now a lady of Amsterdam. Or rather, of Rotterdam and The Hague, for around 1664 van der Neer moved to Rotterdam, near Delft and The Hague. Caspar Netscher, ter Borch's former pupil, painted portraits of the aristocracy in The Hague and in 1665 made a drawing that appears to follow, in reverse, ter Borch's original composition (Gudlaugsson 1959–60, vol. 1, p. 161, pl. XVI, fig. 4). Van der Neer is known to have spent time at The Hague; in that city he later joined Pictura, the painters' confraternity, of which Netscher had been a member since 1662. Did Netscher own ter Borch's original painting, or did he at least make it known to van der Neer? The question is of interest not only for their relationship, but for Vermeer's treatment, during the mid-1660s, of the subject of a woman looking up from her writing at a table in the foreground (*Lady Writing a Letter*, National Gallery of Art, Washington, D.C.; *Lady with Her Maidservant*, Frick Collection, New York).

The present picture was recorded in a Liechtenstein inventory of 1720. WL

FURTHER REFERENCES: Cat. 1780, no. 267; Smith 1829–37, vol. 4, p. 178, no. 29; Cat. 1873, no. 721; Cat. 1885, no. 475; Hofstede de Groot 1908–1927, vol. 5, pp. 490–91, no. 59; Cat. 1931, no. 475; Cat. 1970, no. 5; Baumstark 1980, no. 112.

FLEMISH PAINTINGS

175

Quentin Massys
Flemish, 1466–1530

PORTRAIT OF A CANON
Oil on wood; 29⅛ × 23⅛ in. (74 × 60 cm.)
Liechtenstein inv. no. 928

This portrait, remarkably well preserved and recently cleaned anew, is one of the great masterpieces from Vaduz. It was seen by Passavant (1836, pp. 317–18) at Fonthill Abbey, when it belonged to William Beckford. Subsequently it passed through the Wilson and Secrétan collections (see Paris 1881, no. 62, and Paris 1889, no. 138, respectively) and it was acquired by Prince Johannes II in 1889.

Quentin (also spelled Quinten) Massys (also spelled Metsys and Matsys) was the greatest Flemish artist of his generation. In the course of his artistic development, he became the first Netherlandish painter to make the transition from a late medieval to a full-blown Renaissance style. Born in Louvain, he became in 1491 a master in the painters' guild of Antwerp, where he lived until his death. His early works show the influence more of the Bruges painter Hans Memling than of Dieric Bouts, the leading painter in Louvain prior to Massys. His work after 1512 displays the marked influence of Leonardo da Vinci.

The identity of the man represented here is not known. His black biretta, diaphanous white surplice, and almuce carried over his left arm indicate that he is a canon, that is, a secular clergyman associated with a cathedral or collegiate church. He regards the viewer with a shrewd eye; it appears as though his studies have just been interrupted—he has removed his glasses and marks with two fingers the places in the book where he was at comparative reading.

In the nineteenth century the Liechtenstein painting was thought to be a portrait of Stephen Gardiner (ca. 1497–1555) and was attributed to Hans Holbein the Elder. According to second-hand information reported by Conway (1921, p. 319 n. 1), the panel once had glued to its back a bit of old vellum inscribed in Elizabethan script "Stephen Gardiner, Bishop of Winchester." That information seems spurious. There is an inscription on the panel's reverse written in ink in what appears to be not earlier than a nineteenth-century hand (William Beckford's?): "Stephen Gardiner—H. Holbein." Baumstark (1980, no. 32) proposes a reconsideration of the former identification of the sitter. Gardiner, who became a doctor of civil law in 1520 and of canon law in 1521, was named secretary to Cardinal Wolsey, Lord Chancellor of England, in 1525. In that capacity he was sent on diplomatic missions to France in 1527 and to

Rome in 1528 and 1529. If the Liechtenstein portrait is so late (see below), and if Gardiner traveled through Antwerp during one of these trips, it is conceivable that he might have commissioned the portrait from Massys. Subsequently he became Bishop of Winchester and ultimately Lord Chancellor under Queen Mary I.

Authenticated portraits of Gardiner (Trinity Hall, Cambridge [reproduced in Trapp and Herbrüggen 1977, no. 206]; Corpus Christi College, Oxford; Marquess of Anglesey collection, Plas Newydd, Wales)—all mediocre, possibly seventeenth-century copies of a portrait made of Gardiner late in life—record a man with features not exceedingly different from those of the subject of the Liechtenstein portrait. However, lacking other documentation it seems likely that Gardiner's name was attached to the Vaduz picture in a learned attempt to match a well-known historical figure with an excellent anonymous portrait. Silver (1984, p. 165) attempts to identify the sitter as Nicolai Aegidius, whose brother, Pieter Gillis (Petrus Aegidius), was portrayed by Massys in 1517. His argument, based on slim circumstantial evidence, is also not convincing.

Like so much of Quentin's art, the landscape in the present picture, albeit wondrously observed, is archaizing. It harks back to the tranquil, bright landscape backgrounds found in works by Rogier van der Weyden and Hans Memling. The format of the portrait too, with the sitter in an open landscape, derives from the type introduced in the Netherlands by Memling, although Massys synthesizes Memling's invention with more recent North Italian developments of the type. Portraits by the Milanese follower of Leonardo, Andrea Solario, such as the one dated 1505 of Giovanni Cristoforo Longoni (National Gallery, London), seem particularly to have exerted an influence.

As Friedländer (1929, p. 64) observes, Quentin was not primarily a portraitist by profession. Instead of adopting a formulaic approach to portraiture, he addressed each sitter with originality, devising schemes appropriate to the individual circumstances of the subject. As a result, the twenty or so portraits attributable to Massys hardly cohere stylistically. And, not surprisingly, his portraits are most often painted in a decidedly more naturalistic style than are his religious subjects. These factors make dating his portraits on stylistic grounds difficult.

Six portraits of the seven by Massys that are dated or datable by external evidence were painted between 1509 at the earliest and 1523 at the latest—the portrait of Christian II of Denmark wearing the collar of the Order of the Golden Fleece (Episcopal Museum, Kroměříž, Czechoslovakia) must have been painted before the latter date, the year he ended his stay in Antwerp, but it was probably painted soon after 1519, the year he was named to the Order. It is apparent that the present portrait is later than all of these. The *Portrait of a Man* dated 1527 (Royal

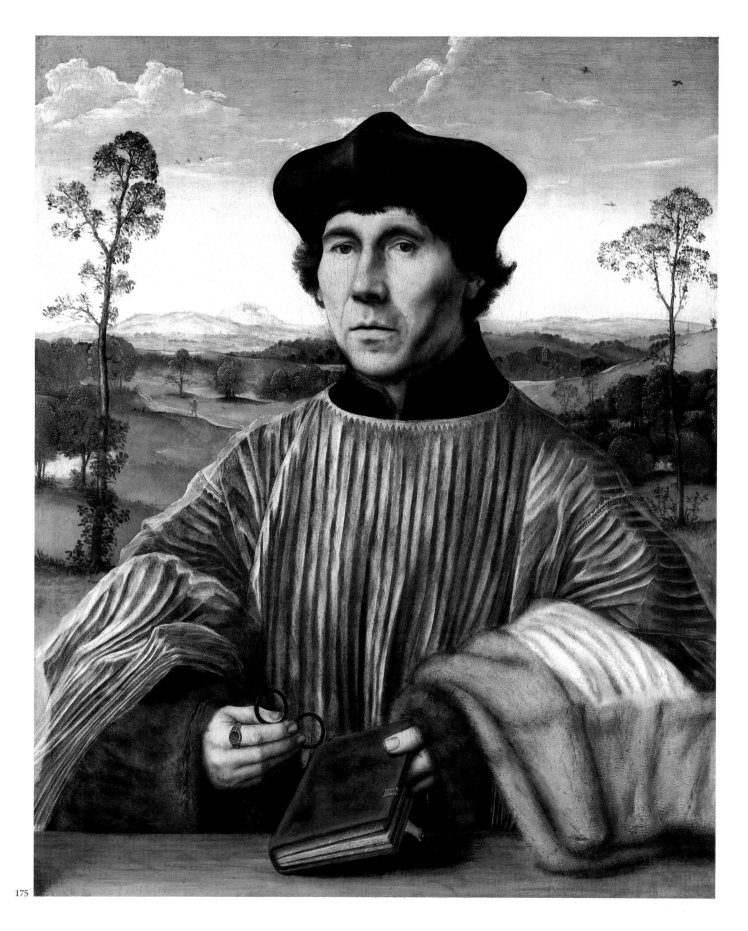

collection, Windsor Castle) is an anomaly; the date might also be read 1521, but even so the portrait's appearance is surprisingly conservative.

The *Portrait of a Canon* is related to two other portraits thought to be among the artist's latest: the *Portrait of a Notary* (National Gallery of Scotland, Edinburgh) and the *Portrait of a Man with Glasses* (Städelsches Kunstinstitut, Frankfurt). The first is not so finely painted, but the second vies with the Vaduz painting for the honor of being Quentin's greatest achievement in portraiture.

There is often a tendency in art-historical methodology to date works showing the highest quality to the artist's latest phase. Bosque (1975, pp. 240–42) dates both the Liechtenstein and the Frankfurt pictures to the last years of Massys's activity, 1525–30. Comparison of the Frankfurt picture with Quentin's *Virgin and Child* dated 1529 (Louvre, Paris) justifies its dating to the artist's latest period. However, there seems to be no compelling reason to assign the present picture to the same time. The most that can be said with certainty about the date of the *Portrait of a Canon* is that it is one of the later portraits painted in the 1520s.

GCB

FURTHER REFERENCES: Suida 1890, p.120; Bode 1895a, p. 120; Friedländer 1903, no. 190; Cohen 1904, pp. 74–75, 90–91; Scheibler 1904, p. 537; Clemen and Firmenich-Richartz 1905, no. 163; Dülberg 1905, p. 544; Bosschère 1907, pp. 106–107; Brising 1908, p. 36; Höss 1908, pp. 47–48, 65–66; Wurzbach 1910, vol.2, p. 119; Ring 1913, p.50; Friedländer 1916b, pp. 94–95 (English trans. 1956, pp. 72–73); Winkler 1924, p. 206; Burger 1925, p. 108; Delen 1926, p. 78; Muller 1926, p. 390 n. 1 (as Jan [sic] Massys); Friedländer 1929, vol. 7, pp. 65, 121, no. 39 (English trans. 1971, vol. 7, pp. 34–35, 64, no. 39); Cat. 1931, no. 928; Baldass 1933, pp. 156, 173; Schöne 1939, pp. 22, 31; Boon [1942], p. 51; Strohmer 1943, p. 95; Lucerne 1948, no. 77; Mallé 1955, pp. 101–102; Salvini 1958, p. 129; Broadley 1961, pp. 97, 103ff.; Cat. 1965, no. 61; Benesch 1965, p. 88; Faggin 1968, pp. 15–16; van Puyvelde 1968, p. 231; Cuttler 1968, p. 422; Robbins 1972, p. 65; Bosque 1975, pp. 60, 61, 68; Baumstark 1980, p. 7, no. 32; Silver 1984, pp. 114–15, 166–67, 169, 172, 239–40.

176

Jan de Cock
Flemish, act. by 1506–d. before 1527

THE MEETING OF SAINTS ANTHONY ABBOT AND PAUL OF THEBES

Oil on wood; 13⅛ × 18½ in. (33.4 × 47 cm.)
Liechtenstein inv. no. 710

This small painting is the masterpiece of Jan de Cock. It has as its subject the meeting in around the year 341 of two hermit saints, Anthony Abbot and Paul of Thebes. The story of the saints' meeting is told in Jerome's account of the life of Paul.

Anthony renounced worldly pleasures when still young and retreated to a solitary existence in the desert. At the age of ninety, believing himself unique in having so long served God in this way, he learned of Paul, the first hermit, his senior by twenty-three years. He found the elder ascetic living at the edge of the Theban desert where his sustenance was provided by a date palm and by a raven that brought him a loaf of bread each day. On the day of their encounter, the raven, the agent of divine providence, delivered a double ration. Anthony lived with Paul until the elder saint's death a few years later. In the background of the present painting, Anthony is seen twice again—burying his friend and continuing his wanderings.

The cluster of palms at the right is nearly the only indication of the Egyptian desert where the meeting took place. The artist has fabricated an intimately viewed landscape with the two old men cozily seated in a well-worn clearing in a forest teeming with life. Besides the raven that occupies a central position in the narrative, there are grazing deer, a goat, rabbits, a lizard, many small birds, and an owl—the false basis for the attribution made by Bode (1895a, p.118) to Herri met de Bles (see cat. no. 177). The goat, silhouetted on the horizon at the upper right, derives from Albrecht Dürer's renowned engraving *Adam and Eve*, dated 1504, which seems generally to have influenced our artist's view of nature. Dürer's woodcut of around 1503 appears also to have provided a model for the composition, though the Flemish painter's treatment greatly surpasses Dürer's in its evocative conception of man as an integral part of the forces of nature. This is particularly evident in the prominent truncated tree that balances the composition at the right. Its gnarled and twisted form echoes that of Paul, providing as much visual interest as the human figures.

The composition is as rich in iconographic detail as it is in naturalistic observation. It appears that Paul has rid himself of all worldly possessions save one—the old, battered drinking cup by his side—possibly alluding to his role as a latter-day Diogenes. Anthony's attributes, the tau cross and the bell attached to it, postdate his life by many centuries. They derive from the dress of members of the Order of Hospitalers of Saint Anthony, which was founded around 1100. Hospitalers wore black robes bearing a blue tau cross and went about ringing bells to attract alms. A piece of branched red coral in the shape of a tau cross lies to the side of the path in front of these attributes (an observation kindly brought to the author's attention by Robert A. Koch). This is an appropriate talisman for Anthony, who had a history of being tormented by devils, for in the *Hortus sanitatus*, a book of natural history popular at the time the picture was painted, it is written "Devils fear coral, for its branches are often in the form of a cross" (see Charbonneau-Lassay 1940, p. 771).

The artist under whose name the present picture and numerous others are grouped is often called the "putative Jan de Cock" because the evidence for assigning a body of work to him is very slim. A print (reproduced in Lafond 1914, facing p. 98),

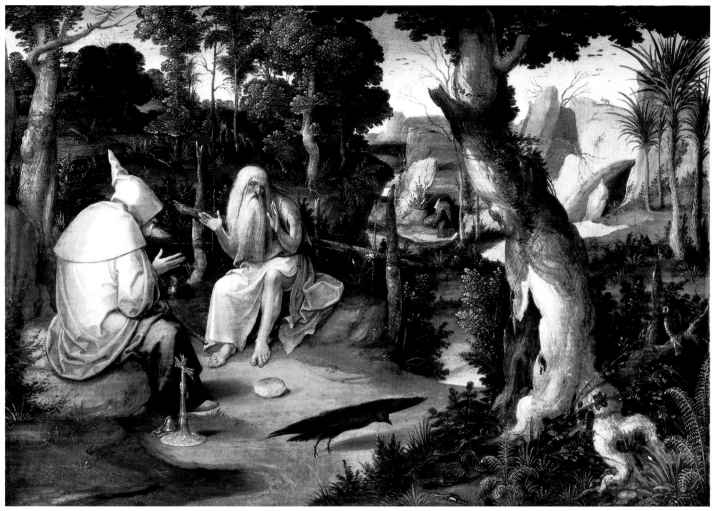

176

apparently pulled from a plate engraved in the third quarter of the sixteenth century, reproduces in reverse a painting of Saint Christopher (Baroness Elisabeth von Bissing collection, Oberaudorf, Germany, in 1969). It bears an inscription of three elegiac Latin couplets that comment on the subject. The print exists in two states, the later of which includes the phrase "C. Dankertz Exc." Cornelis Danckerts was a publisher who worked in Amsterdam toward the middle of the seventeenth century. In both this state, and the earlier one, an impression of which is in the Metropolitan Museum (56.500.198), the phrase "Pictum J. kock" appears on two lines just to the right of the third couplet. Though its form is unusual, the inscription can only mean that the painting which the print is after was painted by J. Kock. Friedländer (1915, p. 88) proposes that the reference is to Jan de Cock. The Bissing collection *Saint Christopher* remains the sole basis for all subsequent attributions to this artist.

The historical personage Jan de Cock is known from the archives of the Antwerp painters' guild, from which it emerges that he was a fairly important figure. He registered apprentices in 1506 and 1516, and in 1520 he served as dean of the guild together with Joos van Cleve. In the accounts of Antwerp Cathedral for the period Christmas 1528–Christmas 1529, there is mention of his widow.

If Jan de Cock is identical with "Jan Wellens, alias Cock," known from other Antwerp archives, then he died in 1526 at the latest. (According to an unpublished document cited by van den Branden [1883, vol. 1, p. 289 n. 2], the widow of the latter was remarried by January 19, 1527.) Accepting this likelihood, it is almost sure that our artist was the father of Matthijs Cock (d. before 1548), a landscape painter, and of Hieronymus Cock (1507–1570), the renowned printmaker and publisher. The identification of Jan de Cock with Jan Wellens makes it unlikely that Jan de Cock is to be regarded, as is usually suggested, as the "Jan van Leyen" (Jan from Leiden) who in 1503 registered as a freemaster in the Antwerp painters' guild.

The Liechtenstein picture is among the first to be considered as painted by the same artist as the Bissing collection *Saint Christopher*. Friedländer (1933, pp. 61-62) cites plausible evidence for dating both pictures to the early 1520s. The background of the *Saint Christopher* includes a scene in which a crowd of specta-

tors gathers about a beached whale. Dürer records in his journal that in 1520 he made an excursion from Antwerp to Zierikzee in order to witness just such a spectacle, which he describes as a rare occurrence. Friedländer assumes that the representation in the *Saint Christopher* refers to this event and hence provides a terminus post quem for the Bissing collection painting. A possible terminus ante quem for the present painting is provided by a woodcut dated 1522 depicting in its foreground the Temptation of Saint Anthony (reproduced in Lafond 1914, facing p. 90; an impression is in the Metropolitan Museum [40.40]). The background of the woodcut includes a representation of the meeting of Saints Anthony and Paul so similar in composition to the one seen here that the Liechtenstein picture appears to have been its inspiration. The less attractive alternative is that they share a common source that remains to be identified.

Friedländer's argument found general acceptance until Beets (1936, pp. 61, 69) put forward a different view. Because many of the paintings attributed to Jan de Cock are closely related stylistically to works by Cornelis Engebrechtsz. (1468–1527), Beets contends that they must have been painted by an artist working in Leiden. He recalls that the traditional attribution for the Liechtenstein painting, extending back to the middle of the seventeenth century, was to Lucas van Leyden, Engebrechtsz.'s most famous student. Rightly considering that attribution untenable, Beets suggests as the artist responsible Lucas Cornelisz. de Kock (1495–1552), the youngest of Engebrechtsz.'s three sons, all of whom were artists. If this hypothesis is correct, the engraver of the *Saint Christopher* erred in inscribing J. instead of L. as the initial for the first name of the artist.

Baldass (1937, pp. 127–28, 130–31) adheres to Friedländer's view, but Beets's proposal is accepted by Hoogewerff (1939, p. 368). As is evident from the lengthy bibliography, the attribution of this painting has been controversial. Though Beets's argument for Lucas has been all but totally dismissed, his view of the artist as from Leiden has found some support. Gerson (1950, p. 23) puts forward the name of Lucas's older brother, Cornelis Cornelisz. Kunst; no documented work by Cornelis exists.

In the 1520s the artistic connections between Leiden and Antwerp were especially strong, and there is often uncertainty or disagreement among scholars about which paintings and drawings should be assigned to which town. Nevertheless, the style of the Liechtenstein painting is sufficiently Flemish to have convinced all writers who have studied the picture that its artist must have spent considerable time in Antwerp. Insofar as attempts have been made to identify by name the artist who painted it and the Bissing collection picture, Friedländer's argument remains most plausible. Writers such as Hoogewerff (1939, pp. 357–60) and Franz (1969, p. 166) who want to deny the evidence of the *Saint Christopher* print suggest that the inscription identifies the publisher as Hieronymus Cock, whose first name in Latin might be abbreviated with I or J. This notion is discounted by Riggs (1977, p. 39 n. 7).

One objection to assigning these two pictures to Jan de Cock is that many of the works that have been grouped around them display a style of landscape regarded by some as postdating this artist's probable death in 1526. Indeed, Franz, who does not take into account the related woodcut dated 1522, considers the present picture to have been painted later than 1526. It should be borne in mind that many of the pictures in question have been attributed to Jan de Cock erroneously. Still, the objection cannot be easily dismissed. The assignation to Jan de Cock of *The Meeting of Saints Anthony Abbot and Paul of Thebes* must remain provisional.

There are at least two old copies of the Liechtenstein painting. One from the Khanenko collection (stolen during World War II from the Art Museum of the Ukrainian Academy of Sciences, Kiev) appears from reproductions to have been painted in Antwerp in the first part of the seventeenth century. The same holds for the other (Muzeum Narodowe, Warsaw), which is coarser in execution. A similar representation of the meeting of Saints Anthony and Paul appears in the background of a painting attributed to Jan de Cock, *The Temptation of Saint Anthony* (Stedelijk Museum 'De Lakenhal,' Leiden).

The present picture is traceable in the Liechtenstein collections since 1712. Though there is no record of its purchase, it was probably bought, as were so many Liechtenstein paintings, from the art-dealing firm Fourchoudt, which evidently had the picture sent from Antwerp to Vienna in 1668 (see Denucé 1931, p. 99, no. 5). Inventories of the estates of three seventeenth-century Antwerp painters mention a painting of Saints Anthony and Paul said to be by Lucas van Leyden: those of Peter Paul Rubens in 1640 and of Jeremias Wildens in 1653 (see Denucé 1932, p. 64, no. 178, and p. 167, no. 574, respectively), and that of Frans Snyders in 1659 (see Denucé 1949, p. 189). These references may be to one or more paintings, any one or all of which might be identical with the present one. (The last two references were kindly brought to the author's attention by Jeffrey Muller.) Hoogewerff (1939, p. 371) suggests that the present picture may be the one of "Elijah" (who was also fed by a raven) said to be by Lucas van Leyden mentioned in the 1668 estate of Jan-Baptist Borrekens (see Denucé 1932, p. 253).

GCB

FURTHER REFERENCES: Cat. 1767, no. 245 (here and in subsequent publications until 1914 as Lucas van Leyden, unless otherwise noted); Cat. 1780, no. 108; Waagen 1862, p. 151; Waagen 1866, p. 277; Woltmann and Woermann 1887, vol. 2, p. 78 (rejects L. van Leyden attribution); Cat. 1885, no. 710; Suida 1890, p. 122 (as Herri met de Bles); Dülberg 1899, p. 76; Scheibler 1904, pp. 553–54; Clemen and Firmenich-Richartz 1905, p. 28, no. 204 (as master close to C. Engebrechtsz.); Höss 1908, p. 66; Wurzbach, 1910, vol. 2, p. 35; Cohen 1914, p. 528; (hereafter as Jan de Cock, unless otherwise noted); Baldass 1918, p. 129; Cohen 1921, pp. 79–80; Winkler 1924, p. 213; van Gelder 1927, p. 74; Dülberg 1929, p. 150; Cat. 1931, no. 710; Friedländer 1933, pp. 62–63, 64, 126, no. 108 (English trans. 1974, pp. 38–39, 78, no. 108); Hoogewerff 1947, vol. 5, p. 137, no. 10 (as Lucas C. de Kock); van de Waal 1942, p. 39; Lucerne 1948, no. 80; Friedländer 1949, p. 86; Białostocki 1955, p. 487; Salvini 1958, p. 128; van Puyvelde 1962, p. 159; Cat. 1965, no. 19; Benesch 1965, p. 98; Franz 1969, pp. 59, 114–15, 116; Gibson 1977, pp. 196–97, 200, 259, no. 75 (as Master of the Vienna *Lamentation*—an artist from Antwerp in the workshop of Cornelis Engebrechtsz.); Baumstark 1980, no. 31.

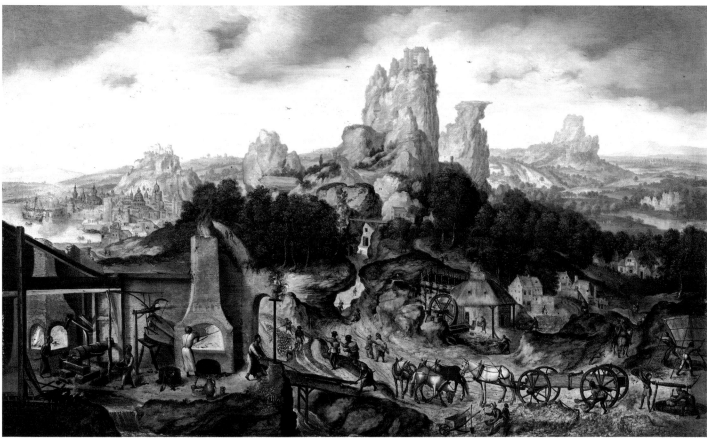

177

177

Herri met de Bles
Flemish, act. by 1535?–d. after 1550?

LANDSCAPE WITH FORGE
Oil on wood; 19⅛ × 32 in. (48.6 × 81.4 cm.)
Liechtenstein inv. no. 749

Herri met de Bles—his name translates literally "Herri with the blaze" and derives from a striking physical characteristic, his white forelock—is known in Italy as Il Civetta (the owl) because he often included a representation of that bird in his compositions. His given name is not known for certain, but it is likely that he was the "Herry de Patenir" who became a master in the Antwerp painters' guild in 1535 and that he was a relation of Joachim Patinir (act. by 1515–d. 1524), an Antwerp artist whose landscape paintings provided the model for Herri's own. Herri met de Bles is the first Flemish painter after Patinir to have specialized in the genre of landscape.

There is also uncertainty about his place of birth. Early writers provide conflicting reports. Guicciardini (1567), who was followed by Vasari (1568), gives Dinant; Lampsonius (1572), who was followed by van Mander (1604) and Sandrart (1675), gives Bouvignes. These authors report just the opposite as the birthplace of Joachim Patinir. The two towns are across from each other on the river Meuse, so the difference might be regarded as negligible. However, as Koch (1968, pp. 5–6) observes, Dinant was associated politically with the town of Liège, Bouvignes with Namur. Lampsonius, who served as secretary to the Bishops of Liège, may have wanted to claim for Dinant the more prestigious artist, Patinir, the innovator. The earlier and more objective report of Guicciardini, an Italian who after 1542 resided in Antwerp, is probably more reliable.

Probably born too late to have been trained directly by Patinir, Herri nonetheless succeeded him as the greatest landscape painter of his generation. Constructed differently from Patinir's, Herri's landscapes are also more atmospheric and naturalistic. In the minute detail of the present work, he appears consciously to emulate the manner of Jan van Eyck a century earlier—the closer one looks, the farther one sees, as if the pictorial reality created defies perception by the naked eye. For example, in the vista at the right, one finds a farmer plowing his field, a shepherd tending his flock, and two wanderers approaching the castle in front of the outcrop of rock in the far distance. Although such exaggerated outcroppings seem fantastic, they derive from

Fig. 41 Detail from cat. no. 177

geological formations in the terrain surrounding Dinant. Though not meant to suggest that they actually existed, it is of interest to note that the two prominent formations at the center of the Liechtenstein picture, one surmounted with a castle and another behind it, anvil-shaped, recur in Herri's *Landscape with Sacrifice of Abraham* (Cincinnati Art Museum).

The subject of this painting, the industrial scene in the foreground, is also drawn from the artist's local environment. The region of Namur was and still is a center of iron and steel production. Herri met de Bles appears to be the first artist to have treated this theme—the Liechtenstein painting dates from about 1535, some twenty years before the woodcut illustrations by Hans Rudolf Manuel Deutsch for Georgius Agricola's *De re metallica* (1556). The modernity of his vision is lost to us today but must have had great contemporary appeal. There are four other versions of this subject by the artist. One in Florence (Uffizi) hung in the Tribuna of the Uffizi in 1589, an indication of the high esteem in which it was held. There is a replica of the Uffizi picture in Prague (Národni Galeri). The third version is in Graz (Alte Galerie am Landesmuseum Joanneum). The fourth, in Budapest (Szépmüvészeti Múzeum), is most closely related compositionally to the Liechtenstein picture, but it is inferior in quality and appears to be a shopwork.

The artist's fascinatingly precise pictorial documentation of the manufacture of steel can be followed step by step as if it were a scientific illustration. At the vertical entrances to the shafts on the right, four men use a windlass to hoist the raw ore from the mine below. Alongside, a woman with her child breaks

up the ore, and the exposed metal is shoveled onto a wagon for transport to the smelting furnace behind. Coal to fuel the furnace is piled up within a wattle fence behind the structure. The exterior view shows only the waterwheel that drives the bellows. Molten ore flows from the oven into a trough in the ground, where it cools into a bar of pig iron. One bar, still hot though not glowing, is transported on rollers across a bridge to the forge at the left where it will be worked into steel. Here the device of a structure in half-ruin allows an interior view. An unseen waterwheel and belt provide power to pump the bellows and to turn the heavy, cannon-shaped axle that works the drop hammer. Its handle and the spokes that raise it were lubricated with goose fat, so the flock of geese to the right has its place in this industrial scheme as well. Indeed, no detail seems gratuitous but one—the little owl perched in the corner that is Herri's personal mark.

At an early date the Liechtenstein panel was expanded about 1½ in. (3.8 cm.) at the top and ¾ in. (1.9 cm.) on both sides. The added strips are clearly visible because of their darkened paint. The original composition had a perimeter tangential to the ship at the left and the castles at the top and right.

The picture is first recorded in the Princely Collections in 1723. It is inscribed on the reverse in what appears to be an eighteenth-century hand "N 26 Ihre Dhlt d Fürstin Eleonora v Liegtenstein" (No. 26, Her Serenity the Princess Eleonore of Liechtenstein). The Princess Eleonore referred to is probably Prince Joseph Johann Adam's sister (1703–1757); her daughter married the Prince's son, Prince Johann Nepomuk Karl. The Prince whom Eleonore's father succeeded, Johann Adam Andreas (1657–1712), is documented as having acquired a painting by Civetta (Herri met de Bles) in 1695.

GCB

FURTHER REFERENCES: Cat. 1873, no. 1109 (as Pieter Aertszen); Cat. 1885, no. 749 (as P. Aertszen); Scheibler 1887, p. 288; Bode 1895a, p. 121 (as P. Aertszen); Cat. 1931, no. 749; Lucerne 1948, no. 98; Friedländer 1936, vol. 13, p. 149, no. 93 (English trans. 1975, vol. 13, p. 81, no. 93); Weisz 1950, pp. 46–47; Dasnoy 1952, pp. 621–25, pl. 3; Évrard 1955, p. 31; van Puyvelde 1962, p. 227; Cat. 1965, no. 8; Franz 1969, p. 79; Baumstark 1980, no. 33; Florence 1980b, p. 269.

Lucas van Valckenborch

Flemish, ca. 1535–97

A MOUNTAINOUS LANDSCAPE WITH A WATERFALL AND MILL

Oil on wood; 10⅝ × 14⅝ in. (27 × 37 cm.)
Inscribed (lower right, on rocks): 1595/L/vv
Liechtenstein inv. no. 563

This view of a city in an extensive river valley dates from van Valckenborch's last years, when he ran a busy studio in Frankfurt am Main (1593–97). As did the other leading Flemish landscape painters and draughtsmen of his time, such as Hans Bol and Gillis van Coninxloo (cat. no. 179), van Valckenborch adhered closely to the native tradition though he worked mostly outside the Southern Netherlands. The Spanish Fury of 1566

drove him from Mechelen, where he had joined the painters' guild six years earlier, to Liège and then to Aachen. The artist settled in Antwerp in 1575. By that date he had arrived at his usual subject, of which this picture is an excellent example, and at the style that, with little variation, he practiced until the end of his career.

Imaginary mountain views of this kind formed the main current of Flemish landscape painting until about 1600. They descended from the pioneering works of Joachim Patinir and from Herri met de Bles to Pieter Brueghel the Elder, van Valckenborch, and Bol, to the prolific printmaker Hieronymus Cock, and to lesser figures such as Cornelis van Dalem. The most important influence upon van Valckenborch's early work was probably that of Bol, who joined the guild in his native Mechelen in 1560, as did van Valckenborch, and was active in Antwerp from 1574 to 1584. Bol's series of landscape prints published by Cock in 1562 includes three or four views of river valleys that anticipate van Valckenborch's mature compositions

178

(Franz 1965, pp. 27–31, figs. 13–24; compare also figs. 51–54, 59, 83–85, 95a, and 96 to the paintings by van Valckenborch reproduced in Wied's monographic article [1971]). Van Valckenborch also must have seen some of Brueghel's drawings from life of Alpine views, which date from as early as 1553 and which inspired Bol and a number of his contemporaries.

Van Valckenborch himself would have had the opportunity to experience Alpine scenery at first hand after he left Antwerp for Linz in 1582 with his patron, Archduke Matthias of Austria. There, on the Danube, and at his next residence in Frankfurt am Main, the artist lived in cities on rivers, with surrounding hills and mountains—that is, at locations rather like the one depicted in this painting. According to Bode (1894b, p. 105), it represents a view of Linz, but the panel dates from van Valckenborch's Frankfurt period, and the artist's panoramic picture of Linz, in the Städelsches Kunstinstitut, Frankfurt (Wied 1971, fig. 140), is a faithful portrait of another place.

The subject more closely corresponds to sixteenth-century Frankfurt, apart from the height and proximity to the city of the mountainous terrain. The long bridge that crossed the Main between the town of Sachsenhausen and Frankfurt met the city's walls at a square tower like the one seen here; many other square or round towers completed Frankfurt's fortifications. The Cathedral is similar in scale and style to the great church on the right, although the tower is different (Lübbecke and Wolff 1931; Frankfurt am Main 1959). However, many details cannot be identified with those found in contemporary views and maps of the city. Furthermore, Frankfurt lies on the southern bank of the Main, whereas the view here, to judge from the alignment of the churches and the fall of light, is from north to south (in the early morning). It may be concluded that van Valckenborch's city, although reminiscent of Frankfurt, is imaginary.

The question calls for careful consideration since the artist painted a number of similar views of actual towns, some of which have only recently been identified, while others are as yet unidentified. In this painting, the composition, with its emphatic repoussoir of trees and a castle-crowned escarpment, is essentially the same arbitrary arrangement that is found in his paintings dating from the same period and from twenty years earlier. Several of these include a castle on a rocky prominence, and others reveal an interest—recalling Dürer's—in various kinds of mills and such industrial sites as mines and blast furnaces (discussed in Poprzecka 1973).

There is nothing specialized about the mill in this picture: it is probably meant to represent one engaged in grinding corn, and all the figures in the foreground pursue routine tasks of agrarian life. Boats on the river, a wagon rumbling along a quay at the lower right, and other details suggest a prosperous society, living in harmony (or so it seems in such a panoramic scene) with all of creation. The same impression is made by such earlier Flemish landscapes as Bol's series of engravings, dating from 1562, and Pieter Brueghel the Elder's paintings of the Months, dated 1565. After the Spanish Fury, however, such a view of

modern life was more likely to be that of an expatriate.

The present painting has been recorded in the Princely Collections since 1780.

WL

FURTHER REFERENCES: Cat. 1780, no. 478; Cat. 1873, no. 840; Cat. 1885, no. 563; Cat. 1931, no. 563; Schulz 1940, pp. 49–50; Lucerne 1948, no. 100; Wied 1971, pp. 172, 205, no. 58; Poprzecka 1973, p. 43 n. 1; Baumstark 1980, no. 43.

179

Gillis van Coninxloo
Flemish, 1544–1606

FOREST LANDSCAPE
Oil on wood; 17⅜ × 24¾ in. (44 × 63 cm.)
Signed (lower left): G V CONINXLOO 1598
Liechtenstein inv. no. 751

This work has long been considered one of the finest and most advanced examples of van Coninxloo's art, as well as one of the most important pictures in the early evolution of Dutch and Flemish landscape painting. There can be no doubt about the first of these claims. The composition, while rich in inviting vistas and delicate details, is effectively focused at the trees in the center, where a hunter is resting in a patch of sunlight. Some artists adopted van Coninxloo's designs and thereby gave their woodland views greater breadth and unity, but few of them approached his mastery of evocative mood. Here, in a kind of northern arcadia, man is at home in nature; the dense shadows and massive trees seem as comforting as the open spaces and the warm light. The sun appears to be setting, but the hunter is in no hurry to leave.

The second claim made for this painting in particular and for others like it by van Coninxloo—that they inspired such artists as Jan Brueghel the Elder (cat. nos. 181–82), Roelant Savery (cat. no. 180), Gillis d'Hondecoeter, and David Vinckboons—deserves qualification in the light of recent research. Van Coninxloo is rightly remembered as the leader of the so-called Frankenthal school (Plietzsch 1910). The Rhineland town of Frankenthal, which lies in the Palatinate between Heidelberg and Worms, was a haven for Protestants who fled the Southern Netherlands during the second half of the sixteenth century. Van Coninxloo arrived there in 1587, seventeen years after he had joined the painters' guild in Antwerp. In 1595 he moved to Amsterdam, where he died in late 1606.

In the past it was presumed—perhaps with reference to later works of the Frankenthal school, such as those of Anton Mirou, or to examples showing van Coninxloo's influence in Amsterdam—that his more advanced pictures evolved out of the works that he painted in Frankenthal and that they constituted a turning point in the development of Dutch landscape painting (Franz

179

1965, pp. 270–88; see also the standard survey books on Dutch and Flemish art). However, none of the known Frankenthal pictures depart from Antwerp conventions of earlier years. In Amsterdam, by contrast, van Coninxloo became a leading landscape painter (there was none better at the time, according to the contemporary biographer Carel van Mander) by joining, not nurturing, a circle of the most innovative landscapists active in Northern Europe. These included the Flemish emigrants in Amsterdam, Hans Bol and Jacob Savery (Franz 1965; Roelofsz 1980, pp. 312–16), who gleaned many of their ideas, mostly by way of engravings, from Jan Brueghel the Elder, from Paul Bril, or from the true founder of the forest landscape, Pieter Brueghel the Elder (Gerszi 1976, pp. 201–29).

In support of this view, Gerszi compares the Liechtenstein panel, which is the earliest dated example of this kind of landscape in van Coninxloo's oeuvre, with Jan Brueghel's *Forest Landscape* of about 1595–96 (Ambrosiana, Milan); with related drawings and paintings by Jan Brueghel; with similar works by Bril; and with Lucas van Valckenborch's *Angler by a Forest Pond*, dated 1590 (Kunsthistorisches Museum, Vienna). Van Coninx-

loo's landscapes, then, represent a culmination and—for later Dutch artists and the Flemish emigrants Vinckboons and Roelant Savery—a synthesis of the Brueghel tradition of woodland views. Perhaps the most important beneficiary of van Coninxloo's legacy in Amsterdam was a much younger painter, Jacob van Ruisdael.

The present picture was acquired at the sale of the collection of Prince Anton Kaunitz in Vienna (March 13, 1820, lot 77).

WL

FURTHER REFERENCES: Cat. 1873, no. 1058; Cat. 1885, no. 751; Bode 1896, pp. 92, 123; Frimmel 1907, vol. 3, p. 83; Plietzsch 1910, pp. 3, 39, 44–47, 54, no. 14; Thieme-Becker, vol. 7 (1912), p. 303; Frimmel 1914, vol. 2, p. 339; Frimmel 1918–19, p. 14; Cat. 1931, no. 751; Raczyński 1937, pp. 34–35; Stix and Strohmer 1938, fig 32; Lucerne 1948, no. 87; Klauner 1949–50, pp. 12–13; Stechow 1966, p. 66; Cat. 1967, p. 12, no. 751; Franz 1969, vol. 1, pp. 274–75, 278; von der Osten and Vey 1969, p. 333, fig. 297; Gerszi 1976, pp. 227–28; Baumgart 1978, p. 41; Ertz 1979, p. 198; Baumstark 1980, no. 37.

Roelant Savery
Flemish, 1576–1639

LANDSCAPE WITH A FLOCK OF SHEEP
Oil on wood; 10⅛ × 8 in. (25.8 × 20.5 cm.)
Signed (lower center, on block of stone): R·SAVERY·/1610
Liechtenstein inv. no. 485

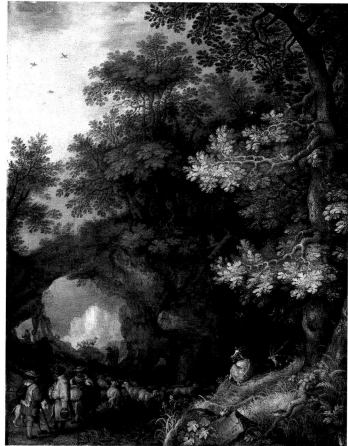

180

The Savery family, including the painters Jacob Savery (ca. 1560–1602) and his brother Roelant, fled the troubled Southern Netherlands and their native Courtrai in about 1591. They settled in Amsterdam, where Roelant was probably taught by his elder brother; Jacob was himself a pupil of the important landscape painter and printmaker Hans Bol, who also came from Courtrai. Bol and the highly regarded landscapist Gillis van Coninxloo (cat. no. 179) were evidently the main influences upon the Saverys' subjects and style in Amsterdam. Two years after his brother's death in 1602, Roelant went to Prague as a court painter of the Emperor Rudolph II. An erratic and unstable ruler, Rudolph was absorbed by eccentric intellectual pursuits and insatiable collecting of artistic and natural curiosities. Savery was one of the last in a line of Flemish artists in Prague that included the painters Bartholomäus Spranger and Joris Hoefnagel, the sculptor Adriaen de Fries (cat. nos. 35–36), and the painter-architect Jan Vredeman de Vries.

Savery was sent to the Tirol around 1606–1608 to sketch views of the Emperor's lands (the fact that Rudolph's relatives had just declared him incompetent to rule appears not to have affected his assignment). The present panel, dated 1610, probably derives from this experience, although it was painted in Prague; it has been described as a "blend of traditional landscape art with direct observation from nature" (Baumstark 1980, p. 140). On the one hand, the picture recalls the topography and populace of the Tirol; most of the Tiroleans tended sheep and cattle, which were—as they are here?—taken up to mountain pastures during the spring. On the other hand, a comparison with two somewhat earlier Flemish landscapes in the Liechtenstein collection—van Coninxloo's (cat. no. 179), where the repoussoir of trees on the right and the decorative treatment of the foliage are similar; and van Valckenborch's (cat. no. 178), where the terrain to the left and much of the staffage seem to anticipate Savery's—reveals the considerable extent to which the younger artist followed Flemish conventions. The same may be said for most of Savery's paintings dating from this period (see, for example, the panel dated 1609 in the Kunsthistorisches Museum, Vienna [Ghent 1954, pl. 13]); however, two forest views of 1608, in the Niedersächsische Landesgalerie, Hannover (Ghent 1954, nos. 7–8), appear to approximate more closely actual views that Savery might have recorded in the evergreen forests in the foothills of the Alps.

After Rudolph died in January 1612, Savery served his brother and successor, Matthias, in Prague. In the summer of 1613, the artist went to Amsterdam to help settle his own brother's estate. The Emperor expected Savery to return to the court in Vienna, but there is no evidence that he did. The frequently published information that he was in Munich and Salzburg in 1615, in the Tirol in 1616, and in the imperial household from 1614 to 1616 has recently been refuted. In January 1615 and January 1616 Savery was recorded in Amsterdam. He was cited in Haarlem in 1618, and in 1619 he joined the painters' guild in Utrecht. He remained there until his death (for these substantially revised biographical details, see Spicer 1979, chap. 1).

Savery's most celebrated works date from the second and third decades of the century and represent such themes as the Earthly Paradise and Orpheus and the Animals (Białostocki 1958, pp. 69–92; Fechner 1966–67, pp. 93–99; Balis 1982, pp. 43, 90–95). The painter's teeming menageries are set in forests that are sometimes said to be Tirolean in type (on this question, see Šíp 1973, pp. 69–75). However, it is clear that Roelant, and before him his brother Jacob (Roelofsz 1980, pp. 312–16), were inspired by earlier Flemish Paradise scenes and that the "Tirolean" landscapes, such as the one illustrated here, should be regarded also as poetic inventions. Indeed, the present picture embodies both a pastoral ideal—the simple life that was frequently extolled in courtly art and literature—and the fanci-

ful notion of an ancient, unspoiled wilderness, which, from about 1500 onward, was appreciated at the German courts as a refuge from the miseries of civilization (Silver 1983, pp. 4–43). Rudolph knew much about such miseries and was inclined to favor artistic antidotes. Examples of these must have been made known to Savery partly through earlier German art and perhaps especially through Altdorfer's paintings and prints of primeval forests.

The present picture was acquired in 1677 by Prince Karl Eusebius von Liechtenstein from the Viennese dealer Regnier Megan. Lower Austria had long been the native land of the Liechtenstein family, and Savery's scene may therefore have been as sympathetic to the Prince as it had been to the Emperor.

<div align="right">WL</div>

FURTHER REFERENCES: Cat. 1767, no. 216; Cat. 1780, no. 269; Cat. 1873, no. 1051; Cat. 1885, no. 485; Bode 1894a, p. 107; Bode 1894b, p. 93; Fleischer 1910, p. 52; Cat. 1931, no. 485; Lucerne 1948, no. 91; Cat. 1967, p. 21; Baumstark 1980, no. 40.

181

Jan Brueghel the Elder
Flemish, 1568–1625

LANDSCAPE WITH THE YOUNG TOBIAS
Oil on copper; 14⅛ × 21⅝ in. (36 × 55 cm.)
Signed (lower left): ·BRUEGHEL·1598·
Liechtenstein inv. no. 477

This extraordinary painting on copper is one of the earliest and most important landscapes in Brueghel's oeuvre. It dates from 1598, two years after the artist returned to Antwerp from a six-year stay in Italy. His journey over the Alps is recalled here by the obvious and—as with most Flemish landscape painters—inadmissible evidence of the mountains in the background: this kind of view and type of composition were developed by Brueghel during his residence in Rome.

His early "coastal" landscapes, to which this view in a river valley and the contemporary *Harbor with Christ Preaching* in the Alte Pinakothek, Munich (Ertz 1979, no. 46, pl. 8), are closely related, derive ultimately from the landscape drawings made

181

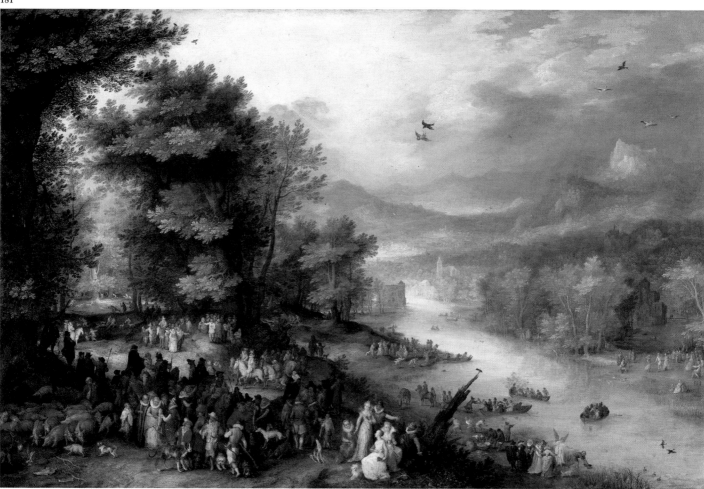

by the artist's father, Pieter Brueghel the Elder, during his Italian travels of the early 1550s. Jan Brueghel was born a year before his father's death, but he knew, and probably owned, many of the elder Brueghel's drawings. He would also have become familiar, during his early years in Antwerp, with engravings after drawings by Pieter Brueghel and by artists he influenced, such as the brothers Mathys and Hieronymus Cock (Riggs 1977).

In Rome Jan's work evolved more or less independently, although the drawings of his father, the paintings of Paul Bril (1554–1626), and the patronage of Cardinal Federigo Borromeo provided him with various kinds of inspiration and support. The type of composition that, in regard to its breadth of view and unity of space, reaches an early stage of maturity in the Liechtenstein picture was first formulated by Jan Brueghel around 1595 (Gerszi 1982, pp. 143–71).

The indispensable role of Jan Brueghel in the development of realistic landscape painting is revealed in pictures of the late 1590s such as this one and in those produced in the next decade (cat. no. 182). It should be stressed, however, that at least until the turn of the century his work represented a refinement of certain qualities that are considered characteristic of the late Mannerist period. The rhythms and patterns in the present picture, as well as the shapes of the trees, with their bouquet-like bunches of leaves, are more decorative—closer, for example, to Savery's style (cat. no. 180)—than those in van Coninxloo's *Forest Landscape* (cat. no. 179), which also dates from 1598. The palette of the *Landscape with the Young Tobias*, while suggestive of daylight and atmosphere, is conceived as much according to taste as it is recorded from life, and even such a festive crowd would not, in Brueghel's day, have displayed the preference for primary colors evident in the costumes here. These accents pick out particular figures within an astonishing sea of details. On the whole, Brueghel's approach recalls the "world landscapes" of earlier artists such as Albrecht Altdorfer (for example, *The Battle of Alexander* of 1529 in the Alte Pinakothek, Munich) and responds to the demand of connoisseurs such as Cardinal Borromeo for cabinet pictures in which every aspect of a certain season, element, or other comprehensive category is catalogued.

Indeed, Brueghel's painting is like a discourse on the structure of society as it appears on a day in the country. The main theme is hunting—the hunting of creatures of the land, the sea, and the air is addressed—but there are digressions on dancing, on dressing up, and on herding pigs. At the lower right a group of city folk seems to compare different forms of fishing: Tobias catches a fish in his hands while nets are used nearby. The various parts of the picture are linked by incidents and gestures; for example, upturned faces in the crowd direct the viewer's gaze to the fighting birds above, and from them the eye descends to the mountains and thence to the valley that leads to the foreground. Distant villages along the winding river suggest that everything perceived close at hand is but a corner of creation.

The question remains: how do Tobias and the angel fit in? One could refer to earlier Flemish landscapes in which these figures are important (for example, one of Hans Bol's Tobias prints of 1565) and to others in which they are merely staffage. Brueghel painted a number of pictures in the late 1590s in which biblical figures, such as Christ or John the Baptist preaching, are found in the middle of a multitude. As in his father's work, the crowd is contemporary. Pieter Brueghel occasionally used this shift in time to make a political point, but there does not appear to be any special connection between the book of Tobit and Jan Brueghel's view of society. His message, if any, is more likely that spiritual events, even miracles, may happen in the midst of everyday life.

WL

FURTHER REFERENCES: Cat. 1873, no. 1052; Cat. 1885, no. 477; Wurzbach 1906–1911, vol. 1, p. 204; Cat. 1931, no. 477; Stix and Strohmer 1938, fig. 33; Lucerne 1948, no. 93; Wilenski 1960, vol. 1, p. 515; Cat. 1967, pp. 10–11, no. 477; Faggin 1968, fig. 225; Ertz 1979, pp. 41–47, 81, 93, 178, 479, 565, no. 47; Baumstark 1980, no. 38; Welu 1983, p. 35 n. 6.

182

Jan Brueghel the Elder
Flemish, 1568–1625

THE ROAD TO MARKET
Oil on copper; 6¼ × 8⅝ in. (16 × 22 cm.)
Signed and dated (lower left): BRVEGHEL·1604
Liechtenstein inv. no. 561

Jan Brueghel developed a realistic style of landscape painting in his drawings and paintings dating from the first decade of the seventeenth century. The Mannerist qualities of his earlier works (cat. no. 181) were gradually abandoned in favor of compositions that, as in this picture, are simpler in structure, more clearly focused, and seemingly less contrived in the choice of motifs. This tendency may be considered reformative, since many of the landscapes that date from the first years of the seventeenth century are more closely related to drawings by the artist's father, Pieter Brueghel the Elder, than are Jan's inventions of the 1590s.

In the case of landscapes especially, the innovations made by artists active around 1600 are usually most evident in their drawings. Two drawings by Jan Brueghel are directly related to this painting of 1604: *Landscape with Tobias and the Angel* (Szépmüvészeti Múzeum, Budapest) and *Trees on a Hill* (Albertina, Vienna). It is now generally agreed that the Budapest drawing was made in the mid- to late 1590s and that it depends upon a design by Gillis van Coninxloo and a lost drawing by

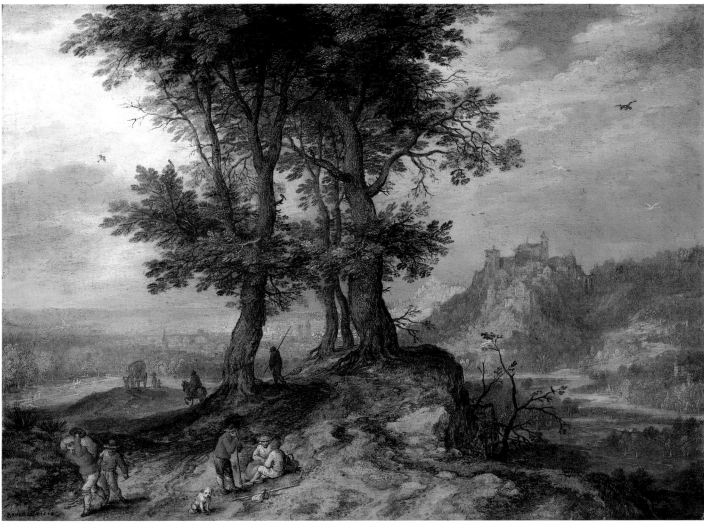

182

Pieter Brueghel the Elder (Gerszi 1965, pp. 108–10, fig. 13; Winner 1975, no. 117; Ertz 1979, p. 146). Copies of Pieter Brueghel's drawing (Winner 1975, no. 46) show an approximate correspondence to the arrangement of trees, to the hill, and to the view of a fortified town on the right in the Liechtenstein painting and in the drawings in Budapest and Vienna. The elder Brueghel's composition has itself been traced back to Barent van Orley's drawing of about 1521–25, *Landscape with a View of the Village of Etterbeck near Brussels* (Louvre), which may be compared, in turn, with Domenico Campagnola's landscape woodcuts dating from 1517 (Winner 1975, nos. 46, 208).

Thus the scheme of setting off a panoramic view behind a central repoussoir of a few trees on a hill was at least eighty years old when Jan Brueghel first used it. However, in the Budapest drawing he elaborated the idea by filling in the view to the left with trees in the foreground and the background; their calligraphic silhouettes create a decorative effect and tend to counter the impression of space to the left and in the center of the composition. In the Vienna drawing, which dates from about

1603 (Ertz 1979, p. 146, following—but wrongly citing—Winner 1961, p. 210, fig. 18), the trees to the far left in the Budapest drawing are eliminated, and a road leading to a distant village takes their place. This design was employed, in a modified form, in Jan Brueghel's small oil on copper, *The Way to Market*, dated 1603, in the Kunsthistorisches Museum, Vienna (Ertz 1979, p. 143; Winner 1961, fig. 17). Finally, in the Liechtenstein picture only the central trees remain, and the view between them has been opened. The background has been rearranged into zones that establish a horizontal continuity across the composition. The trees are fuller above, and the figures in the foreground are fewer: both changes allow the viewer's gaze to be more easily drawn into the distance. Of all the closely interrelated compositions, this is the only one in which there is a strong natural sweep from side to side. That the space continues beyond the frame is suggested by the now unobstructed sides of the view and by the insertion of two figures walking toward the lower left. One of these men and the dog look out at the viewer, a nuance not found in the earlier works.

A group of gypsies gather next to an ass (adopted from Pieter Brueghel's design) in the Budapest and Vienna drawings. The painted versions of this compositional type show peasants traveling along the road or resting on the hill (Ertz, p. 143, suggests that some "village entrances"—that is, pictures of roads coming into villages—may be pendants to paintings of the open road). These figures are perhaps more picturesque, and more expected of a cultivated artist such as Jan Brueghel, than the peasants presented by his father as hard at work or hard at play. Contemporary views of villages and of country roads have been related to pastoral poetry, in which agrarian life is idealized, in contrast to the careworn routines of urban existence (Spickernagel 1979, pp. 133–48, especially p. 135). Jan Brueghel's small landscapes dating from shortly after 1600 must have been similarly appreciated in the troubled city of Antwerp. In their refinement and scale, they are ideally suited to a collector's cabinet: the subject is rural, but the taste is urbane.

WL

FURTHER REFERENCES: Cat. 1780, no. 316; Cat. 1873, no. 1080; Cat. 1885, no. 561; Cat. 1931, no. 561; Lucerne 1948, no. 92; Thiéry 1953, p. 176; Wilenski 1969, vol. 1, p. 515; Cat. 1967, p. 11, no. 561; Ertz 1979, pp. 143–56, 574–75, no. 105; Baumstark 1980, no. 39; Ertz 1981, p. 86.

183

Joos de Momper
Flemish, 1564–1635

LANDSCAPE WITH A MOUNTAIN PASS
Oil on wood; 17⅝ × 26⅛ in. (44.8 × 66.3 cm.)
Liechtenstein inv. no. 1789

Joos de Momper was one of the few important Flemish landscapists of the period around 1575–1625 who remained in the Southern Netherlands (see the discussion in cat. nos. 178–80). Many of the pictures that he painted in Antwerp belong to the tradition of alpine views in the manner of Pieter Brueghel the Elder. Unlike such contemporaries as Kerstiaen de Keuninck, Roelant Savery, and (in his mountainous landscapes) Gillis van Coninxloo, however, de Momper conveys an impression of actual experience rather than of fantasies contrived in the studio. His synthesis of the old and the new—of invention and observation—earned de Momper considerable success in his lifetime and the flattery of imitators active both before and after his death.

The painter was a pupil of his father, Bartholomeus de Momper, who, as dean of the Guild of Saint Luke, entered his

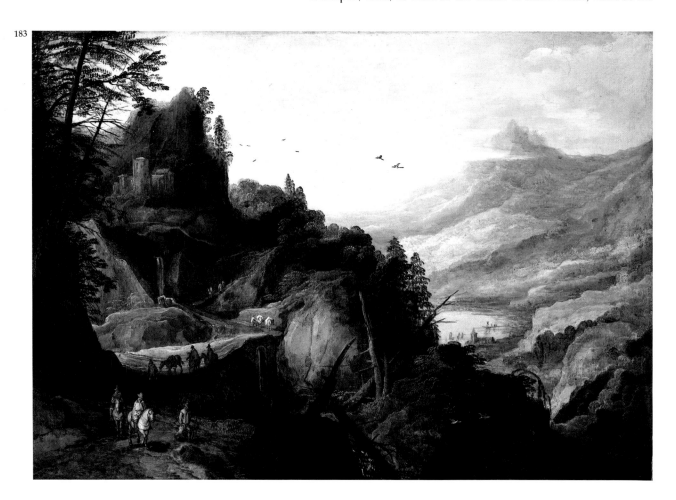

183

seventeen-year-old son's name in the register in 1581. The next record of the young de Momper is that of his marriage in 1590. A few of the intervening years presumably were spent on an Italian journey: particular motifs in his mountainous landscapes, and the effect of the whole in most of them, are too distinctive and convincing to have been borrowed from other Flemish artists. De Momper's style—his painterly technique and coloristic conception—also suggests cisalpine experience. It appears likely that he studied with Lodewijk Toeput, called Pozzoserrato, around 1585–90 and adopted some of the Venetian and Mannerist qualities of that transplanted Fleming's landscapes (Franz 1968–69, pp. 58–60, 63).

A survey of de Momper's oeuvre reveals the ease with which he manipulated compositional patterns to produce new works. This picture, for example, is similar in design to van Valckenborch's *Mountainous Landscape* (cat. no. 178) and to a number of earlier Flemish inventions (Pieter Brueghel's especially). At the same time, de Momper must have returned repeatedly to drawings made in Switzerland and in Northern Italy. It has been proposed that de Momper made a second trip to Italy after 1611, when he served as dean of the Antwerp guild (Raczyński 1937, p. 67). But the essential nature of the artist's work speaks against this hypothesis. His landscape paintings are more like memories than empirical records. The great masses of the mountains, the unexpected vistas into endless space, and the picturesque play of light and atmosphere are his main concerns; more specific motifs do, however, serve as testaments of firsthand experience, like ticket stubs tucked into a diary.

De Momper developed a technique suitable to this subject at an early stage of his career. He applied the paint fluidly throughout most of the picture; in the background the touch is more delicate, with stippled highlights or shadows overlaying contrasting colors. The traditional scheme of brown, green, and blue is employed to suggest atmospheric perspective, but any impression of naiveté is allayed by making this palette not only the apparent product of brilliant sunlight but also the vehicle of decorative effects.

De Momper's works are almost never dated, and they can only be ordered into groups corresponding to broad stylistic tendencies of the period. *Landscape with a Mountain Pass* is certainly an example of the artist's mature abilities, and it may date from between 1615 and 1625 (on de Momper's chronology see Thiéry 1967, pp. 233–46).

This picture was acquired by Prince Karl Eusebius von Liechtenstein between 1674 and 1680 from the Viennese art dealer Peter Bousin.

WL

FURTHER REFERENCES: Cat. 1767, no. 44(?); Cat. 1780, no. 183; Cat. 1873, no. 789; Cat. 1931, no. A790; Raczyński 1937, p. 71; Lucerne 1948, no. 96; Cat. 1967, p. 17, no. 1789; Baumstark 1980, no. 42; Naumann 1983, pp. 66, 68–69.

184

Roelant Savery
Flemish, 1576–1639

A BOUQUET OF FLOWERS
Oil on wood; 19½ × 13⅝ in. (49.5 × 34.5 cm.)
Signed and dated (lower left): ·R·SAVERY·1612·
Liechtenstein inv. no. 789

Though not well known, Savery's flower pieces appear to have been exceedingly important for the early development of still-life painting in the Netherlands. They are also among the most refined and individual works of their kind. Only twenty examples survive (about ten percent of the painter's oeuvre), all of them in private collections or in out-of-the-way museums. Two are dated 1603, which is earlier than any date found on the flower pieces of Ambrosius Bosschaert the Elder and the other pioneering representatives of the genre (Bergström 1956a, p. 88; Bol 1982, p. 68, fig. 1; Segal 1982a [p. 311, fig. 1, and p. 335 n. 14] gives a list of Savery's flower still lifes).

The botanical studies made by Joris Hoefnagel in Prague, and, after Savery returned from there to Holland (see cat. no. 180), the flower pictures of Jan Brueghel the Elder, were surely of interest to Savery, but neither artist's work could be described as a formative influence on his style. Jacob de Gheyn the Younger has been cited as a possible precursor (Segal 1982b, pp. 28–29); in the absence of evidence, this suggestion must remain an educated guess. Perhaps Roelant's older brother Jacob, who died in 1602, was his instructor in still life as well as in landscape painting. Jacob Savery is said to have decorated a pier in Saint Bavo's, Haarlem, in 1585, with an interlaced arrangement of flowers and fruit, and "a large bouquet" by him was appraised at the very high value of three hundred guilders in an inventory of 1617 (Bol 1982, p. 73).

Whatever his sources, Roelant Savery was an innovative artist. He differs from Bosschaert and, speaking broadly, from Bosschaert's three sons and gifted brother-in-law Bartholomeus van der Ast in the overall tonality of paintings such as *A Bouquet of Flowers*: a subtle use of glazes blends the local colors, suggesting fine transitions of light and shade. Well before 1619, when Savery moved to Utrecht and came into regular contact with the Bosschaert circle, he had avoided the artificial appearance of most early flower pieces by employing the qualities one might expect of a landscapist. This assessment is supported by a comparison of Savery's still lifes and the passages of abundant foliage and flowers in his landscape paintings. Even the "mysteriousness and tenderness" (Segal 1982a, p. 309) first found in Savery's flower pictures and then in those by van der Ast seem to grow out of the Fleming's romantic forest scenery.

Savery's subject, too, may be distinguished from that of his contemporaries, for he painted some species of flowers not found in their work; he did not depict a few species which they often

289

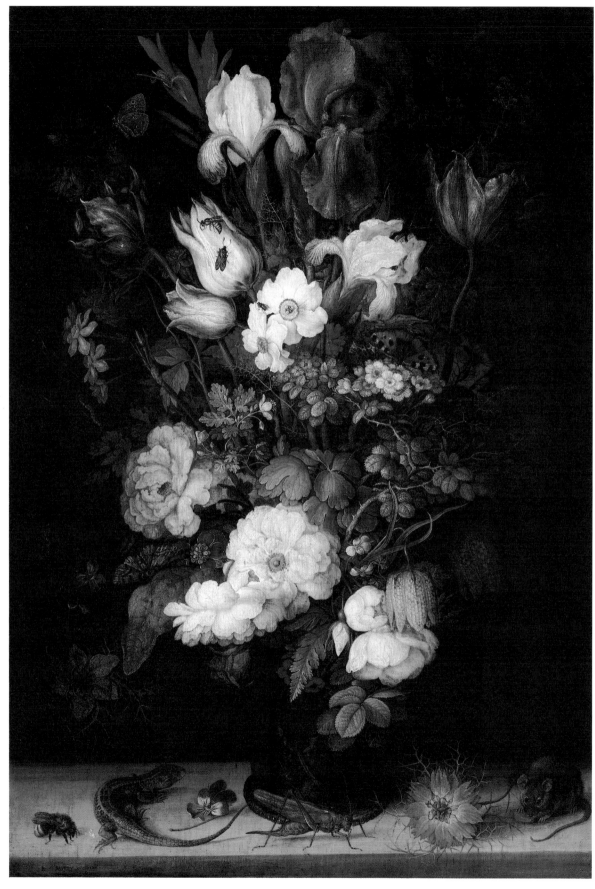

Fig. 42 Chart of cat. no. 184

culture. **9.** French marigold (*Tagetes patula* L.), Mexico, Guatemala. **10.** Hen-bit (dead-nettle) (*Lamium amplexi-caule* L.), Europe. **11.** Chicory (*Cichorium intybus* L.), Europe. **12.** Greater celandine (*Chelidonium majus* L.), Europe. **13.** Water forget-me-not (*Myosotis scorpioides* L.), Europe, culture. **14.** Jonquil (*Narcissus jonquilla* L.), Spain, Portugal, France, Italy. **15.** Pheasant's-eye narcissus (*Narcissus poeticus* L.), Southern Europe. **16.** Maltese cross (*Lychnis chalcedonica* L.), Northern and Eastern Russia. **17.** Tulip hybrid (*Tulipa clusiana* DC. × *T. gesnerana* L.), culture (Southwestern Asia). **18.** Columbine (*Aquilegia vulgaris* L. *semiplena*), most of Europe, culture. **19.** Larkspur (*Consolida ambigua* [L.] Ball & Heywood), Southern Europe. **20.** Tulip hybrid (*Tulipa gesnerana* L. × *T. suaveolens* Roth), culture (Southwestern Asia). **21.** Tulip hybrid (*Tulipa saxatilis* Sieb. × *T. clusiana* DC.), cultured (Crete, Southwestern Asia). **22.** Variegated flag (*Iris variegata* L.), Southern Europe, Southeastern Europe, Balkans. **23.** Field gladiolus (*Gladiolus segetum* Ker–Gawler), Southern Europe. **24.** German flag hybrid (*Iris germanica* L. × *I. pallida* Lam.), culture (Southeastern Europe). **25.** Fennel (*Foeniculum vulgare* Mill.), Southern Europe. **26.** Tulip hybrid (*Tulipa sylvestris* L. × *T. suaveolens* Roth), culture (Southeastern Europe, Southwestern Asia). **27.** Jacob's-ladder (*Polemonium caeruleum* L.), North and Central Europe. **28.** Harebell (*Campanula rotundifolia* L.), Europe. **29.** Sweet William (*Dianthus barbatus* L.), Southern Europe. **30.** Peony (*Paeonia officinalis* L.), Southern Europe. **31.** Field pansy (*Viola arvensis* Murr.), Europe. **32.** Fool's parsley (foliage) (*Aethusa cynapium* L.), most of Europe. **33.** Snake's-head (fritillary) (*Fritillaria meleagris* L.), Northern Europe, culture. **34.** Austrian briar (*Rosa foetida* Herrm.), Southwestern Asia. **35.** Love-in-a-mist (*Nigella damascena* L. *semiplena*), Southern Europe. **a.** Sand lizard (*Lacerta agilis* L.). **b.** House mouse (*Mus musculus* L.). **c.** Magpie moth (*Abraxas grossulariata* L.). **d.** Cinnabar moth (*Tyria jacobaeae* L.). **e.** Large heath (*Cynonympha tullia* Müll.). **f.** Small tortoise shell (*Aglais urticae* L.). **g.** Caterpillar (*Aglais urticae* L.). **h.** House fly (*Musca domestica* L.). **i.** Wasp (*Vespa vulgaris* L.). **j.** Coenagrion demoiselle-fly (*Coenagrion puella* L.). **k.** Earth bumblebee (*Bombus terrestris* L.). **l.** Bush cricket (*Decticus verrucivorus* L.).

1. Male fern (*Dryopteris filix-mas* [L.] Schott), Europe, North America, Asia. **2.** Pheasant's-eye adonis (*Adonis flammea* Jacq.), Southern and Central Europe. **3.** French rose (*Rosa gallica* L. *semiplena*), Southern and Central Europe. **4.** White rose (*Rosa x alba* L.), culture (hybrid). **5.** Apothecary rose (*Rosa gallica* L. Cv. *Officinalis*), culture (Southern and Central Europe). **6.** Comfrey (foliage) (*Symphytum officinale* L.), most of Europe. **7.** Love-in-a-mist (*Nigella damascena* L.), Southern Europe. **8.** Wild pansy (heartsease) (*Viola tricolor* L.), Europe,

treated; and he did not, as they did, repeat precisely particular flowers. Segal, a botanist as well as an art historian, concludes that the artist was a serious naturalist who traveled widely to record the many species, some quite rare, of flowers seen in his twenty known bouquets. The same scholar identifies eleven species of dragonflies and damselflies, "both male and female, sometimes copulating" (Segal 1982a, pp. 319–20).

Savery's interest in still life began in the Netherlands and appears to have flourished there after he returned from Prague in the middle of 1613. However, at least two flower pieces, one said to be dated 1609 and the other 1611, were probably painted for Rudolph II. The present picture, dated 1612, might have been begun for the Emperor, but since he died in January of that year the painting was more likely made for his successor, Matthias. (The same may be said for the small flower picture on copper, dated 1612, that was sold in London in 1980 and is now in a private Dutch collection; see Bol 1982, p. 69, fig. 3.)

The Liechtenstein painting is similar in composition to Savery's earliest still lifes, although here the flowers are more tightly grouped, light and atmosphere are more convincingly suggested, and the niche that defines the space behind most of the artist's floral arrangements is not included. A bee, a lizard, a grasshopper, and a mouse, along with two fallen flowers, are set out on the shelf as if for scientific scrutiny.

Savery was as sophisticated as any contemporary still-life painter in addressing symbolic themes. His colleague in Prague, Hoefnagel, was a master of emblematic conceits (Vignau-Schuurman 1969), and the Emperor Rudolph delighted in iconographic niceties, particularly those with philosophical or occult significance. In this panel by Savery, for example, the insects might represent the element of air, the mouse and the flowers could stand for earth, the lizard might be associated with fire (Segal 1982a, pp. 324, 336 n. 32), and the water in the vase might complete an allegory of the Four Elements. The Four Seasons are suggested by the selection of flowers that bloom at different times of the year. One cannot say with certainty that these conceits were deliberately referred to here by the artist, but they were common in the art and literature of the period. The *vanitas* theme—the expression of life's brevity —might be discerned by the viewer who reflects on how quickly blossoms fade and who observes the insects nibbling the flowers. Butterflies, by contrast, mature through a sort of resurrection and are a familiar symbol of the soul. Specific flowers also have meanings which are usually religious, but deciphering them is a rather speculative exercise. Nonetheless, it is possible that here, as in Savery's earliest flower still lifes, the roses stand for the love (or the Passion) of both Mary and Christ, the thorns recall those of Christ's crown, and the irises, being three-parted, refer to the Trinity (Segal 1982a, p. 325).

WL

FURTHER REFERENCES: Cat. 1873, no. 1181; Cat. 1885, no. 789; Frimmel 1892, p. 50 n. 1; Bode 1894a, p. 107; Cat. 1931, no. 789; Hairs 1955, p. 232; Cat. 1967, p. 21, no. 789; Baumstark 1980, no. 41; Segal 1982a, p. 335 n. 14, fig. 7.

185

Jan Davidsz. de Heem
Dutch, 1606–1684

FRUIT STILL LIFE WITH A SILVER BEAKER
Oil on wood; 18⅛ × 25⅝ in. (46 × 65 cm.)
Signed and dated (upper left): J. D. Heem f./A 1648
Liechtenstein inv. no. 778

Jan Davidsz. de Heem is one of the most distinguished representatives of still-life painting in the Northern Netherlands, but almost all his mature works were produced in Antwerp. His earliest pictures are precocious fruit pieces that date from the mid-1620s and reveal the strong influence of Bartholomeus van der Ast, who was then active in de Heem's native Utrecht. De Heem moved to Leiden shortly before his marriage there in 1626; his *vanitas* still lifes and monochrome "breakfast" or "banquet" pieces (*banketjes*) of the next five years are very much in the manner, respectively, of the Leiden school and of the Haarlem painters Pieter Claesz. and Willem Claesz. Heda (Bergström 1956a, pp. 162–64, 191–95; Bergström 1956b, pp. 173–82).

The latter artists formulated the type of composition employed by de Heem in this picture, but its rich decorative effects—the local colors, the lively interplay of light and shade, and the rhythms linking all the elements—were adopted from the examples of Flemish painters such as Frans Snyders, Daniel Seghers, and Adriaen van Utrecht. De Heem arrived in Antwerp in 1636; his portrait was recorded at about this date by his friend Adriaen Brouwer in the figure on the right in *The Smokers* (Metropolitan Museum).

In addition to the stylistic qualities just mentioned, three Flemish types of still life distinguish the Antwerp oeuvre of de Heem: flower pieces; garlands and hanging arrangements of flowers and fruit; and cartouches of flowers and fruit surrounding a portrait or religious image painted by another artist. Also Flemish are the large-scale and elaborate designs of some of de Heem's banquet pieces; these pictures in particular feature the exotic fruits that were to be found in Antwerp and in few other ports. However, de Heem remained a Dutch painter in the sensitive fidelity with which he described each motif and in his realistic rendering of light and space. Furthermore, many of his compositions, such as this one of 1648, retain the simplicity and structure (and some motifs) of his early works. The Dutch qualities of de Heem's still lifes affected the whole genre in the Southern Netherlands. Jan Fyt's mature paintings, and those of Abraham Mignon, are among the many of the second half of the seventeenth century that attest to the great impression made by de Heem's art in Antwerp.

De Heem is considered one of the most original and influential artists of those who were responsible for the resurgence of symbolism in still life that occurred around the middle of the century. *Fruit Still Life with a Silver Beaker* is certainly symbolic, but an

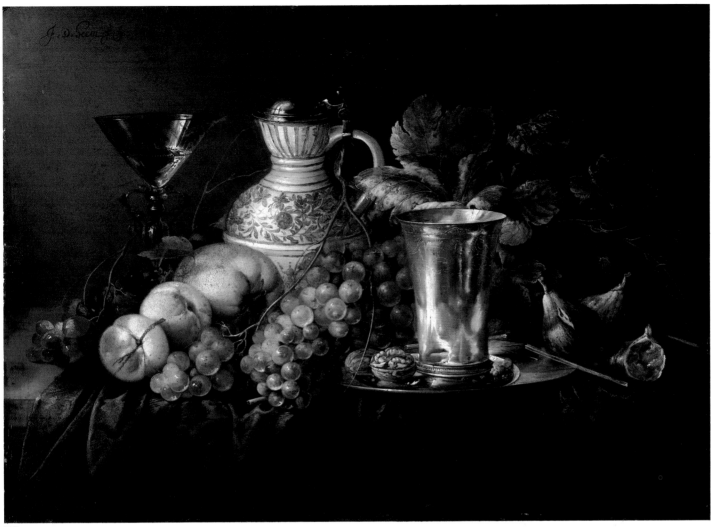

185

interpretation of its iconography must remain tentative because each element, or at least each fruit, has many possible meanings and because the significance of an individual motif depends upon the context of the whole. Furthermore, the importance of symbolism in Dutch painting is a subject much debated. The painter and a patron may have agreed upon the meaning of a work, but they also may have had no contact at all, and a picture may have been bought by someone who was solely interested in its aesthetic appeal.

These considerations notwithstanding, the Liechtenstein painting appears to have a specific theme. The various fruits, from left to right, are grapes, peaches, a large quince, more grapes, an open walnut, and figs. All are associated with fertility; the quince may refer to love and marriage, but the peach was usually interpreted more negatively as a sign of lust (contemporary authors observed that the exotic edible had soft flesh and a hard heart). The popular moralist Jacob Cats recommended sending peaches to enemies and figs to friends (Cats 1665, vol. 1, p. 145; Segal 1983, p. 16). One might plausibly suggest that the fruits

to the left and the fashionable Venetian glass represent temptation and that the walnut and the fig (each of which were sometimes assigned religious meanings), along with the silver beaker (of a type sometimes used in religious ceremonies such as baptism and marriage), present a spiritual alternative. The wine in the delftware pitcher and the grapes could indicate an inclination toward either Bacchus or Christ, which would be consistent with the idea of presenting a moral choice.

However, modern readings of Dutch and Flemish pictures often have surface value and little else. Three motifs in this painting, along with the general references to fertility or fruitfulness, suggest that it may, by contrast, celebrate the sacrament of marriage. First, walnuts are mentioned by Vergil and other Roman writers in connection with newlyweds; Boswell's journal reveals that the Roman practice of scattering walnuts at weddings was still well known in the eighteenth century (Harris 1981, p. 197). Cats compares a first marriage with the nut in a metaphor that would be well represented here: "so as the two halves of one shell fit together, so no two people

fit together better than two who have grown up together" (Cats 1627, vol. 3, emblem no. 28, cited by Segal 1983, p. 36). Second, the silver beaker might have been understood in this context as a marriage cup, although only an inscription, or an engraved image such as an appropriate saint, would establish this with certainty. Third, the prominent placement of the stem above the bunch of grapes strongly recalls another of Cats's once-familiar metaphors for marriage (the stem stands for marriage, the grapes for physical love): "That's the proper way, to gain your cherished aim,/ To take it without stain, to hold it without blame" (de Jongh 1974, pp. 166–71; Cats 1618, cited by de Jongh 1974, p. 174).

In more than one sense, then, the tone of this picture seems to differ from that of the monochrome banquet pieces that were painted in Haarlem, which usually have an admonishing theme. The painting would have made a perfect wedding present. Whether it actually was can only be determined by a document, in the absence of which the picture's symbolism must remain a matter of conjecture.

<div align="right">WL</div>

FURTHER REFERENCES: Cat. 1767, no. 95; Cat. 1780, no. 86; Cat. 1873, no. 1170; Cat. 1885, no. 778; Toman 1888, pp. 132–33; Greindl 1956, p. 174; Bergström 1956a, p. 204; Baumstark 1980, no. 80.

186

Jan Fyt
Flemish, 1611–61

CONCERT OF BIRDS

Oil on canvas; 47¼ × 67¾ in. (120 × 172 cm.)
Signed and dated (at left, in music book): ·1658· / · JOANNES · FYT ·
Liechtenstein inv. no. 823

Only a few paintings by Fyt depicting various kinds of birds are known. In each of them a peacock dominates the center of the composition and, with its opulent plumage, sets a standard for decorative effects that the artist brilliantly maintains throughout the picture. Fyt's sensitivity to values of color and of tone and his extraordinary facility in rendering soft textures were ideally suited to the subject. Canvases like this one were frequently set into wall panels in country houses; somewhat later examples by the Dutch painter Melchior d'Hondecoeter (1636–95) are known to have decorated the walls of patrician houses in Amsterdam and of the royal palaces Soestdijk and Het Loo. Fyt's painterly handling and bright palette in the *Concert of Birds* may have been intended to be appreciated from a distance and in the context of a richly appointed room.

Different kinds of birds, some of them exotic, were included in the early seventeenth-century Paradise pictures by Jan Brueghel the Elder and Roelant Savery. Savery influenced

186

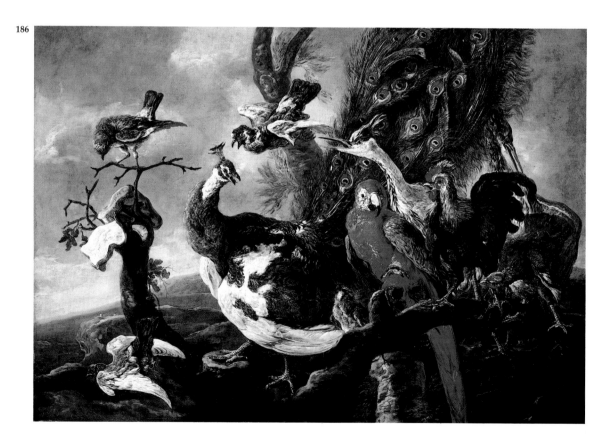

the Amsterdam landscapists Gillis d'Hondecoeter (d. 1638) and his son Gysbert (1604–1653); a good number of paintings of groups of birds, including some exotic species (for example, the early *Birds of Diverse Plumage* in the Museum Boymans–van Beuningen, Rotterdam) were produced by Gysbert, whose son Melchior has been mentioned above. Fyt was briefly in Holland in 1642 and, as has often been noted, was influenced by Dutch still-life painters.

Nonetheless, the most immediate model for the animated —not to say noisy—*Concert of Birds* may be found in the oeuvre of Fyt's own teacher, Frans Snyders. In Snyders's large undated *Concert of Birds* in the Hermitage, Leningrad (1981 cat. no. 607), some three dozen birds of many species perch on the limbs of a blasted tree; they pay little heed, in their cacophonous excitement, to the conducting efforts of the owl or to the open songbook that hangs from a branch. This composition, in its complicated rhythm, is much closer to Fyt's painting than is Snyders's evidently earlier *Concert of Birds (The Owl's Sermon to the Birds)* which was once owned by the pioneering American collector Robert Gilmor, Jr. (Rutledge 1949, p. 26, fig. 2).

The birds depicted in Fyt's painting would not be found together in nature and are not known for their musicality (Baumstark 1980, p. 168). Peacocks and macaws did, however, serve as ornithological ornaments of elegant domestic life. Fyt may be making a witty contrast between the beauty of their plumage and the raucousness of their calls.

The present picture is dated 1658. An autograph replica in the Prado, Madrid, is dated 1661—the year Fyt died—and measures 53⅛ × 68½ in. (135 × 174 cm.). Comparison of the compositions and their dimensions suggests that the Liechtenstein canvas has been slightly trimmed above (about 5⅞ in. [15 cm.]).

The present painting was acquired in 1808 by Prince Johannes I from the collection of Count Anton Gundacker Starhemberg.

WL

FURTHER REFERENCES: Cat. 1873, no. 1153; Cat. 1885, no. 823; Wurzbach 1906–1911, vol. 1, p. 562; Cat. 1931, no. 823; Lucerne 1948, no. 108; Cat. 1967, p. 15; Baumstark 1980, no. 78.

187

Jan Fyt
Flemish, 1611–61

HOUNDS GUARDING THE KILL
Oil on canvas; 47¼ × 67⅜ in. (120 × 171 cm.)
Signed (lower center): Joannes · FYT · / ·1659·
Liechtenstein inv. no. 993

This is a late and exceptionally fine example of a type of picture that Fyt was largely responsible for establishing in Flanders. Through his pupils, such as Pieter Boel, and through various

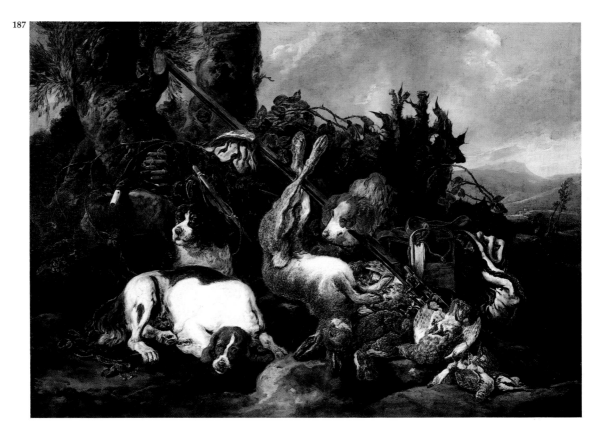

187

followers, the gamepiece also became popular in the Netherlands and France. Paintings like this one may be described broadly as hunting trophies; they usually served a decorative function in the public rooms of country residences, and they reflect the importance of hunting as an aristocratic pursuit. This picture once hung in Eisgrub Castle, a Liechtenstein property in Moravia.

Fyt, the son of an affluent Antwerp merchant, was a pupil of Frans Snyders, who determined the younger artist's early style and his specialization in still life. After visiting Paris, Venice, and possibly Rome in the 1630s, Fyt settled in his native city and pursued an industrious and successful career. The subtlety of Fyt's mature manner, which is more attentive to values of texture and light than is Snyders's style, was inspired in part by Dutch still-life painters, especially Jan Davidsz. de Heem (cat. no. 185).

Fyt's pictures of dogs resting beside dead game date from as early as 1641, when the subject, although anticipated by Snyders, was something of an innovation: most earlier gamepieces stress the idea of gastronomic gratification rather than the sporting life. In this light, Fyt's trophy paintings appear as a quiet branch of the stream of hunting scenes that descends from sources in medieval manuscripts and tapestries to the tumultuous hunts of Rubens (Voss 1961).

Hounds play an important part in Fyt's game pictures. Their attentiveness here, and the hunting equipment, implies the proximity of their master, with whom the patron might identify. Portraits of individuals and of families were occasionally combined by Fyt with large still lifes of dead game (for example, *The Hunter*, Cummer Gallery of Art, Jacksonville, Fla.). The long-barreled gun and the small prizes in the picture suggest expert marksmanship. Such efficient equipment as the rolled-up net, the cage for a decoy bird, and the game bag might remind the modern viewer that hunting was a practical necessity: its appreciation as a sport represents a refinement of everyday activity.

There are too many similar compositions and nearly identical motifs in Fyt's oeuvre to cite them here. It should be noted, however, that the two dogs to the left are depicted alone in a signed canvas (22⅝ × 27⅝ in. [57.5 × 70.2 cm.]) that was at Newhouse Galleries, New York, in 1961.

WL

FURTHER REFERENCES: Wurzbach 1906–1911, vol. 1, p. 562; Greindl 1956, p. 163; Feldkirch 1971, no. 14; Baumstark 1980, no. 79; Sullivan 1984, p. 21.

188

Dirk Valkenburg
Dutch, 1675–1721

STILL LIFE WITH A DEAD SWAN AND
A DOG CHASING A FOX
Oil on canvas; 53⅛ × 71¼ in. (135 × 181 cm.)
Signed (on stone slab): D: Valckenburg/Fecit
Liechtenstein inv. no. 763

A native of Amsterdam, Dirk Valkenburg was the last artist in a long line of distinguished Dutch still-life painters. With his teacher, Jan Weenix (1640–1719), who died only two years before Valkenburg, he was the most accomplished specialist in the newly fashionable genre of the gamepiece, or hunting still life, at the end of the seventeenth century and the beginning of the eighteenth century in the Netherlands.

It is worth briefly sketching this tradition of still lifes and other pictures featuring birds and animals because it is a typical but not well-known instance of dynastic descent through generations of Dutch and Flemish artists. Although Valkenburg was not a member of such a family, he was Weenix's only known pupil, and he was also influenced by his teacher's cousin Melchior d'Hondecoeter (1636–95). Weenix and d'Hondecoeter both studied under the former's father, Jan Baptist Weenix (1621–1660/61); d'Hondecoeter was also tutored by his father, Gijsbert d'Hondecoeter (1604–1653), who himself was the pupil of his father, Gillis (d. 1638). One is thus led back to the Paradise pictures of Jacob and Roelant Savery (cat. no. 180), since Gillis d'Hondecoeter, though trained by his father, Niclaes, painted landscapes filled with birds and animals that closely follow the examples of the Saverys.

The Weenix and d'Hondecoeter families worked in both Utrecht and Amsterdam (as did Roelant Savery), but the youngest artist of each family was active mostly in the more cosmopolitan center, and Jan Weenix, at least, enjoyed an international clientele. The large, decorative "still lifes" (often, as here, there are live animals or birds as well) in parklike settings that Valkenburg painted throughout his career depend directly upon the compositions and frequently upon particular motifs of pictures by Melchior d'Hondecoeter and especially by Jan Weenix. Paintings and drawings by the latter were listed in Valkenburg's estate.

In 1695, at the age of twenty, Valkenburg set off for Italy, but two of his earliest supporters, Baron Knebel von Katzenellenbogen in Augsburg and then Prince Johann Adam von Liechtenstein in Vienna, altered the artist's itinerary. The present picture and the *Still Life with a Dead Heron* (cat. no. 189) are from a group of four canvases ordered by Johann Adam in 1698 and delivered the following year. Valkenburg was paid the considerable sum of a thousand guilders for these pictures.

It has frequently been observed that hunting was a prerogative

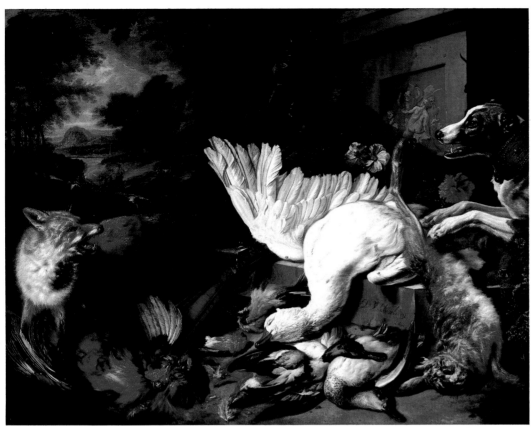

188

of the aristocracy and that the gamepiece "with wild boars, stags, hares, pheasants, partridges, and other fowls" was intended for "princes' and noblemen's fancies" (van Hoogstraten 1678, quoted by Sullivan 1984, p. 3). Swans and stags (one of the latter is being caught in the background) were especially prized, which explains the prevalence of the former in still lifes by Weenix and Valkenburg. The garden sculpture depicted here suggests the proximity of a castle or country house; the statue may represent the handsome hunter Adonis and one of his hounds.

The gamepiece was a late development within Dutch art. It found an earlier and socially more suitable home in Flanders, where the leading practitioner was Jan Fyt (cat. no. 187). There are many obvious similarities between Fyt's hunting still lifes and these early works by Valkenburg; Fyt more than Jan Weenix is recalled by the overall design of the Liechtenstein pictures and by the placement of the gun here. However, Weenix was Valkenburg's more immediate model for almost every motif: dead swans and hanging hares in virtually the same positions occur repeatedly in Weenix's oeuvre. The same provenance may be traced for the statue and pedestal (see Sullivan 1984, figs. 124–31, for typical compositions by Weenix).

That Valkenburg adhered to such well-established forms is certainly not unexpected. Both the decorative function and the expectations of the patron, who probably requested specific details (for example, the inclusion of the rifle in the pendant picture), made the gamepiece a rather restricted art form. In the Liechtenstein paintings the young Valkenburg demonstrates a complete mastery of the idiom and a taste for luxuriant color which in the plumage of the birds is more brilliant than anything Weenix and d'Hondecoeter allowed themselves.

WL

FURTHER REFERENCES: Cat. 1873, no. 1154; Cat. 1885, no. 763; Wurzbach 1906–1911, vol. 2, p. 739; Wilhelm 1914, col. 37; Cat. 1931, no. 763; Thieme-Becker, vol. 34 (1940), p. 52; Cat. 1970, no. 40; Wilhelm 1976, p. 74; Baumstark 1980, no. 121.

189

Dirk Valkenburg
Dutch, 1675–1721

STILL LIFE WITH A DEAD HERON AND A DOG BARKING AT A BIRD
Oil on canvas; 53⅛ × 71¼ in. (135 × 181 cm.)
Signed (upper left): D. Valckenburg/Fecit
Liechtenstein inv. no. 765

The present picture and *Still Life with a Dead Swan* (cat. no. 188) are from a group of four canvases ordered by Prince Johann Adam von Liechtenstein in 1698 and delivered the following

297

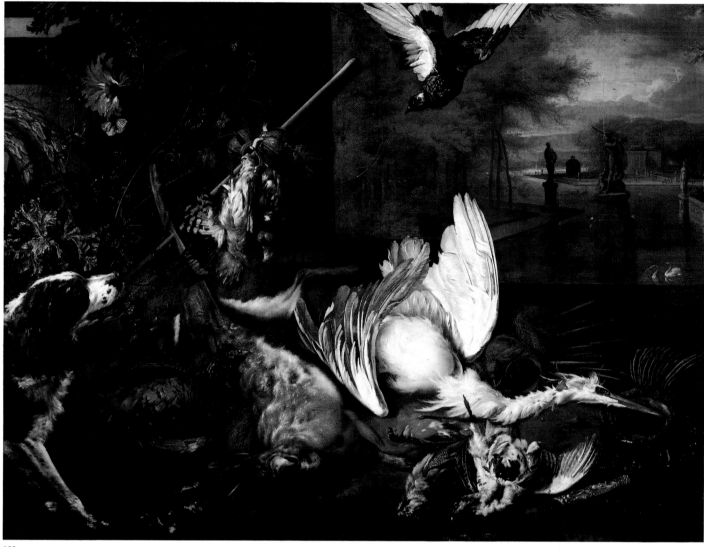

189

Fig. 43 Detail from cat. no. 189

year (for a discussion of the artist's hunting still lifes and his work for the Prince, see cat. no. 188).

The wheellock rifle to the lower right was one of the treasures of the Prince's armory and is included in this exhibition (cat. no. 83). Valkenburg's master, Jan Weenix, frequently depicted a dog barking at a flying bird; other motifs, as mentioned in cat. no. 188, derive from that artist's oeuvre. Two falcon hoods refer to an aristocratic form of hunting not represented by any object in the other picture; the allusions to life at a great country house are also much stronger here. A painting or a drawing by Jan Weenix must have been the model for the dead heron: four of them, one in the same position as that found here, occur in Weenix's study sheet in the collection of the late J. Q. van Regteren Altena, Amsterdam.

WL

FURTHER REFERENCES: Cat. 1873, no. 1156; Cat. 1885, no. 765; Wurzbach 1906–1911, vol. 2, p. 739; Wilhelm 1914, col. 37; Cat. 1931, no. 765; Thieme-Becker, vol. 34 (1940), p. 52; Cat. 1970, no. 41; Wilhelm 1976, p. 74; Blair 1979, pp. 49–50; Baumstark 1980, p. 242; Münster 1980, p. 253.

190

Adriaen Brouwer
Flemish, 1606?–1638

A LAUGHING PEASANT WITH A JUG
Oil on wood; 7¼ × 5⅜ in. (18.5 × 13.6 cm.)
Monogrammed (at right center): AB
Liechtenstein inv. no. 469

Brouwer's paintings of peasant life and of individual peasants earned him a great reputation during his short career, particularly among his fellow artists. Rubens owned seventeen pictures by Brouwer; Rembrandt had six and a sketchbook. Brouwer's early work in Haarlem, where he apparently worked in Frans Hals's studio during the 1620s, was crucial for the future course of Dutch genre painting of this kind, and specifically for the early work of Brouwer's supposed copupil under Hals, Adriaen van Ostade. Brouwer's later work in Antwerp, where he joined the painters' guild in 1631–32, strongly influenced David Teniers the Younger and other painters of peasant life in Brouwer's native land.

This picture dates from Brouwer's Antwerp period and belongs to a series of small oval paintings representing the Seven Deadly Sins. This theme was frequently treated by Northern artists; *The Tabletop of the Seven Deadly Sins* (Prado, Madrid), attributed to Hieronymus Bosch, is one of the best-known examples, but for Brouwer the most familiar precedent was probably the engravings by Pieter van der Heyden after Pieter Brueghel the Elder (Münz 1961, nos. 130–36, pls. 127–33).

Brouwer's series was engraved by the accomplished printmaker Lucas Vorstermans; the engraving after *A Laughing Peasant with a Jug* is inscribed *Gula* (Gluttony) and is accompanied by a four-line commentary in verse. Brouwer's shrewd understanding of character enabled him to portray the figure in such immediate terms that, without a knowledge of the other subjects in the series, one would not likely recognize this as an allegorical image. The man's devotion to smoking and drinking, two forms of indulgence that were widely condemned, is conveyed by his expression: his appetites possess him as much as he, with his emphatic embrace, possesses the jug.

The series to which this painting belongs survives in part and may be reconstructed as follows (the references are to Hofstede de Groot 1908–1927, vol. 3, pp. 564–66, nos. 6–13; Bode 1924; and Knuttel 1962):

1. *Pride* (HdG, no. 6; Bode, fig. 74). A woman seated at a table before a mirror. Formerly in the Kaiser-Friedrich-Museum, Berlin (1911 Berlin cat., no. 853A, ill. p. 372). The panel measures 7⅛ × 5⅜ in. (18 × 13.5 cm.).

2. *Anger* (HdG, no. 7; Bode, fig. 75). A seated cavalier in an inn, facing the viewer and drawing his sword impetuously. The version listed by Hofstede de Groot and illustrated by Bode as being with Duveen is a little smaller (6 × 5 in. [15.2 × 12.7 cm.]) than the standard size of the series, and as Knuttel observes (p. 150 n. 1), the image is not reversed in the engraving. Other versions are listed by Hofstede de Groot, and one of them may be the original painting (it is also possible that more than one version is by Brouwer himself).

3. *Luxury* (HdG, no. 9). A half-length view of a cavalier in fashionable dress before a landscape. He holds a glass of wine in front of him; the manner in which his fingertips grasp the glass's base suggests social refinement. The composition was engraved by Lucas Vorstermans the Younger (see Buyck 1964, p. 223, fig. 2) and substituted for Brouwer's first idea of *Luxury* (Lust), a nude woman sitting on a bed and facing the viewer (HdG, no. 8). No author has cited a painted version of *Luxury* (the cavalier), but Brouwer's original picture is apparently the panel (7¼ × 5¼ in. [18.4 × 13.3 cm.]) sold at Parke-Bernet Galleries, New York (December 2, 1944, no. 68, ill.) for $1200.

4. *Sloth* (HdG, no. 10; Bode, fig. 73; Knuttel, fig. 98). A young woman, perhaps a maidservant, sitting at a table and supporting her head with her hand. The version listed by Hofstede de Groot and illustrated by Bode as being with Duveen (see also *Anger*, no. 2 above) is a little smaller (6 × 5 in. [15.2 × 12.7 cm.]) than the standard size of the series. The painting illustrated by Knuttel as "formerly Bayerische Staatsgemäldesammlungen, Munich" (on loan?) is apparently the same picture. No other versions are recorded.

5. *Envy* (HdG, no. 11). "A young peasant wearing a high cap around which a snake is coiled. He sits on a tub, pressing a pig on his left knee" (HdG). No painted versions are known.

190

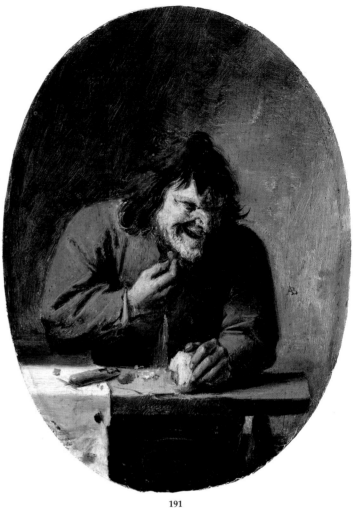

191

6. *Avarice* (HdG, no. 12; Knuttel, fig. 99). A man sitting at a table and pressing a bag of money to his breast. The panel (7⅛ × 5⅜ in. [18 × 13.5 cm.]) in the Czernin collection (Salzburg 1955, no. 22) is apparently the original. Hofstede de Groot records at least one other version.

7. *Gluttony* (HdG, no. 13; Bode, fig. 76). The present painting is the original, as all authors have agreed. A copy is in Koblenz (1874 Koblenz cat., no. 14; where it is described as a pendant to a copy [1874 Koblenz cat., no. 15] of *Pride*, no. 1 above).

The present painting has been recorded in the Princely Collections since 1712.

<div align="right">WL</div>

FURTHER REFERENCES: Cat. 1767, no. 339; Cat. 1780, no. 515; Cat. 1873, no. 715; Cat. 1885, no. 469; Bode 1896, p. 109; Hofstede de Groot 1908–1927, vol. 3, p. 566, no. 13; Bode 1917, p. 319; Bode 1924, p. 117; Cat. 1931, no. 469; Lucerne 1948, no. 195; Knuttel 1962, p. 147; Baumstark 1980, no. 69.

191

Adriaen Brouwer
Flemish, 1606?–1638

A PEASANT AT A TABLE
Oil on wood; 7¼ × 5⅜ in. (18.4 × 13.5 cm.)
Monogrammed (at right center): AB
Liechtenstein inv. no. 470

This small panel and Brouwer's *A Laughing Peasant with a Jug* (cat. no. 190) have been together since they were recorded in the Liechtenstein collection in 1712. Scholars have never considered them as originally belonging to the same series of pictures. However, their similarities in subject, size, composition, and execution suggest some close relationship between them at an even earlier date.

For example, one of the panels may have replaced the other as an allegory of Gluttony within a series representing the Seven Deadly Sins. It will be recalled that such a substitution did take place in the case of Brouwer's allegory of Luxury (see dis-

cussion in cat. no. 190). It is also conceivable that *A Laughing Peasant with a Jug* may have been separated from its original series or, alternatively, that the composition may have been repeated by Brouwer himself, in order to place it in another series of which *A Peasant at a Table* was part. Since the painting depicts a man eating bread and sausage, it could have represented Taste, while *A Laughing Peasant with a Jug* could have become an allegory of Touch, providing that panels representing the other three of the Five Senses made this clear. In the absence of additional evidence, one can only speculate along these lines. It may be that the pairing of these two pictures is entirely fortuitous, in which case *A Peasant at a Table* could represent either Gluttony or Taste. WL

FURTHER REFERENCES: Cat. 1767, no. 340; Cat. 1780, no. 516; Cat. 1873, no. 716; Cat. 1885, no. 470; Bode 1896, p. 109; Hofstede de Groot 1908–1927, vol. 3, p. 644, no. 193; Bode 1917, p. 319; Cat. 1931, no. 470; Lucerne 1948, no. 196; Knuttel 1962, p. 510; Baumstark 1980, no. 69.

192

David Teniers the Younger
Flemish, 1610–90

HORSE TRADING
Oil on copper; 9⅞ × 13⅝ in. (25 × 34.7 cm.)
Signed (lower left): DAVID·TENIERS·F
Dated (on drawing over fireplace): A 1645
Liechtenstein inv. no. 553

In this peculiar, personal picture, Teniers, the well-dressed figure in the foreground, presents himself as a tasteful consumer, passing an expert eye over a pretty, dappled gray pony. The horse has been brushed and shod, the long mane is fluffed, and the tail is braided, but the artist seems to see through this and the old groom's recommendation and to consider instead the animal's conformation. The boy behind Teniers, his son

192

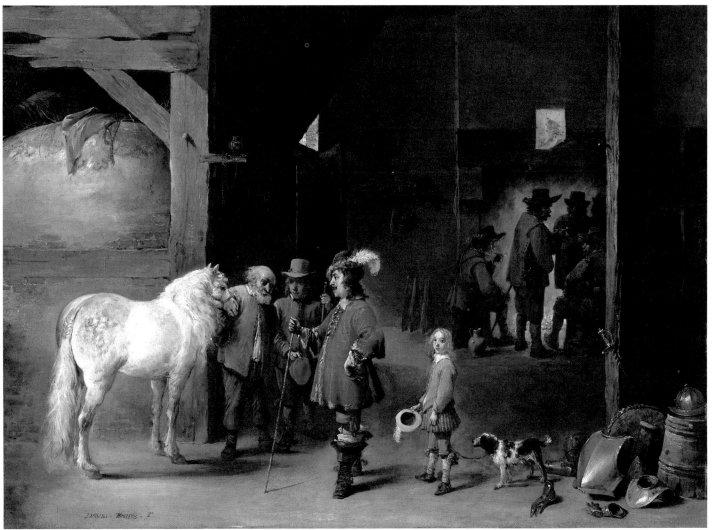

David III, will probably be the pony's proud recipient. Nothing less would do for a young man with such a fine suit of clothes and such a successful father.

The story of Teniers's social ambitions is now well known. The son of a painter, Teniers was the son-in-law of the prominent artist Jan Brueghel the Elder (Rubens witnessed Teniers's marriage to Anna Brueghel in 1637). Teniers became dean of the painters' guild in Antwerp in 1645, the same year that is inscribed on this picture. Two years later he was in the service of the new Governor of the Southern Netherlands, Archduke Leopold Wilhelm, who named Teniers court painter in 1651. During the 1650s the artist served the Archduke's successor, John of Austria (Governor from 1656 to 1659), and launched an untiring and ultimately successful campaign to obtain a patent of nobility (Vlieghe 1961–66, pp. 123–49; Dreher 1978, p. 683).

These somewhat later circumstances, and Teniers's purchase of a country estate (which appears in several of his paintings dating from the 1660s), are consistent with what *Horse Trading* reveals about the artist. It is an eccentric kind of equestrian portrait—an aristocratic art form—presented in the guise of a scene from everyday life. Though belonging to a different category of subject matter, the painting is comparable to Rembrandt's *Self-Portrait* of 1640 (National Gallery, London), in which the artist, in a less prosaic manner, presents himself as a gentleman and a man of means. Teniers's small work on copper was, however, probably intended not as a public gesture but as a private memento, and considered as a portrait of a father and son, it is a rather charming one.

The choice of copper as a support and the care devoted by the artist to the composition are indications that the picture was conceived as a work of special significance. Teniers set the subject in a stable or barracks, which allowed him to include the picturesque passages of the armor in the foreground and the soldiers silhouetted against the fireplace. The spatial effect of the whole is worthy of Brouwer, who is recalled by the drawing of a peasant tacked up on the mantlepiece.

This picture was in the Princely Collections by 1805.

WL

FURTHER REFERENCES: Cat. 1873, no. 832; Cat. 1885, no. 553; Bode 1896, p. 110; Cat. 1931, no. 553; Cat. 1967, p. 22; Baumstark 1980, no. 72.

193

David Teniers the Younger
Flemish, 1610–90

PEASANTS MAKING MUSIC
Oil on wood; 14⅝ × 11 in. (37 × 28 cm.)
Signed (lower right): D· TENIERS · FEC ·
Liechtenstein inv. no. 525

Today Teniers is not usually associated with patrician patrons (the dealer Duveen, for example, would not recommend low-life scenes to his wealthy clients), but in the artist's own time his genre paintings were purchased in numbers by such distinguished collectors as Archduke Leopold Wilhelm (Governor of the Southern Netherlands), Queen Christina of Sweden, King Philip IV of Spain (whose many pictures by Teniers filled a special gallery in Madrid), and Prince Karl Eusebius von Liechtenstein. The Prince owned over a dozen paintings by Teniers, including this one, which was previously in Leopold Wilhelm's collection.

The panel probably dates from about 1650. Its subject and style are broadly based upon Adriaen Brouwer's works of the 1630s, but during the next two decades Teniers kept pace with Dutch genre painters (the arrangement of space here is very similar to that found in pictures of the early 1650s by younger Dutch artists such as Pieter de Hooch), and he took a rosier view of peasant life than did Brouwer. Indeed, Teniers's conception of the peasant's existence is not historically reliable; rather, it represents the way in which the urban middle class and aristocratic landowners liked to think about their less fortunate compatriots.

This approach to the subject might be considered condescending when Teniers sees humor or even immorality in the peasant's unpolished manner; in paintings very similar to this one, for example, a yokel comically manhandles the unfamiliar form of a chamber instrument such as a lute (Leppert 1978, figs. 10–12, 14). A guitar, stemware, and the delicate way in which the young man in the present painting holds his glass would, however, be more expected in a "good home" than in a public house (on the guitar, see Mirimonde 1967, pp. 187–90).

Teniers's treatment of peasants and their pastimes is generally sympathetic, and *Peasants Making Music* is certainly an example of his benignity. In similar paintings of impromptu musical moments, an old woman is often shown gazing into the room with concern, as if she were worried that the party would become improper or raucous. In the present painting, however, the expression of this stock character is more open to interpretation; indeed, any fears that she might have would appear to be unfounded. The trio seems earnestly engaged in making music for its own sake (by contrast, in Teniers's *The Duet* [Koninklijk Museum, Antwerp] a theorbo serves as an instrument of seduction). The guitarist knows how to play, and his right foot

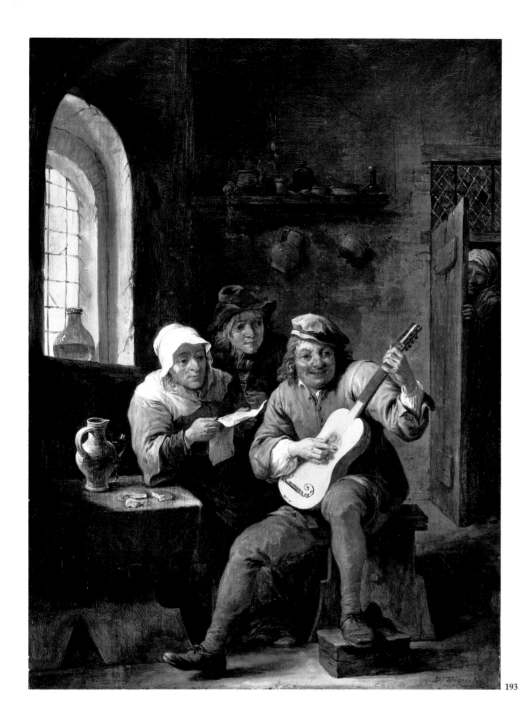

193

taps the beat. Here Teniers associates musical measure with
the virtue of temperance; this idea was common in seventeenth-
century art and literature, especially in connection with stringed
instruments. In some approximately contemporary Dutch and
Flemish paintings, temperance is alluded to not only by the
maintenance of musical time but also by the watering of wine
(see, for example, van Thiel 1967–68, p. 91). The same image is
evident here: a flask of wine is set aside on the windowsill, and
a jug of water stands on the table.

WL

FURTHER REFERENCES: Cat. 1767, no. 240; Cat. 1780, no. 292; Cat. 1873, no.
780; Cat. 1885, no. 525; Suida 1890, p. 108; Fleischer 1910, p. 49; Sommer
1920, no. 64; Cat. 1931, no. 525; Denucé 1931, pp. 142, 180; Lucerne 1948,
no. 200; Cat. 1967, p. 22; Leppert 1978, pp. 87–88; Baumstark 1980, no. 70.

194

Joos van Craesbeeck
Flemish, ca. 1608–d. before 1662

THE LUTE PLAYER
Oil on wood; 11¾ × 9 in. (30 × 23 cm.)
Monogrammed (below, on bench): CB
Liechtenstein inv. no. 476

Van Craesbeeck, like his father, was a baker from Neerlinter (near Louvain). His career as a painter apparently came about from an unexpected association with Adriaen Brouwer. In 1630 van Craesbeeck married into a family that ran the bakery in the Antwerp citadel. Brouwer was imprisoned there in 1633. Van

Craesbeeck became Brouwer's best pupil and his friend; their relationship is described by the biographer Cornelis de Bie (1661, p. 109) with the proverb familiar from paintings by Jacob Jordaens: "Soo d'oude songhen, soo pypen de jonghen" (As the old ones sing, so the young ones peep).

Insofar as they may be distinguished among van Craesbeeck's always undated works, his earliest efforts are entirely indebted to Brouwer in subject and style. After van Craesbeeck became a widower and heir in 1637, and after Brouwer's early death in 1638, the former baker evidently turned to painting full-time and to other artists for inspiration. Like David Teniers the Younger, he seems to have borrowed ideas from contemporary Dutch painters, although Antwerp artists, above all Brouwer, remained van Craesbeeck's usual source of ideas. Ever eclectic, he nonetheless had a distinctive approach to the themes of every-

194

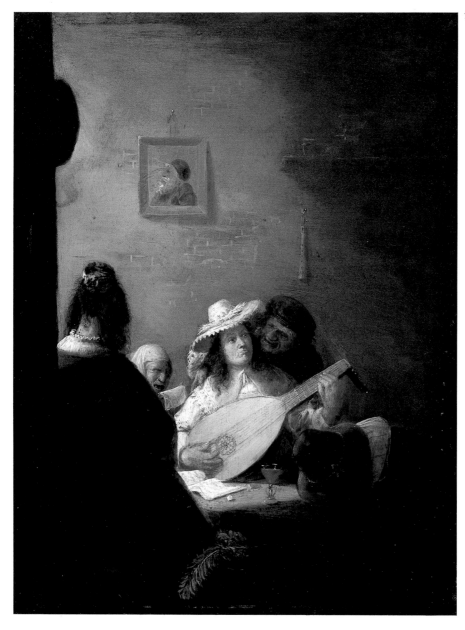

day life (both low and high types, which sometimes meet in his work) and a manner of execution that, in its energy, compensates for technical deficiencies.

This rough style suits the subject in van Craesbeeck's pictures of tavern interiors. The artist is a true follower of Brouwer in his ability to tell a story clearly and with what most contemporaries would have regarded as knowing wit. In the Liechtenstein painting two women are entertaining a cavalier, who has passed out with a full glass of wine in front of him. The ladies' hairdos, hats, and dresses, like the lute and the Venetian glass, suggest that they are trying to maintain a certain social level, but the one they have found is defined by the two craggy choristers. The flute hanging on the wall just above the old man's head indicates, by its shape, the sort of thoughts that occupy his mind.

A man too old for his inamorata was a venerable motif in Flemish art long before its occurrence here. But in other ways van Craesbeeck's composition is rather advanced for its date, which to judge from the feminine fashions is of the early 1650s. As did Vermeer in his early *Cavalier and Young Woman* (Frick Collection, New York), van Craesbeeck modernized a pattern employed by Northern Caravaggesque painters—namely, figures seated around a table, with those in the foreground seen in silhouette—by more fully describing the interior space (here, as so often after 1650, it is the corner of a room, with a window to the left), by increasing the amount of daylight and demonstrating its particular effects, and by changing the format of the picture in favor of its height.

The theme of music in the works of Vermeer and his contemporaries, who include, in a broad view, van Craesbeeck and Teniers, was also adopted from Caravaggesque compositions (Mirimonde 1965, pp. 113–73). Thus, *The Lute Player* might be considered as a conventional Merry Company scene, but with the intrusion of two of Brouwer's types. This is precisely how the lutenist herself might describe the situation, to judge from the look on her face.

WL

FURTHER REFERENCES: Cat. 1767, no. 239; Cat. 1780, no. 270; Cat. 1873, no. 722; Cat. 1885, no. 476; Frimmel 1907, p. 29; Cat. 1931, no. 476; Denucé 1931, p. 179; Lucerne 1948, no. 189; Legrand 1963, pp. 131, 141, 148; Baumstark 1980, no. 73.

PAINTINGS BY RUBENS AND VAN DYCK

195

Anthony van Dyck
Flemish, 1599–1641

SAINT JEROME
Oil on canvas; 62⅝ × 52 in. (159 × 132 cm.)
Liechtenstein inv. no. 56

This extraordinary and powerful painting is the work of a young artist, exceptionally gifted, but still tentatively finding his way. It seems to have been painted in 1616, when van Dyck was only seventeen years old and had not yet been declared a master. In showing Saint Jerome (340?–420) writing in the wilderness, van Dyck blends two pictorial traditions. The first presents the saint as a scholar in his study, pondering the Vulgate, his Latin translation of the Bible; the second shows Jerome as a hermit who leads an ascetic life in the desert, venerating the cross and fervently doing penance. The combination of both aspects of the saint's life heightens the intensity of the present image; here the desert flowers as a place of learning. The herculean ascetic, leathery from the Syrian sun, writes with great physical effort, as if overwhelmed by the power of the sacred word. At his feet lies his companion, the happily domesticated lion, whose sleep recalls the silence of the wilderness that surrounds Jerome.

Between 1616 and 1618 van Dyck painted at least four versions of Jerome in the desert (excluding derivations and copies). Since he never returned to it as a mature artist, this theme apparently interested him only in his youth. The present version marks the beginning of this series, followed by a large canvas in the Museum Boymans–van Beuningen, Rotterdam. In the second picture Jerome, sitting frontally and spreading a parchment scroll, is about to write with a pen that an angel hands him. Slightly later, in a half-length depiction in the Prado, Madrid, van Dyck returned to the traditional subject of Jerome venerating the cross. Around 1618 he expanded that idea in the most impressive version of the series, the large painting in the Gemäldegalerie, Dresden, in which the saint is placed in a splendidly visualized landscape. Comparison of these different versions gives an insight into the young artist's struggle for expressive imagery. Van Dyck seems to have thrown himself into the task of painting Jerome repeatedly to test his powers and to prove his command of history painting. Rubens must have immediately recognized the value of these precocious works, since he owned three of van Dyck's Jeromes, among them certainly the one in Rotterdam and probably that in Dresden.

The 1653 inventory of the estate of the Antwerp collector Jeremias Wildens listed three originals and three copies of this subject by van Dyck, whereas in 1691 the estate of Jan Baptist Anthoine, another Antwerp collector, included three originals (Denucé 1932, pp. 66, 156, 160–61, 164, 170, 357). Not all of these paintings came from Rubens's collection, since the version now in Rotterdam was sold shortly after the master's death in 1640 to Philip IV of Spain. The present painting, traceable in Antwerp since 1698 and sold from there in 1701 by the art dealer Forchoudt to Prince Johann Adam von Liechtenstein, might be one of the versions in the collection of Wildens or Anthoine.

The experimental quality of these early works—almost exercises to test and expand the young artist's skill—becomes even more evident when van Dyck's paintings of Jerome are related to their pictorial tradition. The present work, for example, looks back to Rubens's life-size painting (around 1615) of the kneeling Jerome venerating the cross in the wilderness (Gemäldegalerie, Dresden). Van Dyck must have known that Rubens had based his composition on a famous picture by Titian, which the older Flemish master seems to have studied at the original location in Santa Maria Nuova, Venice (now in the Brera, Milan; Wethey 1969, vol. 1, no. 105). This line of artistic ancestors must have presented a challenge to the young artist, which he accepted and, in fact, tried to surpass. His competitive spirit led to the innovation mentioned earlier—he extended and enriched the meaning of Jerome's desert life by presenting him as both penitent and scholar. Furthermore, van Dyck gives Jerome a new vitality, evident in the saint's energetic yet strangely haggard body. When the picture is compared with Rubens's representation, it can be seen that the young artist has exaggerated every detail—the disheveled hair of the ascetic, his wrinkled skin, his bare feet, and the voluminous red mantle that wraps around his waist and billows in forceful movement. In stressing the hermit's tensely bent back, van Dyck—besides learning from Rubens—seems to have depended upon a print by Agostino Carracci from about 1602, showing the kneeling Jerome with the cross in his hand (de Grazia 1979, no. 213). The young van Dyck must have been particularly fond of this motif; he used the bent back as a sign of physical strength again and again in his early works, among them *Christ Crowned with Thorns* (formerly Kaiser Friedrich-Museum, Berlin), *The Betrayal of Christ* (Prado, Madrid), and *The Entry of Christ into Jerusalem* (Indianapolis Museum of Art). The readiness to learn and the urge to compete—two pillars of van Dyck's youthful art—may be noted in his other paintings of Jerome. Models from the Flemish tradition and from the international Caravaggesque movement, especially by Abraham Janssens, have been utilized in the Rotterdam version of the saint sitting frontally. And in the Dresden version

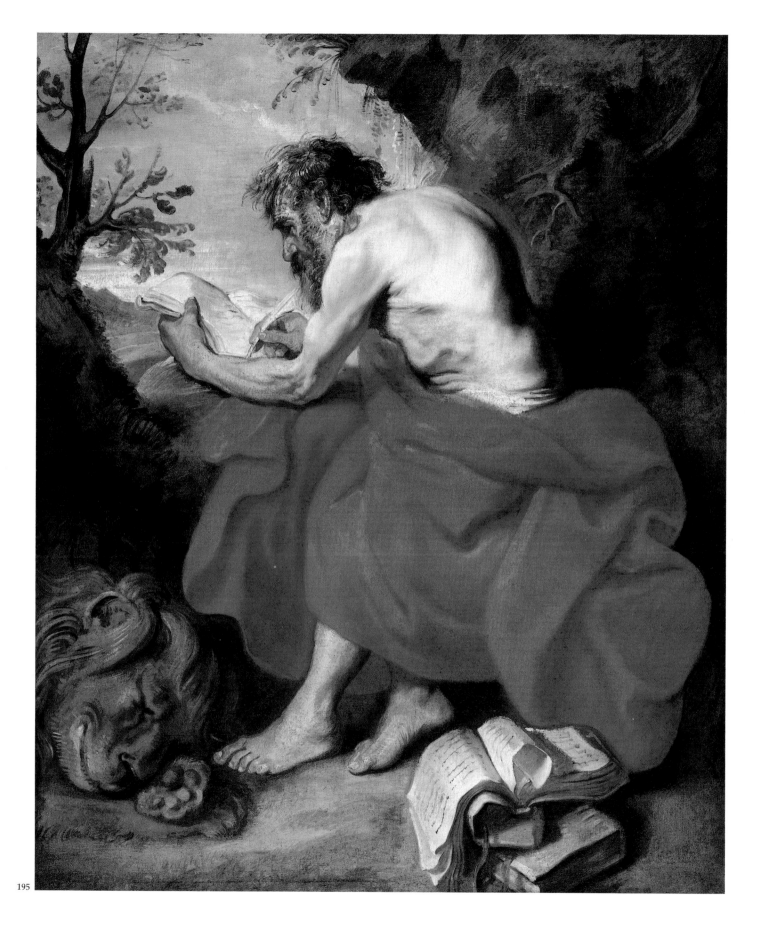

195

he, like Rubens before him, took Titian as a point of departure for the landscape in which he placed the ascetic saint.

Although the present painting is firmly rooted in the art of Rubens—its intense physicality finds parallels in earlier works by that master, like the Jerome in the latter's altarpiece *The Real Presence of the Holy Sacrament* (ca. 1609) in the church of Saint Paul, Antwerp—it is obvious that van Dyck quite intentionally departed from the painting technique that Rubens had developed around 1610. Instead of Rubens's careful layering of colors to achieve an enamel-like effect in the flesh tones, van Dyck's paint is impatiently spread with unconcealed, slashing brushstrokes. The freedom of the brushwork, which sometimes has an almost calligraphic quality, shows a boldness found in Rubens only in the oil sketches that express his first ideas about a composition. Van Dyck, however, used the master's sketching technique in areas of his painting—the sleeping lion, for example—that are nearly life-size and that he presented as completely finished. Impulsiveness and youthful opposition to the inescapable dominance of Rubens's art were likely to be driving forces behind van Dyck's earliest achievements. Examples of Tintoretto's nervous technique, however, may also have helped shape the eccentricity the young Fleming so manifestly cultivated.

Looking back from the mature work of the artist, thoroughly dominated by restraint and elegance, one may be puzzled by this beginning, which left so few traces in the later work. But one admires all the more an artistic temperament that developed through a kind of painterly Sturm und Drang.

RB

FURTHER REFERENCES: Cat. 1767, no. 351; Cat. 1780, no. 648; Cat. 1873, no. 108; Cat. 1885, no. 56; Bode 1889, p. 37; Cust 1900, p. 13; Rosenbaum 1928b, p. 46; Cat. 1931, no. 56; K.d.K. 1931, pp. 9, 518; Denucé 1931, pp. 248, 249, 252; Glück 1933, pp. 282, 285–86; van Puyvelde 1941, p. 182; van den Wijngaert 1943, p. 25; Lucerne 1948, no. 123; Baumstark 1980, no. 61; Larsen 1980, vol. 1, p. 91; McNairn 1980, pp. 161–62.

196

Anthony van Dyck
Flemish, 1599–1641

PORTRAIT OF A WOMAN
Oil on wood; 41 × 29½ in. (104 × 75 cm.)
Inscribed: A° 1618. Aet. 58
Liechtenstein inv. no. 71

This portrait and its pendant in Vaduz are dated 1618, the earliest date found on a work by van Dyck. Highly valuable for understanding and reconstructing van Dyck's development, the pair of portraits is even more important as a record of a most significant event in the artist's life. On February 11, 1618, van

Dyck was accepted as master into the Guild of Saint Luke, the Antwerp painters' guild. Four days later his father declared the eighteen-year-old youth to be of full legal age, thus recognizing his new status. Since the guild did not allow the sale of an artist's works until he had been declared master, the date so explicitly shown on the present painting marks the beginning of van Dyck's official career.

He had, of course, painted before 1618. A precocious talent, he must have quickly outgrown the art of his teacher, Hendrick van Balen, whose apprentice he had become in 1609. (It is not known when he left this master's shop.) A self-portrait in Vienna shows the young artist at about fifteen years of age, and shortly thereafter he must have painted a series of busts of apostles, now in various collections. (This series should not be confused with the so-called Boehler Series of apostles, which is of a later date.) In 1660 a witness in a legal proceeding made a statement, quoted repeatedly in studies of van Dyck, that describes such a series and maintains that van Dyck was running a shop with assistants as early as 1616; this statement, however, does not seem at all reliable (Roland 1984). Finally, there are powerful attempts in the field of history painting (cat. no. 195), certainly done before van Dyck came into contact with Rubens's

196

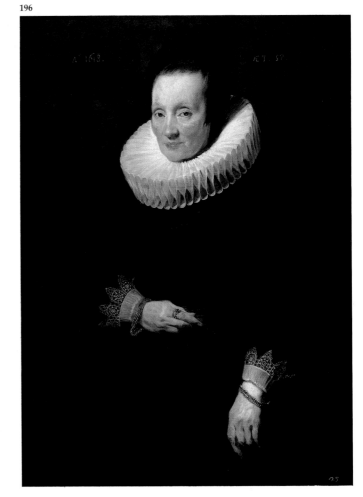

atelier around 1618. All these early works can be regarded as practice pieces, the exercises of a young genius. To judge truly the youthful accomplishment of van Dyck, however, one should turn to those works that he executed as a professional after he established himself as master.

The date 1618 is inscribed not only on the pair of portraits in Vaduz but also on another pair in Dresden, showing an elderly couple. Some further undated portraits might be added, forming a coherent group that displays van Dyck's earliest portrait style. In this group the Dresden pair should be ranked as the earliest, followed by the male portrait in Vaduz. The latter picture and its pendant, the present portrait of a woman, were not painted side by side; their dimensions are slightly different, and a stylistic assessment indicates that the present portrait was carried out shortly after its male counterpart. Its background has been applied thinly and hastily, while the same area is solid and well-covered in the male portrait. Furthermore, the artist's skill seems to be more advanced, indicating how rapidly van Dyck developed in a year's time. The identities of the sitters are not known. The only clues are the carefully inscribed ages, *Aet. 57* for the man and *Aet. 58* for the woman. Further evidence might be offered by the depiction of the man's left hand, which seems to be an artificial wooden limb that was later overpainted and revealed only after the recent cleaning of the picture. Van Dyck shows the couple unpretentiously in conventional three-quarter-length portraits. Both face the observer in a rather stiff but open manner. Looking like prosperous Antwerp citizens in their Sunday clothes, they are well-dressed in black and wear white ruffs. Showing remarkable deftness, the young master enlivens the dark costumes with a rich tonality and gives physical substance to the collars' folds and to the lace of the cuffs. The sparkle of the jewelry is captured by sketchily applied impasto; the flesh tone, also vehemently worked in free and still-unblurred brushstrokes, is an extraordinary example of the artist's brilliant assurance and painterly skill. The earliest portraits by the nineteen-year-old van Dyck are admirably painted; their weaknesses—inconsistency in dealing with a multitude of details and a certain lack of compositional sophistication—would soon be overcome. They were the initial successes in a body of work that would become one of the most superb achievements of Western portraiture.

RB

FURTHER REFERENCES: Cat. 1767, no. 367; Cat. 1780, no. 662; Cat. 1873, no. 146; Cat. 1885, no. 71 (as Rubens); Bode 1889, pp. 42–43; Rooses 1890, p. 317 (as Rubens); Rosenbaum 1928a, p. 332; Rosenbaum 1928b, pp. 15–17; Cat. 1931, no. 71 (as Rubens); K.d.K. 1931, pp. 81, 528; Lucerne 1948, no. 120; van Puyvelde 1950, pp. 112, 123, 127, 129, 137; Baldass 1957, pp. 256–57; McNairn 1980, pp. 7, 116; Larsen 1980, vol. 1, p. 96.

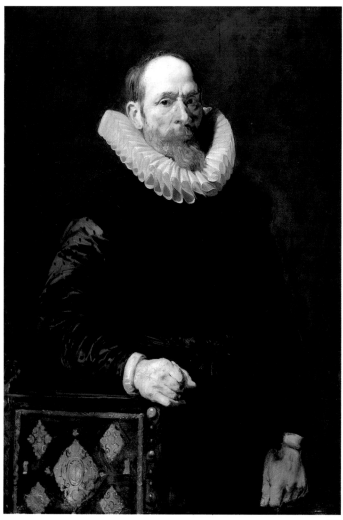

197

197

Anthony van Dyck
Flemish, 1599–1641

PORTRAIT OF AN ELDERLY MAN
Oil on wood; 42⅛ × 29⅛ in. (107 × 74 cm.)
Inscribed (on back): oudt 55 Jaren
Liechtenstein inv. no. 95

The identity of this bearded man, shown by van Dyck in a three-quarter-length portrait, is unknown, but he was probably a high-ranking citizen of Antwerp. An old inscription on the back of the panel gives his age as fifty-five. He stands behind a chair, on which his right hand rests, and faces the observer with a firm gaze. The portrait is the work of the nineteen-year-old van Dyck, apparently painted in 1618, just after the artist was received as master in the Antwerp guild of Saint Luke. It is the most accomplished of a group of portraits, some of them dated (cat. no. 196), and has therefore to be considered the true masterpiece of van Dyck's early attempts in portraiture. It is

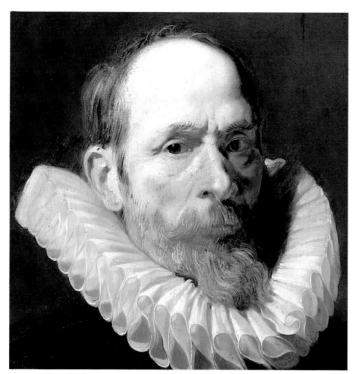

Fig. 44 Detail from cat. no. 197

striking for its loose painterly style, uncommon until then in the contemporaneous Flemish school dominated by Rubens. The sitter's doublet, with its subtly depicted woven ornament, gleams in various tones of black. The right sleeve is a particularly splendid example of van Dyck's rapid brushwork; rather hasty strokes of white describe the light playing over the lustrous silk. The speed and impulsiveness with which van Dyck worked can still be sensed. The white ruff, which many painters handled in a more uniform fashion, has here a lively delicacy, presented with bravura. The ruff's folds are displaced by the sitter's chin and beard, and its irregular hollows and rounded surfaces catch the light brilliantly (pentimenti show that van Dyck initially had difficulties in constructing this most artificial object). The young master's skill is most obviously revealed, however, by the way in which the flesh tones of the head and right hand have been built up. Creamy layers of paint are spread with a rather broad brush, and touches of green heighten the coarse forms. The restlessness of the precocious van Dyck left its mark in every detail of this masterly portrait.

The loose and hasty execution here seems to anticipate the achievement of the Haarlem master Frans Hals, an artist totally different in character and origin. The two artists may have met, however, during Hals's stay in Antwerp two years earlier in 1616. Hals maintained the technique of spontaneous brushwork throughout his career, while van Dyck was attracted to it only during a short interval around 1618. It seems reasonable therefore to ascribe the initiative to the older and then more accomplished artist from Haarlem. But although Hals may have affected van Dyck, the main stimulation came from Rubens. In

Antwerp his art was the inescapable example that the young painter tried to emulate and perhaps surpass. Portraits like that of Jan Vermoelen, painted by Rubens in 1616 (cat. no. 198), are the exact models on which van Dyck based his early portraiture around 1618. There are, of course, differences in style and technique. In a finished painting Rubens would never allow the hurried brushwork that van Dyck used, and unlike the younger artist, he always had careful control over the economical layering of colors. Displayed together, the vigorous, self-confident art of the older and the nervous, at this stage almost boastful efforts of the younger cannot be confused. And yet these portraits have generated some controversy in recent literature. The Jan Vermoelen has been repeatedly declared an early work by van Dyck, whereas the name of Rubens was long attached to the present painting. Even today, this uncertainty has been extended to a portrait of a bearded man in the Herzog Anton Ulrich-Museum, Brunswick, like the present painting a splendid work by the young van Dyck, but still erroneously ascribed to Rubens. The painting in Brunswick, however, forms a homogeneous group with the pair of portraits in Vaduz, dated 1618 (cat. no. 196), the present painting, and an undated portrait of a man in the Metropolitan Museum. The dimensions of these panels are almost identical, as if they were made and delivered to the painter at the same time. The present exhibition, with its telling juxtaposition of van Dyck's earliest portraits with their Rubensian model, may render further disagreement about the exact share of both artists superfluous.

RB

FURTHER REFERENCES: Cat. 1767, no. 368; Cat. 1780, no. 665; Cat. 1873, no. 143; Cat. 1885, no. 95 (as Rubens); Bode 1889, pp. 43–44; Rooses 1890, p. 317 (as Rubens); Rosenbaum 1928a, p. 332; Rosenbaum 1928b, pp. 13–14, 16, 19; Cat. 1931, no. 95 (as Rubens); K.d.K. 1931, pp. 78, 528; Lucerne 1948, no. 118; Baldass 1957, pp. 259–60; Larsen 1980, vol. 1, p. 90.

198

Peter Paul Rubens
Flemish, 1577–1640

PORTRAIT OF JAN VERMOELEN
Oil on wood; 49⅝ × 37⅞ in. (126 × 96.2 cm.)
Inscribed (upper left, beneath coat of arms): AETATIS SVE 27/A 1616
Liechtenstein inv. no. 87

The identification of the sitter as Jan Vermoelen, a member of an old Antwerp family, was established by Rooses in 1890 (vol. 4, no. 1075), who deciphered the coat of arms in the upper left of the painting. The son of Gilles Vermoelen and Maria Reyniers, Jan Vermoelen was born in 1589 and baptized in the Antwerp

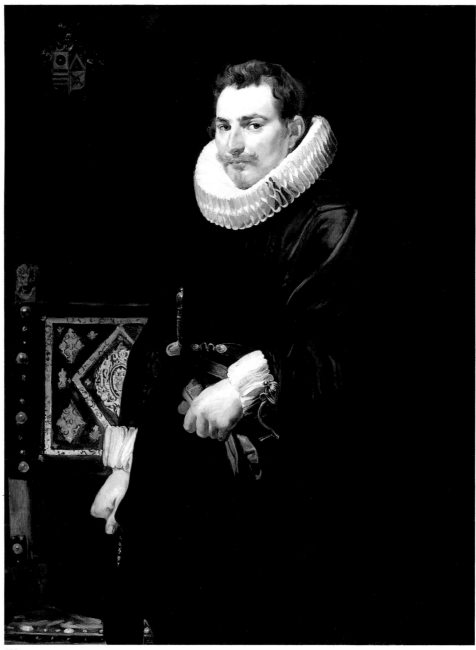

198

Cathedral on December 12 of that year. He later joined the Spanish navy, thus serving the foreign power that governed his native land. Rising to general commissioner and admiral of the Spanish fleet in the Southern Netherlands, he lived mostly in Spain and married Ludovica Canze of Seville. Vermoelen lost his life during a naval battle. He is shown by Rubens at the age of twenty-seven and therefore at the beginning of his career, but one can sense the imposing personality so evident in the further course of his life.

In 1656 this portrait was attributed to van Dyck in an inventory of the estate of Peter Vermoelen, the sitter's brother (Denucé 1932, p. 192). On the basis of this document Oldenbourg and

Glück (1933, p. 309), and later van Puyvelde (1950, pp. 112, 126, 129, 137) and Valentiner (1950, p. 93), attributed the painting to the young van Dyck. With Gerson (1960, p. 114) and Slive (1974, vol. 3, p. 1) this attribution found supporters in recent literature. Opposing this line of thought, Bode (1888b, pp. 28–29), Rosenbaum (1928b, p. 14), Baldass (1957, pp. 252–56), and most recently McNairn (1980, p. 12), argued convincingly in favor of Rubens as author of the picture. Indeed, assuming an attribution to van Dyck means accepting the portrait as his earliest dated work, painted in 1616 by a seventeen-year-old youth, about two years before he became a master in the Antwerp guild. With the exception of the inventory cited above, there is absolutely

no reason to support such a view. In fact, van Dyck's beginnings as a painter of portraits are only known from examples in Dresden and Vaduz dated two years later in 1618 (cat. nos. 196–97). These pictures show him as a precocious artist mastering the task of portrait painting impulsively and with a heavily loaded brush, yet with a certain lack of sureness. Compared to these juvenilia—and the present exhibition allows such a telling comparison—the portrait of Jan Vermoelen is steady and powerful. The sitter is presented with bold outlines and strong forms. His look is firm, his hands are active, and the whole composition is clearly the work of a mature painter. Rubens's hand is nowhere more evident than in the way in which the flesh tones are built up. Careful attention has been paid to the enamel-like translucent glazes with their bluish shading and the touches of red in the dark tones, so typical of the master and never replicated by his followers. One detail underlines the painterly quality of the work: the back of the chair skillfully gives the illusion of a golden pattern imprinted on leather. This has been achieved by simply silhouetting the ornament on the yellow-brown priming of the panel; no additional work was then done on this ground. Compared to the overlabored effort in van Dyck's portrait of 1618 (cat. no. 197), which shows a very similar patterned chair back, the solution found by Rubens is economical and ingenious. Such comparisons, which could be extended, prove conclusively that the attribution of the Vermoelen portrait to Rubens is correct. In this case the painting itself is clearly more reliable than the misleading inventory of 1656. Bode's statement of 1888 still holds true: "In this painting every inch is by Rubens."

The present portrait is one of the few firmly dated works in Rubens's oeuvre. Its date—1616—has a wider relevance, for in that year the Haarlem master Frans Hals visited Antwerp. Hals may have seen recent portraits such as the *Jan Vermoelen*, and although his character as a portraitist is entirely different from that of Rubens, there are Flemish traits discernible in the work of the Dutch master. Portraits such as his *Burgomaster Nicolaes van der Meer* (Frans Halsmuseum, Haarlem) seem to recall Rubens's 1616 painting. Another artist who must have studied the *Jan Vermoelen* carefully was van Dyck, since it seems to be the prototype of the young master's 1618 portrait. In fact, the similarity of the two caused the confusion over the attribution of the present painting which is discussed above. Rubens continued to paint this type of three-quarter-length portrait, and later examples include the portrait of Ambrogio Spinola (Herzog Anton-Ulrich Museum, Brunswick). Shortly before his death Rubens returned once again to this portrait type in his moving self-portrait in Vienna.

RB

FURTHER REFERENCES: Cat. 1873, no. 117; Cat. 1885, no. 87; K.d.K. 1921, p. 452 (as van Dyck); Cat. 1931, no. 87; K.d.K. 1931, pp. 77, 528 (as van Dyck); Larsen 1967, p. 3.

199

Anthony van Dyck
Flemish, 1599–1641

PORTRAIT OF A MAN
Oil on canvas; 50 × 39¾ in. (127 × 101 cm.)
Inscribed: AET.S 32. 1624:
Liechtenstein inv. no. 61

In early October 1621 van Dyck left Antwerp for Italy, where he spent the next six years traveling, studying the art of his great Italian predecessors, and carrying out a seemingly inexhaustible number of commissions. Like Rubens some twenty years earlier, van Dyck fell under the spell of Italy, stimulated by its art and its patronage. His first long stop was in Genoa, like Antwerp a seaport and a center of trade. There had long been cultural and commercial ties between the two cities; unlike Antwerp, however, Genoa was dominated not by wealthy burghers but by a group of noble families. In 1605–1606 Rubens had served that aristocratic society, mirroring their stylishness in splendid portraits. Like the older master, van Dyck was favorably received, and he continued the luxurious portrait style for which he was particularly well qualified by his marked sense of elegance. Genoa became the center of his artistic activities, and he returned there after his various trips throughout Italy. Although he painted a considerable number of portraits in other Italian capitals, the work he did in Genoa clearly occupied a dominant position. Van Dyck's Italian sojourn is therefore generally referred to as his Genoese period.

The present portrait of a thirty-two-year-old cavalier is a typical example of van Dyck's Genoese style. It is dated 1624 and therefore might have been painted in that city, where the artist spent the spring, late autumn, and winter of that year. During the summer months van Dyck made a voyage to Sicily, but an outbreak of plague forced him to stay in Palermo and finally to flee the island. Obviously the painting could also have been executed in Sicily, especially since it is closely related in style to van Dyck's portrait, painted in Palermo, of the Sicilian Viceroy Emmanuele Filiberto, Prince of Savoy (Dulwich College Picture Gallery, London). The painting's place of origin—either Genoa or Palermo—will be determined only when the identity of the sitter, still unknown, has been established. The young man with his blond curly hair, blue eyes, and pointed mustache may have been a compatriot of the artist. He is the same age as the painter and art dealer Cornelis de Wael, van Dyck's Flemish host in Genoa, and might have belonged to his circle. Earlier identifications of the sitter as Wallenstein, commander of the imperial forces during the Thirty Years' War, or as Don Livio Odescalchi, nephew of Pope Innocent XI, are totally unfounded on the basis of the sitter's age alone. The presence of a classical column in a portrait, such as the one which appears here, usually indicates the sitter's elevated or noble status. This

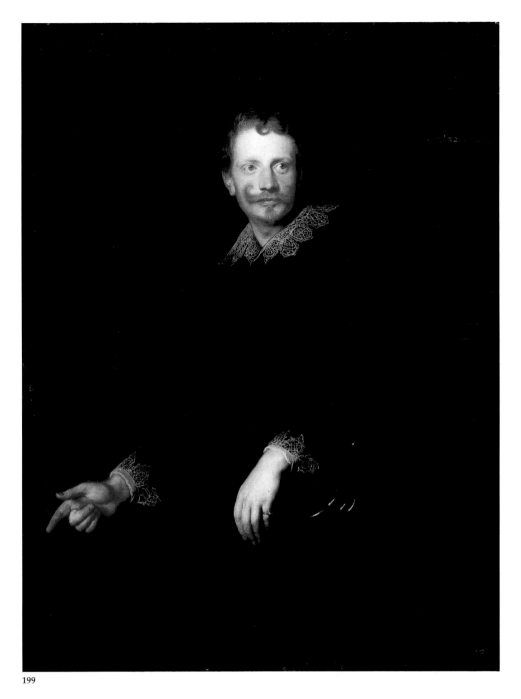

199

vigorous cavalier does not, however, seem to be a person of highest importance, since van Dyck did not include his likeness in the *Iconographia*, the collection of engravings of his most famous portraits which was published by the artist.

It has long been recognized that van Dyck's main formative experience during his sojourn in Italy was his exposure to the works of Titian. The pages of van Dyck's Italian Sketchbook (British Museum, London) show the almost obsessive care with which he studied and recorded the paintings of the great Venetian artist, who had died some forty-five years earlier. This enthusiasm, immediately and powerfully evident in the works of the Genoese period, had an effect so profound and lasting

that Titian may be regarded as the mature van Dyck's true master. In the present painting Titian's influence is clearly visible. Compared to van Dyck's Antwerp portraits of 1618, painted only six years earlier in a distinctively Flemish style, the present Italian work has a new grandness, rendering the sitter with a heightened sense of liveliness and individuality. The surface of the flesh is now sensuously refined with light-saturated colors, modeled on examples by the great Venetian painter. But the work is also informed by Titian's authority in a literal sense, being based on one of his portraits, whose location is unknown today. Van Dyck studied this portrait of a bearded man in the Genoese palazzo of Niccolò Doria and drew it on

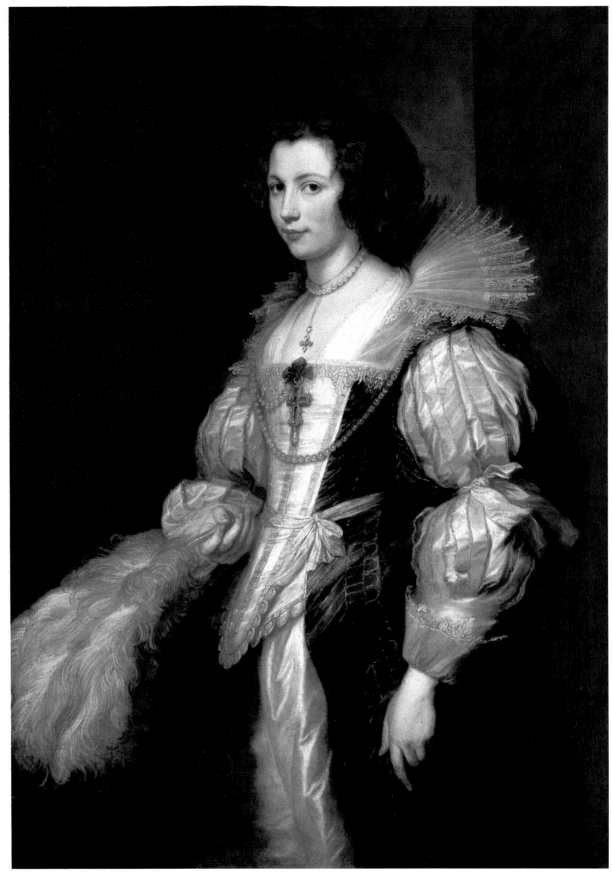

folio 104 of his Italian Sketchbook. Two motifs—the outstretched right arm with pointing index finger and the left hand resting on the pommel of a sword—are borrowed directly from Titian's painting, although van Dyck reversed the sitter's position. The counterbalancing play between gesture and gaze —the right hand as if stressing a point, the head seemingly turned in a sudden decision—leads to a masterly opening up of the pictorial space and an impression of physical presence and vivid directness. In his portrait of Giovanni Vincenzo Imperiale (Musées Royaux des Beaux-Arts, Brussels), dated 1626, van Dyck repeats the rhetorical gesture of the right hand, a most effective device to enliven the portrayal. This search for liveliness—the hallmark of van Dyck's portraiture from the Genoese period on—is therefore firmly rooted in Titian's art.

<div align="right">RB</div>

FURTHER REFERENCES: Cat. 1767, no. 357; Cat. 1780, no. 670; Cat. 1873, no. 118; Cat. 1885, no. 61; Bode 1889, p. 47; Cat. 1931, no. 61; K.d.K. 1931, pp. 170, 538; Lucerne 1948, no. 121; van Puyvelde 1950, p. 113; Baldass 1957, p. 266; Baumstark 1980, no. 64; Larsen 1980, vol. 1, p. 117.

200

Anthony van Dyck
Flemish, 1599–1641

PORTRAIT OF MARIA LOUISA DE TASSIS
Oil on canvas; 51⅛ × 36¾ in. (130 × 93.5 cm.)
Liechtenstein inv. no. 58

Maria Louisa de Tassis, painted in three-quarter-length by van Dyck, was a member of an old Italian family, originally from Bergamo and variously called Tassis, Tasso, and Taxis. At the end of the fifteenth century the Tassis established the first postal system in Europe and thereafter spread their service throughout the Continent. From the sixteenth century onward a branch of the family was settled in Antwerp, where one of its members traditionally held the office of imperial postmaster. It has recently been proved that Maria Louisa was not the daughter of Postmaster Maximilian de Tassis, as was assumed earlier, but of his brother Antonio. As a young man Antonio de Tassis had entered on a military career; he fought against the rebellious Dutch provinces and received distinguished awards from King Philip III of Spain. In 1609 he married Maria Scholiers, and on July 2, 1611, their only child, Maria Louisa, was born. After the death of his wife in 1613, Antonio de Tassis did not remarry but took up the life of a churchman; he was ordained in 1629 and served henceforth as a canon at the Cathedral of Antwerp. On his death in 1651, he left one of the most remarkable art collections in Flanders. In van Dyck's portrait of Anto-

nio de Tassis, painted as a pendant to the present one, the canon is shown as a man of learning. He holds a book in his right hand, and his stance and costume ingeniously hide the fact that he had lost his left arm in battle. The portraits of both father and daughter were acquired in 1710 from the Antwerp art dealer Jan Pieter Bredael by Prince Johann Adam Andreas von Liechtenstein and have been kept since then in the Princely Collections, still paired as the artist intended. Maria Louisa de Tassis married Henri de Berchem in 1636; she died two years later, shortly before her twenty-seventh birthday. In the present portrait van Dyck has depicted Maria Louisa when she was about nineteen years old.

Both the age of the sitter and the style of the painting point to a date around 1630. Furthermore, the portrait can be linked to other works dated by the artist. Van Dyck seems to have taken his portrait of Anna Wake, wife of Peter Stevens (Mauritshuis, The Hague), as a point of departure for the present work. Although he reversed the position of the sitter and changed details of the costume, he used the same basic arrangement, even repeating the picturesque detail of the ostrich feather fan. The portrait of Anna Wake is dated 1628, providing a terminus post quem. The present painting, on the other hand, is likely to antedate the portrait of the sixteen-year-old Marie de Raet (Wallace Collection, London), painted by van Dyck in 1631. A further clue is given by van Dyck's portrait of Dona Polyxena Spinola Guzman de Leganés (National Gallery of Art, Washington, D.C.), which, although much weaker, is clearly based on the present work. External evidence proves this derivation must have been painted between 1630 and 1632.

The portrait of Maria Louisa de Tassis has thus to be placed in the very center of van Dyck's second stay in Antwerp, a period starting with his return from Italy in the fall of 1627 and ending in March 1632 with the artist's departure for England, where the final years of his short career would be passed. These few years that van Dyck spent in his native city—referred to as his second Antwerp period—have always been recognized as the time when he reached the true climax of his art. He had assimilated the experience of Italy and was guided once again by the Flemish tradition; he was not yet pressed, as later in England, to maintain a vast output of portraiture and to oversee a busy atelier. The present painting is one of the finest works from these most serene years. Lionel Cust's remark (1900, p. 75) still holds true: "This portrait has deservedly been reckoned among the principal triumphs of van Dyck, and indeed is generally allowed to rank among the masterpieces of the painter's art." Indeed, van Dyck captures the sitter's maidenly grace and charm with naturalness and ease. Slightly smiling, Maria Louisa regards the viewer with a lively expression. She is lavishly dressed and wears an array of jewels. With exceptional delicacy van Dyck renders the splendor of the costume with all its gleaming highlights of pearls, gold braid, and silk. He had intended to adorn the cream-colored fabric with a pattern of scattered flowers but then

changed to the even more brilliant contrast of white and gold. Traces of the flower pattern are, however, still discernible, and these touches of color add to the extraordinarily rich and Titianesque tonality of the paint. In the engraving of his portrait, published in van Dyck's *Iconographia*, Antonio de Tassis is referred to as "Picturae, Statuariae, nec non omnis Elegantiae amator et admirator" (lover and admirer of paintings, sculptures, and all that is particularly elegant). As patron of the present painting, he certainly appreciated it as a splendid work of art. Enjoying both the beauty of the portrait and the loveliness of its subject, Maria Louisa's father may indeed have been deservedly called "amator et admirator."

RB

FURTHER REFERENCES: Cat. 1767, no. 374; Cat. 1780, no. 650; Cat. 1873, no. 115; Cat. 1885, no. 58; Bode 1889, p. 48; Cust 1900, p. 75; Cust 1911, no. 12; Wilhelm 1911, p. 102; Cat. 1931, no. 58; K.d.K. 1931, p. 333; van den Wijngaert 1943, p. 97; Lucerne 1948, no. 122; Baldass 1957, pp. 267–68; Bregenz 1965, no. 32; Wilhelm 1976, p. 72; Baumstark 1980, no. 65; Larsen 1980, vol. 2, p. 87; Brown 1982, p. 106; Bergamo 1984, pp. 91, 95, 122–23.

201

Peter Paul Rubens
Flemish, 1577–1640

THE VIRGIN ADORNED WITH FLOWERS
Oil on wood; 25⅛ × 19⅛ in. (63.9 × 48.5 cm.)
Liechtenstein inv. no. 116

The subject of this oil sketch, obviously related to the youth of the Virgin, has not yet been satisfactorily explained. Mary, who is said to have been a maid in the Temple in Jerusalem, is shown standing between her parents. Saint Anne bends over her child with motherly care, and Saint Joachim turns his eyes to heaven, his arms outstretched. This family group, which prefigures the Holy Family, is surrounded by angels who offer flowers with which Anne adorns the Virgin's hair. Previous interpretations of this scene as the Education of the Virgin are not convincing since the essential component of that traditional subject, an open book on the teacher's lap, is missing. Rubens was aware of this necessary iconographical element; he used it in its profane form in his *Education of Maria de' Medici* (Louvre, Paris) and in its sacred form in his later *Education of the Virgin* (Koninklijk Museum voor Schone Kunsten, Antwerp). Compared with these paintings, the present work clearly is not meant to present an educational scene.

Held (1981, pp. 61–62), without being able to explain the subject definitively, stressed the significance of the angel's bestowing flowers for the crowning of the Virgin. An apocryphal text dealing with the Virgin's youth may illuminate this scene,

but a survey of relevant sources has as yet been fruitless. The key to the work's general meaning may be found, however, in the context of the doctrine of the Immaculate Conception. The Church has always held that the Virgin was under divine protection from the earliest moment of her existence. She was immaculately conceived; that is, her soul did not bear the mark of Original Sin, the stigma that was shared by all humankind because of the Fall of Adam. The Virgin was truly Immaculata (Latin, without stain or blemish). Religious art has tried to give expression to this most unvisual doctrine through various symbolical representations. Among others, there is a group of sixteenth-century Spanish works, compiled by Kleinschmidt (1930, pp. 210–16), dedicated to the Trinitas Terrestris (Earthly Trinity) of Saints Anne and Joachim venerating their daughter as Immaculata. Rubens might not have known these Spanish examples, and marked differences in composition do not support too close a comparison. But nevertheless an analogous visualization of the doctrine of the Immaculate Conception—so important in the Counter-Reformation Church—might have been attempted here. Further research is needed, however, to support such a reading of the delightful family scene presented by Rubens in this sketch.

In the earlier literature on Rubens, the rank of the present work had been repeatedly questioned. Bode (1888b) believed in Rubens's authorship, but he was puzzled by "some strangeness" in the painting. Rooses declared the sketch to be by van Dyck, and Oldenbourg (1916) excluded it from Rubens's oeuvre as being "too inferior for the master." Burchard (1926) claimed it was merely a copy of a sketch otherwise unknown. Following Glück (1933), however, the painting became widely accepted as a work by Rubens and, one must add, a splendid one indeed. The difficulties that earlier writers encountered may have arisen from the painting's particular style. Its rather dark tonality and vigorous, almost finished modeling are not immediately comparable to Rubens's well-known sketching technique, with its light colors and very free brushwork. This seeming difference becomes much less puzzling when the painting's date is taken into account. Glück argued for its being painted just after Rubens's return from Italy in 1609, a most convincing date, given the artist's stylistic development. A later dating around 1613–14, suggested by Held (1980, vol. 1, pp. 505–6) cannot, however, be accepted here. The closest stylistic comparisons are offered by sketches that are recorded for the years 1609 and 1610, like those for the *Adoration of the Magi* (Groninger Museum, Groningen), painted for the Antwerp corporate chamber (the large painting now in the Prado, Madrid); for the *Raising of the Cross* (Louvre, Paris), commissioned for the church of Saint Wallburg in Antwerp (the altarpiece now in the Antwerp Cathedral); for the *Samson and Delilah* commissioned by Burgomaster Rockox (Cincinnati Art Museum; the large painting now in the National Gallery, London); and finally for the *Philopoemen* (Louvre, Paris; the large painting now in the Prado, Madrid). Furthermore, the Metropolitan Museum's *Holy Family*, also dat-

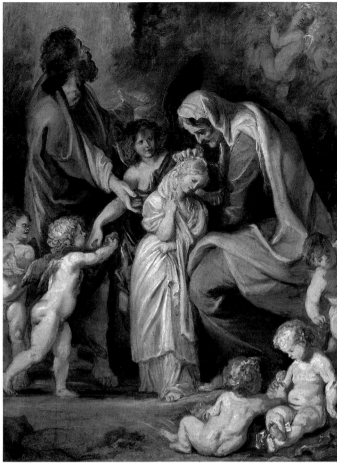

201

portraits" (Haskell and Penny 1981, pp. 300–301). Rubens later used the statue as a model for female saints in his *Holy Women at the Sepulcher* (Norton Simon Foundation, Pasadena, Calif.) around 1612 and his triptych of Saint Ildefonso (Kunsthistorisches Museum, Vienna) around 1630–32. On a sheet in the Pushkin-Museum, Moscow, the *Pudicitia* motif appears with other sketches. In this drawing, as in the present painting, the figure's head is bent; this is a departure from the antique prototype, which stands fully erect. Held (1980, vol. 1, p. 505) tried to relate the drawing and the present painting and was therefore forced to date the latter around 1613–14, because the former preserves studies for paintings unquestionably from that period. Such a direct dependence between the drawing and the painting cannot, however, be accepted here. The repeated quotation of the *Pudicitia* in Rubens's oeuvre proves his predilection for that antique model. In fact, the Moscow drawing may indicate another use of that motif—later to be eliminated—in the Visitation that is represented on the left wing of the *Descent from the Cross* in the Antwerp Cathedral, since first ideas for this triptych have been drawn on this sheet.

The use of an antique sculptural model for painterly inventions corresponds to the principles Rubens advanced in his treatise *De imitatione statuarum*. Classical sculptures, believed to be exemplary, would be enlivened by means of painting, and their reinterpretation would broaden the meaning of the composition in which they appeared. In the present sketch, the Virgin's image gains significance not only in being modeled after a venerable prototype, but also by adopting the attribute of purity, represented by the marble's whiteness, barely disguised by Rubens. In placing the Roman statue in the context of Christianity, Rubens most tellingly presents the Virgin Immaculata as a Christian *Pudicitia*.

Similar relations to the antique sculpture may be traced for the putto, seen from the back in the lower right foreground. Although slightly at variance and almost certainly restudied like his little counterpart from a living model, the putto has been based on one of the twins, Romulus and Remus, from the antique statue of the reclining river-god Tiber (now Louvre, Paris). Rubens had studied in the Belvedere statue court of the Vatican the fragmented group of the she-wolf feeding the two boys and had recorded it with a drawing (now in the Pinacoteca Ambrosiana, Milan; Held 1982, pp. 100–101). The putto on the sculpture's right side serves as a model for his mate in the present sketch, although his posture has been reversed. About 1618 Rubens repeated that figure in the same reversed position for his painting *Romulus and Remus* (Museo Capitolino, Rome), which is indebted even more to its famous antique prototype. The same putto had already been quoted by Rubens around 1615 in *The Infant Jesus with Saint John and Angels* (Kunsthistorisches Museum, Vienna), where he is again united with the second putto of the Vaduz sketch. The latter, a sitting child seen nearly frontally, was repeated by Rubens at least twice, in the *Mystic Marriage of Saint Catherine* (drawing in the Allen

able around 1609, corresponds well stylistically to the present painting; Saint Anne's expression is also the same in both works. The paintings whose preparatory sketches are mentioned above are only a few of the large number of commissions Rubens received immediately after returning from Italy to Antwerp. Oil sketches, which he had occasionally used in Italy, now proved to be a most useful tool in preparing the large compositions that were so much in demand. The present work is one of these incunabula of designing technique produced on the eve of Rubens's establishing his atelier in his native town. Even at the very outset, his brilliance in conceiving ideas and in sketching them rapidly on small panels is evident.

Glück was the first to recognize that Rubens had based the central figure of his composition, the standing Virgin, on an antique prototype. His model was the Roman female statue called *Pudicitia* (Chastity), almost certainly studied by the artist at the Villa Mattei, Rome (the sculpture is now in the Musei Vaticani, Braccio Nuovo, Vatican, Rome). Rubens seems to have been one of the earliest admirers of the *Pudicitia*, which did not belong to the canon of the most renowned antiques, frequently drawn and discussed by artists during the sixteenth and seventeenth centuries; in the eighteenth century, however, "it became perhaps the most celebrated of all Roman female

Memorial Museum of Art, Oberlin, Ohio) and in the pagan realm of *The Triumph of Silenus* (formerly Kaiser Friedrich-Museum, Berlin).

It is likely that the present design, almost certainly for an altarpiece, was not realized as a full-scale painting. The repeated references in later pictures to motifs first utilized in the sketch suggest a decision to abandon the design's actual execution. Rubens then seems to have felt free to reuse some of the sketch's pictorial ideas in other works.

One can only speculate about Rubens's original purpose in designing the present scene. In the fall of 1608, on learning that his mother, Maria (née Pijpelinckx), was seriously ill, Rubens set out from Italy for Antwerp; she died, however, in October 1608, before he had arrived. Nearly two years later, on September 29, 1610, Rubens arranged for a large altarpiece to be mounted over his mother's tomb in the Antwerp church of Saint Michael. Certainly not without the intention of proudly demonstrating his art, the painter chose a painting originally designed for the high altar of the Chiesa Nuova in Rome but replaced there and taken to Antwerp (now in the Musée de Peinture et de Sculpture, Grenoble). One might ask whether the present sketch, presuming a date of 1609, expresses an especially conceived and personally related composition for the tomb, later abandoned for reasons unknown to us. Rubens thus would have honored his deceased mother with a most human and loving image of her patron saint.

RB

FURTHER REFERENCES: Cat. 1767, no. 128; Cat. 1780, no. 565; Cat. 1873, no. 196; Cat. 1885, no. 116; Rooses 1886–92, vol. 1, p. 183 (as van Dyck); Bode 1888b, p. 21; Schaeffer 1909, p. 428 (as van Dyck); Oldenbourg 1916, p. 281; Oldenbourg 1918, p. 63; Burchard 1926, p. 3; Cat. 1931, no. 116; Glück 1933, pp. 22–24, 26, 74, 375–76, 382; Lucerne 1948, no. 116a; Vlieghe 1972, p. 119; Cat. 1974, no. 8; Knipping 1974, vol. 2, p. 251.

202

Peter Paul Rubens

Flemish, 1577–1640

THE LAMENTATION

Oil on canvas; 59 1/16 × 80 1/4 in. (150 × 205 cm.)
Liechtenstein inv. no. 62

Although the present painting was acquired by Prince Johann Adam in 1710 from the Antwerp dealers Jacob van Bedt and Justus Forchoudt for the considerable sum of 2,500 guilders as a work by Rubens, it appeared in the first printed catalogue of the Liechtenstein gallery in 1767 as a van Dyck. This attribution, maintained in all Liechtenstein catalogues up to 1931, was further supported by Rooses (1886–92, vol. 2, no. 326) and by Cust (1900, p. 13) in their authoritative monographs on Rubens

and on van Dyck, respectively. Bode (1888b, pp. 22–23), however, was the first to argue in favor of Rubens's authorship, stating that, despite van Dyck's early and quite Rubensian period, here "any possibility of confusion [between the painters] is excluded." Following Bode's argument, Rubens's authorship has been accepted, but the painting's quality was valued low: all writers, Bode included, described it as having been executed mainly by the master's workshop. This classification seemed to be supported by the existence of a whole group of works by Rubens on the same subject—among them the deservedly famous *Christ à la Paille* (Koninklijk Museum voor Schone Kunsten, Antwerp)—which led to the present painting's reputation as yet another studio production. Rarely studied by scholars at firsthand, and not exhibited since 1940, the present picture, however, discloses its true merits under close inspection, facilitated by a recent cleaning. Not only is this a most splendid work, painted entirely by the master himself, without assistance even in passages of lesser importance, but it also has to be dated considerably earlier than any other depiction of the theme by Rubens. Stylistic considerations point to its execution about 1612, contemporaneously with the *Descent from the Cross* in Antwerp Cathedral, with which it shares the general color range and the almost classicizing handling of the paint that is in striking contrast with the sketchiness of those forms that appear to recede in space.

Once recognized, the masterly achievement of the present painting clearly stands out, as compared with Rubens's subsequent depictions of the subject, which now must be considered as derivations, and mostly of inferior quality. Thus, the *Lamentation* (42 3/8 × 45 5/8 in. [107.5 × 115.5 cm.]) in the Kunsthistorisches Museum, Vienna, composed with three figures, includes, although in abbreviated form, some of the motifs seen here; painted about 1614, it is obviously by Rubens himself. This cannot be said about the small *Lamentation* (15 15/16 × 20 11/16 in. [40.5 × 52.5 cm.]) in the same museum, despite an old inscription stating Rubens's name together with the date 1614, and the general willingness among scholars to accept it as authentic. Lacking the brilliance of execution that one expects in a picture of such small scale, in parts it is literally copied from the present work—a procedure quite alien to Rubens. The hardly original attempt to render the scene with full-length figures, as in the small *Lamentation*, is repeated, almost verbatim and certainly by the same hand, in another *Lamentation* (21 9/16 × 29 1/8 in. [55 × 74 cm.]) in the Koninklijk Museum voor Schone Kunsten, Antwerp. Rubens's final and most well-known treatment of the theme, again inspired by the present painting, is the *Christ à la Paille* (54 3/4 × 35 7/16 in. [139 × 90 cm.]) in the same museum. Painted about 1617, this work served as an epitaph for Jan Michiels. Considering these various approaches to the theme of the Lamentation, one must acknowledge that the present painting has the richest iconographic meaning, compared with which all other versions are lacking in intensity. Furthermore, here the composition is rendered with life-size figures, lending

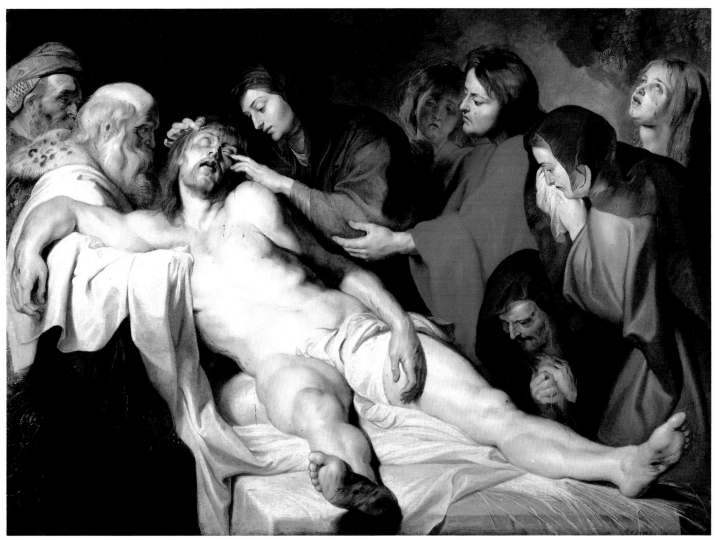

202

it the monumental effect Rubens always sought. The present painting thus takes its place among the highly distinguished group of solemn religious statements that Rubens devoted to the subject of Christ's Passion.

Although the events immediately following the Crucifixion are described in the gospels only in passing, the Deposition and the Entombment developed as independent artistic subjects. Related to these depictions, centering on the loving care for the dead body of Christ, is the Lamentation, which combines the emotions of grief and veneration in a single image. The subject became even more spiritualized in representations of the Pietà that depict the sorrow of the mother for her dead son. Although the gospels do not mention the distress of Christ's followers, or the role of the Virgin at the burial of her son, religious art has attempted to endow these events with compassion. By arousing pity among the faithful, such representations were not merely historical narratives, but were meant to encourage, as devotional images (*Andachtsbilder*), the worship

of Christ. Panofsky (1951, p. 274) saw as the very essence of these pictures the underlying theme of a "last farewell."

The present painting, too, may be described as a "last farewell." Christ's body has been laid before his disciples, and the Virgin, in a moving gesture of parting, closes his eyes and removes the thorns from his forehead, where the crown of thorns had implanted them. As tears run down his cheeks, John, whom Christ had designated to assist his mother, gently supports the Virgin. The grief is underscored by the group of women, whose presence at the Crucifixion and whose witnessing of the burial are explicitly mentioned in all four gospels. Their names are given as Mary Magdalen—perhaps the weeping woman at the right, looking upward in despair—Mary Cleophas, and Salome. According to the gospels, Joseph of Arimathaea, a wealthy disciple, had requested permission from Pilate to take the dead body of Christ and had made available his own tomb for the burial. Rubens—indicating Joseph's status by his sumptuous cloak—shows him supporting the upper part of Christ's body

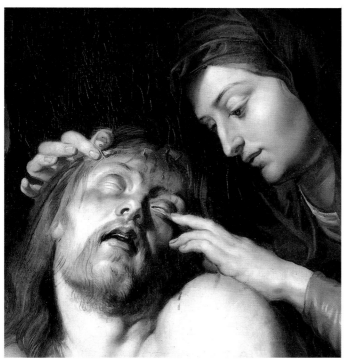

Fig. 45 Detail from cat. no. 202

with the linen shroud as he gravely looks upon him. Behind him stands Nicodemus, distinguished as a *princeps judaeorum* by his turban. As related in the Gospel of John, Nicodemus provided the myrrh and aloes with which the body of Christ was anointed. Taken together, the various reactions to the death of Christ represent, indeed, the fulfillment of the sad offices of a last farewell, but the scene carries, in fact, some further meaning.

In Rubens's depiction, the dead Christ rests on a stone slab, conspicuously shown in the picture's foreground, half hidden by the shroud. This is the Stone of Unction on which, it was traditionally believed, Christ's body was anointed and which, since medieval times, has been venerated as a holy relic. (The Stone of Unction was kept for some time in Constantinople but is now enshrined in the Holy Sepulcher in Jerusalem.) The anointing of Christ, "as the manner of the Jews is to bury" (John 19:40), had occasionally been represented in art—for example, in a drawing by Dürer (Winkler, no. 882) and in an altarpiece by Federico Barocci (Pinacoteca Nazionale, Bologna). One of Rubens's earliest drawings (Museum Boymans–van Beuningen, Rotterdam) takes up this theme, which is usually identified by the presence of jars containing the myrrh and aloes that were used for the anointing. In the present painting, these are missing, and Rubens may have chosen to show the preparations, rather than the ritual itself—of which only the stone slab serves as a reminder. The holy stone appears even more conspicuously in Caravaggio's *Entombment* (Pinacoteca Vaticana, Rome). Rubens knew Caravaggio's powerful altarpiece, painted in 1604 for the Vittrice Chapel in the Chiesa Nuova in Rome, since a painting for the high altar of the same

church was commissioned from the Flemish master in 1606. Rubens later adapted Caravaggio's composition, partly copying it and partly developing it in a narration more suited to his own art, in a small-scale painting (formerly in the Liechtenstein collection but now in the National Gallery of Canada, Ottawa). Although Rubens's interpretation of Caravaggio's Chiesa Nuova altarpiece must have been painted at roughly the same time as the present picture, the latter shows no traces of the Italian master's invention. Instead, Early Netherlandish traditions prevail here—a distinction that is apparent throughout the artist's work of the first decade after his return from Italy.

A thorough study by Eisler traces the roots of the Antwerp *Christ à la Paille* to the art of Rubens's Flemish predecessors (Eisler 1967, pp. 68–69). The large *Lamentation* by Hugo van der Goes (now lost, but known as a once-famous composition from some forty copies, one of the best of which is in the Museo Nazionale di Capodimonte, Naples) must especially have impressed Rubens. The dense composition, crowded with three-quarter-length figures, and the position of the dead body of Christ close to the picture plane seem to have influenced the present painting. Even more important as a pictorial source is the *Entombment* by the Master of Flémalle (Courtauld Institute Galleries, London), in which Nicodemus, carrying the dead Christ, prefigures, in placement and pose, Joseph of Arimathaea in the present painting, and John's gesture of consolation is almost identical to that depicted by Rubens. However, Rubens not only proved himself the proud descendant of the Flemish fifteenth-century masters in compositional matters, but he also translated the complex symbolism of Early Netherlandish art into the forcefully persuasive pictorial language promoted by the Counter-Reformation.

In her splendid interpretation of the iconography of Caravaggio's *Entombment*, Graeve (1958, pp. 227–33) describes the Stone of Unction as a symbol of the altar: the marble slab that supported the sacred corpse anticipates the altar at which the sacrifice of the daily mass is celebrated, where bread and wine are transubstantiated into Christ's flesh and blood. While Caravaggio makes only a general allusion to this idea, with Rubens the conception becomes central to his depiction. The Eucharistic reference is strengthened further by the wheat on which Christ's body rests. With this seemingly rustic detail, Rubens alludes vividly to one of the most profound theological mysteries, the equation of flesh and bread. Moreover, it is highly significant that special attention is directed as well to the blood issuing from all five of Christ's wounds. The symbolic wheat beneath Christ's body is repeated by Rubens in the Antwerp *Christ à la Paille* and the *Resurrected Christ Triumphant* (Palazzo Pitti, Florence). As pointed out by Eisler, this motif already appeared in the *Portinari Altarpiece* (Uffizi, Florence) by Hugo van der Goes, where the newborn Christ lies on the bare ground, beside a bundle of wheat. Such a Eucharistic allusion also distinguishes the above-mentioned *Entombment* by the Master of Flémalle, who filled the background of his altarpiece with in-

tertwining vine shoots. Thus, unlike a traditional *Lamentation* scene, the present painting is dominated by the *Corpus Christi*: the transubstantiated body of Christ is surrounded by his followers, who act like celebrants at a holy rite. Accordingly, Joseph of Arimathaea carries the sacred corpse with veiled hands, a time-honored gesture of veneration that, until recently, was also observed in the liturgy of the Catholic Church. Although Rubens, in his other representations of the Passion, is never as strict as here, only the Virgin is allowed to touch what is sacred.

The role of Mary in the present picture is, indeed, remarkable. This is not the often-encountered Virgin overcome with grief and an excess of compassion. Amid the manifold expressions of sorrow offered by the other female mourners at the present scene, the Virgin is distinguished by her complete composure. Although her eyes are red and her face is as pale as death, she neither weeps nor is caught in motionless passivity: instead, she acts with solemn dignity. Rubens here sides with a theological school of thought opposed to the popular image of the swooning Virgin at the foot of the cross. Based on the famous dictum by Ambrose, "I read that she stood [at the cross], but I do not read that she wept" (tantem illam lego, flentem non lego), theologians of the sixteenth century, such as Cardinal Cajetan and the Jesuit Petrus Canisius, had instead favored a Virgin who, in consenting to the sacrifice of Christ as part of the Redemption, took an active share in the work of Salvation (see Hamburgh 1981, pp. 45–75). Although such teachings could not diminish the high esteem accorded the mournful images of the Virgin's motherly distress, Counter-Reformation writers such as Joannes Molanus, in his influential *De picturis et imaginibus sacris* (Louvain, 1570), and Jerome Nadal, in his *Adnotationes et meditationes in evangeliam* (Antwerp, 1595), still were concerned about the shortcomings of such representations. Rubens therefore depicts the Virgin in agreement with Counter-Reformation thought, but he does it with an almost mystic fervor. Mâle (1951, pp. 282–83) has recognized that the extremely affecting motif of the Virgin closing the eyes of the dead Christ recalls the visions of Saint Bridget of Sweden. As far as we know, this is the first representation of a scene that, in its emotionalism, embodies the "last farewell" in a single image. Rubens may have come across the medieval source of this vision in the *Jesu Christi Crucifixi Stigmata* by Joannes Mallonius, published in Venice in 1606, where not only Saint Bridget's *Revelationes* are quoted but also texts by the devotional writer Juan de Cartagena. The latter had also described the other motif depicted by Rubens —the extracting of the thorns. According to him, the Virgin was also pierced by the thorns, so that her blood mingled with that of Christ. In distinguishing the color of the fresh blood on the tips of the Virgin's fingers and Christ's darker blood, already clotted, Rubens gave visual expression to this symbol of mystical union. Again, the extracting of the thorns is rarely shown in religious imagery, but Rubens certainly knew well the one famous prototype, the *Lamentation* altarpiece by Quentin Massys in Antwerp Cathedral (Koninklijk Museum voor

Schone Kunsten, Antwerp), in which Joseph of Arimathaea is shown removing the thorns with almost surgical care.

Thus, not only the Eucharistic references, but also the highly expressive countenance of the priestlike Virgin calls attention to the dead body of Christ. This is the painting's focus. With almost shocking explicitness, Rubens has rendered the corpse in strong foreshortening, and by showing the feet pointing outward beyond the picture space, he directs the viewer's attention to the body of Christ. Mantegna had likewise used the device of foreshortening—although in an even more uncompromising form—in the *Dead Christ* (Brera, Milan). His painting is believed to have inspired comparable attempts at foreshortening, leading Eisler to consider the present picture a "Mantegnesque Lamentation." Yet, it remains questionable whether Rubens indeed looked back to Mantegna, since the foreshortened body of Christ had become a familiar motif in Passion scenes. Examples range from drawings by Dürer (Winkler, nos. 378, 578) to Pordenone's fresco in the Cathedral of Cremona, a depiction by Titian recorded by van Dyck in his Italian Sketchbook (fol. 23v), and Annibale Carracci's painting in the Staatsgalerie, Stuttgart—to cite only a few. From his early Italian *Lamentation* (Galleria Borghese, Rome), to his later Antwerp *Trinity* (Koninklijk Museum voor Schone Kunsten, Antwerp), and in the drawing of *The Raising of Lazarus* (Kupferstichkabinett, Staatliche Museen Preussischer Kulturbesitz, Berlin-Dahlem), Rubens displayed a willingness to represent a corpse in foreshortening. The prevalence of this motif is underscored by the fact that the dramatic, disturbing viewpoint almost seems to stress the debased position of the dead—a point that holds true even as late as Daumier's lithograph *Rue Transnonain, 15 avril 1834*, as Białostocki (1966, p. 115) has shown.

In the present painting, too, Christ appears humiliated, despised, and tortured by man. He is the Man of Sorrows, as conveyed by the deeply devotional character of the picture, regardless of whether it was meant to serve as an altarpiece or as an epitaph. Christ's face carries the marks of his suffering, but his expression, even in death, ennobles the pain that he bore. In that, Rubens's depiction is close to Dürer's poignant drawing of the head of Christ, dated 1503 (Winkler, no. 272). At a time when, with Counter-Reformational zeal, the real presence of Christ in the Eucharist was defended, this painting almost literally brought the mysteries of the Incarnation, of suffering, and of transubstantiation before the faithful. Rubens has turned the veneration of the *Corpus Christi* into imagery that confirms this tenet of Catholic faith with compelling force.

RB

FURTHER REFERENCES: Cat. 1767, no. 343 (as van Dyck); Cat. 1780, no. 654 (as van Dyck); Cat. 1873, no. 126 (as van Dyck); Cat. 1885, no. 62 (as van Dyck); Rooses 1890, p. 317 (as van Dyck); K.d.K. 1921, p. 76; Oldenbourg 1922, pp. 107–8; Denucé 1931, p. 270; Cat. 1931, no. 62 (as van Dyck); Held 1959, vol. 1, p. 112; Glen 1975, p. 93; Liess 1977, pp. 225, 232–34, 338, 344; Vienna 1977a, p. 62.

Peter Paul Rubens
Flemish, 1577–1640

HEAD OF A BEARDED MAN
Oil on wood; 25⅞ × 19⅛ in. (65.7 × 49.7 cm.)
Liechtenstein inv. no. 113

This bust of a bearded man might be mistakenly considered a true portrait, but it is, in fact, a study head, a type of work that Rubens used primarily in his studio. He sketched study heads like the present one to capture the features and expressions, using them later for characters in his narrative paintings. An aid for both master and assistants, study heads were invaluable in the preparation of large, multifigured compositions. It is significant that most of Rubens's known study heads date from about 1612 to 1618, a period during which his studio was at its busiest. The execution of these preparatory works is not unlike that of Rubens's sketches; the free brushwork gives the liveliness of direct observation, and there is no attempt at achieving a finished rendering. Van Dyck is known to have adopted Rubens's technique, and study heads by both masters are listed in the 1640 inventory of Rubens's estate as "tronien of koppen naer't leven" (faces or heads done from life). Obviously, they had remained in the workshop as a stock of readily available motifs. This practice may be traced back to the Antwerp Mannerist Frans Floris (1517?–1570), who was the first to recognize the advantage of preparing large compositions with the help of study heads. Rubens seems to have followed his example directly. In fact, the present head compares well with a study by Floris, also showing a frontal view of a bearded man of about the same age (Grzimek collection, Friedrichshafen, West Germany; van de Velde 1975, no. 85).

In the nineteenth century the function of this work was completely misjudged, and it was identified as a portrait of the Antwerp painter Theodoor Rombouts (1597–1637). Apparently acting on this erroneous belief, a restorer enlarged the painting on the left and right sides and overpainted the sketchy background and parts of the drapery. These additions, which were intended to give the picture a more portrait-like look, were removed during a recent restoration. The identification with Rombouts proved to be totally unfounded and has been rejected by Bode (1888b, p. 28), Rooses (1890, vol. 4, no.1135), Held (1980, vol. 1, pp. 597, 611), and the present writer (Baumstark 1980, p. 141). Rombouts, whose features are known to be different from those of the model for the present painting, was, after all, born in 1597 and thus was too young to be shown bearded.

The present study head has been unanimously dated about 1616 to 1618, a rare case of agreement in the literature on Rubens. A close inspection, however, makes it clear that this dating is much too late. Several elements point to a date around 1612:

the range of cool colors in the background; both the shadows of gray and the heavy use of red in the flesh tones; and, most significantly, the absence of the striped priming, a thin glaze over the chalk ground of the panel that Rubens always applied from about 1614 onward.

It has been stated repeatedly that the study head is closely linked to a painting by Rubens in the Alte Pinakothek, Munich, showing two satyrs, one holding grapes and facing the viewer, the other drinking wine. The satyr with the grapes is taken from the same bearded model as the present study. The complete frontality and the expression of the eyes are the same in both works. The conclusion that the Munich painting was directly prepared by the present study has been stated in the recent literature and was shared by the present writer; this hypothesis is, however, incorrect. There are important differences between the two works, including disparate light sources and a change in the direction of the character's glance. Most importantly, the much denser tonality of the Munich painting points to a date about six years later than the present study head.

Rubens must have known the sitter, apparently a good-humored man, quite well. From 1612 on, his strong features, framed by short dark hair and a thick beard, appear frequently in the artist's work. We know of four study heads showing this same model. Besides the present frontal study, there is a three-quarter profile taken over the left shoulder in the Los Angeles County Museum, a pure profile from the left in the Národni Galeri, Prague, and a receding profile taken over the right shoulder in the Dr. Fry collection, Manuden, still erroneously ascribed to van Dyck (for the last see Jaffé 1966, vol. 1, p. 94 n. 58, pl. IV). The profile in Prague can be dated exactly, since it was used for the depiction of Nicodemus in Rubens's 1612 altarpiece *Descent from the Cross* (Cathedral, Antwerp). The same head is also found, in reverse, in *Christ's Charge to Peter* (Wallace Collection, London), and there are similar views of the bearded model on the inner left wing of the triptych *Descent from the Cross* (Cathedral, Antwerp), and in the *Great Last Judgment* (Alte Pinakothek, Munich). The study in the Fry collection is used, in reverse, for an apostle in the *Christ in the House of Simon* (Hermitage, Leningrad). Finally, the present frontal view served for a Saint Paul (Hermitage, Leningrad), a work of the master's atelier. There may have been a fifth study, now lost, that showed the bearded model with slightly bent head. Such a view is seen in *Saint Ambrose and Emperor Theodosius* (Kunsthistorisches Museum, Vienna) and *Adoration of the Magi* (Musée des Beaux-Arts, Lyons) and in representations of the Holy Family in the Palazzo Pitti, Florence, and the Art Institute, Chicago.

This impressive list, documenting Rubens's use of the same model in a variety of paintings, covers only the period from 1612 to 1618 and may be incomplete. It nonetheless reveals how economically Rubens mastered the task of inventing large compositions crowded with actors. One must admire how in this case he used one model's features to achieve depictions ranging from a tender Saint Joseph to a noble disciple of Christ,

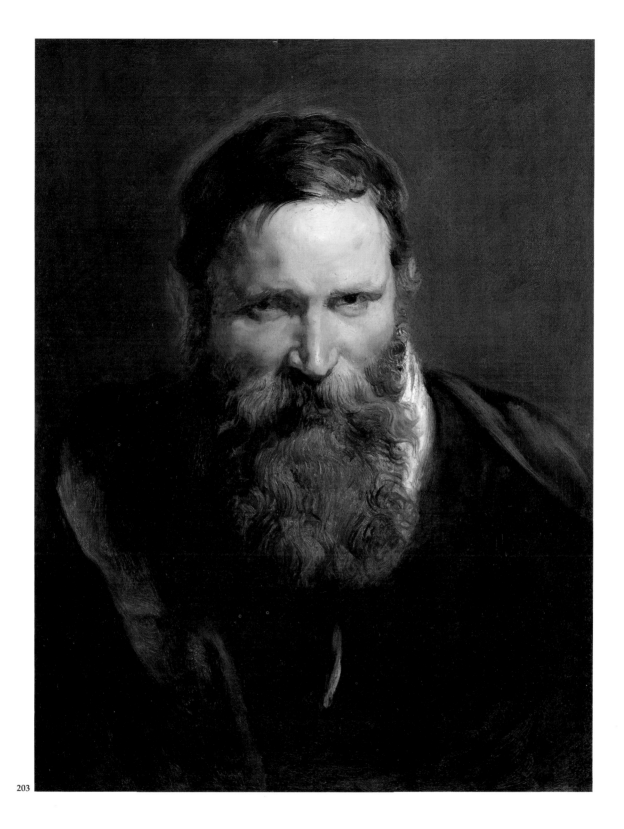

203

from an earnest onlooker to a lusty satyr. The present study suggests that such an exploitation may have been stimulated by the model's forceful character; such great expressiveness was clearly not lost on Rubens.

RB

FURTHER REFERENCES: Cat. 1767, no. 377; Cat. 1780, no. 9; Cat. 1873, no. 193; Cat. 1885, no. 113; K.d.K. 1921, p. 134; Cat. 1931, no. 113; Goris and Held 1947, p. 30; Lucerne 1948, no. 135; Baldass 1957, pp. 255–56; Müller-Hofstede 1968, p. 249, no. 39; Martin 1970, p. 33; Cat. 1974, no. 7; Varshavskaya 1975, p. 246; Vienna 1977a, p. 79.

204

Peter Paul Rubens
Flemish, 1577–1640

PORTRAIT OF CLARA SERENA RUBENS
Oil on canvas, mounted on wood; 13 × 10⅜ in. (33 × 26.3 cm.)
Liechtenstein inv. no. 105

This head of a child, which dates about 1616, is a most perfect cabinet piece of the art of portrait painting. The loveliness, innocence, and charm of a young girl are captured, and the painting is suffused with a loving empathy. Rubens has rendered her individuality carefully, without glossing over the irregular set of the eyes or the slight twist of the mouth. From beneath golden brown hair, which has been swept back, the large eyes gaze out with an earnest and lively candor.

The tender intimacy of this small painting seems to indicate a personal bond between painter and model, and critics have long identified the sitter as a child of Rubens. Bode (1888b, p. 28) considered the three-year-old Albrecht a likely candidate, but since Rooses (1890, p. 156) it has become gradually accepted that the sitter is Rubens's daughter Clara Serena at the age of about five. This identification finds its only but strong support in the great physical similarities seen when this portrait is compared with depictions of Rubens and his first wife, Isabella Brant. Clara Serena, their eldest child, must have especially favored her mother, since she bears a striking resemblance to portraits of Isabella Brant, among them Rubens's drawing of about 1622 in the British Museum, London.

Clara Serena was baptized on March 21, 1611, in the Antwerp church of Saint Andrew. Her godfather was Philip Rubens, the painter's brother, and the child's Christian name was taken from her maternal grandmother, Clara Moy, who was a witness at the ceremony. It is likely that Infanta Isabella Clara Eugenia, the Regent of the Spanish Netherlands and the official employer of Rubens, patronized the child, since the girl's middle name, in alluding to the title Serenissima, seems meant to honor the Infanta. There are no further records of Clara Serena until her death at the age of twelve. In a postscript, apparently attached to his letter (now lost) of October 25, 1623, Rubens must have told his friend Fabri de Peiresc about her death. Peiresc's comforting words have survived: "sua figliolina unica, già arrivata a tanto merito" (his one and only little daughter, who had already shown such accomplishment).

Shortly before Clara Serena's death, Rubens almost certainly portrayed his daughter in a famous drawing (Graphische Sammlung Albertina, Vienna). In this work the girl is about twelve years old, and her resemblance to her mother has grown even stronger. The maidenly features correspond exactly with the more childish appearance of the Vaduz painting; even the way she wears her hair has changed very little. Two oil sketches

in the Metropolitan Museum, and the Musée Diocésaén, Liège, are further portrayals of Clara Serena around the same time, but they are too weak to be accepted as works by Rubens and should be attributed to followers. The Vienna drawing, on which another portrait of the girl in the Hermitage, Leningrad (again not autograph), is based, was later annotated "Sael dochter van de Infante tod Brussel" (the Infanta's maid of honor in Brussels). There is no further proof that Clara Serena attended the court at Brussels, but it is likely that Rubens would have wanted his daughter to be educated in the entourage of his sovereign. He himself, at roughly the same age, had been trained in courtly manners, serving the Countess of Lalaing as a page.

A small portrait of Clara Serena Rubens was listed in the estate of her grandfather Jan Brant in 1639. Although that work is described as being painted on panel, it might be identified with the present one, which, according to a seal dated 1656 on the back, must have been glued to the new wooden support before that date. This seal, showing the Hapsburg coat of arms and the letter w, most probably indicates that the painting was the property of Archduke Leopold Wilhelm (1614–62); before 1712, however, it must have entered the Liechtenstein collection.

The nature of the present work has not been viewed unanimously in the literature on Rubens, being variously called a study head, sketch, or portrait. A closer inquiry, facilitated by a recent cleaning, proves, however, that the painting is a true portrait, left unfinished by Rubens and cut down on all sides at an early date. Clara Serena's likeness therefore remains a fragment, immensely valuable though it is. In judging the evidence of incompleteness, a most telling comparison is offered by the Madrid portrait of Maria de' Medici, Queen of France, begun in 1622 by Rubens and also left unfinished (Prado, Madrid). Both works reveal the same procedure that the artist used in developing his portraits. In both the outlines were sketched with dark paint on the prepared ground. Strokes of almost calligraphic quality are preserved at the lower part of the present work. The bodies and costumes of the sitters are lightly traced, and the sketched heightenings in the white of the collar, and in the sleeves of the Medici portrait are deliberately used as a foil to frame the rosiness of face and hands. The flesh tones—and this is the most characteristic feature linking the portraits in Madrid and Vaduz —stand out as completed in contrast to the almost sketchy underpaint of the rest of the work. Rubens seems to have painted the face, the most crucial element in portraiture, while confronting the sitter; he would, however, leave further elaboration to be done later. Parts of that incomplete area of the present work—there is no evidence of how much (perhaps even the girl's hands)—were cut away before 1656, reducing the expressiveness of the portrait to the head of the child alone.

The direct frontal view and hence the immediate contact with the viewer, so stimulating in the present work, are rather uncommon in the portraiture of the time. Rubens used this

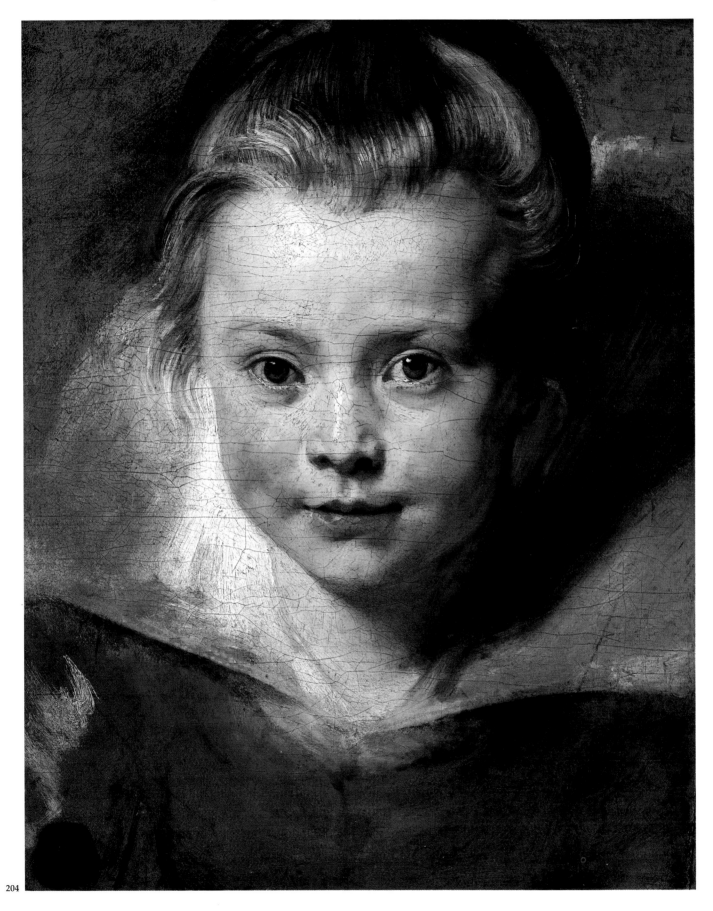

type especially for depictions of a distinctively personal nature, as in his portrait of Isabella Brant in the Uffizi, Florence. Furthermore, Held has published an X-ray of a study of two sleeping children in the National Museum of Western Art, Tokyo, showing beneath the present surface a later-overpainted head of a child, looking frontally out at the viewer (Held 1981, p. 53, fig. 26). It might be that this preliminary stage of the Tokyo painting, datable around 1612 and almost certainly depicting a child of the painter's brother Philip Rubens, presents the first shaping of an idea, later taken up by Rubens for his portrait of Clara Serena.

Beginning with the jubilant putti of his early Italian altarpieces and continuing throughout his entire oeuvre, Rubens constantly painted children, always with ease and loving care. Angels and the infants Jesus and Saint John, as well as the secular amoretti of his paintings, convey the artist's knowledge of children's bodies and temperaments. Because of his search for veracity, his own children and those of his brother Philip frequently served as models for his angelic company. The present painting, however, strikes a more pensive tone. Like the double portrait of his sons Albrecht and Nicolas—with the present picture the gems of the Rubens collection in Vaduz—it testifies to a loving familiarity with the child, an intimacy that Rubens would never achieve in an official portrait. Presenting his daughter's likeness must have appealed to Rubens both as a painter and as a father, and it is this synthesis of the artist's skill and his paternal love that gives Clara Serena's portrait its enchanting beauty.

RB

FURTHER REFERENCES: Cat. 1767, no. 389; Cat. 1780, no. 585; Cat. 1873, no. 119; Cat. 1885, no. 105; Rooses 1886–92, vol. 4, no. 1134; K.d.K. 1921, pp. 135, 460; Cat. 1931, no. 105; Lucerne 1948, no. 111; van Puyvelde 1948, p. 79; Gombrich 1952, p. 320; Rotterdam 1953, p. 65; Garas 1955, p. 191; Held 1959, vol. 1, p. 138; Cat. 1974, no. 4; Varshavskaya 1975, pp. 175–76; Baudoin 1977, p. 168; Vlieghe 1977, pp. 89–90; Vienna 1977a, no. 17; Vienna 1977c, p. 92; Baumstark 1980, no. 44; Held 1980, vol. 1, p. 597.

205

Peter Paul Rubens

Flemish, 1577–1640

THE DISCOVERY OF THE INFANT ERICHTHONIUS

Oil on canvas; 85¾ × 124⅞ in. (217.8 × 317.3 cm.)
Liechtenstein inv. no. 111

The classical myth about the Infant Erichthonius embodies ancient archetypes of fertility and fruitfulness. Vulcan, the god of fire, attempted to rape Minerva, the virginal goddess of wisdom, but she escaped from his embrace. The god's seed fell on the ground, impregnating the earth-goddess Gaea, who gave birth to the boy Erichthonius. The offspring of an unnatural union, the infant was monstrously misshapen, his legs taking the form of snakes. Minerva concealed the child in a basket, which she entrusted to the daughters of the Attic King Cecrops, the sisters Aglauros, Pandrosos, and Herse. Minerva commanded them never to open the basket, but Aglauros, the most inquisitive of the three, disobeyed and exposed the god's secret. It is this moment that Rubens chose to depict. Amazement at their discovery is evident on the maidens' faces; only their lapdog is revulsed by the miscreation.

In a garden-grotto, screened by trees and shrubs and adorned with shells, the nude women appear to have just finished bathing. The marble fountain sculpture of the Ephesian Diana here represents the earth-goddess Gaea, the mother of Erichthonius. From her many-breasted bosom life-giving water gushes abundantly, as it does from the dolphins she holds, animals that since ancient times were regarded as driven by unbridled lust. In the well-tended garden, opening up the view, a herm of Pan, god of the fields and a most lascivious deity, corresponds to the fountain sculpture. The lavish profusion and ripeness of nature find their fullest expression, however, in Rubens's depiction of the three women, a radiant image of sensuality and beauty.

Most ancient sources, among them Euripides, Apollodorus, Pausanias, and Hyginus, recounted that the daughters of Cecrops were punished for their disobedience by being transformed into ravens. Previous writers have expressed surprise that Rubens did not hint at this cruelty, but Held (1976, pp. 34–35) has recently established that his most likely source was Ovid (*Metamorphoses* 2.552–65, 708–835), who permits the maidens' curiosity to be left unpunished. Mercy was shown them because Herse, the loveliest of the three, had excited a god's passion—in Ovid's account Mercury fell in love with her after seeing her during a Panathenaean procession. Rubens has anticipated the Ovidian outcome by singling out Herse from her sisters. Among the glowing triad of purple, blue, and red draperies, the most radiant color is worn by her. The gleaming fabric plays like a fiery aureole around her nude body, and Herse alone among the sisters has no need to enhance her beauty with jewelry. Furthermore, her delicate gesture of concealment is taken from an image of Venus Pudica, and she is thus praised and elevated by a godlike appearance. Cupid himself looks up at her in admiration, recognizing her as the future bride of a god. According to the ancient writer Apollodorus, demigods and heroes, among them Adonis, were the offspring of Mercury and Herse, his beautiful beloved.

The genesis of the present composition has been repeatedly treated in recent literature, but no convincing thesis has emerged. These discussions are stimulated by rich source material, comprising two roughly identical oil sketches, one formerly in the Seilern collection, London (now in the Courtauld Institute Galleries, London), the other lost (formerly in the Bloch

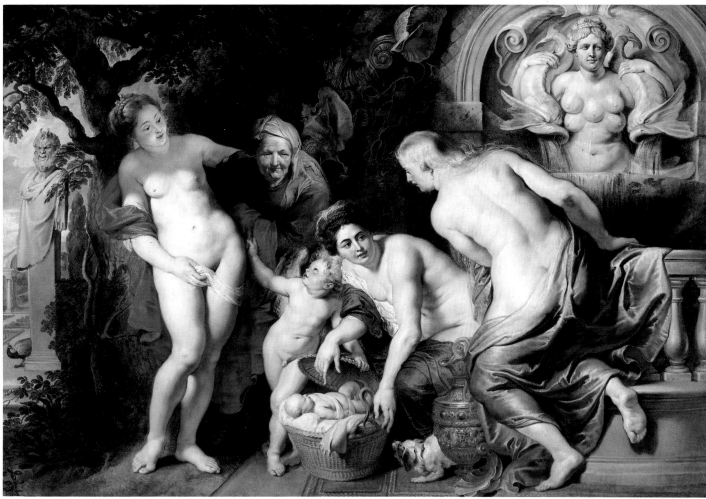

205

collection, Vienna); a drawing in the Teylers Museum, Haarlem, that served as a model for a print by Pieter Sompelen; and finally a drawing in the British Museum, London, also considered a print-model but apparently never used. Burchard (1953–54, pp. 4–11), followed by Stechow (1963, pp. 30–33), believed that the Seilern sketch was Rubens's earliest expression of the Erichthonius theme. A second stage, recorded in the Haarlem drawing and with it the print by Sompelen, would transform the composition. The third stage was said to have been preserved in the London drawing; the final version then would be the Vaduz canvas. This sequence has been opposed by Renger (1974, pp. 18–24), who argued that the Haarlem drawing, and with it the Sompelen print, was the final version, created after the Vaduz canvas and incorporating later improvements. Both of the sequences, however, rest on bases that must be described as insecure. Contrary to both Burchard and Renger, the corrections in the Haarlem drawing, meager as they are, cannot be accepted as carried out by the painter himself. Pieter Sompelen, furthermore, belonged neither to Rubens's atelier

nor to the circle of engravers frequently employed by the master. It is difficult to accept that Rubens, having "scruples about the composition" (Renger 1974, p. 22) of the Vaduz painting, would have made his corrections only in a drawing as insignificant as the Haarlem one. Therefore the argument that Rubens's improved the achievement of the Vaduz canvas in this drawing must be rejected.

The quality of the drawing in London must also be regarded less than favorably. Its attribution to the master's atelier is not convincing because it lacks the quality known, for example, from the engraver Vorsterman's fine print-models. Since the drawing in London corresponds to the Vaduz canvas precisely, except in minor details, such as a flying putto over Herse, it is considered here as a paraphrase of the painting, done after it. Doubts must be expressed about the Seilern sketch as well, despite its being approved by scholars. Burchard (1953–54, p. 10) declared the sketch to be a copy but later withdrew that opinion. The work, however, undeniably lacks the facility so evident in Rubens's sketching technique and may therefore in-

deed be done after the lost sketch in the Bloch collection. In any case, even as a copy, the Seilern sketch provides an insight into an early stage of Rubens's development of the Erichthonius theme. Here the group is placed deeper in the picture's space; furthermore, the finding of the child is conceived as a dramatic event, reflected in the maiden's agitated movements and gestures. The transition from a vehement to a more balanced narration, as seen in the Seilern sketch and the Vaduz canvas, is characteristic of Rubens's inventive process and can be well documented by other examples.

In summary, it seems unquestionable that in the Vaduz canvas Rubens created the most satisfying rendering of the theme, with splendid figures almost filling the picture's space; that the execution of this final solution was not entrusted to the atelier but was painted entirely—and magnificently indeed—by Rubens himself; and that finally and most importantly this masterpiece is one of the great achievements of the years 1612 to 1620, years that are unanimously acknowledged as Rubens's most classical period.

Rubens's occupation with the Erichthonius theme may be fixed securely before 1617. A terminus ante quem is provided by one of the earliest dated paintings by the young Jacob Jordaens, which is devoted to the same subject and takes the composition of the present canvas as its point of departure (Koninklijk Museum voor Schone Kunsten, Antwerp; d'Hulst 1982, p. 76). A date for the Vaduz painting around 1616 might be preferred on stylistic grounds as well and is supported by reference to other works by Rubens of the same period. Around 1615 he is likely to have painted the Vaduz *Venus in Front of a Mirror*, where the Venus is a fair-haired woman shown from the back and in lost profile. Slightly later, in the present painting, the same model reappears in the same posture as Pandrosos, who looks up from the fountain which she has been using as a mirror while combing her hair. She is seen again as a nymph in Rubens's *Neptune and Amphitrite* from about 1616 (formerly in the Kaiser Friedrich-Museum, Berlin). The Amphitrite in this last painting is a slightly altered version of the Herse in the present picture. This nude female figure, who stands bending in a marked contrapposto, has been traced by Kieser (1933, p. 119 n. 24) to the figure of Venus in Mantegna's *Parnassus* (Louvre, Paris). But it is more than likely that she is based on Rubens's close and direct study of the antique. In the Rubens-cantoor in the Kongelige Kobberstiksamling, Copenhagen, which comprises drawings apparently used as working material in Rubens's atelier, there is a pupil's copy, almost certainly done after a lost original by Rubens, showing a version of the Cnidian Venus without head and arms. Herse's posture and her body's modeling obviously refer to the sculpture shown in the drawing and may therefore have been taken from the antique, to whose authority Rubens was always willing to submit. An alleged connection between the Herse nude and a drawing by Rubens in the Rijksprentenkabinet, Amsterdam, established by Boon (1966, pp. 155–56), does not exist, however. Müller-Hofstede's sug-

gestion (1967, pp. 117–18) that a Rubens drawing in the Stedelijk Prentenkabinet, Antwerp, is the first draft of the crouching Aglauros is also not convincing. Furthermore, a drawing in the Nasjonalgalleriet, Oslo, claimed by Madsen (1953, p. 305) as a study for Erichthonius, is in fact a copy of a sixteenth-century Flemish painting of a sleeping Infant Christ. Rubens's head study of an old woman (National Gallery of Canada, Ottawa), on the contrary, has been rightly acknowledged by Held (1980, vol. 1, p. 610) as the model for the serving woman on whom Herse leans. This woman's role in the narrative is open to question; she is not mentioned in the classical sources, nor does she take part in the discovery of Erichthonius. Held (1976, pp. 40–41) suggests that her meaningful look outward expresses a sibylline foreknowledge. But whatever her role or character, it is obvious that Rubens skillfully used the old woman's features to emphasize by contrast the full bloom of youthful beauty so evident in the Greek King's three daughters.

RB

FURTHER REFERENCES: Cat. 1767, no. 363; Cat. 1780, no. 684; Cat. 1873, no. 191; Cat. 1885, no. 111; Bode 1888b, pp. 14–15; Rooses 1886–92, vol. 3, no 606; Burckhardt 1898 (1938 ed.), pp. 44–45, 60, 122; K.d.K. 1921, p. 124; Cat. 1931, no. 111; Kieser 1933, p. 120 n. 26; van Puyvelde 1936, p. 226; London 1955, pp. 41–43; Held 1959, p. 110; Müller-Hofstede 1962, p. 93; Alpers 1967, pp. 272, 280–85; Stechow 1967, col. 1243; Müller-Hofstede 1968, p. 213; London 1971, p. 26; Cat. 1974, no. 12; Renger 1974, pp. 18, 22–24; Wilhelm 1976, p. 68; Cavalli-Björkman 1977, p. 34; Vienna 1977a, no. 18; Göttingen 1977, p. 82; Baumstark 1980, no. 47; Held 1980, vol. 1, pp. 318–19.

206

Peter Paul Rubens
Flemish, 1577–1640

LANDSCAPE WITH MILKMAIDS AND COWS
Oil on wood; 29¾ × 41⅝ in. (75.5 × 105.7 cm.)
Liechtenstein inv. no. 412

Among the different categories of painting, ranging from portraiture to history, all practiced by Rubens with unfailing mastery, landscape seems to have had the most personal meaning for him. Although some of his landscapes were sold during the artist's lifetime, such as two listed in 1628 in the collection of the Duke of Buckingham, the greater number—and the most important examples of works in this genre—were kept by the artist and were removed from his house only during the sale following his death in 1640. Rubens may have been attached to his landscapes—a small group in the context of his vast oeuvre —not only because these works were entirely free from the strain of commissions, and were done to enjoy painting as a purely private pleasure, but also because they depicted his beloved Flemish countryside, and particularly the estates he

206

owned or chose as his retreats. He had inherited from his mother property in the country, including some farms, and in 1628 he bought an estate, the Hof van Ursele, in Eekeren, north of Antwerp, where he frequently spent part of the summer. Finally, Rubens's acquisition of the Castle Steen in 1635 led to the grandest flourishing of his genius as a landscapist. The rural environment, therefore, was not regarded by Rubens as simply picturesque, as it would be by a typical city-dweller; country life was a deeply felt experience, sympathetically recorded in drawings and paintings. His portrayals of the Flemish countryside are built upon the profound knowledge of what must have seemed to Rubens the embodiment of peace and simplicity.

The present landscape, acquired for the Princely Collections in 1880, is part of a group of paintings that have to be placed at the beginning of Rubens's interest in landscape, generally dated 1616–21. In fact, the Liechtenstein painting was believed by scholars such as Kieser (1926, pp. 11–13) and Glück (1940, p. 21) to be the earliest of these and thus the first independent

landscape done by Rubens. It has gone unnoticed that most of the early Rubens landscapes originally shared the same dimensions, as if the painter wanted to underline the inner coherence of his first attempts. This similarity is today hidden by the fact that, in the process of painting, Rubens enlarged some of his compositions, among them the *Farm at Laeken* (Buckingham Palace, London), *Landscape with a Cart* (Hermitage, Leningrad), and *The Polder* (Alte Pinakothek, Munich). Without their later additions, however, these paintings would correspond exactly in size to the Liechtenstein landscape and two other early landscapes with classical ruins (Louvre, Paris; the other lost). For stylistic reasons, the latter two are regarded here as the first in the sequence of early landscapes. Their Italianizing staffage suggests, furthermore, that Rubens began this new activity on relatively "safe" classical ground and with Italian prototypes in mind. After this debut he turned to the rural landscape, and the present painting, done around 1616, is apparently his first depiction of the Flemish countryside. This early picture is

marked by some conventional elements, especially the way in which the landscape is shown under a rather constructed view. A narrow strip of land serves as the foreground, a stage for a pastoral company, two milkmaids followed by some cows. Trees on both sides of the picture frame the composition, forming a proscenium through which is seen the main view—a small river enclosed by high, reedy banks and overhung by the thick brush. The river bends sharply around a hill, opening up two diagonal vistas leading into the distance, an optical device that is strengthened by rows of trees along the water. Compositional devices similar to these were frequently used in Flemish landscape painting around 1600. Gillis van Coninxloo (1544–1606), in particular, had developed similar arrangements in his forest views (for a splendid example see cat. no. 179). Rubens might have been acquainted with Coninxloo's art through Jan Brueghel the Elder (1568–1625), his friend and colleague in Antwerp, who composed his own minute landscapes along comparable lines (cat. no. 182). The Flemish underpinning of Rubens's early landscape is blended with the romanticizing mood that distinguishes the work of the landscape painter Paul Bril (1554–1626), whom Rubens had met in Rome. How deeply this early attempt is rooted in tradition may further be seen in the way Rubens, with his innate sense for the particular, has rendered the different species of trees, each one presented almost as an individual portrait. This carefully detailed differentiation is known in earlier Netherlandish works, and Guy Bauman has pointed out to the author that Jan de Cock's small panel (cat. no. 176), which was in Rubens's collection in 1640, may have presented one such model for the master.

One might regard Rubens's first landscapes as rather conventional and therefore of limited interest. But this dismissal would ignore the extraordinary atmosphere, then entirely original, created by the exuberant vegetation, rendered in searching detail, and the dense, mysterious spatiality. Furthermore, a most exceptional feature of Rubens's early landscapes became known only in the light of a recent discovery. Winner (1981, pp. 16–65) published a drawing (Kunsthalle, Hamburg) that shows the same river view and hilly landscape, but without the framing trees in the foreground. This drawing, undoubtedly done from an actual site, records more faithfully than the present painting certain details, for example a brick structure, presumably an abandoned pier built into the water, which in the painting has been transformed into the hill around which the river bends. Because of the poor quality of draughtsmanship, Winner's attribution of the drawing to Rubens cannot be followed here, but the sheet clearly indicates a stage prior to the painted version and may reflect a lost original by Rubens. It had been generally believed that Rubens's early landscapes were idealizing and largely imaginary; now, however, one must begin to recognize that, while using known compositional patterns, the artist based his depictions on direct observation, rather than on a generalized knowledge of rural Flanders. Obviously and in a quite modern sense, his landscapes were done primarily from

nature. The 1640 inventory of Rubens's estate singled out some of his landscapes, noticing that they were "ter plaetze geteekend" (drawn on the spot). It is exactly this quality that makes the present painting so extraordinary for its time: the beauty of nature has not been invented but observed, studied, and rendered according to its own truth.

The same can be said about the country life, first represented here in the milkmaids and cattle and developed fully in Rubens's later landscapes. Again, the artistic ancestry is evident: first, the Flemish tradition of depicting the peasant's simple world, embodied above all in the work of Pieter Brueghel the Elder—his drawing in the National Gallery, Washington, D. C., showing a landscape with a herd of cows and peasants, compares well with Rubens's present bucolic subject (Berlin 1975, no. 38). Furthermore, the Italian sources, especially Titian's landscapes published as prints, must be cited. Titian's woodcut *Landscape with a Milkmaid* (Washington, D. C., 1976, no. 21) seems to have been owned by Rubens, since young van Dyck in his Antwerp Sketchbook copied figures from that model, almost certainly while staying in Rubens's atelier. The pastoral mood of Titian's print anticipates Rubens's depiction of the countryside, and the present painting's curious motif of a cow truncated by the picture frame is found there. Rubens also seems to have borrowed the picturesque motif of the dead tree on the left, whose boughs are covered with hanging moss, from Titian's woodcut *The Stigmatization of Saint Francis* (Washington, D. C., 1976, no. 23), as noted by Hermann (1936, pp. 21, 33). But without diminishing the impact of these models, it must be emphasized that it is the careful observation of reality that creates Rubens's unique and enchanting vision of nature: the apparent pleasure of the cow peacefully rubbing its head against the bark of a tree; the bony hindquarters of a second cow that bends down to drink; the glimpse of a smile on one of the maidens' faces; the reflection of the sun on the copper pitcher carried by her companion. Perhaps echoing Rubens's experience on his country estates, the peasants and cattle are here the most vital element of the landscape. In his landscapes Rubens created a green and living stage on which rural scenes were played out: after all he was at heart a painter of narrative histories.

RB

FURTHER REFERENCES: Cat. 1885, no. 412; Rooses 1886–92, vol. 4, no. 1182; K.d.K. 1921, p. 181; Cat. 1931, no. 412; McLaren 1936, p. 208; Raczyński 1937, p. 79; Evers 1942, pp. 236–40; Lucerne 1948, no. 139; Thiéry 1953, pp. 94–95; Gerson and ter Kuile 1960, p. 107; Cat. 1974, no. 16; Jaffé 1977, p. 54; Downes 1980, p. 53; Baumstark 1980, no. 46; Adler 1982, pp. 69–72, 83–85; Vergara 1982, pp. 27–32, 71, 94, 196.

207

Peter Paul Rubens
Flemish, 1577–1640

MARS AND RHEA SILVIA

Oil on canvas, transferred from panel; 18¼ × 25⅜ in. (46.3 × 64.5 cm.)
Liechtenstein inv. no. 115

The present oil sketch represents Ruben's first draft of a composition that he later developed in a large-size painting. Since 1710, the latter painting has been in the possession of the Princes of Liechtenstein, and, with the acquisition of the sketch for the same collection in 1977—the quatercentenary of the painter's birth—the *modello* and its final version were reunited. Until then, only the great Rubens collection in the Kunsthistorisches Museum, Vienna, could offer a direct comparison of the artist's initial idea with its finished version.

Rubens depicts the love of Mars, the god of war, for Rhea Silvia, daughter of King Numitor, as told in ancient literature. Rhea Silvia served as a priestess in the sanctuary of the Temple of Vesta, where the statue of Pallas Athena, the Palladium, was worshiped as a powerful idol. The statue, which was believed to have been brought from Troy, had become the most sacred image in Rome. Virgin priestesses, clad in white, were charged with guarding an eternal fire in front of the Palladium and with protecting the statue from being desecrated by the presence of men. With abbreviated but effective means, Rubens describes the performance of the cult and its profanation by a god's intervention. The Vestal Rhea Silvia sits beside the altar on which the eternal flame burns in honor of the Palladium, directly behind. Neglecting her duty to guard, the priestess glances lovingly at Mars, who rushes toward her. Although guilty, in the eyes of the law, of neglecting her sacred obligations —for which she would later be punished by death—Rhea Silvia is nevertheless received among the gods. As a result of her loving union with Mars, she gave birth to the twins Romulus and Remus, the legendary founders of Rome, who were nursed by a she-wolf after the death of their mother. Through his portrayal of the mythical encounter of god and priestess, Rubens touches upon the legendary history of the founding of Rome.

The subject of the painting has long been misidentified. The large version on canvas was acquired in 1710 as a Mars and Venus, but following the publication in 1767 of the earliest catalogue of the Princely Collections, it was believed to represent Ajax and Cassandra. However, Evers (1943, pp. 255–57), reestablishing the painting's actual theme, pointed out that the picture does not show a struggle taking place during the Fall of Troy; instead, it is a meeting of lovers brought together by Cupid, who conspicuously occupies the center of the composition. Furthermore, Evers cited the philological treatise *De Vesta et Vestalibus Syntagma*, which was published in Antwerp in 1605 by Justus Lipsius, a Flemish scholar who was greatly admired

by Rubens. Consulting the book, one realizes that Rubens was remarkably conscientious in depicting in the painting what could be learned about the cult of the Vestal Virgins. Lipsius, for example, describes the Palladium as a statue of the goddess Pallas, poised in midstride, and carrying a lance in her raised right hand and a distaff and spindle in her left. Rubens omitted the spindle but otherwise based his conception of the Palladium on this description and on the illustrations of Roman coins that accompanied Lipsius's text. The appreciation of the antique, in the seventeenth century, was fostered, in part, by the study of Roman numismatics, which repeatedly provided Rubens with source material for his scholarly rendering of the classical past. Thus, almost certainly, the motif of the seated Rhea Silvia derived from the reverse sides of Roman coins, which showed Vestals seated on similar chairs. Rubens could have found illustrations of such coins in Guillaume du Choul's *Discours de la religion des anciens Romains* (Lyons, 1555), a book that he probably owned. Yet, an even more important source from antiquity might have served Rubens as a model: the famous sarcophagus in the Palazzo Mattei, Rome—known to artists from the sixteenth century on. It shows the very same subject chosen by Rubens, the encounter of Mars and Rhea Silvia. There are similarities between both, not only in the relief-like compositions, which are lacking in depth, but also in such motifs as Mars entering the scene from the left, with a long stride, extending his right arm toward Rhea Silvia, who sits opposite him. The modeling of a composition on a classical prototype exemplifies Rubens's veneration of the antique. Frequently, he used examples from antiquity as his points of departure, infusing them with a powerful vitality, emotion, and energy—as demonstrated by the present sketch. In his own treatise *De imitatione statuarum*, Rubens explicitly advocates such a reliance upon sculptural prototypes as a worthy task for painters, who, in so doing, give new life to the art of the past.

Compared with his other oil sketches, Rubens here aims at presenting the complete composition, in greater detail. Perhaps this may be explained by the artist's intention, from the very outset, to leave the execution of the large version to his workshop. The sketch would serve as a *modello* for his assistants, providing guidelines for transferring the composition to a life-size format, almost certainly without resorting to the intermediate stage of a drawing. Unlike the large canvas, indeed executed primarily by Rubens's workshop, the sketch is an entirely autograph work by the master himself. Comparing both versions, one notes how remarkable was Rubens's ability to enliven the gestures and expressions of his dramatis personae even at the preliminary stage of his sketch. Only in the *modello* does Mars truly storm the scene—a movement appropriate to the aggressive god of war; in the larger version, he simply seems to walk toward the altar. Rhea Silvia's pose, too, is rendered more sensitively in the sketch, where her timidity forces her to shrink back slightly. And only in the sketch are the glances between lover and beloved exchanged with great intensity. Thus, the oil

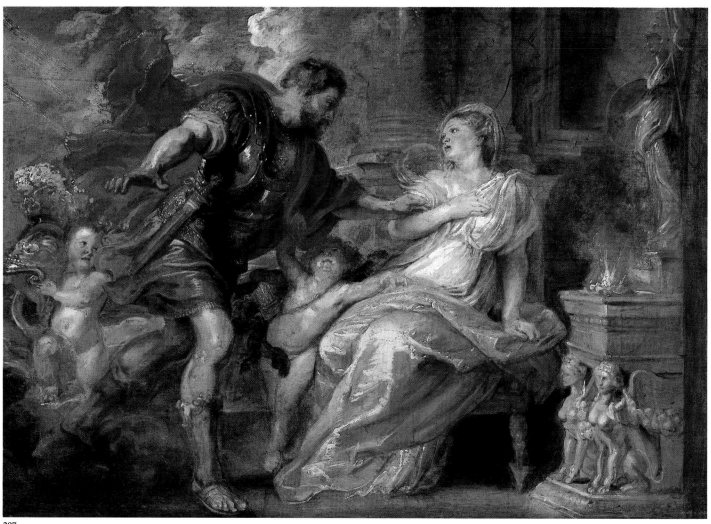

207

sketch preserves not only Rubens's preliminary ideas and his original creative impulse, but it also represents the subject in its most effective form; the large version does not surpass this initial achievement.

The date of the *Mars and Rhea Silvia* and the purpose for which it was intended must be deduced from Rubens's large version of the subject. Quite obviously, the Vaduz canvas served —like the paintings in the Decius Mus series—as a cartoon for a tapestry. Out of technical necessity, tapestries are woven from behind, therefore reversing the composition of the cartoon. This is attested by the present picture, in which the weapons are carried by Mars, Cupid, and the statue of Pallas, as if their bearers were left-handed. Although several tapestries of the *Mars and Rhea Silvia* were executed by the Brussels factory of Frans van den Hecke and Jan Raes, the place of this composition within a hypothetical set of wall hangings remains uncertain (see Göbel 1923, vol. 1, p. 207). Earlier, the large painted version was thought to be yet another design for the Decius

Mus series, but differences in size, subject, and style make this hypothesis totally unfounded. In fact, both the present sketch and its final version date from about 1620 and are therefore later than the Decius Mus paintings. As opposed to the more classical style of the earlier series, the *Mars and Rhea Silvia* presents a rather classicizing approach to events of the past. About 1620 Rubens may have planned a cycle of tapestries on the early history of Rome, only later to be postponed and finally dropped when he became involved with his major project, the Maria de' Medici cycle, begun in Paris in 1621. The situation is further complicated, however, by the evidence of other sketches by Rubens depicting scenes from the life of Romulus, again first designs for tapestries, as indicated by their apparently reversed compositions (see Held 1980, nos. 279–82). These sketches are datable about 1630, which raises the question of whether the earlier *Mars and Rhea Silvia* might be included in that group. However, all of these sketches could be considered as fragments of an incomplete narrative cycle devoted to Rome's he-

roic past that seems to have preoccupied Rubens throughout much of his life. Only further research can solve the intriguing puzzle of the exact place of the present work within such a cycle.

<div align="right">RB</div>

FURTHER REFERENCES: Cat. 1974, p. 16; Baumstark 1977, pp. 35–51; Baumstark 1980, no. 58; Held 1980, vol. 1, pp. 336–37.

208

Peter Paul Rubens
Flemish, 1577–1640

PSYCHE TAKEN UP INTO OLYMPUS
Oil on wood; 25¼ × 18⅞ in. (64 × 47.8 cm.)
Liechtenstein inv. no. 117

Rubens's brilliant inventiveness finds a particularly striking expression in the oil sketches with which he prepared his large commissions. Here the foreshortenings and the drastic view from below make it almost certain that this is a sketch for a ceiling painting. A line, scratched into the priming, indicates that the projected format was a roundel, exceeded, however, by Rubens at the lower right as if in the haste of a first draft. The sketching of this complicated subject in the lasting medium of oil paint instead of relying on a drawing, which lends itself to changes, is otherwise extraordinarily sure. The power of the rapid brushwork makes the present work not only the finest example in the rich collection of Rubens's oil sketches at Vaduz, but also one of his most remarkable achievements in this field.

In this sketch the cloudy "floor" of heaven has been cleverly dissolved so that the viewer's gaze is drawn upward to the assembly of Olympic gods. In whirling flight the girl Psyche, still a mortal, is carried aloft by Mercury, the messenger of the gods, to the throne of Jupiter. The father of the gods, majestically overlooking Olympus, is about to celebrate the marriage between Psyche and Amor, the boyish god of love, who kneels, awaiting his bride with outstretched arms. Venus stands at the upper left behind her son Amor, and Juno sits beside her husband, Jupiter; both goddesses act as witnesses to the marriage, while the Three Graces hold the bridal wreath in readiness. Every element of the sketch contributes to the effect of soaring airiness; even marginal figures like the flying putto with a torch —Hymen, the genius of marriage—and Jupiter's eagle with the bundle of lightning bolts in its claws add to the feeling of celestial height and movement. In depicting the marriage between Amor and Psyche, Rubens followed the Latin story by Apuleius, which told of the love between the god and the mortal. Anguished by separations and misunderstandings, they were finally joined in celestial union, and Psyche was deified. Since

antiquity this story has also been regarded as an allegory of the mystical union between Love and the Soul (hence Psyche); as such—and as a literal narrative—the tale of Apuleius has been depicted repeatedly from the Renaissance on.

Rubens's sketch was not executed as a monumental ceiling painting, and we have no certain information about its commission and original purpose. The field, therefore, is open to scholarly speculation. Taking the subject as a point of departure, Burchard and d'Hulst (1963, pp. 39, 309), followed by Croft-Murray (1962, vol. 1, pp. 38, 208) and Parry (1981, pp. 141–42), tried to prove that the sketch was a contribution to a commission, given to and finally executed by Jordaens. This was a series of ceiling paintings, depicting the history of Psyche, which was intended to adorn a small room in the Queen's House at Greenwich, a royal villa outside London. A few months before he died, Rubens was asked by an English agent if he would compete with Jordaens's project; nothing came of this proposal, and it is wholly unlikely that Rubens, given the circumstances, would have wasted energy on a painted design. In any event, for stylistic reasons, the present sketch cannot be dated as late as 1640 but must be placed close to the oil sketches done around 1622 for the Medici cycle. It is exactly this period to which another hypothesis points, which was convincingly brought forward by Palme (1956, pp. 255–59) and accepted by Held (1980, pp. 187, 188, 190–92) and earlier by the present writer (Baumstark 1980, pp. 152–53). Palme suggested that the sketch expressed Rubens's first ideas for the sequence of ceiling paintings to be done for the Banqueting House in Whitehall, London. We know that in 1621 Rubens had hoped to be asked about this challenging task. In his letter of September 13, 1621, which contains his proudest statement about his art, he wrote to William Trumbull, a political agent of the British monarch James I, saying that he would be happy to have the honor of a commission from the King or the Prince of Wales. With regard to the hall in the newly erected Banqueting House, he wrote that "by instinct I am more inclined to make large works rather than small curiosities. Everyone in his own way. My talent is such that no undertaking, no matter how large in size, or varied in subject, has ever exceeded my confidence." His enthusiastic and self-assured letter did not bear immediate fruit—the commission for the monumental ceiling paintings was not awarded to him in 1621, when the reception hall for the English court at Whitehall had just been completed, but some years later during his stay in London in 1629–30. In the absence of any specific evidence, one can only speculate about why the decoration of the Banqueting House was postponed for so long, but the present sketch lends itself to a plausible reading of the events. Viewed against the political situation of 1621, Apuleius's tale about the union of lovers in the face of all adversities appears to have a deeper level of meaning and takes on the aspect of allegorical praise of the British sovereign. Since 1619 King James I had been pursuing the project of a marriage between his heir (later Charles I) and the Spanish Infanta Maria, who was the sister of

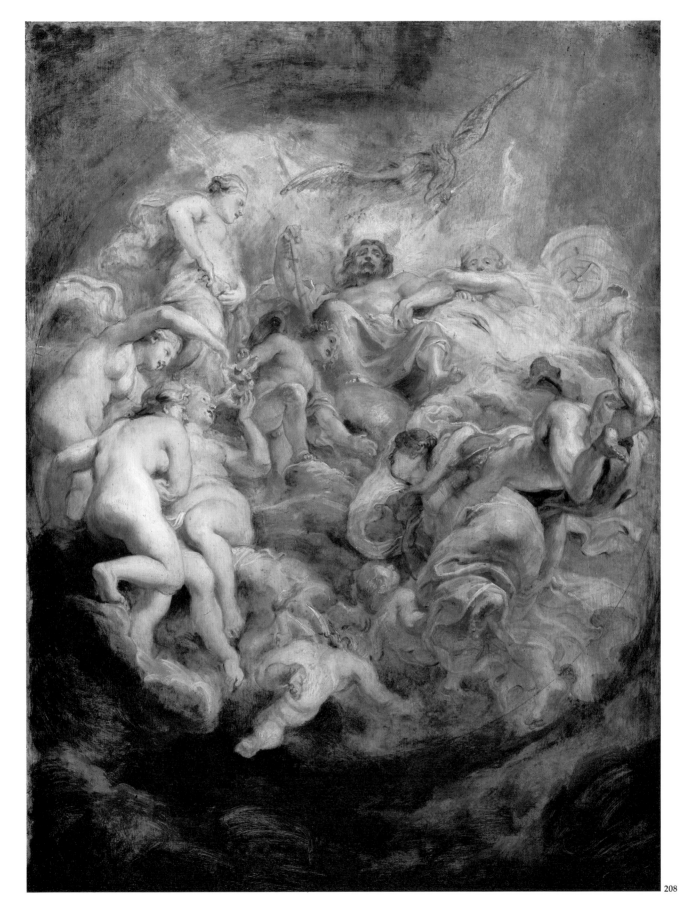

208

Philip IV of Spain. James's vision of peace for Europe was founded upon a reconciliation between the two great maritime powers, which would be sealed by the proposed marriage. Envoys traveled between London and Madrid to negotiate the marriage, and finally the Prince of Wales himself journeyed to Spain to win the bride through his own persuasion. But in 1623 the project collapsed over religious differences (the Prince was Protestant and the Infanta Catholic), and so too did the hopes for peace that were bound up with it. The present sketch, depicting a matrimonial bond arranged by Jupiter, would have been a most fitting celebration of James I as the Prince of Peace in the early 1620s. But political reality thwarted cloud-based illusions, and Rubens's "great and diversified" subject became a casualty of onrushing events. In a letter of January 10, 1625, Rubens remarked that he would have been obliged to go to London if the proposed marriage proposal had been successfully concluded. This remark appears to refer to a first project for the ceiling of the Banqueting House, alluded to in 1621, which, although not documented otherwise, is supported by the striking evidence of the present sketch.

An objection to this interpretation, primarily based on Palme, has been raised by Martin (1966, pp. 613–14) but must be ruled out here. Although Martin linked the present sketch with an initial stage of the Whitehall program, he stated that the episode from Apuleius alluded to the marriage finally celebrated in 1625 between Charles I and his French bride, Princess Henrietta Maria, daughter of the late Henry IV (d. 1610) of France. But the allegorical elements which seem to be found in the present sketch make sense only when an equation is made between Jupiter and James I; the British monarch had, however, died before his son's marriage and therefore did not play the significant role he had taken in the proposed Spanish match of a few years before.

On the occasion of the marriage by proxy, which occurred in Paris in May 1625, Rubens first met the Duke of Buckingham, the powerful favorite of Charles I, whose support was indispensable for any new artistic venture. As their acquaintance developed, Buckingham commissioned a ceiling project from Rubens. The artist, recognizing that the present sketch was of no further use, placed the group of the Three Graces and the brilliantly conceived flying Mercury into a new composition allegorically honoring the Duke of Buckingham and designed in 1625 or shortly thereafter (oil sketch in the National Gallery, London; Held 1980, pp. 390–93). The artistic ancestry of the Graces makes it clear that the group was invented not for the Buckingham but the Whitehall sketch, establishing once more the priority of the latter over the former. Raphael's depiction of the Graces, part of his cycle on the history of Psyche in the Farnesina, Rome, was a direct and most appropriate model for Rubens's rendering of the story. Again, as so often in his career, Rubens measured himself against the great masters of the past. This spirit is also evident in the present work in a quotation from an antique sculpture, which has apparently gone unnoticed.

During Rubens's Italian sojourn a Roman statue of Psyche had been kept in the garden of the Villa d'Este in Tivoli (now in Museo Capitolino, Rome), and this work seems to have been the source for Psyche's crouching pose, the gesture of her right hand, and her upward gaze. Thus, even the sketch's most ingeniously imagined figure—the girl expressing maidenly wonder as she is lofted into the realm of heaven in defiance of terrestrial gravity—finds its source in classical art.

RB

FURTHER REFERENCES: Cat. 1767, no. 497; Cat. 1780, no. 566; Cat. 1873, no. 197; Cat. 1885, no. 117; Rooses 1886–92, vol. 3, no. 673; Bode 1888b, p. 17; K.d.K. 1921, p. 470; Burchard 1930–31, pp. 7–18; Cat. 1931, no. 117; van Puyvelde 1948, p. 80; Lucerne 1948, no. 110; Jaffé 1965, p. 381; Held 1980, pp. 200, 391, 392.

209

Peter Paul Rubens
Flemish, 1577–1640

HENRY IV SEIZES THE OPPORTUNITY TO CONCLUDE PEACE
Oil on wood; 25 ¼ × 19 ¾ in. (64.2 × 50 cm.)
Liechtenstein inv. no. 100

This sketch, jotted down with hasty brushstrokes, displays Rubens's ability to transform an abstract play of ideas into vivid, concrete imagery. The division of the representation into two parts and different levels of meaning is a skillful invention. The female figure seated before an open landscape in the lower part of the sketch is Vigilantia, the personification of Watchfulness. Her pose expresses her patient attentiveness, while her attributes, a serpent and a club, illustrate prudence paired with force, the qualities that distinguish her. Finally, the eagle at her side brings to mind her sharp-sightedness. Above this figure hangs a tapestry which shows a figurative scene that carries the main message of the picture. In the center of the group of figures is Pax, the personification of Peace, whose attribute, a cornucopia, is held by a putto at her side. From the left Saturn, the winged hoary god of time, urges forward the half-nude Occasio, the personification of Favorable Opportunity, whose pose reveals her submission to the force of Time. Occasio's long forelock can be seized by anyone she faces but is inaccessible once she turns away. Pax has grasped this forelock and is about to present it to an armored hero, who rushes in with outstretched arms from the opposite side. Minerva, goddess of wisdom, follows him, pushing him toward Peace. A flying putto holds a laurel wreath, ready to crown the hero. The meaning of this allegory may be read thus: the victorious hero, protected by wisdom, seizes the opportunity afforded by propitious times to conclude peace.

335

Rooses (1886–92, vol. 3, no. 761) was the first to connect the present sketch with the painting cycle on the reign of Henry IV of France that Rubens planned as a counterpart to that on the life of the royal widow, Maria de' Medici (now in the Louvre, Paris). The Queen's cycle was completed in 1625, but a comparable homage to her late husband was abandoned because of the growing hostility of French policy under Cardinal Richelieu. The proposed project therefore resulted only in sketches and unfinished paintings. Unlike the designs already convincingly assigned to the Henry cycle, the present sketch and a similar one in the Liechtenstein collection interpret historical events in allegorical terms and use a two-layered pictorial space. (Three further sketches by Rubens, to be published by the present writer shortly, might be added to this group.) Since her reconstruction of the Henry cycle has no place for such allegorical depictions, Jost (1964, pp. 189–91), followed by Müller-Hofstede (1969, pp. 227–28, 241, no. 165) and in 1974 the present writer (Baumstark 1974, pp. 170–72, 223, no. 362), doubted that the two Vaduz sketches belonged to this series. More recently, however, Held (1975, pp. 219–27) has marshaled the arguments for their being closely connected to the Henry cycle. Rooses (1890, pp. 528–29) suggested that these sketches were cartoons for a series of tapestries, and following this hypothesis, Held proposed that such hangings might have been intended to furnish rooms adjoining the main gallery, where the paintings of the Henry cycle would have hung. They would have continued the cycle's homage to the great King but with allegorical rather than historical narration. After the painting cycle came to nought, further preparation for the set of tapestries would have been abandoned, and the preliminary works would thus survive as scattered fragments. Thus, following Burchard and d'Hulst (1963, pp. 259–60), the present sketch might be related to the Peace of Vervins (1591), which concluded the war between France and Spain. The recent literature dates this sketch about 1628; this dating is confirmed by the work's close link to the Henry cycle and is convincing stylistically, whereas a later date (around 1638), put forward by Müller-Hofstede, must be ruled out.

Rubens himself invented the motif of Favorable Opportunity introduced by Time and seized by a hero protected by supernatural forces. This theme, which seemed to have appealed to the artist, was treated in two further oil sketches. A gouache (Staatliche Kunstsammlungen, Weimar) and several painted large versions, done mainly by his atelier, also present the same subject but without allusion to Henry IV. In 1676 Philipp Rubens, the painter's nephew, described such a canvas under the title *L'Occasion*, calling it one of his uncle's masterworks from the years 1630–40 (see *Rubens-Bulletijn*, vol. 2 [1883], p. 166).

There have been repeated attempts to establish a chronology of the different versions of the Occasio theme, thus reconstructing the development of this pictorial theme. Most recently, Held (1980, pp. 346–50) examined the various Occasio depictions in great detail. He postulated that the composition originated with rapid sketchings on a panel whose reverse was later used for a portrait of a woman (now in the Royal collection, Windsor). Taking an oil sketch, formerly in the collection of the Duke of Arenberg and now lost, as an intermediate stage, the present sketch would be the third version of this subject. Then, after reviewing his initial efforts in the Windsor sketchings, Rubens finally designed the group of larger canvases and the colored drawing in Weimar. Held's proposal is a thoughtful attempt to solve a complex problem. He seems to have been guided by the progressive consolidation of the theme—from the hastiness of the Windsor designs to the final stage of workshop production. Here, however, a different sequence must be given to the various depictions; a proposed chronology, first published by the present writer in 1974, may stand up to renewed examination.

The pictorial idea appears to have passed through two distinct stages—one preserved in the present sketch, and the other evident in all other depictions of the Occasio theme. Only in the Vaduz sketch is Peace the central point of the action. In the other versions one can only guess what promising chance the gods are urging the hero to grasp. While in the Vaduz sketch Minerva is the moving force behind the hero, in the other version she is the mediator who unites the hero with Occasio. In this role, played by Pax in the Vaduz sketch, she is Minerva Pacifera (Minerva the Peace-Bearer). Finally, only the Vaduz sketch evinces the reversed rendering of tapestry design. Here the hero holds Occasio's forelock with his left hand, whereas he grasps Favorable Opportunity with his right hand in all other versions. Obviously, the latter were not composed with the thought of transferring the image into a tapestry.

In summary, Rubens invented his Occasio allegory for a projected tapestry cycle supplementing the Henry IV paintings. His first composition is preserved in the present Vaduz sketch. After the project failed, he used basic elements from this first draft in the Arenberg sketch, but not aiming anymore to prepare a tapestry. (Peculiarities of the frame in the Arenberg sketch have led Held to suggest that it was intended to be executed as a relief.) From the Vaduz sketch Rubens borrowed the figure of Occasio, who is now directed to the hero by Minerva. Contrary to Held, the figure at the left of the Arenberg sketch is here interpreted as a personification of Good Government. On the whole, the allegory has lost at its second stage some of its concrete and specific meaning. It is revealing that in the lower sections of the Arenberg sketch, the Vaduz Providentia is replaced by a less allusive figure of Fortune. In his sketches on the back of the Windsor portrait, Rubens revised the Arenberg composition. Following his usual practice of progressively changing his designs, he now completely reformulates the figure of Occasio. Distinguished by her shy maidenly pose as a Venus Pudica, Occasio now evinces a loving attitude toward the hero, who seems to be deeply moved as well. This new pictorial idea has been characterized by the present writer as a secular *sposalizio*, the rendering of a sacred engagement in Italian Renaissance art. This conception would be fully realized in an independent

209

composition, such as Philipp Rubens described in 1676, and is preserved today in several versions from Rubens's atelier.

The Vaduz sketch was the spark that ignited this complex chain of inventions. It is clear that the master's imagination not only changed intellectual conceptions into vivid actions but also, struggling for the most valid rendering, constantly renewed and improved a pictorial idea.

<div align="right">RB</div>

FURTHER REFERENCES: Cat. 1767, no. 479; Cat. 1780, no. 563; Cat. 1873, no. 461; Cat. 1885, no. 100; K.d.K. 1921, p. 319; Cat. 1931, no. 100; Simson 1936, p. 386; Wittkower 1938, p. 314; Evers 1943, pp. 307–8; Lucerne 1948, no. 112; van Puyvelde 1948, no. 35; Panofsky 1966, p. 316; Vienna 1977a, no. 44; Baumstark 1980, no. 56.

Peter Paul Rubens

Flemish, 1577–1640

THE DECIUS MUS CYCLE

The sequence of paintings on the history of the Roman consul Decius Mus, which has been one of the glories of the Liechtenstein collection since its acquisition in 1693, occupies a significant position in the work of Rubens. In it the artist uses for the first time the cycle form—that is, the narration of a story through a series of paintings. The development of a sequence of monumental works with abundant imagery and forceful visual impact had a great attraction for Rubens. Again and again he turned his artistic energy to creating cycles, the foremost being the huge paintings celebrating the life of the French Queen Maria de' Medici (Louvre, Paris), followed by the cycle on her late husband King Henry IV, a magnificent undertaking even in its fragmentary state. Further cycles concentrate on Constantine, on Achilles, on allegorical praise of Catholic doctrine (*The Triumph of the Eucharist*), and on the greatness of Britain under James I. The number and importance of Rubens's cycles indicate how eagerly he took up this challenging form that allowed full play to his unparalleled inventiveness. His well-known letter, written in 1621 about the proposed cycle for the Banqueting House in Whitehall, London, presents what might be regarded as his manifesto: "I confess that by instinct I am more inclined to make large works rather than small curiosities. Everyone in his own way. My talent is such that no undertaking, no matter how large in size, or how varied in subject, has ever exceeded my confidence." This self-assessment is borne out by the Decius Mus cycle, his initial attempt at cyclical narration; the demanding complexity of this task allowed his art to achieve a truly monumental scale.

In yet another sense the Decius Mus cycle may be considered as a seminal force in Rubens's career. It is one of the earliest works in which he presented an episode from Roman history; here he made one of his first forays into classical antiquity, a domain from which he later drew the subjects of some of his most important paintings. Rubens himself can be understood only in the context of his extensive classical education. As a member of a circle of humanists around Justus Lipsius, the great master of classical philology and Neo-Stoical philosophy, Rubens was well acquainted with antique thought, literature, and art, regarding as preeminent the authority of ancient thinkers. His letters, many of which have fortunately survived, show the intensity with which he pursued classical studies, and it is most significant that Rubens had Roman authors read aloud in Latin while he painted. He engaged in learned correspondence with the foremost classical scholars of his time, and the archaeological publications of his son Albrecht present insights—into, for instance, Roman coins and carved gems—that are based on his father's studies. Rubens's artistic preoccupation with the antique is most easily seen in his empathy for ancient sculptures, but to understand his interpretation of Greek and Roman subjects, one must also appreciate the master's immersion in the spirit of the classical past. The Decius Mus cycle is an early and most telling example of the force of the antique, both formally and intellectually, in Rubens's oeuvre.

Finally, the Decius Mus cycle represents the artist's first venture into tapestry design. These large paintings were not planned as autonomous works of art; rather, these canvases were cartoons, designs that were followed by the weavers as they transformed the master's compositions into tapestries. The Decius Mus cycle was an extraordinarily successful debut in the field of tapestry weaving, a time-honored art that was developed in his native Flanders and later spread throughout Europe. A magnificent series of tapestry cycles designed by Rubens followed this first coup—as mentioned above, *The History of Constantine* (1622–23), *The Triumph of the Eucharist* (1625–27), and *The History of Achilles* (ca. 1630–ca. 1635). Other Flemish artists, especially Jacob Jordaens, followed Rubens's example, thus reaffirming Flanders as the center of tapestry weaving in seventeenth-century Europe.

We are fairly well informed about date and circumstances of the commission of the Decius Mus cycle. In two letters dated May 12 and 26, 1618, written to the English diplomat Sir Dudley Carleton, resident in The Hague, Rubens mentions his cycle. He states that, having much experience with tapestry weaving in Brussels ("per la gran prattica ch'io ho con quei tapizzieri di Brusseles"), he has done some truly superb cartoons that were commissioned by certain Genoese noblemen ("ho fatto alcuni cartoni molto superbi a requisitione d'alcuni Gentilhuommi Gennoesi"). He writes that his cartoons were then being executed as tapestries in Brussels. In the following letter Rubens notes the cycle's subject—the history of the Roman consul Decius Mus who sacrifices himself to gain victory for the Roman people ("mio Cartone della storia di Decius Mus Console Romano che si devovò per la vittoria del Popolo Romano"). Again he points out that all the cartoons have been sent to Brussels; apparently answering a query from Carleton, he writes that the exact dimensions of the works could be obtained only from the tapestry workshop in Brussels. These remarks are supported by a contract, dated November 9, 1616, between the Brussels tapestry weavers and dealers Jan Raes and Frans Sweerts and the Genoese merchant Franco Cattaneo. This document calls for delivery within a year of two complete but slightly different tapestry series on the history of Decius Mus, and it expressly states that the designs were to be prepared by Rubens and the completed wall hangings submitted for his approval. Rubens's actual preparatory work on the cycle has to be fixed, therefore, between November 1616 and May 1618, and the artist may have devoted the greater part of 1617 to this cycle. Here the documentary evidence ends.

The Genoese merchant certainly acted only as a middleman,

but the actual commissioners of the series remain unknown. It seems likely that the subject, never before represented by an artist, had a special and appropriate meaning for the patrons of the series; the identities of these "Gentilhuommi Gennoesi" must, however, be known to make such speculation meaningful. A number of Genoese nobles were mentioned by the artist in letters and documents; one nobleman in particular would seem to be a likely patron of the series—Marchese Niccolò Pallavicini, whom Rubens chose in March 1618 as godfather for his son Nicolas and who two years later commissioned from him the painting for the high altar of the Jesuit church in Genoa. But such an identification is far from certain, and the patrons could as easily have come from any of the great Genoese families, among them the Balbi, Brignoli, Doria, Giustiniani, Grimaldi, and Spinola. Rubens frequently visited Genoa during his Italian sojourn, particularly in 1605 and 1606, and became well acquainted with patrons in that city. He had served the Genoese nobility with splendid portraits, and some years later, in 1622, he published their residences in a volume of engraved views, cross sections, and ground plans, collected by the artist during his stays in Genoa. The first two Decius Mus tapestry series (the *editiones principes*, as the first sets of tapestries are called), mentioned in the contract of 1616, were apparently intended for two of these palaces, unfortunately still unidentified.

The question of whether or not the Liechtenstein paintings should be classified as cartoons has been dealt with several times in the Rubens literature. Most authors have argued that Rubens would not have chosen the expensive medium of oil for cartoons rather than the conventional cartoon technique —charcoal and colored chalks on paper—that had been used since Raphael. Rubens was familiar with this technique, which apparently would have been more appropriate for this project. In fact, late eighteenth-century sources mention tempera cartoons on paper representing scenes from the Decius Mus cycle (these works have since been lost). But there is no proof that these tempera cartoons came from Rubens's atelier, let alone were executed by the master himself. Instead, they seem to have been later works used for one of the many sets of Decius Mus tapestries produced in the second half of the seventeenth century.

It has also been proposed that the Liechtenstein canvases could be repetitions of original but lost cartoons, implying that Rubens regretted "wasting" his compositions in tapestries and recreated them as oil paintings. This hypothesis is, however, highly questionable; such repetitions or *ricordi* are virtually unknown in Rubens's oeuvre, and in the present case the extraordinary amount of work necessary for a recreation would make such a project extremely unlikely. Furthermore, it must be remembered that the Liechtenstein paintings are clearly bound to the preparatory process of tapestries in showing the depiction reversed (for example, a sword worn on the left side and wielded with the right hand appears in the cartoon in reversed position). This inversion is due to the fact that tapestries are

worked on from behind and therefore reverse their models, a procedure always taken into account by the artists who created the designs. If the Liechtenstein paintings were conceived as autonomous works, it seems unlikely that Rubens would have retained the reversed depiction necessary only for tapestry weavers. The true status of these paintings should, however, be based on Rubens's own words. The artist's letters expressly state that cartoons were done by him and sent to the Brussels weaver. Everything points to identifying these cartoons as the Liechtenstein paintings. It is clear from his letter to Sir Dudley Carleton that Rubens had kept no large versions of the Decius Mus series from which measurements might be taken. The artist's proud description—"alcuni cartoni molto superbi"—is fitting for the Liechtenstein pictures, inasmuch as that for the first time fully painted models were supplied to a tapestry manufactory, a practice that was later followed periodically by Rubens as well as by his Flemish successors. Poorter (1978, pp. 136–49) has studied the function of these painted models in the tapestry-weaving process, but our knowledge of seventeenth-century weaving procedure remains incomplete. For example, whether or not "calques" (tracings on paper used to facilitate the transferral of details of the design) were made by the weavers of the Decius Mus cycle is difficult to ascertain. In any case, it must be firmly stated that the Liechtenstein canvases—which Rubens himself declared to be cartoons—represent precisely the contribution of the designing artist to the weaving process.

It might be asked why Rubens undertook a cartoon series in oil when these works could have been produced more easily and economically by conventional methods. We know, however, of the effort and supervision that Rubens expended on the preparation of prints after his own works. He seems to have taken equal care in the medium of tapestry, another reproduction process that would spread his art beyond his native Flanders. The 1616 contract, for example, states that Rubens would inspect the finished tapestries, thus guaranteeing their overall Rubensian character. Clearly the artist must have been determined to ensure that all such technical multiplications of his designs would reflect his art as faithfully as possible. Therefore Rubens seems to have supplied the manufactory with cartoons expressing the highest qualities of his art; given the extraordinary precision of the finished paintings, the tapestry weavers would be able to follow these models exactly, without resorting to improvisations or additions to complete the design.

It is significant that Rubens received the commission for his tapestry cycle from Genoa. During this period the most magnificent works in the field of cartoon painting—Raphael's cartoons for the tapestry cycle *The Acts of the Apostles*—were preserved in that city. Rubens had studied and recorded these cartoons in drawings during his stay in Italy. Later, with Rubens's assistance, the Raphael cartoons entered the collection of Charles I of England (they are now in the Victoria and Albert Museum, London). Given the personality of Rubens, it seems not unlikely that he would want to prove to Genoa and

to the world that he was capable of works that would equal or perhaps surpass Raphael's cartoons. The concept of the agon —the eagerly entered contest with predecessors or contemporaries—is characteristic of antique art; revived during the Renaissance, it was one of the vital forces that drove Rubens. We continually find him placing himself in competition with the masters of the Renaissance as well as of the classical past. Since he had studied Raphael's cartoons, he might have longed for the opportunity to create an important cartoon series of his own. And by working in oil, he could prove his cartoons to be technically superior to those of his predecessor. Furthermore, as a commission from Genoa, the Decius Mus cycle would be evaluated by contemporary Italian connoisseurs. Ten years earlier, when he completed the Vallicella altarpiece for the Chiesa Nuova, Rome, Rubens took great pride in challenging the achievements of his Italian colleagues. Italy, the "nutrix of art," profoundly influenced Rubens; reliance on and incorporation of masterpieces from both antiquity and the Renaissance, so evident in the Decius Mus cycle, demonstrate the lessons he had learned from Italy. In his art, however, these antique and Italianate elements were assimilated and transformed in a truly masterly way.

The Decius Mus canvases do not look like simple guides for weavers; the bravura of their execution conceals their original purpose. The participation of the master himself in the painting of the pictures has, however, been repeatedly doubted until recently. Opponents of attributing the works to Rubens's own hand may find support in the testimony of Giovanni Pietro Bellori, who in his biography of Anthony van Dyck records that van Dyck painted the large canvases (1672, p. 254). Still earlier documents from the Antwerp dealers Jan Baptist van Eyck, Gonzales Coques, and Jan Carel de Witte (see below) had attributed the cycle in 1661 to van Dyck, an estimation that was repeated in 1682 and 1692, adding that the pictures were in fact done from sketches prepared by Rubens. In 1693 Prince Johann Adam Andreas von Liechtenstein acquired the series as works by van Dyck, and this attribution was unchallenged during the eighteenth and part of the nineteenth century. Only with the beginning of modern scholarship in the field of Flemish seventeenth-century art was Rubens again cited as the author of the cycle, but with the predominant opinion that the master's own work in the execution should be judged as being slight.

Close examination of the large canvases does indeed prove that parts quite clearly should be attributed to Rubens's atelier. Since the painted area is approximately one hundred square yards (about 85 sq. m.), this participation is not surprising. However, in those areas completed by the atelier, it does not seem possible to identify the hand of van Dyck, the precocious young genius whose style at this time is well known, an example being his roughly contemporaneous *Saint Jerome* (cat. no. 195). As we know, van Dyck must have come into contact with Rubens's workshop when the Decius Mus cycle was being executed, and it can be assumed that the eighteen-year-old artist

participated in this large undertaking. But he, like the other members of the atelier, would have worked without any regard for personal expression. The success of Rubens's atelier lay in the subordination of individual talents to the conceptions of the master artist. Only under such strict direction could the vast output of works from the Rubens atelier, especially in the decade following the master's return from Italy in 1608, achieve its astonishingly homogeneous character. It is questionable, therefore, whether an attribution of any part of the cycle to any particular assistant is possible.

Rather than engaging in futile attempts to label workshop areas in the large canvases with the names of assistants, it is of much greater import to distinguish accurately between the work of Rubens himself and that of his assistants in the execution of the cycle. Criteria for such a distinction and a tentative survey of the problem, aided by a series of X-rays, have been published by the author (Baumstark 1983, pp. 178–91). Here it can be stated in summary that, contrary to even recent statements in the Rubens literature, large sections of the Vaduz canvases are indeed splendid examples of Rubens's own brushwork with its characteristic forcefulness and with the sparkling lights of his modeling. In particular paintings, such as *Decius Mus Relating His Dream* and *The Consecration of Decius Mus*, the master's brilliantly vivid style is maintained with a confident ease that no assistant, however gifted, could achieve.

The Decius Mus cycle unquestionably has to carry Rubens's name. It was commissioned from him and was produced in his atelier; he developed the composition in a sequence of oil sketches (Held 1980, vol. 1, pp. 22–30). Furthermore, the large Liechtenstein canvases unmistakably bear the stamp of his personal involvement. Among the four tapestry cycles designed by Rubens, the Decius Mus cycle is the only one in which the artist can be proved to have participated in the actual execution of the monumental cartoons. This task stimulated him to a performance of overpowering grandeur. Again we find Rubens's words confirmed—he wrote that his cartoons were superbly executed.

The Decius Mus cycle comprises eight cartoons, six with scenes of the narrative action and two with female personifications and a trophy intended to serve as so-called *entre-fenêtres* for narrow strips of walls between windows. The first sets of tapestries were woven by the Brussels workshop of Jan Raes the Elder, as set forth in the contract of 1616. During the seventeenth century the Decius Mus series was extraordinarily popular, and some twenty further sets were produced from Rubens's designs, but by other manufactories and with varying completeness and border decoration. Since the late nineteenth century parts of a set by Jan Raes woven with gold threads have been in the Liechtenstein collection; these might possibly be identified with one of the two sets, the *editones principes*, produced for Genoa. A comparable series is in the Prado, Madrid.

The further history of the large canvases begin with a document of 1661 that states that the Antwerp painters Gonzales Coques and Jan Baptist van Eyck, together with Jan Carel de

Witte, acquired five paintings representing scenes from the Decius Mus history to add to the one they already owned. After the deaths of the other two co-owners, van Eyck retained the paintings, which were seen in his Antwerp house and described in 1687 by the Swedish architect Nicodemus Tessin. Finally the six Decius Mus paintings appeared in the inventory of van Eyck's estate in 1692. On July 7, 1692, two days before the inventory was made, the Antwerp art dealer Marcus Forchoudt wrote to Prince Johann Adam von Liechtenstein, informing him that the paintings would soon be put up for sale. They were in fact acquired by the Prince in the following year, but a 1695 document of the princely court certifies that eight paintings were purchased for a total of 11,000 gulden. In the interim, Forchoudt seems to have succeeded in extracting the two other paintings from imperial possession, since the second picture of the series, *The Interpretation of the Victim*, has on its back a seal with the coat of arms of Emperor Leopold I. It was with considerable pride that the Prince announced his acquisition to the painter Franceschini in a letter of January 19, 1694. His admiration for this series is still to be read in the exceptionally sumptuous carved cartouches of their frames, which, commissioned by the Prince from the sculptor Giovanni Giuliani in 1706, were intended to enhance what was considered, and remains, the greatest pride of the Liechtenstein collection.

RB

FURTHER REFERENCES: Ruelens and Rooses 1887–1909, vol. 2, pp. 150, 171, 173–74; Rooses 1890, pp. 265–72; Donnet 1898, pp. 91–92; Fleischer 1907; *Kunstchronik* 1907–1908, pp. 146–47; Rooses 1908, pp. 205–15; Göbel 1923, pp. 206–7, 357, 364–65, 423; Denucé 1932, p. 371; Evers 1942, pp. 180–86; Crick-Kuntzinger 1955, pp. 17–23; Genoa 1977, pp. 164–65; Poorter 1978, pp. 136–49; Blazkova 1978, pp. 49–74; Duverger 1976–78, pp. 15–42; Baumstark 1980, nos. 49–54.

210

DECIUS MUS RELATING HIS DREAM

Oil on canvas; 115½ × 109 in. (293.5 × 277 cm.)
Liechtenstein inv. no. 47

Although well known and repeatedly cited as a model of virtue, the story of Decius Mus did not appeal to any artist before Rubens. His Vaduz cycle is therefore the first painted narration of this heroic episode in the war between the Romans and the Latins, recounted by Livy (*Ab urbe condita* 8.6.8–8.10.10). The Latins, a tribe inhabiting the plains of Latium, had long been subject to Rome. They rose in rebellion in the Latin War (340–338 B.C.), which began inauspiciously for Rome. Both armies pitched their camps near Capua, and the Roman leaders, the co-consuls Titus Manlius and Decius Mus, faced an enemy far superior in strength. At this critical point, "in the stillness of the night both consuls are said to have been visited by the same apparition, a man of greater than human stature and more majestic, who declared that the commander of one side, and the army of the other, must be offered up to the Manes and to Mother Earth; and that in whichever host the general should devote to death the enemy's legions and himself with them, that nation and that side would have the victory." Only a personal act of extraordinary bravery would therefore save Rome. The sacrifice of his life would enable one of the two consuls to restore Rome's invincibility, and death would be linked most dramatically to victory. With this prophecy—the premise of the further action and the center of the plot—Rubens takes up his narration. It is fascinating to observe how the painter adapted the classical source in selecting, interpreting, and dramatically sharpening the action according to his own need. Thus, Rubens restricts his account to the hero of his cycle, disregarding, except in his last painting, Titus Manlius, co-consul and one of the story's protagonists. While Livy unfolds the conflict between the two armies that forced the Roman side to consider winning by sacrificing a commander in the battle, Rubens simply starts by illustrating the military functions of his hero: here Decius alone steps up to his troops and tells them of his dream. Standing on an elevation, the *suggestus*, the consul addresses his soldiers; his words are vividly emphasized by his raised right arm which is extended in a rhetorical gesture. To the right, standard-bearers of different units and in varying battle-dresses stand, their eyes riveted on their commander. Though few in number, they are ingeniously arranged to give the impression of a listening crowd.

The scene of a commander addressing his legates and tribunes from an elevated position is based, as previous writers have noted, on the *adlocutio*, a pictorial formula which was frequently used in Roman art. In recreating this heroic event, Rubens therefore turned to an ancient image as the most trustworthy prototype. The *adlocutio* had occupied a distinctive role in Roman political propaganda, expressing both the authority of military leaders and the loyalty of their forces. Showing not only an oration but also a ceremonial act of state, the *adlocutio* combined aspects of narrated reality and martial glorification. Examples may be found on the reverse of coins from the imperial era and especially on such Roman triumphal monuments as the Column of Trajan, the Column of Marcus Aurelius, and the Arch of Constantine. Titian had used this device for his *Allocution of Alfonso d'Avalos, Marchese del Vasto* (Prado, Madrid; Panofsky 1969, p. 76). Rubens's rendering of the theme, however, follows the antique's authority more conscientiously, and he achieves a surprising affinity to his particular model, a relief of the helical frieze of the Column of Trajan. Emerging from and appealing to a scholarly mind, this archaeological reconstruction nevertheless succeeds in reanimating a formula of the classical past, a past that Rubens regarded as one of the pillars of his art. In his treatise *De imitatione statuarum*, the painter advocated such an inventive adaption of an exemplary work of antique art. Ac-

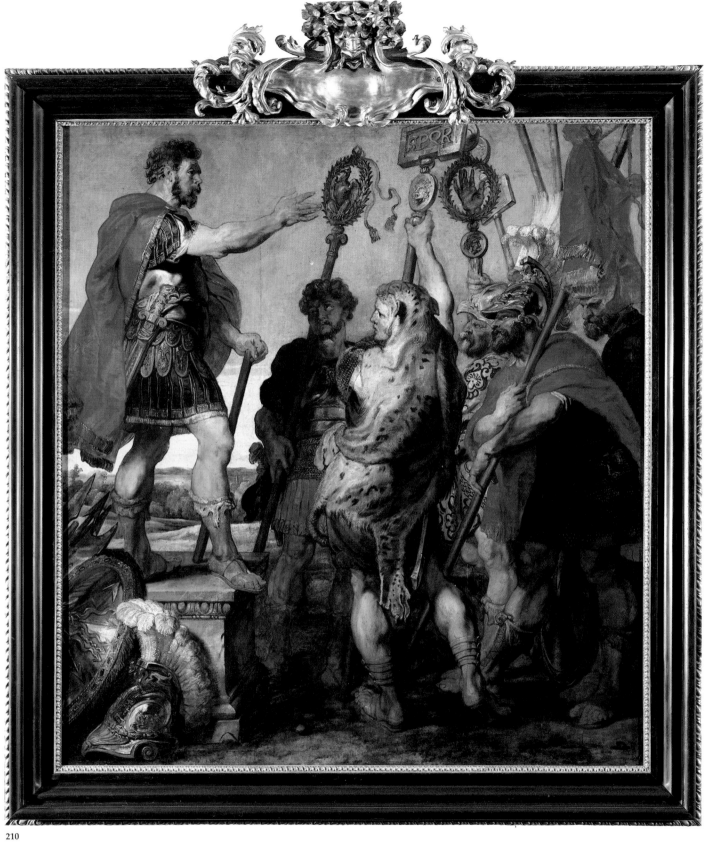

210

cordingly he would later quote the *adlocutio* theme in his Constantine cycle (oil sketch in the Philadelphia Museum of Art) and adopt it to sacral use in his *The Miracles of Saint Francis Xavier* (Kunsthistorisches Museum, Vienna) and *Judas Maccabaeus Preaching for the Dead* (Musée des Beaux-Arts, Nantes).

Rubens did not restrict his acceptance of the authority of the antique to a single motif such as the *adlocutio*. Far more important, the flow, rhythm, and structure of his narration of the story of Decius Mus are firmly rooted in Roman historical representations, such as the helical frieze of the Column of Trajan. A closer look at the changes Rubens introduced between the preparatory work of his cycle and its final version will make this clear. The oil sketch for the present painting (National Gallery of Art, Washington, D.C.) reveals that the painter toyed with the idea of assigning part of the story to the heavenly powers, with Jupiter's eagle soaring above the consul as a divine protector. Rubens would later use such mythical elements in his cycle on the history of Maria de' Medici and, in fact, in all his further political representations and allegories. In the present large version and in the entire Decius Mus cycle, the painter does not, however, extend the action to include supernatural forces. These paintings are limited to historical reality. Describing the res gestae of a Roman consul as concrete events, Rubens uses a heroic narrative style similar to that of Livy's history and of the imperial monuments of Rome.

In a most significant detail, Rubens points out immediately that this is a story about Rome. The embossment of the consul's helmet, piled up with a shield like a still life at the foot of the *suggestus*, shows the she-wolf nursing Romulus and Remus, the founders of Rome. Denoting the owner as a Roman patriot, the gleaming helmet and shield may be regarded as emblems of the military virtue embodied in Decius Mus. Like this detail, the composition as a whole reveals the master's personal conception of a historical past. In the forceful opening of his cycle, Rubens evoked the manly spirit that made Rome and the deeds of its people great.

RB

FURTHER REFERENCES: Cat. 1767, no. 344; Cat. 1780, no. 707; Cat. 1873, no. 89; Cat. 1885, no. 47; Bode 1888b, p. 8; Rooses 1886–92, vol. 3, no. 707; K.d.K. 1927, p. 142; Cat. 1931, no. 47; Kieser 1933, p. 126; Lucerne 1948, no. 210; Rodee 1967, pp. 227–29; Stechow 1968, pp. 69–71; Cat. 1974, no. 17; Eisler 1977, pp. 104–6; Vlieghe 1977, p. 40; Vienna 1977a, p. 178; Baumstark 1980, no. 49; Held 1980, vol. 1, pp. 25–26; Baumstark 1983, p. 182.

211

THE INTERPRETATION OF THE VICTIM
Oil on canvas; 115½ × 162¾ in. (293.5 × 413.5 cm.)
Liechtenstein inv. no. 48

Shortly before their decisive battle against the Latins, the Roman consuls Decius Mus and Titus Manlius offered sacrifices in order to learn which of the two, according to the gods' will, would have to give his life to secure victory for Rome. Sacrificial bulls were slaughtered, and the haruspex (a soothsayer whose predictions were based on examination of entrails) discovered that the bull offered by Decius Mus had an abnormal liver. A piece, known in the language of the augurs as the "head," was missing, as if it had been cut away. Manlius's sacrifice had, however, been successful, and thus Decius was fated to die. In the present painting Rubens depicts the moment when Decius Mus learns of the fatal omen. The dialogue of gestures and gazes—between the gray-bearded haruspex to whom the future has been revealed and the consul who now knows he must die—is the focus of the whole ceremony. The altar is erected in front of the commander's tent; aulos players and acolytes attend the ceremony. Standard-bearers and followers of Decius Mus have gathered to witness this solemn moment; their faces express dismay and sorrow. While the bull to be sacrificed in the name of Titus Manlius is led forward by the *victimarii* (assistants to the sacrifice), the bull offered by Decius Mus lies dead on the ground. Most significantly—as both a thematic and a coloristic device—a golden bowl brimming with the blood of the sacrificed animal stands at the feet of the consul, whose own blood will be shed for his people. This golden vessel parallels that filled with Christ's blood and placed on the ground in Rubens's Antwerp altarpiece *The Descent from the Cross* of about 1612.

While presenting this scene as a dramatic prelude to the forthcoming sacrifice, that of a human victim, Rubens was determined to reproduce the Roman ceremonial rites with great accuracy. He incorporated archaeological elements in his composition, and in this he had a powerful model in Raphael's *Sacrifice at Lystra*, a cartoon for the Acts of the Apostles, a tapestry cycle intended for the Sistine Chapel at the Vatican. Rubens had studied the series of cartoons (now in the Victoria and Albert Museum, London) in Genoa in 1604, and the Decius Mus cycle may be Rubens's response to the challenge of these most renowned examples of cartoon painting on the grand scale. This urge to compete is perhaps most evident in the present painting, where Rubens discloses his knowledge of Raphael's cartoon by borrowing from it the figure at the far left and the design of the altar. Rubens went so far as to correct some small inaccuracies of his great predecessor. Raphael had shown a bull being slaughtered while wearing an *infula* (a sacred woolen fillet), but according to Roman ritual, the *infula* would have been removed before the animal was killed. Rubens, however, shows the *infula* appropriately—here it is worn only by the live bull. It seems

211

almost certain that Rubens was acquainted with the ancient pictorial sources of the *immolatio* scene on which Raphael had based his composition, namely the sacrificial scene of the Aurelian reliefs in the Palazzo dei Conservatori in Rome, sarcophagi in the Uffizi, Florence, and the Palazzo Ducale, Mantua, showing the sacrifice of a bull, and one of the reliefs on the Column of Trajan in Rome (Brendel 1930, pp. 203–26; Shearman 1972, pp. 122–23). A minor detail of the present painting—the acolyte blowing on the flame of his torch—allows us to observe how Rubens worked from direct study of the Florentine sarcophagus. He seems to have taken special interest in a fragmentary figure of an acolyte standing behind the altar. This figure had once played an aulos, but when Rubens saw the sculpture, this musical instrument was missing (it has since been restored). Misreading the puffed-up cheeks of the sarcophagus figure, Rubens "restored" the acolyte into the young torch-bearer of the present painting.

Such a conscientious following of antique sources is even more evident in Rubens's treatment of the bull led to be slaughtered. In his famous discussion of Greek pictures, Pliny the Elder praised Pausias for painting a sacrifice in which the bull was shown frontally, the volumes of its body rendered by skillful foreshortenings (*Naturalis historiae* 35.126–27). Pliny also remarked with admiration that, contrary to custom, Pausias had shown those parts of the bull that were nearest to the picture plane as dark and heavily shadowed, while the rest of the animal was painted in lighter tones. Although Raphael seems to have been inspired by Pliny's remarks, only Rubens succeeded in achieving the qualities praised in Pausias; he thus surpassed not only Raphael's attempt at a reconstruction but also the ancient prototype, the sarcophagus in Florence, which had served the latter as a model. Only in the present picture does the bull emerge from the depth of the space through a dramatic use of foreshortening, the technique admired by Pliny. Furthermore, only Rubens worked out a distribution of light and shade that corresponds to Pliny's description by ingeniously placing a kneeling *victimarius* in front of the bull and using the man's shadow to achieve the desired effect. Pliny's account was therefore literally translated into the Baroque painting. The elements praised in Pausias could now be admired in Rubens: challenged by a celebrated literary description, Rubens proved his art capable of emulating the skills of an antique painter. This success did not, however, diminish his awesome regard for the classical artists; in a letter of August 1, 1637, dealing with Pliny's work, he writes of his debt to "the shades of those ancient artists whom I deeply revere and of whom I can sooner say that I follow in their tracks with admiration and wonder than that I would even imagine I could come close to them, though it be only in thought." The present painting demonstrates both Rubens's deep veneration and knowledge of antiquity and his proud expansion of the Renaissance traditions embodied in Raphael. Here the earlier works so important to Rubens are subsumed and transformed into a most personal and powerful

representation of a scene in which the word of the gods is conveyed to man.

RB

FURTHER REFERENCES: Cat. 1767, no. 345; Cat. 1780, no. 708; Cat. 1873, no. 90; Cat. 1885, no. 48; Bode 1888b, p. 8; Rooses 1886–92, vol. 3, no. 708; K.d.K. 1921, p. 143; Cat. 1931, no. 48; Lucerne 1948, no. 211; Cat. 1974, no. 18; Koella 1975, p. 60; Baudoin 1977, p. 161; McGrath 1978, pp. 259–60; Baumstark 1980, no. 50; Held 1980, vol. 1, pp. 26–27; Baumstark 1983, pp. 182ff.

212

THE CONSECRATION OF DECIUS MUS

Oil on canvas; 113 × 131½ in. (287 × 334 cm.)
Liechtenstein inv. no. 49

The consul's death—announced in a dream, confirmed by augury, and accepted with a manly willingness to sacrifice himself to ensure Rome's victory—could not occur without ceremony. According to Roman custom, it was necessary for the chosen victim to undergo a solemn rite, called the *devotio*. The most detailed ancient description of that ritual which survives is given by Livy in his account of Decius Mus. The hero destined for death had to devote his life and that of his enemies to the Manes, the gods of the underworld, and to Tellus, goddess of earth. Speaking the formulaic prayer, he had to stand with both feet on an arrow "with head covered and a hand emerging from under a mantle wrapped closely beneath the chin," as Pliny explains. The truly heroic act of self-sacrifice finds expression in the somber, elevated language of the death prayer: "Janus, Jupiter, Father Mars, Bellona, Lares, divine Novensiles, divine Indigites, you gods in whose power both we and our enemies stand, and you, divine Manes, I invoke and worship you; I beseech and crave your favor; grant the people of Rome superiority and victory, but let terror, calamity, and death come over their enemy. As I have here expressly vowed, so here, for the Roman people, for the army and its legions, I dedicate the legions of the enemy and myself to the divine Manes and to Earth."

Again Rubens faithfully records Livy's narrative. Followers of both the consul and the priest have stepped aside, leaving the two protagonists in the center of attention. Decius Mus stands with bowed head before the high priest Marcus Valerius, as his name is given by Livy; with the authority of one who represents divine power on earth, the priest reaches out and touches the consul's head in the time-honored gesture of blessing. In Livy this scene takes place in the heat of the battle, but Rubens chooses to emphasize the moving pathos of the ceremony and places martial episodes in his later battle piece. Solemnity and grave pageantry mark the present scene, and it is the prayer itself that constitutes the action. At the very core of this ritual is the Roman virtue of *pietas*—that is, righteous behavior toward god and man. *Pietas* requires a readiness to submit humbly to the direction of the heavenly powers and a veneration of the word of gods; it is the foremost manly virtue. Thus, Vergil gives the epithet *pius* to the hero Aeneas; like him, Decius Mus is here characterized as a hero who embodies this distinctive Roman virtue. Not only because of this empathy with ancient thought, but also because of the powerful austerity of its composition and the imposing sonority of its color scheme, the present painting stands out as the emotional climax of the cycle.

The picture's masterly accomplishment is heightened by the exceptional extent to which it was executed by Rubens himself. Large areas of this canvas display the characteristic forcefulness of Rubens's manner with the heavy contours and the sparkling lights of his modeling. Faces and hands—for example, those of Marcus Valerius—show a free and almost sketchy layering of colors, and the violent use of pure red in the flesh has to be acknowledged as a hallmark of the master's painting technique. The high priest's robe, where gleaming light establishes a sumptuous, weighty, yet animated surface, is a splendid example of his rapid brushwork. It is likely that Rubens wanted to refer to Early Netherlandish tradition in this depiction of patterned gold brocade. By contrast, the equivalent motif done by the atelier in the earlier scene of the sacrifice discloses the marked difference in quality between Rubens's own work and that of his followers. Another element executed by the master himself is the consul's battle steed, held by waiting soldiers. This is undoubtedly one of the most remarkable areas of the cycle, and it served as a model for the horses in the two following paintings done by the atelier. Here bold strokes outline the sculpturesque body and expose the skeletal structure. The horse's coat has a brilliant sheen, as does the exuberant flow of its mane, which is highlighted by delicately curved lines scratched into the wet paint by Rubens with the wooden end of his brush. Even here Rubens never forgets his urge to compete with the ancient masters. The foam on the horse's mouth has been wiped on the canvas with a sponge, exactly as Pliny had described the method of the Greek painter Protogenes (*Naturalis historiae* 35.103–4), who is said to have invented this curious technique, which was also used by Nealkes. Despairing of ever painting lifelike foam, Protogenes angrily threw a sponge against the picture and ironically found that he had achieved his goal.

The horse's noble body has been traced to Titian and moreover to antique depictions (see Held 1958, pp. 146–47, for a discussion of van Dyck's analogously painted horse of Charles I of England). Rubens, however, distinguishes himself from all his forerunners in creating a living horse capable of sensing its companion's destiny. In the present painting the battle steed, though barely restraining its fighting spirit, seems to listen to its master's prayer, for like him it bows its head. Its grave look implies that the horse is aware of its great task—to bear its master to his death.

RB

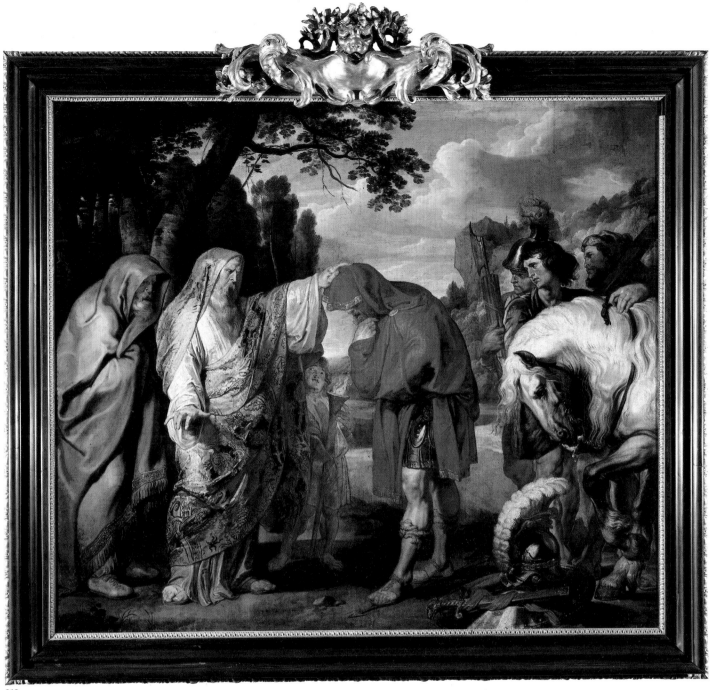

212

FURTHER REFERENCES: Cat. 1767, no. 346; Cat. 1780, no. 709; Cat. 1873, no. 91; Cat. 1885, no. 49; Bode 1888b, pp. 8–9; Rooses 1886–92, vol. 3, no. 709; K.d.K. 1921, p. 144; Cat. 1931, no. 49; Lucerne 1948, no. 212; Cat. 1974, no. 19; Baumstark 1980, no. 51; Held 1980, vol. 1, p. 27; Baumstark 1983, pp. 179-80.

213

THE DISMISSAL OF THE LICTORS
Oil on canvas; 111¾ × 134⅝ in. (284 × 342 cm.)
Liechtenstein inv. no. 50

Livy recounts that "after the death prayer, Decius Mus told the lictors to go immediately to Titus Manlius and tell him that he had chosen to die for the good of the army. Then the consul, wrapped in a toga flung over his shoulder and fully armed, mounted his horse and plunged into the midst of the enemy."

347

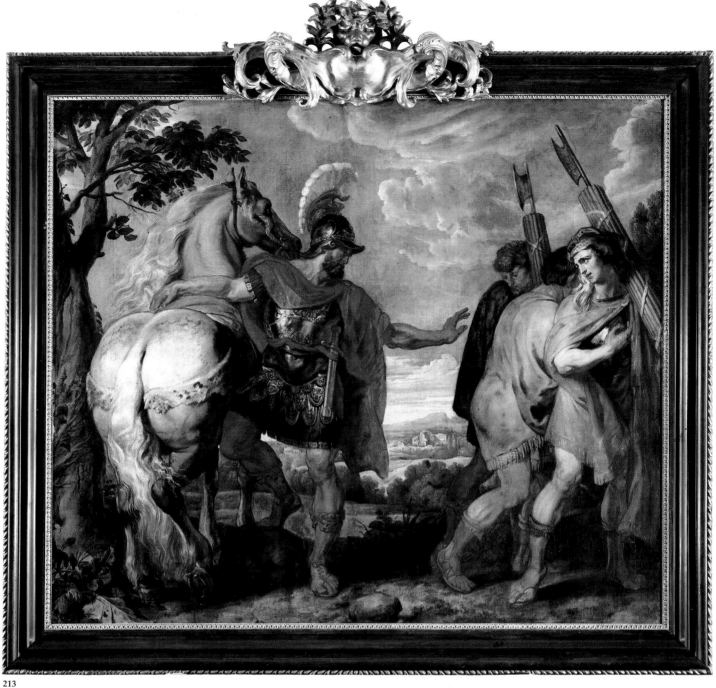

213

Here again Rubens follows Livy's text closely except, as in the previous scene, for the reference to the battle. The figure of the consul, ready for combat and death, looms large. His head and helmet, shown in profile, are modeled, as Kieser (1933, p. 127) has observed, after the Roman statue of Mars Ultor, which once stood in the temple of the same name in the Forum Augustus in Rome; this lost work was known in the seventeenth century only through copies and variants. The motif of mounting the horse, here indicating the hero's determination to meet his fate—the left leg planted on the ground expresses firmness in almost emblematical terms—was later repeated in reverse by Rubens around 1630 for his *Henry IV of France at the Siege of Amiens* (Konstmuseet, Göteborg). In that large unfinished canvas,

which is part of the uncompleted cycle dedicated to the great French King, Rubens expressed the King's absolute determination to subdue his enemies by showing him mounting his horse. Unlike the representation of Henry IV, the present picture does not have a confident, triumphant tone. Instead, grief is revealed on the faces of the lictors, who carry fasces, the bundle of rods bound around an ax, which was the sign of the authority of the Roman magistrate. Leaving to fulfill the commander's order, the foremost lictor looks back at Decius Mus, whose arm—in the very center of the composition—is raised in a final salute. The somber mood of leave-taking is mirrored in the distant landscape, the only broadening view of the entire cycle. Rubens created this landscape from memories of his Italian sojourn,

quoting the ruins of an ancient temple as a remote recollection of the cylindrical temple of Minerva Medica in Rome. The ruins, elegiac reminders of decayed greatness, reinforce the melancholy timbre of the scene.

In the rhythm of Rubens's narration of the story of Decius Mus, the present painting pauses in quiet reflectiveness. Following the principles of dramatic art, such a respite is needed before the summit of the action is reached in the battle piece that follows. Besides serving as a dramatic device, this meditative interval reveals the hero's state of mind. In the equanimity of his conduct, Decius Mus is here characterized by Rubens as an embodiment of the Roman ideal of virtue postulated by Stoicism. This philosophy, which found an important expression in the works of Seneca, was revived by the great Leyden scholar Justus Lipsius, the fatherly friend of Rubens. Guided by Lipsius, the artist was attracted to Stoicism throughout his life. Seneca and his followers had advocated mastery over emotions and passions, strength of mind, and imperturbability in the face of life's sorrows. These Stoical virtues sustain Decius Mus; while preparing himself for death, he carries out his official duties and gives his final commands. Unlike the grief-stricken lictors, who are not facing death, the doomed consul shows a calm detachment. In a similar way, Rubens honored the Stoical ideal of inner serenity in his painting of the dying Seneca (Alte Pinakothek, Munich). In 1584 Justus Lipsius published his influential *De constantia . . . in publicis malis,* in which he set forth his Neo-Stoical philosophy. The essence of this teaching might apply to Decius Mus as well, who, in the *publicum malum* (evil or calamity suffered by the people or state) of war and in the sight of death, exemplifies *constantia,* the firm determination so valued by Lipsius.

RB

FURTHER REFERENCES: Cat. 1767, no. 347; Cat. 1780, no. 710; Cat. 1873, no. 92; Cat. 1885, no. 50; Bode 1888b, p. 9; Rooses 1886–92, vol. 3, no. 710; K.d.K. 1921, p. 145; Cat. 1931, no. 50; Lucerne 1948, no. 213; Cat. 1974, no. 20; Cavalli-Björkman 1977, pp. 79–80; Baumstark 1980, no. 52.

214

THE DEATH OF DECIUS MUS

Oil on canvas; 113⅜ × 195⅝ in. (288 × 497 cm.) (without later addition [6¼ in.; 16 cm.] to the right side)
Liechtenstein inv. no. 51

The battle between the Romans and the Latins and the death of Decius Mus were fused by Rubens in this single monumental composition. The present painting brings together various strands of action to demonstrate that the Romans faced defeat until the consul's sacrifice brought them brilliant victory. Against a background of attacking Romans and fleeing Latins, the main

group of the painting towers with monumental sculptural power above a kind of pedestal composed of mortally wounded warriors. The bodies of horses are the pillars of Rubens's composition: framed by two brown horses, one already laid low and the other with hind legs kicking, the consul's dappled gray steed rears up regally. With the commanding posture, in which force is exerted against resistance, the battle reaches its peak. It was in just this way that Vergil describes the climax of an equestrian fight: "Straight up reared the steed, its hoofs whipping the air, and threw off its rider headlong" (*Aeneid* 10.892). And Vergil, drawing on the ancient appreciation of animals as possessing living souls, writes that such a fighting steed shed tears over its hero's death (11.90). Here the horse of Decius Mus seems imbued with the same mettle as its ancient Vergilian comrade; its rearing motion and grave look express a spirit equal to its rider's and worthy of his virtues.

Rubens had already painted this dappled gray horse in the same position in his *Defeat of Sennacherib* (Alte Pinakothek, Munich) and in hunt pictures now in the Musée des Beaux-Arts, Rennes, and the Gemäldegalerie, Dresden. The roots of his ability to depict horses are found in Leonardo da Vinci. Roger de Piles, one of the earliest of Rubens's biographers, mentions a treatise by Rubens, since lost, in which the Flemish master stated that he studied the notebooks of Leonardo in Arezzo and was deeply impressed by the thoroughness with which his great predecessor had mastered anatomy. Piles comments that "in describing the anatomy of the horse in particular, Rubens took into account the observations made by Leonardo and the drawings connected with them that he had likewise seen" (1699, p. 168). Studies resulting from this interest were confined by Rubens to drawings he did as teaching aids; these works are known today only from copies ascribed to van Dyck and called his Antwerp Sketchbook (the Duke of Devonshire, Chatsworth, Derbyshire). In these drawings Rubens used Leonardo's method of comparative anatomy, and in his quest for the underlying rules of nature, he set down the features of man and beast in interchangeable forms. Thus, in one drawing he developed a horse's head in profile into one of the strongest and most well-known physiognomies of Roman antiquity, inscribing it *Julius Caesar ex equo* (Jaffé 1966, vol. 2, pp. 242–43). These studies were more than ingenious games for Rubens. They were the basis for the telling spiritedness that marks his depiction of horses and permits them to take a conscious part in the dramatic action.

Rubens's debt to the art of Leonardo goes beyond their common interest in equine anatomy. It has long been recognized that in Rubens's scenes of mounted hunts and battles —and nowhere more than in this representation of the death of Decius Mus—he was following the example of Leonardo's famed *Battle of Anghiari.* Rubens could not have studied this depiction of belligerent passion in its original state, since Leonardo's wall painting had perished soon after it was completed, but basing it on Leonardo's studies for the composition as well as from

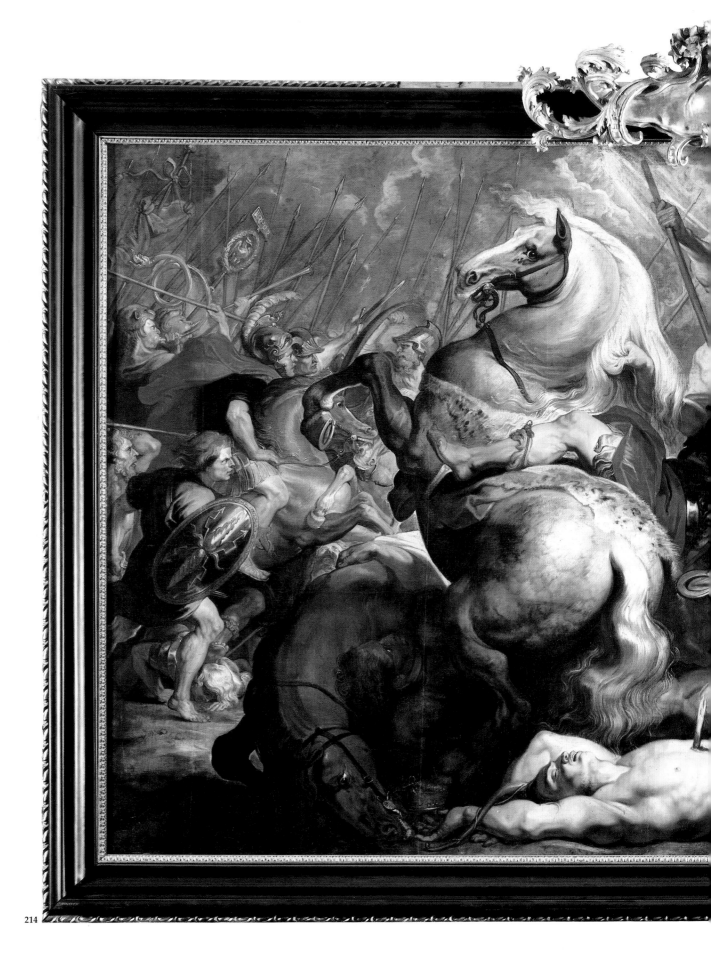

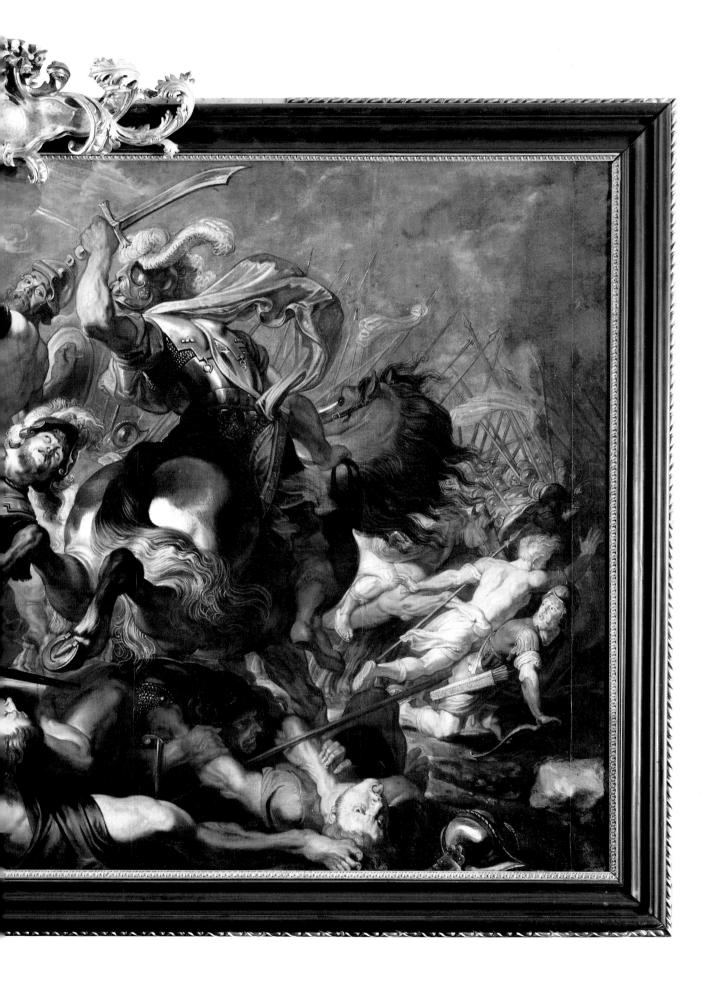

copies done by others, he was able to do a drawing (Louvre, Paris). The principle on which Leonardo had shaped his battle has obviously been absorbed in the present painting. Both depictions express the crucial points of the action through horses, which rise like cliffs above the slaughter around them. The similarity extends even to detail: in both representations the space below the horses' bodies is filled with fighting warriors of earthy brutality.

Although Rubens incorporated models and motifs from other artists into his own pictorial language with sovereign mastery, his transforming genius makes evident the individuality and originality of his own artistic approach. While Leonardo's composition depicted a bestial, frenzied rage—almost a single visual emblem of war—Rubens was concerned with the ethical implications of battle. In the present painting the ideal of heroic self-sacrifice overrides the violent images of inhuman slaughter. This ideal is treated throughout the cycle with a steady growth of intensity; here it reaches its apotheosis—the manly sacrifice of the one for the many. The hero, who submits courageously to the will of the heavenly powers, meets his death with open eyes and transfigured countenance. And like a Christian martyr, he catches sight of an opening heaven. In the oil sketch for this painting (Prado, Madrid), Rubens makes this allusion to martyrdom explicit; there an angelic genius descends and presents a laurel wreath and a palm branch as celestial prizes of victory to the dying consul. Rubens was not alone in putting forth this Christian interpretation; Augustine, the Early Christian philosopher, had presented Decius Mus as a shining example to Christians in his *City of God* in the section (5.18) entitled: "What courageous Romans did for their worldly country, Christians will do far more willingly and joyfully for their heavenly one." Even in the present large version, from which the allegorical elements of the sketch have been deleted, Rubens stresses the martyr-like death of his hero. The consul's head viewed obliquely from below—his eyes seeking the heavens, his mouth gaping more in one last breath of life than in any cry of complaint—is quoted by Rubens in a number of paintings of martyrs from around the same time, notably his *Saint George* (Musée des Beaux-Arts, Bordeaux), *Saint Stephen* (Musée des Beaux-Arts, Valenciennes), *Saint Sebastian* (Staatliche Museen Preussischer Kulturbesitz, Berlin), and *Daniel in the Lion's Den* (National Gallery of Art, Washington, D.C.). This motif—the head turned toward the light of heaven in a moment of deadly peril—can be traced to the *Dying Alexander*, a Hellenistic sculpture in Florence (for the sculpture see Schwarzenberg 1969, pp. 400ff.). This *exemplum doloris* (a model of pain and grief borne with greatness of soul) was used by Rubens to express a Stoical victory over the terrors of death; he did, however, infuse the ancient formula with a marked Christian spirit.

While Rubens usually follows Livy's text closely, it is interesting to note a deviation here in a significant detail. Livy stated explicitly that Decius Mus was shot by arrows, but in Rubens's painting he is killed by the thrust of a spear. The benefit of this change of weapon is obvious; the composition can now present the hero's death in a single concentrated image. Under the blow's full force the consul falls from his horse, and in a powerful diagonal the spear leads into the center of the composition, emphasizing the fatal wound. But this change expresses more than the painter's eye for an effective detail. Here Rubens appears to think in terms rather more Roman than even Livy. The *hasta*, a long and heavy spear, was an ancient Roman national weapon, sacred to Mars, the god of war, and worshiped in his temple on the Palatine in Rome. A symbol of Mars himself, the *hasta* would be venerated, even worshiped, in the god's name. Taking this Roman belief into account, Decius Mus consecrates his death to the god of war, who—in the wording of the sacrificial language passed down by Livy—accepts this heroic offer of Roman virtue with delight.

RB

FURTHER REFERENCES: Cat. 1767, no. 348; Cat. 1780, no. 711; Cat. 1873, no. 93; Cat. 1885, no. 51; Bode 1888b, p. 10; Rooses 1886–92, vol. 3, no. 711; Burckhardt 1898 (1938 ed.), pp. 78, 167–68, 180; K.d.K. 1921, p. 146; Cat. 1931, no. 51; Kieser 1933, p. 124 n. 33; Evers 1943, pp. 129, 262, 310; Lucerne 1948, no. 214; Held 1959, p. 133; Rosand 1969, pp. 35–36; Cat. 1974, no. 21; Padron 1975, p. 310; Vlieghe 1977, pp. 93–94; Vienna 1977a, pp. 46–47; Baumstark 1980, no. 53; Held 1980, vol. 1, pp. 28–29; Baumstark 1983, pp. 180, 183.

215

THE OBSEQUIES OF DECIUS MUS
Oil on canvas; 114⅛ × 183⅛ in. (290 × 465 cm.) (without later addition [6¾ in.; 17 cm.] to right and left sides)
Liechtenstein inv. no. 52

Livy recounts that the body of Decius Mus could not be recovered after the battle because night fell and shrouded the searching Romans in darkness. The next day his body was discovered in the tallest heap of slain foes; his co-consul ordered funeral rites of a solemnity befitting such a heroic death. Since Livy does not describe the details of the funeral ceremonies, Rubens drew on his own antiquarian knowledge in presenting the dead consul's lying in state as a somber ritual of victory celebration. Now the figure of Titus Manlius, Decius's co-consul, appears for the first time in the cycle; according to Livy's report, he arranged the last tribute to his dead comrade. A *tropaeum* (a memorial of captured weapons, standards, and severed heads) has been erected, and martial music is being played on tubas while soldiers cut down foliage and branches for the funeral pyre. Booty is carried in—the herculean bearer had already appeared (in reverse) in Rubens's *Adoration of the Magi* (Prado, Madrid) and *The Meeting of Abraham and Melchizedek* (Musée des Beaux-Arts, Caen)—and gold and silver are heaped up in splendid vessels. Bound prisoners cringe beneath the heavy hand

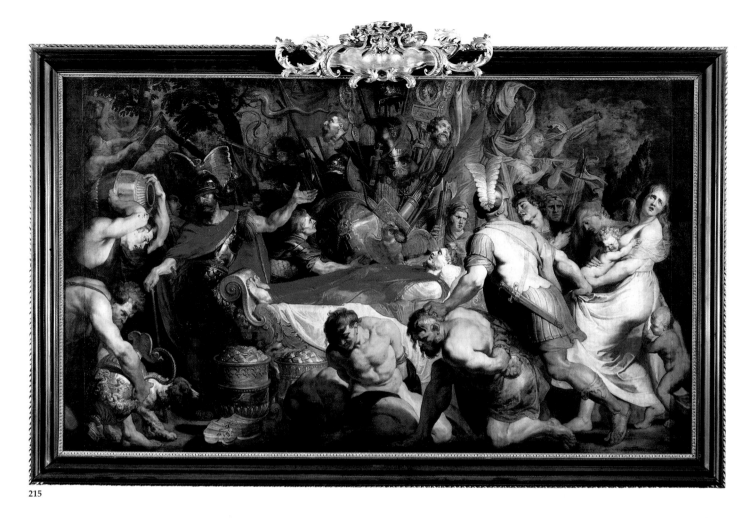

215

of their conquerors; a captive woman is dragged forward weeping, her children clinging desperately to her. Rubens borrowed, as Haberditzl (1911–12, pp. 294–95) observed, this motif of cruel mercy toward the enemy from the Gemma Augustea (Kunsthistorisches Museum, Vienna), a precious cameo that presents Roman imperial iconography in its most classical terms. This work, from which he took his authentic image of a Roman victory celebration, had been studied by Rubens from a cast and recorded in a drawing (St. Annen-Museum, Lübeck). In the lower row of that cameo a *tropaeum* is shown being erected; bound prisoners sit on the ground; and at the right a woman, dragged by her hair by a Roman soldier, is the direct model for her sister in distress in the Flemish master's present painting. The complex depiction of the Gemma Augustea was discussed in a treatise, published in 1665 by the master's son Albrecht, that incorporated Rubens's reflections and reproduced a print prepared by him.

The center of the present work is again occupied by the cycle's hero; he is the pivot of both the celebration and the suffering. The dead consul, his head wreathed with laurel, lies in state on a sumptuously carved and gilded bier. As in the previous scenes of the drama, Decius Mus is once again distinguished by his red toga. The flamelike color of this garment, a leitmotif through the entire cycle, alludes not only to the doomed hero's consular

dignity but also to his bloody sacrifice. Jakob Burckhardt, one of the most perceptive commentators on Rubens's art, wrote in 1898 (1938 ed., pp. 124–25): "The homage to the dead body is a most sublime moment whose impression is not sweetened by any generous ruefulness: these are victors and Romans." And he sums up the message of the entire cycle: "In these pictures there lives a powerful and unaffected feeling for Roman grandeur such as David and his Neoclassicist imitators, for all their pathos, never attained."

RB

FURTHER REFERENCES: Cat. 1767, no. 349; Cat. 1780, no. 712; Cat. 1873, no. 94; Cat. 1885, no. 52; Bode 1888b, pp. 10–11; Rooses 1886–92, vol. 3, no. 712; K.d.K. 1921, p. 147; Cat. 1931, no. 52; Lucerne 1948, no. 215; Burchard and d'Hulst 1963, vol. 1, pp. 139–40; Cat. 1974, no. 22; Volk 1975, p. 170; Baumstark 1980, no. 54; Held 1980, vol. 1, pp. 29–30.

216

VICTORIA AND VIRTUS
Oil on canvas; 113 × 106⅞ in. (287 × 271.5 cm.)
Liechtenstein inv. no. 78

Since the first printed catalogue of the Liechtenstein gallery (1767), this painting, unanimously called *Triumphant Roma*, has been regarded as the concluding work of the Decius Mus cycle. Accordingly, Victoria, the winged goddess of victory, was said to be offering a laurel wreath to Roma, the armed goddess of the Roman capital. Roma—as described by Winner (1977, pp. 86–87), following Held (1959, p. 117)—was identified by the helmet, shortsword, and lance; an Amazon-like figure, she places her foot on the globe to indicate her worldwide rule. This interpretation cannot, however, be accepted here.

The two figures appear to face each other, but in actual fact the painting is a combined cartoon for two separate tapestry hangings, each depicting a single figure. When large tapestries were hung in a room, the bare spaces between windows and around doors were covered with narrow tapestries (*entre-fenêtres*). The contract, dated November 9, 1616, in which Jan Raes and Franco Cattaneo agreed to weave the Decius Mus tapestry cycle, refers not only to the main pieces but also to three such narrow hangings. Held (1980, p. 21) was undoubtedly correct in relating these *entre-fenêtres* with the two figures shown in the present cartoon and with the trophy, also realized as a canvas painting (cat. no. 217). Furthermore, a narrow tapestry (153½ × 60¼ in. [390 × 153 cm.]), woven in the manufactory of Jan Raes and showing the figure of the so-called Roma alone, has been preserved in the Liechtenstein collection in Vaduz, proving conclusively that the present canvas was intended as a cartoon for two separate single-figured tapestries. These narrow hangings were not intended, however, to advance the narrative action of the Decius Mus cycle; instead, in commenting on the main theme, they provide a kind of pictorial annotation. It might therefore be expected that both female personifications here are used more to express praise of the consul's heroic feat than to serve as a general reference to Rome.

The helmet, the shortsword, the globe, and even the staff on which the figure on the right is leaning might easily be regarded as attributes of Roma. However, in his various depictions of the city goddess, Rubens distinguished her by two signs of dignity which are absent here. Taking the antique statue of Roma in the Cesi garden in Rome (now in the Museo Capitolino, Rome) as his model, the Flemish master developed a representational type—the goddess enthroned—which is seen, for example, in *The Triumph of Rome* (oil sketch in the Mauritshuis, The Hague, which is the concluding scene of his later Constantine cycle) and in his design for the title page of *Nomismata Imperatorum Romanorum*, a numismatical work by Jacob de Bie published in Antwerp in 1614 (Judson and van de Velde 1978, no. 39). In all further representations by Rubens, which show Roma in a more

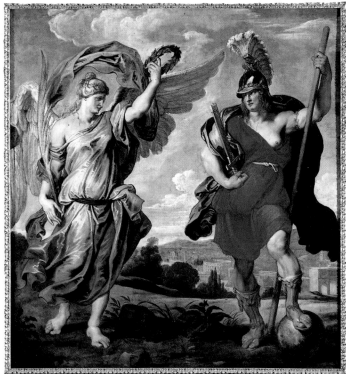

216

active role, she carries in her hand a statuette of Victoria, representing her victorious power. Such depictions are found, for example, once again in the Constantine cycle, this time in *The Entry into Rome* (oil sketch in the Indianapolis Museum of Art) and in the design for the title page of *Romanae et Graecae Monumenta* by Hubert Goltzius published in Antwerp in 1645 (Judson and van de Velde 1978, no. 82). Both signs of honor, the throne and statuettes, are missing, however, from the present female personification. All of the figure's attributes, including the *sphaera* (globe), were instead repeatedly used by Rubens in depicting Virtus. The figure may therefore be considered as a representation of this embodiment of military virtue. A drawing for a wooden sculpture (Musée Plantin-Moretus, Antwerp; Held 1959, no. 138) may be cited, as well as an oil sketch in Vaduz, connected with the Henry IV cycle and showing among others Virtus with sword and helmet sitting on a globe. Finally, Virtus appears as a statue on the rear of the Arch of Ferdinand, designed by Rubens in 1635 as part of his decoration for the *Pompa Introitus Ferdinandi* in Antwerp (Martin 1972, no. 40). The direct prototype for the present militant personification is an antique figure in the *Adventus Augusti* on the Arch of Constantine in Rome. That figure had been drawn presumably by van Dyck in his Antwerp Sketchbook—obviously not from the original but with the help of a print by Marcantonio Raimondi—and was interpreted with an annotation as "Roma virtus" (Jaffé 1966, vol. 2, p. 228), thus combining both names claimed for the present depiction. Even earlier, Otto van Veen, Rubens's teacher, used the same antique prototype for a depiction of

Virtus in his *Emblemata Horatiana*, a collection of emblematic prints published in Antwerp in 1607. Pictorial tradition and iconographical usage in the oeuvre of Rubens prove therefore that the present personification should be regarded as Virtus. Together with Victoria she denotes the two qualities that inform the heroic deed of Decius Mus: it was the Roman virtue of this man that gave victory to Rome.

<div style="text-align: right">RB</div>

FURTHER REFERENCES: Cat. 1767, no. 350; Cat. 1780, no. 713; Cat. 1873, no. 506; Cat. 1885, no. 78; Bode 1888b, pp. 11–12; Rooses 1886–92, vol. 3, no. 713; Cat. 1931, no. 78; Lucerne 1948, no. 216; Burchard and d'Hulst 1963, p. 159; Cat. 1974, no. 24; Held 1980, vol. 1, p. 21.

217

THE TROPHY
Oil on canvas; 113¾ × 49⅝ in. (289 × 126 cm.)
Liechtenstein inv. no. 53

In Roman times the *tropaeum*, a trophy of weapons seized from the vanquished enemy, was erected as a monument of victory, usually on the battlefield itself (for a detailed discussion see Crous 1933, pp. 35ff.) Depictions of such trophies on the reverse of imperial coins might have served Rubens as models. According to Roman custom, he shows arms, armor, standards, and even the severed and pierced head of an enemy piled on the ground and attached in a colorful arrangement to the stump of a tree. Gold taken as booty is heaped in precious vessels in front of the *tropaeum*. Rubens introduced comparable depictions of Roman military trophies in both his Constantine cycle of 1622 and the design for the Arch of Ferdinand in his decoration of the *Pompa Introitus Ferdinandi* of 1635 (Held 1980, no. 44; Martin 1972, nos. 36, 40). The present painting served as a cartoon for an *entre-fenêtre*, a narrow tapestry hanging that complemented the sequence narrating the story of Decius Mus. Like its companion piece, the representation of Victoria and Virtus (cat. no. 216), it was entirely executed by the master's atelier, although the design was certainly produced by Rubens himself.

<div style="text-align: right">RB</div>

FURTHER REFERENCES: Cat. 1767, no. 20; Cat. 1780, no. 18; Cat. 1873, no. 99; Cat. 1885, no. 53; Bode 1888b, p. 11; Rooses 1886–92, vol. 3, no. 714; Cat. 1931, no. 53; Lucerne 1948, no. 217; Cat. 1974, no. 23; d'Hulst 1974, vol. 2, p. 580; Held 1980, vol. 1, p. 21.

217

218

Peter Paul Rubens
Flemish, 1577–1640

THE ASSUMPTION OF THE VIRGIN
Oil on canvas, 198⁷/₁₆ × 138⅝ in. (504 × 352 cm.)
Liechtenstein inv. no. 80

The altarpieces of Rubens—which powerfully fulfill the aim of religious art to instruct and to move the faithful—are dominated by three subjects: the Adoration of the Magi, the Passion of Christ, and the Assumption of the Virgin. Of these, only the Assumption is not based on an authenticated literary source, since the Bible describes neither the Virgin's death nor the events immediately following it. Instead, the story of the apostles gathered around the empty tomb to witness the Virgin's Assumption into heaven was embroidered upon in apocryphal and legendary accounts, such as Jacobus de Voragine's famous *Golden Legend*. Despite only slight written evidence, since early medieval times the Church had strengthened the belief in the exceptional honor bestowed upon the Virgin, thereby acknowledging the immortality of her corporeal existence. The doctrine of the Virgin's Assumption can be traced to the writings of the Fathers of the Eastern Church, who, since the eighth century at least, advocated the *assumptio corporis* rather than the *assumptio animae* originally advocated by the Palestinian churches. This distinction between the assumption of the soul and the body was long maintained in the West until, gradually, the latter was favored. It was only in 1950 that the dogma of the Assumption of the Virgin was finally proclaimed with full authority by the Catholic Church.

Although the actuality of the Assumption of the Virgin was unquestioned at the time of the Counter-Reformation, churchmen still were concerned with how the event should be depicted. Following the precepts advocated by the Council of Trent, religious art had to reflect faithfully the teachings of the Church and the Bible and to avoid legendary accounts. However, exceptions had to be made, and such subjects as the Virgin's Assumption fulfilled a need in the religious struggles at that time: in their rejection of traditional doctrines, the Protestants had attacked the veneration of saints and the cult of the Virgin, so central to Catholic doctrine, and they diminished the Virgin's role in the redemption of humankind. To counteract this hostility toward images, the Catholic Church propagated a new art, with Counter-Reformational zeal, thereby venerating the saints and the mother of Christ. Images honoring the Virgin now became the means of triumphantly perpetuating orthodox belief. Thus, relying on the persuasive power of images, depictions of the Virgin's Assumption—the very essence of Marian piety—prevailed in all Catholic countries. This subject, emphatically linking heaven and earth by focusing on the apostles' fervor in recognizing the miracle, was ideally suited to convey the final

promise to the faithful: like the Virgin—who prefigured and came to symbolize the Church—they would be rewarded by being elected and received in heavenly glory.

The present painting, a late work in the artist's oeuvre, can be shown to summarize Rubens's lifelong experience with the theme of the Virgin's Assumption. Shortly after his return from Italy, Rubens was asked to submit designs for a painting for the high altar of Antwerp Cathedral, to replace Frans Floris's *Assumption of the Virgin*, which had been destroyed in 1581. On April 22, 1611, the painter presented two oil sketches to the cathedral chapter (one sketch is now in the Hermitage, Leningrad), but the commission—the artist's initial approach to the theme—was delayed for reasons unknown to us. However, Rubens seems to have started work on a large panel that was finally finished about 1620 and was installed in the Lady Chapel of the Jesuit church in Antwerp (the picture is now in the Kunsthistorisches Museum, Vienna). Some of the ideas that Rubens first formulated in 1611 were reused by him in a large composition of the Virgin's Assumption that was commissioned about 1614 for the high altar of the Church of the Discalced Carmelites in Brussels (it is now in the Musées Royaux des Beaux-Arts). Another monumental altarpiece of the same subject (now in the Kunstmuseum, Düsseldorf) was painted by Rubens about 1616 for the high altar of Notre-Dame-de-la-Chapelle in Brussels. These three attempts to depict the miracle of the Virgin's Assumption—the Vienna painting, suffused with energy; the Brussels picture, marked by greater restraint; and the Düsseldorf painting, more pensive in feeling—culminated in the entirely new and most glorious rendering of the subject painted by Rubens between 1624 and 1626 for the high altar of Antwerp Cathedral, where it remains in place to this day. Besides these major works, Rubens received commissions for additional altarpieces of the Assumption of the Virgin, but these were executed mainly by his workshop; one, for the Heiligkreuzkirche in Augsburg, was painted about 1626 and is still in situ; another, of about 1620, is now in the Neues Schloss Schleissheim. Furthermore, there is an engraving of the Virgin's Assumption in the *Breviarium Romanum*, after a design by Rubens dating from 1613–14, and, finally, a ceiling painting of the subject, made for the Antwerp Jesuit church in 1620 but destroyed in 1718. The variety with which Rubens approached the subject of the Virgin's Assumption is further underscored by the diversity of his preparatory oil sketches and drawings (for a discussion of Rubens's depictions of the Assumption of the Virgin see Freedberg 1984, pp. 138–80).

The present painting—one of the artist's largest altarpieces—is Rubens's final and most monumental rendering of the theme. The history of its commission is only partly known. According to the inscription in an epitaph, transcribed by Rooses (1886–92, vol. 2, p. 182), the painting was ordered by the brothers Charles and Johannes Angelus Schotte for the high altar of the Carthusian church in Brussels, in memory of their parents, Theodorus Schotte and Elisabeth van den Brandt. Theodorus

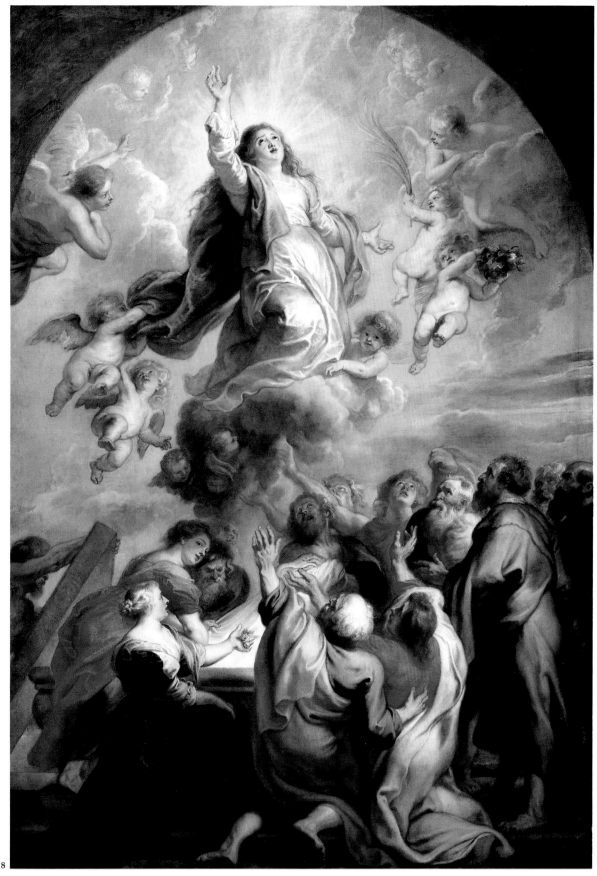

357

Schotte, a high military judge, had died in 1629, which gives a terminus post quem for the painting's execution. An engraving by Jan Witdoeck, published in 1639 by Rubens, records the composition faithfully, although it is reversed and adapted to an angled, instead of the original arched, top. Without further clues, only stylistic considerations can help to establish a more precise date for the picture.

Among the altarpieces from the last decade of the artist's life—altarpieces that, surprisingly, were executed primarily by Rubens himself—the present one most likely falls in sequence between the *Martyrdom of Saint Livinus*, painted about 1633 for the Jesuit church in Ghent, and the *Christ Bearing the Cross*, painted in 1636 for the Abbey of Affligem (both pictures are now in the Musées Royaux des Beaux-Arts, Brussels). These three altarpieces—as well as the *Coronation of Saint Catherine* (commissioned in 1633 for the church of the Augustinians in Mechlin and now in the Toledo Museum of Art)—are distinguished by an ethereally light palette, in contrast to the more somber and hastily executed works of the years immediately preceding the artist's death in 1640. These include the *Martyrdom of Saint Peter*, painted for the church of Saint Peter in Cologne and still in situ; the *Martyrdom of Saint Thomas* and the *Saint Augustine at the Seashore*, both commissioned for the church of Saint Thomas in Prague (now in the Národni Galeri, Prague); the *Martyrdom of Saint Andreas* (Prado, Madrid); and the *Madonna and Child Adored by Saints*, which hangs above the painter's tomb in the church of Saint Augustine in Antwerp. Thus, a date of about 1635—contrary to Burchard, Held, and Rooses, who have proposed 1630, 1637, and 1638, respectively—seems likely for the present work, as suggested by Gerson, Haverkamp-Begemann, and Freedberg. This, however, implies the astonishing fact that the Carthusians, who owned the picture, seem to have parted with their treasure only eight years after its installation, for, in 1643, a painting of the Assumption of the Virgin by Rubens is mentioned as in the possession of the Princes of Liechtenstein. The Liechtenstein court painter Johann Hostiz reported in that year that he had copied such a painting as faithfully as possible despite the fact that the canvas was unstretched and he had no immediate access to it. Later in the seventeenth century, the present painting was in Feldsberg, the main residence of the Liechtenstein princely family in Lower Austria (in what is today Czechoslovakia), where it adorned the high altar of the parish church. The church was begun in 1631 on the order of Prince Karl Eusebius but was not consecrated until 1671. However, as late as 1659, Antonius Sanderus mentioned an *Assumption of the Virgin* by Rubens as in the Carthusian church in Brussels, although he may have seen a copy that had been substituted for the original. Surprisingly, another copy of this composition was painted for the same church in 1755; it survived the demolition of the church in 1820, only to be destroyed in 1973. Since we do not know why the Carthusians might have been forced to sell the altarpiece so soon after its acquisition, it cannot be proven that the version owned by the

Fig. 46 Detail from cat. no. 218

Princes of Liechtenstein in 1643 was the present one. Yet, its early history is further confirmed by Prince Johann Adam having ordered a small painting from Venice in 1710 to crown the larger composition above the Feldsberg altar. The painting, which shows the Trinity surrounded by angels, was not delivered until 1720, and it still adorns the high altar in the Feldsberg church, above a 1764 copy of the present picture. This copy was made by the painter and inspector of the Liechtenstein gallery, Vincenzo Fanti, when the present altarpiece was moved from the parish church to the princely gallery in Vienna. (Fanti might have been responsible also for the restoration and partial overpainting of the original, since he was paid 111 florins in 1761 for work on an altarpiece.) Even when the Brussels copy was still listed in printed guides to that city, the present altarpiece had become one of the major attractions of the Liechtenstein gallery. It was on view in Vienna until 1940 and was exhibited in 1948 in Lucerne, but since then it has neither been shown publicly nor studied by scholars. A thorough restoration—unusually demanding, in light of the picture's monumental dimensions—was undertaken in 1984 by Dr. Hubertus Falkner von Sonnenburg, who, in removing older overpainting and cleaning the surface, returned the picture to its former beauty.

Two oil sketches—one in the Courtauld Institute Galleries, London (formerly in the Count Seilern collection), and the other, painted slightly later, in the Yale University Art Gallery, New

Fig. 47 Detail from cat. no. 218

Haven—bear witness to Rubens's search for a definitive rendering of the present composition. (Their different approach toward the subject, and their relationship to the final version, has been discussed at greater length by Haverkamp-Begemann, Held, and Freedberg.) Of the sketches, the one at Yale contains elements that distinguish the final altarpiece from all previous depictions of the theme by Rubens. First of all, he drastically reduced the number and scale of the angels and putti surrounding the Virgin, creating an airy space large enough to allow the Virgin to float unhindered, high above the heads of the apostles. Her Assumption now occurs amidst the gestures and glances of all the participants and is carried by a movement entirely directed heavenward, filling the sky and transforming it into a field of energy and motion. Another remarkable motif is the kneeling Virgin, never before depicted in this posture by Rubens. Contrary to the earlier representations of the Virgin enthroned among the clouds in almost apotheosis-like majesty, this innovation stresses her humble consent to God's will: even in the moment of her greatest triumph, the Virgin remains the handmaiden of the Lord. She turns her head toward the heavenly light, and her outstretched hands and upturned palms express her deeply felt joy. (Rubens earlier had sketched a veil floating about her head like an aureole—as shown in the Witdoeck engraving—but painted out the motif in the final canvas in order not to detract from the heavenward glance. He had made a similar change in the Vienna *Assumption* [see Vienna 1977a, p.

69].) The Virgin's upturned palms—again expressing the yearning to reach the realm of heaven—occur earlier, in sketches and drawings by Rubens, but were dispensed with in the large versions in favor of gestures directly addressing the apostles. Thus, this is the first example of the motif in a major altarpiece by Rubens (exceptions are the studio picture in Augsburg and the destroyed ceiling painting in the Antwerp Jesuit church). Raised arms are a most effective expression of inner feeling, but as in Raphael's *Vision of Ezekiel* (Palazzo Pitti, Florence) and in the *Transfiguration of Christ* (Pinacoteca Vaticana, Rome), they also may denote a state of otherworldly transformation. That this is, indeed, intended here is underscored by the unusual choice of white for the color of the Virgin's dress. Except for Rubens's first altarpiece in Vienna, all of his other depictions of the Virgin show her canonically clad in blue. In the gospels, a white garment —"shining, exceeding white as snow; so as no fuller on earth can white them" (Mark 9 : 3)—signaled Christ's Transfiguration to the apostles who witnessed it. (Accordingly, in 1583, Cardinal Paleotti had advised that the Virgin be painted, in her Assumption, "con la veste candida come si suole nella trasfiguratione de N.S.re"; see Prodi 1965, p. 193.) White is used in the present *Assumption* to signify that, miraculously, not only has the Virgin's dead body been elevated from the grave, but her radiant appearance indicates that she has experienced a state of transfiguration: she has been reborn and has already entered the realm of heaven. The rapturous exaltation of the apostles is therefore less in response to the empty tomb than to the sight of heavenly beauty.

In depictions of the Assumption, the witnesses' divided attention between the tomb and the apparition of the Virgin had always defined the terrestrial part of the scene. It is remarkable, however, that all of Rubens's versions of the event are distinguished by a motif for which no written sources exist, and for which pictorial precedents are only rarely found: among the apostles he included holy women, ranging in number from four to two, as here. As if to stress their less-than-authenticated role in the story, these women are given the task, usually assigned to the apostles, of revealing the roses found in the shroud. This apocryphal detail, described in Voragine's *Golden Legend*, was highly significant and was therefore an often-represented enlargement upon the miracle. Whatever their identity, it is clear that the female witnesses add to the impact of the spectators' reactions of joy and incredulity and serve as a foil against which the spirituality of the Assumption is set off. The blond woman in black, who especially attracts our attention in the present picture, also figures in other paintings by Rubens, among them the *Christ Bearing the Cross* (Musées Royaux des Beaux-Arts, Brussels), where she appears as the Magdalen, and the *Martyrdom of Saint Andrew* (Prado, Madrid), as well as the secular *Rape of the Sabine Women* (National Gallery, London) and the *Feast of Venus* (Kunsthistorisches Museum, Vienna). In each of these late works, as here, she constitutes the emotional focus of the action while clearly embodying Rubens's ideal of female

beauty that was inspired by his young wife, Helena Fourment, whom he had married in 1630.

However, the most profoundly affected witnesses to the miracle are the apostles, most of them of advanced age, whom Rubens depicted with variously thoughtful and highly expressive faces. Only a few of them are identifiable, since Rubens did not refer back for their likenesses to the series of apostle portraits that he had painted earlier (they are now in the Prado, Madrid) but established a new iconography. The apostle who bends down to inspect the empty tomb may be identified as Saint Thomas, based upon the similarity in facial type to the figure in the slightly later *Martyrdom of Saint Thomas* (Národni Galeri, Prague), and the white-haired apostle (the second from the right) is perhaps Saint Andrew, judging from his resemblance to the figure in Rubens's *Martyrdom of Saint Andrew* (Prado, Madrid)—an altarpiece, too, of a somewhat later date. The youthful figure who stands in the background looking upward can be identified as Matthew, since that apostle is usually represented as a young man. The two foremost apostles of the twelve, Peter, "the Prince of the Apostles," and John, who had cared for the Virgin after the death of Christ, are the powerful figures who kneel in the foreground, with their backs to us. The boldly realistic effect of Saint Peter's bare feet projecting outward toward the viewer recalls Caravaggio's *Madonna di Loreto* (Sant'Agostino, Rome), but this motif is not without precedent in other, much earlier depictions of the Assumption: Dürer had shown Saint Peter in a similar pose in his woodcut of the Assumption from the Life of the Virgin series, and Federico Barocci had depicted a kneeling apostle with bare feet in a similar position in his *Assumption* (Gemäldegalerie, Dresden). Bare feet traditionally signified that one had entered a holy place —which Rubens conveys through all the participants in the scene. The most moving indications that a holy event is taking place, however, are the gestures of Peter and John. Since Titian's famous *Assunta* (Santa Maria Gloriosa dei Frari, Venice), the motif of arms thrown upward with great emotion has come to represent a powerful response to the witnessing of the Assumption; a figure in such a pose seems almost to be retracing in the sky the movement of the Virgin's flight. Rubens had looked back to this Venetian prototype in all his versions of the Assumption, primarily distinguishing Saint John by this noble gesture. In the present picture, where, for the first time in an altarpiece, Rubens shows him kneeling, John's arms are again outstretched with longing, but he is now joined by Peter, who raises his left arm as his younger companion raises his right. Their fervid reactions, in unison, are meant to mirror the human response to the Assumption. Saints Peter and John, by occupying the immediate foreground of the picture, look on from below and at a distance, strengthening the illusion of the Virgin's Assumption. Kneeling like her and revealing their inner excitement by emotionally raising their hands, the two apostles are earthly reflections of the Virgin's exaltation, as if her heavenly joy has cast its shadow upon them.

The recent cleaning has revealed that the painting is splendidly preserved and that the brushwork is entirely Rubens's own. The master seems to have used an economy of means— there are large areas where the paint is extraordinarily thinly applied—bearing in mind that the altarpiece, unlike a gallery picture, would not be subjected to close scrutiny but would have to make its impact felt across the spaciousness of a Baroque church. It is thus all the more surprising that Rubens took up the task of painting the altarpiece himself, in spite of his advanced age and his often-proved ability to organize a highly efficient workshop—an ability that he put conspicuously to the test in 1635 with the decorations for the entry of the Cardinal Infante Ferdinand of Spain into Antwerp. However, like his other altarpieces of the same period, the present one bears evidence that, in the last decade of his life, Rubens took great pride in demonstrating not only the undiminished power of his brush but also the greater spontaneity and ease of his late style. Enhanced by the rapid brushstrokes, the dots of barely glazed color, and the hastily applied paint, the extraordinary sureness in the handling endows the picture with a pronounced forcefulness and vigor. Similarly, the late work of Titian is characterized by a highly personal application of the color, in which the broad brushstrokes convey an overall grandeur rather than the refinement of specific detail. That, throughout his life, Rubens had revered Titian is shown repeatedly in the work of the Flemish master. Especially following his stay at the court in Madrid in 1628–29, where he had had the renewed opportunity to make a thorough study of the Titians in the collection of the Spanish king, Rubens did not conceal his admiration for the great Venetian. In the present altarpiece, the Venetian influence is apparent in the sketchiness of the brushwork and, even more so, in the picture's light, delicate, and almost ethereal tonality, which is in marked contrast to the bold color of Rubens's earlier work. That the master's style during the last decade of his life achieved such a lightheartedness is due not only to his renewed study of Titian's art but might also reflect his personal happiness following his marriage to Helena Fourment. Only rarely does an artist's late style surpass his earlier efforts in clearly expressing its author's peace of mind. Rubens's last depiction of the *Assumption of the Virgin* is such a work, in which his unceasing creativity has reached a newfound serenity.

RB

FURTHER REFERENCES: Cat. 1767, no. 329; Cat. 1780, no. 39; Cat. 1873, no. 168; Cat. 1885, no. 80; Bode 1888b, pp. 18–21; Rooses 1886–92, vol. 2, no. 360; Rooses 1890, pp. 583–84; Höss 1908, pp. 10–12; Wilhelm 1918, cols. 34, 48; K.d.K. 1921, p. 352; Cat. 1931, no. 80; Kieser 1941–42, p. 303; Strohmer 1943, pl. 39, p. 97; Lucerne 1948, no. 218; London 1955, pp. 54, 67; Aust 1958, p. 187; Gerson and ter Kuile 1960, p. 104; Haverkamp-Begemann 1967, pp. 705–6; Logan 1976, p. 300; Wilhelm 1976, pp. 39, 71, 126; Antwerp 1977, p. 227; Baumstark 1980, no. 60; Held 1980, vol. 1, pp. 514–16; Freedberg 1984, pp. 21, 26, 138, 141, 152, 173, 181–84, 186, 187.

BIBLIOGRAPHY

Abbate, F. 1968. Review of *Piero di Cosimo*, by M. Bacci. *Paragone* 215: 71–78.

Adler, W. 1982. *Landscapes*. Corpus Rubenianum Ludwig Burchard, part 18. London.

Adriani, G. 1965. Review of *Johann Heinrich Schönfeld*, by H. Voss. *Jahrbuch für Geschichte der Oberdeutschen Reichsstädte, Esslinger Studien* 11: 368–71.

Alazard, J. 1924. *L'abbé Luigi Strozzi: Correspondent artistique de Mazarin, de Colbert, de Louvois et de la Teulière. Contribution à l'étude des relations artistiques entre la France et l'Italie au XVIIe. siècle.* Paris.

Aldrovandi, U. 1556. *Le antichità de la città di Roma . . . raccolte da chiunque ne ha scritto, ò antico ò moderno . . . et insieme ancho di tutte le statue antiche, che pertuta Roma* Venice.

Allison, A. H. 1976. "Four New Busts by Antico." *Mitteilungen des Kunsthistorischen Institutes Florenz*, 20 (2): 213–24.

Alpers, S. L. 1967. "Manner and Meaning in Some Rubens Mythologies." *Journal of the Warburg and Courtauld Institutes* 30: 272–95.

Amelung, W. 1908. *Die Sculpturen des Vaticanischen Museums*. Vol. 2, *Tafeln*. Berlin.

Amsterdam 1973. Rijksmuseum. *Beeldhouwkunst in het Rijksmuseum*. Edited by Jaap Leeuwenberg. 1976. Rijksmuseum. *Tot lering en vermaak*. (Exhib. cat.). 1982. P. de Boer Gallery. *A Flowery Past*. (Exhib. cat.). 1983. P. de Boer Gallery. *A Fruitful Past*. (Exhib. cat.).

Arco, C. d'. 1857. *Delle arte e degli artefici di Mantova*. Vol. 2. Mantua.

Arfelli, A. 1934. "Lettere inedite dello sculture G. M. Mazza e dei suoi corrispondenti." In *L'Archiginnasio* 29.

Arisi, F. 1961. *Gian Paolo Panini*. Piacenza.

Aschengreen-Piacenti, K. 1963. "Le opere di Balthasar Stockamer durante i suoi anni romani." *Bollettino d'arte* 48 (1–2): 99–110. 1983. "Rubens e gli intagliatori di avorio." In *Rubens e Firenze*. Florence.

Ascione, B. 1973. *San Sebastiano, . . . nella storia e nell'arte*. Naples.

Augsburg. Zeughaus. 1980. *Welt im Umbruch: Augsburg zwischen Renaissance und Barock*. Vol. 1. (Exhib. cat.).

Avignon 1983. *L'art gothique siennois*, by M. Lonjon. (Exhib. cat.).

B. *see* Bartsch.

Baccheschi, E. 1973. *L'opera completa del Bronzino*. Milan.

Bacci, M. 1966. *Piero di Cosimo*. Milan. 1976. *L'opera completa di Piero di Cosimo*. Milan.

Bachmann, F. 1968. "Zur Datierung der Frühwerke und der Mondscheinlandschaften des Aert van der Neer." *Weltkunst* 38 (Aug.): 705–7. 1970. "Die Brüder Rafel und Jochem Camphuysen und ihr Verhältnis zu Aert van der Neer." *Oud Holland* 85: 243–50. 1975. "Die Herkunft der Frühwerke des Aert van der Neer." *Oud Holland* 89: 213–22. 1982. *Aert van der Neer*. Bremen.

Back, F. 1914. *Grossherzogliches Hessisches Landesmuseum in Darmstadt: Verzeichnis der Gemälde*. Darmstadt.

Baldass, L. von. 1918. "Die niederländische Landschaftsmalerei von Patinir bis Bruegel." *Jahrbuch der Kunsthistorischen Sammlungen des Allerhöchsten Kaiserhauses* 34 (4): 111–58. 1922. "Die Bildnisse der Donauschule." *Städel-Jahrbuch* 2: 73–86. 1933. "Gotik und Renaissance im Werke des Quinten Metsys." *Jahrbuch der Kunsthistorischen Sammlungen in Wien*, n.s. 7: 137–82. 1937. "Die niederländischen Maler des spätgotischen Stiles." *Jahrbuch der Kunsthistorischen Sammlungen in Wien*, n.s. 11: 117–38. 1957. "Some Notes on the Development of van Dyck's Portrait Style." *Gazette des Beaux-Arts* 50 (Nov.): 251–70.

Baldini, U.; Giusti, A.-M.; and Pampaloni Martelli, A. 1979. *La Cappella dei Principi e le pietre dure a Firenze*. Milan.

Baldinucci, F. 1772. *Notizie de' professori del disegno da Cimabue in qua*. Edited by D. M. Manni. Vol. 12. Florence.

Balis, A. 1982. *Het aards paradijs*. Antwerp.

Balogh, J. 1982. *see* Schallaburg. Schloss. 1982.

Bange, E. F. 1922. *Die italienischen Bronzen der Renaissance und des Barock*. Vol. 2, *Reliefs und Plaketten*. Berlin.

Bartsch, A. 1876. *Le peintre-graveur*. Vol. 16. Leipzig.

Basan, P. F. 1771. *Recueil d'estampes gravées d'après les tableaux du cabinet de Monseigneur le Duc de Choiseul*. Paris.

Basel. Kunstmuseum. 1974. *Lukas Cranach: Gemälde, Zeichnungen, Druckgraphik*. 2 vols. (Exhib. cat.).

Bauch, K. 1960. *Der frühe Rembrandt und seine Zeit*. Berlin.

Baudoin, F. 1977. *P. P. Rubens*. Königstein.

Bauer, R., and Haupt, H. 1976. "Das Kunstkammerinventar Kaiser Rudolfs II.: 1607–11." *Jahrbuch der Kunsthistorischen Sammlungen in Wien* 72.

Baulez, C. 1978. "Notes sur quelques meubles et objets d'art des appartements intérieurs de Louis XVI et de Marie-Antoinette." *La revue du Louvre et des musées de France* 28 (5–6): 359–73.

Baum, E. 1964. *Giovanni Giuliani*. Vienna. 1980. *Katalog des Österreichischen Barockmuseums im unteren Belvedere in Wien*. Vol. 1. Vienna.

Baum, J. 1938. "Strigel." In Thieme-Becker 32: 187–91.

Baumgart, F. 1978. *Blumen-Brueghel (Jan Brueghel d. Ä.): Leben und Werk*. Cologne.

Baumstark, R. 1974. "Ikonographische Studien zu Rubens Kriegs- und Friedensallegorien." *Aachener Kunstblätter* 45: 125–234. 1979. *see* Cat. 1979. 1980. *Masterpieces from the Collection of the Princes of Liechtenstein*. Translated by R. Wolf. New York. (*Meisterwerke der Sammlungen des Fürsten von Liechtenstein*. Zurich.) 1983. "Notes on the Decius Mus-Cycle." In *The Ringling Museum of Art Journal*.

Bean, J. 1979. *17th Century Italian Drawings in The Metropolitan Museum of Art*. New York.

Beckenbauer, A. 1979. "Ein welscher Maler in Landshut und sein persönliches Leid: Notizen zu einer neu entdeckten Grabschrift in St. Martin." *Verhandlungen des Historischen Vereins für Niederbayern* 105: 15–19.

Beelaerts van Blokland, W.A. 1935. "Nederlandsche kasteelen." *Historia* 1: 25–29.

Beets, N. 1936. "Zestiende-eeuwsche kunstenaars IV: Lucas Cornelisz de Kock." *Oud Holland* 53: 55–78.

Béguin, S. 1975. *see* Paris 1975.

Béguin, S., and Pressouyre, S. 1972. "La galerie Françoise Ier au Château de Fontainebleau, dossier documentaire." *Revue de l'art* 16–17: 3–174.

Belli Barsali, I. 1965. *Dizionario biografico degli Italiani*. Vol. 7. Rome.

Bellori, G. P. 1672. *Le vite de' pittori, scultori e architetti moderni*. Reprint. Edited by E. Borea. Turin, 1976.

Benedictis, C. De. 1974. "Naddo Ceccarelli." *Commentari* 25 (3–4): 139–54. 1979. *La pittura senese 1330–1370*. Florence.

Benesch, O. 1928. "Die Fürsterbischöfliche Gemäldegalerie in Kremsier." *Pantheon* 1: 22–26. 1933. "Beiträge zur oberschwäbischen Bildnismalerei." *Jahrbuch der Preuszischen Kunstsammlungen* 54: 239–54. 1956. "Die Rembrandtausstellung in Warschau." *Kunstchronik* 9: 189–204. 1965. *The Art of the Renaissance in Northern Europe*. 2d ed. London.

Berenson, B. 1904. *The Florentine Painters of the Renaissance*. 2d ed. New York. 1909. *The Florentine Painters of the Renaissance*. 3d ed. New York. 1932. *Italian Pictures of the Renaissance*. Oxford. 1936. *Pitture italiane del Rinascimento*. Milan. 1963. *Italian Pictures of the Renaissance: Florentine School*. London. 1968. *Italian Pictures of the Renaissance: A List of the Principal Artists and Their Works with an Index of Places. Central Italian and North Italian Schools*. 3 vols. London.

Bergamo 1984. *Le Poste dei Tasso: un'impresa in Europa*. (Exhib. cat.).

Bergmann, M. 1981. Review of *Les portraits romains II: De Vespien à la Basse-antiquité*, by V. Poulsen. *Gnomon* 53 (2): 176–90.

Bergsträsser, G. 1979. "Niederländische Zeichnungen 16. Jahrhundert im Hessischen Landesmuseum Darmstadt." *Kunst im Hessen und Mittelrhein* 18–19, *Beiheft*.

Bergström, I. 1956a. *Dutch Still-Life Painting in the Seventeenth Century*. London. 1956b. *Dutch Still-Life Painting in the Seventeenth Century*. New York.

Berlin 1899. Akademie der Künste. *Ausstellung von Kunstwerken des Mittelalters und der Renaissance aus Berliner Privatbesitz*, by W. von Bode. (Exhib. cat.). 1911. *Das Kaiser Friedrich Museum: Amtliche Ausgabe*. 2d ed. Führer durch die Königlichen Museen zu Berlin. 1929. Rudolph Lepke. *Galerie eines Wiener Sammlers*. (Sale cat. of Dec. 3). 1975. Staatliche Museen Preussischer Kulturbesitz, Kupferstichkabinett. *Pieter Brueghel d. Ä. als Zeichner: Herkunft und Nachfolge*. (Exhib. cat.). 1977. Staatliche Museen Preussischer Kulturbesitz, Kupferstichkabinett. *Peter Paul Rubens, kritischer Katalog der Zeichnungen: Originale—Umkreis—Kopien*, by H. Mielke and M. Winner. (Exhib. cat.).

Berliner, R. 1926. *Die Bildwerke in Elfenbein, Knochen, Hirsch- und Steinbockhorn*. Kataloge des Bayerischen Nationalmuseums, vol. 13: *Die Bildwerke*, part 4. Augsburg.

Berling, K. 1910. *Festschrift zur 200 jährigen Jubelfeier der ältesten europäischen Porzellanmanufaktur Meissen*. Leipzig.

Bernath, M. H. 1912. "Naddo Ceccarelli." In Thieme-Becker 6: 253–54.

Bernheimer, R. 1952. *Wild Men in the Middle Ages*. Cambridge, Mass.

Bernstein, F. 1933. "Hendrik Gerritsz. Pot." In Thieme-Becker 27: 301–2.

Bernt, W. 1969. *Die niederländischen Maler des 17. Jahrhunderts.* Munich. 1970. *The Netherlandish Painters of the Seventeenth Century.* London.

Bertele, H. von, and Blau, L. 1977. "Habermel's Universalkalendar." In *Annali dell'Instituto e Museo di Storia della Scienza di Firenze 2.*

Berti, L. 1980. *see* Florence 1980a.

Białostocki, J. 1958. "Les bêtes et les humains de Roelant Savery." *Bulletin des Musées Royaux des Beaux-Arts 7*: 69–92. 1972. *Spätmittelalter und beginnende Neuzeit.* Berlin.

Białostocki, J., and Walicki, M. 1955. *Malarstwo europejskie w zbiorach polskich, 1300 – 1800.* Kraków.

Bie, C. de. 1661. *Het gulden cabinet van de edele vry schilderconst.* Lier.

Bieber, M. 1960. *The Sculpture of the Hellenistic Age.* New York.

Birke, V. 1974. *Studien zu Matthias Rauchmiller.* Dissertation. Vienna 1976–77. "Zum Frühwerk Matthias Rauchmillers im Rheingebiet." *Mainzer Zeitschrift 71 – 72* (1976 – 77): 164–75. 1981. *Matthias Rauchmiller: Leben und Werk.* Vienna.

Bistram, J. B. von. 1978. "Ein Radschlossbüchsenpaar von J. Michael Maucher: Zu einem waffengeschichtlich bedeutsamen Fund." *Waffen- und Kostümkunde 20* (2): 129–36.

Blair, C. 1979. "Les armes à feu de la collection des Princes de Liechtenstein." *Connaissance des arts 331* (Sept.): 44–53.

Blanc, C. 1857. *Le trésor de la curiosité, tiré des catalogues de vente.* Vol. 1. Paris.

Blankert, A. 1968. "Over Pieter van Laer als dier- en landschapschilder." *Oud Holland 83* (2): 117–34. 1982. *Ferdinand Bol (1616 – 1680): Rembrandt's Pupil.* Doornspijk.

Blažková, J. 1978. "Les tapisseries de Décius Mus en Bohême." *Artes textiles 9*: 49–74.

Blunt, A. 1967. *Nicolas Poussin.* New York.

Boccia, L. G. 1972. "Armi e armature." In *Il Museo Poldi Pezzoli.* Milan. 1974. "Gli archibusi a ruota del Bargello." *L'illustrazione italiana 1* (2): 84–110.

Bode, W. von. 1881. *see* Bode and Scheibler 1881. 1888a. "Die Fürstlich Liechtensteinsche Galerie in Wien." *Die graphischen Künste 11*: i–iii. 1888b. "Peter Paul Rubens." *Die graphischen Künste 11*: 1–36. 1889. "Antoon van Dyck." *Die graphischen Künste 12*: 39–52. 1891. "Rembrandt van Ryn und seine Schule in der Liechtenstein-Galerie in Wien." *Die graphischen Künste 14*: 1–12. 1892. "Die Bilder italienischer Meister in der Galerie des Fürsten Liechtenstein in Wien." *Die graphischen Künste 15*: 85–102. 1894a. "Das holländische Still Leben." *Die graphischen Künste 17*: 100–102. 1894b. "Die Kleinmeister der holländischen Schule in der Galerie des Fürsten Liechtenstein." *Die graphischen Künste 17*: 79–99. 1894c. "Die vlämischen Kleinmeister." *Die graphischen Künste 17*: 103–7. 1895a. "Die altniederländische und die altdeutsche Schule." *Die graphischen Künste 18*: 114–29. 1895b. "Bertoldo di Giovanni und seine Bronzebildwerke." *Jahrbuch der Königlich Preussischen Kunstsammlungen 16*: 143–59. 1895c. "Die französische Schule." *Die graphischen Künste 18*: 109–13. 1899. *see* Berlin 1899. 1905. *Denkmäler der Renaissance-Sculptur Toscanas.* Text vol. Munich. 1908. *The Italian Bronze Statuettes of the Renaissance.* Vol. 1.

London. 1910. *Bronzes of the Renaissance and Subsequent Periods: Collection of J. Pierpont Morgan.* 2 vols. Paris. 1917. *Die Meister der holländischen und vlämischen Malerschulen.* Leipzig. 1924. *Adriaen Brouwer: Sein Leben und seine Werke.* Berlin. 1925. *Bertoldo und Lorenzo dei Medici: Die Kunstpolitik des Lorenzo il Magnifico im Spiegel der Werke seines Lieblingskünstlers Bertoldo di Giovanni.* Freiburg.

Bode, W. von, and Scheibler, L. 1881. "Bernhard Strigel, der sogenannte Meister der Sammlung Hirscher." *Jahrbuch der Königlich Preussischen Kunstsammlungen 2*: 54–61.

Bodkin, T. 1929. "Two Unrecorded Landscapes by Abraham Bloemaert." *Oud Holland 46*: 101–3.

Boeheim, W. 1886. *see* Brunn 1886.

Bol, L. J. 1969. *Holländische Maler des 17. Jahrhunderts nahe den grossen Meistern.* Braunschweig. 1982. *Goede onbekenden.* Utrecht.

Bologna. Palazzo dell'Archiginnasio. 1959. *Maestri della pittura del seicento emiliano,* by F. Arcangeli.(Exhib. cat.).1962.*L'ideale classico del seicento in Italia e la pittura di paesaggio.* 2d ed. (Exhib. cat.).

Boon, K. G. 1942. "Quinten Massys." In *Van Eyck en zijn tijdgenoten.* Amsterdam. 1966. "Een blad met schetsen voor een Diana en haar nimfen door Rubens." *Bulletin van het Rijksmuseum 14*: 150–57. 1980. *see* Hollstein 1956–80.

Borenius, T. 1921. "A Canaletto Curiosity." *Burlington Magazine 39* (Sept.): 108–13.

Boskovits, M. 1979. "Naddo Ceccarelli." In *Dizionario biografico degli Italiani 23*: 207–9. Rome.

Bosque, A. de. 1975. *Quentin Metsys.* Brussels.

Bosschère, J. de. 1907. *Quinten Metsys.* Brussels.

Bottari, G., and Ticozzi, S. 1832. *Raccolta di lettere. . . .* Vol. 6. Milan.

Bowron, E. P. 1980. *see* Philadelphia 1980.

van den Branden, F. J. 1883. *Geschiedenis der Antwerpsche schilderschool.* Vol. 1. Antwerp.

Braun, E.W. 1925–26. "Ein unbekanntes Porträt von Hans Mielich." *Zeitschrift für bildende Kunst* n.s. 59: 78–80. 1940. "Matthias Rauchmiller." In *Oberrheinische Kunst 9.* 1942. "Matthias Rauchmiller." In *Oberrheinische Kunst 10.*

Bregenz 1965. Künstlerhaus Palais Thurn und Taxis. *Meisterwerke der Malerei aus Privatsammlungen im Bodenseegebiet.* (Exhib. cat.). 1967. Künstlerhaus Palais Thurn und Taxis. *Meisterwerke der Plastik aus Privatsammlungen im Bodenseegebiet.* (Exhib. cat.). 1968. Vorarlberger Landesmuseum. *Angelica Kauffmann und ihre Zeitgenossen.* (Exhib. cat.).

Brendel, O. 1930. "Immolatio Boum." *Mitteilungen des Deutschen Archaeologischen Institutes (Röm. Abteilung) 45*: 196–226.

Briganti, G. 1982. *Pietro da Cortona: O della pittura barocca.* 2d ed. Florence.

Brinckmann, A. E. 1923. *Süddeutsche Bronzebildhauer des Frühbarocks.* Munich.

Brising, H. 1908. *Quinten Matsys und der Ursprung des Italianismus in der Kunst der Niederlande.* 2d ed. Leipzig.

Broadley, H. 1961. *The Mature Style of Quinten Massys.* Dissertation, N.Y.U. New York.

Brown, C. 1982. *Van Dyck.* Oxford.

Brown, C. M. 1982. *Isabella d'Este and Lorenzo da Pavia.* Geneva.

Bruck, R. 1917. *Ernst zu Schaumburg: Ein kunstfördernder Fürst des siebzehnten Jahrhunderts.* Berlin.

Brügge 1902. *Meisterwerke der niederländischen Malerei des XV. and XVI. Jahrhunderts auf der Ausstellung zu Brügge 1902,* by M. J. Friedländer. Munich, 1903.

Brünn. Mährischen Gewerbemuseum. 1886. *Kunstgewerbliches aus der Ausstellung von Waffen, Kriegs- und Jagd-Geräthen.* Edited by A. Prokop and W. Boeheim. (Exhib. cat.).

Buchner, E. 1928. "Der ältere Breu als Maler." In *Beiträge zur Geschichte der deutschen Kunst.* Vol. 2, *Augsburger Kunst der Spätgotik und Renaissance.* Augsburg. 1935. "Schäufelein." In Thieme-Becker 29: 557–61.

Buchwald, C. 1899. *Adriaen de Vries.* Leipzig.

Bukovinská, B. 1972. "Další florentské mozaiky z Prahy." *Umění 20*: 363–70.

Burchard, L. 1926. "Skizzen des jungen Rubens." In *Sitzungsberichte der Berliner Kunstgeschichtlichen Gesellschaft.* 1953–54. "Rubens' *Daughters of Cecrops.*" *Allen Memorial Art Museum Bulletin 11* (1): 4–27.

Burchard, L., and Hulst, R. A. d'. 1963. *Rubens Drawings.* Vol. 1. Brussels.

Burckhardt, J.C. 1869. *Der Cicerone: Eine Anleitung zum Genuss der Kunstwerke Italiens.* Vol. 3, *Malerei.* 2d ed. Edited by A. von Zahn. Leipzig. 1898. *Erinnerungen aus Rubens.* Vienna, 1938.

Burger, W. 1925. *Die Malerei in den Niederlanden 1400–1550.* Munich.

Burlington Magazine 1954. "Museum acquisitions."

Buyck, J. 1964. "Aantekeningen bij een zogenaamd 'Zelfportret' van Adriaan Brouwer in het Mauritshuis." *Nederlands kunsthistorisch jaarboek 15*: 221–28.

Cahn, E. B. 1966. *Adrian de Vries und seine kirchlichen Bronzekunstwerke in Schaumburg.* Rinteln.

Cailleux, J. 1975. "L'art du dix-huitième siècle: Hubert Robert's Submissions to the Salon of 1769." *Burlington Magazine 117* (Oct. advert. suppl.): i–xvi.

Callahan, V. 1979. "Comments on the Iconography of Six Engravings by Meloni after Franceschini." *Record of The Art Museum, Princeton University 38* (1): 9–10.

Camesasca, E. 1956. *Tutta la pittura di Raffaello.* Milan. 1974. *L'opera completa del Bellotto.* Milan.

Cappelli, A. 1973. *Dizionario di abbreviature latine ed italiane.* 6th ed. Milan.

Carli, E. 1949. "A Recovered Francesco di Giorgio." *Burlington Magazine 91* (Feb.): 32–33. 1983. *Raffaello: Armonia e splendore del Rinascimento.* Milan.

Carlson, V. 1978. *see* Washington, D.C. 1978.

Carpegna, N. di. 1969. *see* Rome 1969.

Carrington, V. 1980. "Rinascimentali superatentici: Una stupenda nostra a Londra." Review of London, 1980. *Bolaffi gioielli 8* (Sept.): 12–13.

Cartwright (Ady), J. M. 1906. *The Painters of Florence from the Thirteenth to the Sixteenth Century.* London.

Casper von Lohenstein, D. 1680. "Blumen." In *Sämtliche Gedichte.* Breslau.

Cat. 1767. *Descrizzione completa di tutto ciò che ritrovasi nella galleria di pittura e scultura di Sua Altezza Giuseppe Wenceslao del S.R.I. Principe Regnante della casa di Lichtenstein,* by V. Fanti. Vienna.

Cat. 1780. *Description des tableaux et des pièces de sculpture que renferme la gallerie de son Altesse François Joseph Chef et Prince Regnant de la Maison de Liechtenstein,* by J. Dallinger. Vienna.

Cat. 1873. *Katalog der Fürstlich Liechtensteinischen Bilder-Galerie im Gartenpalais der Rossau zu Wien,* by J. Falke. Vienna.

Cat. 1885. *Katalog der Fürstlich Liechtensteinischen Bilder-Galerie im Gartenpalais der Rossau zu Wien.* Vienna.

Cat. 1931. *Führer durch die Fürstlich Liechtensteinsche Gemälde Galerie in Wien*, by A. Kronfeld. Vienna.

Cat. 1948. *Meisterwerke aus den Sammlungen des Fürsten von Liechtenstein*. (Exhib. cat.). Kunstmuseum, Lucerne.

Cat. 1950. *Wiener Biedermeier-Maler und Carl Spitzweg: Aus den Sammlungen des Fürsten von Liechtenstein*. (Exhib. cat.). Kunstmuseum, Lucerne.

Cat. 1952. *Waffen aus vier Jahrhunderten, mit einer Sonderschau: Der goldene Wagen und höfische Kostüme des 18. und 19. Jahrhunderts. Ausstellung . . . aus den Sammlungen . . . des Regierenden Fürsten von Liechtenstein*. (Exhib. cat.). Vaduz.

Cat. 1967. *Flämische Malerei im 17. Jahrhundert: Ausstellung aus den Sammlungen seiner Durchlaucht des Fürsten von Liechtenstein*, by G. Wilhelm. (Exhib. cat.). Vaduz.

Cat. 1969. *Österreichische Meisterwerke aus Privatbesitz und Stiftsgalerien: Von der Spätgotik zum Barock*. (Exhib. cat.). Salzburger Residenzgalerie.

Cat. 1971. *Die Jagd in der bildenden Kunst aus Beständen der Sammlungen des Regierenden Fürsten von Liechtenstein*. (Exhib. cat.). Palais Liechtenstein, Feldkirch.

Cat. 1972. *Italienische Kunst des XIV. bis XVI. Jahrhunderts aus den Sammlungen des Fürsten von Liechtenstein*, by G. Wilhelm. (Exhib. cat.). Vaduz.

Cat. 1974. *Peter Paul Rubens: Aus den Sammlungen des Fürsten von Liechtenstein*, by G. Wilhelm. Vaduz.

Cat. 1979. *Deutsche Malerei 15.–17. Jahrhundert aus den Sammlungen des Regierenden Fürsten von Liechtenstein*, by R. Baumstark. Vaduz.

Cats, J. 1618. *Maechden-plicht ofte ampt der ionck-vrouwen in eerbaer liefde aen-ghewesen door sinne-beelden*. Middelburg. 1627. *Proteus, ofte, Minne-beelden verandert in sinne-beelden*. Vol. 3. Rotterdam. 1665. *Spiegel van den Ouden en Nieuwen Tijdt*. In *Alle de wercken*, vol. 1. Amsterdam. (First published 1632.)

Cavaliere, G. B. de' [Before 1584.] *Antiquarum statuae urbis Romae*. Vol. 2. Rome.

Cavalli-Björkman, G. 1977. *Rubens i Sverige*. Stockholm.

Cervetto, L. A. 1903. *I Gaggini da Bissone*. Milan.

Chambers, D. S., and Cocks, A. S. 1981. see London 1981.

Charbonneau-Lassay, L. 1940. *Le bestiare du Christ*. Bruges.

Châtelet, A., and Thuillier, J. 1963. *La Peinture française de Fouquet à Poussin*. Geneva. (*French Painting from Fouquet to Poussin*. Geneva.)

Cheney, I. H. 1976. *Francesco Salviati (1510–1563)*. Dissertation, N.Y.U. New York.

Cicero. 1913. *De officiis*. Translated by W. Miller. Vol. 1. London.

Clark, A. M. 1959. "Some Early Subject Pictures by P. G. Batoni." *Burlington Magazine* 101 (June): 232–38. 1968. see Bregenz 1968. 1985. *Pompeo Batoni: A Complete Catalogue of His Paintings and Drawings*. Oxford.

Clemen, P., and Firmenich-Richartz, E. 1905. see Düsseldorf 1905.

Cleveland. Cleveland Museum of Art. 1966. *Handbook*.

Cohen, W. 1904. *Studien zu Quinten Metsys: Ein Beitrag zur Geschichte der Malerei in den Niederlanden*. Bonn. 1914. "Cornelis Engebrechtsz." In Thieme-Becker 10: 526–28. 1921. "Der antwerpener Maler Jan Cock." *Genius* 3: 79–82.

Collura, D. 1980. *Cataloghi del Museo Poldi Pezzoli*. Vol. 2, *Armi e armature*. Milan.

da Como, U. 1930. *Girolamo Muziano 1528–1592: Note e documenti*. Bergamo.

Conway, M. 1921. *The van Eycks and Their Followers*. London.

Craven, S. 1975. "Three Dates for Piero di Cosimo." *Burlington Magazine* 117 (Sept.): 72–76.

Crick-Kuntziger, M. 1955. "Tapisseries bruxelloises d'après Rubens et d'après Jordaens." *Revue belge d'archéologie et d'histoire de l'art* 24: 18–28.

Crinò, A. M. 1953. "Note di documentazione su due autoritratti della collezione degli Uffizi." *Rivista d'arte* 28: 185–97. 1960. "Documents Relating to Some Portraits in the Uffizi and to a Portrait at Knole." *Burlington Magazine* 102 (June): 256–61.

Croft-Murray, E. 1962. *Decorative Painting in England 1537–1837*. Vol. 1, *Early Tudor to Sir James Thornhill*. London.

Cropper, E., and Panofsky-Soergel, G. 1984. "New Elsheimer Inventories from the Seventeenth Century." *Burlington Magazine* 126 (Aug.): 473–88.

Crous, J. W. 1933. "Florentiner Waffenpfeiler und Armilustrium." *Mitteilungen des Deutschen Archaeologischen Institutes (Röm. Abteilung)* 48: 1–119.

Crowe, J. A., and Cavalcaselle, G. B. 1871. *A History of Painting in North Italy*. 2 vols. London. 1882–85. *Raphael: His Life and Works*. 2 vols. London. 1885–1908. *Storia della pittura in Italia dal secolo II al secolo XVI*. 11 vols. Florence. 1914. *A History of Painting in Italy: Umbria, Florence and Siena, from the Second to the Sixteenth Century*. Vol. 6, *Sienese and Florentine Masters of the Sixteenth Century*. Edited by T. Borenius. London.

Cumont, F. 1942. *Recherches sur le symbolisme funéraire des Romains*. Paris.

Cust, L. H. 1900. *Anthony van Dyck: An Historical Study of His Life and Works*. London. 1911. *Anthony van Dyck: A Further Study*. London.

Cuttler, C. 1968. *Northern Painting from Pucelle to Bruegel: Fourteenth, Fifteenth, and Sixteenth Centuries*. New York.

Cuzin, J. P. 1983. *Raphaël: Vie et oeuvre*. Fribourg.

Dacier, E. 1910. *Catalogues de ventes et livrets de Salons illustrés par Gabriel de Saint-Aubin*. Vol. 2, part 3, *Catalogue de la vente A. Du Barry (1774)*. Paris.

Dacos, N. 1969. *La découverte de la Domus Aurea et la formation des grotesques à la Renaissance*. London.

Dallinger, J. 1780. see Cat. 1780.

Daniels, J. 1976a. *L'opera completa di Sebastiano Ricci*. Milan. 1976b. *Sebastiano Ricci*. Hove.

Darcel, A. 1891. *Notice des émaux et de l'orfévrerie*. New edition. Louvre, Paris.

Darmstadt. Residenzschloss. 1914. *Jahrhundert-Ausstellung deutscher Kunst 1650–1800*. Leipzig. (Exhib. cat.).

Dasnoy, A. 1952. "Henri Blès: Peintre de la réalité et de la fantasie." In *Études d'histoire & d'archéologie Namuroises dédiées à Ferdinand Courtoy*. Vol. 2: 619–26. Namur.

Decker, H. 1943. *Barock-Plastik in den Alpenländern*. Vienna.

Degenhart, B. 1933. "Piero di Cosimo." In Thieme-Becker 27: 15–17.

Delbanco, G. 1928. *Der Maler Abraham Bloemaert (1564–1651)*. Strasbourg.

Delen, A. J. J. 1926. *Metsys*. Brussels.

De Logu, G. 1958. *Pittura veneziana dal XIV al XVIII secolo*. Bergamo.

Denucé, J. 1931. *Art-Export in the 17th Century in Antwerp: The Firm Forchoudt*. The Hague. (Cited by Bauman, Draper, and Liedtke.) *Kunstausfuhr Antwerpens im 17. Jahrhundert: Die Firma Forchoudt*. Antwerp. (Cited by Baumstark.) *Kunstuitvoer in de 17e eeuw te Antwerpen*. Antwerp. (Cited by Liedtke.) 1932. *The Antwerp Art-Galleries: Inventories of the Art-Collections in Antwerp in the 16th and 17th Centuries*. The Hague. (Cited by Bauman and Liedtke.) *De Antwerpsche konstkamers: Inventarissen van kunstverzamelingen te Antwerpen in 16e en 17e eeuw*. Antwerp. (Cited by Baumstark.) 1949. *Na Peter Pauwel Rubens: Documenten uit den kunsthandel te Antwerpen in de XVIIe eeuw van Matthijs Musson*. Antwerp.

Derschau, J. von. 1922. *Sebastiano Ricci: Ein Beitrag zu den Anfängen der venezianischen Rokokomalerei*. Heidelberg.

Detroit. Institute of Arts. 1974. *The Twilight of the Medici: Late Baroque Art in Florence, 1670–1743*. (Exhib. cat.). 1981. *The Golden Age of Naples: Art and Civilization under the Bourbons 1734–1805*. Vol. 1. (Exhib. cat.). 1985. *Italian Renaissance Sculpture in the Time of Donatello*, J. D. Draper. (Exhib. cat.).

Deusch, W. 1935. *Deutsche Malerei des sechzehnten Jahrhunderts: Die Malerei der Dürerzeit*. Berlin.

Dhanens, E. 1956. *Jean Boulogne, Giovanni Bologna Fiammingo*. Brussels.

Diemer, C. 1977. "Balthasar Ferdinand Moll und Georg Raphael Donner: Die Porträtreliefs im österreichischen Barockmuseum und ihre Vorbilder." *Mitteilungen der Österreichischen Galerie* 21: 67–113.

Dimier, L. 1904. *French Painting in the Sixteenth Century*. London.

Distelberger, R. 1979. "Dionysio und Ferdinand Eusebio Miseroni." *Jahrbuch der Kunsthistorischen Sammlungen in Wien* 75: 109–88. 1980. "Pietra Dura Works of the Prince of Liechtenstein." *Connaissance des arts* 343 (Sept.): 52–59. 1983. *Werke der Goldschmiede- und Steinschneidekunst*. Textband. Haupt.

Donnelly, P. J. 1969. *Blanc de Chine: The Porcelain of Têhua in Fukien*. New York.

Donnet, F. 1898. *Documents pour servir à l'histoire des ateliers de tapisserie de Bruxelles*. Brussels.

Donzelli, C. 1957. *I pittori veneti del settecento*. Florence.

Dorotheum Kunstauktionhaus. 1925. see Vienna 1925.

Douglas, R. L. 1946. *Piero di Cosimo*. Chicago.

Downes, K. 1980. *Rubens*. London.

Draper, J. D. 1978. "Giovanni Bologna in Edinburgh, London and Vienna." Review of Edinburgh, 1978. *Antologia di belle arti* 6: 155–56. 1984. see New York 1984. 1985. see Detroit 1985.

Dreher, F. P. 1978. "The Artist as Seigneur: Châteaux and Their Proprietors in the Work of David Teniers II." *Art Bulletin* 60 (Dec.): 682–703.

Dreyer, P. 1977. see Munich 1977.

Du Choul, G. 1556. *Discours de la religion des anciens Romains*. Lyon. (Reprinted in *The Renaissance and the Gods*. New York, Garland, 1976.)

Dülberg, F. 1899. *Die Leydener Malerschule. I: Gerardus Leydanus; II: Cornelis Engebrechtsz*. Dissertation. Berlin. 1905. "Die kunsthistorische Ausstellung zu Düsseldorf im Jahre 1904." *Kunstchronik* n.s. 16: cols. 542–47. 1929. *Niederländische Malerei der Spätgotik und Renaissance*. Potsdam.

Durrieu, P. 1911. "La Renaissance." In *Histoire de l'art*, by A. Michel, 4 (2): 730–31. Paris.

Düsseldorf 1905. Kunsthistorische Ausstellung 1904. *Meisterwerke westdeutscher Malerei und andere hervorragende Gemälde alter Meister aus Privatbesitz,* by P. Clemen and E. Firmenich-Richartz. (Exhib. cat.). Munich.

Dussler, L. 1966. *Raffael: Kritisches Verzeichnis der Gemälde, Wandbilder, und Bildteppiche.* Munich.

Dutuit, E. 1885. *Tableaux et dessins de Rembrandt.* Paris.

Duverger, E. 1968. "Bronnen voor de geschiedenis van de artistieke betrekkingen tussen Antwerpen en de noordelijke Nederlanden tussen 1632 en 1648." In *Miscellanea Jozef Duverger,* vol. 1: 336–73. Ghent.

Duverger, J. 1976–78. "Aantekeningen betreffende de patronen van P. P. Rubens en de tapijten met te Geschiedenis van Decius Mus." *Gentse bijdragen tot de kunstgeschiedenis* 24: 15–42.

Dvorak, M., and Matějka, B. 1910. *Der politische Bezirk Raudnitz.* Part 2, *Raudnitzer Schloss.* Prague.

Dworschak, V. 1962. Letter to G. Wilhelm, March 12.

Eckhardt, W. 1976. "Erasmus Habermel: Zur Biographie des Instrumentenmachers Kaiser Rudolfs II. *Jahrbuch der Hamburger Kunstsammlungen* 21: 55–92. **1977.** "Erasmus und Josua Habermel: Kunstgeschichtliche Anmerkungen zu den Werken der Beiden Instrumentmacher." *Jahrbuch der Hamburger Kunstsammlungen* 22: 13–74.

Edinburgh. Royal Scottish Museum. 1978. *Giambologna, 1529–1608: Sculptor to the Medici.* Edited by C. Avery and A. Radcliffe. (Exhib. cat.). London.

Ehrenthal, M. von, ed. 1899. *Führer durch das Königliche Historische Museum zu Dresden.* Dresden.

Eisenmann, O. 1874. "Die Ausstellung von Gemälden alter Meister aus dem Wiener Privatbesitz." *Zeitschrift für bildende Kunst* 9: 28–30, 59–64.

Eisler, C. 1977. *Paintings from the Samuel H. Kress Collection: European Schools excluding Italian.* London.

Emiliani, A. 1967. *La Pinacoteca nazionale di Bologna.* Bologna.

Emmerling, E. 1932. *Pompeo Batoni: Sein Leben und Werk.* Darmstadt.

Enggass, R. 1964. *The Painting of Baciccio, Giovanni Battista Gaulli, 1639–1709.* University Park, Pa.

Ertz, K. 1979. *Jan Brueghel der Ältere (1568–1625): Die Gemälde mit kritischem Oeuvrekatalog.* Cologne. **1981.** *Jan Brueghel d. Äe. (1568–1625).* Cologne.

Evans, R. J. W. 1973. *Rudolf II and His World: A Study in Intellectual History, 1576–1612.* Oxford.

Evers, H. G. 1942. *Peter Paul Rubens.* Munich. **1943.** *Rubens und sein Werk: Neue Forschungen.* Brussels.

Évrard, R. 1955. *Les artistes et les usines à fer.* Liège.

Faggin, G. T. 1968. *La pittura ad Anversa nel cinquecento.* Florence.

Faldi, I. 1954. *Galleria Borghese: Le sculture dal secolo XVI al XIX.* Rome.

Falke, J. 1873. *see* Cat. 1873. **1877.** *Geschichte des Fürstlichen Hauses Liechtenstein.* Vol. 2. Vienna.

Fanti, V. 1767. *see* Cat. 1767.

Fechner, J. 1966–67. "Die Bilder von Roelant Savery in der Eremitage." *Jahrbuch des Kunsthistorischen Institutes der Universität Graz* 2: 93–99. **1971.** "Die Bilder von Abraham Bloemaert in der Staatlichen Eremitage zu Leningrad." *Jahrbuch des Kunsthistorischen Institutes der Universität Graz* 6: 111–17.

Feil, J. 1856. "Andeutungen über Sebenstein im Jahre 1855." *Berichte und Mittheilungen des Altertums- Vereins zu Wien* 1: 183–203.

Feldkirch. Palais Liechtenstein. 1971. *see* Cat. 1971.

Ferrari, G. 1914. *Les deux Canaletto: Antonio Canal, Bernardo Bellotto, peintres.* Turin.

Ferrari, O., and Scavizzi, G. 1966. *Luca Giordano.* 3 vols. Rome.

Feulner, A. 1928. "Das Metternichdenkmal in Trier und sein Meister." *Pantheon* 2: 553–57.

Filippini, F. 1925. "Raffaello a Bologna." *Cronache d'arte* 2: 201–34.

Fischel, O. 1935. "Raffaello Santi." In Thieme-Becker 29: 433–46.

Flechsig, E. 1900. *Cranachstudien.* Leipzig.

Fleischer, J. 1932. *Das kunstgeschichtliche Material der Geheimen Kammerzahlamtsbücher in den Staatlichen Archiven Wiens von 1705 bis 1790.* Vienna.

Fleischer, V. 1907. "Rubens' Darstellungen der Geschichte des Konsuls Decius Mus in der Liechtenstein-Galerie." *Neue freie Presse* (Oct. 7). **1910.** *Fürst Karl Eusebius von Liechtenstein als Bauherr und Kunstsammler (1611–1684).* Vienna.

Fleming, J. 1961. "Giuseppe Mazza." *Connoisseur* 148 (Nov.): 206–15.

Florence 1968. Galleria degli Uffizi. *Mostra di disegni francesi da Callot a Ingres,* by P. Rosenberg. (Exhib. cat.). **1980a.** Palazzo Strozzi. *Il primato del disegna.* (Exhib. cat.). **1980b.** Palazzo Vecchio. *Palazzo Vecchio: Committenza e collezionismo medici.* (Exhib. cat.). **1983.** *Rubens e Firenze,* by M. Gregori. **1984.** Palazzo Pitti. *Raffaello a Firenze: Dipinti e disegni delle collezioni fiorentine.* (Exhib. cat.).

Fock, C. W. 1974. "Der Goldschmied Jaques Bylivelt aus Delft und sein Wirken in der Mediceischen Hofwerkstatt in Florenz." *Jahrbuch der Kunsthistorischen Sammlungen in Wien* 70: 89–178. **1982.** "Pietre Dure Work at the Court of Prague: Some Relations with Florence." In *Leids kunsthistorisch jaarboek* 1.

Forrer, L. 1909. *Biographical Dictionary of Medallists.* Vol. 4. London.

Forster, A. von. 1910. *Die Erzeugnisse der Stempelschneidekunst in Augsburg und Ph. H. Müller's nach meiner Sammlung geschrieben und die Augsburger Stadtmünzen.* Leipzig.

Frankfurt 1959. Historisches Museum. *Das Bild der Stadt auf Gemälden des Historischen Museums Frankfurt am Main,* by G. Bott. **1982.** Liebighaus Museum alter Plastik. *Dürers Verwandlung in der Skulptur zwischen Renaissance und Barock.* (Exhib. cat.).

Fransolet, M. 1942. *François du Quesnoy: Sculpteur d'Urbain VIII, 1597–1643.* Brussels.

Franz, H. G. 1965. "Hans Bol als Landschaftszeichner." *Jahrbuch des Kunsthistorischen Institutes der Universität Graz* 1: 19–67. **1968–69.** "Meister der spätmanieristischen Landschaftsmalerei in den Niederlanden." *Jahrbuch des Kunsthistorischen Institutes der Universität Graz* 3–4: 19–72. **1969.** *Niederländische Landschaftsmalerei im Zeitalter des Manierismus.* Graz.

Freedberg, S. J. 1961. *Painting of the High Renaissance in Rome and Florence.* Cambridge, Mass. **1971.** *Painting in Italy 1500 to 1600.* Harmondsworth.

Freytag, C. 1974. Review of a lecture given at the Frick Collection, NY, by O. Raggio. [In a review of Pope-Hennessy's Frick catalogue.] *Pantheon* 32 (1): 112.

Friedländer, M. J. 1896. "Die Votivtafel des Estienne Chevalier von Fouquet." *Jahrbuch der Königlich Preussischen Kunstsammlungen* 17: 206–14. **1902.** "Die Ausstellung älterer Kunstwerke in München." *Zeitschrift für bildende Kunst,* n.s. 13: 27–32. **1903.** *see* Brügge 1902. **1908.** Review of *Der Ursprung des Donaustils* (1907), by H. Voss. *Repertorium für Kunstwissenschaft* 31: 393. **1912.** "Das Bildnis von 1456 in der Liechtenstein-Galerie (zu Peter Halms Radierung)." *Zeitschrift für bildende Kunst* n.s. 23: 157–58. **1915.** "Die Antwerpener Manieristen von 1520." *Jahrbuch der Königlich Preussischen Kunstsammlungen* 36 (1): 65–91. **1916a.** "Jean Fouquet." In Thieme-Becker 12: 252–54. **1916b.** *Von Eyck bis Bruegel.* Berlin. **1929.** *Die altniederländische Malerei.* Vol. 7, *Quentin Massys.* Berlin. **1933.** *Die altniederländische Malerei.* Vol. 11, *Die Antwerpener Manieristen, Adriaen Ysenbrant.* Berlin. **1936.** *Die altniederländische Malerei.* Vol. 13, *Anthonis Mor und seine Zeitgenossen.* Leiden. **1949.** "Jan de Cock oder Lucas Kock. In *Miscellanea Leo van Puyvelde:* 84–88. Brussels. **1956.** *From van Eyck to Bruegel.* Translated by M. Kay. New York. **1971.** *Early Netherlandish Painting.* Vol. 7, *Quentin Massys.* New York. **1972.** *Early Netherlandish Painting.* Vol. 11, *The Antwerp Mannerists, Adriaen Ysenbrant.* New York. **1975.** *Early Netherlandish Painting.* Vol. 13, *Anthonis Mor and his Contemporaries.* New York.

Friedländer, M. J., and Rosenberg, J. 1932. *Die Gemälde von Lucas Cranach.* Berlin. **1978.** *The Paintings of Lucas Cranach.* Rev. ed. Ithaca.

Friedman, T. 1977. "Allegory in Stomer's *The Adoration of the Shepherds.*" *Leeds Arts Calendar* 81: 5–9.

Frimmel, T. von. 1884. "Die historische Bronze-Ausstellung in Oesterreichischen Museum." *Zeitschrift für bildende Kunst* 19: 185–91, 221–28. **1886.** "Carl Andreas Ruthart." *Repertorium für Kunstwissenschaft* 9: 129–49. **1892.** *Kleine Galeriestudien.* Vol. 1. Bamberg. **1907.** *Blätter für Gemäldekunde* 3. **1908a.** "Briefkasten." *Blätter für Gemäldekunde* 4. **1908b.** "Das Pantheonbild des Hubert Robert in der Darmstädter Galerie." *Blätter für Gemäldekunde* 4: 180–82. **1912.** "Über einige Bilder in der Fürst-Liechtensteinschen Galerie zu Wien." *Blätter für Gemäldekunde* 7 (5): 65–67. **1913.** "Zu einer Stelle in Rigauds Einnahmebuch." *Studien und Skizzen zur Gemäldekunde* 1 (Mar.): 7–8. **1913–14.** *Lexikon der Wiener Gemäldesammlungen.* 2 vols. Munich. **1918–19.** *Studien und Skizzen zur Gemäldekunde* 4.

Fritz, R. 1959. *Heinrich Aldegrever als Maler.* Dortmund.

Fritzsche, H.A. 1936. *Bernardo Belotto genannt Canaletto.* Burg.

Frizzoni, G. 1912. "Einige kritische Bemerkungen über italienische Gemälde in der Fürstlich Liechtensteinischen Galerie." *Jahrbuch der Kunsthistorischen Institutes der K. K. Zentral-Kommission für Denkmalpflege* 6: 83–98.

Fuhrmann, M. 1770. *Historische Beschreibung . . . von der Residenzstadt Wien und ihren Vorstädten.* Vol. 3 Vienna.

Gaborit, J. R. 1977. "À propos de l'Hercule de Fontainebleau." *Revue de l'art* 36: 57–60. **1984.** *see* Paris 1984b.

Gabrielli, N. 1971. *Galleria Sabauda: Maestri italiani.* Turin.

Gaffurius, F. 1968. *Practica musicae.* Translated and edited by C. Miller. American Institute of musicology, Rome. Studies and Documents, vol 20. Rome.

Gaibi, A. 1978. *Armi da fuoco italiani.* 2d ed. Milan.

Gamba, C. 1906. "Lorenzo Leombruno." *Rassegna d'arte* 6 (5): 65–70.

Gamber, O., and Beaufort-Spontin, C. 1978. *Curiositäten und Inventionen aus Kunst- und Rüstkammer.* Vienna.

Garas, K. 1955. "Ein unbekanntes Porträt der Familie Rubens auf einem Gemälde van Dycks." *Acta historiae academiae scientiarum hungaricae* 2: 189–200.

Gavazza, E. 1981. "Documenti per Filippo Parodi: L'altare del Carmine e la specchiera Brignole." *Arte lombarda* 58–59: 29–37.

Gazola, E. K., and Hanfmann, G. 1970. "Ancient Bronzes: Decline, Survival, Revival." In *Art and Technology: A Symposium on Classical Bronzes.* Cambridge, Mass.

van Gelder, J. G. 1927. "Some Unpublished Works by Jan Wellens de Cock." *Burlington Magazine* 51 (Aug.): 68–79. 1933. *Jan van de Velde, 1593–1641: Teekenaar-schilder.* The Hague.

Gelli, J. 1928. *Divise—motti e imprese di famiglie e personaggi italiani.* 2d ed. Milan.

Genoa. Palazzo Ducale. 1977. *Rubens e Genova.* (Exhib. cat.).

Gerson, H. 1950. *De nederlandse schilderkunst.* Vol. 1, *Van Geertgen to Frans Hals.* Amsterdam.

Gerson, H., and Goodison, J. W. 1960. *Catalogue of Paintings in the Fitzwilliam Museum, Cambridge.* Vol. 1, *Dutch and Flemish.* Cambridge.

Gerson, H., and ter Kuile, E. H. 1960. *Art and Architecture in Belgium 1600 to 1800.* Harmondsworth.

Gerszi, T. 1965. "Landschaftszeichnungen aus der Nachfolge Pieter Bruegels." *Jahrbuch der Berliner Museen* 7: 94–121. 1976. "Bruegels Nachwirkung auf die niederländischen Landschaftsmaler um 1600." *Oud Holland* 90: 201–29. 1982. "Pieter Bruegels Einfluss auf die Herausbildung der niederländischen See- und Küstenlandschaftsdarstellung." *Jahrbuch der Berliner Museen* 24: 143–87.

Gessner, A. 1948. "Schönbornepitaph." In *Jahrbuch der Bistums Mainz* 3.

Ghent. Musée des Beaux-Arts. 1954. *Roelandt Savery 1576–1639.* (Exhib. cat.).

Gibson, W. 1977. *The Paintings of Cornelis Engebrechtsz.* New York.

Giusti, A.-M.; Mazzoni, P; and Pampaloni Martelli, A. 1978. *Museo dell'opificio delle pietre dure a Firenze.* Milan.

Giustiniani, Vincenzo. 1631. *Galleria Giustiniana del Marchese Vincenzo Giustiniani.* Vol. 1. Rome.

Glück, G. 1905. "Über Entwürfe von Rubens zu Elfenbeinarbeiten Lucas Faidherbes." *Jahrbuch der Kunsthistorischen Sammlungen des Allerhöchsten Kaiserhauses* 25 (2): 73–79. 1923. *Die Fürstlich Liechtensteinsche Bildergalerie.* Vienna. 1931. *Van Dyck, des meisters Gemälde.* 2d ed. Klassiker der Kunst, vol. 13. Stuttgart. 1933. *Rubens, van Dyck und ihr Kreis.* Vienna.

Glück, G., and Burckhardt, J. 1940. *Die Landschaften von Peter Paul Rubens.* Vienna.

Göbel, H. 1923. *Wandteppiche.* Vol. 1, *Die Niederlande,* part 1. Leipzig.

Gobiet, R. 1984. *Der Briefwechsel zwischen Philipp Hainhofer und Herzog August d. J. von Braunschweig-Lüneburg.* Munich.

Goetz, W. 1889–90. "Ladislaus von Fraunberg, der letzte Graf von Haag." *Oberbayerisches Archiv für Vaterländische Geschichte* 46: 108–65.

Golson, L. 1957. "Lucca Penni, a Pupil of Raphael at the Court of Fontainebleau." *Gazette des Beaux-Arts* 6th ser., 50: 17–36.

Golzio, V. 1936. *Raffaello.* Vatican City

Gombrich, E. H. 1952. *Die Geschichte der Kunst.* Berlin.

Goodgal, D. 1978. "The Camerino of Alfonso I d'Este." *Art History* 1 (2): 162–90.

Goris, J. A., and Held, J. S. 1947. *Rubens in America.* New York.

Gottingen. 1977. *Rubens in der Grafik.* (Exhib. cat.).

Grancsay, S. V. 1970. *Master French Gunsmiths' Designs of the XVII–XIX Centuries.* New York.

Grassi, L. 1963. *Piero di Cosimo e il problema della conversione al cinquecento nella pittura fiorentina ed emiliana.* Rome.

Grazia Bohlin, D. de. 1979. *Prints and Related Drawings by the Carracci Family.* Washington, D.C.

Greindl, E. 1956. *Les peintres flamands de nature morte aux XVIIe siècle.* Brussels.

Grimschitz, B. 1944. *Wiener Barockpaläste.* Vienna.

Gronau, G. 1916. "Franciabigio." In Thieme-Becker 12: 325–27.

Gudlaugsson, S. J. 1959–60. *Gerard ter Borch.* 2 vols. The Hague.

Guilmard, L. 1974. *see* Paris 1974.

Gusler, W., and Lavin, J. 1977. *Decorated Firearms 1540–1870 from the Collection of Clay P. Bedford.* Williamsburg, VA.

Haak, B. 1984. *The Golden Age: Dutch Painters of the Seventeenth Century.* New York.

Haarløv, B. 1975. *New Identifications of Third Century Roman Portraits.* Odense.

Haberditzl, F. M. 1911–12. "Studien über Rubens." *Jahrbuch der Kunsthistorischen Sammlungen des Allerhöchsten Kaiserhauses* 30 (1): 257–97.

Haberfeld, H. 1900. *Piero di Cosimo.* Dissertation. Breslau.

Haendcke, B. 1902. "Matthias Rauchmüller, der Bildhauer." *Repertorium für Kunstwissenschaft* 25: 89–97.

Hairs, M.-L. 1955. *Les peintres flamands de fleurs au XVIIe siècle.* Paris.

Harris, M. 1981. *The Heart of Boswell.* New York.

Haskell, F., and Penny, N. 1981. *Taste and the Antique: The Lure of Classical Structure, 1500–1900.* New Haven.

Haupt, H. 1983. *Fürst Karl I. von Liechtenstein, Hofstaat und Sammeltätigkeit: Obersthofmeister Kaiser Rudolfs II. und Vizekönig von Böhmen.* 2 vols. Vienna.

Hausenstein, W. 1923. *Das Bild Atlanten zur Kunst.* Vol. 7, *Tafelmalerei der alten Franzosen.* Munich.

Haverkamp-Begemann, E. 1959. *Willem Buytewech.* Amsterdam.

Haverkamp-Begemann, E., and Logan, A.-M. 1970. *European Drawings and Watercolors in the Yale University Art Gallery 1500–1900.* New Haven.

Haverkorn van Rijsewijk, P. 1910. "Pieter de Bloot." In Thieme-Becker, vol. 4: 138.

Hayward, J. F. 1952. *Viennese Porcelain of Du Paquier Period.* London. 1962–63. *The Art of the Gunmaker.* 2 vols. London.

Heer, E. 1978–82. *Der Neue Støckel: Internationales Lexikon der Büchsenmacher, Feuerwaffenfabrikanten und Armbrustmacher von 1400–1900.* 3 vols. Schwäbisch Hall.

Heimbürger Ravalli, M. 1973. *Alessandro Algardi, scultore.* Rome.

Helbig, K. F. W. 1972. *Führer durch die öffentlichen Sammlungen klassischer Altertümer in Rom.* Vol. 4, *Die staatlichen Sammlungen: Museo Ostiense; Museo der Villa Hadraian in Tivoli; Villa Albani.* 4th ed. Edited by H. Speier. Tübingen.

Held, J. S. 1958. "Le roi à la chasse." *Art Bulletin* 40 (June): 139–49. 1959. *Rubens: Selected Drawings.*

Vol. 1. Garden City. 1969. "Rembrandt and the Book of Tobit." In *Rembrandt's Aristotle and Other Rembrandt Studies,* by J. S. Held. Princeton. 1975. "On the Date and Function of Some Allegorical Sketches by Rubens." *Journal of the Warburg and Courtauld Institutes* 38: 218–33. 1976. "Zwei Rubensprobleme: Die Kekropstöchter und die Wunder des Hl. Franz von Paola." *Zeitschrift für Kunstgeschichte* 39 (1): 35–53. (Reprinted as "The Daughters of Cecrops" in Held, 1982). 1980. *The Oil Sketches of Peter Paul Rubens: A Critical Catalogue.* Princeton. 1981. "Rubens' Oelskizzen: Ein Arbeitsbericht." In Munich. *Peter Paul Rubens: Werk und Nachruhm.* 1982. *Rubens and His Circle.* Princeton.

Hempel, E. 1965. *Baroque Art and Architecture in Central Europe.* Baltimore.

Henkel, A., and Schöne, A., eds. 1967. *Emblemata: Handbuch zur Sinnbildkunst des XVI. und XVII. Jahrhunderts.* Stuttgart.

Heppner, A., 1946. "Rotterdam as the Centre of a 'Dutch Teniers Group'." *Art in America* 34 (Jan.): 14–30.

Herbet, F. 1900. "Les graveurs de l'école de Fontainebleau." From *Annales de la Société Historique et Archéologique du Gatinas,* part 4.

Herding, K. 1970. *Pierre Puget: Das bildnerische Werk.* Berlin.

Hermann, H. J. 1910. "Pier Jacopo Alari-Bonacolsi, genannt Antico." *Jahrbuch der Kunsthistorischen Sammlungen des Allerhöchsten Kaiserhauses* 28 (5): 201–88. 1936. *Untersuchungen über die Landschaftsgemälde des Peter Paul Rubens.* Stuttgart.

Hobson, G. D. 1970. *Les Reliures à la fanfare: Le problème de l'S fermé.* 2d ed. Amsterdam.

Hoff, A. 1978. *Dutch Guns and Pistols.* London.

Hofstede de Groot, C. 1908–27. *A Catalogue Raisonné of the Works of the Most Eminent Dutch Painters of the Seventeenth Century, Based on the Work of John Smith.* Translated and edited by E. G. Hawke. 8 vols. London. 1927. "Salomon Koninck." In Thieme-Becker 21: 274–76.

Hollstein, F. W. H. n. d. *German Engravings, Etchings and Woodcuts ca. 1400–1700.* Vol. 3. Amsterdam. 1956–80. *Dutch and Flemish Etchings, Engravings and Woodcuts, ca. 1450–1700.* Vols. 14, 21, 22. Edited by K. G. Boon. Amsterdam.

Hoogewerff, G. J. 1939. *De Noord-Nederlandsche schilderkunst.* Vol. 3. The Hague.

van Hoogstraten, S. 1678. *Inleyding tot de hooge schoole der schilder-konst anders de zichtbaere werelt.* Rotterdam.

Horský, Z., and Škopová, O. 1968. *Astronomy Gnomonies.* Prague.

Höss, K. 1908. *Fürst Johann II. von Liechtenstein und die bildende Kunst.* Vienna.

Houbraken, A. 1718–21. *De groote schouburgh der Nederlantsche konstschilders en schilderessen.* 3 vols. Amsterdam.

Hulin, G. 1904. *L'exposition des "Primitifs français" au point de vue de l'influence des frères van Eyck sur la peinture française et provençale.* Brussels.

Hülsen, C., and Egger, H., eds. 1916. *Die römischen Skizzenbücher von Marten van Heemskerck im Königlichen Kupferstichkabinett zu Berlin.* 2 vols. Berlin.

Hulst, R. A. d'. 1974. *Jordaens Drawings.* Vol. 2 London. 1982. *Jacob Jordaens.* London.

Ilg, A. 1883. "Adrian de Fries." *Jahrbuch der Kunsthistorischen Sammlungen des Allerhöchsten Kaiserhauses* 1 (1): 118–48.

Illustrated Bartsch 1979. Vol. 33. Edited by H. Zerner. New York.

Irwin, D. 1968. "Angelica Kauffmann and Her Times." Review of Bregenz 1968. *Burlington Magazine* 110 (Sept.): 533–37.

Jaffé, M. 1965. "Rubens as a Draughtsman." *Burlington Magazine* 107 (July): 372–81. 1966. *Antwerp Sketchbook* [of van Dyck]. Vol. 2. London. 1977. *Rubens and Italy*. Oxford.

Janitschek, H. 1890. *Geschichte der deutschen Malerei*. Berlin.

Jarlier, P. 1976. *Répertoire d'arquebusiers et de fourbisseurs français*. Saint-Julien-du-Sault. 1981. *Répertoire d'arquebusiers et de fourbisseurs français*. 2d supplement. Saint-Julien-du-Sault.

Jestaz, B., and Bacou, R. 1978. *see* Paris 1978.

Jongh, E. de. 1974. "Grape Symbolism in Paintings of the 16th and 17th Centuries." *Simiolus* 7 (4): 166–91.

Jost, I. 1964. "Bemerkungen zur Heinrichsgalerie des P. P. Rubens." *Nederlands kunsthistorisch jaarboek* 15: 175–219.

Judson, J. R., and van de Velde, C. 1978. *Book Illustrations and Title Pages I*. Corpus Rubenianum Ludwig Burchard, part 21. London.

Just, R. 1961. "Die frühesten Erzeugnisse Du Paquiers." *Keramik-Freunde der Schweiz, Mitteilungsblatt* 55 (Aug.): 27–33.

K. d. K. 1921. *see* Rosenberg, A. 1921. 1931. *see* Glück, H. 1931.

Karlsruhe. Badisches Landesmuseum. 1955. *Der Türkenlouis*. (Exhib. cat.).

Kauffmann, H. 1923. "Die Farbenkunst des Aert van der Neer." In *Festschrift für Adolph Goldschmidt zum 60. Geburtstag*: 106–10. Leipzig. 1940–53. "Dürer in der Kunst und in Kunsturteil um 1600." *Anzeiger des germanischen National-Museums*: 18–60.

Kienbusch, C. O. von. 1963. *see* Princeton 1963.

Kennard, A. N. 1956. "Two Sporting Guns in the Scott Collection." *Scottish Art Review* 6 (1): 22–25.

Kettering, A. M. 1983. *The Dutch Arcadia*. Montclair.

Keutner, H. 1978. *see* Edinburgh 1978.

Keyes, G. S. 1984. *Esaias van den Velde 1587–1630*. Doornspijk.

Kieser, E. R. 1926. *Die Rubenslandschaft*. Rudolstadt. 1933. "Antikes im Werke des Rubens." *Münchner Jahrbuch der bildenden Kunst*. n.s. 10 (1–2): 110–37.

Kisch, M. R. 1984. "The King's Crown: A Popular Print for Epiphany." *Print Quarterly* 1: 43–46, 51.

Klapsia, H. 1944. "Dionysio Miseroni." *Jahrbuch der Kunsthistorischen Sammlungen in Wien* n.s. 13: 301–58.

Klauner, F. 1949–50. "Zur landschaft Jan Brueghel d.Ä." *Nationalmusei Arsbok*: 5–28.

Kleinschmidt, B. 1930. "Die heilige Anna, ihre Verehrung." In *Geschichte, Kunst und Volkstum*. Düsseldorf.

Klinge, M. 1976. "Herman Saftleven als Zeichner und Maler bäuerlicher Interieurs." *Wallraf-Richartz-Jahrbuch* 38: 68–91.

Knapp, F. 1899. *Piero di Cosimo: Ein Übergangsmeister vom Florentiner Quattrocento zum Cinquecento*. Halle. 1911. "Bugiardini." In Thieme-Becker 5: 207–8.

Knipping, J. B. 1974. *Iconography of the Counter Reformation in the Netherlands*. Vol. 2. Nieuwkoop.

Knofler, M. J. 1979. *Das Theresianische Wien: Der Alltag in den Bildern Canalettos*. Vienna.

Knuttel, G. 1962. *Adriaen Brouwer: The Master and His Work*. The Hague.

Koch, R. 1968. *Joachim Patinir*. Princeton.

Koella, R. 1975. *Sammlung Oskar Reinhart*. Zürich.

Koepplin, D., and Falk, T. 1974. *see* Basel 1974.

Köllman, E. 1966. *Berliner Porzellan 1763–1963*. 2 vols. Braunschweig.

Kosel, K. 1967. "Neues Material zum Werk J. H. Schönfelds." *Pantheon* 25: 368–73.

Kozakiewicz, S. 1972. *Bernardo Bellotto genannt Canaletto*. 2 vols. Recklinghausen.

Kraehling, V. 1938. *Saint Sebastien dans l'art*. Paris.

Krapf, M. 1980. *see* Vienna 1980.

Krčálová, J., and Aschengreen-Piacenti, K. 1979. *Dizionario biografico degli Italiani*. Vol. 22. Rome.

Kreisel, H. 1968. *Die Kunst des deutschen Möbels*. Vol. 1. Munich.

Krenn, P. 1983. "Eine Gruppe von Augsburger Doppelschlossmusketen der Spätrenaissance im Landeszeughaus Graz." *Waffen- und Kostümkunde* 25 (1): 42–53.

Kronfeld, A. 1931. *see* Cat. 1931.

Krönig, W. 1968. "Matthias Stomer's *Anbetung der Hirten* in Monreale." In *Miscellanea Jozef Duverger*, vol 1: 289–300. Ghent.

Kunstchronik 1907–08. "Rubens' Decius-Zyklus in der Liechtensteingalerie." In *Kunstchronik* n. F. 19.

Künstler, G. 1975. "Jean Fouquet als Bildnismaler." *Wiener Jahrbuch für Kunstgeschichte* 28: 26–35.

Kunstmarkt 1907. *Der Kunstmarkt*. Vol. 4.

Kurz, O. 1955. *Bolognese Drawings of the XVII and XVIII Centuries in the Collection of Her Majesty the Queen at Windsor Castle*. London.

Laborde, L. de. 1852. *Notice des émaux exposés dans les galeries du Musée du Louvre*. Vol. 1. Paris.

Laclotte, M., and Thiébaut, D. 1983. *L'école d'Avignon*. Paris.

Lafenestre, G. E. 1905. *Jehan Fouquet*. Paris.

Lafond, P. 1914. *Hieronymus Bosch*. Brussels.

Landais, H. 1949. "Musée du Louvre: Sur quelques statuettes leguées par Le Notre à Louis XIV et conservées au Département des objets d'art." *Musées de France* (April): 60–63. 1958. *Les bronzes italiens de la Renaissance*. Paris.

Lane, A. 1954. *Italian Porcelain: With a Note on Buen Retiro*. London.

Langedijk, K. 1981–83. *The Portraits of the Medici*. 2 vols. Florence.

Lankheit, K. 1962. *Florentinische Barockplastik: Die Kunst am Hofe der letzten Medici, 1670–1743*. Munich. 1982. *Die Modellsammlung der Porzellan-Manufactur Doccia*. Munich.

Lanzi, L. 1795–96. *Storia pittorica della Italia*. 2 vols. Bassano.

Larsen, E. 1964. "A Self-Portrait by Godfried Schalcken." *Oud Holland* 79: 78–79. 1967. "Some New van Dyck Materials and Problems." *Raggi* 7: 1–14. 1980. *L'opera completa di van Dyck*. Vol. 1. Milan.

Larsson, L. O. 1967. *Adriaen de Vries*. Vienna. 1982. "Bildhauerkunst und Plastik am Hofe Kaiser Rudolfs II." In *Leids kunsthistorisch jaarboek* 1.

Laurent, M. 1923. "Quelques oeuvres inédites de François Duquesnoy." *Gazette des Beaux Arts* 7 (May): 295–305.

Lavin, J. D. 1967. "The French Pattern Book of Nicholás Bis, Gunsmith to Felipe V of Spain." *Connoisseur* 165 (Aug.): 274–79.

Lavin, M. A. 1955. "Giovannino Battista: A Study in Renaissance Religious Symbolism." *Art Bulletin* 37 (June): 85–101. 1965. "An Attribution to Abraham Bloemaert: *Apollo and Daphne*." *Oud Holland* 80: 123–25.

Lawrence, Kansas. Spencer Museum of Art. 1981. *The Engravings of Marcantonio Raimondi*, by I. H. Shoemaker and E. Brown. (Exhib. cat.).

Lawrence, M. 1961. "Three Pagan Themes in Christian Art." In *Essays in Honor of Erwin Panofsky*, edited by M. Meiss. Vol. 1. New York.

Leber, F. O. von. 1856. "Archaeologische Beschreibung einiger Ritterburgen und Schlossruinen im Kreise unter dem Wienerwald: Sebenstein." *Berichte und Mittheilungen des Altertums- Vereins zu Wien* 1: 159–82.

Leeuwenberg, J., ed. 1973. *Beeldhouwkunst in het Rijksmuseum*. Amsterdam.

Legner, A. 1967. "Anticos Apoll vom Belvedere." *Städel-Jahrbuch* n.s. 1: 102–8.

Legrand, F. C. 1963. *Les peintres flamands de genre au XVIIe siècle*. Brussels.

Leisching, E. 1912. "Theresianischer und Josefinischer Stil." *Kunst und Kunsthandwerk* 10: 493–563.

Leithe-Jasper, M., and Distelberger, R. 1982. *The Kunsthistorisches Museum, Vienna*. London.

Lemoisne, P. A. 1931. *Gothic Painting in France: Fourteenth and Fifteenth Centuries*. Florence.

Lenk, T. R. 1965. *The Flintlock: Its Origins and Development*. Edited by J. F. Hayward. London.

Leppert, R. D. 1978. "David Teniers the Younger and the Image of Music." *Jaarboek van het Koninklijk Museum voor Schone Kunsten, Antwerp*: 63–155.

Leprieur, P. 1897. "Jean Fouquet IV." *La revue de l'art ancien et moderne* 2 (Nov.): 347–59. 1907. "Les récentes acquisitions du Département des peintures au Musée du Louvre (1906)." *Gazette des Beaux Arts* 49e ann., 37 (Jan.): 5–24.

Levenson, J. A. 1973. *see* Washington, D.C. 1973.

Levetus, A. S. 1923. "Bernardo Bellotto Canaletto in Vienna." *Studio* 86 (Sept.): 123–27.

Lhotsky, A. 1945. *Festschrift des Kunsthistorischen Museums zur Feier des fünfzigjährigen Bestandes*. Vol. 2. Vienna.

Liedtke, W. A. 1982–83. "Jordaens and Rombouts in a New York Collection." *Tableau* 5: 289–90. 1984a. *Flemish Paintings in the Metropolitan Museum of Art*. New York. 1984b. "Toward a History of Dutch Genre Painting." In *De arte et libris: Festschrift Erasmus 1934–84*: 317–336. Amsterdam.

Lipparini, G. 1913. *Francesco Francia*. Bergamo.

Lippold, G. 1963. *Bernardo Bellotto genannt Canaletto*. Leipzig.

Lisner, M. 1980. "Form und Sinngehalt von Michelangelos Kentaurenschlacht mit Notizen zu Bertoldo di Giovanni." *Mitteilungen des Kunsthistorischen Institutes in Florenz* 24 (3): 299–344.

Liverpool. Walker Art Gallery. 1957. *Bernardo Bellotto 1720–1780: An Exhibition of Paintings and Drawings from the National Museum of Warsaw*. (Exhib. cat.).

Lombardi, G. 1979. "Giovan Francesco Susini." *Annali della Scuola normale di Pisa* 3d ser. 9 (2): 759–90.

London 1955. A. Seilern. *Flemish Paintings and Drawings at 56 Princes Gate London SW 7*. 1971. A. Seilern. *Corrigenda and Addenda to the Catalogue of Paintings and Drawings at 56 Princes Gate London SW 7*. 1977. National Portrait Gallery. *"The King's Good Servant" Sir Thomas More 1477/8–1535*, by J. B. Trapp and H. S. Herbruggen. (Exhib. cat.). 1980. Victoria and Albert Museum. *Princely Magnificence: Court Jewels of the Renaissance, 1500–1630*. (Exhib. cat.). 1981. Victoria and Albert Museum.

Splendors of the Gonzaga. (Exhib. cat.). **1982.** Royal Academy of Arts. *Painting in Naples 1606–1705: From Caravaggio to Giordano.* (Exhib. cat.). **1983.** Sotheby Parke Bernet & Co. *The Hever Castle Collection.* Vol. 2 (Sale cat. of May 6). **1984.** Heim Gallery. *Paintings & Sculpture of Three Centuries: Autumn Exhibition.* (Exhib. cat.).

Longhi, R. 1955. "Percorso di Raffaello Giovine." *Paragone arte* anno 6 (65): 8–23.

Lonjon, M. 1983. *see* Avignon 1983.

Los Angeles. Los Angeles County Museum of Art. 1981. *A Mirror of Nature: Dutch Paintings from the Collection of Mr. and Mrs. Edward William Carter.* (Exhib. cat.). **1982.** *The Art of Mosaics: Selections from the Gilbert Collection.* 2d ed. (Exhib. cat.).

Lubbecke, F., and Wolff, P. 1931. *Alt-Frankfurt.* Frankfurt-am-Main.

Lucerne. Kunstmuseum. 1948 and 1950. *see* Cat. 1948 and Cat. 1950.

McGrath, E. 1978. "The Painted Decoration of Rubens's House." *Journal of the Warburg and Courtauld Institutes* 41: 245–77.

McKillop, S. 1974. *Franciabigio.* Berkeley.

Maclagan, E. R. D. 1920. "Notes on Some Sixteenth and Seventeenth Century Italian Sculpture." *Burlington Magazine* 36 (May): 234–45.

McLaren, N. 1936. "A Rubens Landscape for the National Gallery." *Burlington Magazine* 68 (May): 207–13.

McNairn, A. 1980. *The Young van Dyck.* Ottawa.

Madsen, S. T. 1953. "Some Recently Discovered Drawings by Rubens." *Burlington Magazine* 95. (Sept.): 304–5.

Mallé, L. 1955. "Quinten Metsys." *Commentari* 6 (2): 79–107.

Mallet, J. V. G. 1968. "The Earliest Vienna Porcelain Figures." *Victoria and Albert Museum Bulletin* 4 (Oct.): 117–27.

van Mander, C. 1604. *Het schilder-boeck. . . .* Haarlem.

Manners, V., and Williamson, G. C. 1924. *Angelica Kauffmann, R. A.: Her Life and Her Works.* London.

Mansuelli, G. A. 1961. *Galleria degli Uffizi: Le sculture.* Vol. 2. Rome.

Manteuffel, K. Z. von. 1916. "Joos van Craesbeeck." *Jahrbuch der Königlich Preussischen Kunstsammlungen* 37: 315–37. **1969.** *Die Bildhauerfamilie Zürn, 1606–1666.* Vol. 2 Weissenhorn.

Marder, T. 1980. "The Porto di Ripetta in Rome." *Journal of the Society of Architectural Historians* 39: 28–56.

van Marle, R. 1923–38. *The Development of the Italian Schools of Painting.* 19 vols. The Hague.

Marquet de Vasselot, J. J. 1914. *Catalogue sommaire de l'orfèvrerie, de l'émaillerie, et des gemmes du Moyen âge au XVIIᵉ siècle.* Louvre, Paris.

Martin, G. 1966. "Rubens and Buckingham's 'Fayrie Ile'." *Burlington Magazine* 108 (Dec.): 613–18. **1970.** *The Flemish School ca. 1600–ca. 1900.* National Gallery Catalogues. London.

Mattingly, H. 1923. *Coins of the Roman Empire in the British Museum.* London.

Mayer, A. 1929. "Bernhard Strigel als Porträtmaler." *Pantheon* 3 (1): 1–10.

van der Meer, J. H. 1983. *Musikinstrumente.* Munich.

Menz, H. 1965. *see* Vienna 1965.

Meyerson, Å., and Rangström, L. 1984. *Wrangel's Armoury: The Weapons Carl Gustaf Wrangel Took from Wismar and Wolgast to Skokloster, in 1645 and 1653.* Uddevalla.

Mezzetti, A. 1962. *see* Bologna 1962.

Middeldorf, U. 1978. "Ein Frühwerk von Georg Petel." *Münchner Jahrbuch der bildenden Kunst* 3d ser., 29: 49–64.

Miller, D. 1957. "Franceschini and the Palazzo Podestà, Genoa." *Burlington Magazine* 99 (July): 230–35. **1961.** "Important Drawings by Marcantonio Franceschini at Cooper Union." *Art Bulletin* 43 (June): 133–34. **1971.** "Some Unpublished Drawings by Marcantonio Franceschini and a Proposed Chronology." *Master Drawings* 9: 119–38. **1979.** "Franceschini's Drawings for the Liechtenstein Garden Palace." *Record of the Art Museum, Princeton University* 38 (1): 2–8. **1982.** "Franceschini's Decorations for the Capella del Coro, St. Peter's: Bolognese and Roman Classicism." *Burlington Magazine* 124: 487–92. **1983.** "An Album of Drawings by Marcantonio Franceschini in the Accademia Carrara at Bergamo." *Master Drawings* 21 (1): 20–32.

Ministero della Pubblica Istruzione, Italy. 1880. *Documenti inediti per servire alla storia dei musei d'Italia.* Vol. 3, *Inventario delle statue di marmo e bronzo, delle miniature ecc. che sono al presente nel Casino di S.A. Ser.ma fuori di Porta Castello, anno 1684.* Florence.

Mirimonde, A. P. de. 1965. "Les sujets de musique chez les Caravaggistes flamands." *Jaarboek van het Koninklijk Museum voor Schone Kunsten, Antwerp:* 113–73.

Missong, A. 1882. *Die Münzen des Fürstenhauses Liechtenstein.* Reprint. With an introduction by N. Heutger. Vaduz, 1983.

Mitsch, E. 1977. *Die Rubenszeichnungen der Albertina.* Vienna.

Modern, H. 1896. "Der Mömpelgarter Flügelaltar des Hans Leonhard Schäufelein und der Meister von Messkirch." *Jahrbuch der Kunsthistorischen Sammlungen des Allerhöchsten Kaiserhauses* 17 (1): 307–97.

Moes, E. W. 1910. "Abraham Bloemaert." In Thieme-Becker 4: 125–26.

Molinier, E., ed. 1898. *Collection Charles Mannheim: Objets d'art.* Paris.

Moltke, J. W. von. 1965. *Govaert Flinck 1615–1660.* Amsterdam.

Montagu, J. 1981. "Made for a Prince." *Connaissance des arts* n.s. 13 (Feb.): 32–37.

Montaiglon, A. de, ed. 1886. *Procès-verbaux de l'Académie Royale de Peinture et de Sculpture 1648–1793.* Vol. 7, *1756–1768.* Paris.

Montaiglon, A. de, and Guiffrey, J., eds. 1901. *Correspondance des directeurs de l'Académie de France à Rome, avec les surintendants des bâtiments.* Vol. 11, *1754–1763.* Paris.

Morelli, G. 1891. *Kunstkritische Studien über italienische Malerei.* Vol. 1. Leipzig.

Morselli, P. 1957. "Ragioni di un pittore fiorentino: Piero di Cosimo." *L'arte* 21: 125–59. **1958.** "Piero di Cosimo: Saggio di un catalogo delle opere." *L'arte* 23: 67–92.

Mrazek, W. 1970. *see* Vienna 1970.

Müller, C. 1927. "Abraham Bloemaert als Landschaftsmaler." *Oud Holland* 44: 193–208.

Müller, H. n.d. *Guns, Pistols, Revolvers.* New York.

Muller, J. A. 1926. *Stephen Gardiner and the Tudor Reaction.* London.

Müller-Hofstede, J. 1962. "Opmerkingen bij enige tekeningen van Rubens in het Museum Boymans-van Beuningen." *Bulletin Museum Boymans-van Beuningen* 13 (3): 86–118. **1965.** "Rubens St. Georg und seine frühen Reiterbildnisse." *Zeitschrift für Kunstgeschichte* 28: 69–112. **1967.** "Aspekte der Entwurfszeichnung bei Rubens." In *Stil und Ueberlieferung in der Kunst des Abendlandes.* Vol. 3: 114–25. Berlin. Akten der 21. Internationalen Kongresses für Kunstgeschichte, Bonn, 1964. **1968.** "Rubens und Jan Brueghel: Diana und ihre Nymphen." *Jahrbuch der Berliner Museen* 10: 200–252. **1969.** "Neue Ölskizzen von Rubens." *Staedel-Jahrbuch* n.F. 2: 189–242.

Munch, G. 1966. "Kaspar von Lohenstein und Matthias Rauchmiller." *Jahrbuch der Schlesischen Friedrich-Wilhelms-Universität zu Breslau* 11: 51–62.

Munch, R. 1980. *Die Reichsgrafschaft Haag.* Haag.

Munich 1906. Galerie Helbing. *Sammlung Professor Egon Ritter von Oppolzer, Innsbruck.* (Sale cat. of Dec. 3). **1938.** *Albrecht Altdorfer und sein Kreis.* (Exhib. cat.). **1966.** Bayerisches Nationalmuseum. *Meissener Porzellan 1710–1810,* by R. Rückert. (Exhib. cat.). **1972.** Münchner Stadtmuseum. *Bayern: Kunst und Kultur.* (Exhib. cat.). **1976.** Schloss Schleissheim. *Kurfürst Max Emanuel: Bayern und Europa um 1700.* 2 vols. (Exhib. cat.). **1977.** Staatliche Graphische Sammlung. *Italienische Zeichnungen des 16–18 Jahrhunderts,* by P. Dreyer. (Exhib. cat.). **1980.** Residenzmuseum. *Um Glauben und Reich: Kurfürst Maximilian I.* (Exhib. cat.). **1981.** Zentralinstitut für Kunstgeschichte. *Peter Paul Rubens: Werk und Nachruhm.*

Münster. Westfälisches Landesmuseum für Kunst und Kulturgeschichte. 1980. *Stilleben in Europa.* (Exhib. cat.).

Münz, L. 1961. *Brueghel: The Drawings.* London.

Murr, C. T. de. 1797. *Description du cabinet de Monsieur Paul de Praun à Nuremberg.* Nuremburg.

Nagler, G. 1842. *Allgemeines Künstler-Lexikon.* Munich. **1858.** *Die Monogrammisten.* Vol. 1. Munich.

Natale, M. 1978. *see* Pfäffikon 1978.

Naumann, O. 1983. *see* New York. 1983.

Nava Cellini, A. 1966a. "Duquesnoy e Poussin: Nuovi contributi." *Paragone* 195: 30–59. **1966b.** *Duquesnoy.* Milan.

Neubauer, E. 1980. *Wiener Barockgärten in zeitgenössischen Veduten.* Dortmund.

Neubecker, O. 1973. "Fahne." In *Reallexikon zur deutschen Kunstgeschichte* 6: cols. 1060–1168.

Neumann, E. 1957. "Florentiner Mosaik aus Prag." *Jahrbuch der Kunsthistorischen Sammlungen in Wien* n.s. 17: 157–202.

New York 1944. Parke-Bernet Galleries. *Gothic and Renaissance Art: Property from the Estate of Stanley Mortimer, New York.* (Sale cat. of Dec. 2). **1946.** Wildenstein. *French Painting of the Time of Louis XIIIth and Louis XIVth.* (Exhib. cat.). **1983.** Hoogsteder-Naumann, Ltd. *A Selection of Dutch and Flemish Seventeenth-Century Paintings.* (Exhib. cat.). **1984.** Metropolitan Museum of Art. *The Jack and Belle Linsky Collection in The Metropolitan Museum of Art.*

Nicola, G. de. 1917. "Notes on the Museo Nazionale of Florence: IV." *Burlington Magazine* 31 (Nov.): 174–77. **1921.** "Due dipinti senesi della collezione Liechtenstein." *Bollettino d'arte* 1: 243–45.

Nicolson, B. 1977. "Stomer Brought Up-to-Date." *Burlington Magazine* 119 (Apr.): 230–45. **1979.** *The International Caravaggesque Movement.* London.

Niemeyer, J. W. 1959. "Het topografisch element in enkele riviergezichten van Salomon van Ruysdael nader beschouwd." *Oud Holland* 74: 51–56.

Norman, A. V. B., and Barne, C. 1980. *The Small Sword and Rapier 1480–1820*. London.

Northampton, Mass. Smith College Museum of Art. 1941. *Italian Drawings, 1330–1780.* 1978. *Antiquity in the Renaissance*. (Exhib. cat.).

Oldenbourg, R. 1916. "Rubens in Italien." *Jahrbuch der Königlich Preussischen Kunstsammlungen* 37 (3): 262–86. 1918. *Die flämische Malerei des 17. Jahrhunderts*. Handbücher der Königlichen Museen zu Berlin.

Oppolzer, E. 1906. *Katalog einer Kunstsammlung*. Munich.

Ortolani, S. 1945. *Raffaello*. 2d ed. Bergamo.

van Os, H. W., and Prakken, M. 1974. *The Florentine Paintings in Holland, 1300–1500*. Maarssen.

Osten, G. von der, and Vey, H. 1969. *Painting and Sculpture in Germany and the Netherlands, 1500 to 1600*. London.

Otto, G. 1964. *Bernhard Strigel*. Munich.

Padron, M. D. 1975. *Museo del Prado: Catalogo de pinturas, escuela flamenca, siglo XVII*. Madrid.

Pallucchini, R. 1960. *La pittura veneziana del settecento*. Venice.

Palme, P. 1956. *Triumph of Peace: A Study of the Whitehall Banqueting House*. Stockholm.

Pannier, G. 1910. "Catalogue des oeuvres peintes par Hubert Robert qui ont passé en vente publique depuis 1770 jusqu'en 1909." In *Hubert Robert 1733–1808*, by Pierre de Nolhac: 91–165. Paris.

Panofsky, E. 1930. *Hercules am Scheidewege und andere antike Bildstoffe in der neueren Kunst*. Leipzig. 1953. *Early Netherlandish Painting: Its Origins and Character*. Vol. 1. Cambridge, Mass. 1966. "Good Government" or Fortune?: The Iconography of a Newly-Discovered Composition by Rubens." *Gazette des Beaux-Arts* ser. 6, 68 (Dec.): 305–26. 1969. *Problems in Titian, Mostly Iconographic*. London.

Paoletti di Osvaldo, P. 1893. *L'architettura e la scultura del rinascimento in Venezia*. Vol. 1. Venice.

Pappenheim, L. F. von. 1956. "Die Rennfahne der Fürsten zu Liechtenstein." Private publication without title. Simbach am Inn.

Paris 1772. *Catalogue des tableaux qui composent le cabinet de Monseigneur le Duc de Choiseul*. (Sale cat. of April 6–10). 1774. *Catalogue de tableaux . . . composent le cabinet de M. 1. C. de Du Barry*. (Sale cat. of Nov. 21). 1881. Galerie Georges Petit. *Catalogue de tableaux de premier ordre anciens & modernes composant la galerie de M. John W. Wilson*. (Sale cat. of Mar. 14–16). 1889. Galerie Charles Sedelmeyer. *Catalogue de tableaux anciens et modernes, aquarelles et dessins et objets d'art formant la célèbre collection de M. E. Secrétan*. (Sale cat. of July 1). 1904a. Louvre. Département des objets d'art du Moyen âge, de la Renaissance, et des temps modernes. *Catalogue des bronzes et cuivres*. 1904b. Louvre. *Exposition des primitifs français au Palais du Louvre et à la Bibliothèque nationale*, by H. Bouchot and L. Delisle. (Exhib. cat.). 1933. Musée de l'Orangerie. *Exposition Hubert Robert 1733–1808: À l'occasion du deuxième centenaire de sa naissance*, by C. Sterling. (Exhib. cat.). 1965. Louvre. *Peintures: École française XIVe, XVe et XVIe siècles*. 1974. Hôtel de la Monnaie. *Louis XV: Un moment de perfection de l'art français*. Entry by L. Guilmard. (Exhib. cat.). 1975. Louvre. Département des peintures, des dessins, et de la chalcographie. *Le stu-*

diolo d'Isabelle d'Este, by S. Béguin. (Exhib. cat.). 1978. Grand Palais. *Jules Romain: L'histoire de Scipion, tapisseries et dessins*. (exhib. cat.). 1984a. Hôtel de la Monnaie. *Diderot & l'art de Boucher à David: Les Salons, 1759–1781*. Entry by M. Roland-Michel. (Exhib. cat.). 1984b. Louvre. Département de la sculpture. *Nouvelles acquisitions du Département des sculptures, 1980–1983*, by J. R. Gaborit.

Parry, G. 1981. *The Golden Age Restored: The Culture of the Stuart Court 1603–1642*. Manchester.

Parthey, G. 1863–64. *Deutscher Bildersaal*. 2 vols. Berlin.

Pascoli, L. 1736. *Vite de' pittore, scultori, ed architetti moderni. . . .* Vol. 2. Rome

Pasetti, M. 1978. "Lorenzo Leombruno in un documento del 1499." *Civiltà mantovana* 12 (71–72): 237–44.

Passavant, G. 1967. *Studien über Domenico Egidio Rossi und seine baukünstlerische Tätigkeit innerhalb des süddeutschen und österreichischen Barock*. Karlsruhe.

Passavant, J. D. 1836. *Tour of a German Artist in England*. London. 1839. *Raphael von Urbino und sein Vater Giovanni Santi*. Vol. 2. Leipzig. 1860. *Raphael d'Urbin et son père Giovanni Santi*. Vol. 2. Paris.

Passeri, G. B. 1934. *Die Künstlerbiographien. . . nach den Handschriften des Autors*. Edited by J. Hess. Leipzig. (First pub. in Rome under title: Vite de' pittori, scultori, e architetti, che hanno lavorato in Roma e che son morti dal 1641 al 1673.)

Pauli, G. 1907. "Heinrich Aldegrever." In Thieme-Becker 1: 240–43. 1931–32. "Aldegrever als Bildnismaler." *Zeitschrift für bildende Kunst* 65: 45–48.

Pauri, G. 1915. *I Lombardi—Solari e la scuola recanatese di scoltura (sec. XVI–XVII)*. Milan.

Pauwels, H. 1953. "De schilder Matthias Stomer." *Gentse bijdragen* 14: 139–92.

Pée, H. 1971. *Johann Heinrich Schönfeld: Die Gemälde*. Berlin.

Pelka, O. 1920. *Elfenbein*. Berlin.

Perina, C., and Marani, E. 1961. *Mantova: Le arti*. Vol. 2, *Dall'inizio des secolo XV alla meta del XVI*. Mantua.

Perkins, F. M. 1909. "Su certe pitture sconosciute di Naddo Ceccarelli." *Rassegna d'arte senese* 5 (1–2): 5–14. 1931. "Pitture senesi poco conosciute, III." *La Diana* 6 (1): 10–36.

Perls, K. G. 1935. "Une oeuvre nouvelle du Maître de 1456." *L'amour de l'art* 16: 313–18. 1940. *Jean Fouquet*. London.

Petrasch, E. 1960. "Über einige Jagdwaffen mit Elfenbeinschnitzerei im Badischen Landsmuseum, Marginalien zum Werk des Büchsenschäfters Johann Michael Maucher." *Waffen- und Kostümkunde* 2: 11–26.

Pfäffikon. Seedamm Kulturzentrum. 1978. *Art venitien en Suisse et au Liechtenstein*. (Exhib. cat.).

Philadelphia. Philadelphia Museum of Art. 1980. *A Scholar Collects: Selections from the Anthony Morris Clark Bequest*, by E. P. Bowron. (Exhib. cat.). 1984. *Masters of Seventeenth-Century Dutch Genre Paintings*, by P. C. Sutton and others. (Exhib. cat.).

Philippovich, E. von. 1961. *Elfenbein*. Braunschweig. 1973. "Hauptwerke des Elfenbeinkunstlers Johannes Caspar Schenck." *Kunst in Hessen und am Mittelrhein* 13: 47–51. 1981. "Eine bunte Welt aus Steinen: Steinintarsien, italienische Technik in Prager Werkstätten." *Kunst und Antiquitäten* 5 (Sept.-Oct.): 22–27. 1982. *Elfenbein*. 2d ed. Munich.

Pigler, A. 1929. *Georg Raphael Donner*. Leipzig. 1974. *Barockthemen*. Vol. 2. Budapest.

Piles, R. de. 1699. *Abregé de la vie des peintres*. Paris.

Planiscig, L. 1919. *Die estensische Kunstsammlung*. Vol. 1, *Skulpturen und Plastiken des Mittelalters und der Renaissance*. Vienna. 1921. *Venezianische Bildhauer der Renaissance*. Vienna. 1930. *Piccoli bronzi italiani del Rinascimento*. Milan.

Plietzsch, E. 1910. *Die Frankenthaler Maler*. Leipzig.

Polzer, J. 1981. "The 'Master of the Rebel Angels' Reconsidered." *Art Bulletin* 63 (Dec.): 563–84.

Poorter, N. de. 1978. *The Eucharist Series I*. Corpus Rubenianum Ludwig Burchard II, part 1. London.

Pope-Hennessy, J. 1963. "Italian Bronze Statuettes: I." *Burlington Magazine* 105 (Jan.-Feb.): 14–23, 58–69. 1964. *Catalogue of Italian Sculpture in the Victoria and Albert Museum*. London. 1965. *Renaissance Bronzes from the Samuel H. Kress Collection*. London. 1970a. *The Frick Collection: An Illustrated Catalogue*. Vol. 3, *Sculpture, Italian*. New York. 1970b. *Italian High Renaissance and Baroque Sculpture*. 2d ed. London. 1971. *Italian Renaissance Sculpture*. 2d ed. London.

Popp, A. E. 1919. Review of *Die Bronzen . . .* , by E. Tietze-Conrat. *Kunstchronik und Kunstmarkt* n.s. 30 (Apr. 18): 557–59.

Poprzecka, M. 1973. "Le paysage industriel vers 1600." *Bulletin du Musée National de Varsovie* 14: 42–51.

Posse, H. 1942. *Lucas Cranach d. Ä*. Vienna.

Pötschner, P. 1978. *Wien und die Wiener Landschaft*. Salzburg. 1981. "Der Brunnen im Hof des savoyenschen Damenstiftes in Wien." *Österreichische Zeitschrift für Kunst und Denkmalpflege* 36: 96–103.

Pötzl-Malicova, M. 1982. *Franz Xaver Messerschmidt*. Munich.

Preimesberger, R. 1969. "Ein Spätwerk Filippo Parodis in Genua." *Pantheon* 27 (Jan.): 48–51.

Princeton, N.J. Princeton University Museum of Historic Art. 1963. *The Kretzchmar von Kienbusch Collection of Armor and Arms*.

Prokop, A., and Boeheim, W. 1886. see Brünn 1886.

Providence, R.I. Brown University. Department of Art. 1975. *Rubenism*, by M. C. Volk. (Exhib. cat.).

Przyborowski, C. 1982. *Die Ausstattung der Fürstenkapelle an der Basilika von San Lorenzo in Florenz*. 2 vols. Dissertation. Berlin.

van Puyvelde, L. 1936. "Jordaen's First Dated Work." *Burlington Magazine* 69 (Nov.): 225–26. 1941. "The Young van Dyck." *Burlington Magazine* 79 (Dec.): 177–85. 1948. *Les esquisses de Rubens*. Basel. 1950. *Van Dyck*. Brussels. 1962. *La peinture flamande au siècle de Bosch et Breughel*. Paris. 1968. *La peinture flamande des van Eyck à Metsys*. Brussels.

Raczyński, J. A. G. 1937. *Die flämische Landschaft vor Rubens*. Frankfurt am Main.

Ragghianti, C. L. 1938. "La mostra di scultura italiana antica a Detroit (U.S.A.)." *Critica d'arte*, anno 3 (Aug.–Dec.): 170–83.

Ratti, C. G. 1769. *Delle vite de' pittori, scultori ed architetti genovesi*. 2d ed. Genoa.

Réau, L. 1959. *L'iconographie de l'art chrétien*. Vol. 3, *Iconographie des Saints*. Paris.

Reber, H. 1976–77. "Fröhlicher oder Rauchmüller." *Mainzer Zeitschrift* 71–72: 176–78.

Reinach, S. 1909. *Répertoire de la statuaire grecque et romain*. Vol. 2, part 2. 2d ed. Paris. 1910.

"L'homme au verre de vin." *Revue archéologique*, sér. 4, 16 (July–Dec.): 236–42.

Renger, K. 1974. "Planänderungen in Rubens-stichen." *Zeitschrift für Kunstgeschichte* 37 (1): 1–30.

Riccomini, E. 1972. *Ordine e vaghezza: Scultura in Emilia nell'età Barocca.* Bologna.

Riegel, H. 1882. *Beiträge zur niederländischen Kunstgeschichte.* 2 vols. Berlin.

Riggs, T. A. 1977. *Hieronymus Cock, Printmaker and Publisher.* New York.

van Rijsewijk, P. H. *see* Haverkorn van Rijsewijk, P.

Ring, G. 1913. *Beiträge zur Geschichte niederländischer Bildnismalerei im 15. und 16. Jahrhundert.* Leipzig. 1949. *A Century of French Painting, 1400–1500.* London. *La peinture française du XVe siècle.* Paris.

Ripa, C. 1603. *Iconologia.* Facsimile edition of the 3d ed. of 1603, Rome. With an introduction by E. Mandowsky. Hildesheim, 1970.

Robbins, D. 1972. *Landscape in the Art of Quentin Massys.* Master's thesis, Univ. of Washington. Seattle.

Robert, L. 1898. *Catalogue des collections composant le Musée d'Artillerie in 1889.* Vol. 4. Paris.

Robert-Dumesnil, A. P. F. 1865. *Le peintre-graveur français.* Vol. 9. Paris.

Rodee, H. 1967. "Rubens' Treatment of Antique Armor." *Art Bulletin* 49 (Sept.): 223–30.

Roelofsz, C. 1980. "Orpheus en de dieren van Jacob Savery." *Tableau* 2 (6): 312–16.

Roetlisberg, M. 1985. "New Works by Bartholomeus Breenbergh." *Oud Holland* 99: 57–66.

Rohde, A. 1923. *Die Geschichte der wissenschaftlichen Instrumente vom Beginn der Renaissance bis zum Ausgang des 18. Jahrhunderts.* Leipzig.

Roland, B. 1963. "Das letzte Selbstbildnis von Godfried Schalken." *Weltkunst* 33 (3): 10–11.

Roland-Michel, M. 1976. *see* Rome 1976. 1984. *see* Paris 1984a.

Roli, R. 1977. *Pittura bolognese 1650-1800 dal Cignani al Gandolfi.* Bologna.

Roman, J., ed. 1919. *Le livre de raison du peintre Hyacinthe Rigaud.* Paris.

Rome 1969. Galleria d'arte antica e gabinetto nazionale delle stampe. *Antiche armi dal sec. XI al XVIII già collezione Odescalchi,* by N. di Carpegna. (Exhib. cat.). 1976. Villa Medici. *Piranèse et les Français 1740–1790.* (Exhib. cat.).

Rooses, M. 1886–92. *L'oeuvre de P. P. Rubens.* 5 vols. Antwerp. 1890. *Rubens' Leben und Werke.* Stuttgart. 1910. "L'histoire de Decius Mus." *Rubens-bulletijn* 5: 205–15.

Rooses, M., and Ruelens, C. L., eds. 1887–1909. *Correspondence de Rubens et documents épistolaires concernant sa vie et ses oeuvres.* 6 vols. Antwerp.

Rosand, D. 1969. "Rubens' Munich *Lion Hunt:* Its Sources and Significance." *Art Bulletin* 51 (Mar.): 29–40.

Rosasco, B. 1984. "The Sculptural Decorations of the Garden of Marly: 1679–1699." In *Journal of Garden History* 4 (2).

Roselli del Turco Sassatelli, T. 1925. *San Giovanni nel deserto di Raffaello Sanzio.* Florence.

Rosenbaum, H. 1928a. "Ueber Früh-Portraits von van Dyck." *Cicerone* 20: 325–32, 364–65. 1928b. *Der junge van Dyck.* Munich.

Rosenberg, A. 1921. *P. P. Rubens: Des Meisters Gemälde.* 4th ed. Edited by R. Oldenbourg. Klassiker der Kunst, vol. 5. Stuttgart.

Rosenberg, J. 1954. "A Drawing by Lucas Cranach the Elder." *Art Quarterly* 17 (3): 281–85.

Rosenberg, J.; Slive, S.; and ter Kuile, E. H. 1966. *Dutch Art and Architecture, 1600–1800.* Baltimore.

Rosenberg, M. 1928. *Der Goldschmiede Merkzeichen.* Vol. 4. 3d ed. Berlin.

Rosenberg, P. 1968. *see* Florence 1968.

Rosenberg, P., and Bergot, F. 1981. *see* Washington, D.C. 1981.

Rothlisberger, M. 1981. *Bartholomeus Breenbergh: The Paintings.* Berlin.

Rotondi, P. 1959. "La prima attività di Filippo Parodi scultore." *Arte antica e moderna* 5: 63–73.

Rotondo Briasco, P. 1962. *Filippo Parodi.* Genoa.

Rotterdam. Museum Boymans-von Beuningen. 1953. *Olieverfschetsen van Rubens.* (Exhib. cat.).

Röttger, B. H. 1931. "Hans Müelich." In Thieme-Becker 25: 212–13.

Roworth, W. W. 1984. "Angelica Kauffman's *Memorandum of Paintings.*" *Burlington Magazine* 126 (Oct.): 629–30.

Rückert, R. 1966. *see* Munich 1966.

Russell, R. 1968. *Catalogue of Musical Instruments: Victoria and Albert Museum.* London.

Rutledge, A. W. 1949. "Robert Gilmor, Jr.: Baltimore Collector." *Journal of the Walters Art Gallery* 12: 18–39.

Salvini, R. 1958. *La pittura fiamminga.* Milan.

Salzburg. Salzburger Residenzgalerie. 1955. *Katalog der Residenzgalerie Salzburg mit Sammlung Czernin.* 1969. *see* Cat. 1969.

Sankt Florian. Augustinerchorherrenstift. 1965. *Die Kunst der Donauschule 1490–1540.* (Exhib. cat.). Linz.

Sarasota, Fla. The John and Mabel Ringling Museum of Art. 1980. *Catalogue of the Flemish and Dutch Paintings 1400–1900,* by F. W. Robinson and W. H. Wilson.

Sartori, A. 1962. "Il Santuario delle reliquie della basilica del Santo a Padova." *Il Santo* 2: 141–205.

Schädler, A. 1973. *Georg Petel 1601/2–1634.* Berlin.

Schaeffer, A. 1897. Letter, dated March 7.

Schaeffer, E. 1909. *Van Dyck: Des Meisters Gemälde.* Stuttgart.

Schalkhausser, E. 1966. "Die Handfeuerwaffen des Bayerischen Nationalmuseums." *Waffen und Kostümkunde* n.s. 8: 1–12.

Schallaburg. Schloss. 1982. *Matthias Corvinus und die Renaissance in Ungarn, 1458–1541.* (Exhib. cat.).

Schedelmann, H. 1940–44. "Der Büchsenmacher Hans Keiner als Meister deutschen Eisenschnitts." *Zeitschrift für historische Waffen- und Kostümkunde,* n.s. 7: 149–50. 1944. *Die Wiener Büchsenmacher und Büchsenschäfter.* Berlin. 1963. "Die Trabantenwaffen der Salzburger Erzbischöfe." *Salzburger Carolino Augusteum-Jahresschrift* 9: 35–41. 1972. *Die Grossen Büchsenmacher.* Brunswick. 1973. "The Master of the Animal-Head Scrolls." In *Arms and Armor Annual* 1.

Scheibler, L. 1887. "Ueber altdeutsche Gemälde in der Kaiserlichen Galerie zu Wien." *Repertorium für Kunstwissenschaft* 10: 271–305. 1904. "Die kunsthistorische Ausstellung zu Düsseldorf 1904: Die altniederländischen und altdeutschen Gemälde." *Repertorium für Kunstwissenschaft* 27: 524–73.

Scherer, C. H. 1897. *Studien zur Elfenbeinplastik der Barockzeit.* Strassburg. 1905. *Elfenbeinplastik.* Leipzig.

Schestag, F. 1872. *Katalog der Kunstsammlung Freiherr Anselm von Rothschild.* Vol. 2. Vienna.

Schikola, G. 1970. "Wiener Plastik der Renaissance und des Barock." In *Geschichte der bildenden Kunst in Wien, Plastik in Wien* n.s. 7 (1).

Schlegel, U. 1976. "Der Kenotaph des Jacob von Hase von François Duquesnoy." *Jahrbuch der Berliner Museen* 18: 134–54.

Schlosser, J. 1910. *Werke der Kleinplastik in der Skulpturensammlung des A. H. Kaiserhauses.* Vol. 1. Vienna.

Schnackenburg, B. 1970. "Die Anfänge des Bauerninterieurs bei Adriaen van Ostade." *Oud Holland* 85: 158–69.

Schneider, A. von. 1923–24. "Neue Zuschreibungen an Matthias Stomer." *Oud Holland* 41: 225–30. 1933. *Caravaggio und die Niederländer.* Marburg.

Schöne, W. 1939. *Die grossen Meister der niederländischen Malerei des 15. Jahrhunderts: Hubert van Eyck bis Quentin Massys.* Leipzig.

Schubring, P. 1915. *Cassoni.* Leipzig.

Schultze, H. 1911. *Die Werke Angelo Bronzinos.* Strassburg.

Schulz, F. T. 1940. "Lucas van Valckenborch." In Thieme-Becker 34: 49–50.

Schwarzenberg, E. 1969. "From the *Alessandro Moriente* to the Alexandre Richelieu: The Portraiture of Alexander the Great in Seventeenth-Century Italy and France." *Journal of the Warburg and Courtauld Institutes* 32: 398–405.

Sedlmayr, H. 1956. *Johann Bernhard Fischer von Erlach.* Vienna.

Segal, S. 1982a. "The Flower Pieces of Roelandt Savery." *Leids kunsthistorische jaarboek:* 309–37. 1982b. *see* Amsterdam 1982. 1983. "The Symbolic Meaning of Fruits." In *A Fruitful Past.* (Exhib. cat.). Amsterdam.

Seidlitz, W. von. 1911. "Canaletto." In Thieme-Becker 5: 487–89.

Seilern, A. *see* London 1955 and 1971.

Semenzato, C. 1957. "Due busti di Filippo Parodi." *Emporium* 126 (Dec.): 254–56.

Seneca, L. A. 1965. *Ad Lucilium epistolae morales.* Edited by L. D. Reynolds. Oxford.

Sentenac, P. 1929. *Hubert Robert.* Paris.

Sesti, E. 1983. *see* Urbino 1983.

Seznec, J. 1953. *The Survival of the Pagan Gods.* New York.

Sheard, W. S. 1978. *see* Northampton 1978.

Shearman, J. 1972. *Raphael's Cartoons in the Collection of Her Majesty the Queen and the Tapestries for the Sistine Chapel.* London. 1983. *The Early Italian Pictures in the Collection of Her Majesty the Queen.* Cambridge.

Shoemaker, I. H., and Brown, E. 1981. *see* Lawrence, Kansas 1981.

Siebmacher, J. 1605. *Neu Wapenbuch.* Nuremberg.

Silius Italicus, T. C. 1934. *Punica.* Translated by J. D. Duff. London.

Silver, L. 1983. "Forest Primeval: Albrecht Altdorfer and the German Wilderness Landscape." *Simiolus* 13 (1): 4–43. 1984. *The Paintings of Quinten Massys with a Catalogue Raisonné.* Montclair, N.J.

Simson, O. von. 1936. *Zur Genealogie der weltlichen Apotheose im Barock, besonders der Medici-Galerie des P. P. Rubens.* Strasbourg.

Šíp, J. 1973. "Savery in and around Prague." *Bulletin du Musée national de Varsovie* 14: 69–75.

Slive, S. 1970–74. *Frans Hals.* 3 vols. London.

Smith, J. 1829–37. *A Catalogue Raisonné of the Works of the Most Eminent Dutch, Flemish, and French Painters.* 8 vols. London.

Sobotka, G. 1914. "Frans Duquesnoy." In Thieme-Becker 10: 188–93.

Sommer, H. 1920. *Die Laute.* Berlin.

Souchal, F. 1973. "La collection du sculpteur Girardon d'après son inventaire après décès." *Gazette des Beaux-Arts*, sér. 6, 82 (July): 1–98.

Spear, R. E. 1982. *Domenichino*. New Haven.

Spicer, J. 1979. *The Drawings of Roelandt Savery*. Dissertation. New Haven.

Spickernagel, E. 1979. "Holländische Dorflandschaften im frühen 17. Jahrhundert." *Städel-Jahrbuch* 7: 133–48.

Sricchia Santoro, F. 1963. "Per il Franciabigio." *Paragone* 163 (July): 3–23.

Stalker, J., and Parker, G. 1688. *Treatise of Japanning and Varnishing*. Oxford.

Stange, A. 1957. *Deutsche Malerei der Gotik*. Vol. 8, *Schwaben in der Zeit von 1450 bis 1500*. Munich. 1964. *Malerei der Donauschule*. Munich.

Stechow, W. 1930. "Bartholomeus Breenbergh: Landschafts- und Historienmaler." *Jahrbuch der Preussischen Kunstsammlungen* 51 (2–3): 133–40. 1963. "The Finding of Erichthonius: An Ancient Theme in Baroque Art." In *Studies in Western Art*, vol. 3. Acts of the 20th International Congress for the Study of Art History. Princeton. 1966. *Dutch Landscape Painting of the Seventeenth Century*. London. 1967. "Erichthon(ius)." In *Reallexikon zur deutschen Kunstgeschichte*, 5: cols. 1241–44. 1968. *Rubens and the Classical Tradition*. Cambridge, Mass. 1973. "A River Landscape by Salomon van Ruysdael." *Bulletin of The Cleveland Museum of Art* 60 (Sept): 222–31. 1975. *Salomon van Ruysdael: Eine Einführung in seine Kunst, mit kritischen Katalog der Gemälde*. 2d ed. Berlin.

Sterling, C. 1933. *see* Paris 1933. 1938. *La peinture française: Les primitifs*. Paris. 1941. *La peinture française: Les peintres du Moyen-âge*. Paris. 1946. Review of *Jean Fouquet und seine Zeit* by P. R. Wescher. *Art Bulletin* 28 (June): 125–31. 1973. "Tableaux espagnols et un chef d'oeuvre portugais méconnus du XVe siècle." In *Actas del XXIII Congreso internacional de historia del arte* 1: 518–24. Grenada. 1984. "À la recherche des oeuvres de Zanetto Bugatto: Une nouvelle piste." In *Scritti di storia dell'arte in onore di Federico Zeri*: 163–78. Milan.

Stix, A., and Strohmer, E. von. 1938a. *Die Fürstlich Liechtensteinische Gemäldegalerie in Wien*. Vienna. 1938b. *Die Fürstlich Liechtensteinischen Kunstkammer*. Vienna.

Støckel, J. F. 1938–43. *Haandskydevaabens Bedømmelse*. 2 vols. Copenhagen.

Stockerau 1902. *Katalog der historischen Ausstellung für Jagd- und Schützenwesen*. (Exhib. cat.).

Stöcklein, H. 1922. "Das Meisterwerk des Armand Bongard." *Belvedere* 1: 95–98.

Stone, R. E. 1982. "Antico and the Development of Bronze Casting in Italy at the End of the Quattrocento." *Metropolitan Museum Journal* 16 (1981): 87–116.

Strauss, W. 1981. *The Intaglio Prints of Albrecht Dürer*. New York.

Strohmer, E. von. 1943a. *Die Gemäldegalerie des Fürsten von Liechtenstein in Wien*. Vienna. 1943b. "Der Meister von 1456 in der Galerie Liechtenstein in Wien." *Pantheon* 31 (Feb.): 25–34. 1947–48. "Bemerkungen zu den Werken des Adriaen de Vries." *Nationalmusei Årsbok*: 93–138. Stockholm.

Stubblebine, J. 1969. "Segna di Buonaventura and the Image of the Man of Sorrows." *Gesta* 8 (2): 3–13.

Sturm, H. 1961. *Egerer Reliefintarsien*. Prague.

Suida, W. 1890. *Die Gemäldegalerie der K. K. Akademie der Bildenden Künste: Die Sammlungen Liechtenstein, Czernin, Harrach und Schönborn-Buchheim*. Stuttgart. 1934–36. "Beiträge zu Raffael." *Belvedere* 12: 161–67.

Sullivan, S. A. 1984. *The Dutch Gamepiece*. Montclair.

Susini, G. F. 1618. *Disegni e misure e regole d'attitudine del corpo umano*. Biblioteca Nazionale. Fondo Magliabecchiano, 14. Florence.

Sutton, P. C. 1984. *see* Philadelphia 1984.

Szendrei, J. 1896. *Ungarische Kriegsgeschichtliche Denkmäler in der Millenniums-Landes-Ausstellung*. Budapest.

Theuerkauff, C. 1964. *Studien zur Elfenbeinplastik des Barock: Matthias Rauchmiller und Ignaz Elhafen*. Dissertation. Freiburg. 1965. "Der Elfenbeinbildhauer Adam Lenckhardt." *Jahrbuch der Hamburger Kunstsammlungen* 10: 27–70. 1968. "Der 'Helffenbeinarbeiter' Ignaz Elhafen." *Wiener Jahrbuch für Kunstgeschichte* 21: 92–157. 1971. "Scultura barocca in avorio: Nuove attribuzioni ad Adam Lenckhardt ed a Dominicus Stainhart." *Antichità viva* 10 (2): 33–51. 1973. "Zum Werk des Monogrammisten B. G. (vor 1662–nach 1680)." *Aachener Kunstblatter* 44: 245–46. 1983. "Jacob Auer 'Bildhauer in Grins'." *Pantheon* 41 (3): 194–208.

Thieme, U. 1892. *Hans Leonhard Schaeufeleins malerische Thätigkeit*. Leipzig.

Thieme, U., and Becker, F. 1907–1950. *Allgemeines Lexikon der bildenden Künstler*. 37 vols. Leipzig.

Thiéry, Y. 1953. *Le paysage flamand au XVIIe siècle*. Brussels. 1967. "Notes au sujet des paysages de Josse de Momper II." *Musées Royaux des Beaux-Arts de Belgique bulletin* 16: 233–46.

Thomas, B. 1941. "Die Beraubung der Wiener und Ambraser Rüstkammer durch die Franzosen 1805 und 1806." In *Liste der 1940 aus Frankreich zurückgeführten militärischen Gegenstände*: 189–94. Berlin. 1969. "Zwei Vorzeichnungen zu kaiserlichen Gardestangenwaffen von Hans Stromaier 1577 und Johann Bernard Fischer von Erlach 1705." *Jahrbuch der Kunsthistorischen Sammlungen in Wien* 65: 61–78.

Tietze, H. 1919. "Domenico Martinelli und seine Tätigkeit in Österreich." *Jahrbuch des Kunsthistorischen Institutes, Wien* 13: 1–46. 1926. *Alt-Wien in Wort und Bild: Vom Ausgang des Mittelalters bis zum Ende des XVIII. Jahrhunderts*. Vienna.

Tietze-Conrat, E. 1910. "Johann Georg Dorfmeister." *Kunstgeschichtliches Jahrbuch der K. K. Zentralkommission für Erforschung und Erhaltung der Kunst- und historischen Denkmale* 4: 228–44. 1918. *Die Bronzen der Fürstlichen Liechtensteinischen Kunstkammer*. Vienna. 1920–21. "Die Erfindung in Relief: Ein Beitrag zur Geschichte der Kleinkunst." *Jahrbuch der Kunsthistorischen Sammlungen in Wien* 35: 99–176.

Toman, H. 1888. "Ueber die Malerfamilie de Heem." *Repertorium für Kunstwissenschaft* 11: 123–46.

Torriti, P. 1975. *Pietro Tacca da Carrara*. Genoa.

Trapp, J. B., and Herbrüggen, H. S. 1977. *see* London 1977.

Treffers, B. 1974. *see* Van Os and Prakken 1974.

Trost, A. 1947. *Canalettos Wiener Ansichten*. Vienna.

Ulm. Museum der Stadt Ulm. 1967. *Johann Heinrich Schönfeld: Bilder, Zeichnungen, Graphik*. (Exhib. cat.).

Urbino. Palazzo Ducale. 1983. *Urbino e le Marche prima e dopo Raffaello*. (Exhib. cat.).

Vaduz 1952, 1967, and 1972. *see* Cat. 1952, Cat. 1967, and Cat. 1972.

Valentiner, W. R. 1950. "Van Dyck's Character." *Art Quarterly* 13 (2): 86–105.

Varshavskaya, M. 1975. *Rubens's Paintings in the Hermitage Museum*. [In Russian] Leningrad.

Vasari, G.—Milanesi, G. 1906. *La vite de' piu eccellenti pittori, scultori ed architettori*. Edited by G. Milanesi. Vol. 3. Florence.

Vecchi, P. de. 1966. *L'opera completa di Raffaello*. Milan. 1981. *Raffaello: La pittura*. Florence.

van de Velde, C. 1975. *Frans Floris (1519/20–1570): Leven en Werken*. Brussels.

Venturi, A. 1911. *Storia dell'arte italiana*. Vol. 7, *La pittura del quattrocento*, part 1. Milan. 1913. Bollettino bibliografico. *L'arte* 16: 479. 1914. *Storia dell'arte italiana*. Vol. 7, *La pittura del quattrocento*, part 3. Milan. 1925. *Storia dell'arte italiana*. Vol. 9, *La pittura del cinquecento*, part 1. Milan. 1935. *Storia dell'arte italiana*, Vol. 10, *La scultura del cinquecento*, part 1. Milan. 1937. *Storia dell'arte italiana*. Vol. 10, *La scultura del cinquecento*, part 3. Milan.

Verdier, P. 1967. *Catalogue of the Painted Enamels of the Renaissance*. Walters Art Gallery, Baltimore.

Vergara, L. 1982. *Rubens and the Poetics of Landscape*. New Haven.

Vienna 1885. *see* Cat. 1885. 1904. Museum für Kunst und Industrie. *Ausstellung von alt-Wiener Porzellan*. (Exhib. cat.). 1925. Dorotheum Kunstauktionhaus. *Doubleten der Ehem. K. K. Österreicheschen Hofgewehrkammer*. (Sales cat. of Nov. 26–28). 1930. Verein der Museumsfreunde in Wien. *Katalog der Maria-Theresia-Ausstellung*. (Exhib. cat.). 1965. Belvedere. *Bernardo Bellotto genannt Canaletto*. (Exhib. cat.). 1970. Österreichisches Museum für angewandte Kunst. *Wiener Porzellan 1718–1864*, by W. Mrazek and W. Neuwirth. (Exhib. cat.). 1977a. *Peter Paul Rubens (1577–1640)*. (Exhib. cat.). 1977b. Kunsthistorisches Museum. *Der goldene Wagen des Fürsten Joseph Wenzel von Liechtenstein*. (Exhib. cat.). 1977c. *Die Rubenszeichnungen der Albertina*. (Exhib. cat.). 1978. Kunsthistorisches Museum. *Giambologna, 1529–1608: Ein Wendepunkt der europäischen Plastik*. (Exhib. cat.). 1980. Kunsthistorisches Museum. *Maria Theresia und ihre Zeit*. 2 vols. (Exhib. cat.). 1983a. Galerie Sanct Lucas. *Gemälde alter Meister: Winter 1983/84*. (Exhib. cat.). 1983b. Historisches Museum der Stadt Wien. *Die Turken vor Wien*. (Exhib. cat.).

Vignau-Schuurman, T. A. G. W. 1969. *Die emblematischen Elemente im Werke Joris Hoefnagels*. Leiden.

Vitry, P. 1904. "Zur Ausstellung französischer Primitiver: Einiges über Jean Fouquet und den Meister von Moulins." *Zeitschrift für bildende Kunst* n.s. 15: 290–96. 1922. *Catalogue des sculptures du Moyen âge, de la Renaissance et des temps modernes*. Vol. 1, *Moyen âge et Renaissance*. Paris.

Vlieghe, H. 1961–66. "David II Teniers (1610–1690) en het Hof van Aartshertog Leopold-Wilhelm en Don Juan van Ostenrijk—1647–1659." *Gentse Bijdragen* 19: 123–48. 1972. *Saints I. Corpus Rubenianum Ludwig Burchard part 8*. London. 1977. *De schilder Rubens*. Utrecht.

Volk, M. C. 1975. *see* Providence, R.I. 1975.

Vollmer, H. 1934. "Rigaud." In Thieme-Becker 28: 349–51. 1950. "Meister von 1456." In Thieme-Becker 37: 366–67.

Volpe, C. 1959. *see* Bologna 1959.

Voss, H. 1907. *Der Ursprung des Donaustils: Ein Stück Entwickelungsgeschichte deutscher Malerei*. Leipzig. 1908. "Charakterköpfe des seicento II."

Monatshefte für Kunstwissenschaft 1: 987–99. **1924.** *Die Malerei des Barock in Rom.* Berlin. **1961.** *Die grosse Jagd.* Munich. **1964.** *Johann Heinrich Schönfeld: Ein schwäbischer Maler des 17. Jahrhunderts.* Biberach an der Riss.

Waagen, G. F. 1862. *Handbuch der deutschen und niederländischen Malerschulen.* 2 vols. Stuttgart. **1866.** *Die vornehmsten Kunstdenkmäler in Wien.* Part 1, *Die K. K. Gemälde-Sammlungen im Schloss Belvedere und in der K. K. Kunst-Akademie, die privat Sammlungen.* Vienna.

van de Waal, H. 1942. "De zoons van Cornelis Engelbrechtsz. of Jan de Cock, alias 'Jan van Leyen?': Een kleine bijdrage tot een groot probleem." In *Aan M. J. Friedländer, 1867–5 juni 1942.* The Hague.

Wackernagel, R. 1966. *Der Französische Krönungswagen von 1696–1825.* Berlin. **1976.** *see* Munich 1976.

Walcha, O. 1981. *Meissen Porcelain.* New York.

Washington, D.C. 1973. National Gallery of Art. *Early Italian Engravings from the National Gallery of Art,* by J. A. Levenson, K. Oberhuber, and J. L. Sheehan. (Exhib. cat.). **1976.** National Gallery of Art. *Titian and the Venetian Woodcut,* by D. Rosand and M. Muraro. (Exhib. cat.). **1978.** National Gallery of Art. *Hubert Robert: Drawings and Watercolors,* by V. Carlson. (Exhib. cat.). **1981.** International Exhibitions Foundation. *French Master Drawings from the Rouen Museum from Caron to Delacroix,* by P. Rosenberg and F. Bergot. (Exhib. cat.).

Waterhouse, E. 1962. *Painting in Britain 1530 to 1790.* Baltimore.

Watson, K. 1978. "Sugar Sculpture for Grand Ducal Weddings from the Giambologna Workshop." *Connoisseur* 199 (Sept.): 20–26. **1983.** *Pietro Tacca, Successor to Giovanni Bologna.* New York.

Ważbiński, Z. 1983. "Adriano de Vries e la sua scuola di scultura in Praga: Contributo alla diffusione dell'accademismo fiorentino in Europa alla fine del XVI e inizio XVII secolo." *Artibus et historia* 4 (7): 41–67.

Weihrauch, H. 1967. *Europäische Bronzestatuetten 15.–18. Jahrhundert.* Brunswick.

Weisz, L. 1950. "Die ältesten Darstellungen der Eisenerzeugung in der Kunst." *Von Roll Werkzeitung* 21: 42–48.

Weller, A. S. 1943. *Francesco di Giorgio 1439–1501.* Chicago.

Welu, J. A. 1983. *see* Worcester 1983.

Wescher, P. R. 1945. *Jean Fouquet und seine Zeit.* Basel. (Eng. ed.: *Jean Fouquet and His Time,* New York, 1947; French ed.: *Jean Fouquet et son temps,* Basel, 1947.) **1946.** *see* Sterling 1946.

Wethey, H. E. 1969. *The Paintings of Titian.* London.

White, C. 1982. *The Dutch Pictures in the Collection of Her Majesty the Queen.* Cambridge.

Wied, A. 1971. "Lucas van Valckenborch." *Jahrbuch der Kunsthistorischen Sammlungen in Wien* 67: 119–231.

van den Wijngaert, F. 1943. *Antoon van Dyck.* Antwerp.

Wilenski, R. H. 1960. *Flemish Painters 1430–1830.* London.

Wilhelm, F. 1911. "Neue Quellen zur Geschichte des Fürstlich Liechtensteinischen Kunstbesitzes." *Jahrbuch des Kunsthistorischen Instituts der K. K. Zentralkommission für Denkmalpflege* 5, Beiblatt: 88–142. **1914.** "Bericht über kunstgeschichtliche Funde im Hausarchiv der Regierendes Fürsten von Liechtenstein." *Jahrbuch des Kunsthistorischen Instituts der K. K. Zentralkommission für Denkmalpflege* 8, Beiblatt: 37–50. **1916.** "Marco Antonio Franceschini." In Thieme-Becker 12: 298–300.

Wilhelm, G. 1947–50. "Fürst Karl von Liechtenstein und seine genealogischen und heraldischen Bestrebungen (Die Entwicklung des Wappens der Fürsten von Liechtenstein)." In *Neues Jahrbuch der Heraldisch-Genealogischen Gesellschaft "Adler"* 2. **1948.** *see* Cat. 1948. **1960.** "Der historische Liechtensteinische Herzogshut." *Jahrbuch des Historischen Vereins für das Fürstentum Liechtenstein* 60: 7–20. **1970.** "Die Rüstkammer des Fürsten Johann Adam Andreas von Liechtenstein (1662–1712) im Schlosse Feldsberg." In *Jahrbuch des Historischen Vereins für das Fürstentum Liechtenstein* 70. **1972.** *see* Cat. 1972. **1974.** *see* Cat. 1974. **1975.** "Die Reise des Fürsten Josef Wenzel von Liechtenstein nach Parma im Jahre 1760." *Jahrbuch des Historischen Vereins für das Fürstentum Liechtenstein* 75: XXVII–XLVIII. **1976.** "Die Fürsten von Liechtenstein und ihre Beziehungen zu Kunst und Wissenschaft." *Jahrbuch der Liechtensteinischen Kunstgesellschaft* 1: 9–179.

Williamson, G. C. 1901. *Francesco Raibolini, called Francia.* London.

Willis, F. C. 1911. *Die Niederländische Marinemalerei.* Leipzig. **1921.** "Gonçalves." In Thieme-Becker 14: 366–67.

Winkler, F. 1924. *Die altniederländische Malerei.* Berlin. **1941.** *Altdeutsche Tafelmalerei.* Munich.

Winner, M. 1961. "Zeichnungen des älteren Jan Brueghel." *Jahrbuch der Berliner Museen* 3 (2): 190–241. **1975.** *see* Berlin 1975. **1977.** *Peter Paul Rubens: Kritischer Katalog der Zeichnungen.* Berlin. **1981.** "Zu Rubens' *Eberjagd* in Dresden (Landschaft oder Historienbild)." In Munich. *Peter Paul Rubens: Werk und Nachruhm.*

Wittkower, R. 1938. "Chance, Time, and Virtue." *Journal of the Warburg Institute* 1: 313–21. **1981.** *Gian Lorenzo Bernini: The Sculptor of the Roman Baroque.* 3d ed. Oxford.

Woeckel, G. 1964. "Paul Troger und die österreichische Barockkunst: Zur Ausstellung in Stift Altenburg." *Kunstchronik* 17 (Feb.): 29–35. **1967.** "Meisterwerke aus Privatsammlungen im Bodenseegebiet: Zur Ausstellung im Künstlerhaus, Bregenz, Palais Thurn und Taxis." *Pantheon* 25 (Nov.-Dec.): 468–69.

Woltmann, A., and Woermann, K. 1887. *History of Painting.* Vol. 2, *The Painting of the Renascence.* Translated by C. Bell. London.

Worcester, Mass. Worcester Art Museum. 1983. *The Collector's Cabinet: Flemish Paintings from New England Private Collections,* by J. A. Welu. (Exhib. cat.).

Wurzbach, A. von. 1906–1911. *Niederländisches Künstler-Lexikon.* 3 vols. Vienna.

Zadoks Josephus Jitta, A. N. 1972. "A Creative Misunderstanding." *Nederlands kunsthistorisch jaarboek* 23: 3–12.

Zambotti, B. 1935. *Diario ferrarese dell' anno 1409 sino al 1502.* Edited by G. Pardi. Bologna.

Zanotti, G. P. C. 1739. *Storia dell'Accademia Clementina.* 2 vols. Bologna.

Zastrow, O. 1978. *Museo d'Arti Applicate: Gli avori.* Milan.

Zeri, F. 1959. "Rivedendo Piero di Cosimo." *Paragone* 115 (July): 36–50.

Zerner, H. 1969. *The School of Fontainebleau: Etchings and Engravings.* Translated by Stanley Baron. New York.

Zimmer, J. 1967. *Joseph Heintz der Ältere als Maler (1564–1609).* Dissertation. Heidelberg.

Zimmermann, H. 1910. "Auszüge aus den Hofzahlamtsrechnungen in der K. K. Hofbibliothek." *Jahrbuch der Kunsthistorischen Sammlungen des Allerhöchsten Kaiserhauses* 29 (2): I–XLVI. **1965.** "Drei Chiaroscuro-Bilder von Andrea Mantegna." *Pantheon* 23: 17–21.

Zinner, E. 1925. *Verzeichnis der astronomischen Handschriften des deutschen Kulturgebietes.* Munich. **1956.** *Deutsche und niederländische astronomische Instrumente des 11.–18. Jahrhunderts.* Munich.

Zobi, A. 1841. *Notizie storiche riguardanti l'Imperiale e Reale Stabilimento dei lavori di commesso in pietre dure di Firenze.* Florence.

Zoege von Manteuffel *see* Manteuffel.

Zurich 1953. Kunsthaus. *Holländer des 17. Jahrhunderts.* (Exhib. cat.). **1979.** Galerie Koller. *The Ernst Brummer Collection: I.* (Exhib. cat.).

INDEX OF ARTISTS